EARTH FROM ABOVE

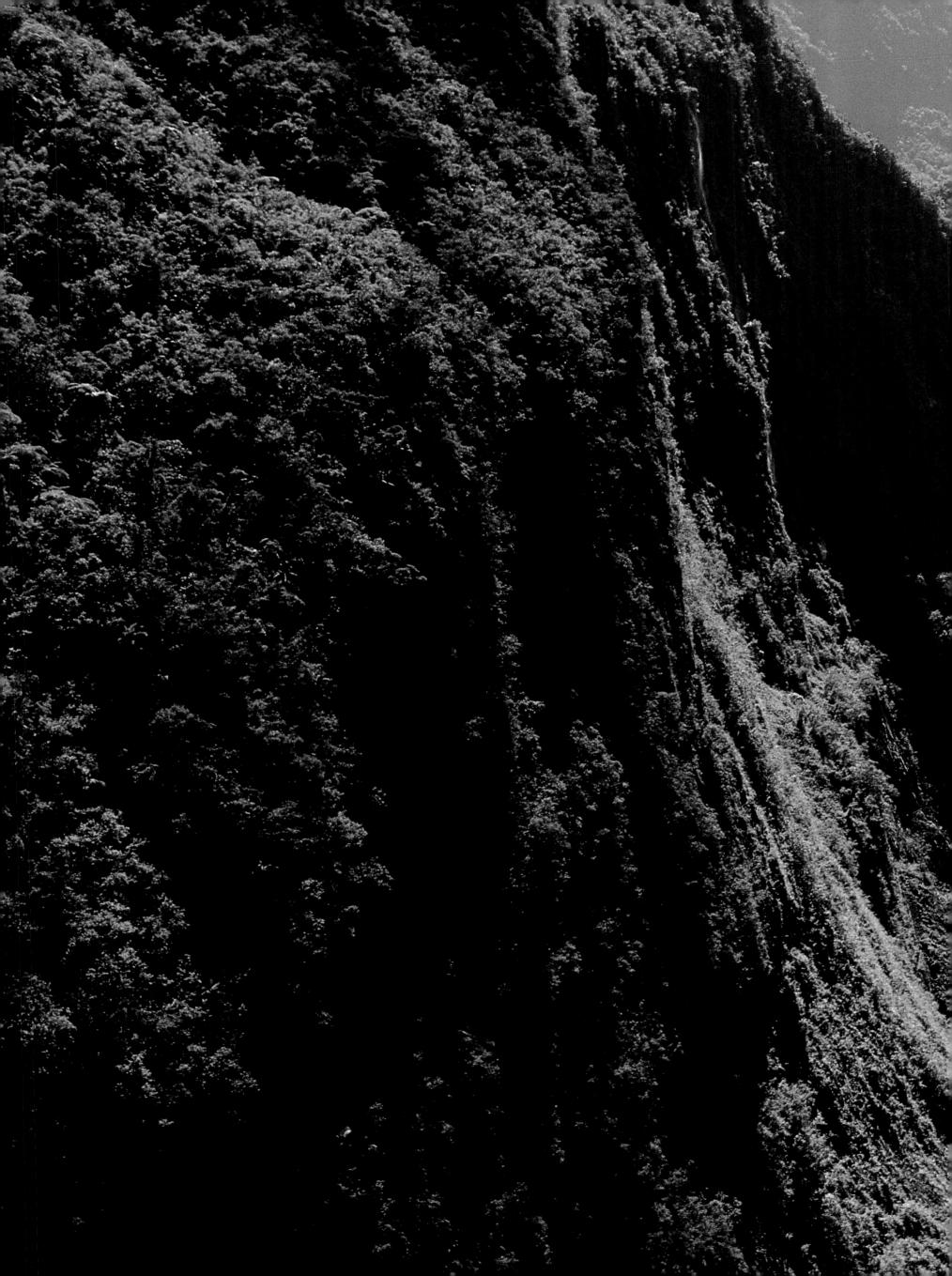

by Yann Arthus-Bertrand

with text by editors of the annual L'état du monde (Éditions La Découverte)

translated from the French by David Baker

Harry N. Abrams, Inc., Publishers For Anne, Tom, Guillaume, and Baptiste. With affection.

This vision of the world could not have been possible without the aid of UNESCO, Fujifilm, Corbis, and Air France.

I am grateful for their confidence and friendship.

Project Manager, English-language edition: Eric Himmel Editor, English-language edition: Nicole Columbus Designer, English-language edition: Tina Thompson

Library of Congress Cataloging-in-Publication Data

Arthus-Bertrand, Yann.
[Terre vue du ciel. English]
Earth from above / photographs by Yann Arthus-Bertrand; with essays by Sophie Bessis ... [et al.]; captions by Astrid Avundo and Frédéric Marchand.
p. cm.

Includes bibliographical references (p.).
ISBN 0-8109-3267-9

1. Aerial photography. 2. Arthus-Bertrand, Yann.
I. Bessis, Sophie, 1947- . II. Title.
TR810.A7713 1999
779°.36°092—dc21 99–23917

English translation copyright © 1999 Harry N. Abrams, Inc., and Thames & Hudson, Ltd. Copyright © 1999 Éditions de La Martinière (Paris, France) Published in 1999 by Harry N. Abrams, Incorporated, New York All rights reserved. No part of the contents of this book may be reproduced without the written permission of the publisher

Printed and bound in France

Yann Arthus-Bertrand has accompanied me throughout my twenty years as a publisher. In 1979 I published his first book at Hachette Réalités. He and his wife, Anne, had just returned from Kenya, where they had lived for two years, and his photographs of lions caused a sensation. Since then, not a year has passed without our publishing one or more books together. I have watched this tireless and talented photographer develop, as he continually crisscrossed the globe in search of humankind—and himself.

Earth from Above represents the end of a journey to which Yann has devoted so much of himself. Ten years of work, hundreds of thousands of miles traveled and photographs taken, stepping out of one airplane and into another, from one country to another, playing with time zones. But all of this would amount to nothing if it were not for his incomparable eye: an eye that always finds the detail to make a photograph more beautiful, an eye that understands and investigates people and places.

This book is not simply a series of pictures. It is the testimony of a citizen of the world at the dawn of the third millennium, who is eager to show his vision of the earth, its beauty as well as its failures. His enthusiasm is coupled with a concern about the transformation of this planet. The texts that accompany these dazzling photographs are a necessary counterpoint, offering an inventory of the earth today.

But the book is not an end in itself. In fact, it is just a beginning. Yann will continue to enrich his record of the world until he leaves it. Who knows, perhaps he will then begin to photograph the next world—a project that he will have eternity to complete.

Yann is not only a photographer whom I admire; he is also my friend. I know him better than anyone, and I can testify to the charismatic force of his personality. This is clear from this work itself, which required the participation of an incredible number of people. Yann recruited and challenged them, and they responded to him.

The following pages are the most wonderful way he could have thanked them.

Hervé de La Martinière Managing Director, La Martinière Groupe

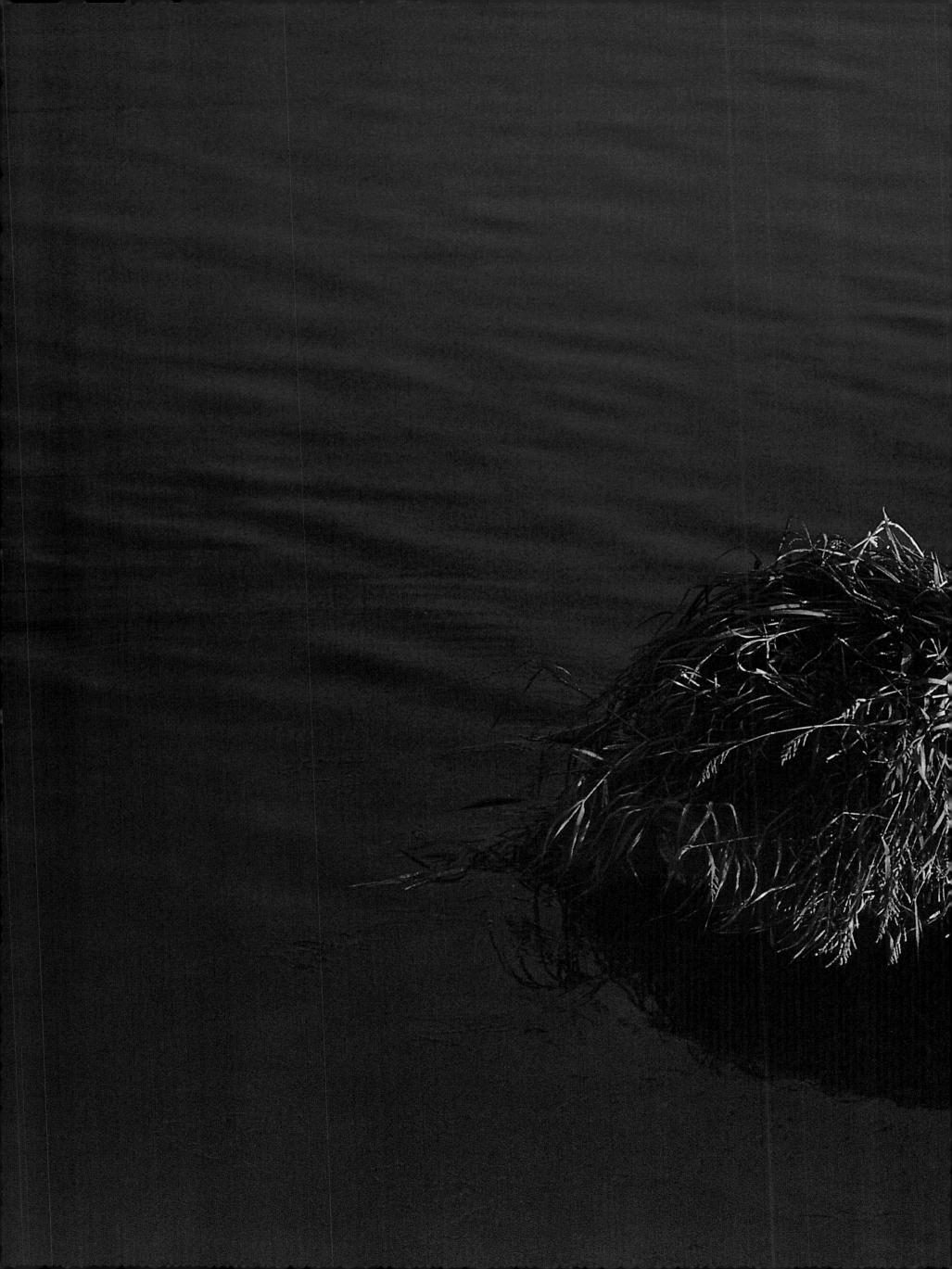

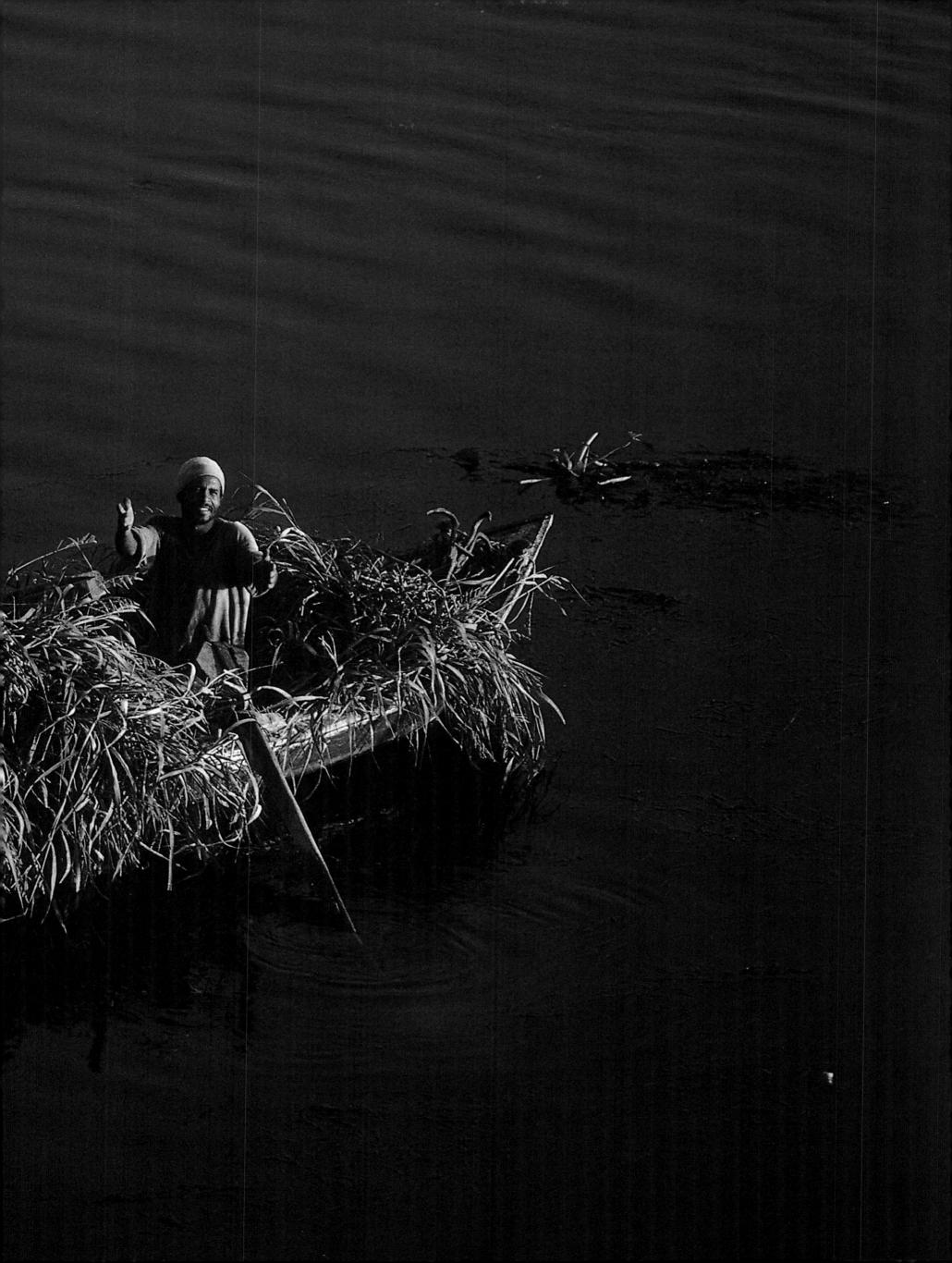

CONTENTS

Title page GORGES OF THE BRAS DE CAVERNE, Island of Réunion, France

Access to the interior of Réunion is made difficult by the numerous gorges of the Bras de Caverne River, which cuts its bed through the volcanic breaks of the Cirque de Salazie. Certain sites were not explored until quite recently, such as the Trou de Fer (Iron Hole), a ravine 820 feet (250 m) deep that was first explored in 1989. Thus preserved from human interference, the tropical forest on the volcanic relief of the island has maintained its primal condition, featuring giant thorns, ferns, and lichens; the forest at lower altitudes has been converted into agricultural or urban regions and has disappeared. More than thirty animal or vegetable species, including approximately twenty that were endemic to the island, have become extinct here in the past four centuries. Island systems have tremendous biological diversity, but they usually experience a higher rate of species extinction.

Previous spread BOAT ON THE NILE, Egypt

The world's second-longest river, the Nile travels through Sudan and Egypt for 4,140 miles (6,671 km). It serves as a means of transport for luxury cruise ships as well as modest boats holding grains. The Nile is the country's main source of water, supplying 90 percent of the water for consumption. At one time the Nile's annual floods only guaranteed available water for three to four months, but the building of the Aswan Dam in the 1960s regulated the river's rate of flow, providing Egypt with water throughout the year. The dam, however, has created major ecological problems: it deprives the river of the silt that fertilized the soil and offset marine erosion of the delta, which is today retreating at a rate between 100 and 650 feet (30 to 200 m) per year.

- 5 Foreword

 Hervé de La Martinière
- 9 THE STATE OF THE WORLD IN THE YEAR 2000 Serge Cordellier
- 49 FROM THE PALEOLITHIC AGE TO GLOBALIZATION Pierre Gentelle
- 89 NATURE AND CULTURE Pierre Gentelle
- 129 TRACES, RUINS, MEMORY Pierre Gentelle
- 169 SPECTACLES AND LANDSCAPES

 Pierre Gentelle
- 209 FUTURE OF THE CITY, FUTURE OF LIFE Paul Blanquart
- 249 A WOUNDED ENVIRONMENT Jean-Paul Deléage
- 289 POPULATION AND THE FUTURE OF HUMANITY Jacques Véron
- 329 GROWING ENOUGH TO FEED THE WORLD Sophie Bessis
- 369 ENDANGERED CLIMATES Jean-Paul Deléage
- 409 TOWARD A SUSTAINABLE DEVELOPMENT Jean-Paul Deléage
- 418 Index
- 420 Afterword: The Story of a Book Joëlle Ody
- 422 Acknowledgments

Captions in the photographic sections were written by Astrid Avundo and Frédéric Marchand

THE STATE OF THE WORLD IN THE YEAR 2000

alization. Is there any merit to this view? Since the early 1980s, swift upheaval in the financial cycles has given rise to a capital market that is uniquely vigorous, and international trade is responding to the advancing triumph of free markets. The internationalization of production, a much older phenomenon, has also intensified. Large corporations, involved in gigantic mergers and restructuring, are expanding their overseas presence, and direct investment is enjoying an unprecedented boom in the triad of North America, Europe, and Japan.

This globalization has been energized by the appearance of "emerging markets" born from the economic resurgence of East Asia and, more recently, from the collapse of the Soviet bloc and the Chinese economy's conversion—in a forced march—to capitalism. Internationalization is also enhanced by the formation of great regional units, common markets such as the European Union or Mercosur in Latin America, or free trade zones such as NAFTA in North America. These economic trends are paired with an acceleration of the blending of cultures; of the speed of communication all over the world, including the exchange of information and images in real time; and of the volume of cross-national transactions.

Nevertheless, we cannot say for certain that our descendants will remember these phenomena as having marked a significant rupture in the long history of the world. Other processes are at work, notably developments in science and technology, not to mention possible geopolitical upheavals of great scope, which may well come to seem more decisive. Moreover, if the times we are living in seem to be marked by

the transnational and supranational phenomena of globalism, local forces are also gaining strength and acquiring new political significance.

Our planet in the year 2000 has approximately 6 billion people, 20 percent of whom live in developed countries and 80 percent in the developing world. Asia alone accounts for 60 percent of the world population. This world is increasingly urban. According to the United Nations Population Fund (UNPF), 45 percent of the world population lives in cities (the figure is 75 percent for developed countries and only 22 percent in the less developed countries or LDC). Forty-one metropolises have more than 5 million inhabitants (half of them have more than 10 million); three-quarters are located in developing countries.

The population is still growing at a uniform rate, but the birthrate has begun to decline perceptibly in every continent. In twenty years the global average has dropped from 3.92 children per woman to 2.79 (5.31 in Africa, 2.65 in Asia and Latin America, and 1.45 in Europe). Today the world population is young: 30 percent is below fifteen years of age and only 6.8 percent is over sixty-five.

RIGHTS OF NATIONS, HUMAN RIGHTS, AND WOMEN'S RIGHTS

The 6 billion people of today are distributed within the territory of 193 sovereign states. One hundred years ago great empires—Ottoman, Russian, Austro-Hungarian, German, British, French, Dutch, Belgian—still covered most of the planet. The twentieth century will go down as the age of decolonization, if not the age of emancipation, as each nation

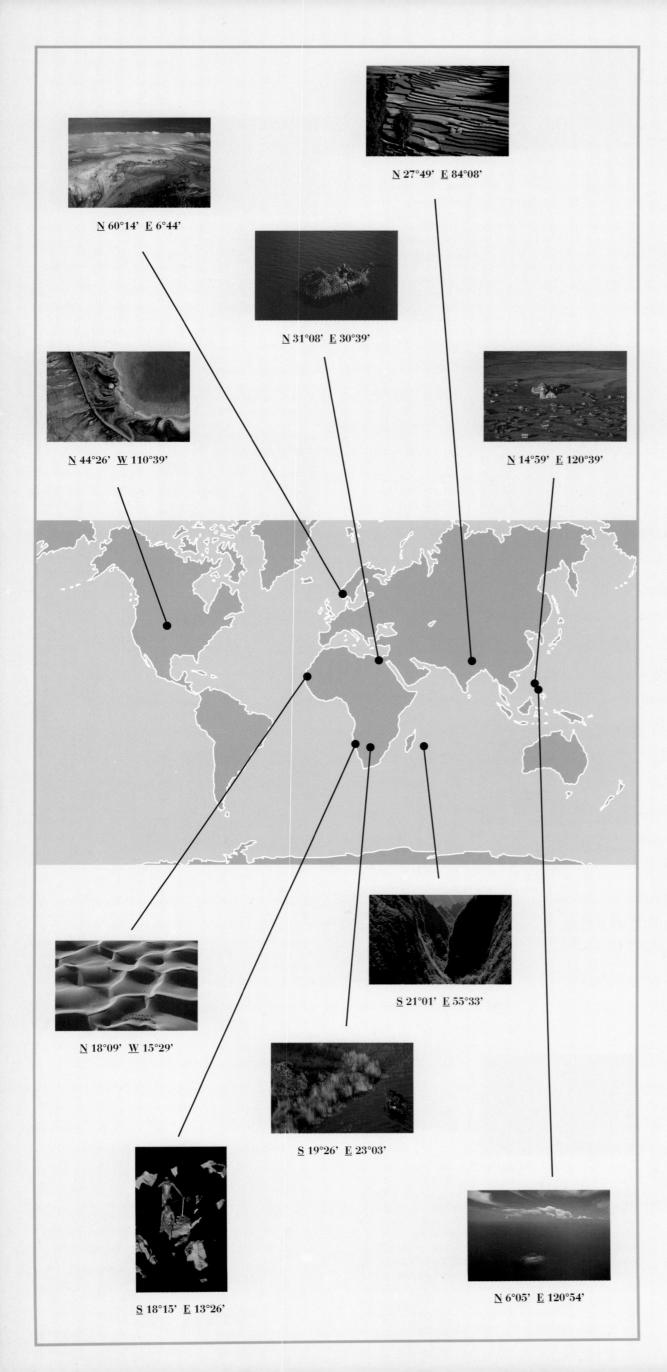

ths by contraceptive methods has made aguish sexuality from procreation. Some r, still use coercive methods to enforce

AND POVERTY

sian crisis that erupted in the summer of se us to overlook the economic readjust-more than twenty years on a global scale. gross domestic product (GDP), a measure ced during the year, stabilized at \$32,735 ections to account for the differences in between countries). Half of this wealth is America (especially the United States, with tropean Union (Germany, France, United y alone making up 13 percent), and East pan, with 9 percent).

ear world exports totaled \$5,400 billion. countries claimed a share of two-thirds of proportion than in 1970 (76.2 percent). ping countries advanced globally between 33.5 percent from 23.8 percent). Asia went ercent, but Africa fell from 4.4 to 2.3 pernerica from 5.6 to 4.3 percent. Among s, Japan won a greater share than before. among industrialized nations has changed past twenty years. According to the Organic Cooperation and Development (OECD), DP per inhabitant was 62.8 percent of the e; by 1997 it had risen to 81.2 percent of igure. The proportion between the Euroe United States has also grown closer, but itage points.

In the area of technological progress, the twentieth century has seen a permanent revolution. The United States, the countries of western Europe, and Japan share the bulk of this innovation: the 1996 statistics of UNESCO state that these nations are the originators of 55.6, 15.3, and 21 percent, respectively, of the patents in the United States. These same countries provide 80 percent of research and development efforts, while China, Taiwan, Singapore, and South Korea count for 10 percent.

In 1960 the richest one-fifth of the world's population had a revenue thirty times higher than the poorest one-fifth; in 1995, according to a comparable study, the richest group's revenue was 82 times higher. The 1998 annual report of the United Nations Development Programme (UNDP) estimates that 225 of the largest fortunes in the world represent a total of more than \$1,000 billion. On the average, in 1998 the annual GDP per inhabitant of the fifteen wealthiest nations of the world exceeded \$20,000, whereas the figure for the fifteen poorest countries was below \$1,000. Between Luxembourg (more than \$30,000) and Mozambique (\$500), the gap was more than sixty to one. On top of this is the question of foreign debt: for developing countries as a whole, it represented more than \$2,000 billion in 1997. However, the inequalities are not only between wealthy nations, the majority of which are located in the Northern Hemisphere, and poor countries, typically in the Southern Hemisphere. Inequality within each individual nation is a crucial concern as well.

FUNDAMENTAL NEEDS AND HUMAN DEVELOPMENT

The degree to which certain basic needs are satisfied, needs such as nutrition, access to drinking water, health, education, and shelter, is highly indicative of the condition of populations and of societies and of their "human development," a term made popular by the UNDP.

Three centuries ago the average age of death was approximately the same everywhere in the world. People died at about the age of thirty, and only two out of three children lived to the age of five. Today the life expectancy on earth has more than doubled (65.6 years on a global average), but the gaps remain immense: over the age of 75 in the United States, Canada, and western Europe, versus an age of 53.8 in Africa. However, in twenty-six years, the life expectancy in developing countries rose from 46 to 62—almost 70 in East Asia and Latin America but only 50 in sub-Saharan Africa).

Globally, infant mortality, measured as the rate of death of children less than one year old per thousand live-born children, continues to decrease. The world average in twenty years went from 87 to 57 per 1,000. In developing countries the average declined by more than half in forty years, but considerable inequalities persist. The situation in many countries remains acute: the infant mortality rate is 86 per 1,000 in Africa, approximately eight times more than the prevailing level in North America and western Europe.

To a great extent, the persistence of a high infant mortality rate (9 million children under one year of age still die each year in the poorer countries) is due to poor hygienic conditions, particularly the absence of basic sanitation and the lack of drinking water. About 30 percent of the population in developing countries do not have drinking water; indeed, in developing countries four out of five illnesses are linked to water. In industrialized nations the situation is totally different: two out of five mortalities result from cardiovascular disease and cancer, both of which are typical of societies of plenty.

Approximately 800 million people still suffer from hunger, notably in Africa and Asia. The most developed nations, for their part, consume more than 50 percent of primary energy although they make up only 20 percent of world population.

Turning to the field of education, we can point to undeniable progress, although global averages mask strong disparities. Between 1970 and 1995, adult literacy levels in developing countries advanced from 48 to 70 percent although the figure remains at 51 percent in southern Asia. The number of university students continues to grow. In the 1990s, according to UNESCO, the most developed countries (United States, Canada, Japan, and the countries of western Europe) accounted for about 45 percent of those enrolled in universities (24 percent for the United States and Canada alone).

THE FUTURE EARTH

In the 1980s environmental problems, formerly only of local concern, took on global proportions and triggered debates, demonstrations, conferences, and international negotiations. The stakes are enormous: to preserve the common heritage of the human race.

For millennia human beings transformed the natural world, without upsetting the earth's fundamental balances. It was only in the twentieth century—and particularly within the last fifty years—that the first dangerous ruptures in these equilibriums occurred. They were born of two vertiginous accelerations in the earth's development: population growth and technological change. These accelerations, in turn, led to greater inequality among people, pollution of many kinds, a squandering of resources, and a reduction in the number of species. In addition, with the knowledge gained in the fields of genetics and biotechnology, humans can henceforth claim—not without some danger—to have "reinvented nature" and to have disturbed a portion of the earth's ecosystems.

Faced with this situation, we cannot simply seek refuge in the contemplation of places where "natural" nature seems to have been preserved. The landscapes of today were fashioned over the course of time by different civilizations. An examination of how human societies have appropriated their environments is a prerequisite for taking stock of the basic challenges we face in the next century: the population explosion, feeding the planet, the distribution of wealth, climatic dangers, and the future of urban civilization.

It is this conviction that inspires the authors of the chapters in this book. Renowned specialists in their fields—geography, history of science, ecology, sociology, demography, economy, and philosophy—they have put their expertise to use in interpreting the future in the light of their respective knowledge and the lessons of history. In this way they contribute toward a picture of the state of the world in the year 2000. This diverse study complements the magnificent photographs by Yann Arthus-Bertrand, who presents through the distance of his aerial lens a different kind of "inventory" of the planet; these photographs offer views of a nature apparently still intact, interspersed with sights of construction and human activity. An inspiring way to mark a date.

Serge Cordellier Editorial Director of the annual *L'état du monde* (Éditions La Découverte)

p. 17 HIMBA COUPLE,

Kaokoland region, Namibia

The region of Kaokoland in northern Namibia is home to 3,000 to 5,000 Himba, nomadic herders of cows and goats who live along the Cunene River. This people, which has maintained its traditions and lives outside the modern world, suffered twin disasters in the 1980s: a long drought that killed three-fourths of the livestock and the war between the South African Army and SWAPO (South West Africa People's Organization). Today the Himba face a threat that is equally important: the planned construction of a hydroelectric dam on the Epupa Falls. This project, which would provide power for a water desalination plant in a country that imports nearly 50 percent of its electricity and is greatly deprived of water resources, would also result in the flooding of hundreds of square miles of pastureland, forcing the Himba herders to migrate to new lands.

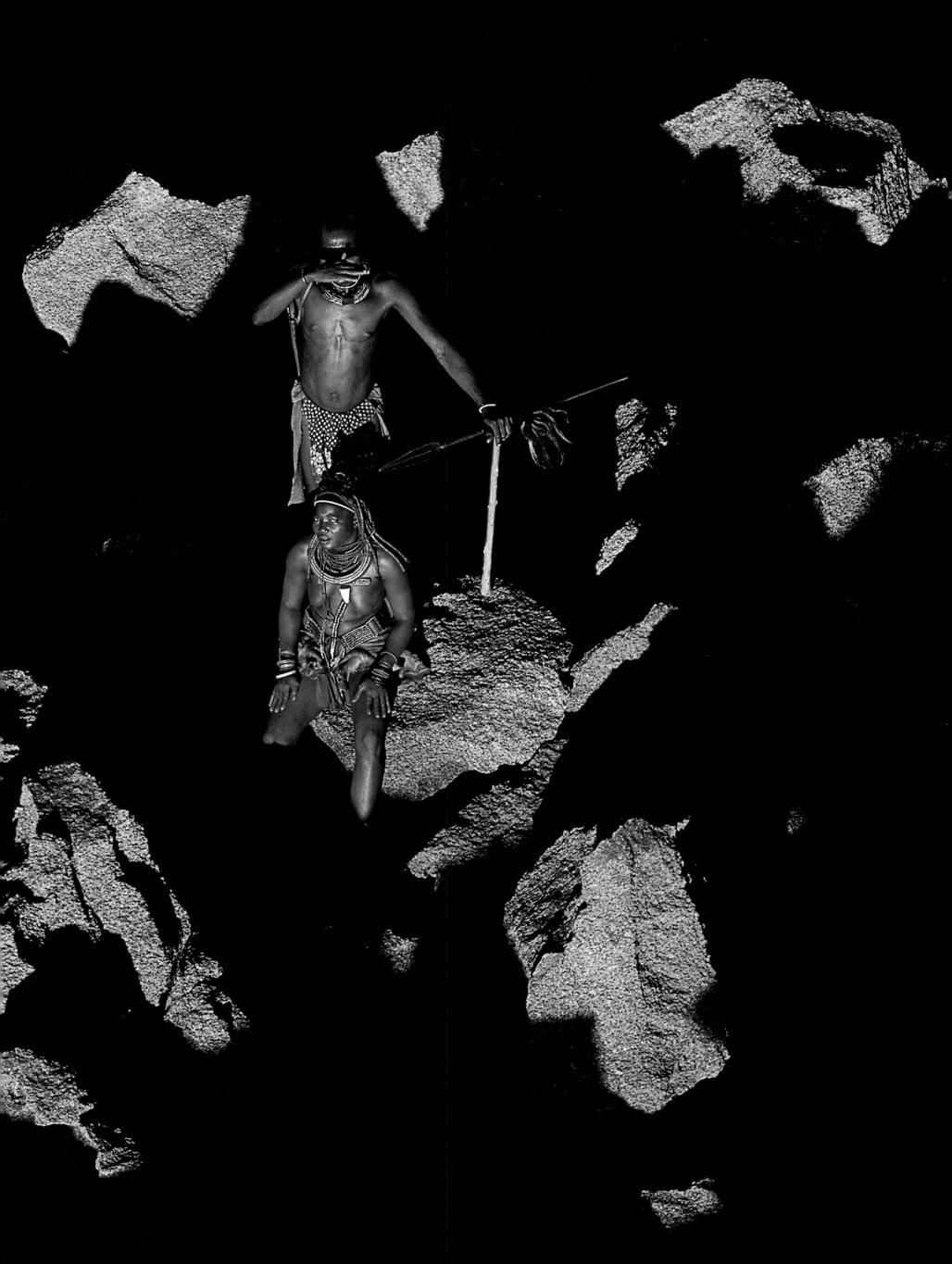

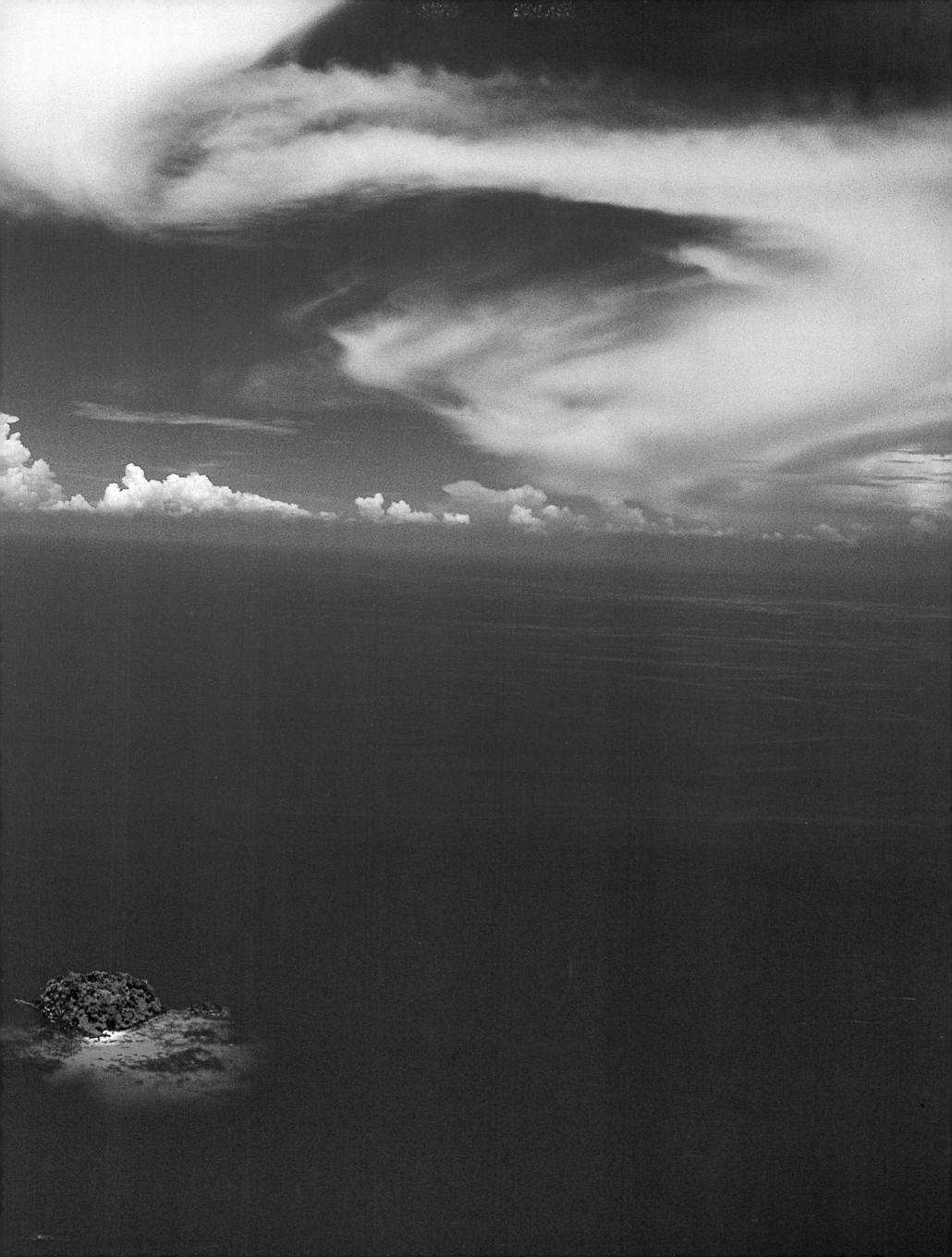

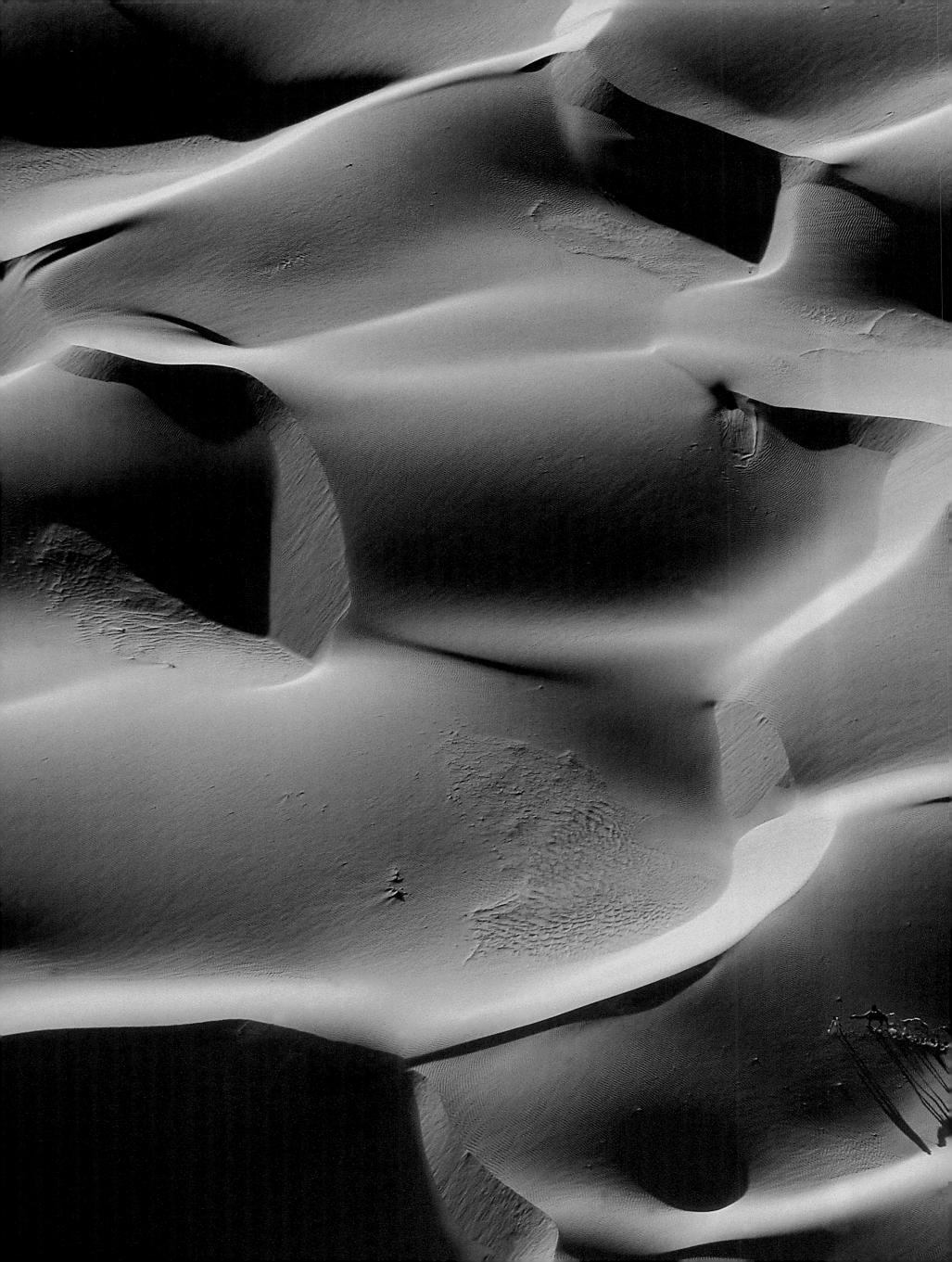

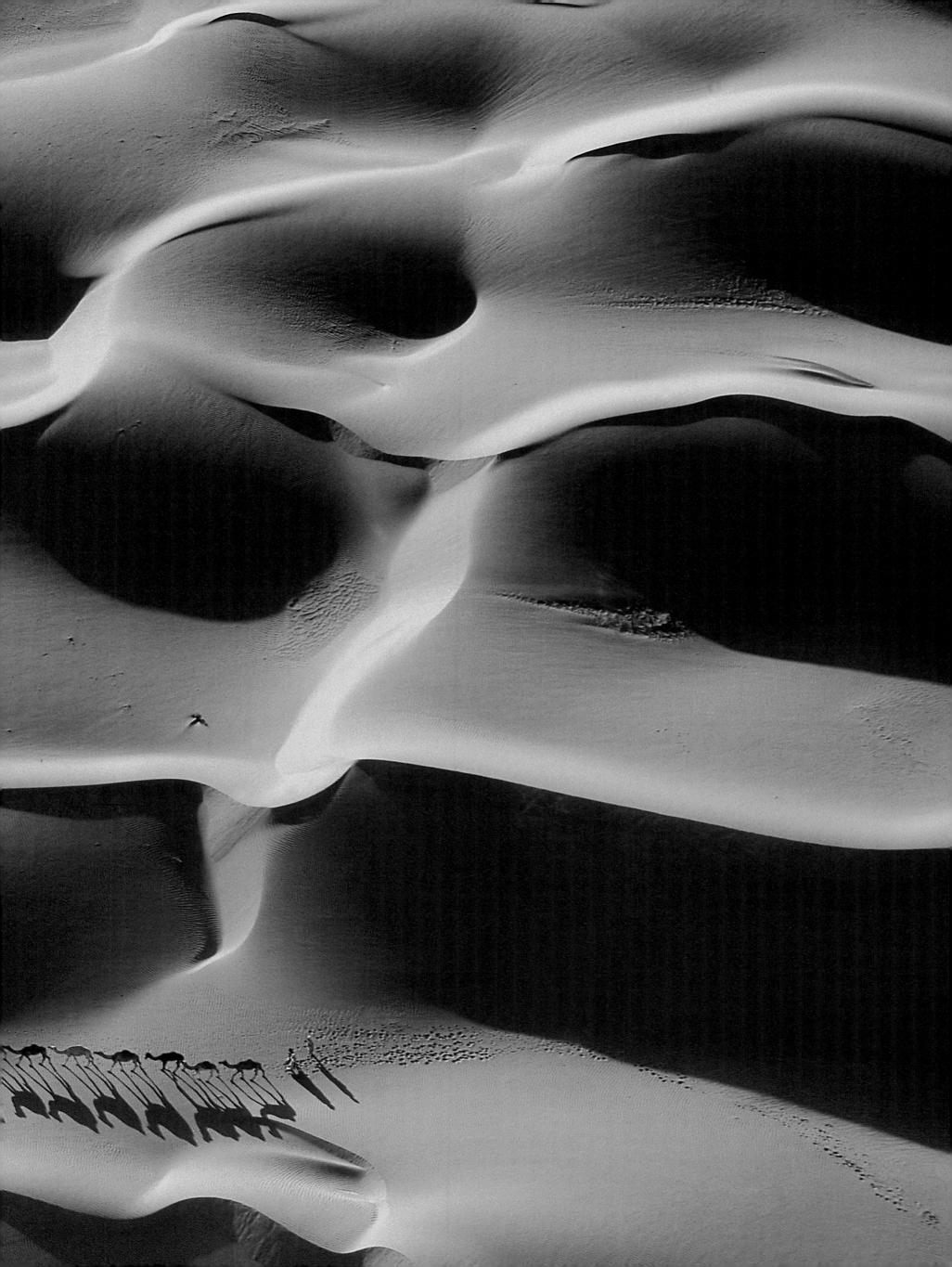

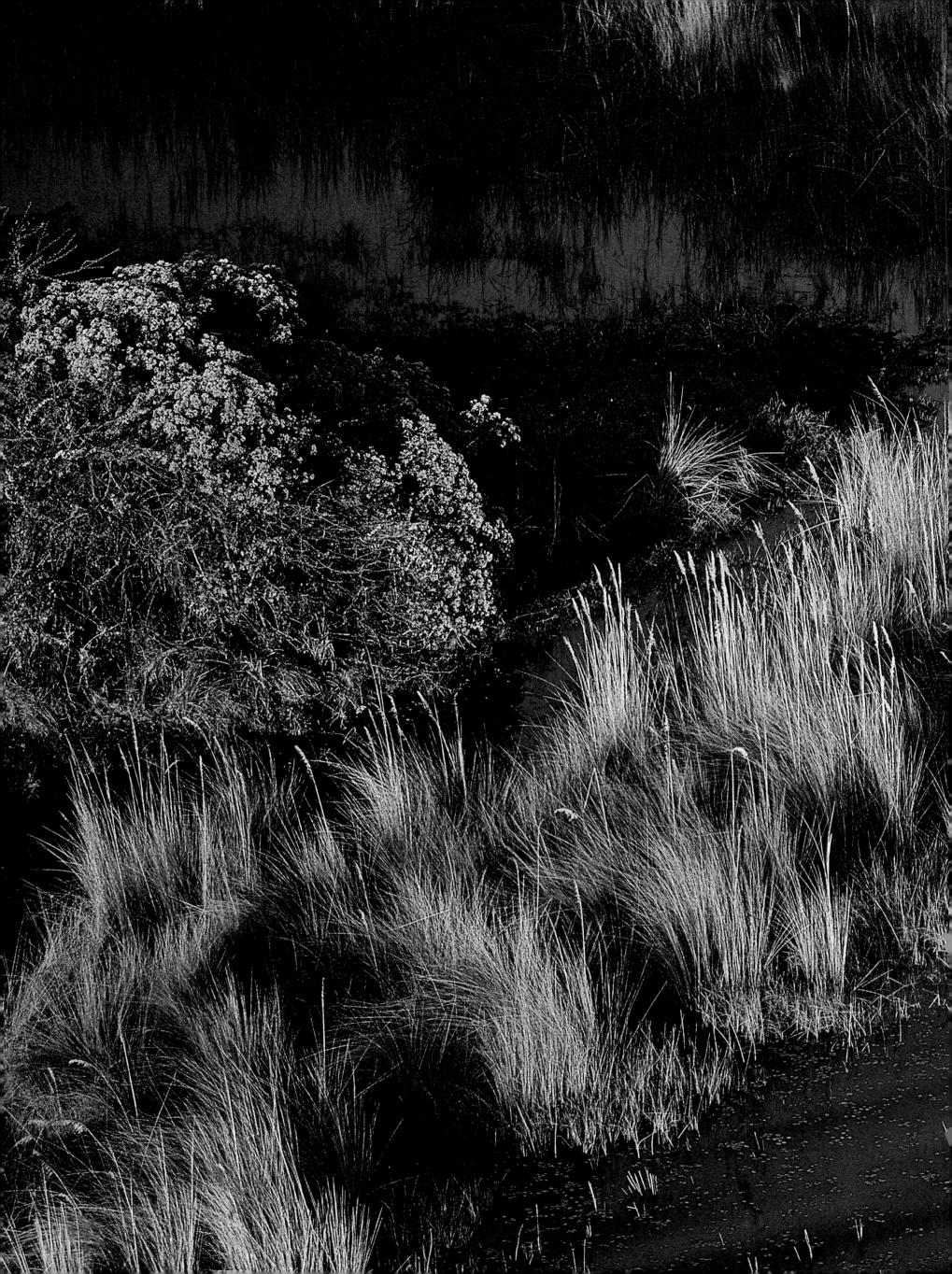

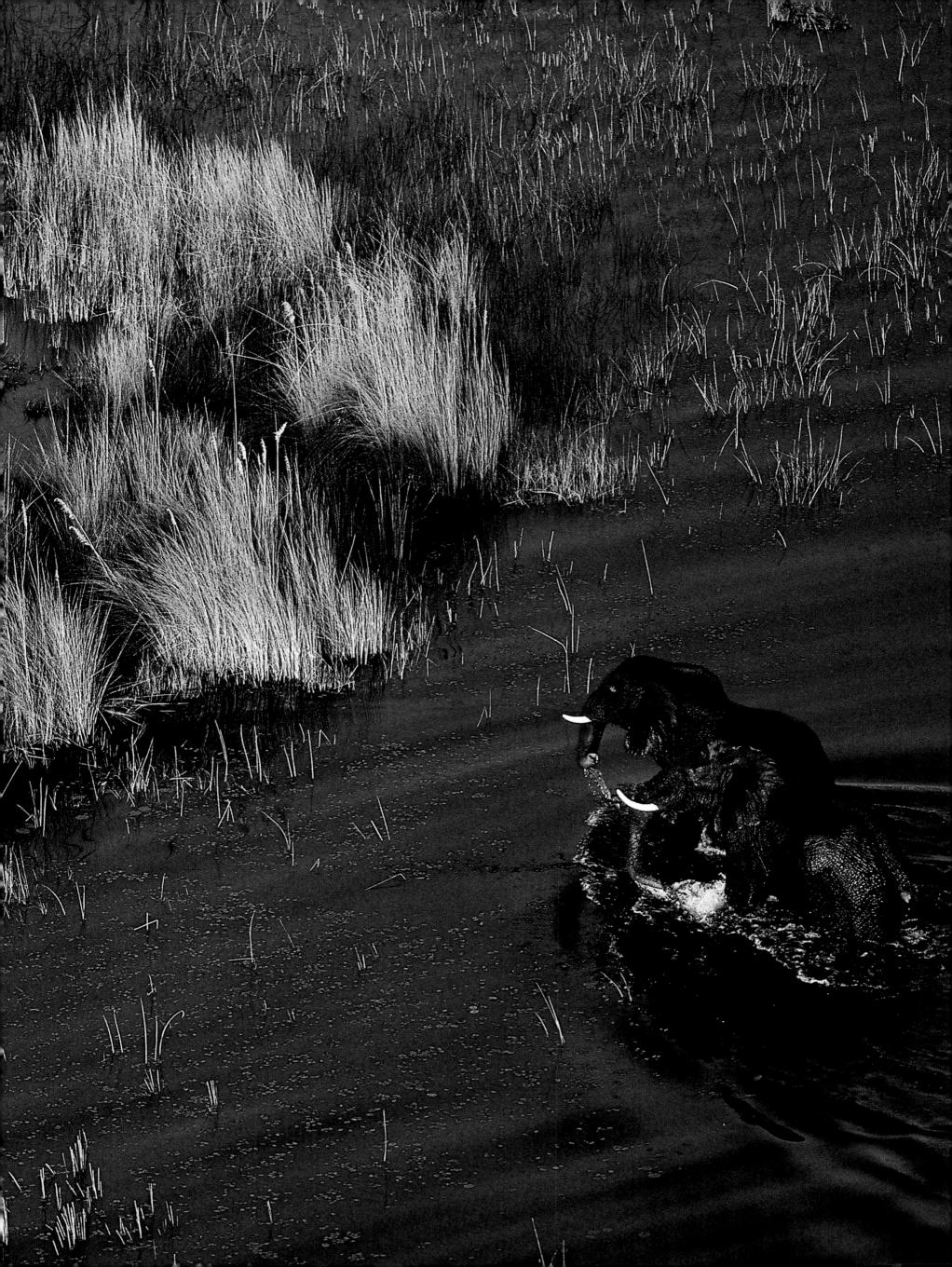

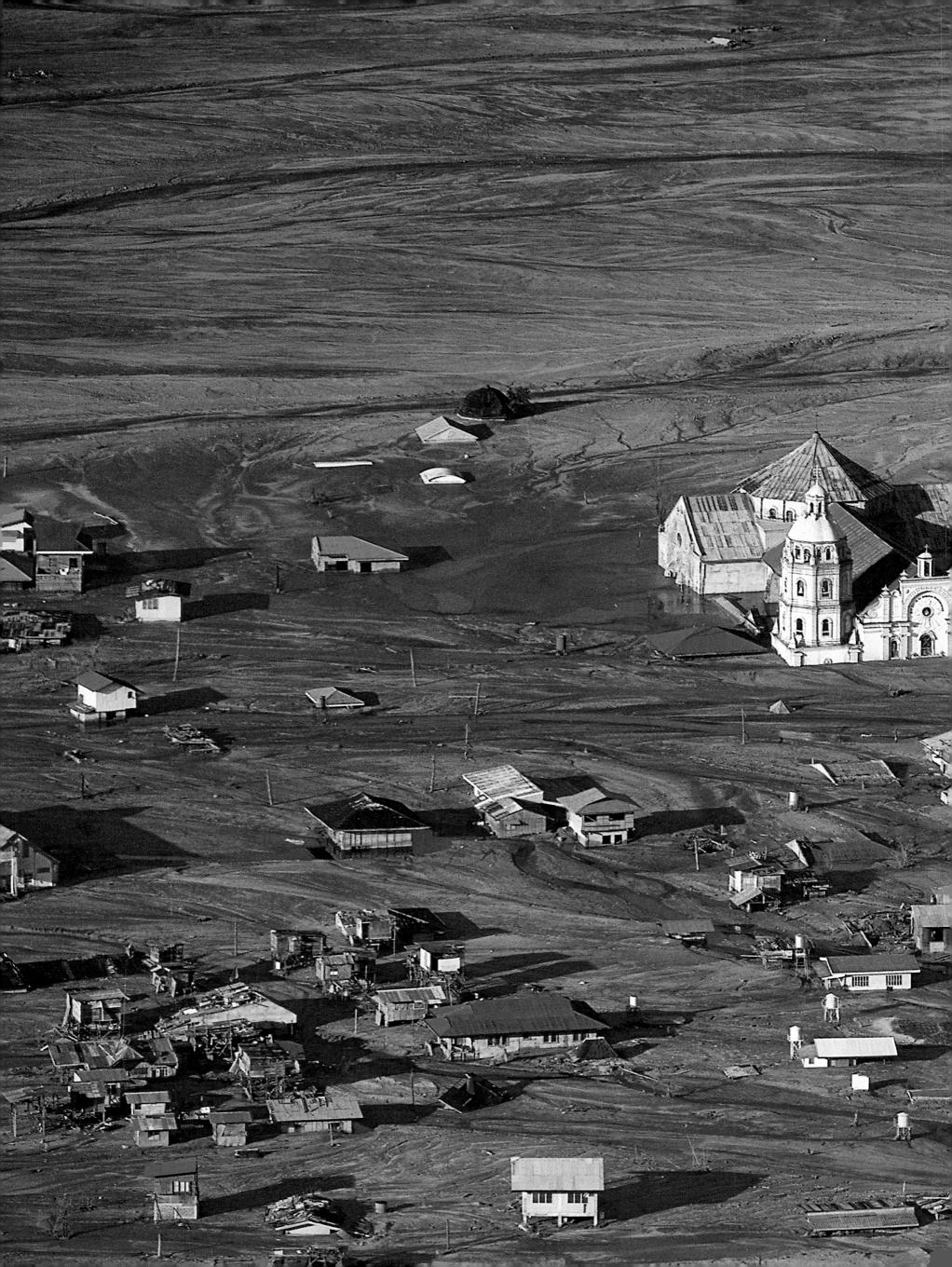

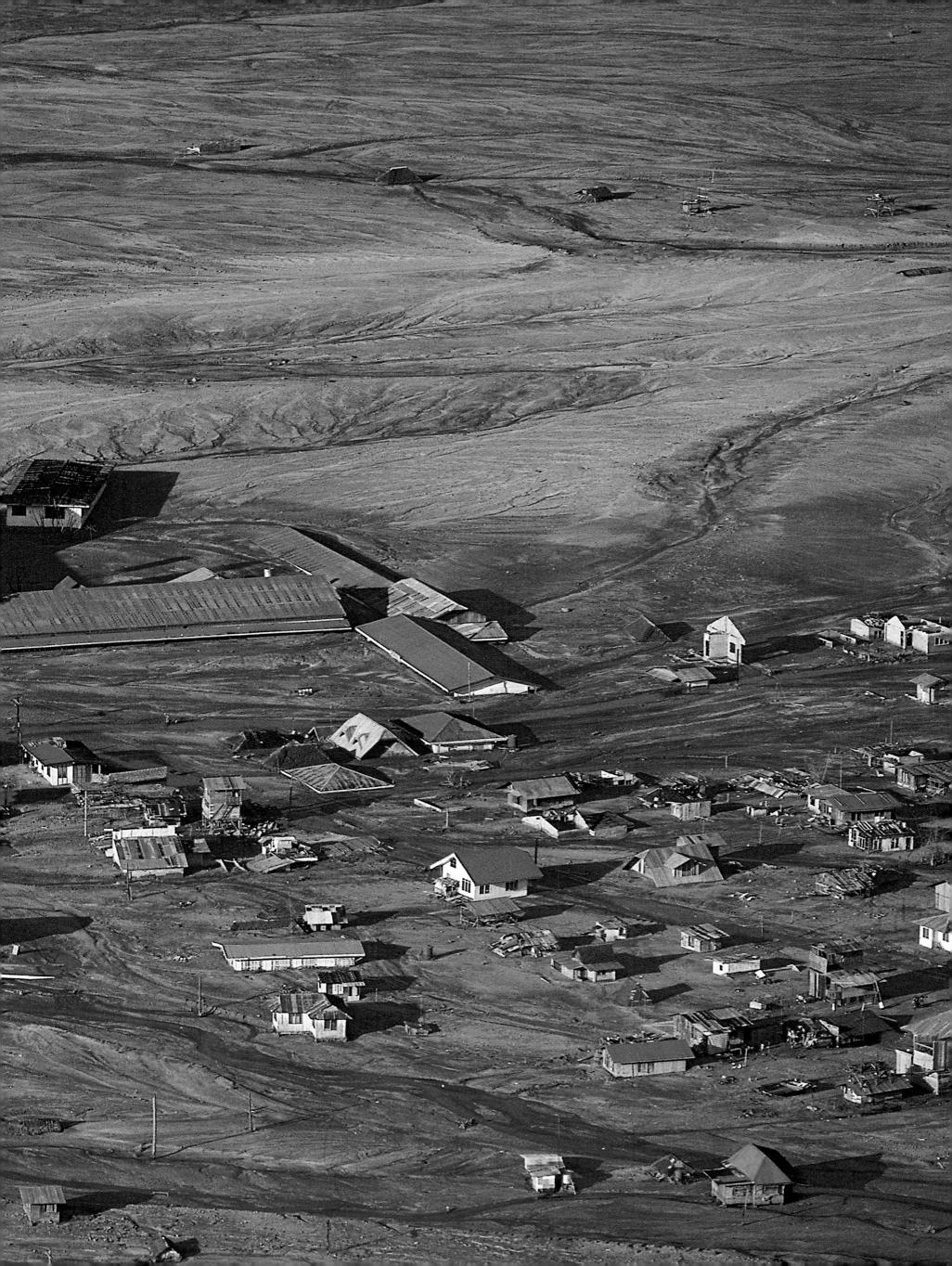

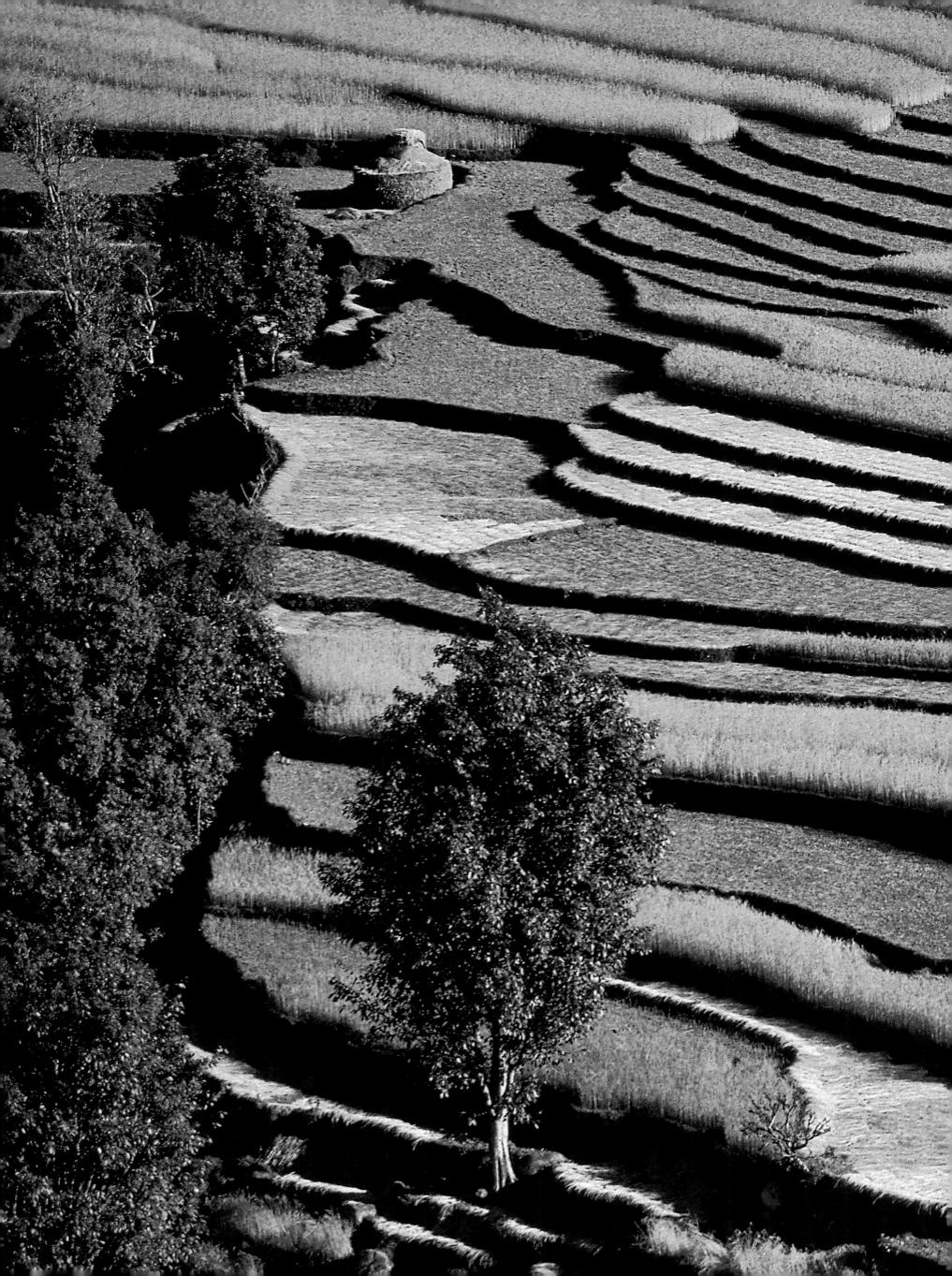

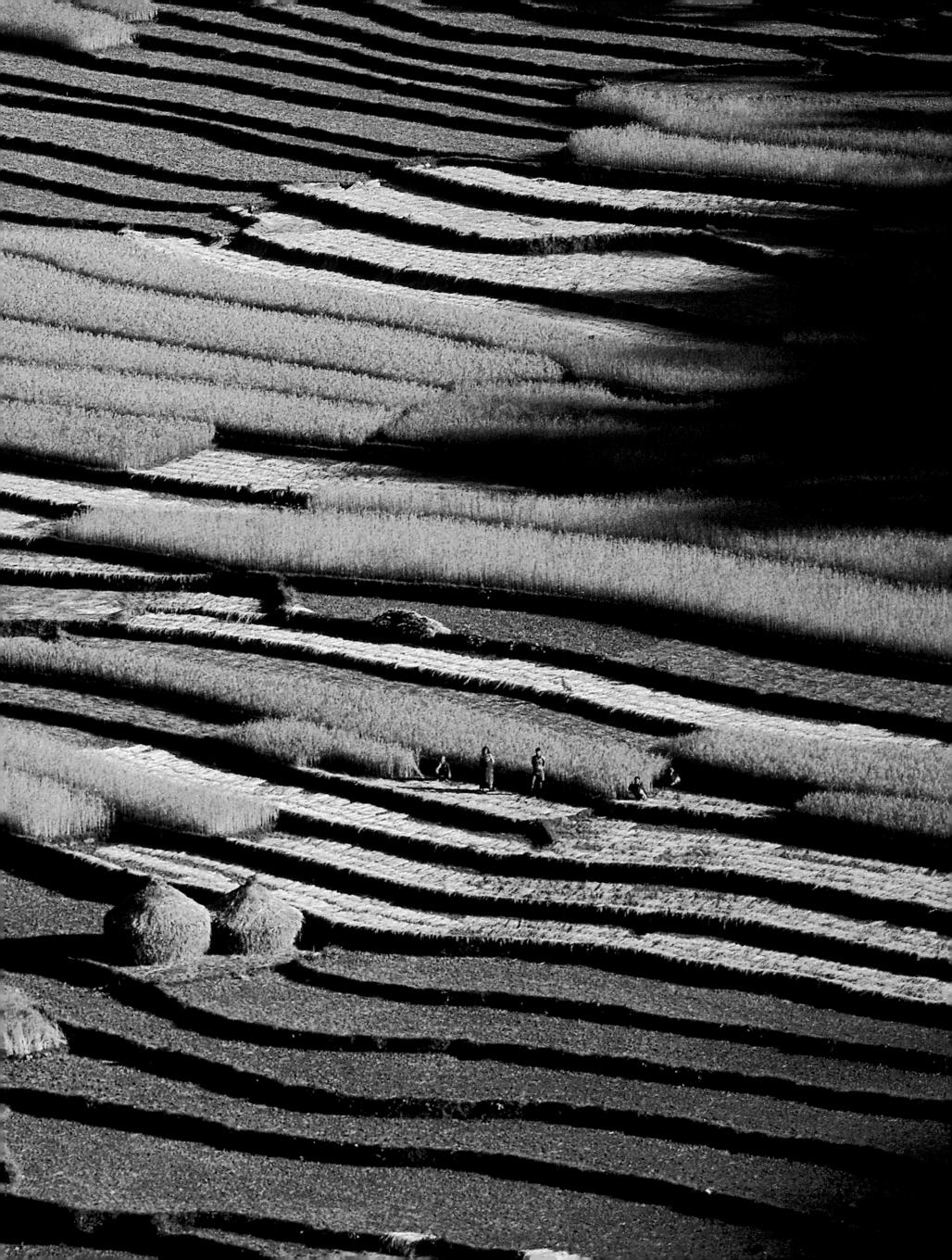

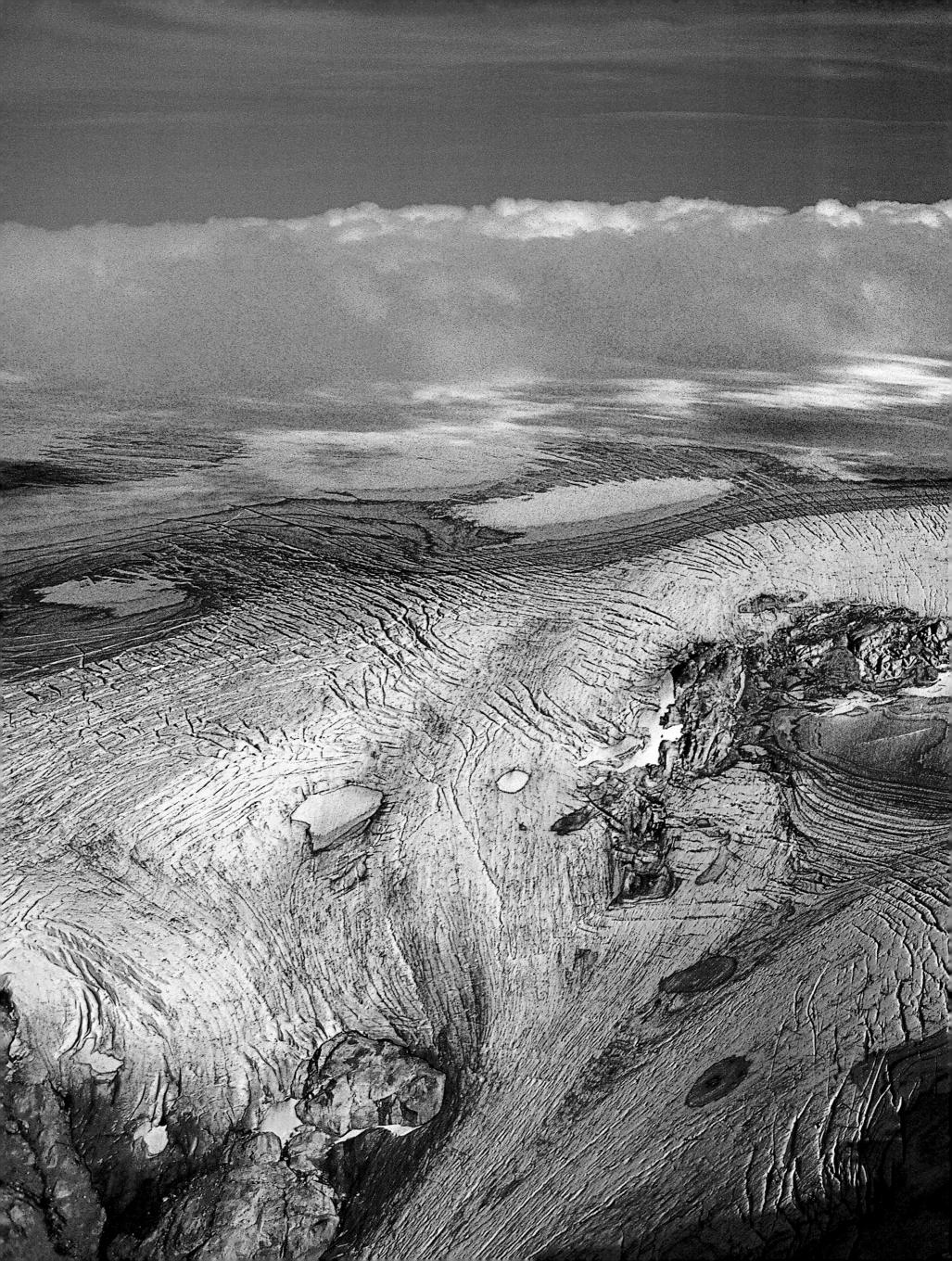

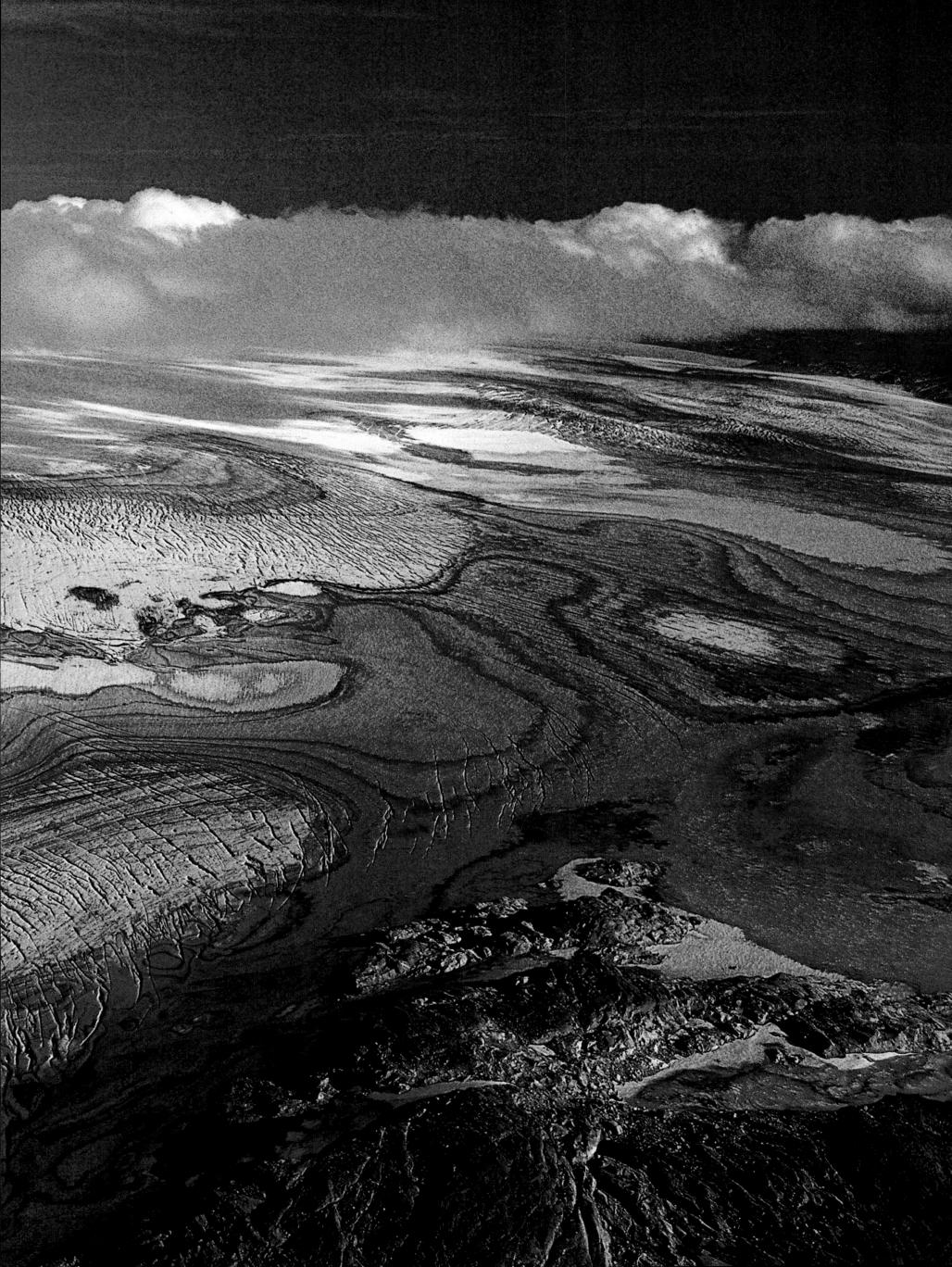

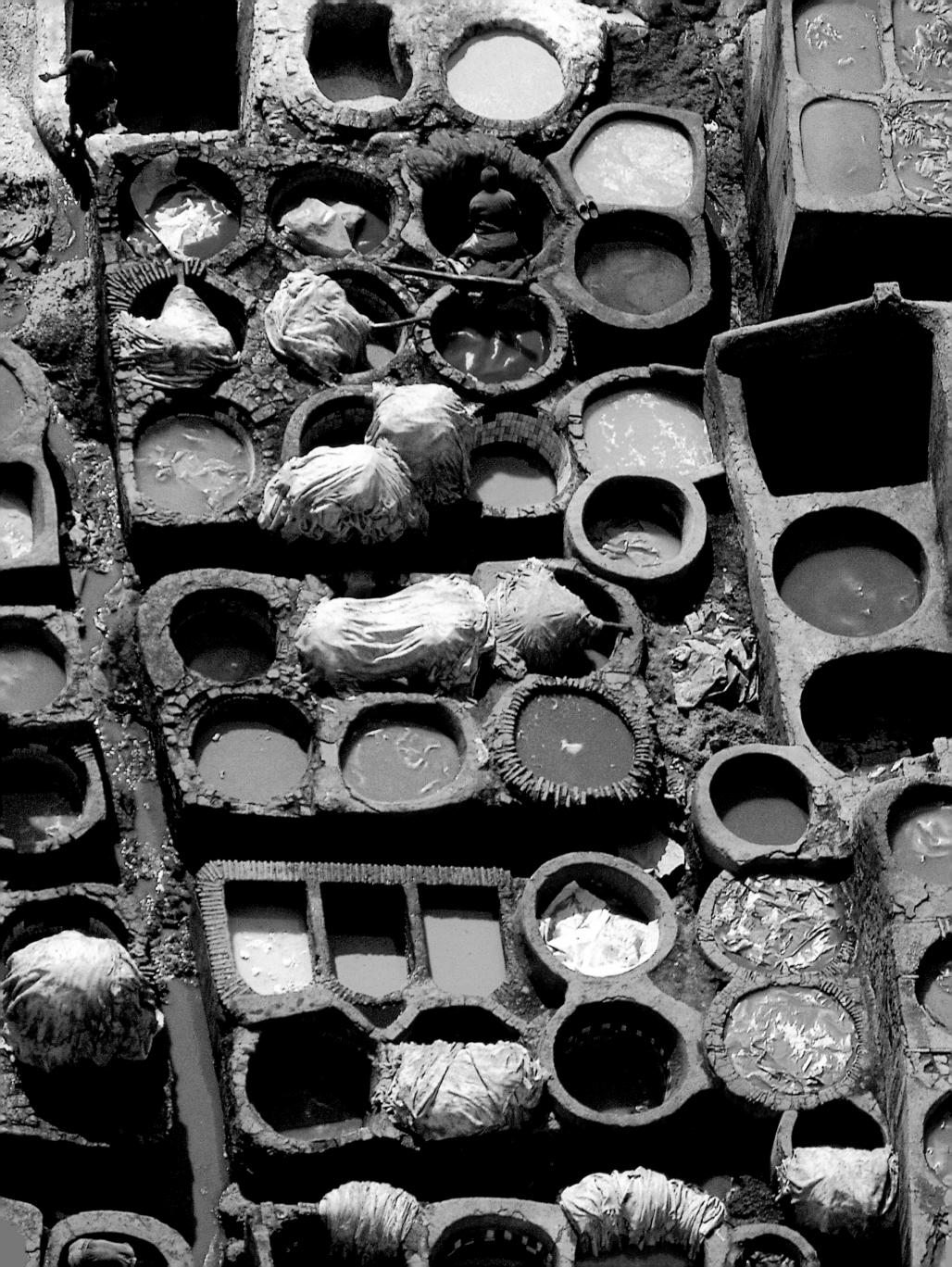

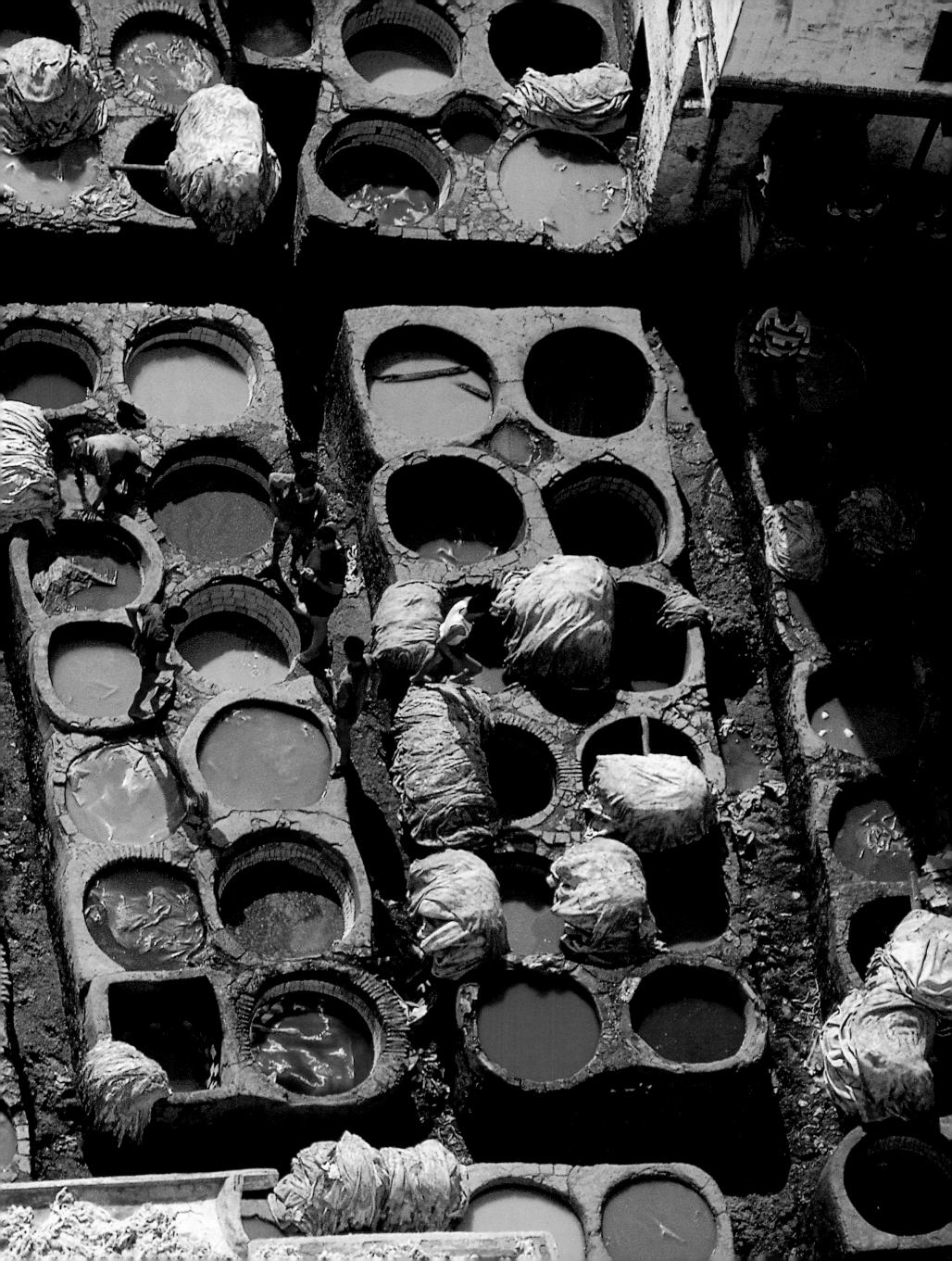

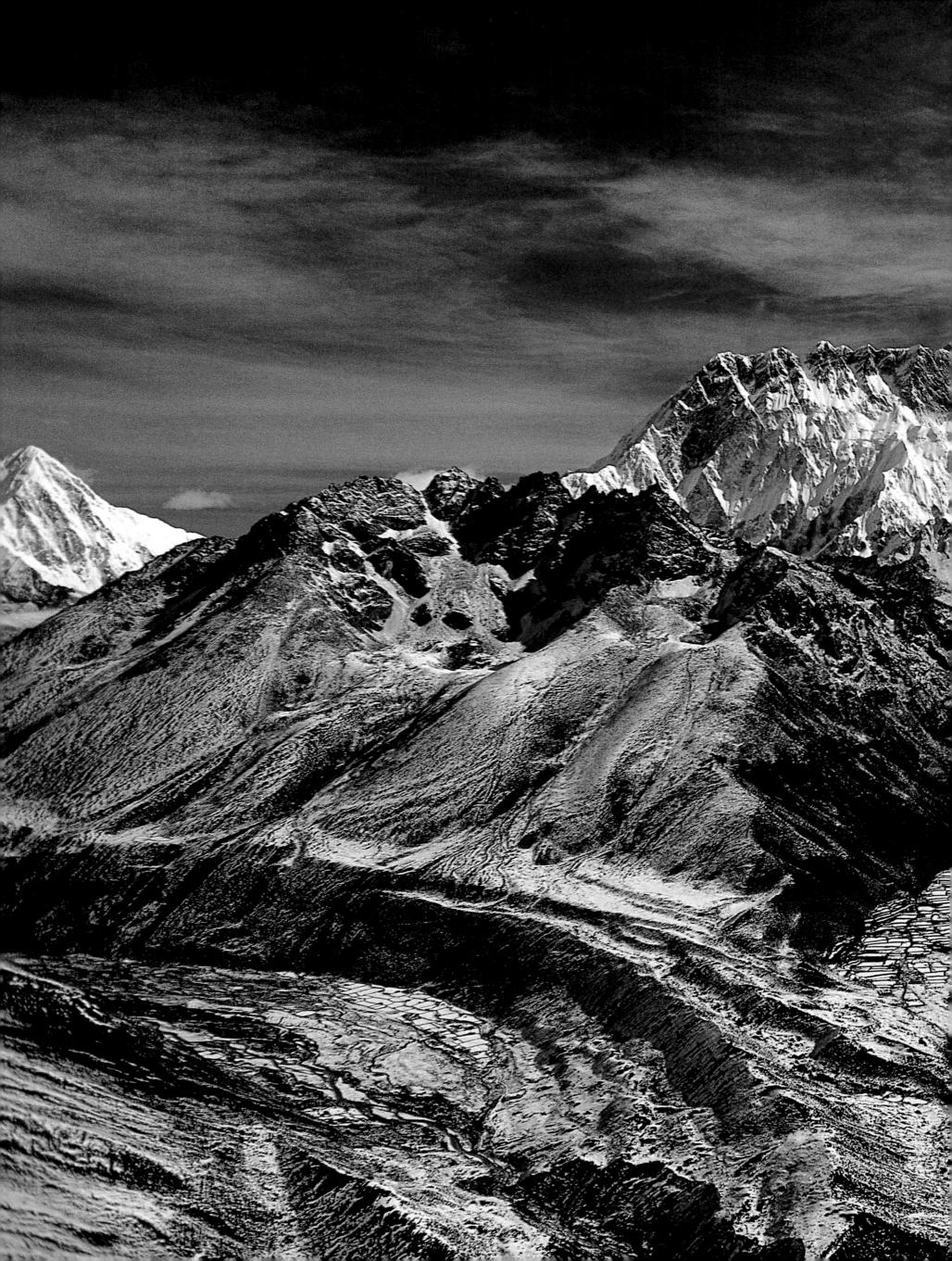

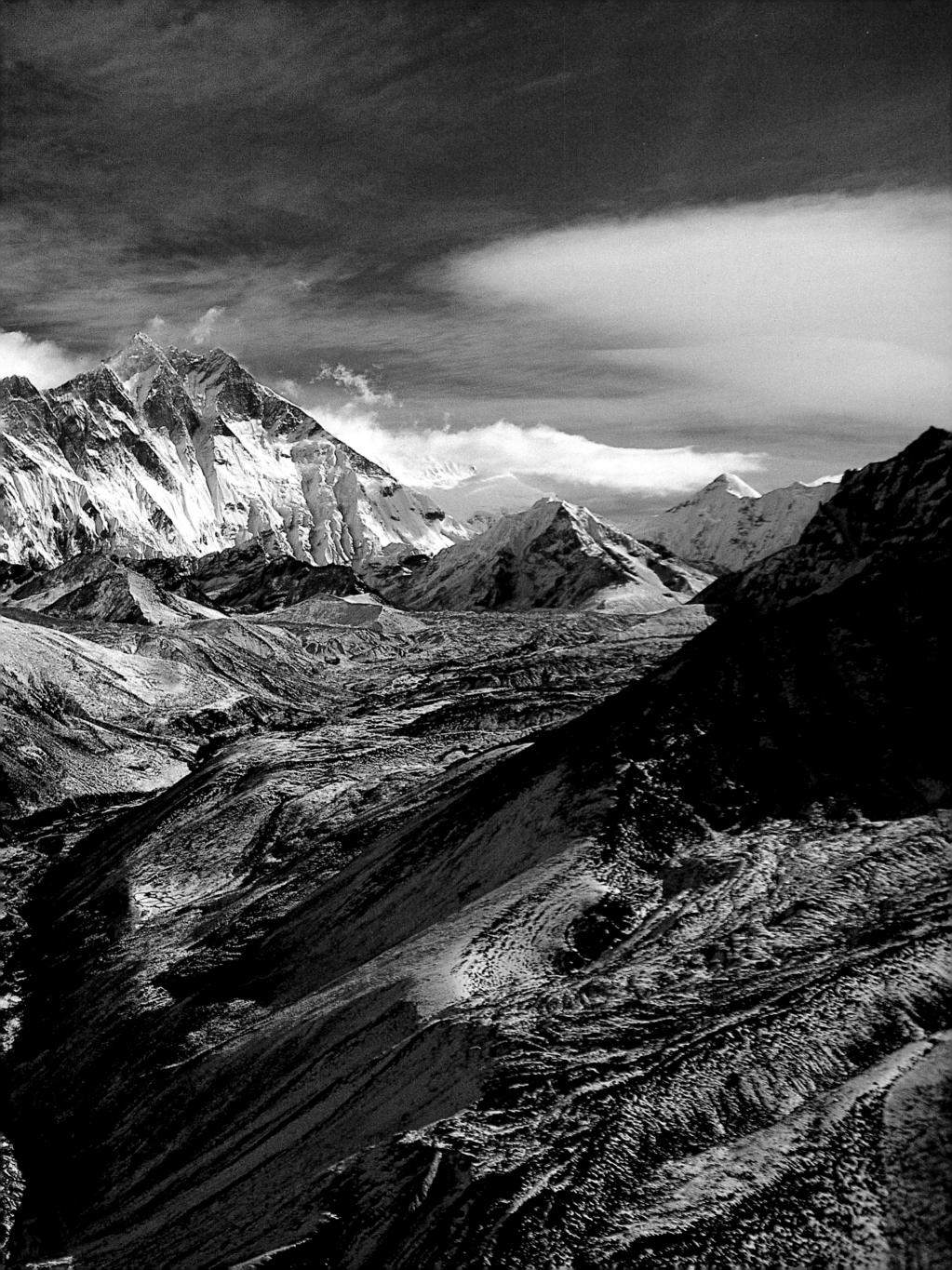

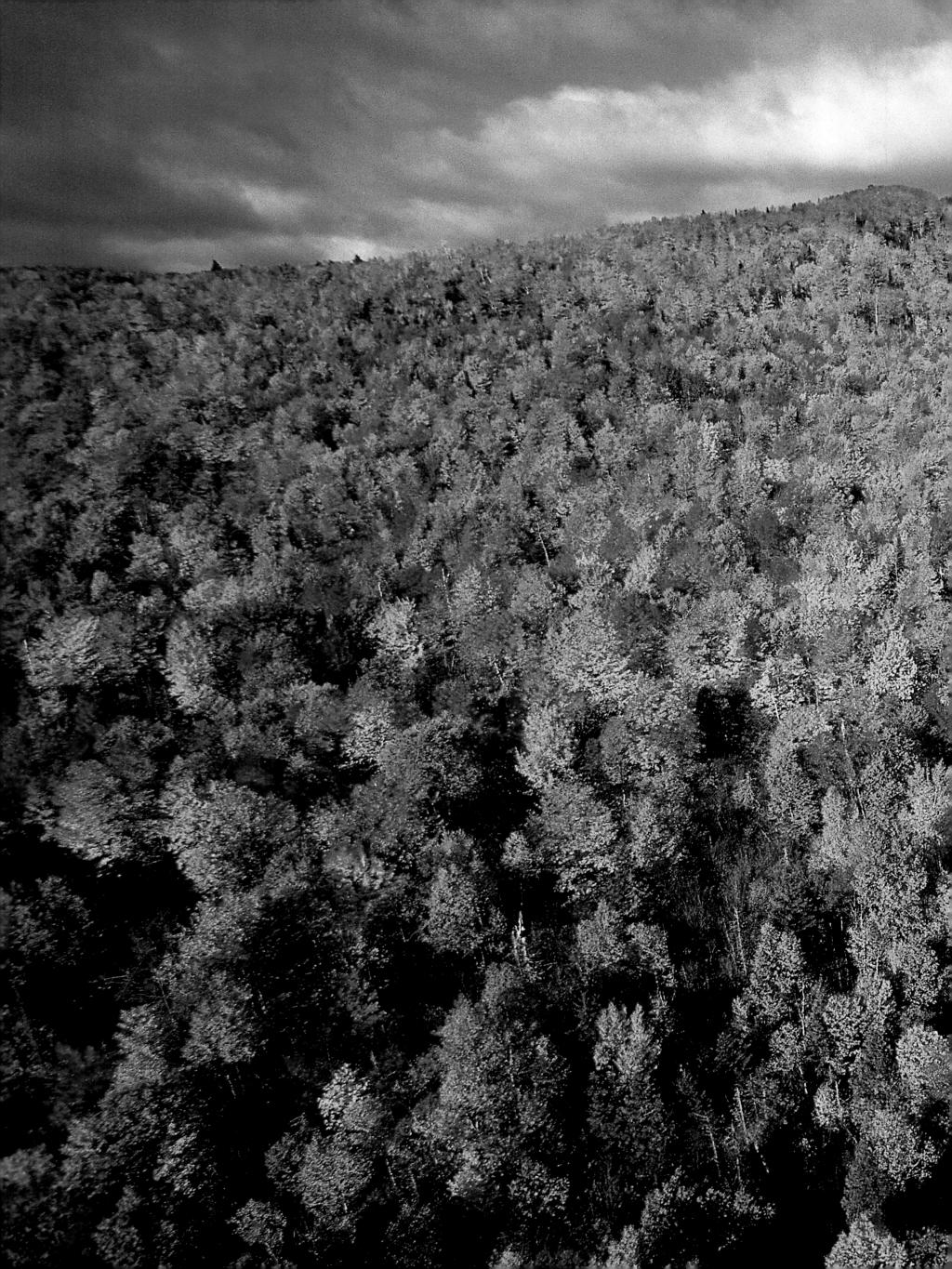

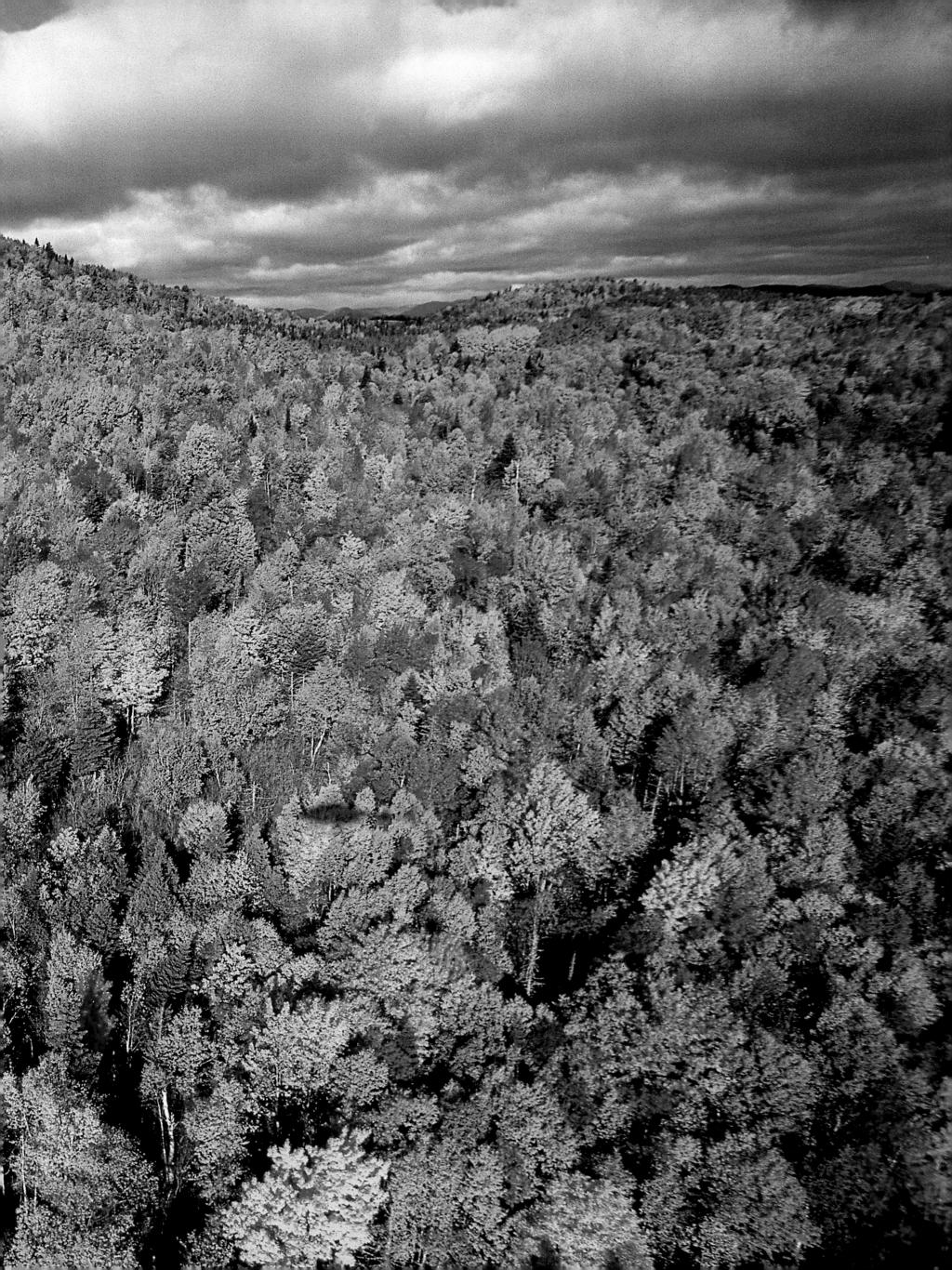

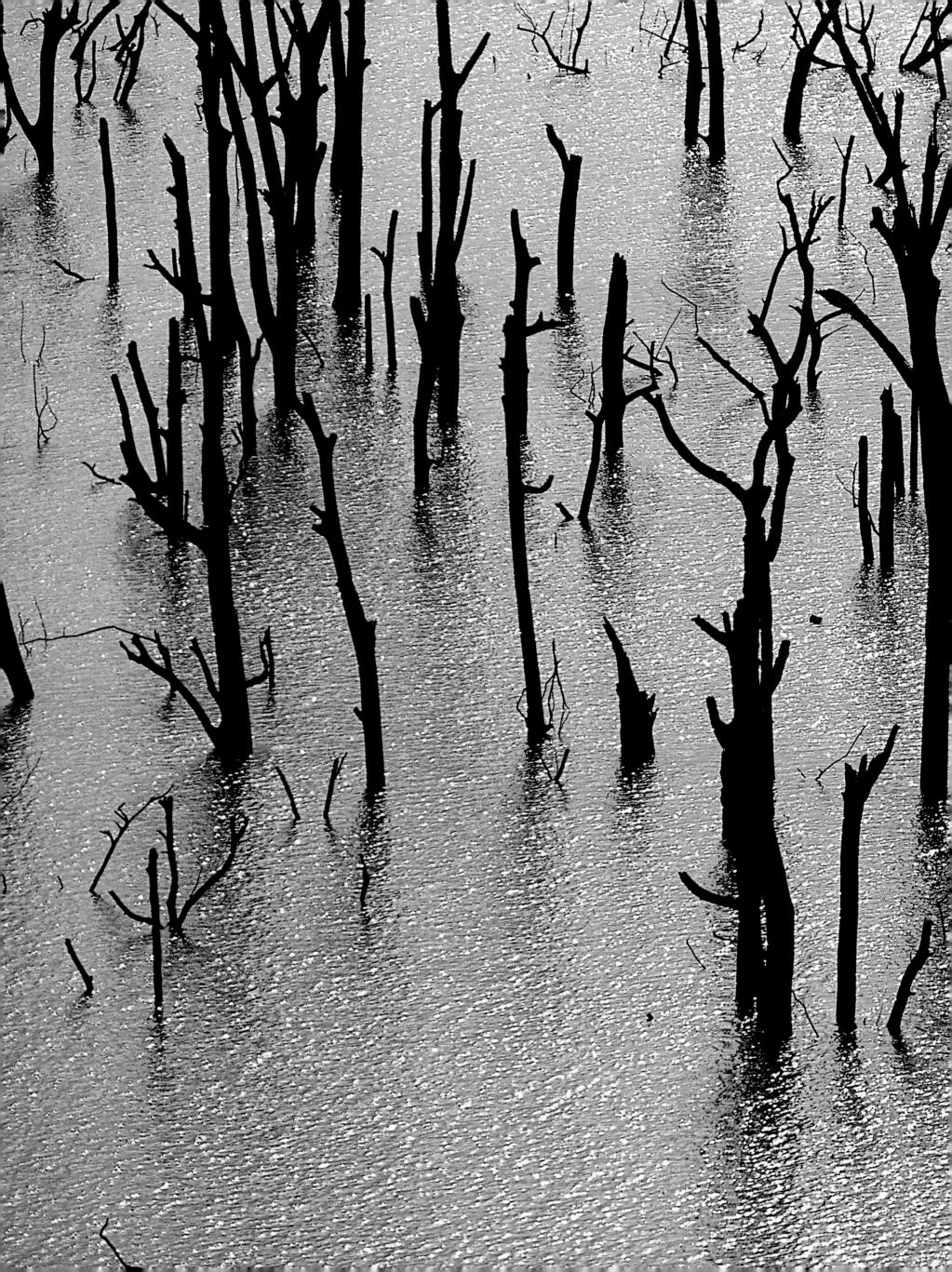

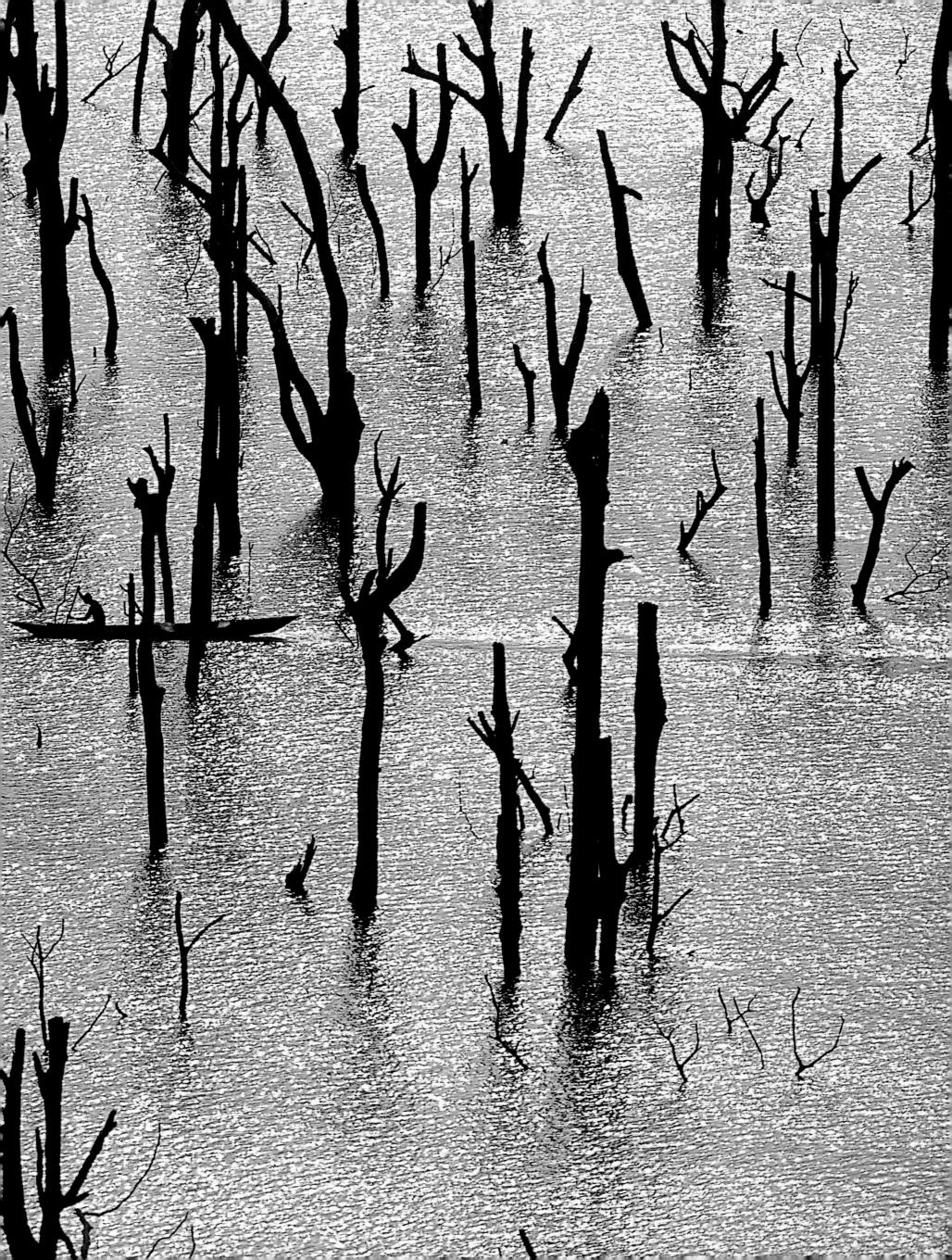

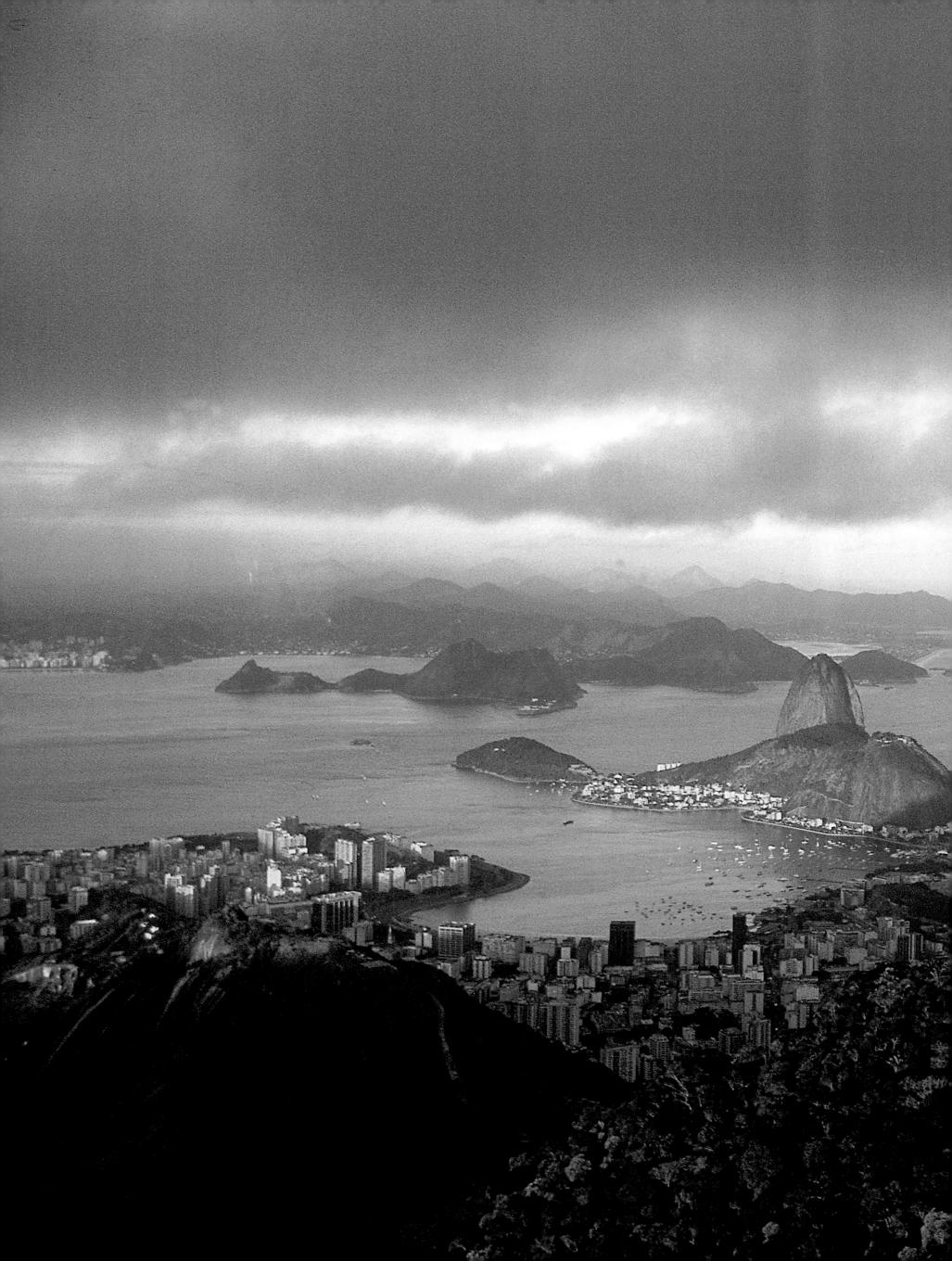

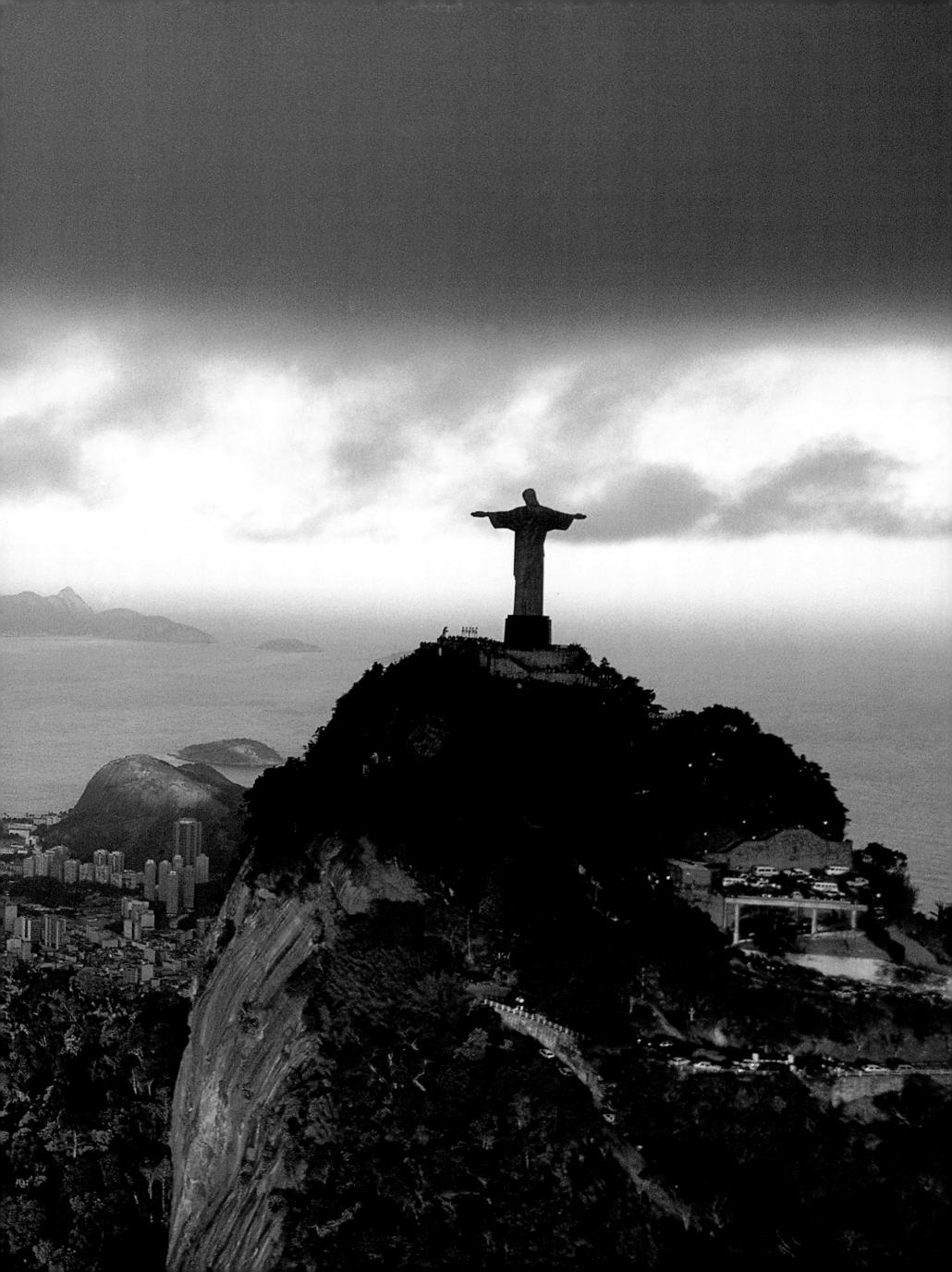

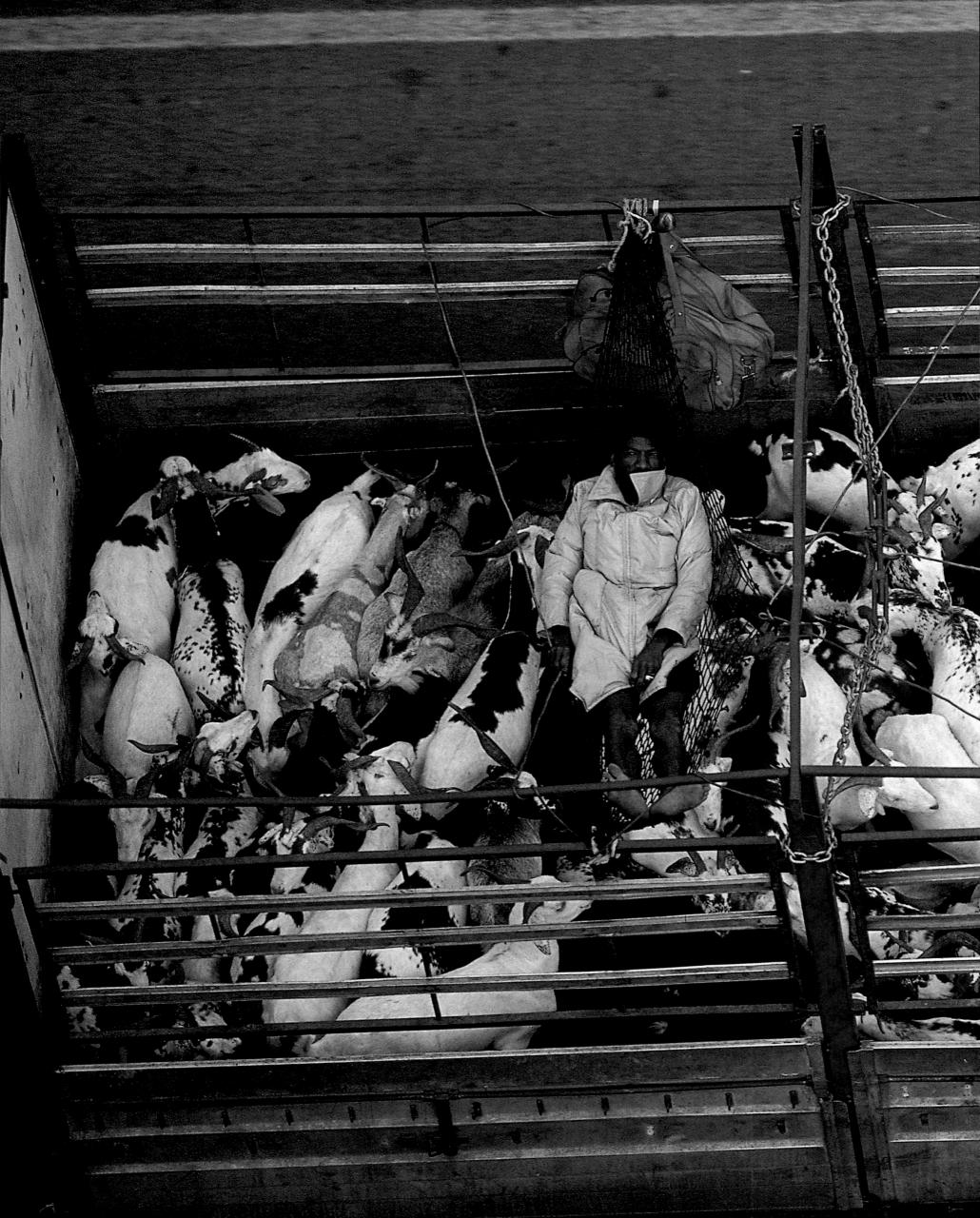

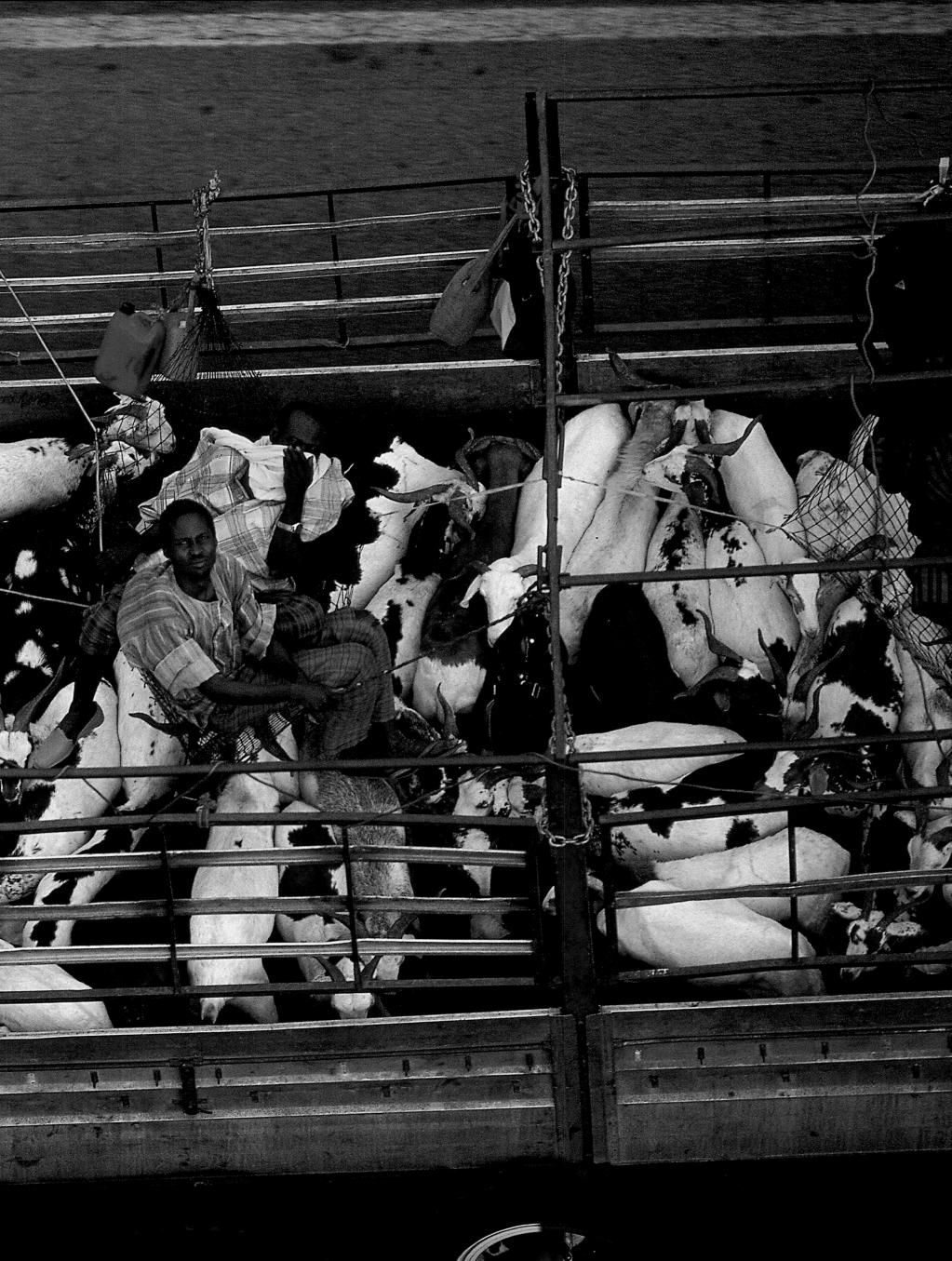

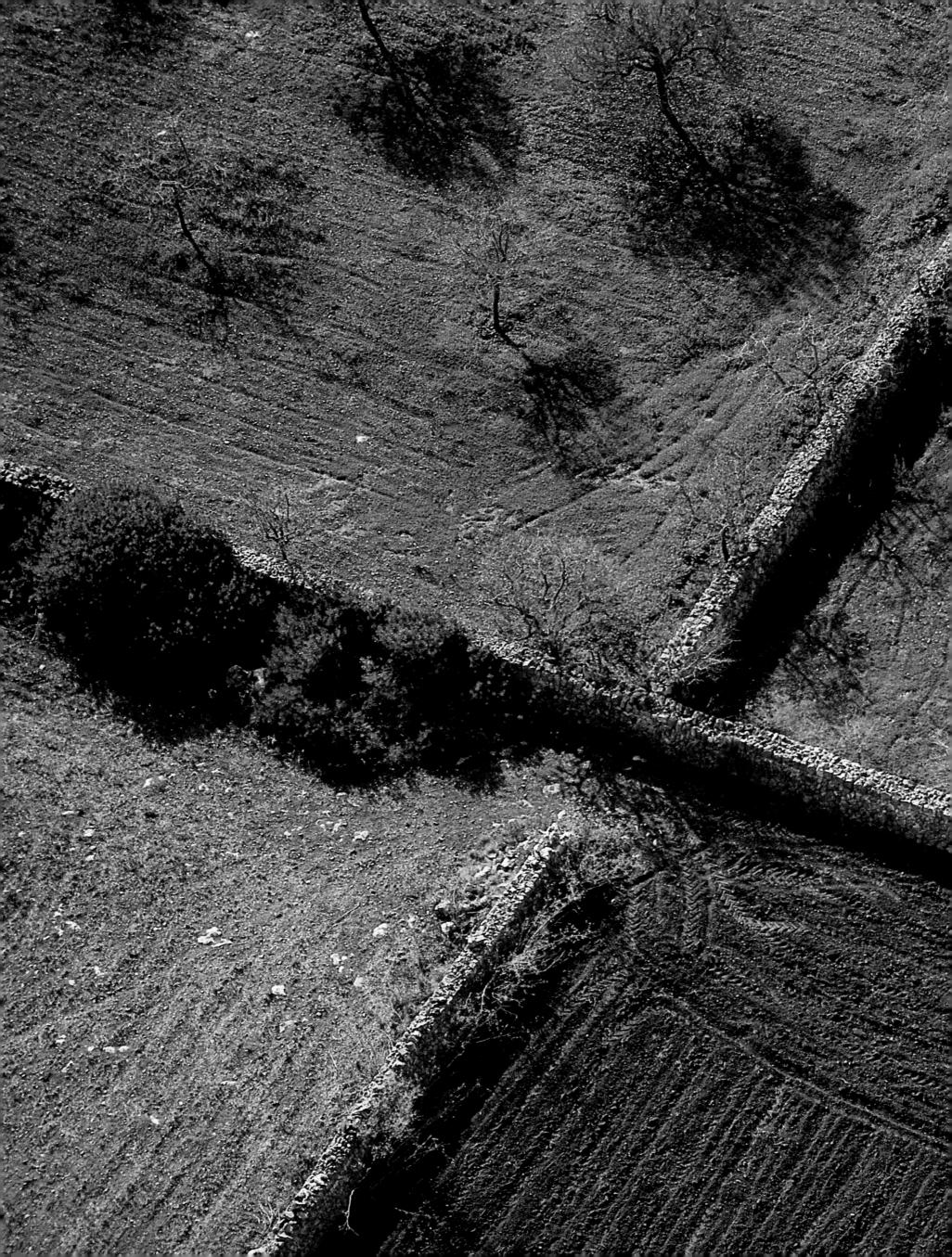

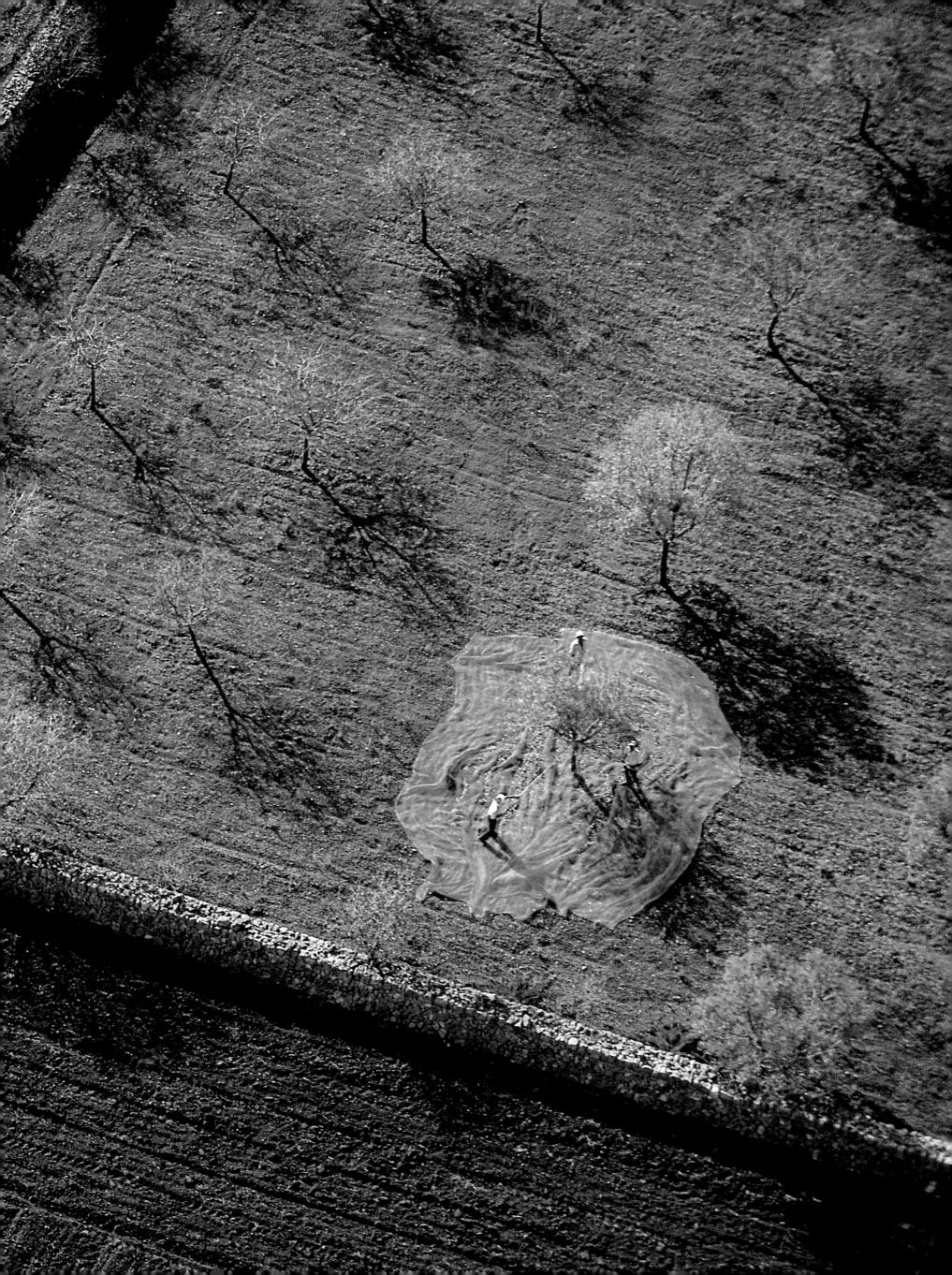

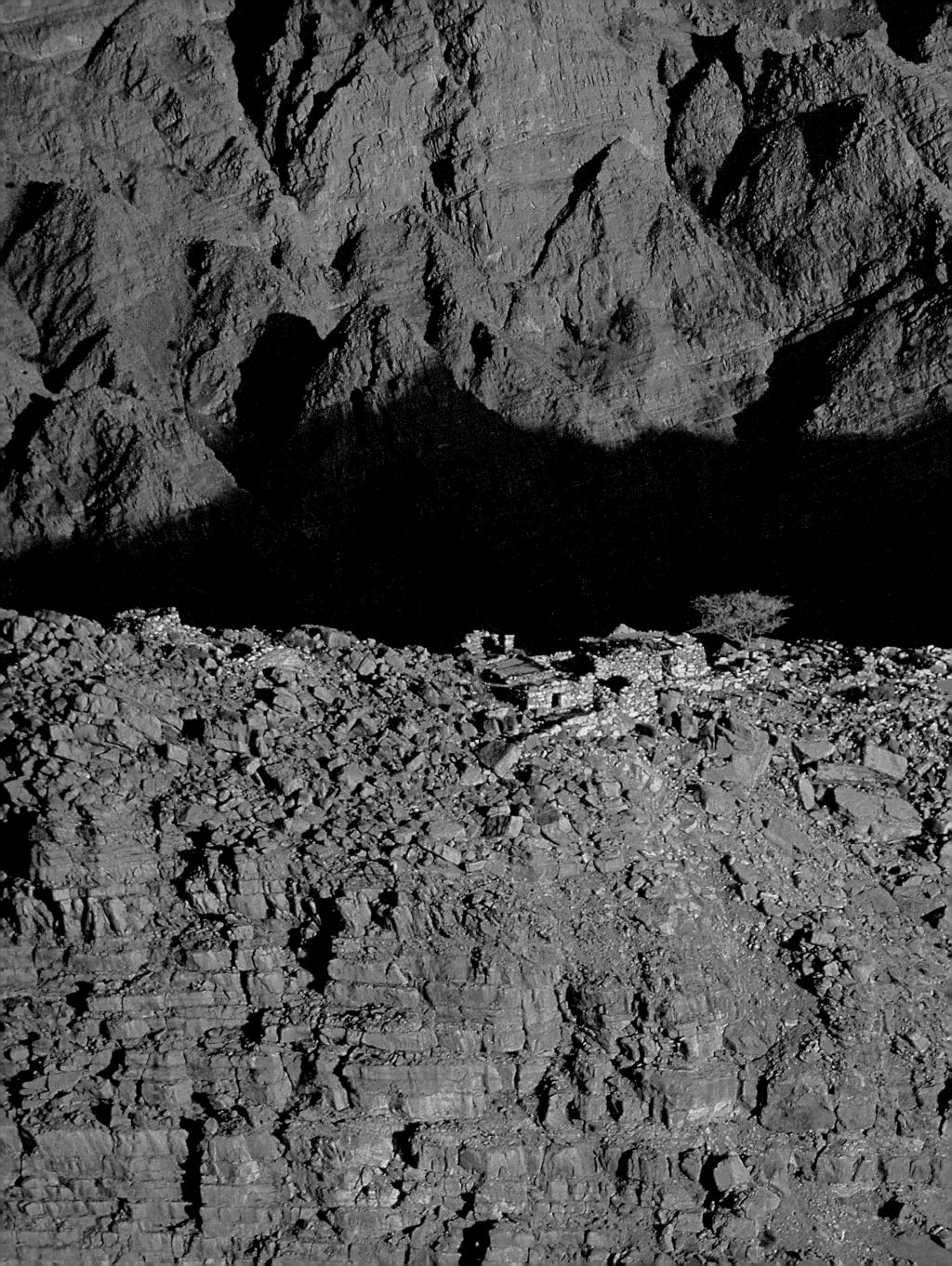

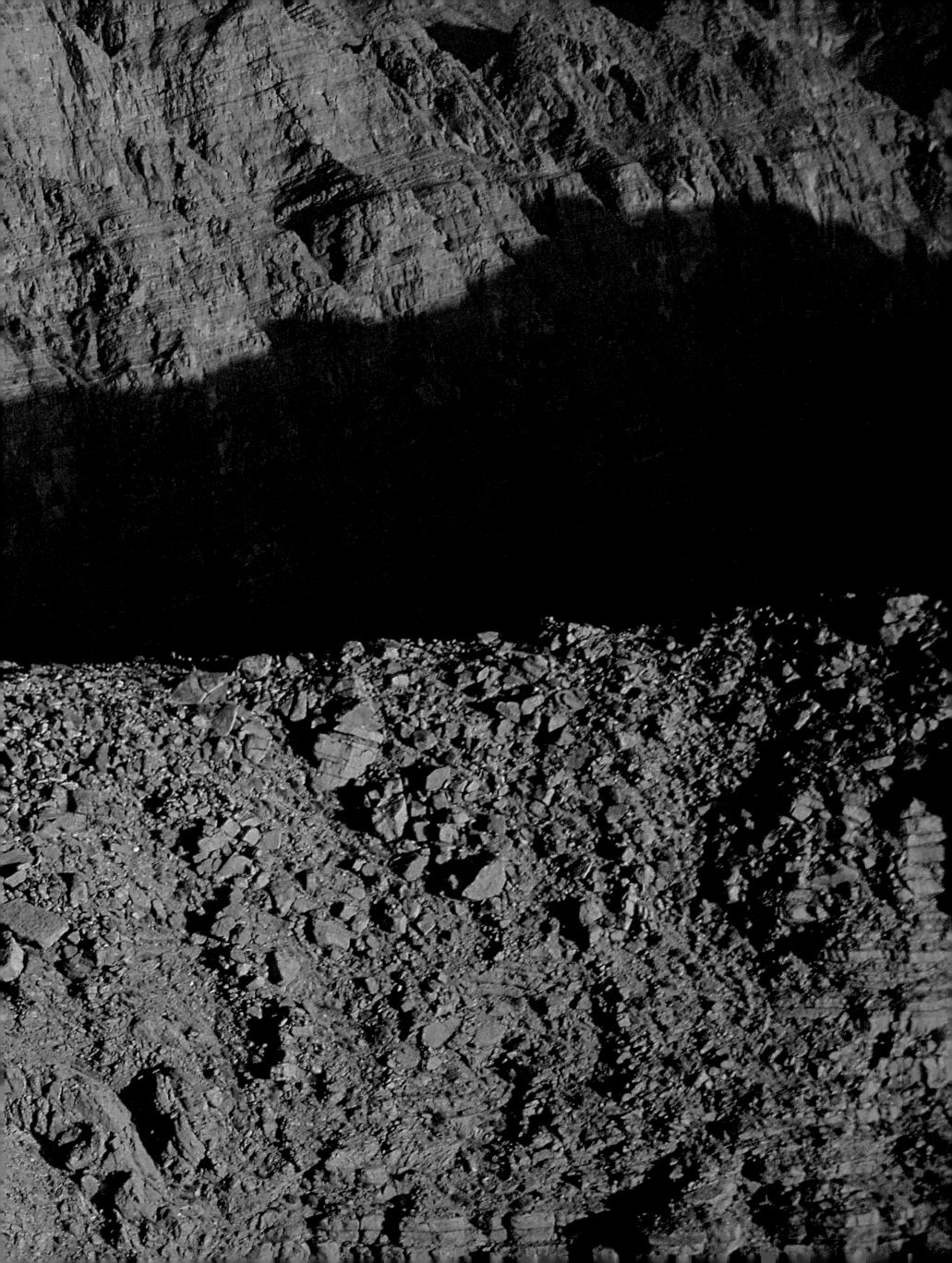

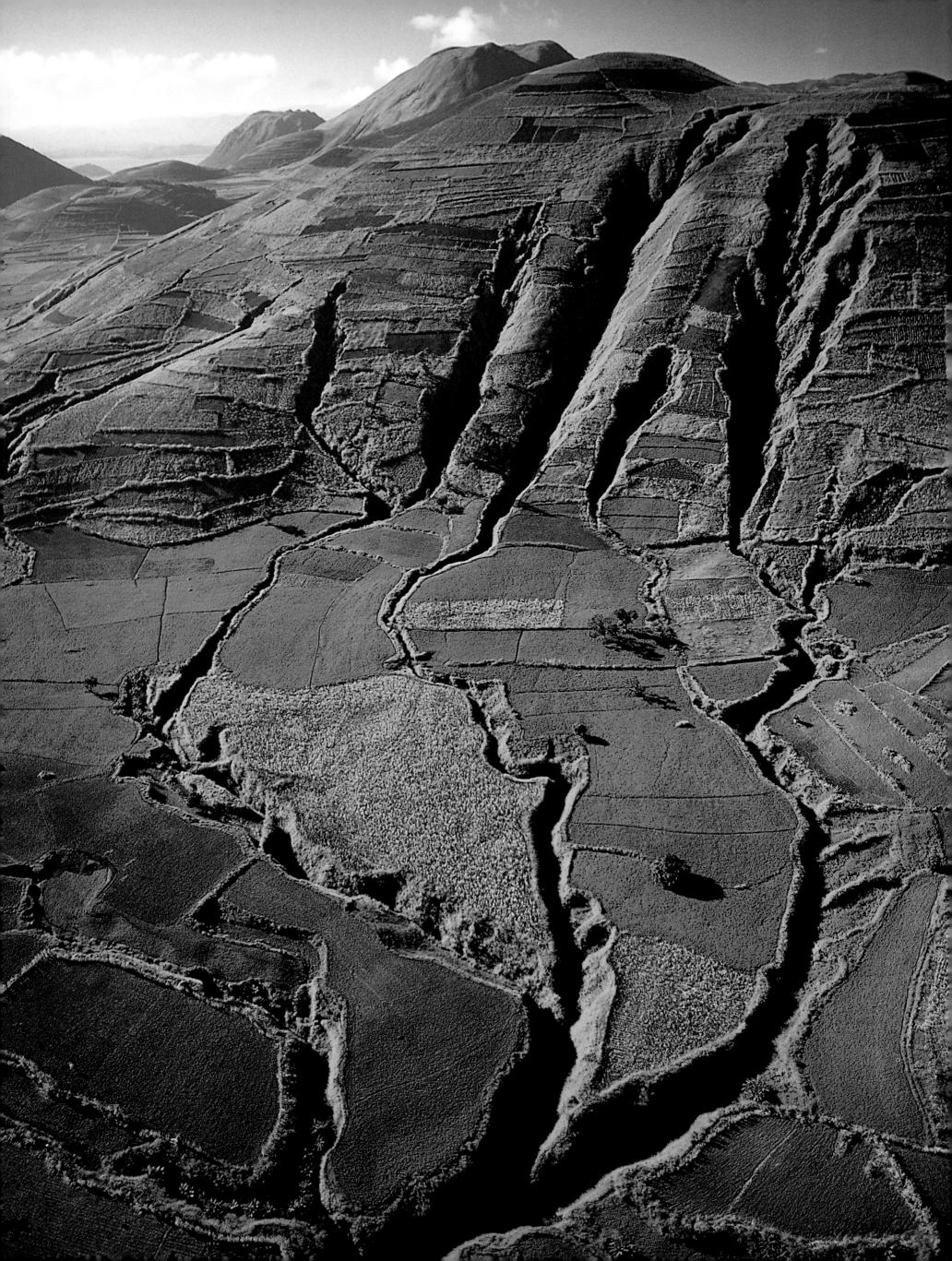

FROM THE PALEOLITHIC AGE TO GLOBALIZATION

he human being is a product of nature. Our species shares 98 percent of its genetic material with our closest species relative, the chimpanzee—a fact that seems even more incredible when we realize that human beings are only 99.8 percent similar to each other. We are members of the animal kingdom, indissolubly bound to the environment, despite our perceived superiority to other species. Nonetheless, the claim to being "outside" nature is perhaps justified by the human capacity to transform its environment.

This ability has long been considered a gift peculiar to the species, whether this claim is true or not, giving humankind carte blanche to use nature without restraint and without regard for consequences. Because of our exercise of this freedom ever since the Paleolithic era, humankind at the dawn of a new millennium is confronted with unforeseen, if not unforeseeable, obstacles. In a growing number of instances, this license has turned into abuse—what was a boon has become a threat to the species.

The human race has managed to extricate itself from nature and manipulate it to such an extent that the environment, the very foundation of life, is now severely imperiled—and thus the future of humanity is in danger as well. Today, faced with the terrible consequences of our abuses, we realize that we are not free to do what we like. We are an integral part of nature and are dependent upon it.

p. 48 EROSION ON THE SLOPES OF A VOLCANO NEAR ANKISABE, near Antananariyo, Madagascar

The origins of the Malagasy people are little known; the first residents apparently settled on the island a mere 2,000 years ago, arriving from Africa and Indonesia in successive waves of migration. For centuries the island has practiced traditional farming by slash-and-burn cultivation, known as *tavy*, which has been particularly devastating for the natural environment because of overexploitation in recent decades. Indeed, due to major demographic growth (the island's population has almost tripled in less than 30 years) and the planting of new crops such as corn since the 1930s, which require broader fields, Madagascar is undergoing rapid deforestation. Agricultural expansion has caused the disappearance of more than 80 percent of the primary forest that once covered 90 percent of the island at the turn of the century, and every year nearly 600 square miles (1,500 km²) of forest are destroyed. Deprived of vegetal cover, the humus and loose earth are stripped away by the rains, uncovering a layer of clay that is not fertile. Faced with the disappearance of arable land, the Malagasy peasants also exploit steep, hilly regions like the sheer sides of mountains, topography in which the risk of erosion is even greater.

THE HUMAN DISTINCTION

At one time we believed that humans alone had the ability to think and to have self-consciousness. However, it has recently been discovered that chimpanzees also have the capacity for self-consciousness, forcing us to redefine our notion of what is distinctively human. For years to come science will continue to give us second thoughts about domains we had considered purely our own. Who would have believed only a few years ago that it would be demonstrated that certain species of ants, insects living in organized societies with

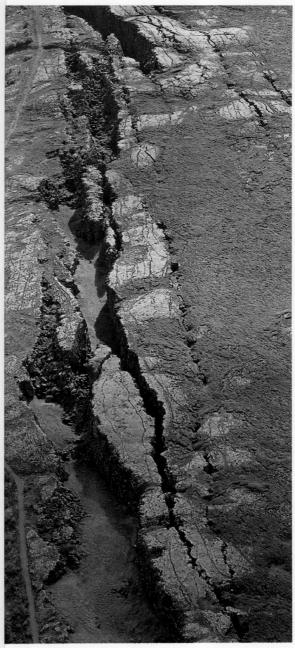

INDIVIDUAL CUMENE

mene—the area of the earth inhabited by man beings, however tenuous their presnbraces the entire planet. The ecumene iety of environments and terrains; some ntial to others, as shown by either a denr a "void." Only recently have we become significant facts. First, the ecumene was , independent of humanity; human inhabcological balances, and this modification to make places unlivable. The second

important fact is that this ecumene only I give to it, by our own intellectual construct. The earth exists independently of us and out us, but our existence depends on f spaces that are hospitable to human hab

Today the equilibriums of our planet sciousness of this threat has only recentl an awareness that can take the form of no

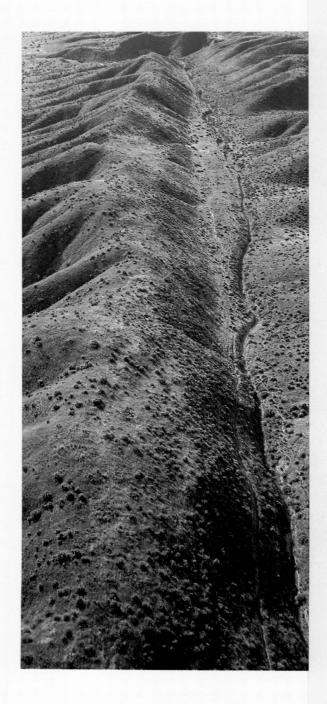

with a growing sophistication in the ability to satisfy the ever-new needs of a carefree and increasingly comfortable society, while the widening network of the media has spread models of wealth across the globe. Yet the full weight of demographic growth falls most heavily on the most destitute. What would be the consequences for the environment, the world we inhabit, if the hundred poorest countries of the planet were to attain the same standard of living as the ten richest?

For the moment, only a small segment of society has arrived, undoubtedly with difficulty, at the conclusion that beliefs should remain private and, consequently, that the management of societies as well as of the environment should come under the control of the public sphere. Of course, individual and collective beliefs and general symbolic systems still play an important part in this management. New rights need

to be recognized that will apply not only to one social group inhabiting one domain but to the entire human population throughout the world. The whole of the earth is progressively becoming the zone of reference for individuals in diverse societies.

Pierre Gentelle

p. 57 ERUPTIVE CONE OF PITON DE LA FOURNAISE, island of Réunion, France

The Piton de la Fournaise ("Peak of the Furnace"), 8,600 feet (2,631 m) high, in southeastern Réunion, is the most active volcano on the planet after Kilauea in Hawaii. Active for the past 400,000 years, it erupts on an average of every 14 months; however, in the great majority of cases, the magma projections do not exceed the three zones of depressions, or *caldeiras*, that immediately surround it. Occasionally, as in 1977 and 1986, more violent eruptions occur in which destructive streams of lava invade the wooded slopes and the residential areas of the island. Today, 140 of the earth's 500 active volcanoes situated above sea level are permanently monitored by scientists. A volcanic observatory was built near the Piton de la Fournaise in 1979, making it one of the most closely watched volcanoes in the world.

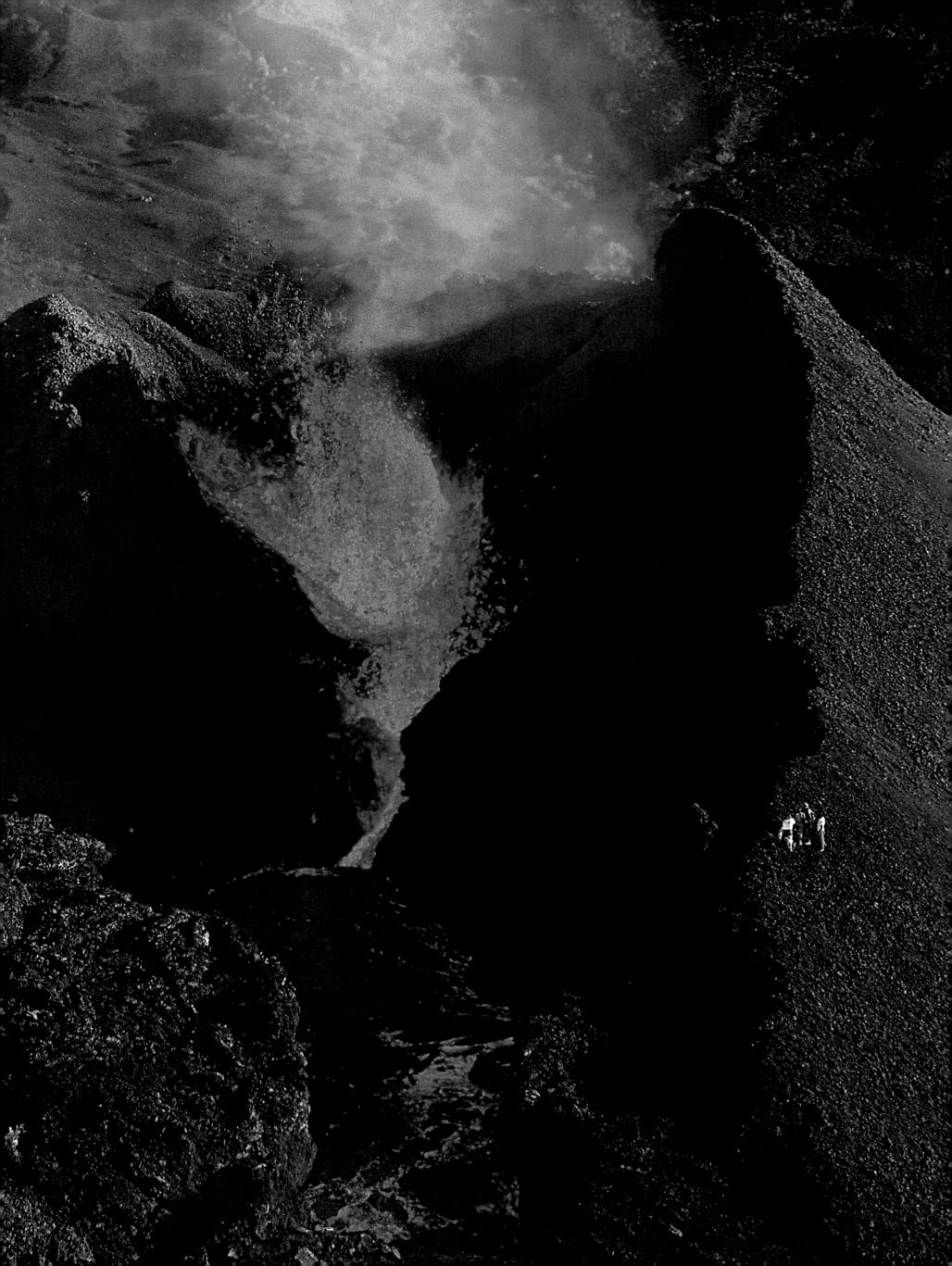

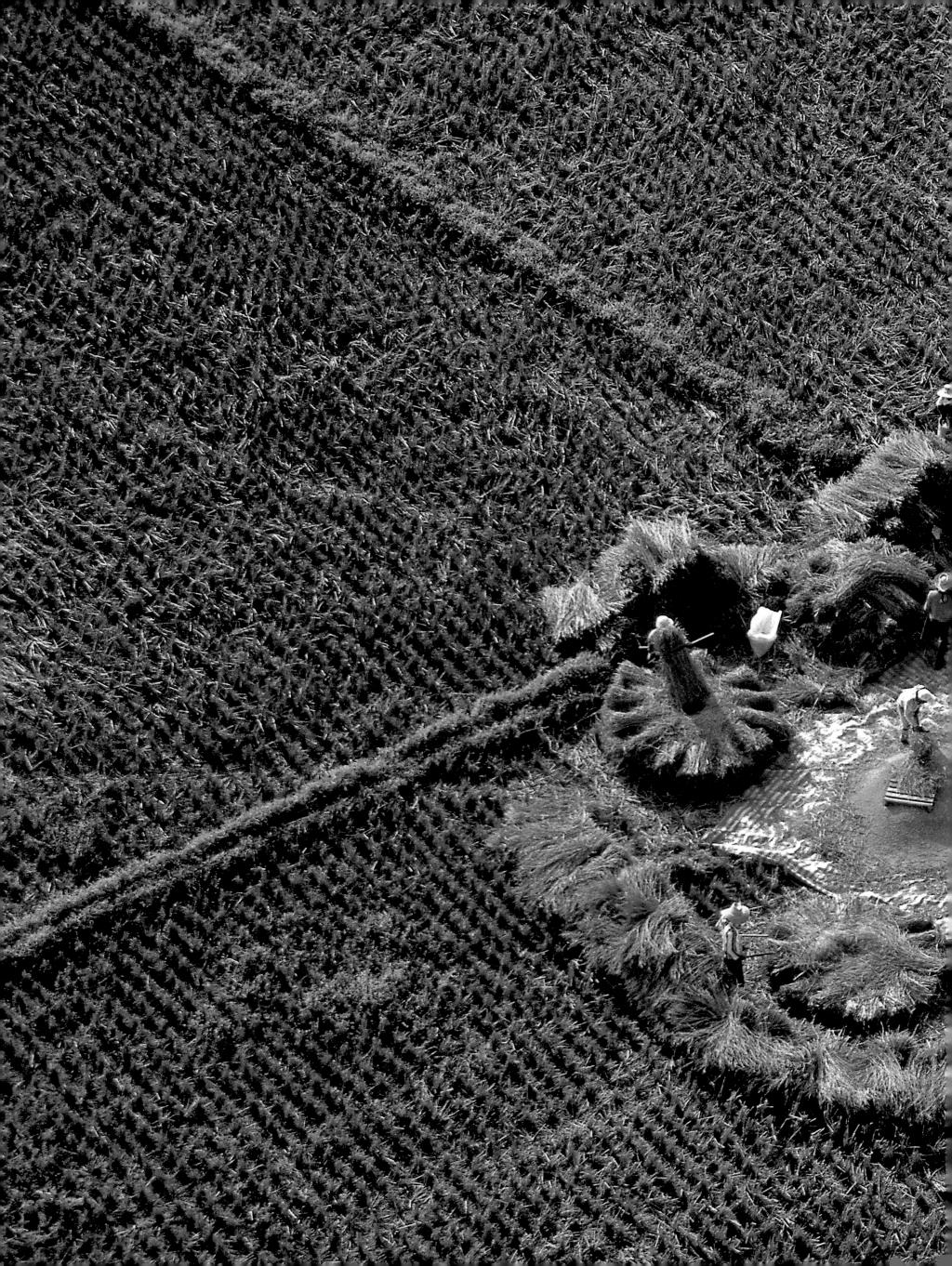

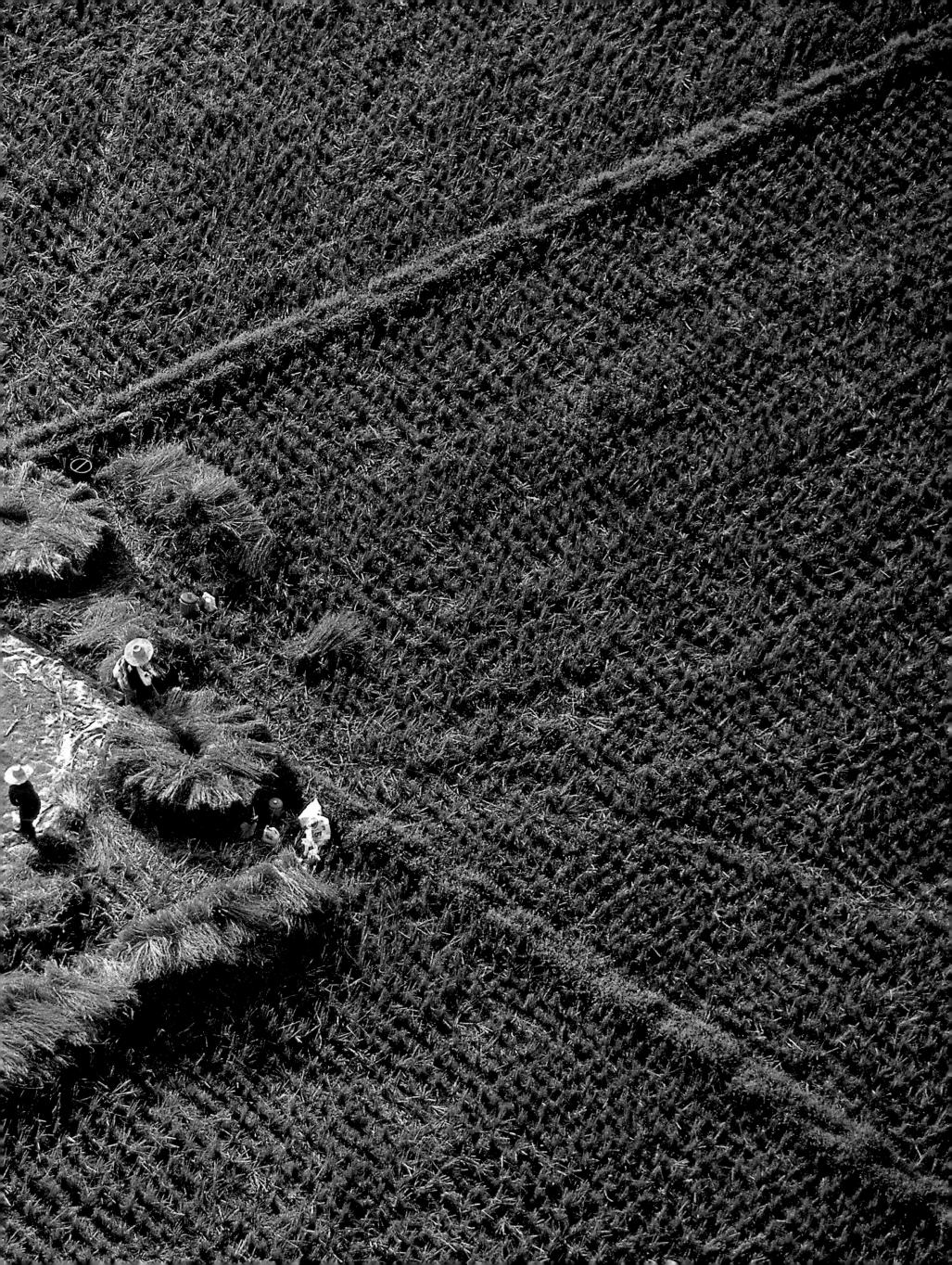

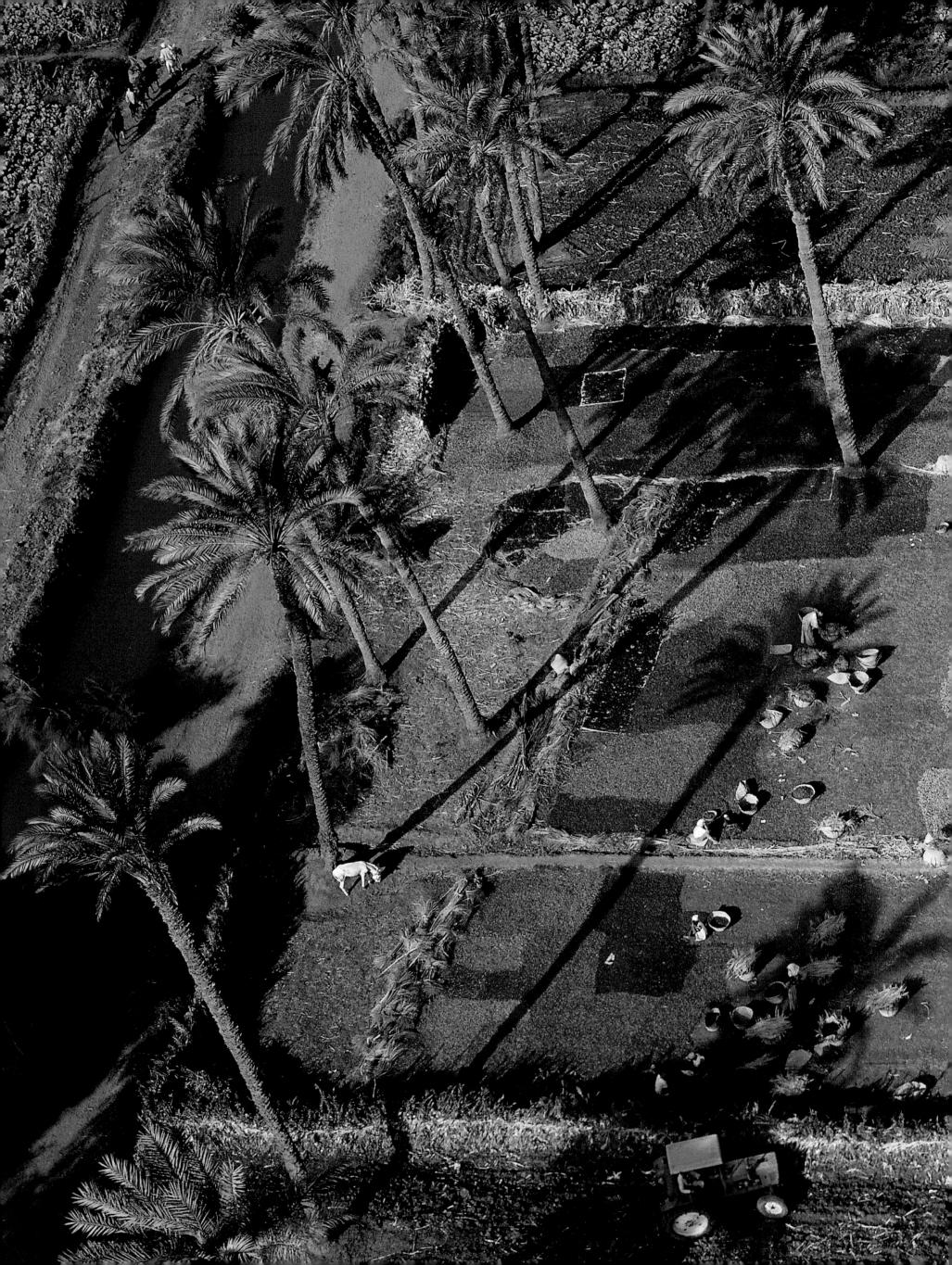

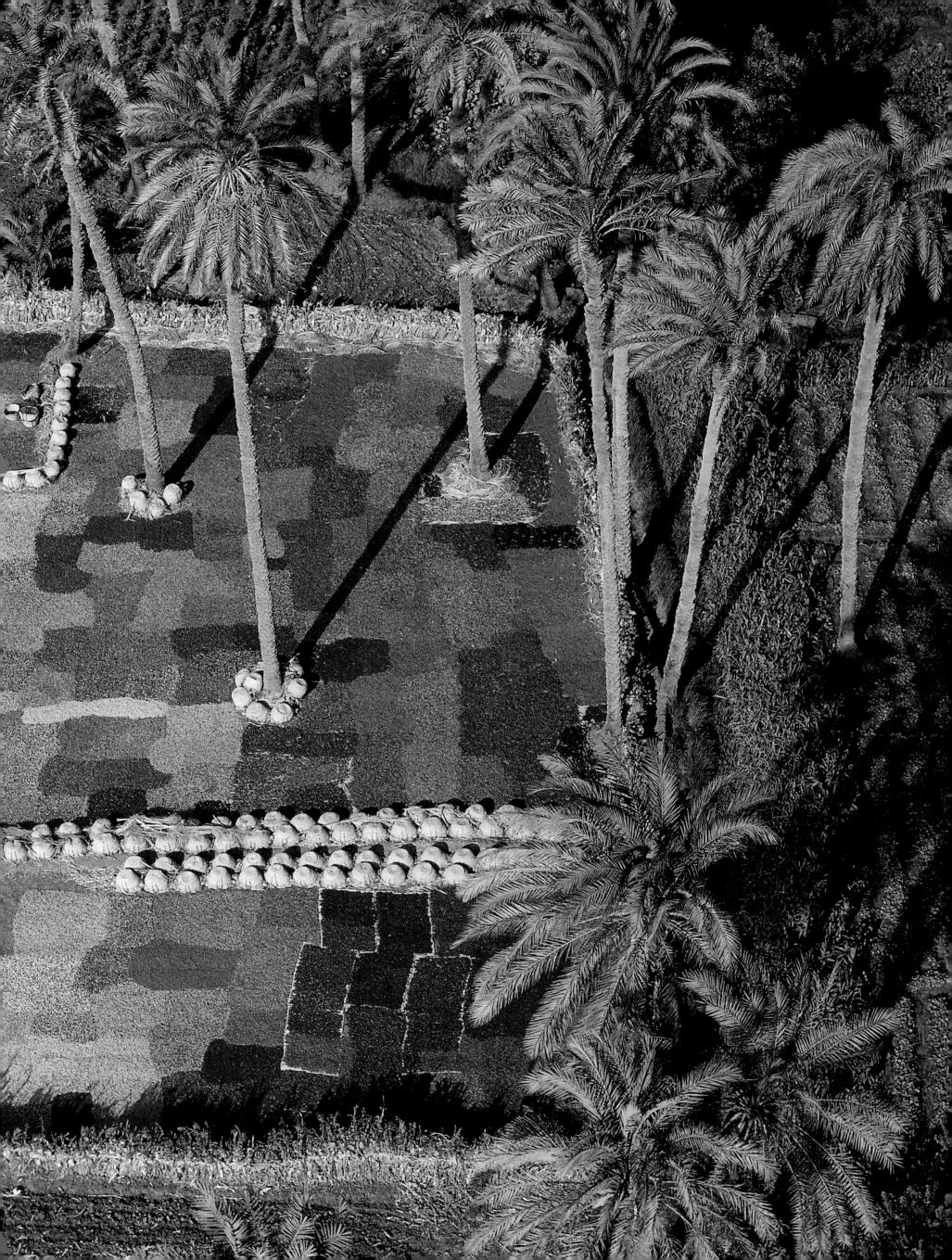

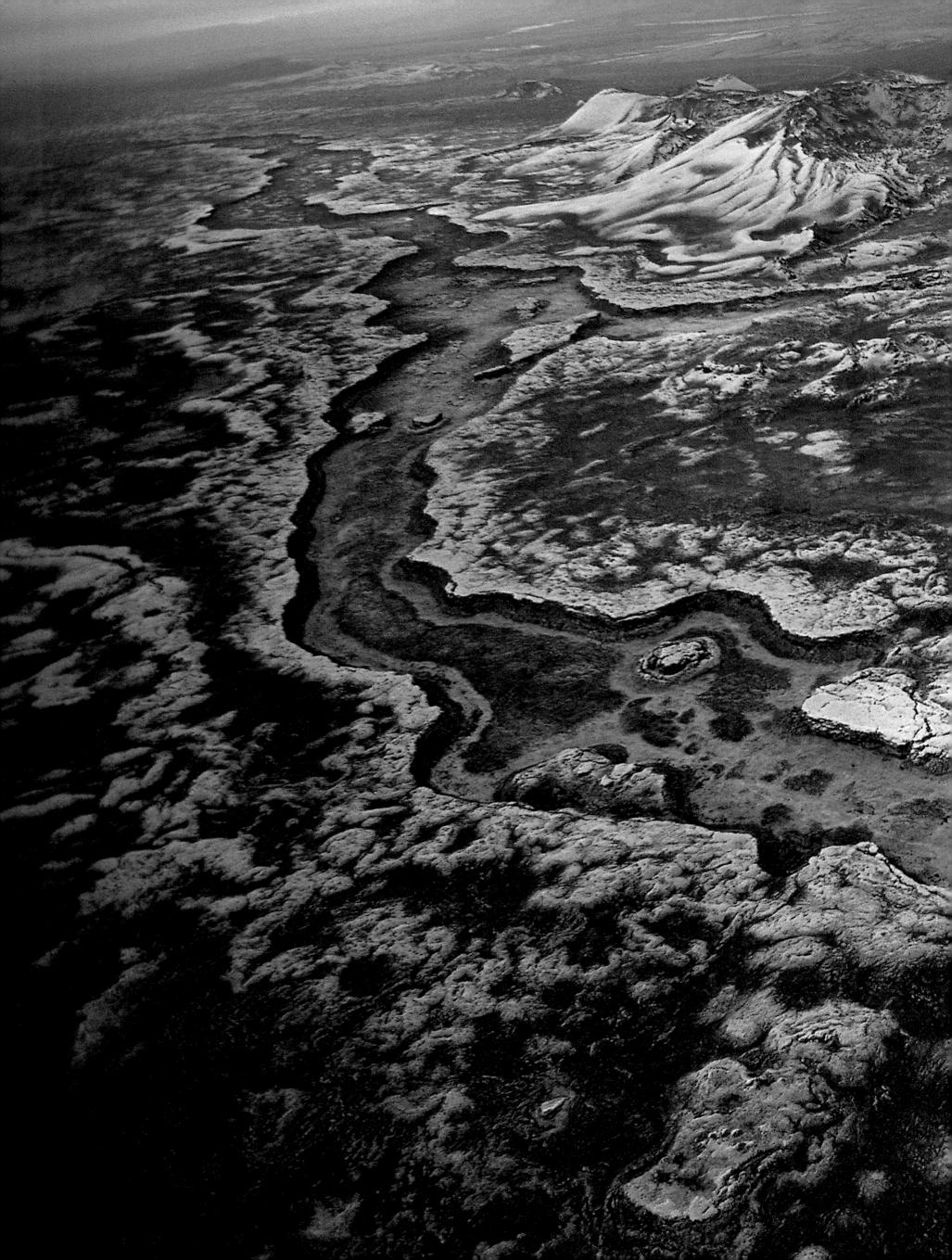

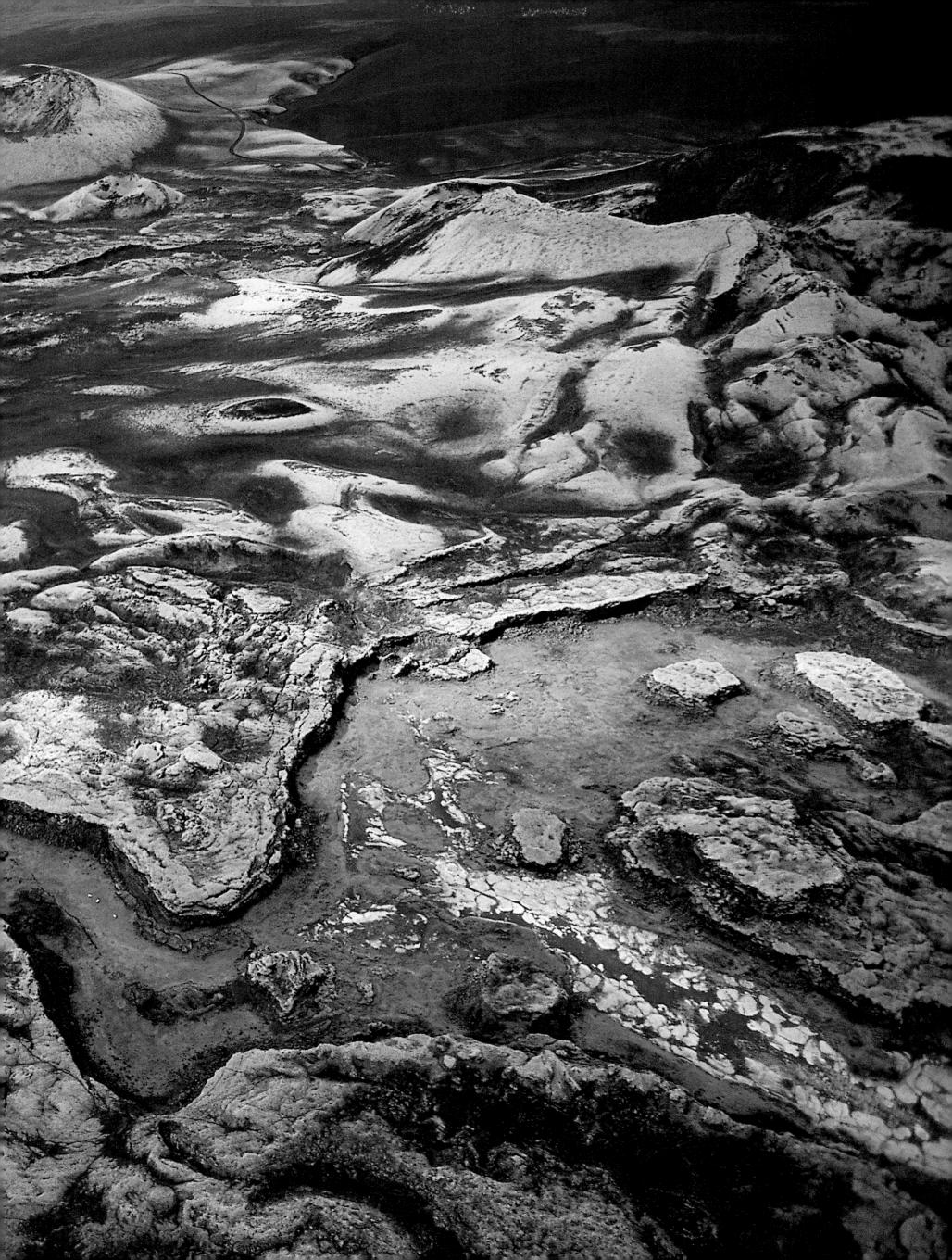

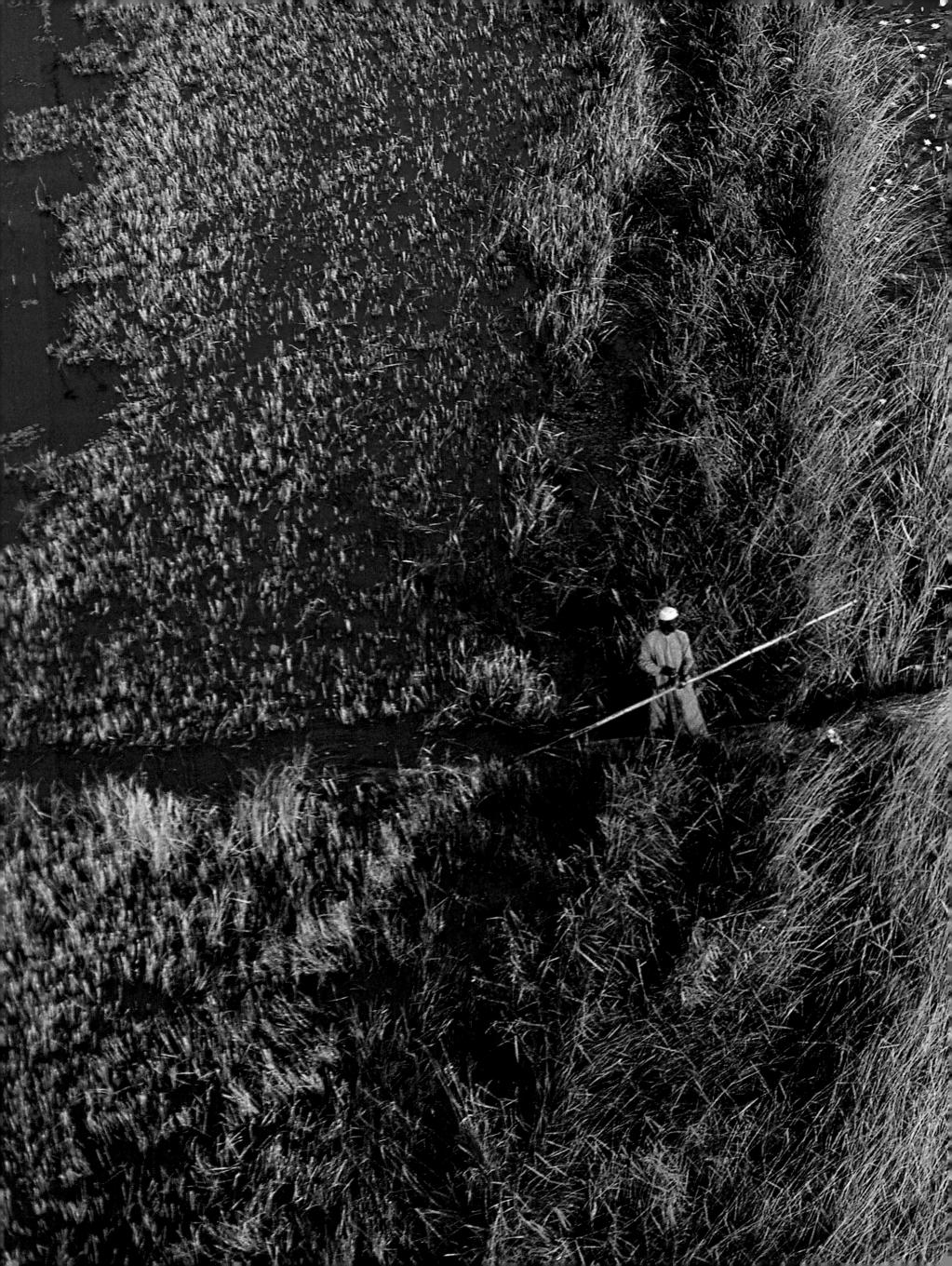

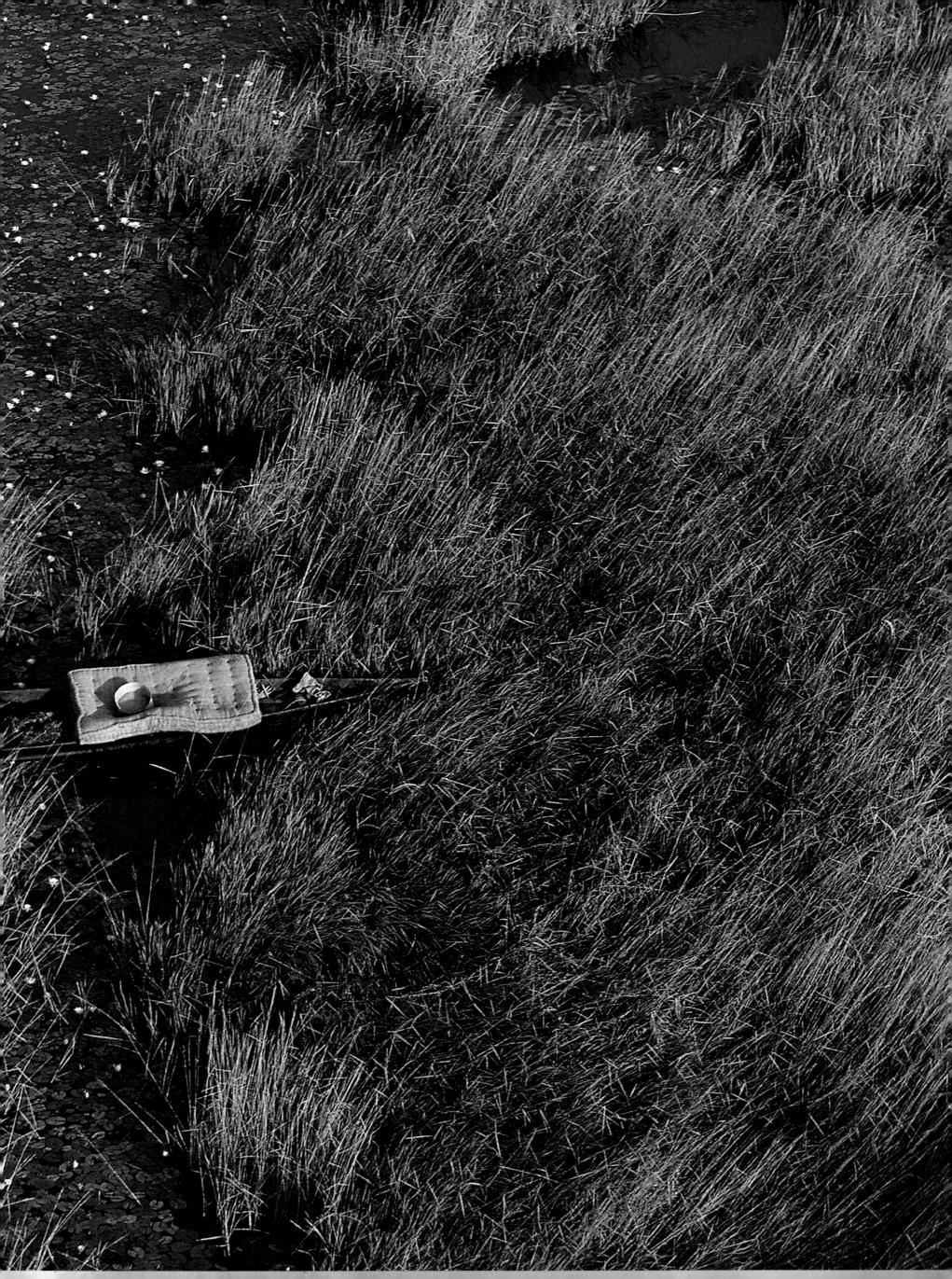

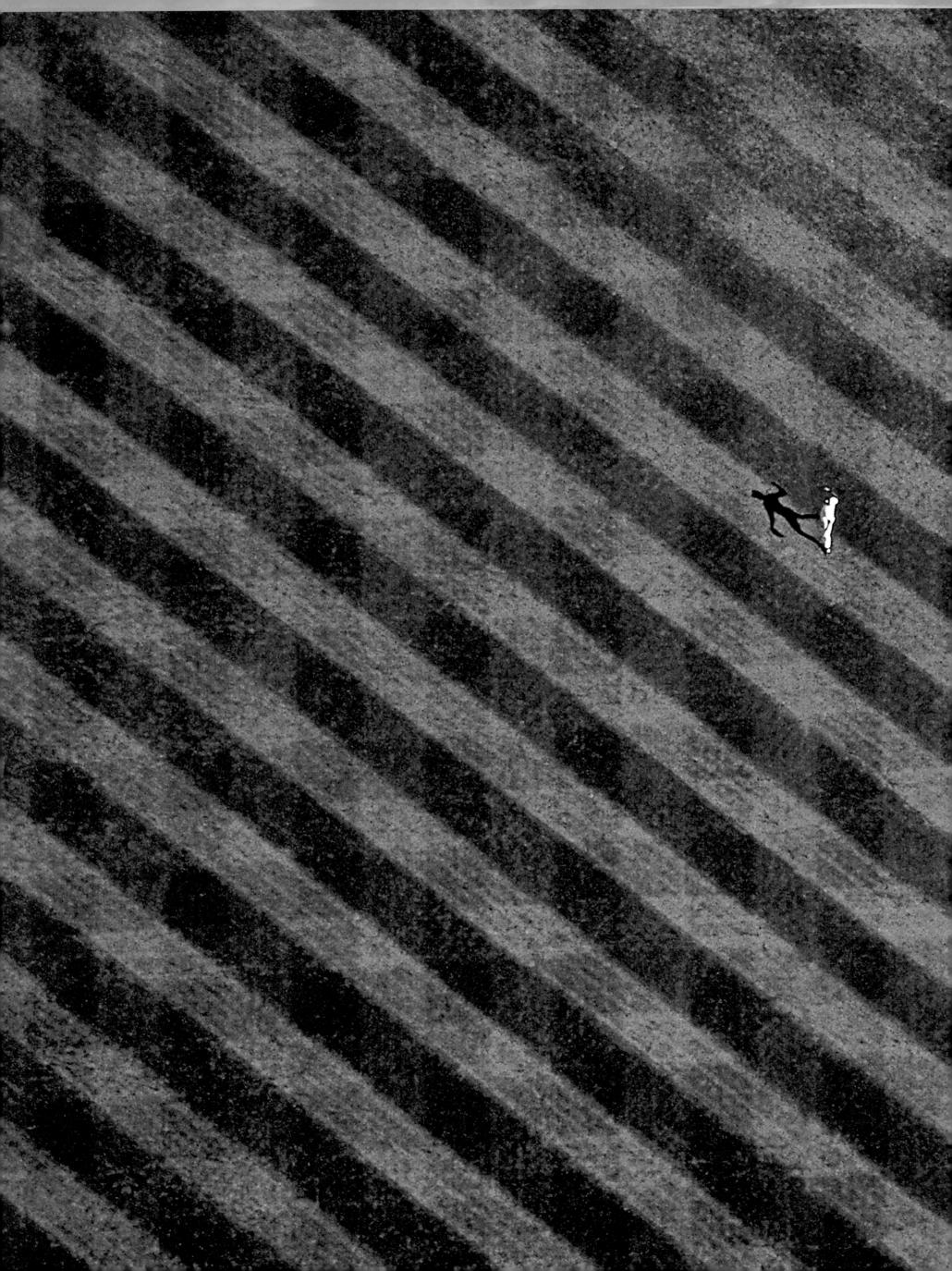

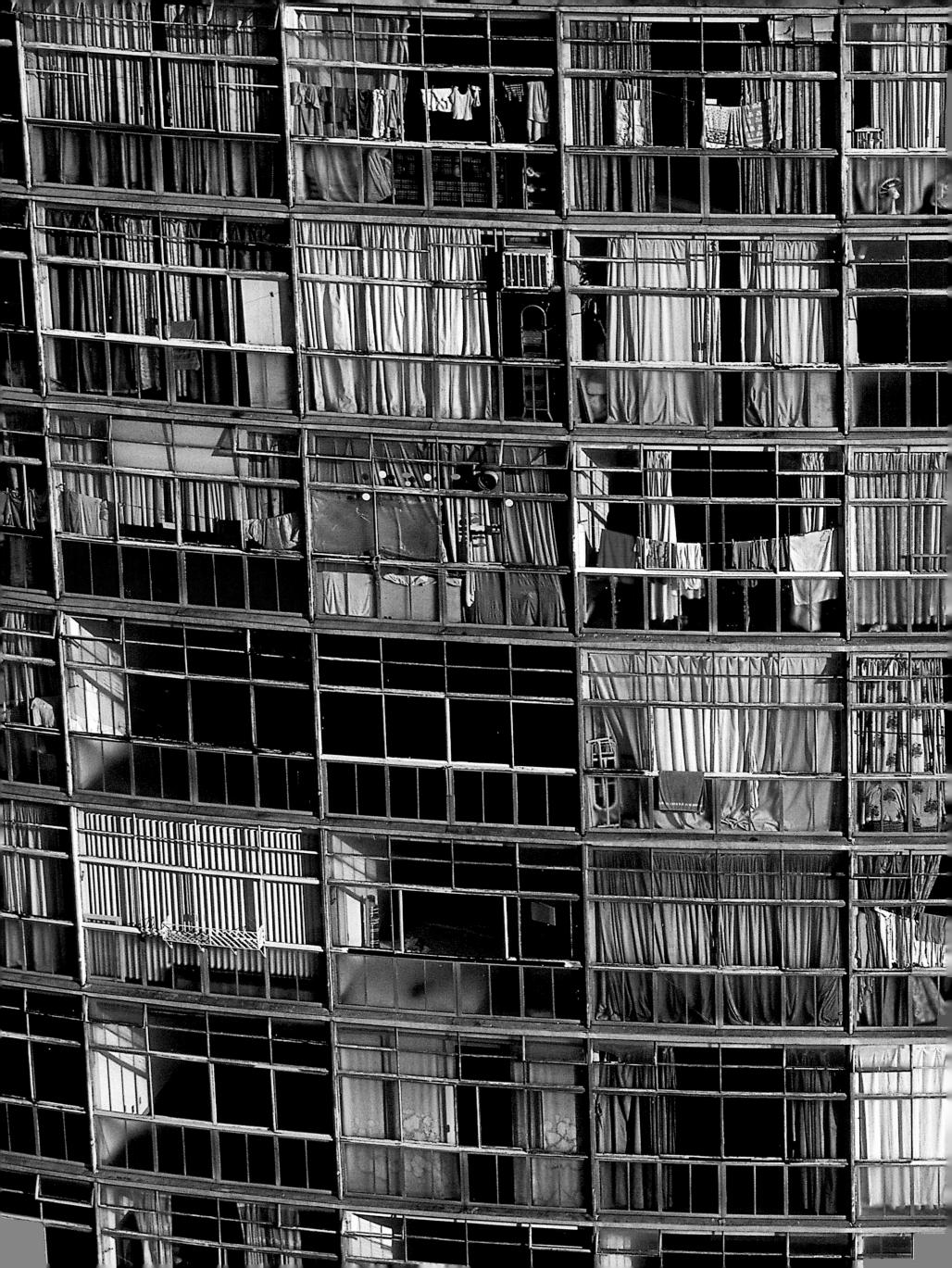

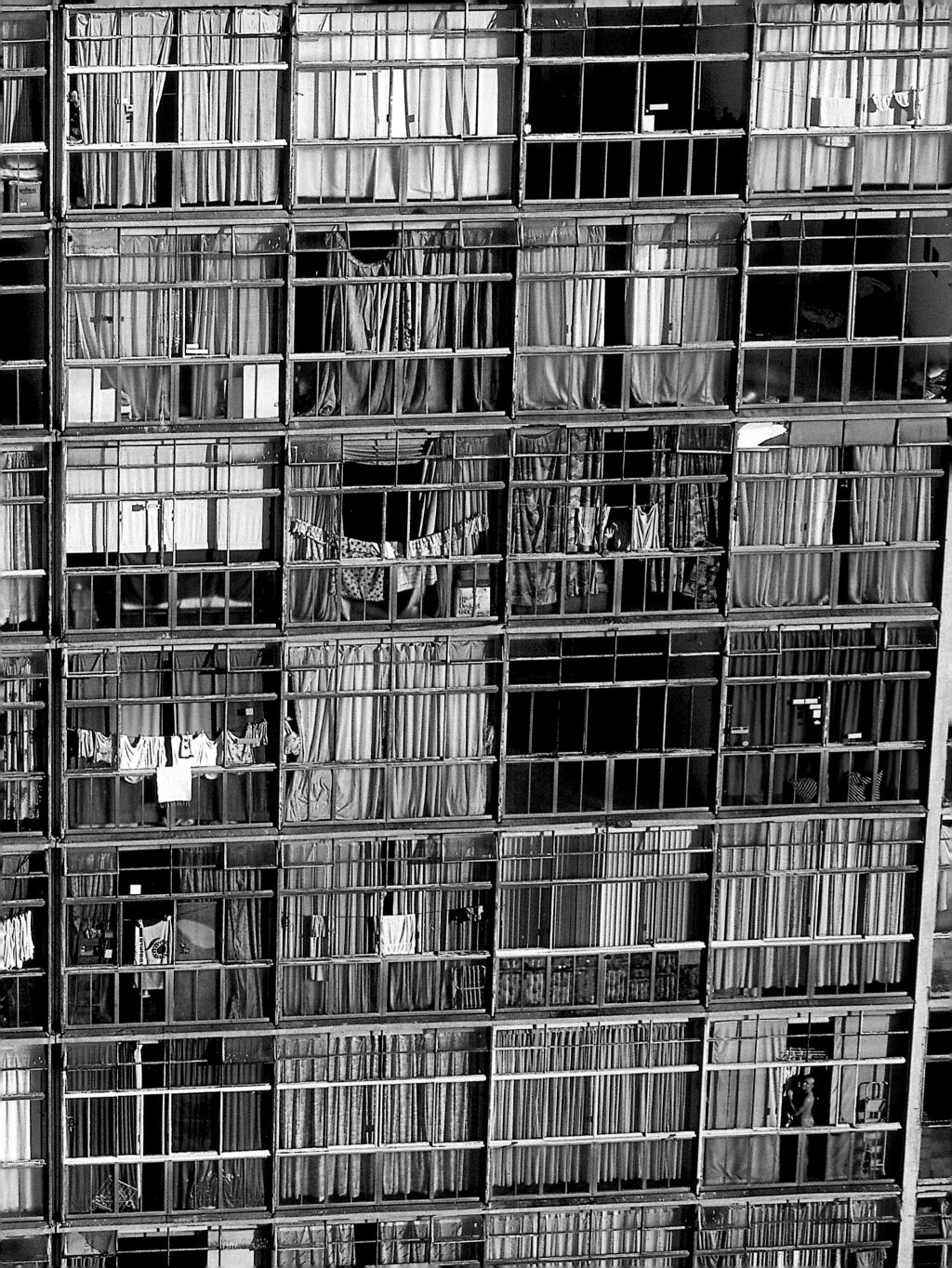

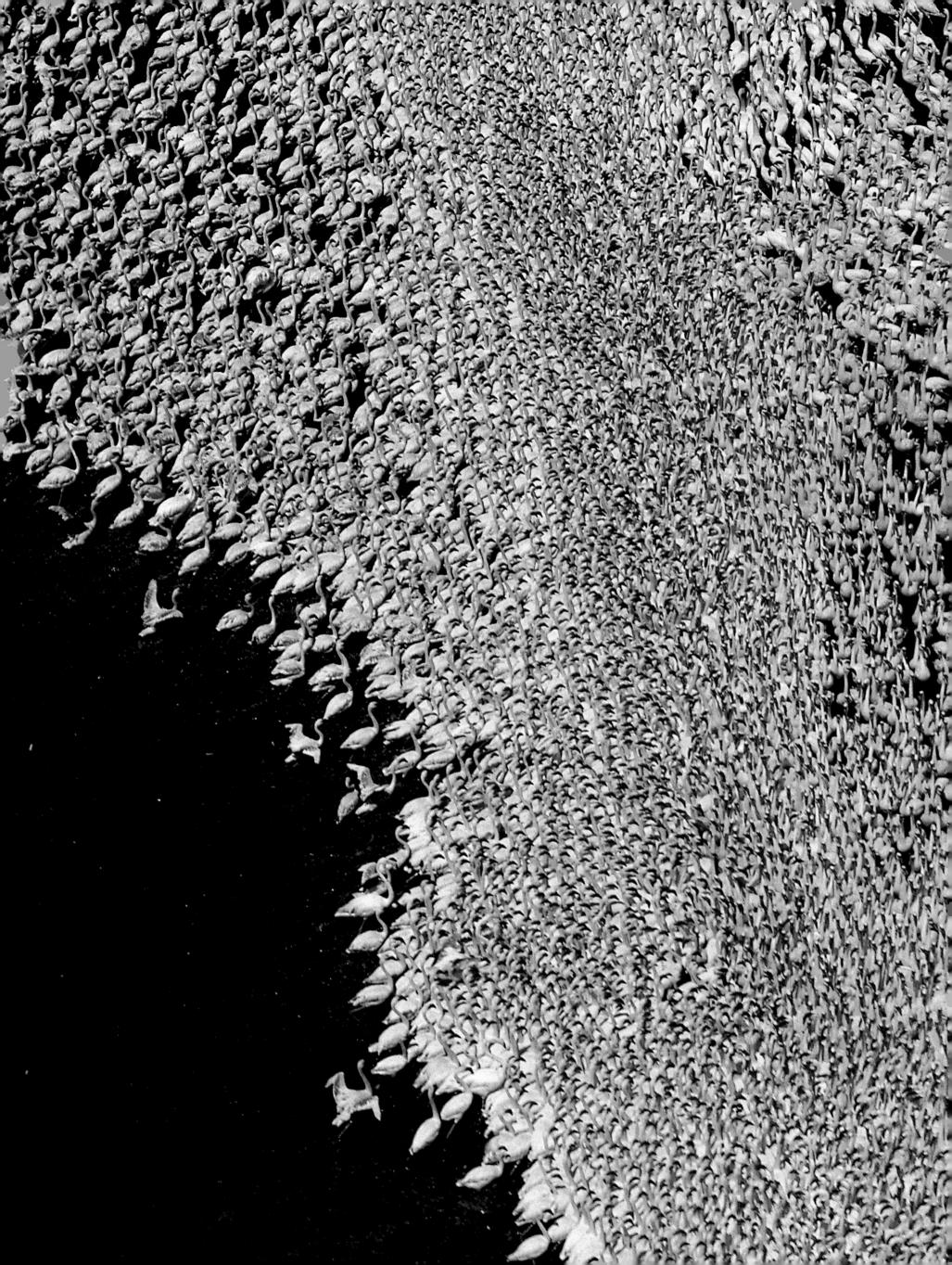

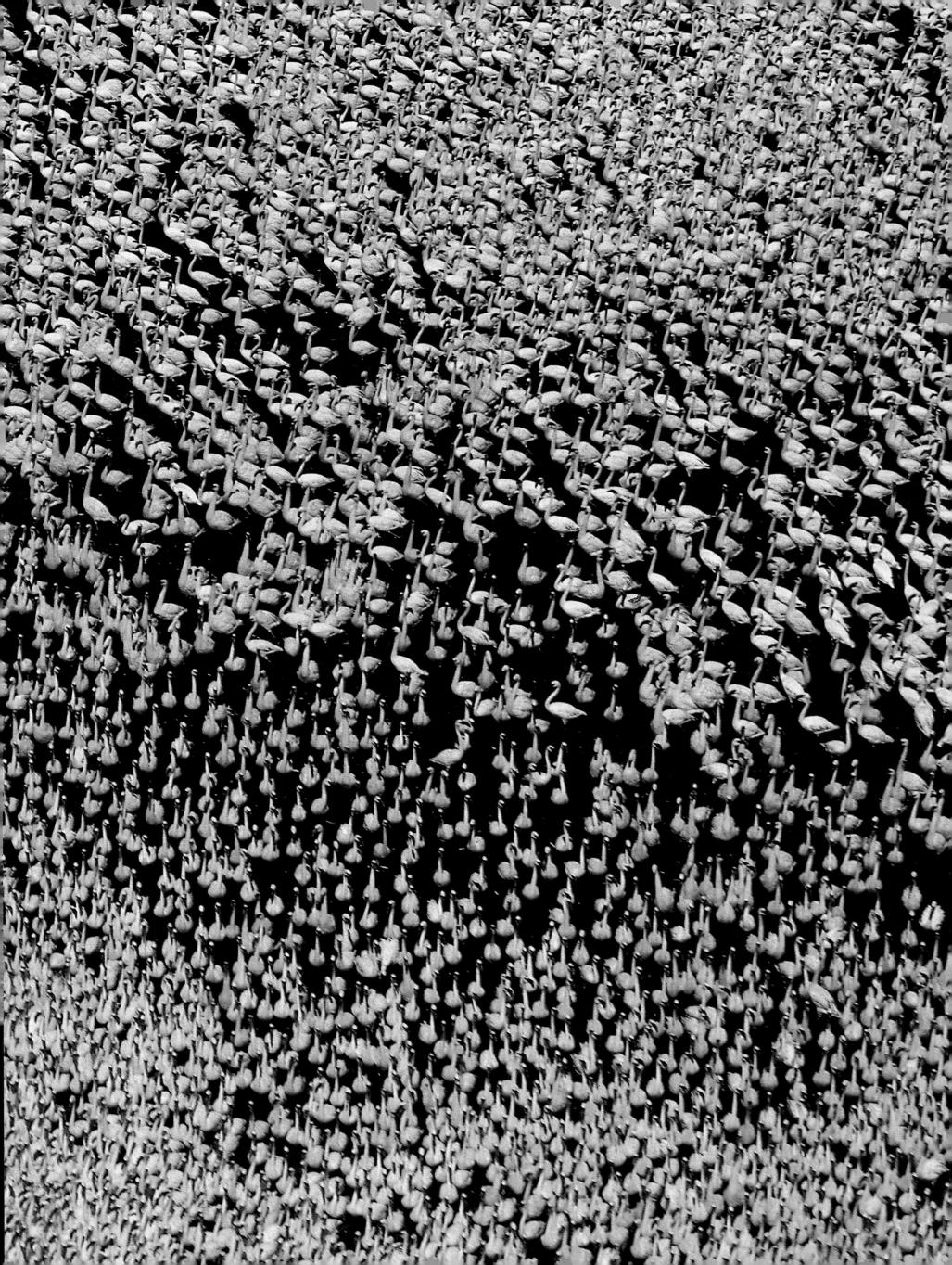

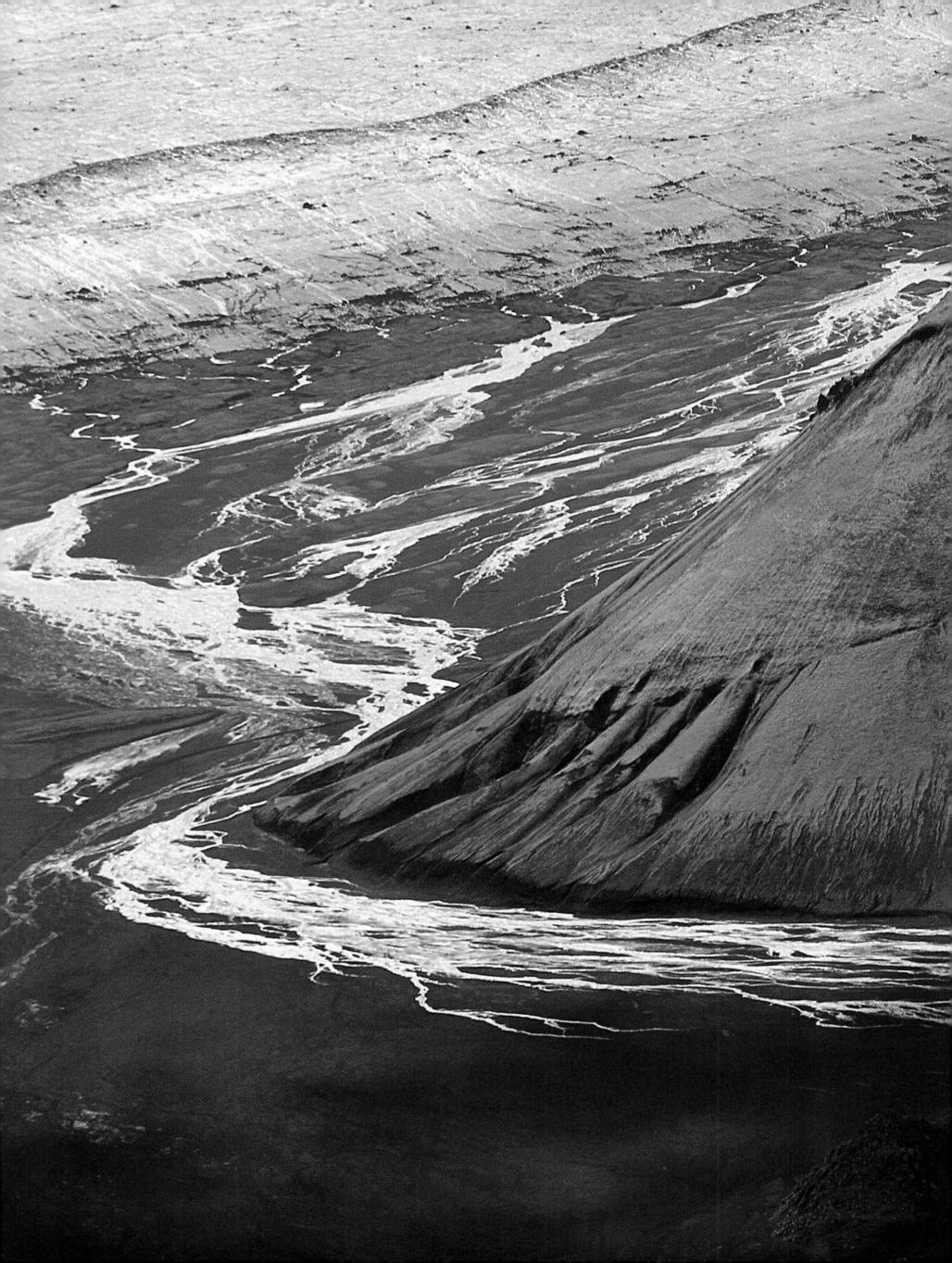

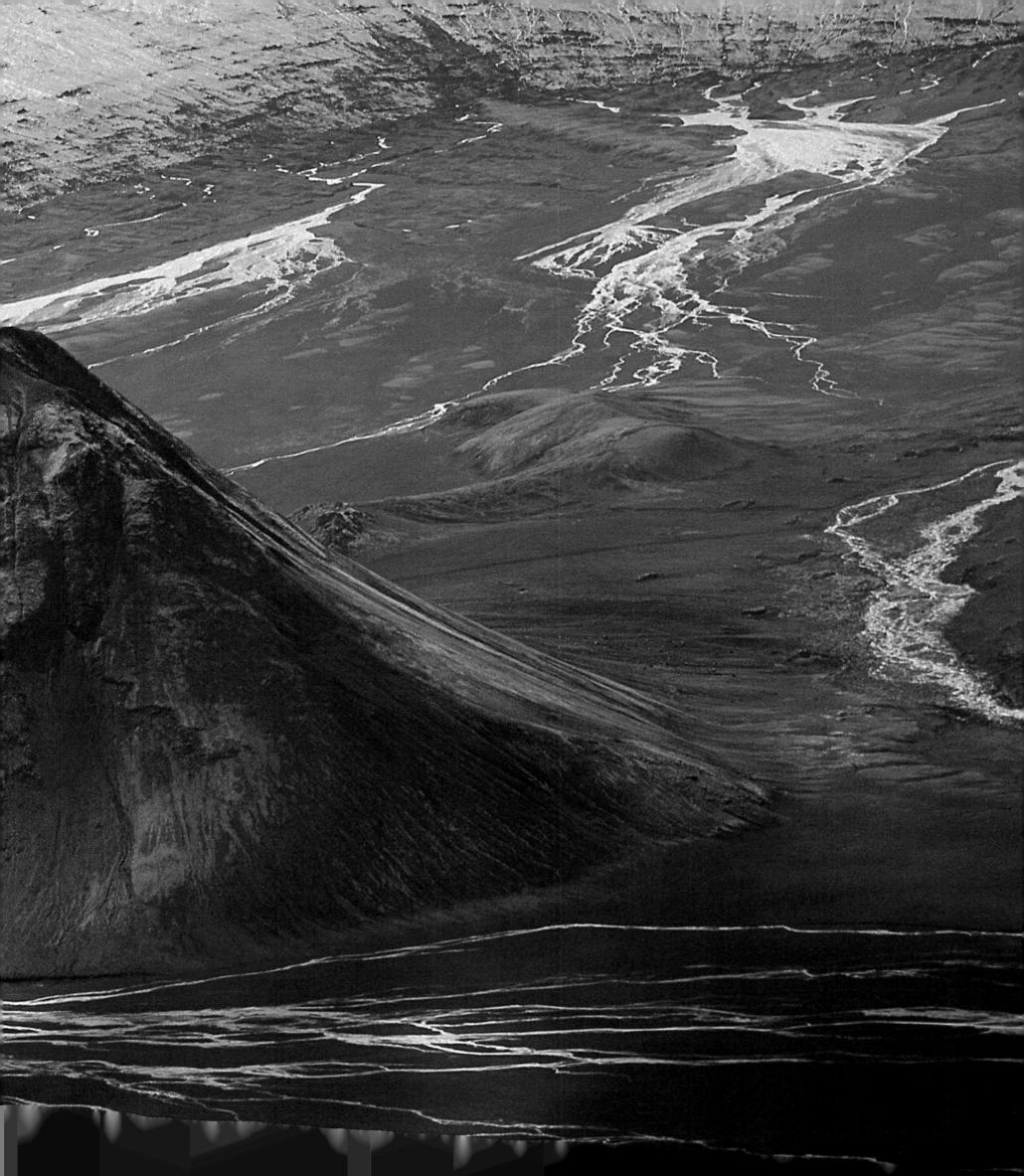

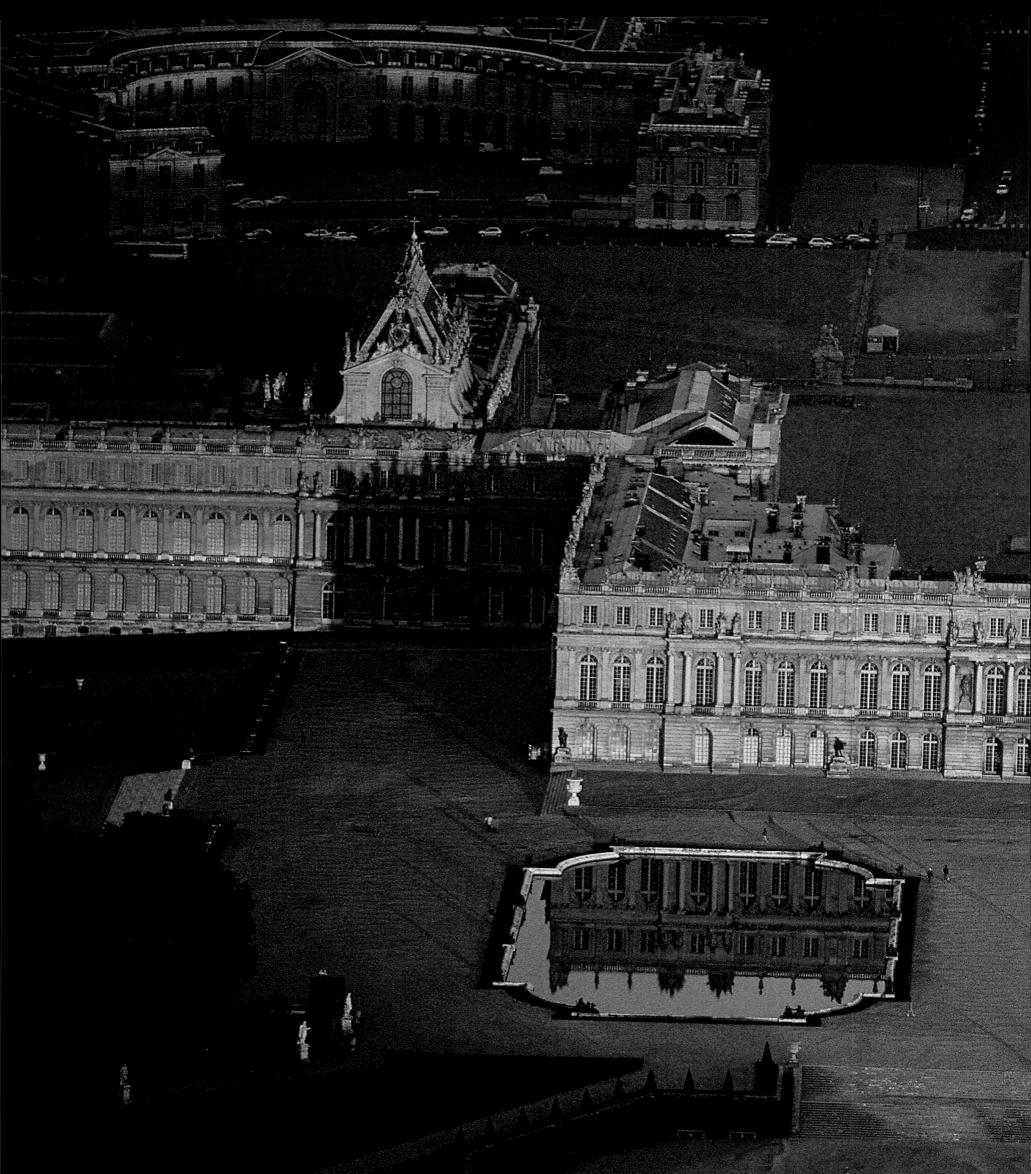

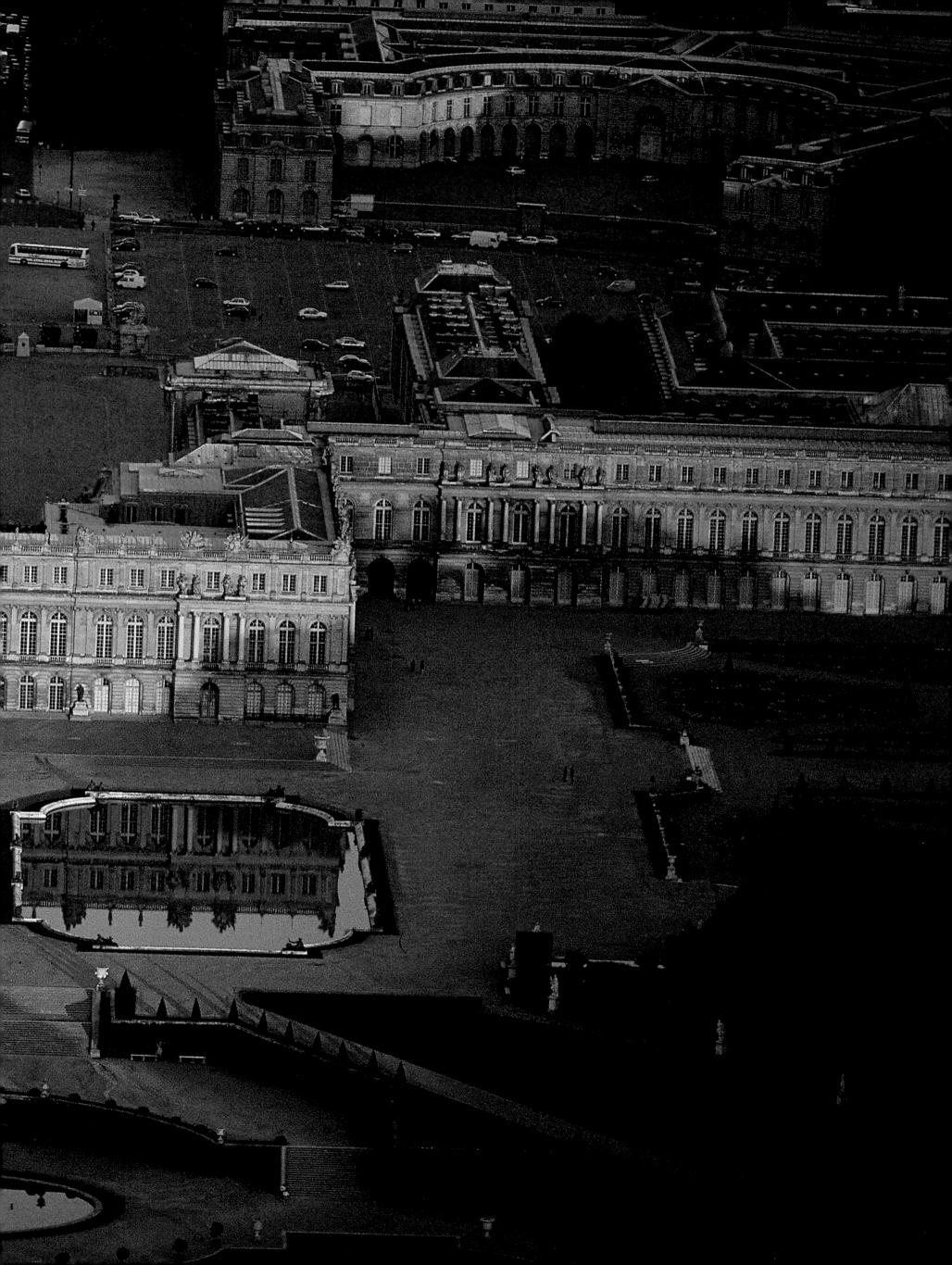

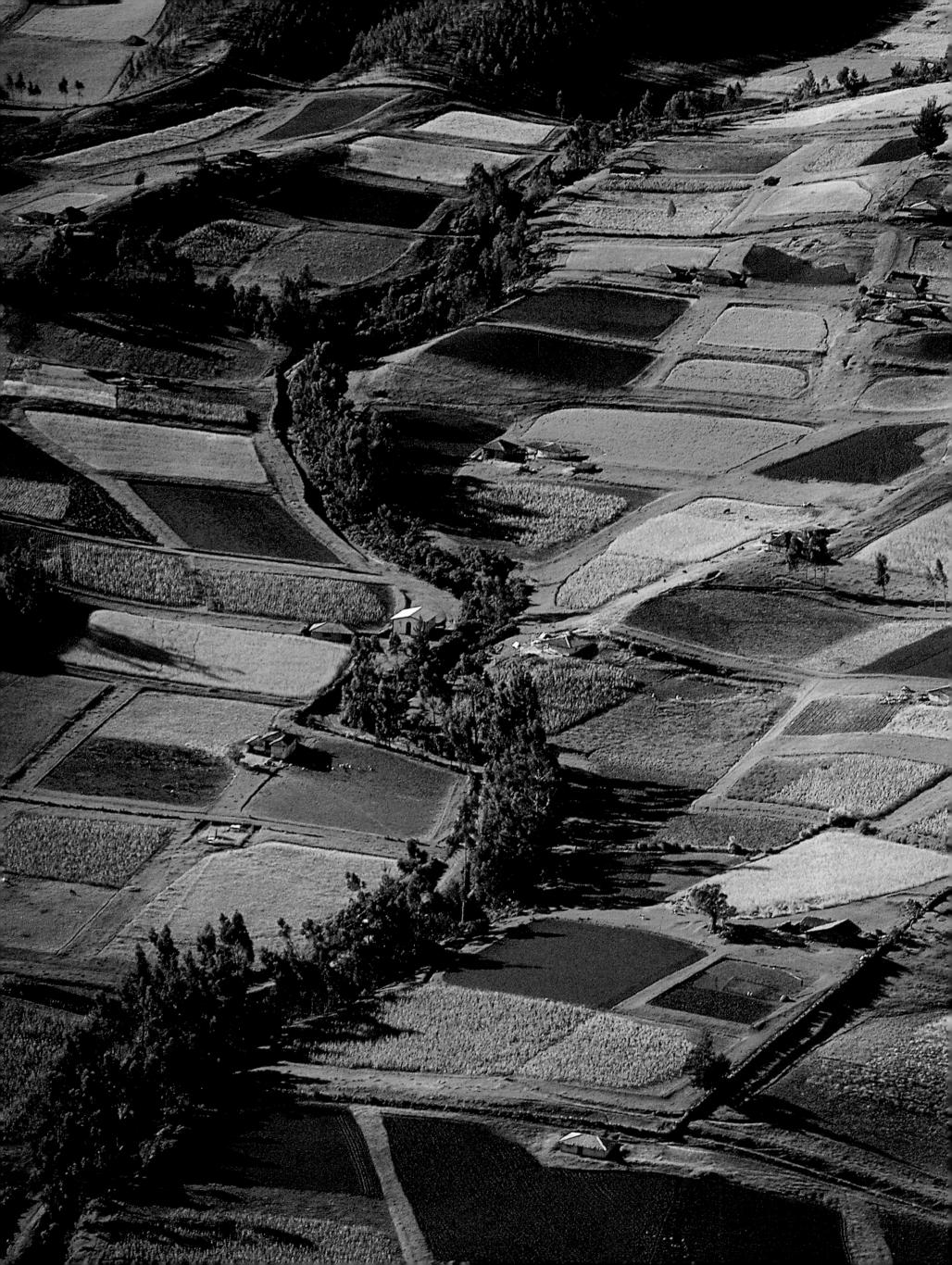

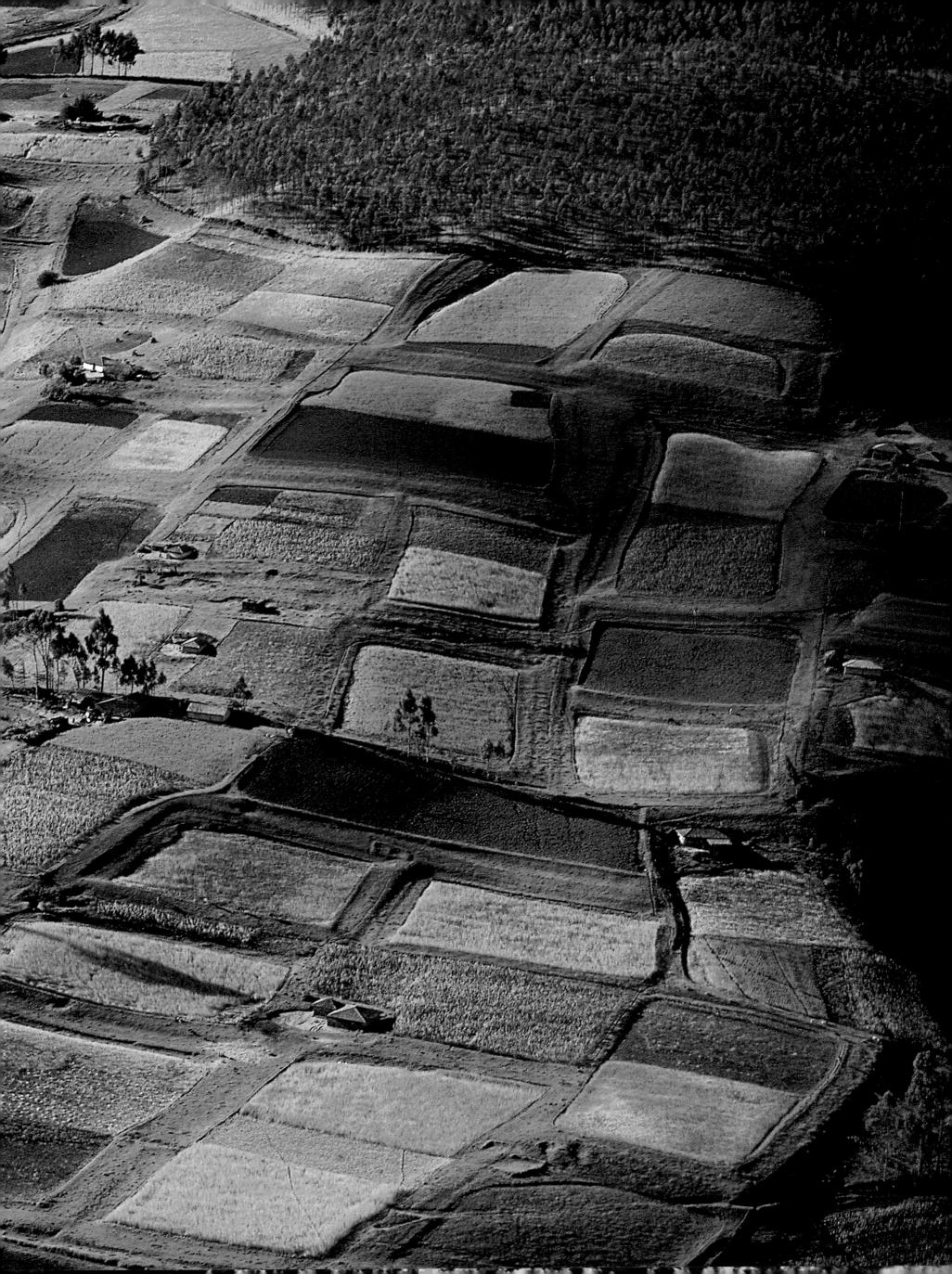

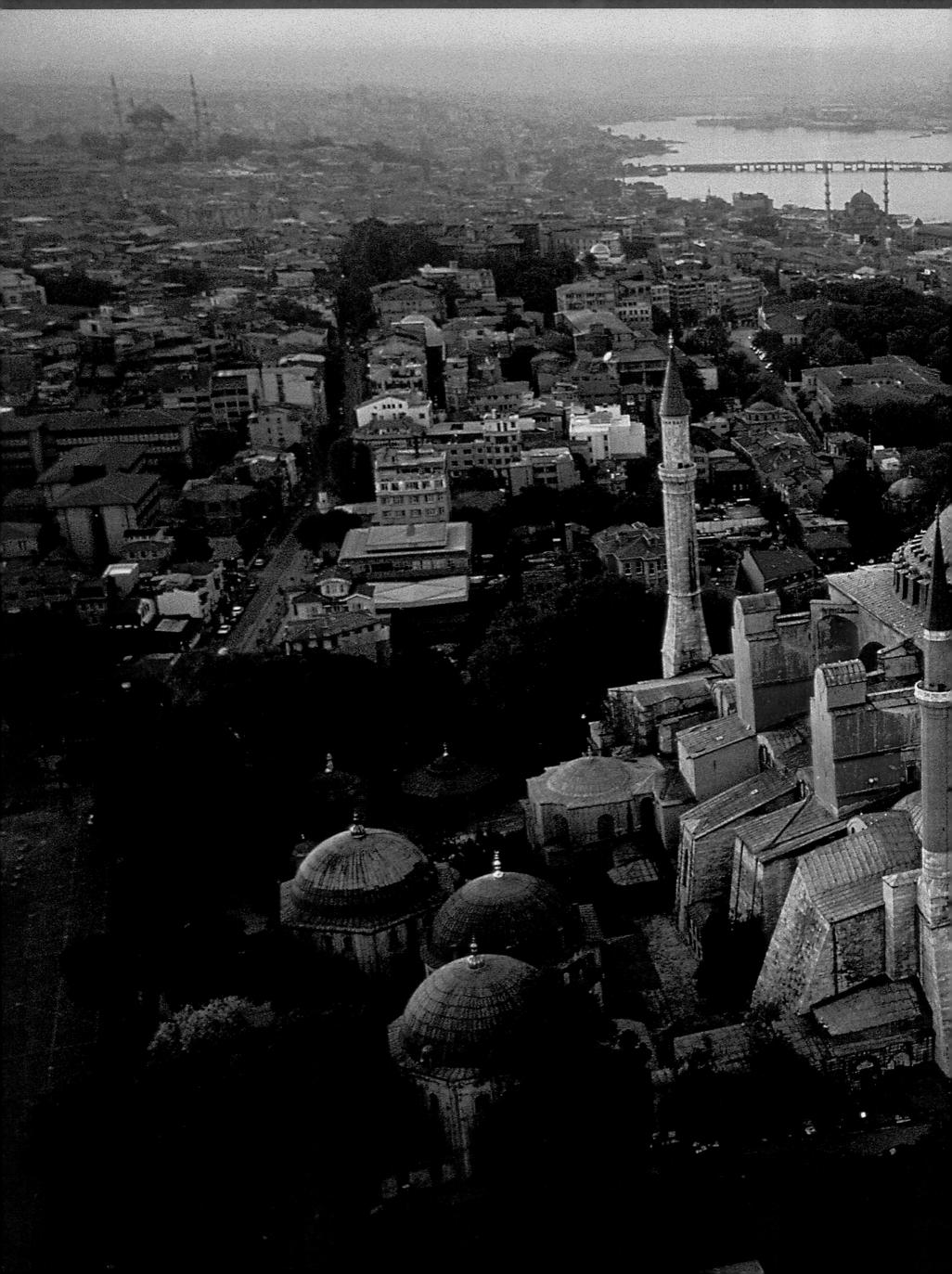

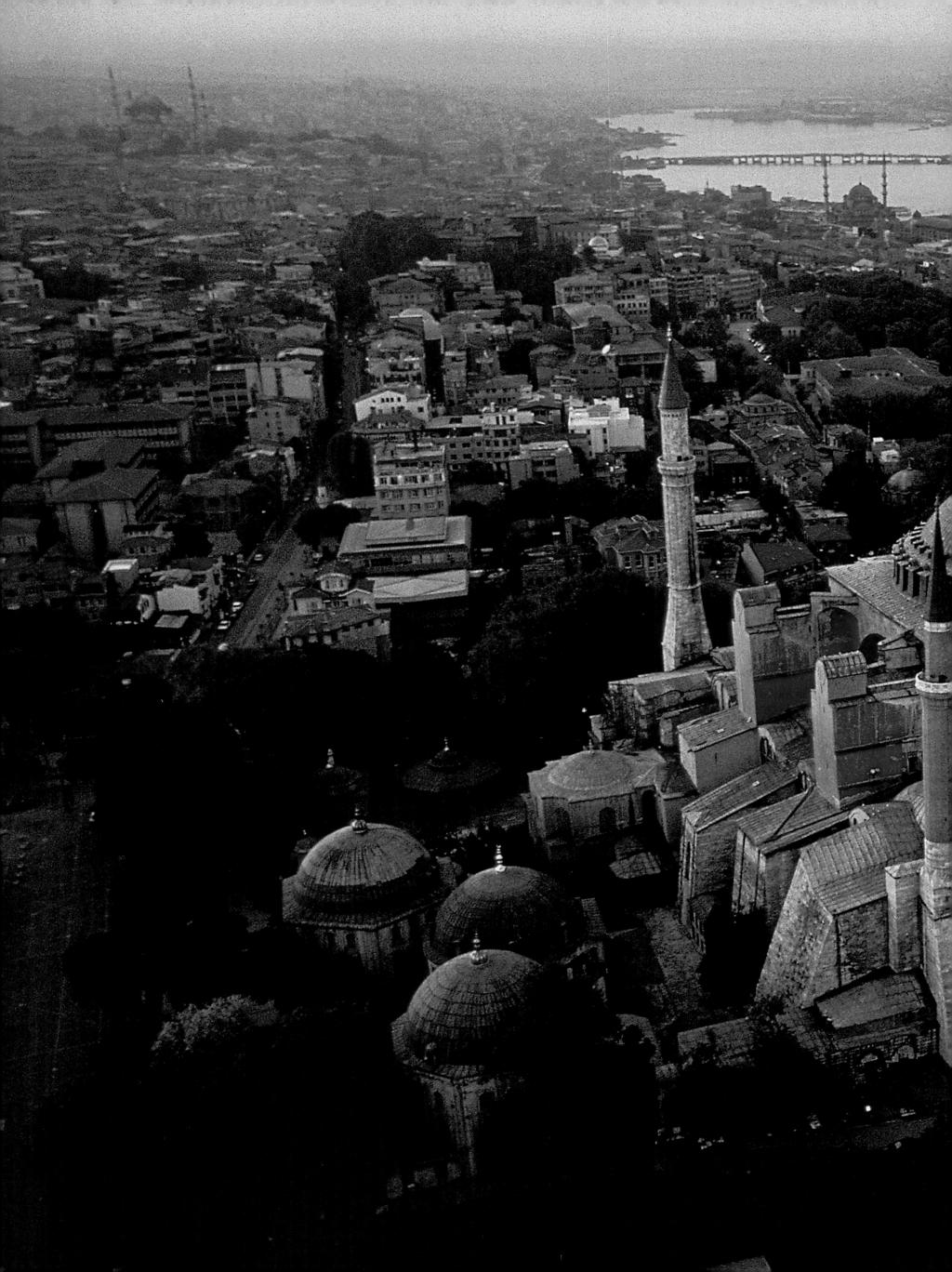

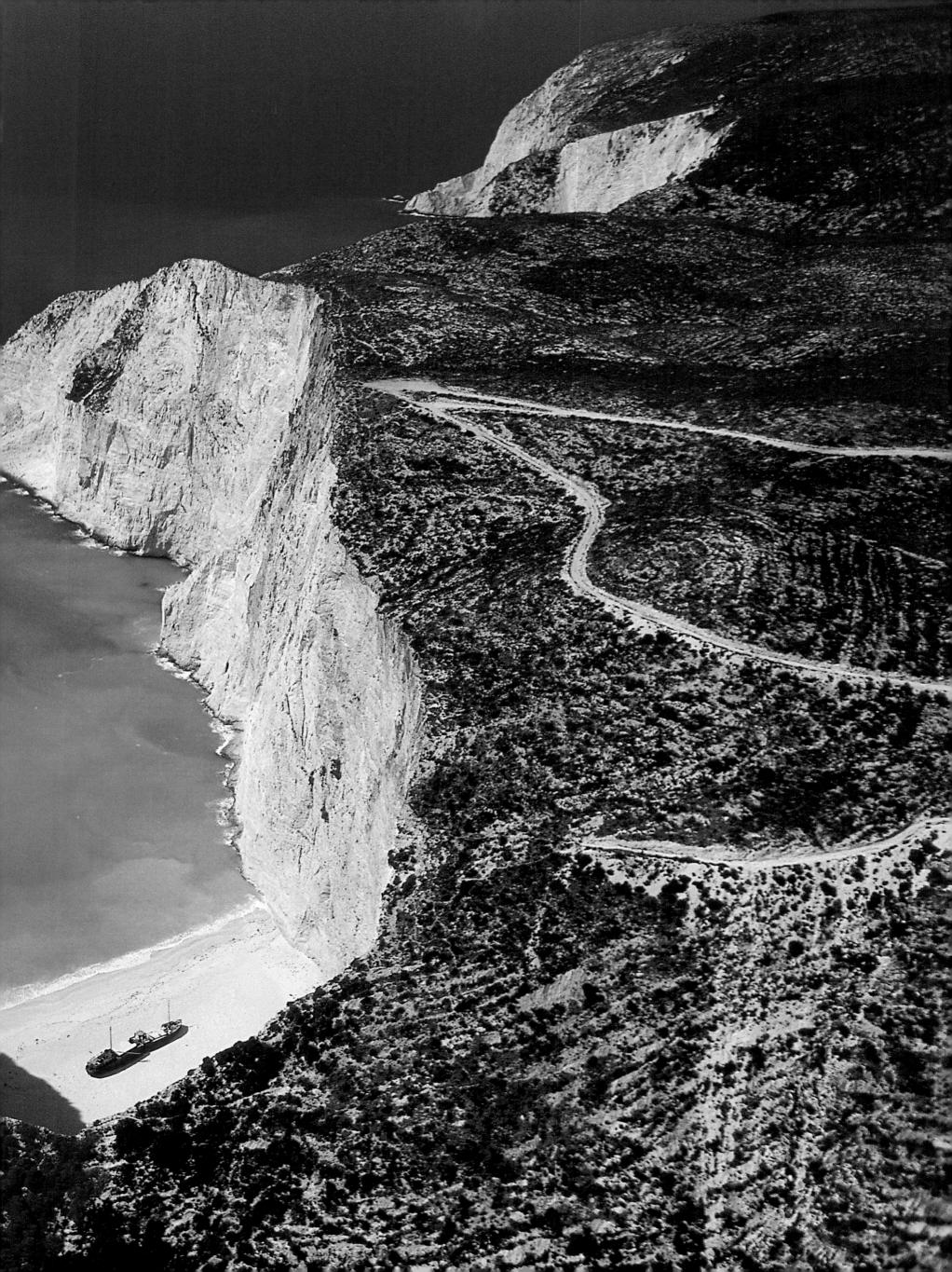

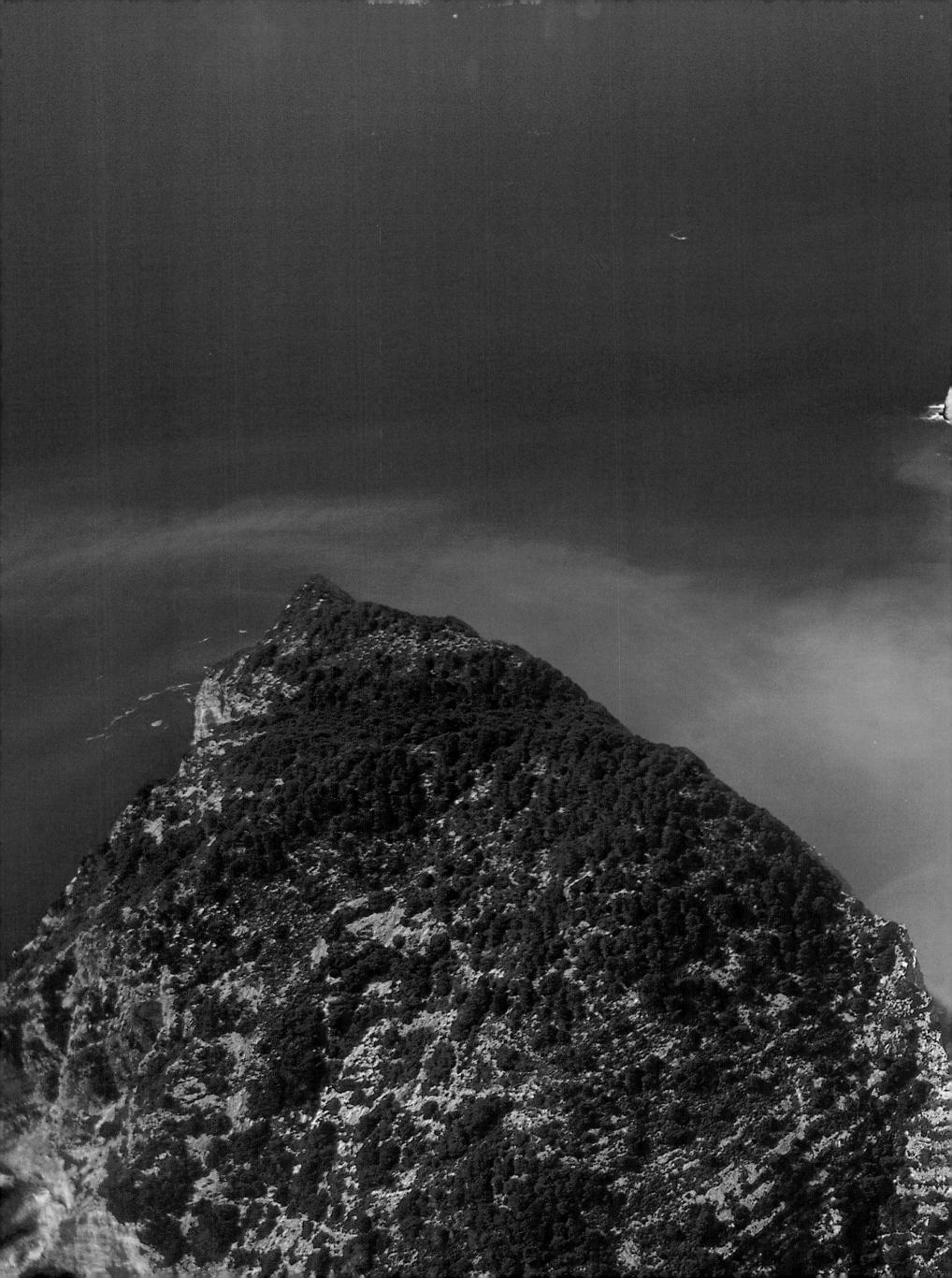

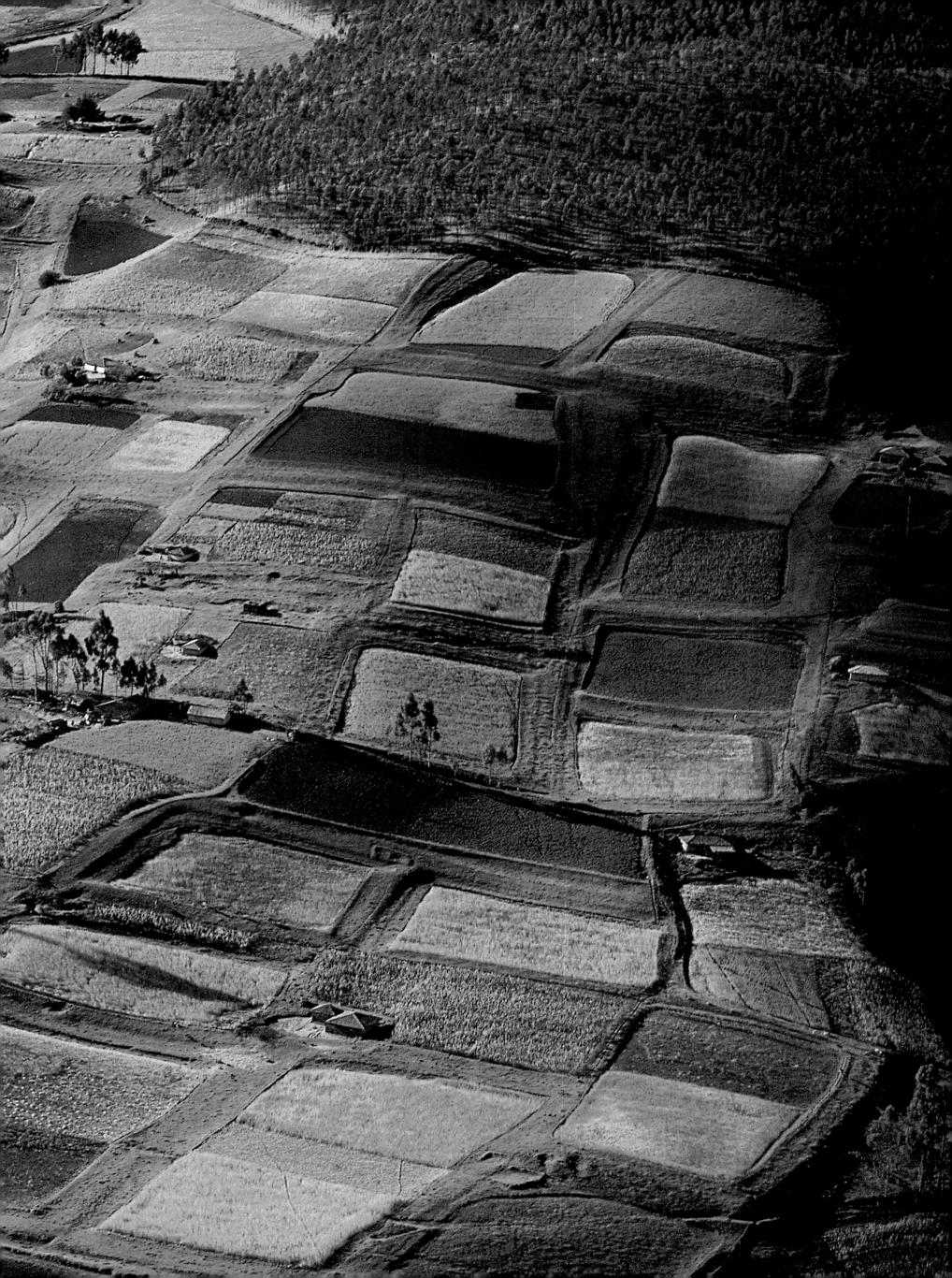

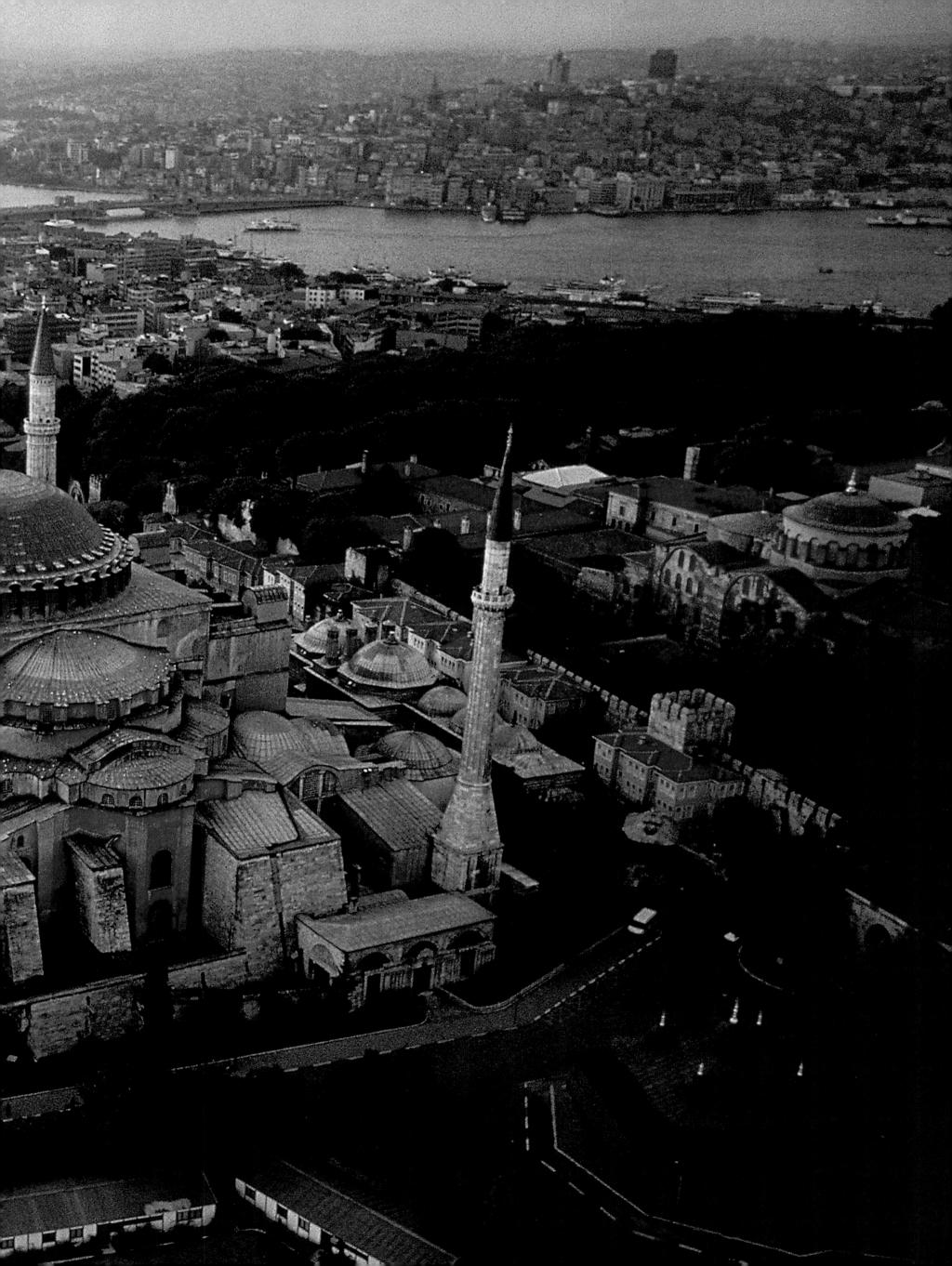

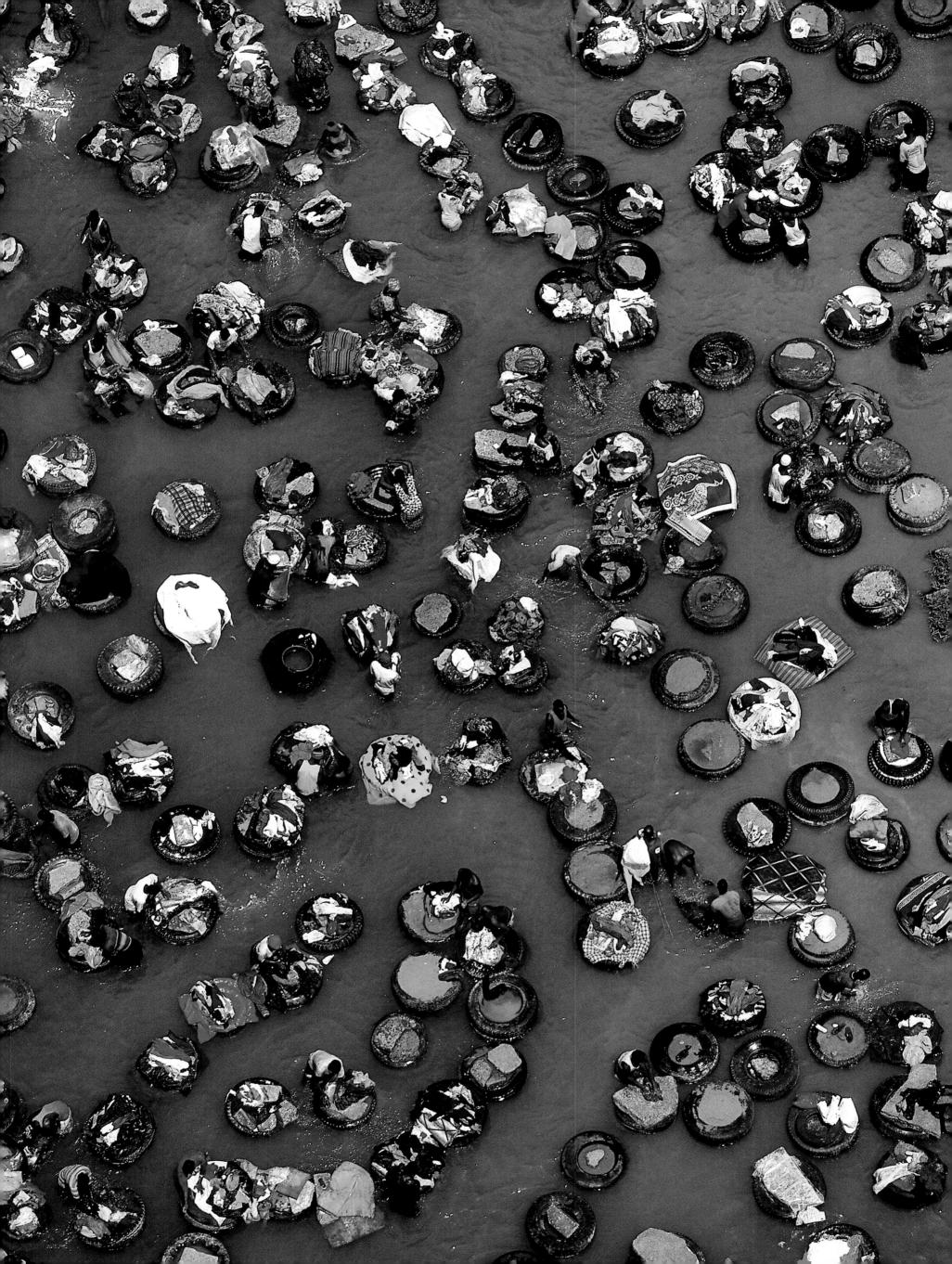

NATURE AND CULTURE

human species, *Homo sapiens sapiens*, produced a nourishing world within a cloud of beliefs intended to give meaning to the incomprehensible. In the development of humanity, the great landmark that followed the recognition of the self was the appearance of cults, which paid homage to nature, in its entirety or in some of its parts (sun, sky, rain), or to the human being itself, beginning with the dead. Rules governing how one lived soon developed, followed by laws and, much later, a system of rights and the constitutional state. This occurred in both hemispheres, north and south, and in every inhabited continent. Each highly structured civilization built a mythology attempting to explain the place of the human being in nature. Thus, the great reli-

gions and cosmogonies appeared: Hinduism and Buddhism, Confucianism and Shinto, Judaism, Islam, and Christianity. Present-day civilizations, the products of very powerful transformations, still navigate among these legacies.

THE STRUCTURE OF SOCIETY IN INDIA AND SOUTHEAST ASIA

The ancient beliefs of the peoples of Southeast Asia stated that natural space is never virgin: the removal of resources from nature first necessitated the placation of the gods preexisting in the place to be cultivated; only then could humans use nature for their own purposes. Under threat of catastrophes such as fires, invasions, or epidemics, people were required to constantly renew alliances with the gods or spirits. It was essential to mollify the displeased, and displaced, spirits and then to give them new lodging. The spirits had to understand that the good plots cleared by burning were not theirs and that they had to be content with the land considered least fruitful by humans. On that basis a functioning alliance was created in which the spirits were participants in a new order created by the human species.

The value system that structures Hindu civilization emphasizes the importance of the whole that constitutes soci-

p. 88 WASHING LAUNDRY IN A CREEK, Adjamé district in Abidjan, Côte d'Ivoire

In the neighborhood of Adjamé in northern Abidjan, hundreds of professional launderers, the *fanicos*, do their wash every day in the creek located at the entrance of the forest of Le Banco (designated a national park in 1953). They use rocks and tires filled with sand to rub and wring the laundry, washing by hand thousands of articles of clothing. Formerly a fishing village, Adjamé is a working-class district without running water or electricity, absorbed gradually by the metropolis of Abidjan. This city of 3.5 million, one of the fastest-growing in West Africa (it multiplied 30 times in 40 years), has seen a proliferation of dozens of small trades in the informal sector, such as these *fanicos*.

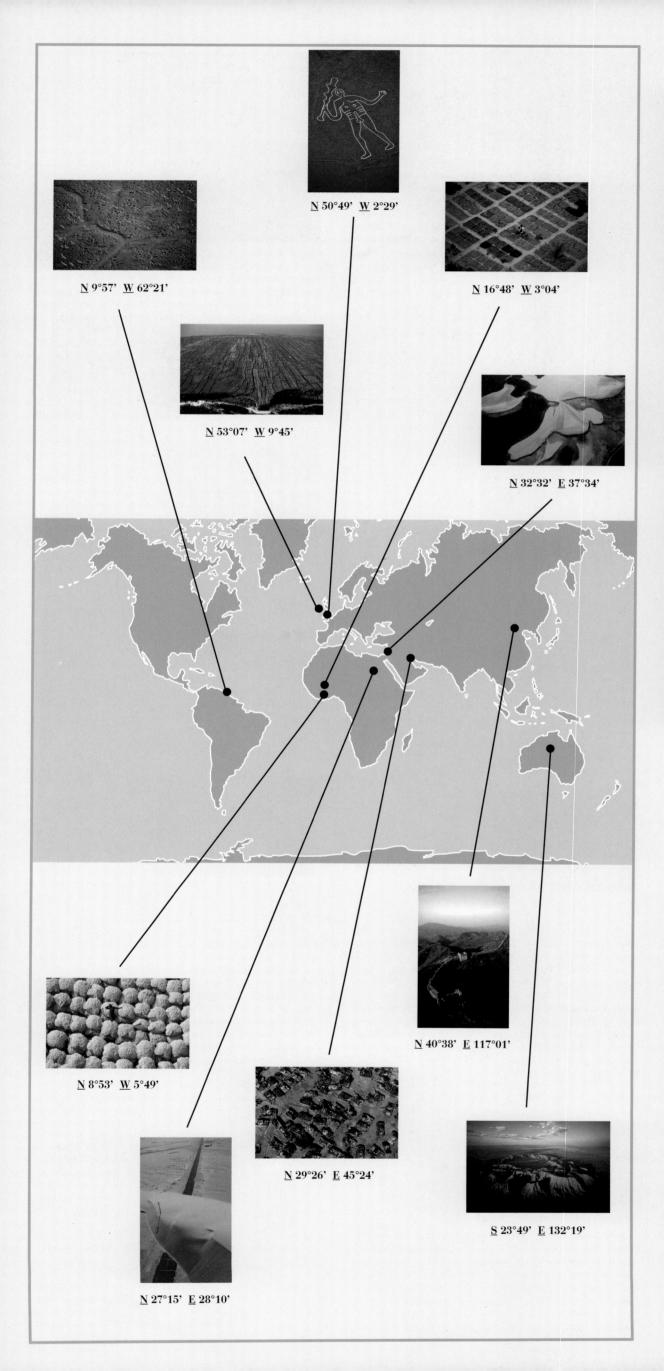

AND COSMOS L ASIA

othere of influence that included Korea, handated that all human action obey s, a law based on respect for proportions ovement. For a happy life, people must not that prevail among the "objects of the the human species. The neo-Confucians ry called this "correct thinking." Philoso-hinkers needed to interpret what actions o cosmic law.

to century Chinese civilization thus built ication of human actions, placed in the preexisting categories of the cosmos. The shan-shui, is not actually the basis for human activities; it is only the expression of the cosmic order. The mountain, shan, yang, and flowing water (river, waterfall) yin, of this energy. The relation between is the explanation of all motion in the cosmos of the cos

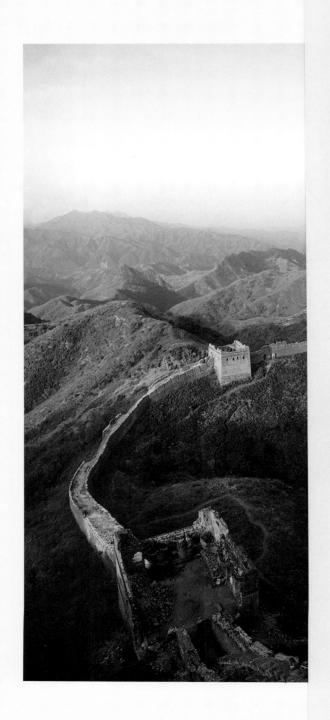

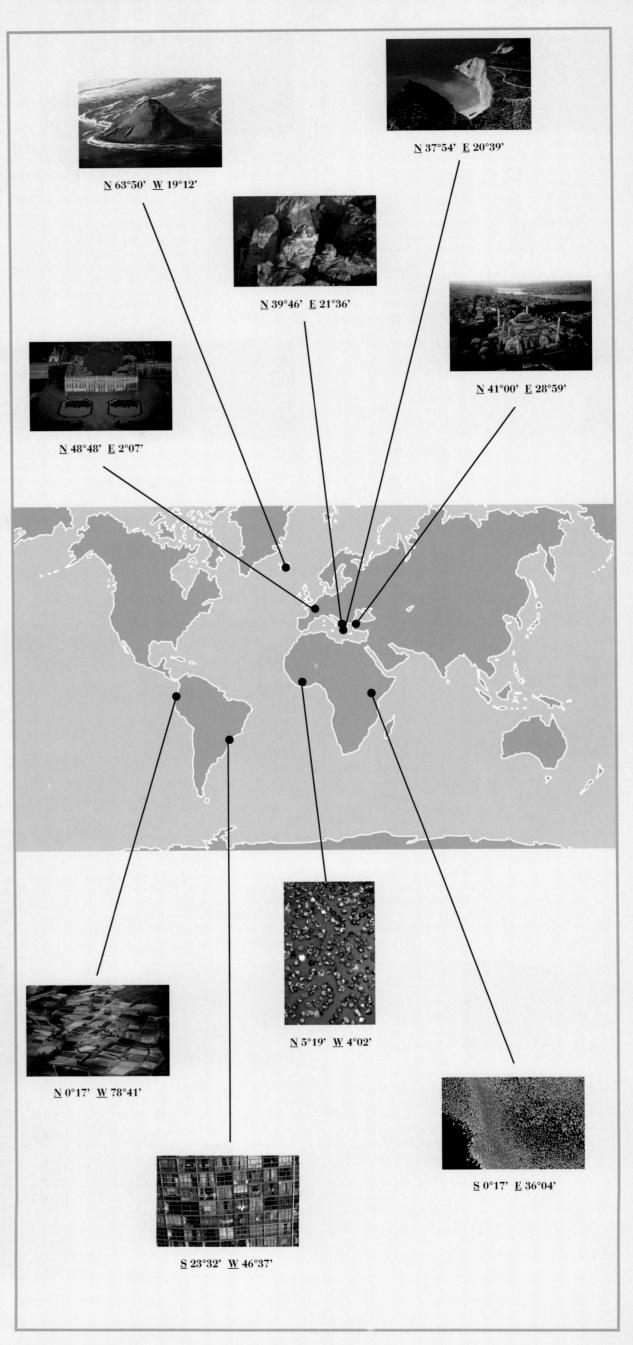

of rice fields, and tombstones. In addition to these gods there are the gods of rice and of commerce, named after their places of residence, who are as much local gods belonging to nature as ancestral gods associated with society.

NATURE AND RATIONALITY IN WESTERN THOUGHT

The Western value system grew out of Greek and Near Eastern antiquity as well as the religions of the Book (Judaism, Christianity, and Islam), a system that Europe made its own throughout the long Middle Ages and the Renaissance from the second to the seventeenth century, leading to the "liberating" explosion of the century of Enlightenment in the eighteenth century and the global spread of a technological society in the nineteenth and twentieth centuries.

The belief in the rationality of man was central, placing civilization in opposition to "irrational" nature. The domination of the natural environment by humankind was positive, the triumph of reason and logic over the savagery of raw, untamed nature.

The imperial spread of Western thought and technology today means that "Western" and "non-Western," "first world" and "third world" are no longer helpful categories for dividing up the world. Industrialization and urbanization have developed all over the earth, and societies are remade in their image.

Pierre Gentelle

p. 97 ROAD INTERRUPTED BY A SAND DUNE, Nile Valley, Egypt

Grains of sand, deriving from ancient river or lake alluvial deposits accumulated in ground recesses and sifted by thousands of years of wind and storm, pile up in front of obstacles and thus create dunes and massifs of dunes. These massifs are stable, but the small dunes move in the direction of the prevailing wind, sometimes even covering infrastructures such as this road in the Nile valley. The spherical shape of the grains of sand and the force of the desert winds make these dunes move at rates as high as 33 feet (10 m) per year. The regions located on the Sahara perimeter must contend with violent sandstorms that destroy vegetation and contribute to the aridification of the environment.

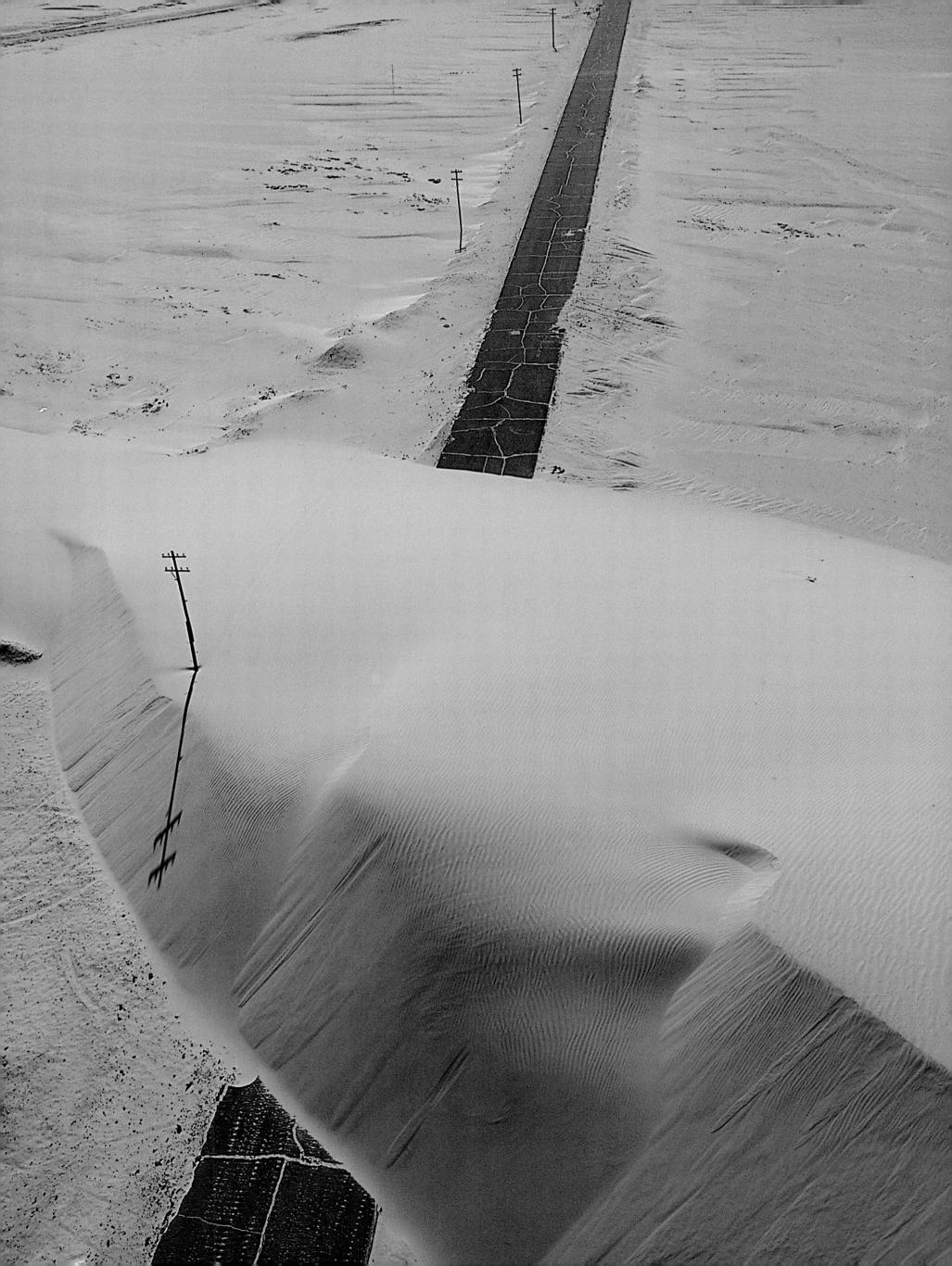

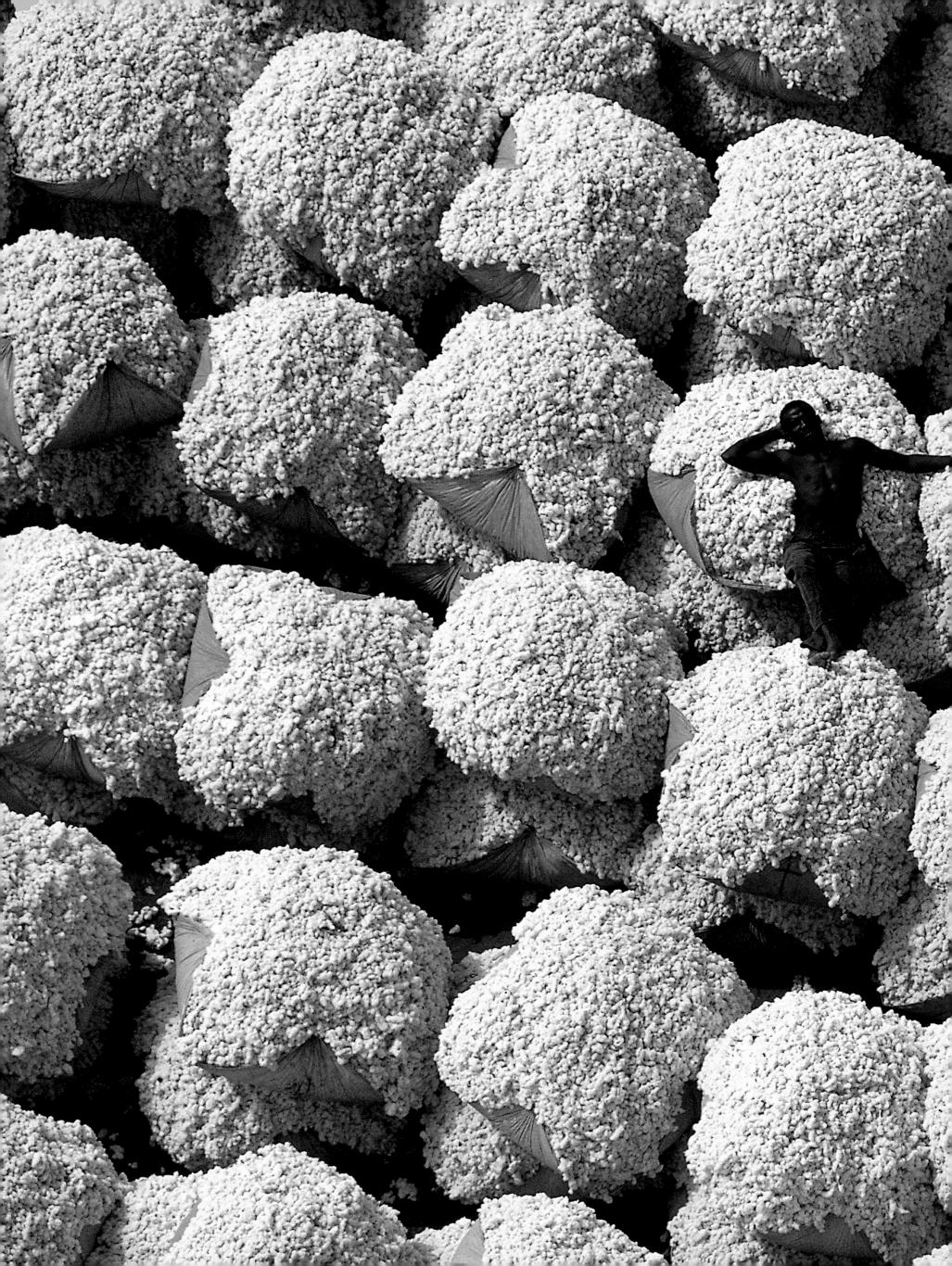

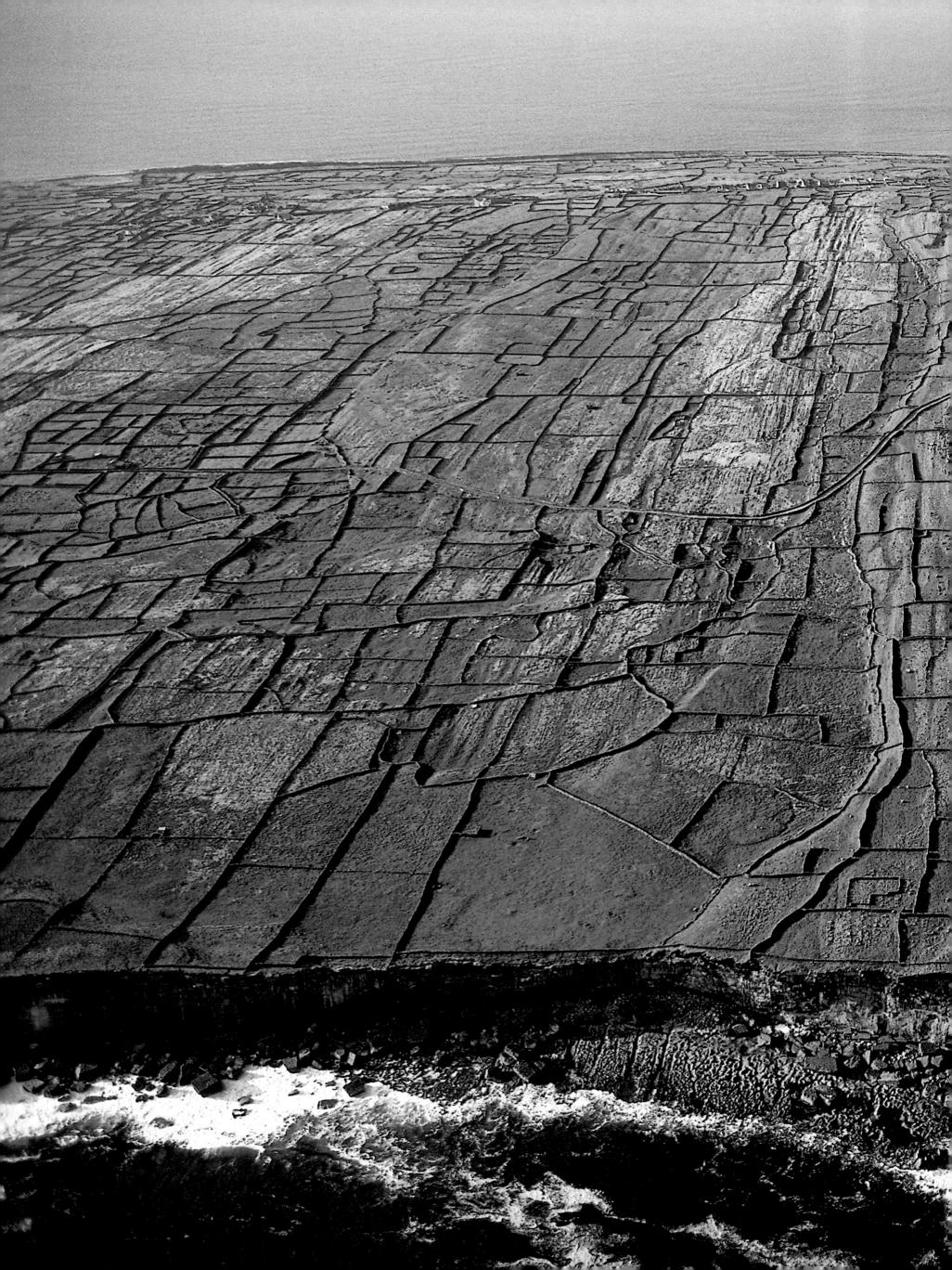

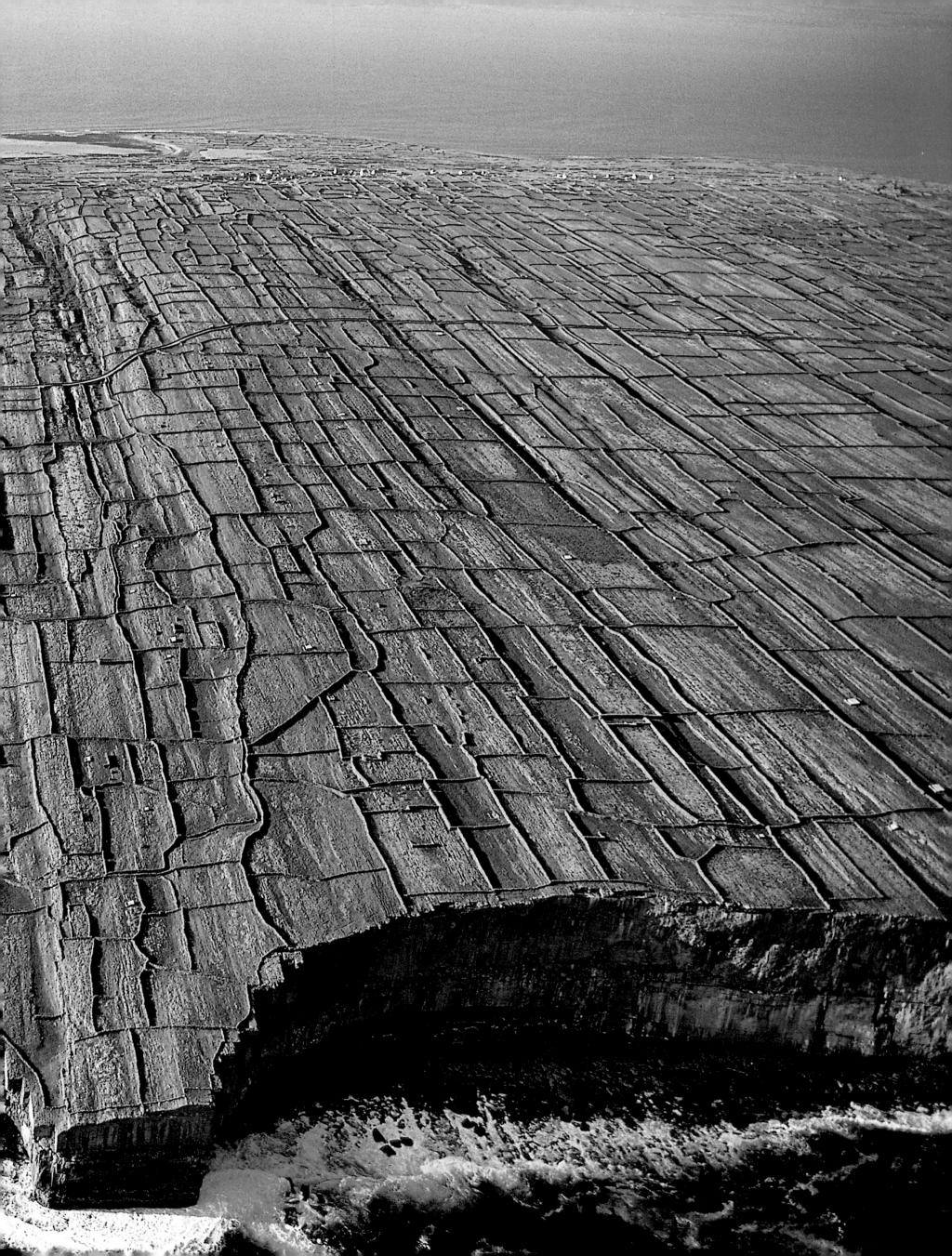

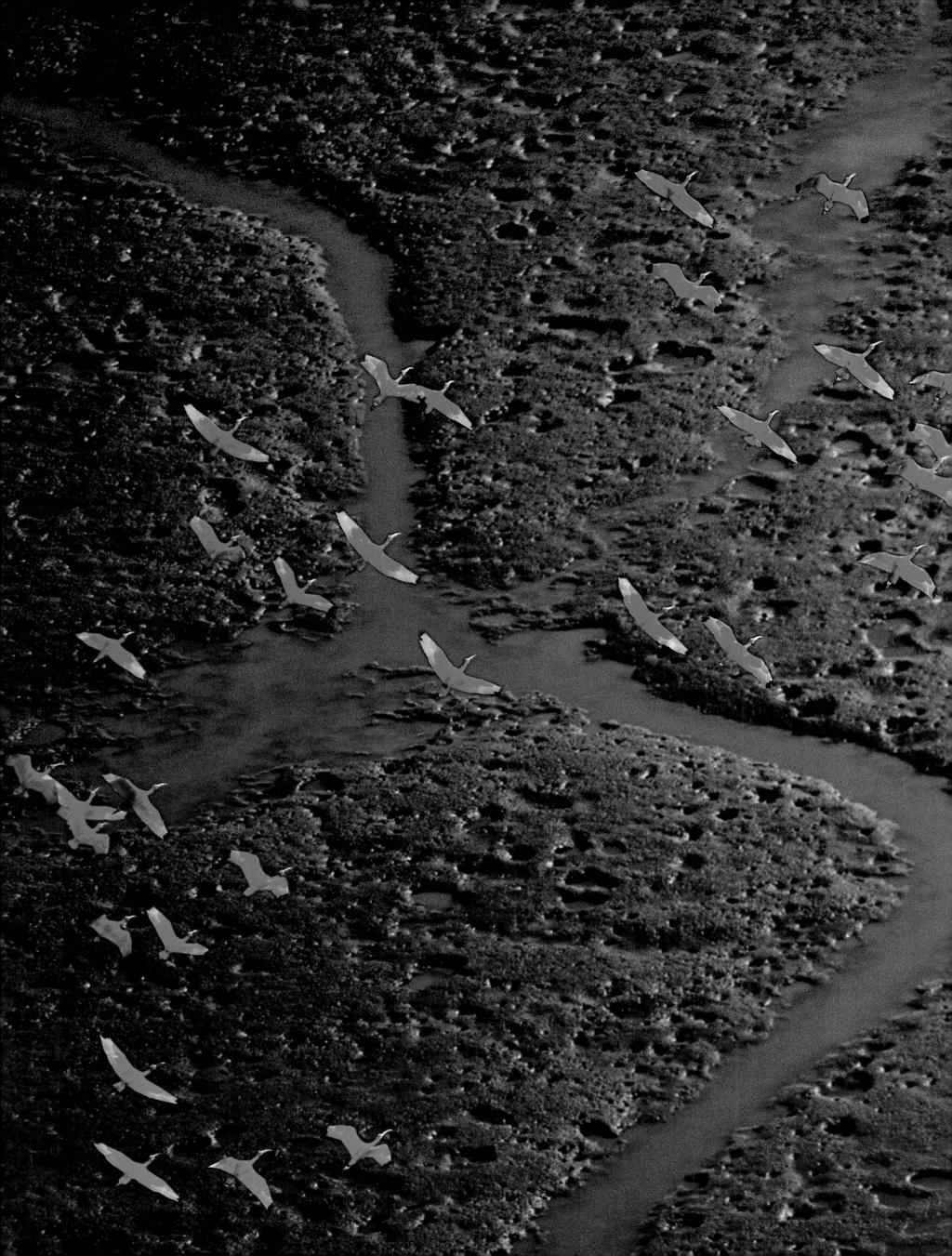

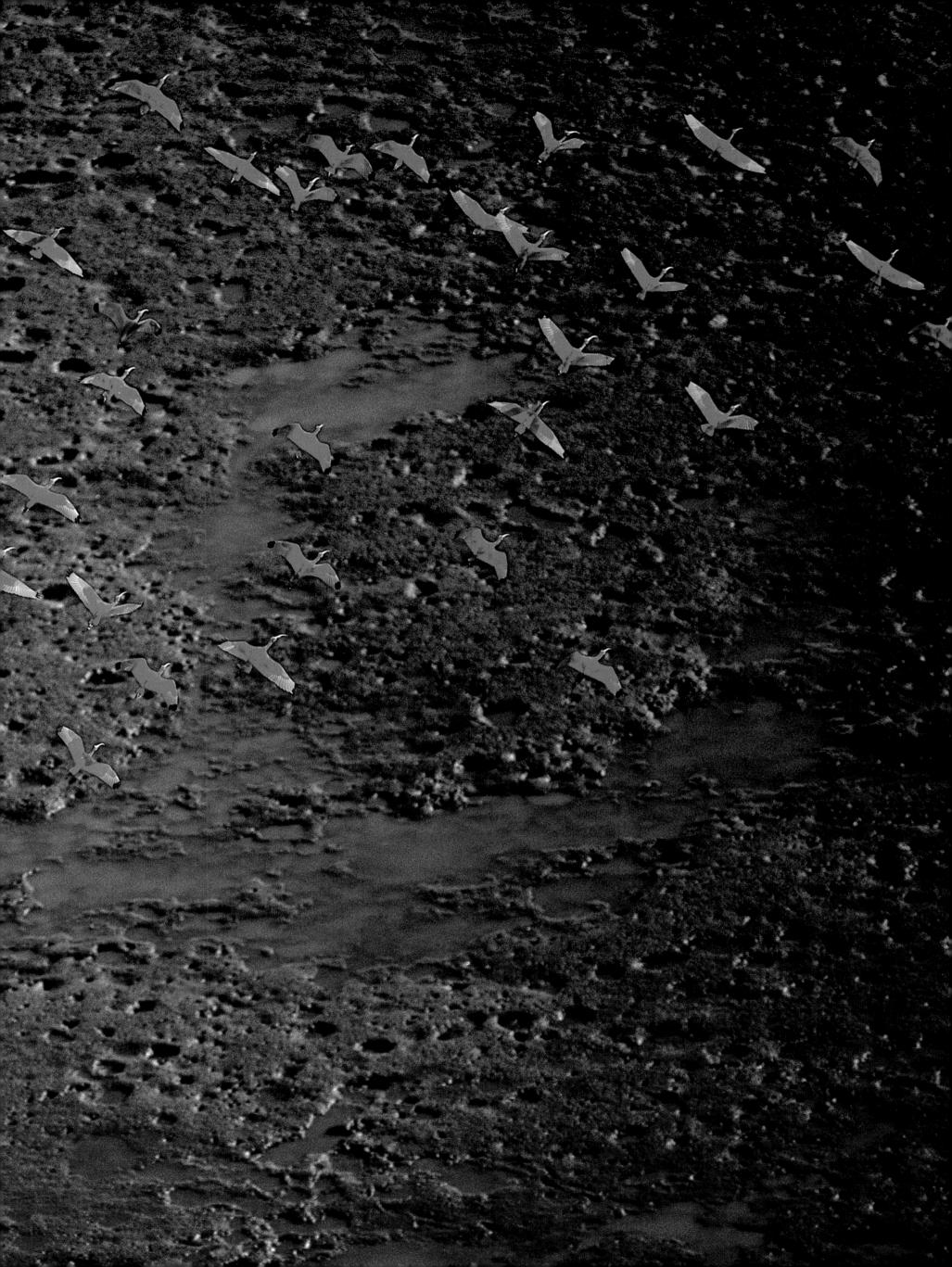

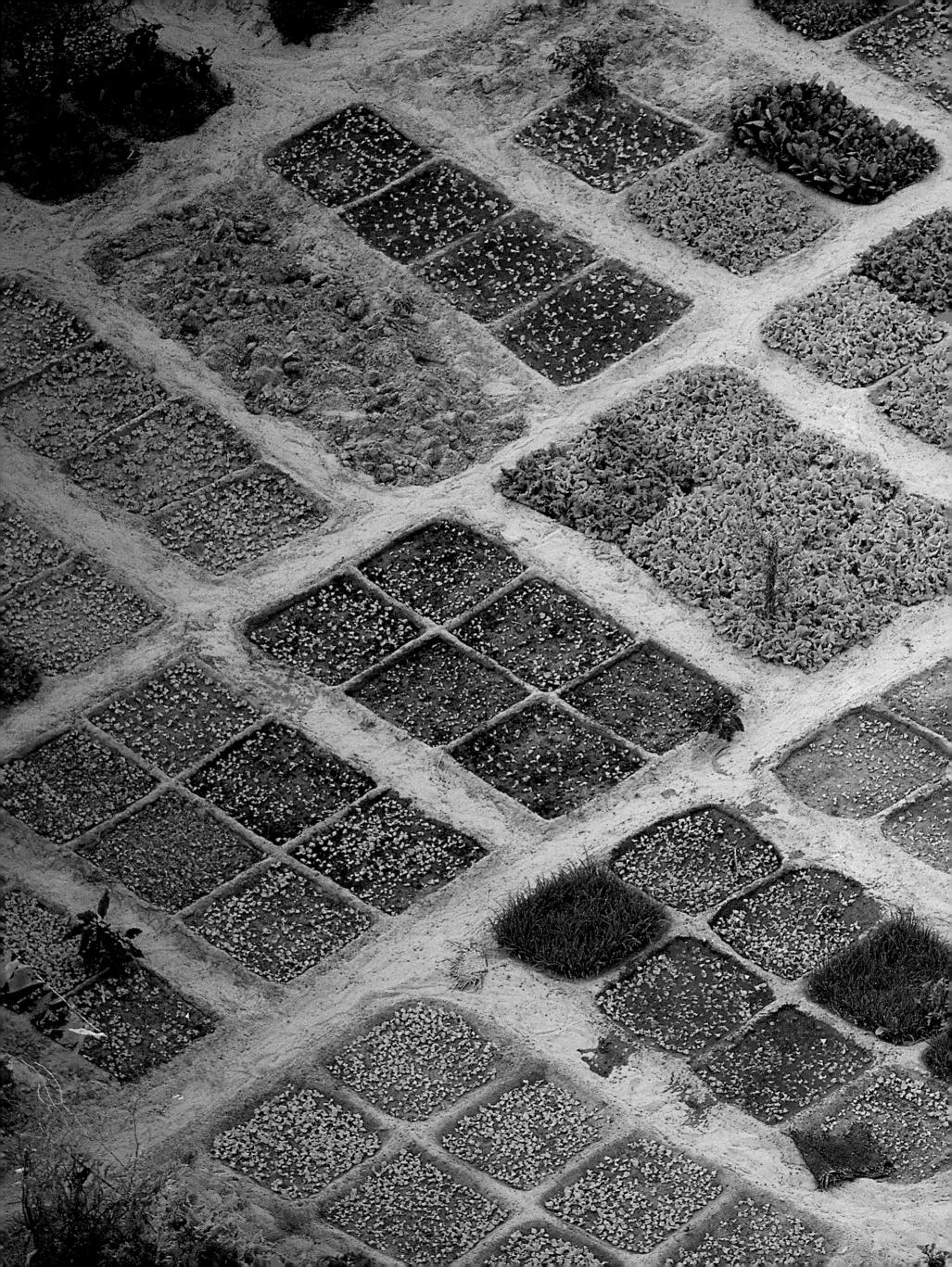

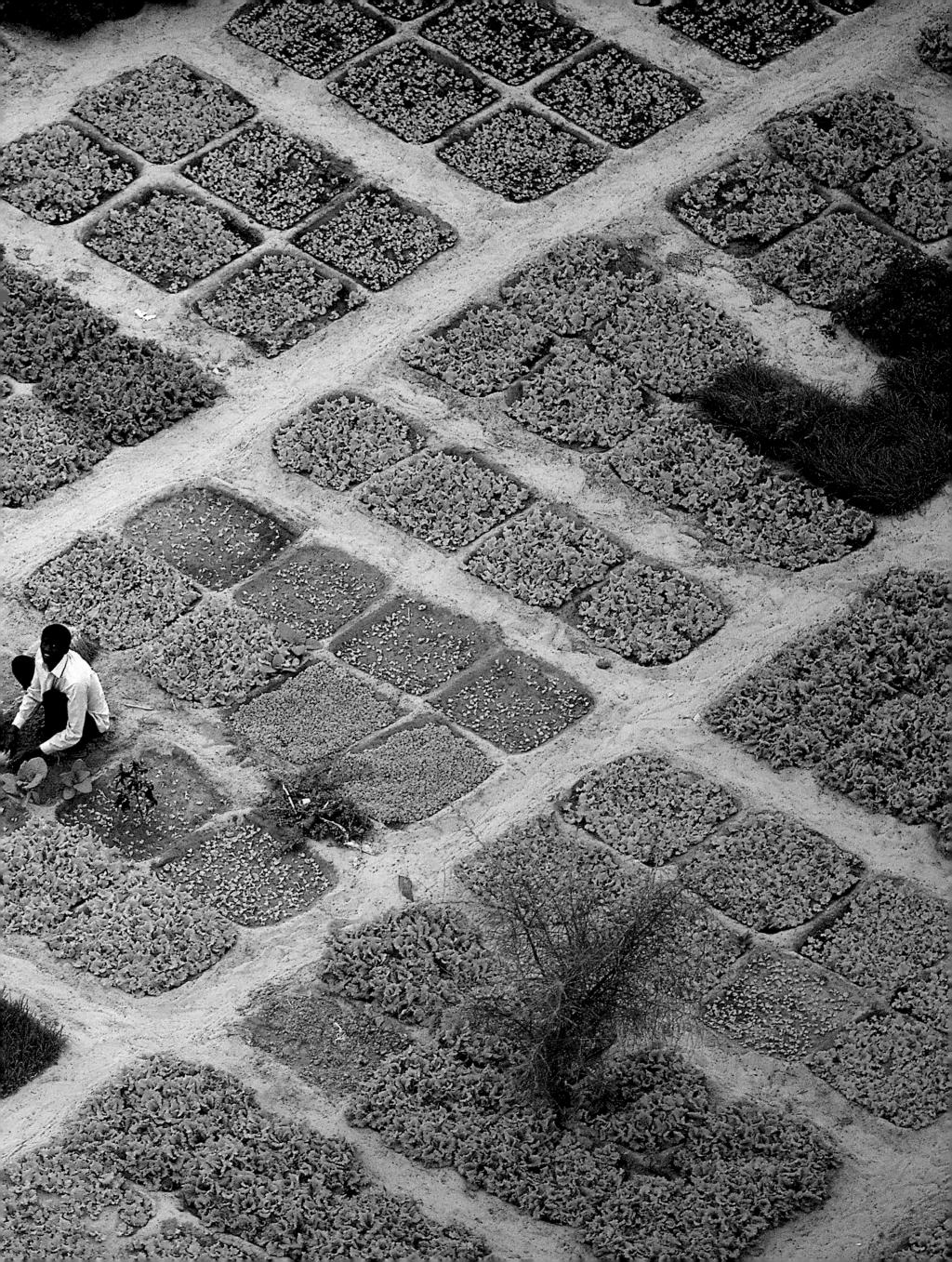

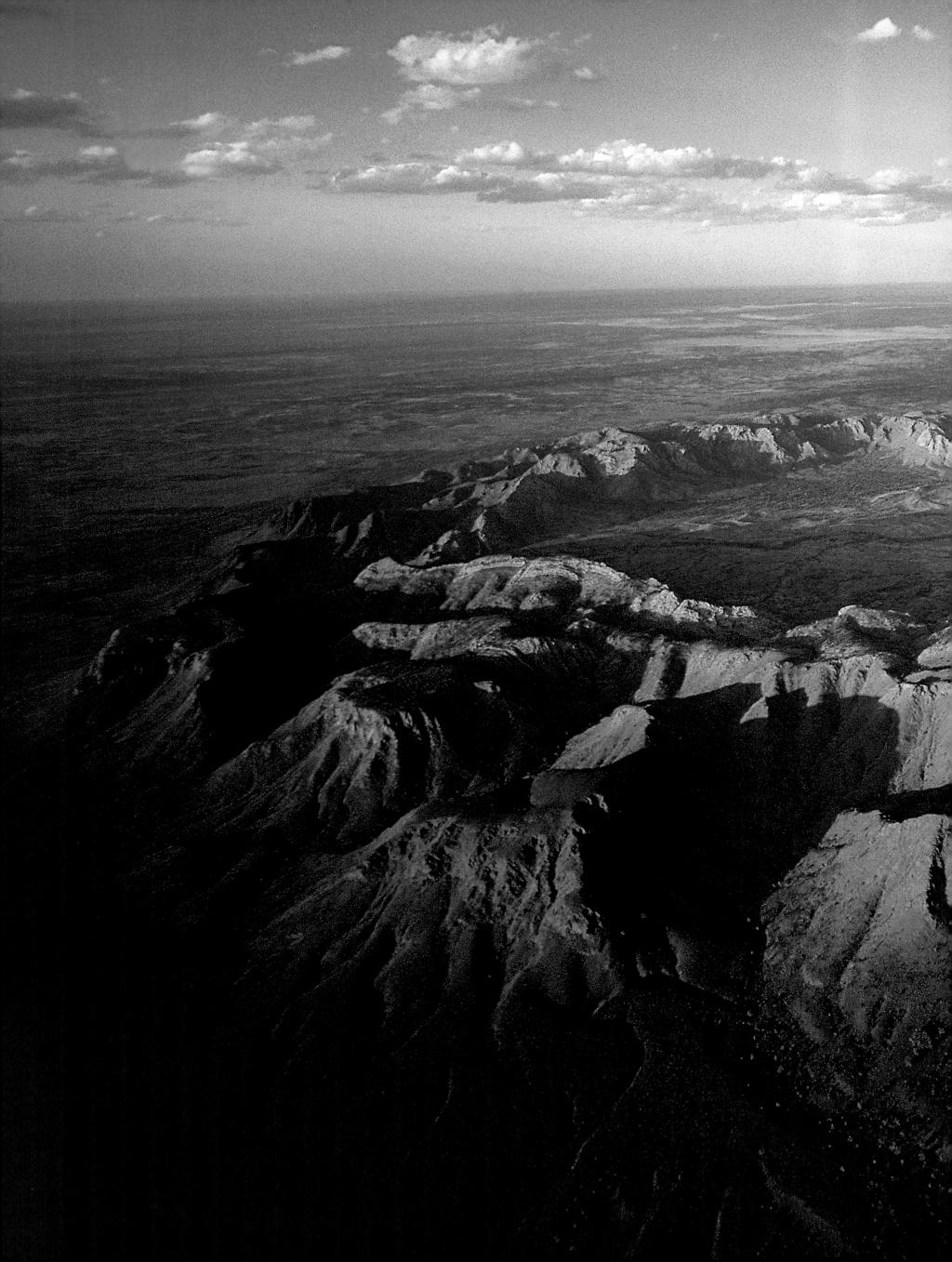

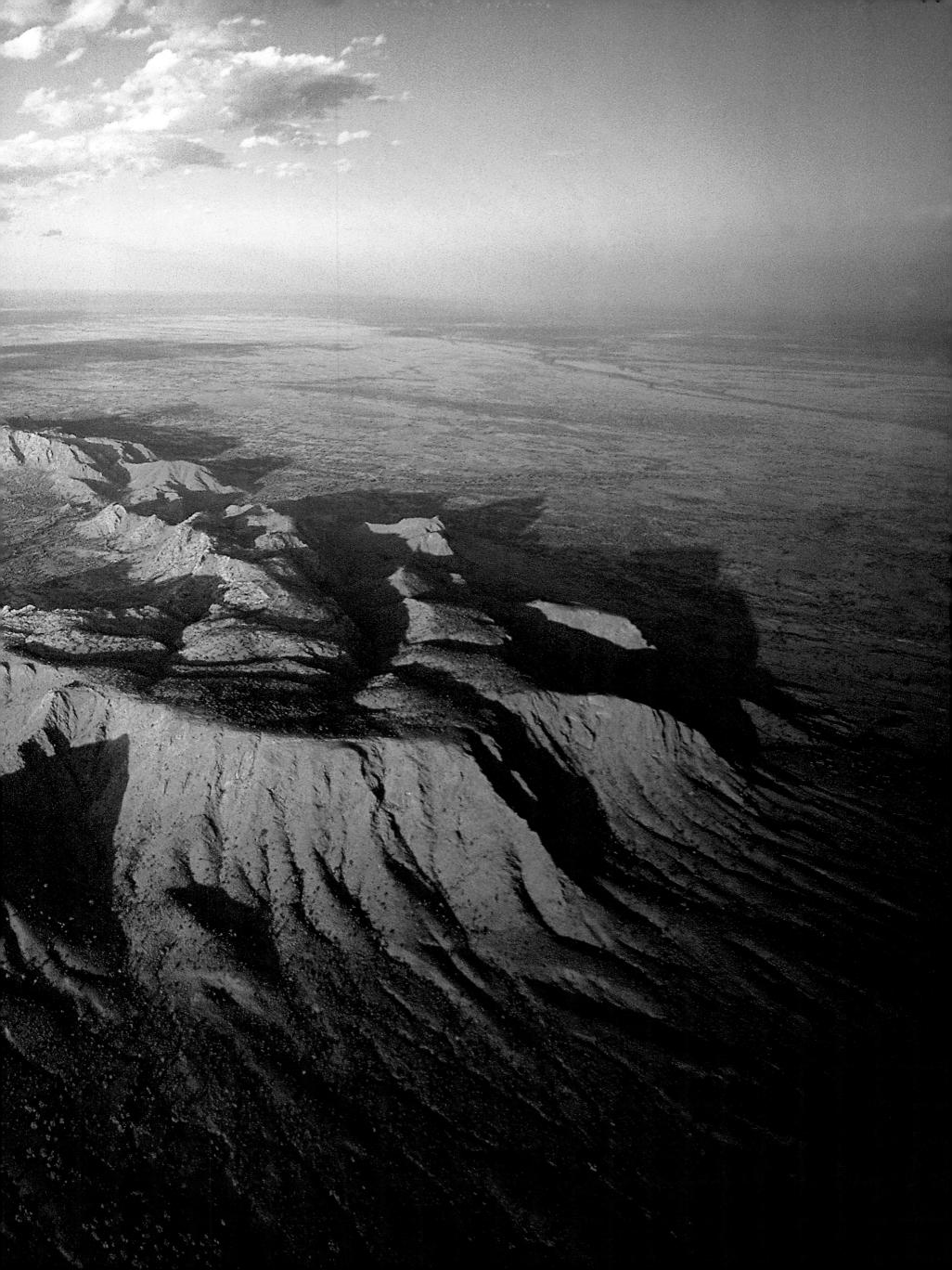

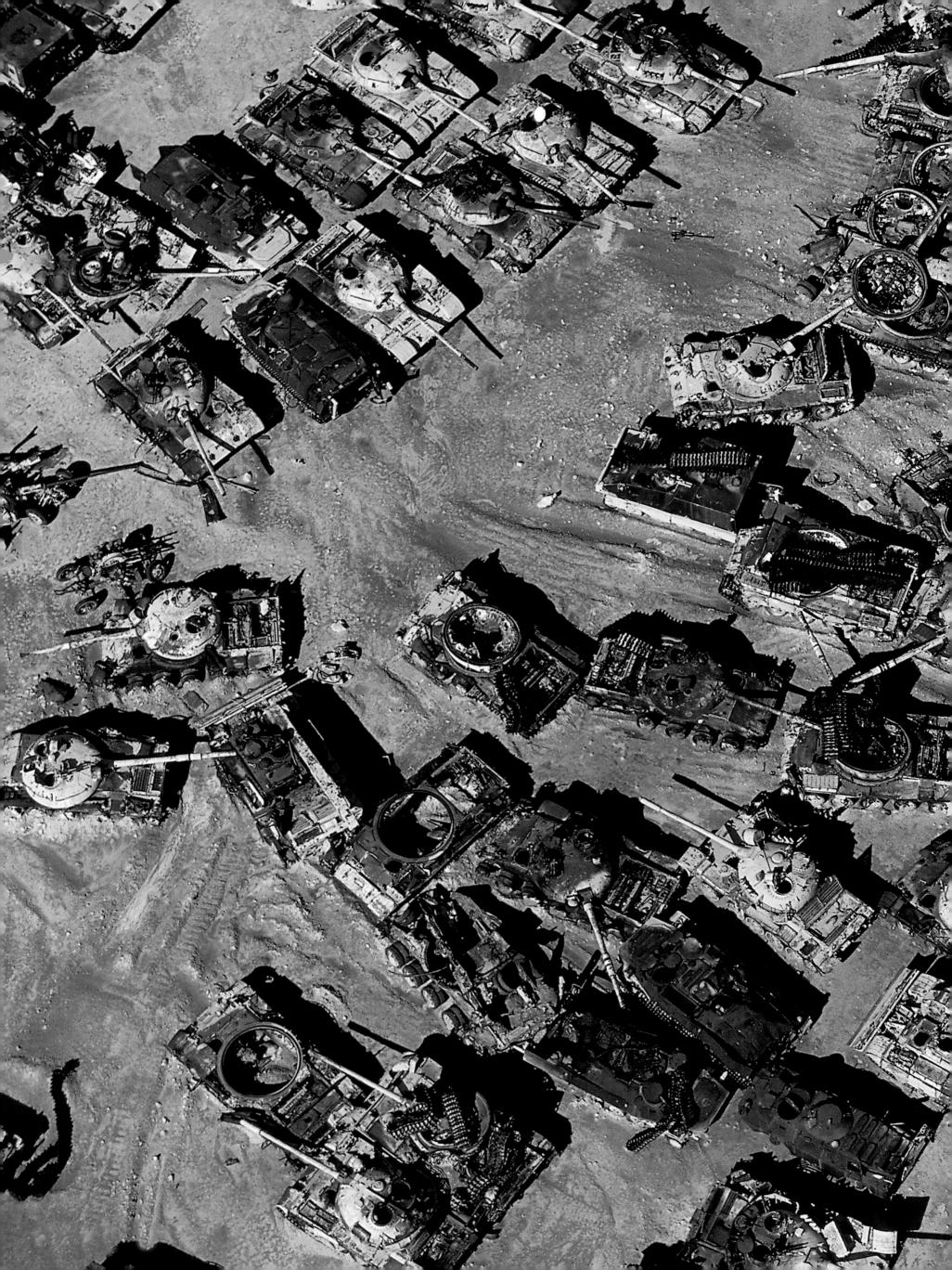

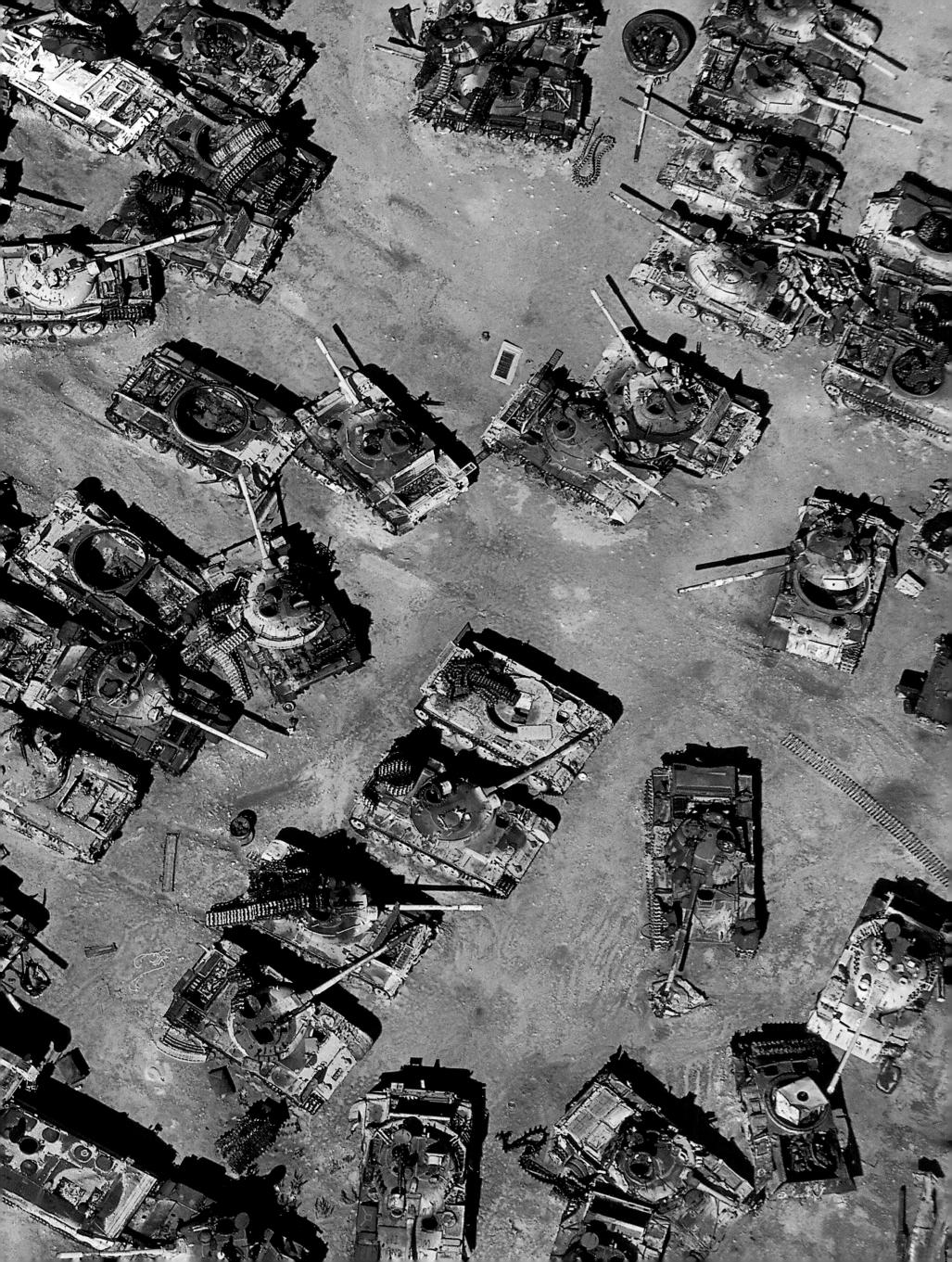

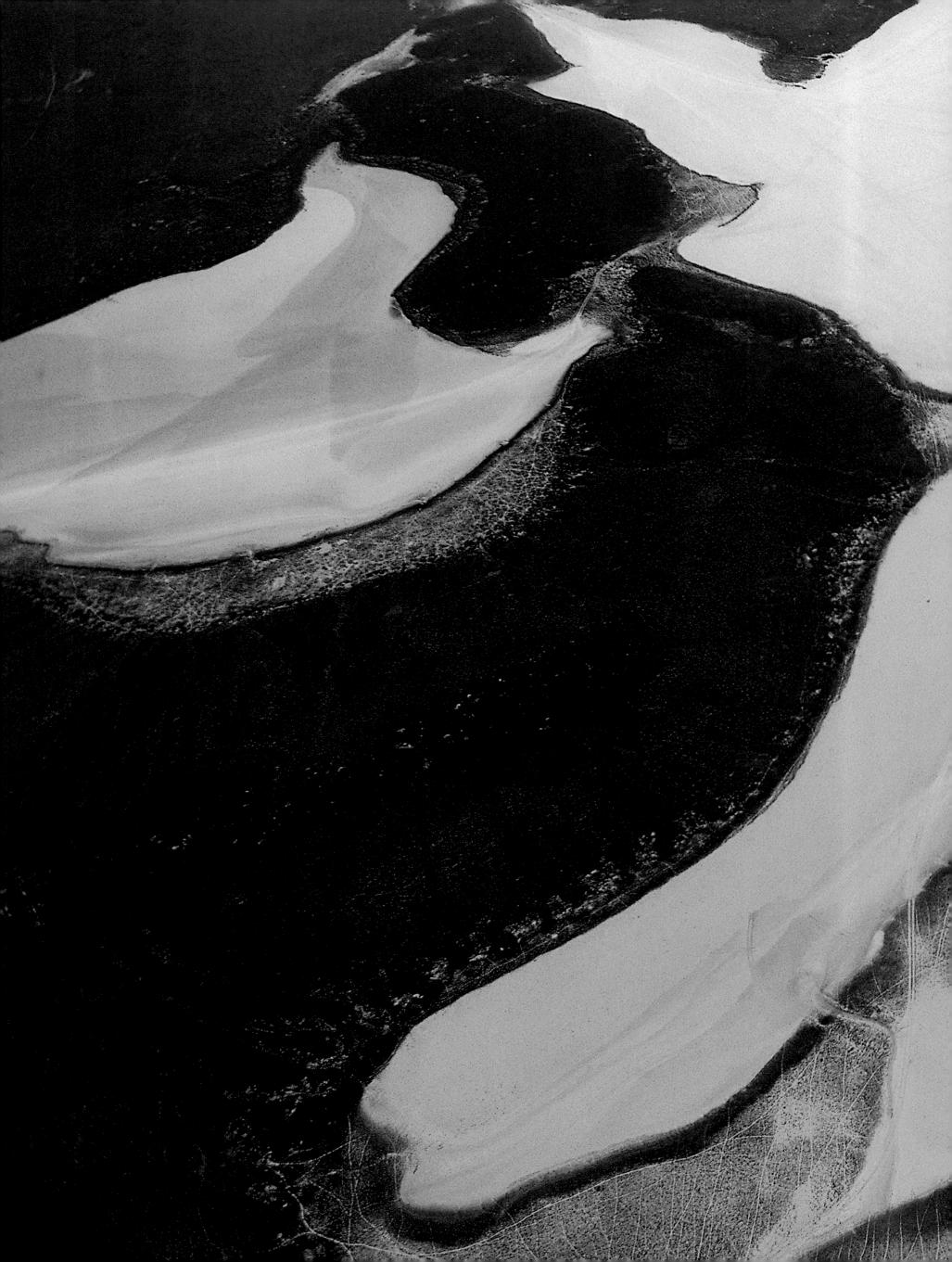

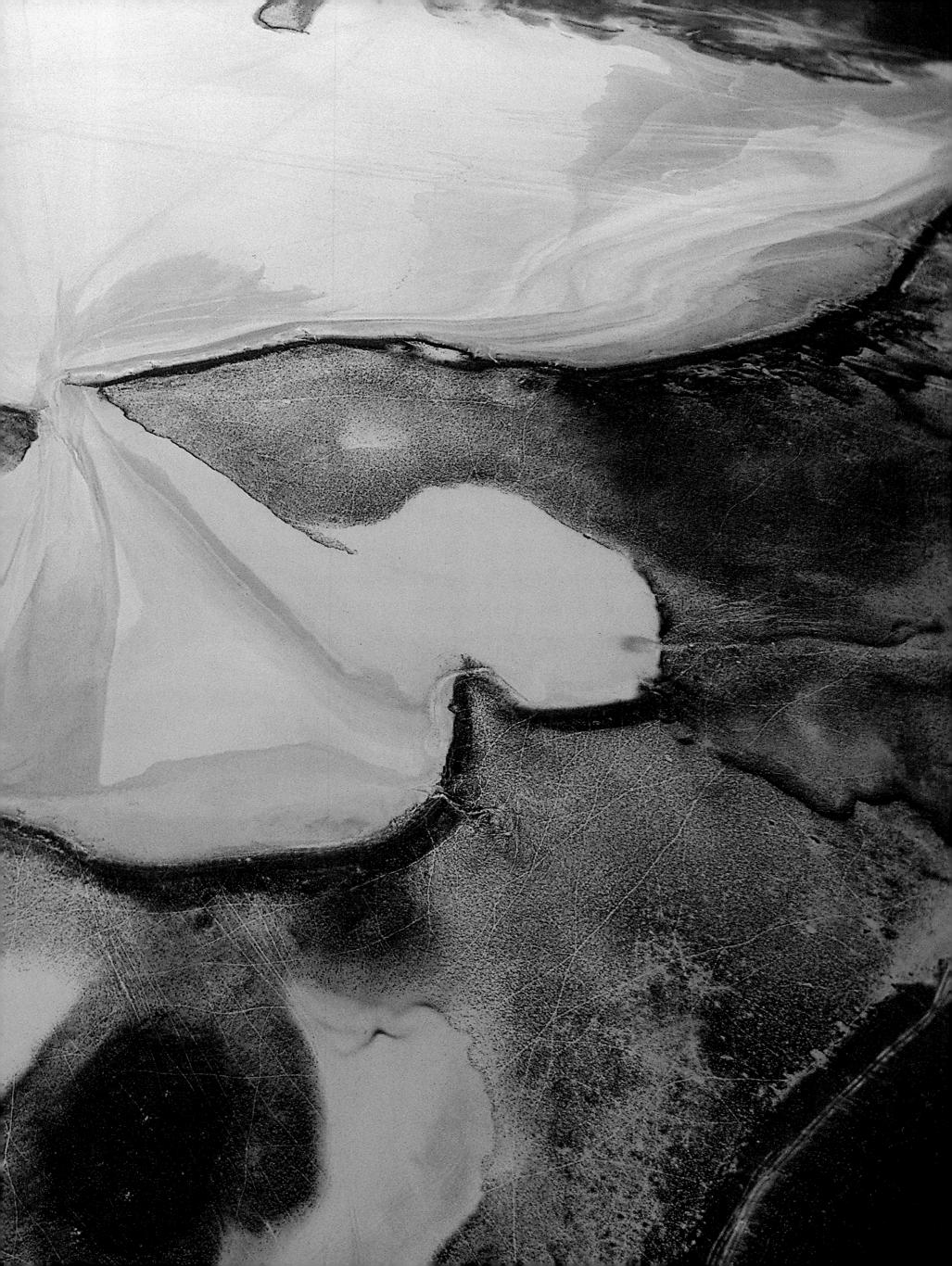

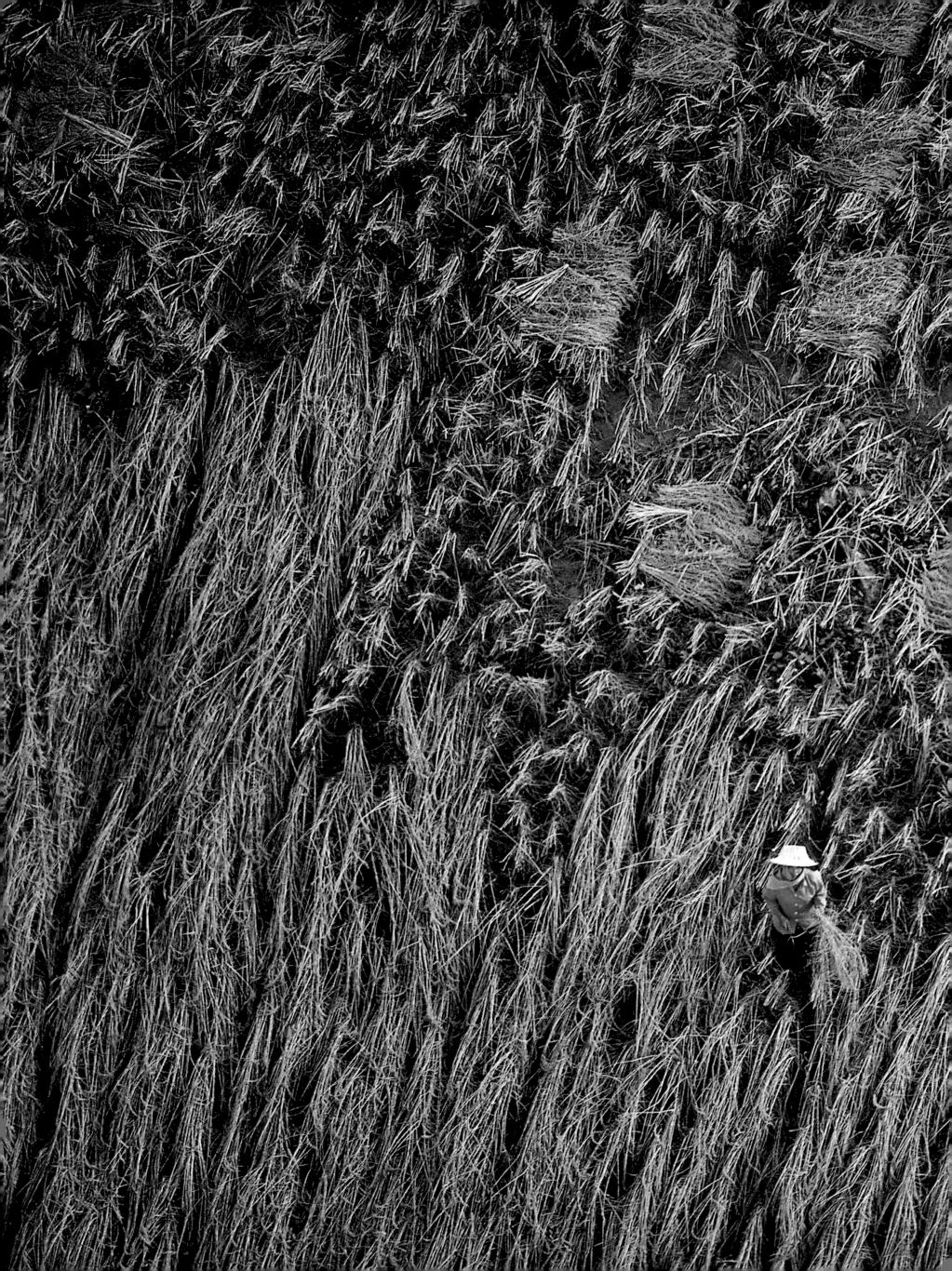

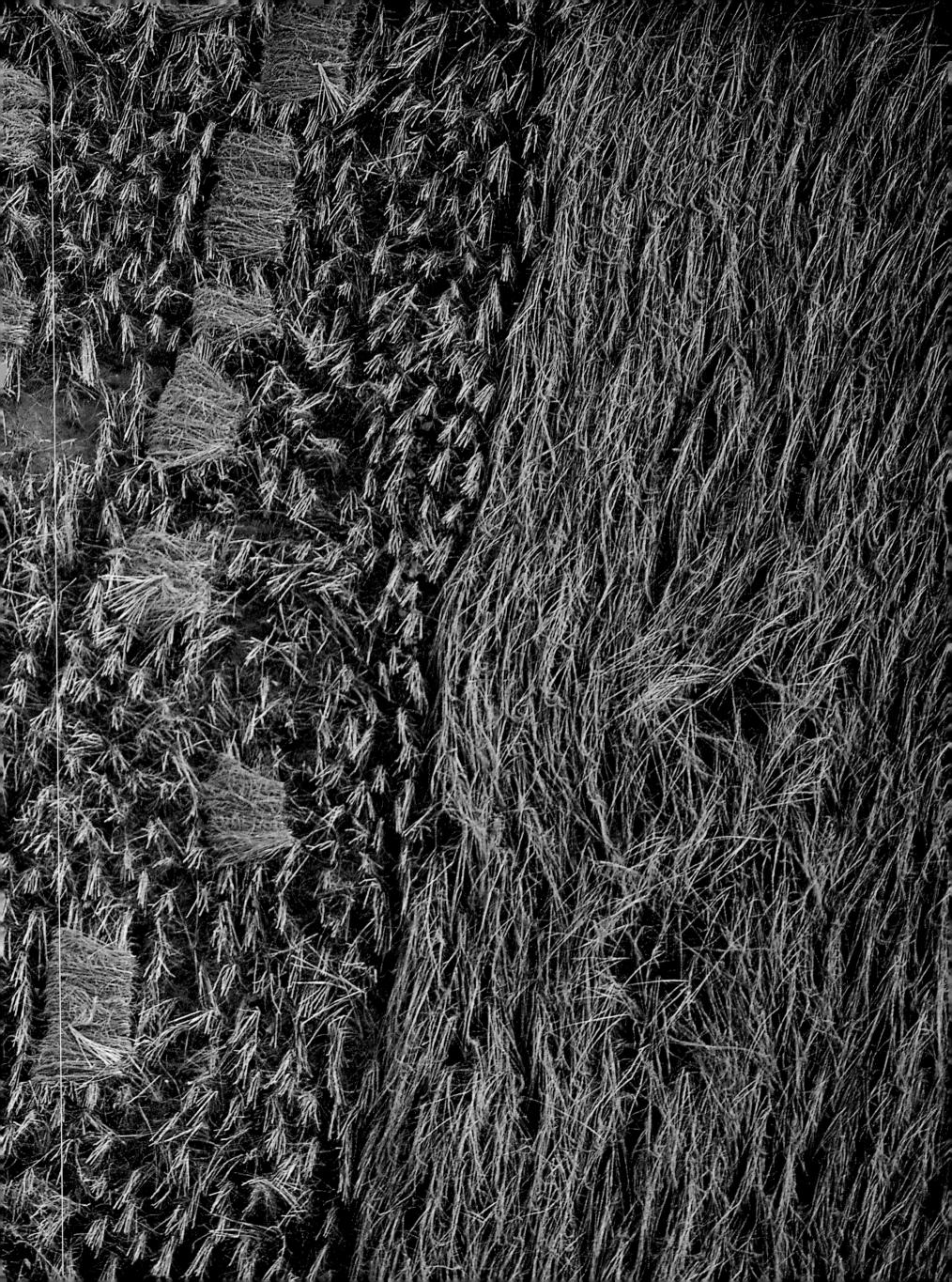

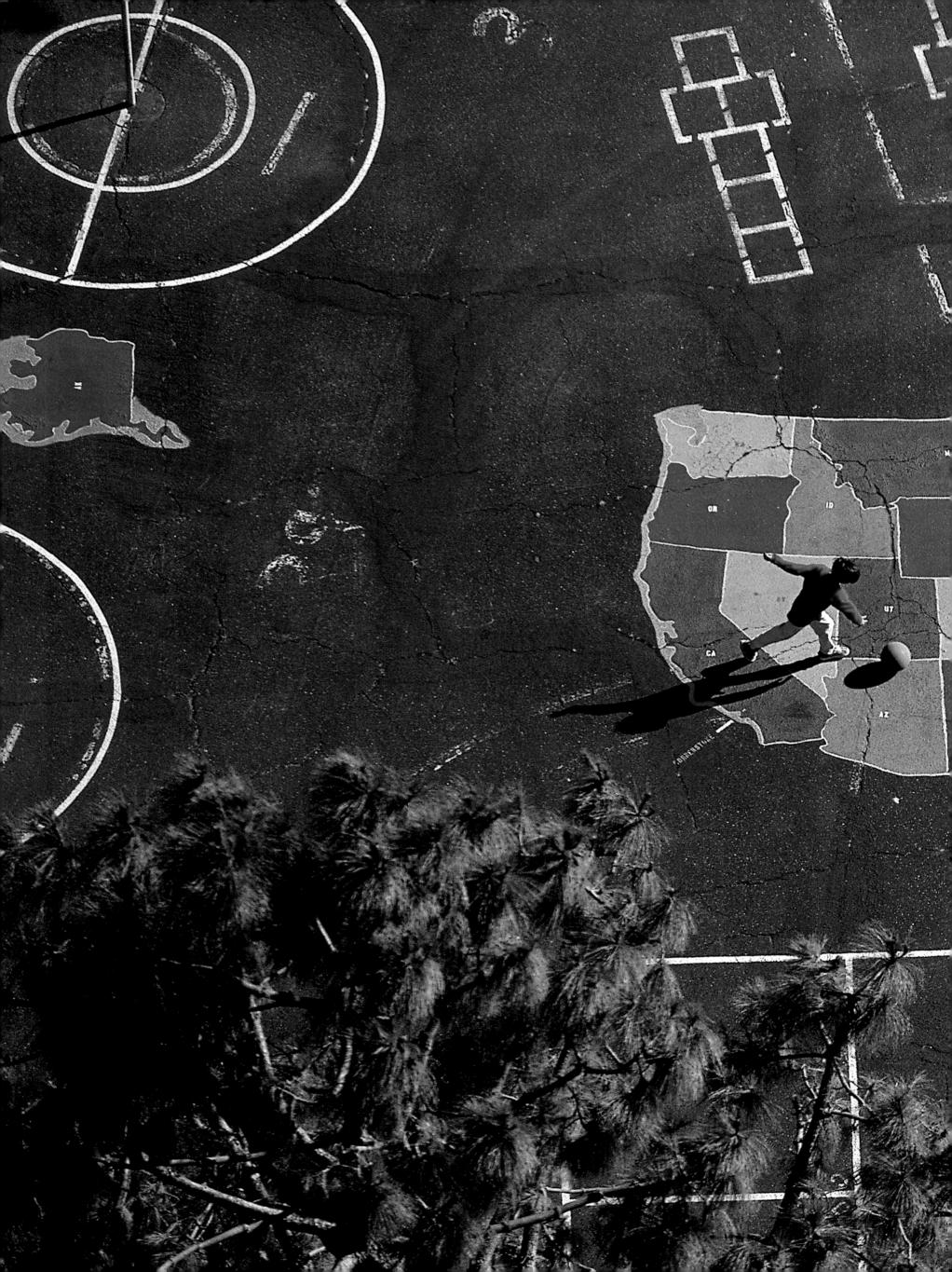

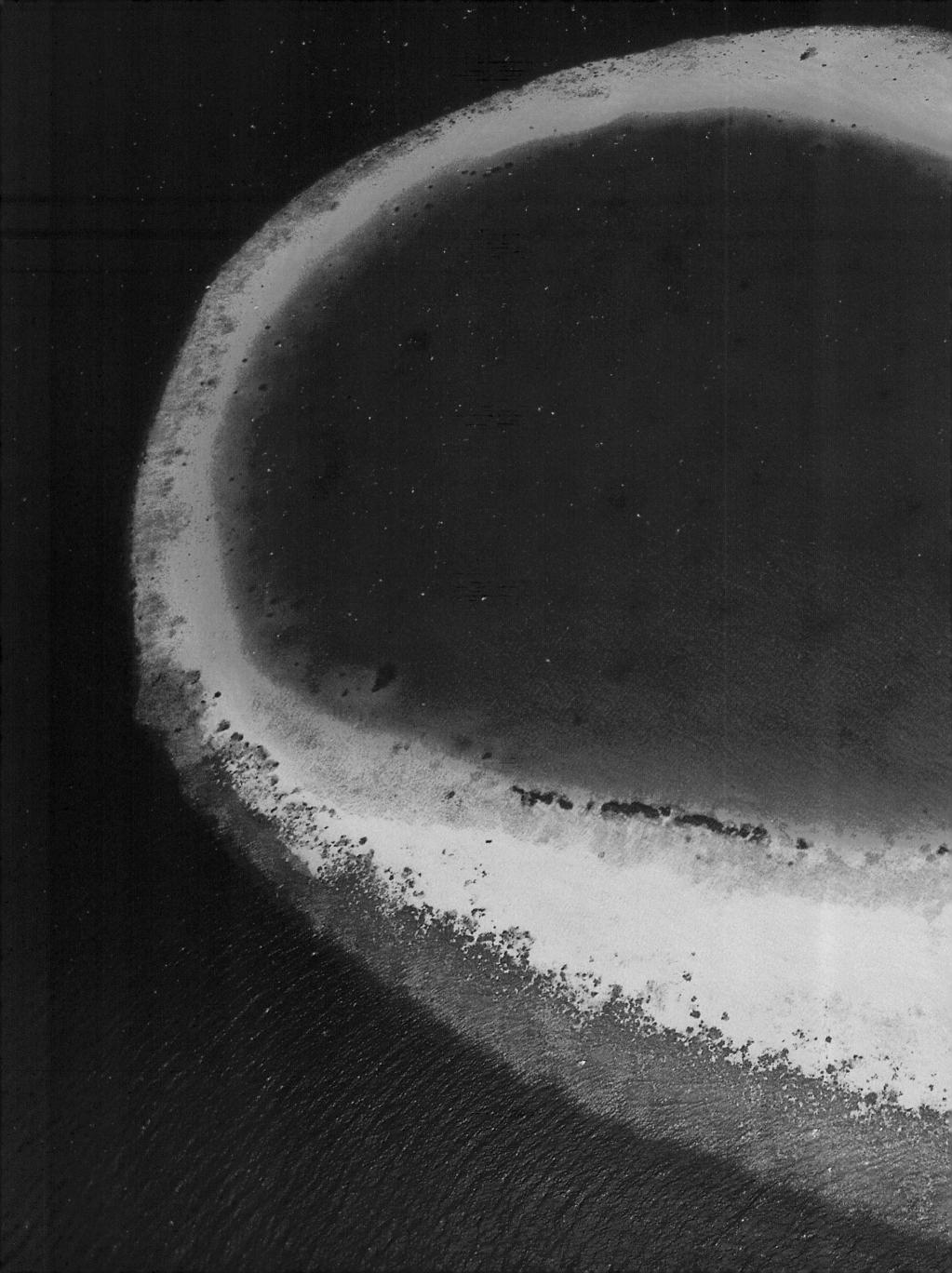

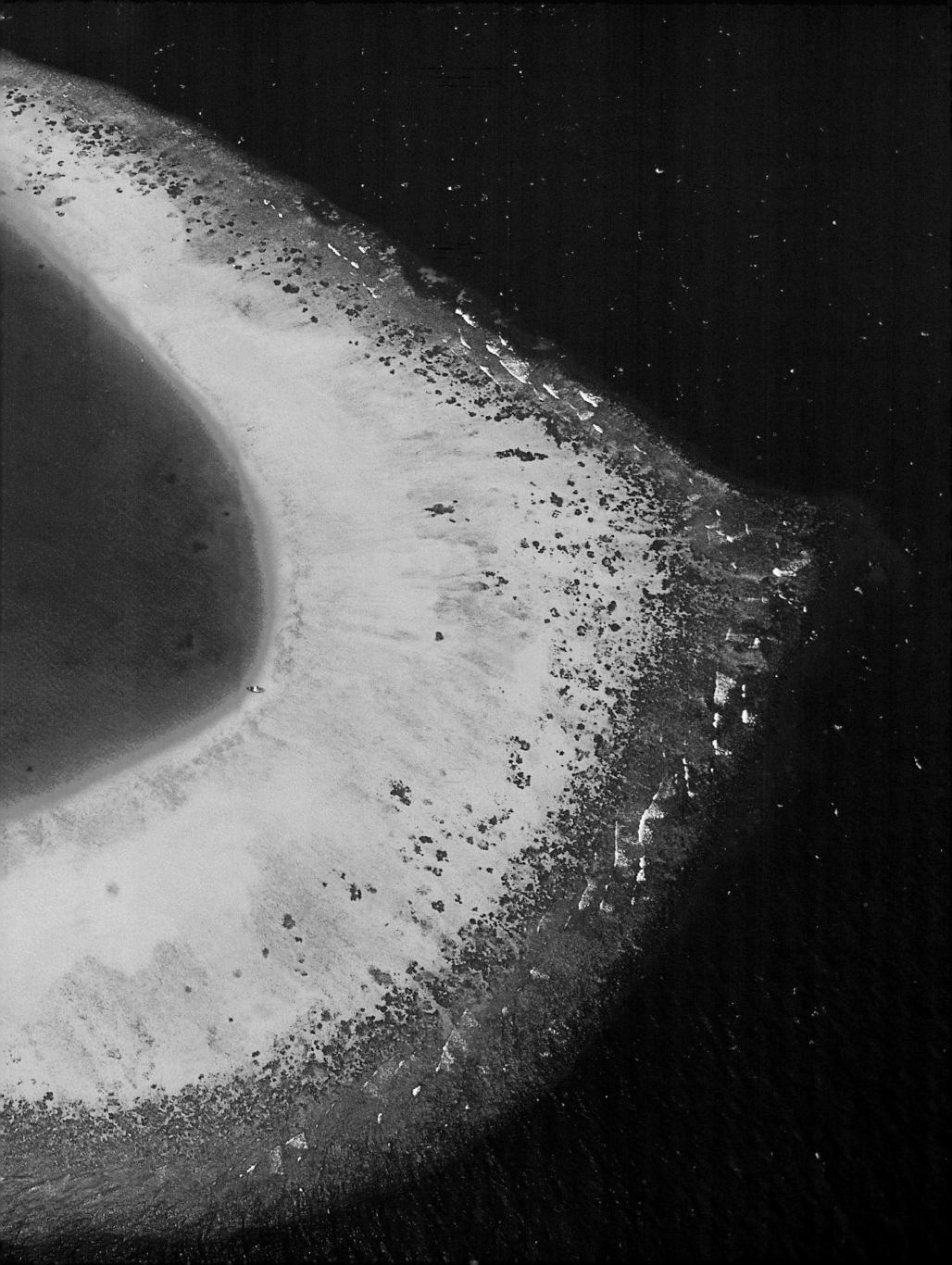

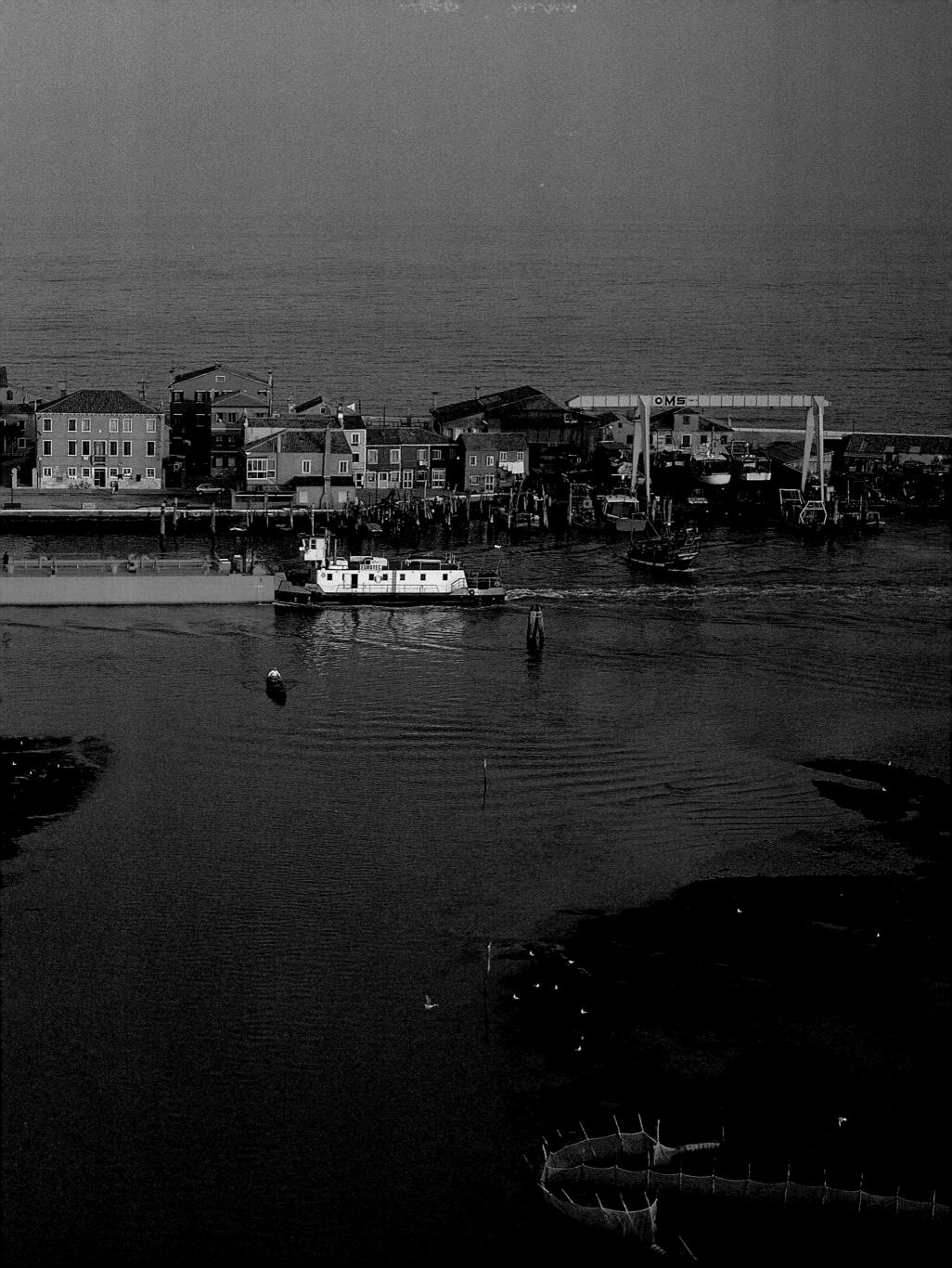

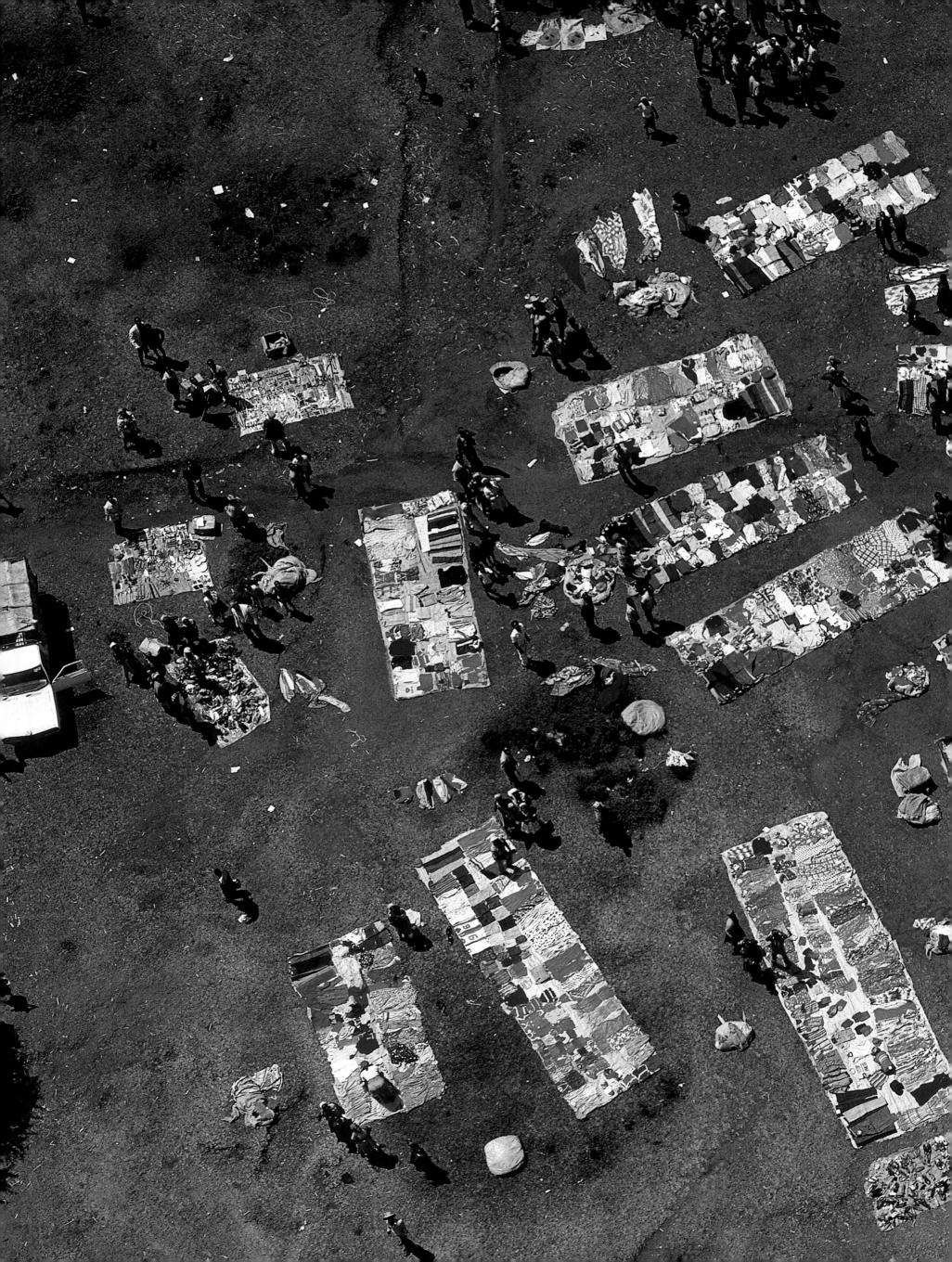

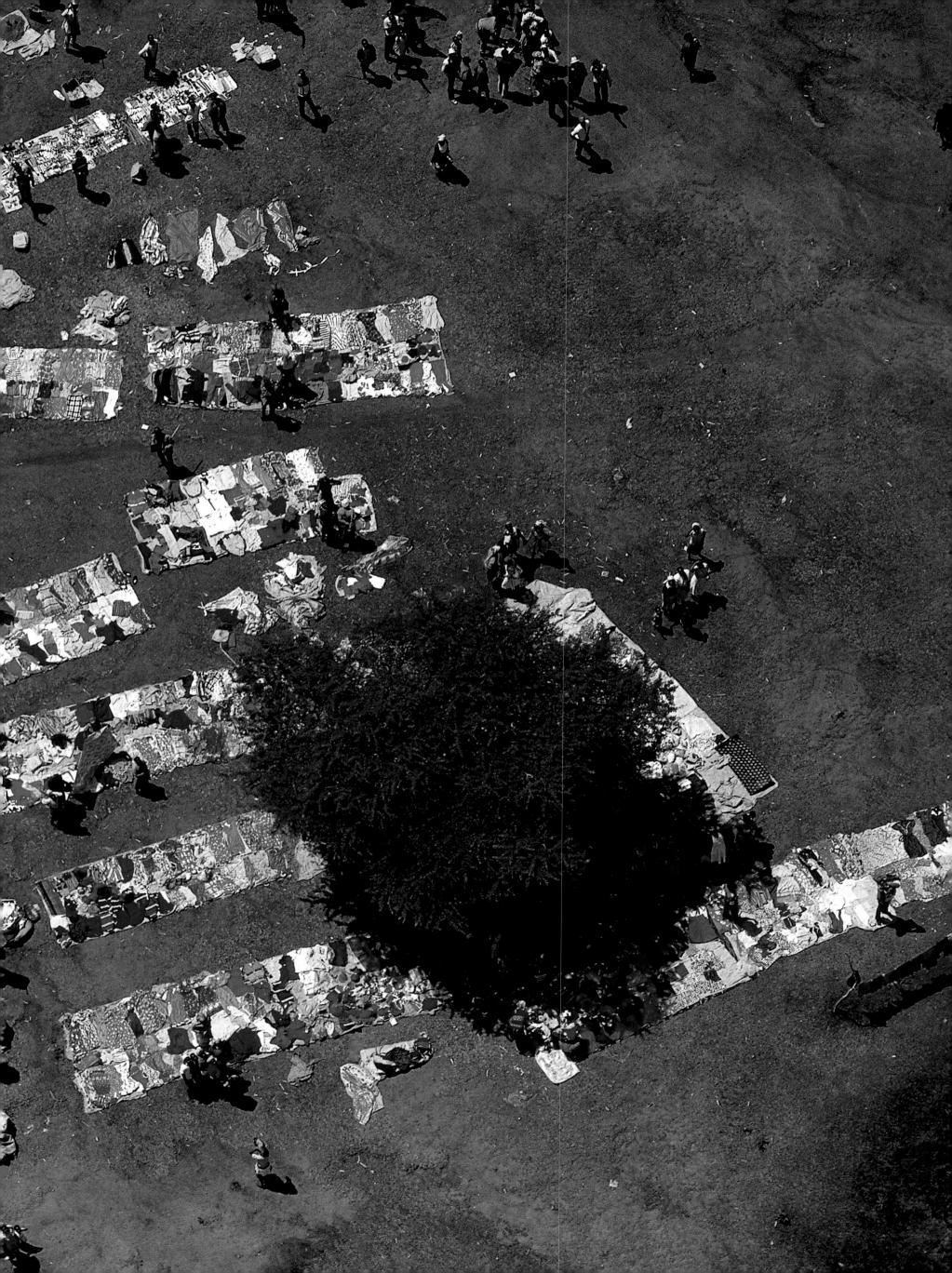

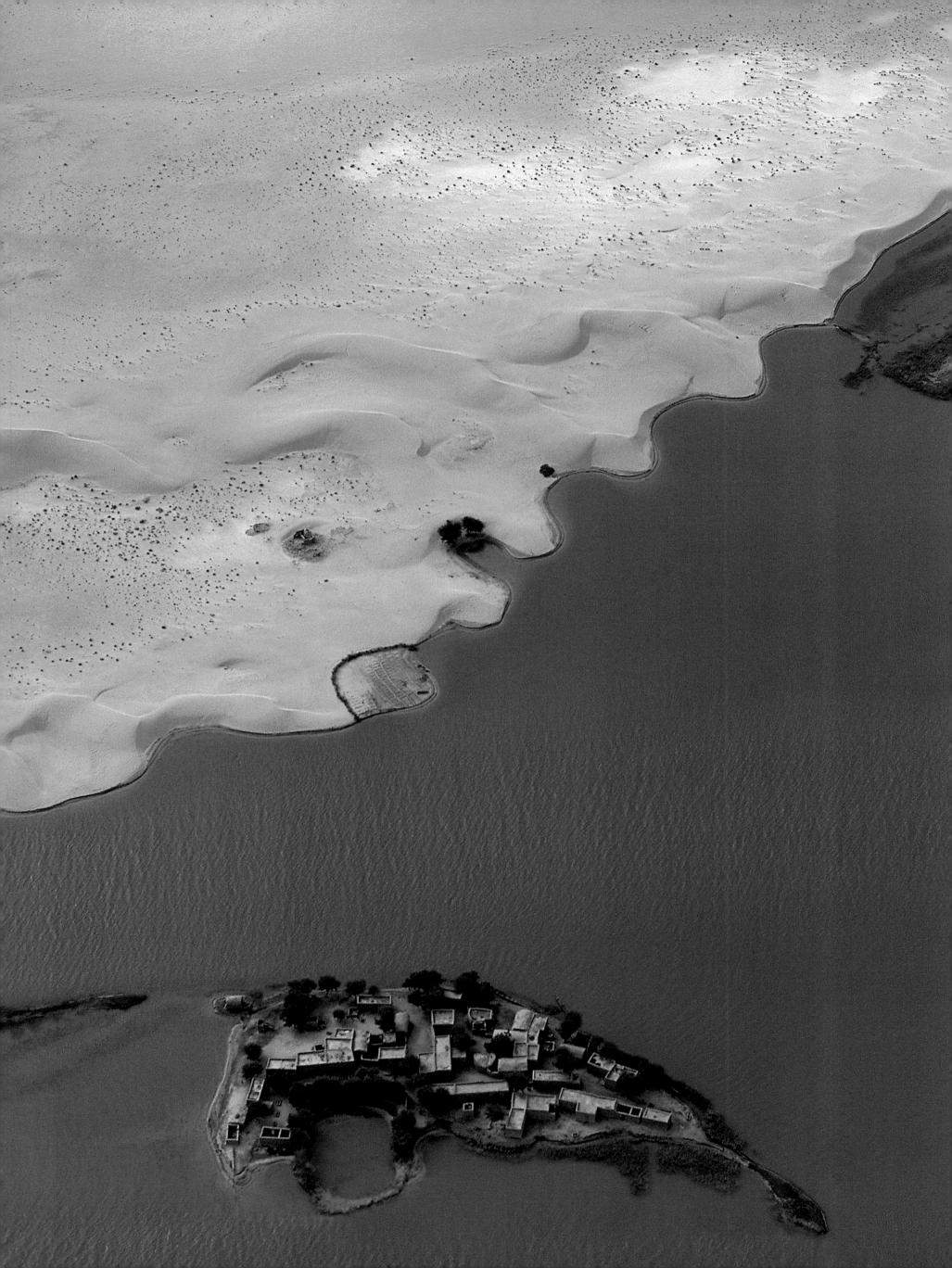

TRACES, RUINS, MEMORY

he existence of traces signifies that humans are at once "geographic" beings who engrave (graphein, from the Greek) the earth (ge) in the course of their existence, leaving signs of their activity wherever they go, as well as "historic" beings because of the way time past is taken into account by new generations. Objects from the past, removed from the sites where they were preserved, fill museums. The places of the past, reutilized or simply abandoned to the state of ruin, form part of the patrimony that

our era will pass down to future generations. Are these ruins anything other than the sometimes incomprehensible traces of human activity? Are they witnesses for history? Yes—they constitute reference points, reminders in the life of present populations, useful elements for measuring time. In history there is always something "before," slightly more erased than what comes "after," far less known, more tenuous, and always incomplete. But who would dare say that a ruin is of no significance, of no importance? There is every reason, on the contrary, to value it and what can be made of it by us and by those who will succeed us.

p. 128 RESIDENCES ON AN ISLAND IN THE NIGER RIVER, between Gourem and Gao, Mali

The Niger River winds among the sands in constant progression south of the Sahara, creating a large loop in Mali called the "camel's hump" by local people. After the rainy season, during periods of high water (from August to January), it floods vast expanses. Left above water are only a few small islets, called *toguéré*, which are sometimes inhabited. Although it occupies less than 15 percent of the Mali territory, the Niger River basin houses nearly 75 percent of the population, in addition to most of the country's metropolises. This river, which waters four countries in West Africa (Guinea, Mali, Niger, and Nigeria), reportedly takes its name from the Berber expression *gher-n-igheren*, which means "the river of rivers."

TEMPORAL REFERENCE POINTS

Every human society transforms its environment, but until the twentieth century this action remained basically unconscious: no civilization before our own technological culture has ever imagined that it could have a palpable effect on the environment. Any thinker who dared express such a

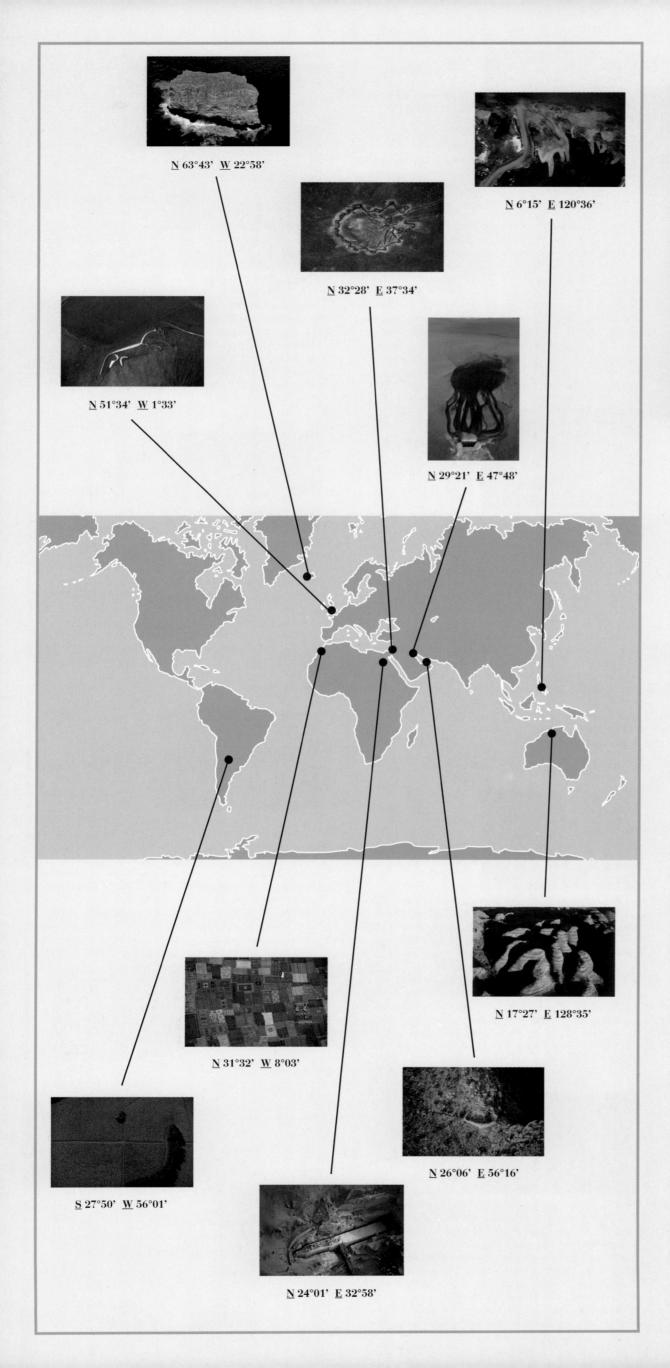

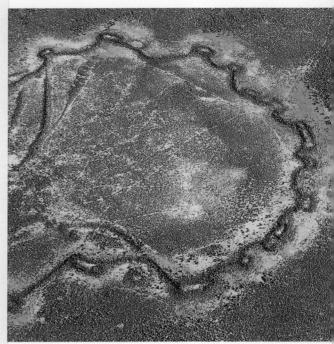

ns, the incredible diversity of human a comparing those that have occupied ifferent times.

RRITORIES

iphs do not show the original surface of societies throughout history have made what the human eye can see of the prefits elements. Looking at these phohelp but note the ubiquity of industriare surprised to discover traces of where we would expect nature to have human presence.

Terrestrial spaces before human as nature made them (mountain, lake and countless other classes of objects), coplaces. When they receive a population, or tion of the soil, they are henceforth situtypes of flux (fluxes of commerce, migramunication). At that point they become pedefined by their locations and the distart but now also by their attributes—their forms assumed by the surface they occur abstract vision is expressed "carnally" landscapes.

Places and territories are defined I materiality—they are manipulated by us but also mentally, as the object of symb representation. Consequently, traces and lizations enter into the consciousness of t among them today. Present-day societies a

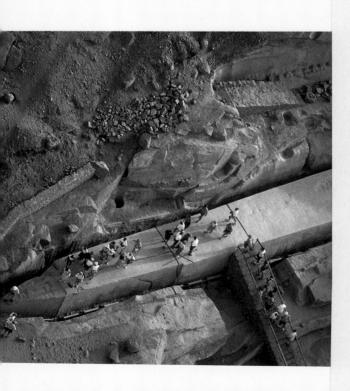

of obsolete technologies to a world of hyperpowerful means.

The modern world never stops reusing ancient customs and, when it no longer understands them, reifying their elements. The result is a profusion of archaeological restorations and the accumulation of art objects in museums. Modern humanity imposes a multiplicity of viewpoints onto the constructions of the past, which serve not only as a basis for our pleasure but also as a springboard for our reflection. "Natural" spaces are subject to the creation of natural parks, reserves, defensive habitats, prohibitions against building, and interventions by landscapers commissioned to restore landscapes in the same manner that a plastic surgeon reconstructs a withered face.

Such protection requires recourse to government, and recent years have witnessed the preservation of spaces that have escaped the scars left by lines of communication and trade—a major sign, from city to city, of the expansion of pre-

sent civilization. But this is not true everywhere. To ensure the global protection of ruins and landscapes of the past it is indispensable to appeal to a worldwide institution whose decisions will be respected.

Pierre Gentelle

p. 137

WASTE FROM A WATER DESALINATION PLANT IN THE SEA OF AL-DOHA,

Jahra region, Kuwait

The two seawater desalination plants at Al-Doha in Kuwait produce 39,600 and 198,000 cubic feet (1,200 and 6,000 m³) of fresh water daily, using the instant thermal distillation technique (also known as the "flash" system). After treatment, water unfit for consumption is rejected into the sea or mixed with the waters of the Persian Gulf, creating the shape of a tentacled monster. For a long time Kuwait depended upon artesian wells and imports from Iraq for its supply of drinking water, but today it has several plants that produce more than 106 million gallons (400 million liters) of desalinated water per year, providing for 75 percent of the country's needs. Requiring enormous amounts of energy, the desalination stations are available only to states that have considerable resources, particularly petroleum, such as those in the Arabian peninsula. Featuring about 40 plants, this area produces more than half of the world's desalinated water.

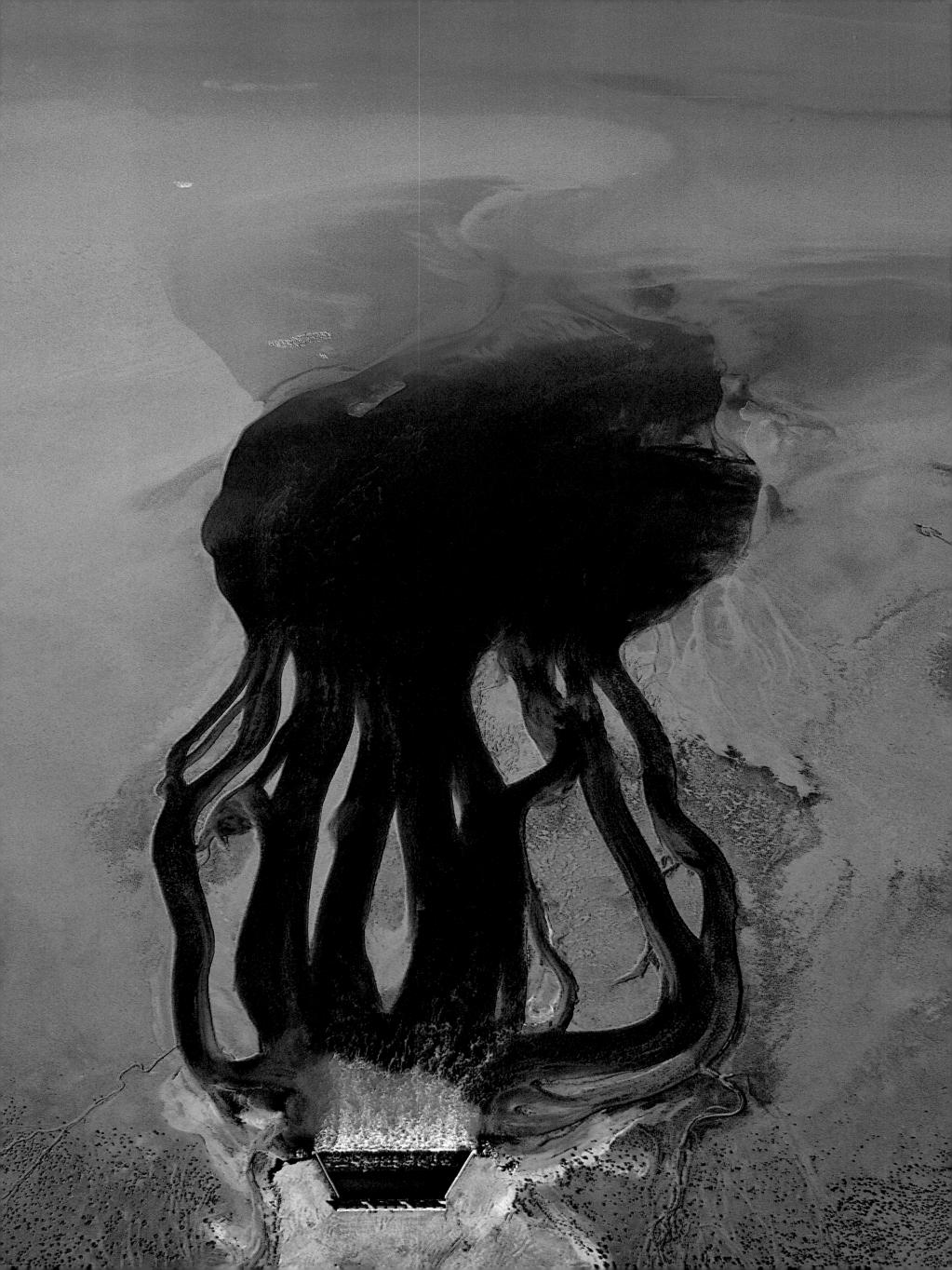

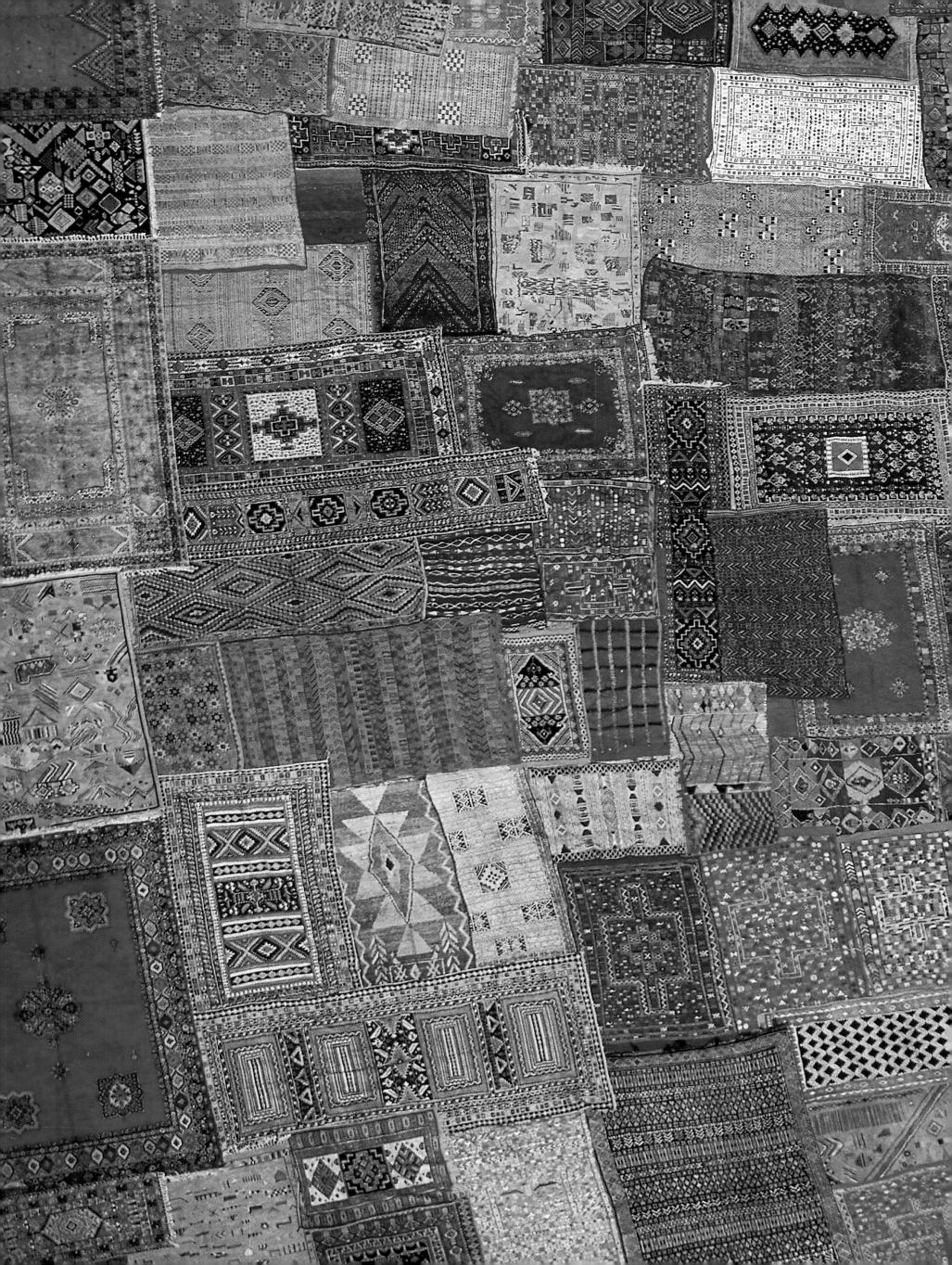

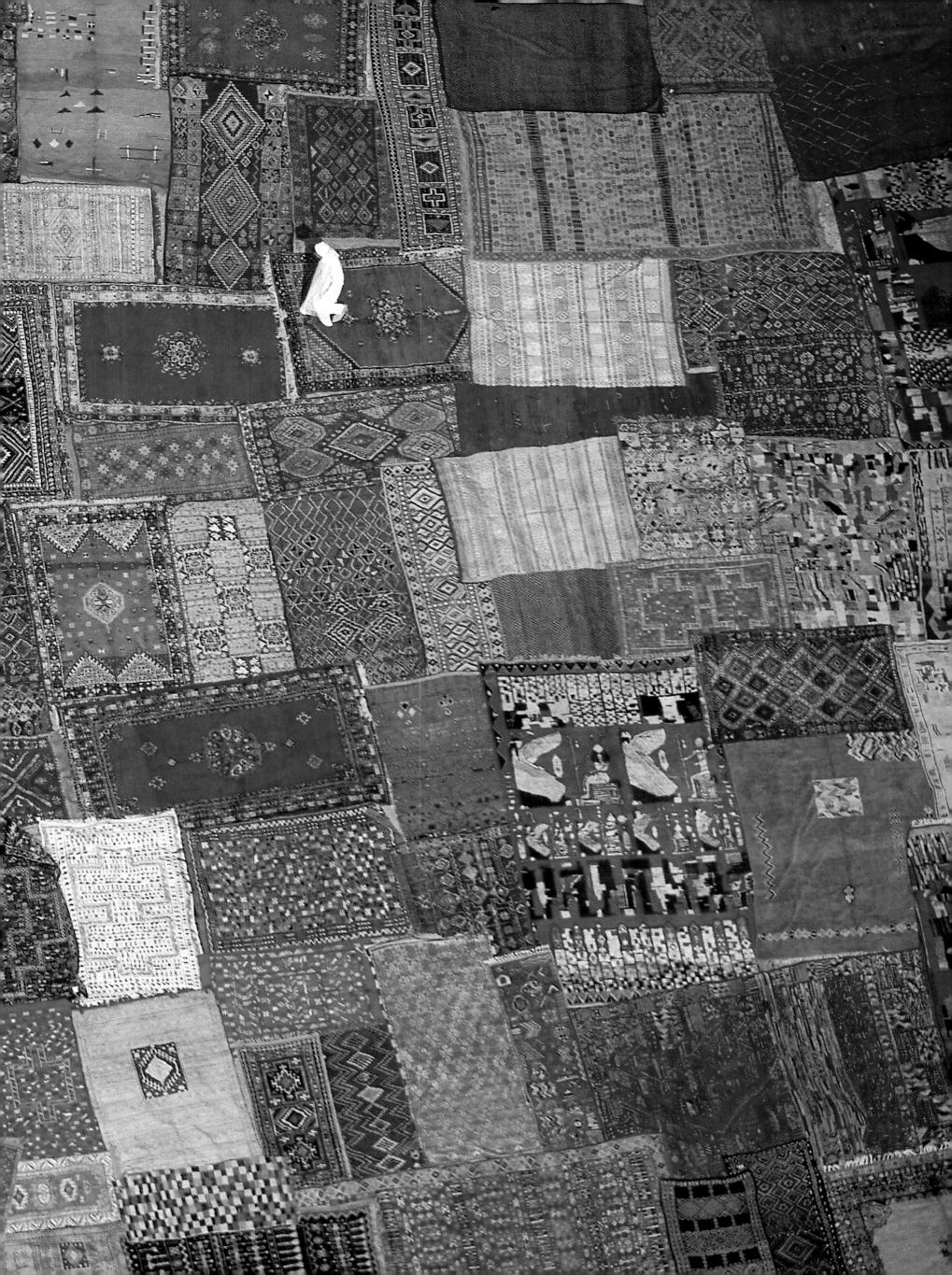

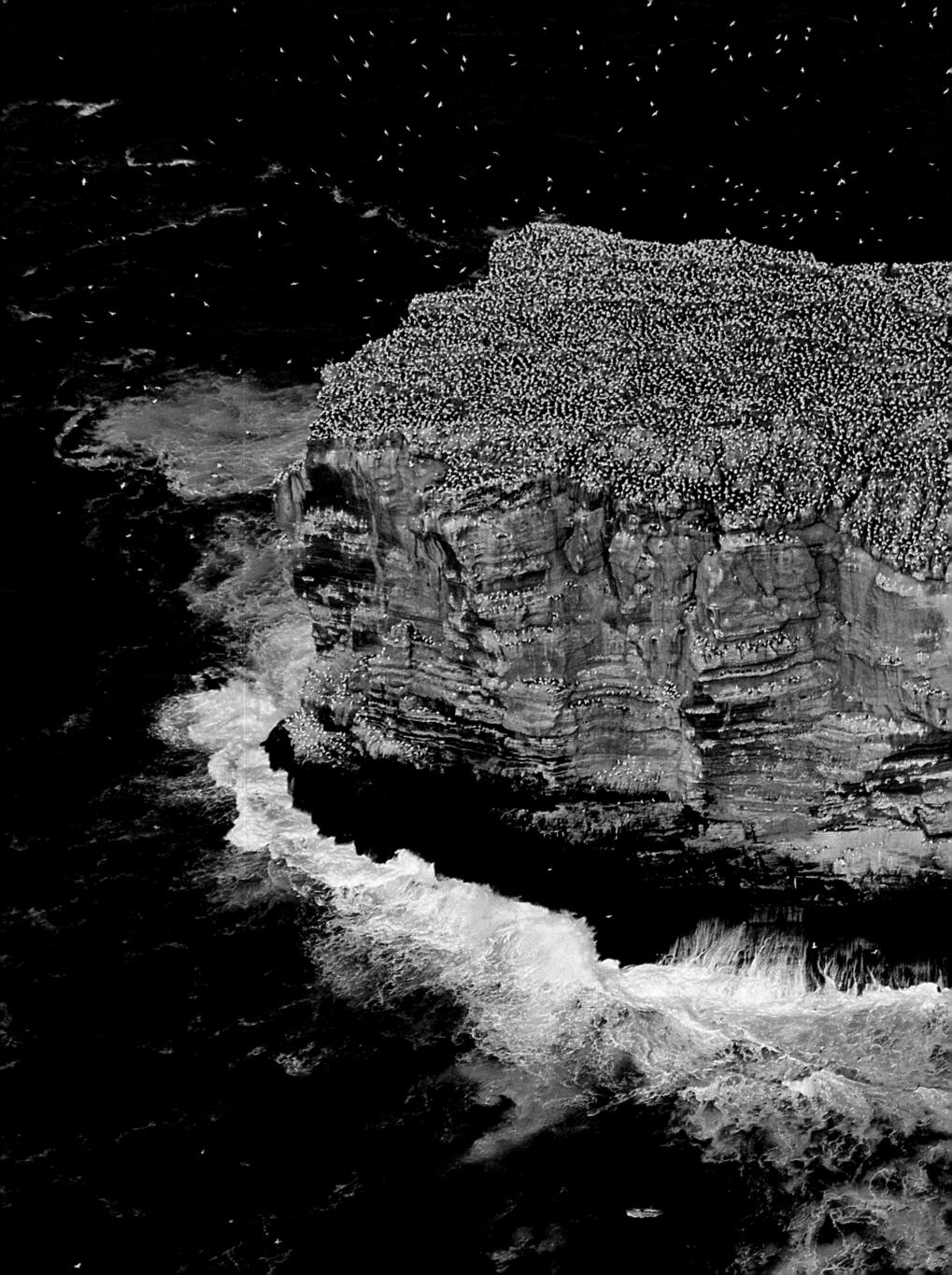

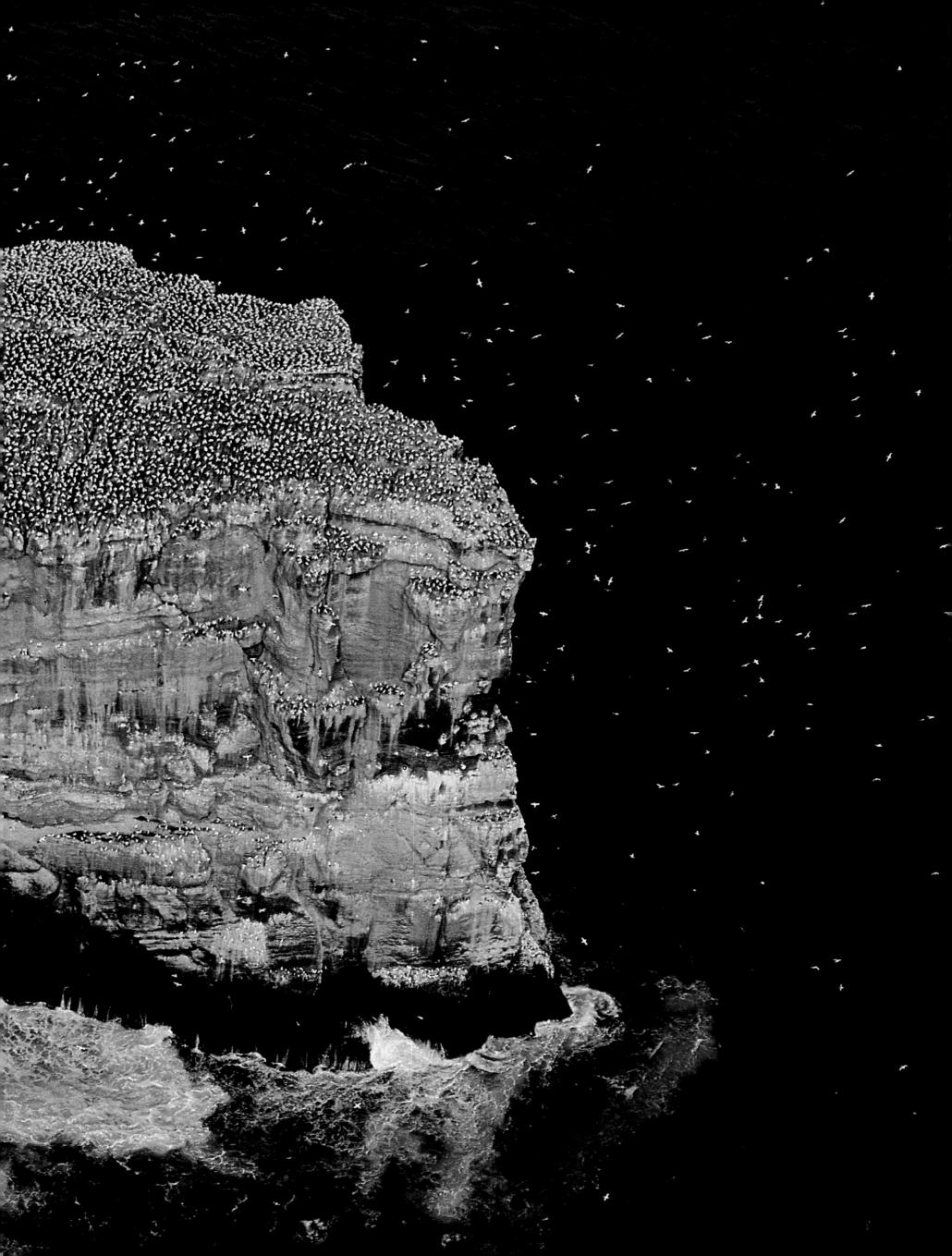

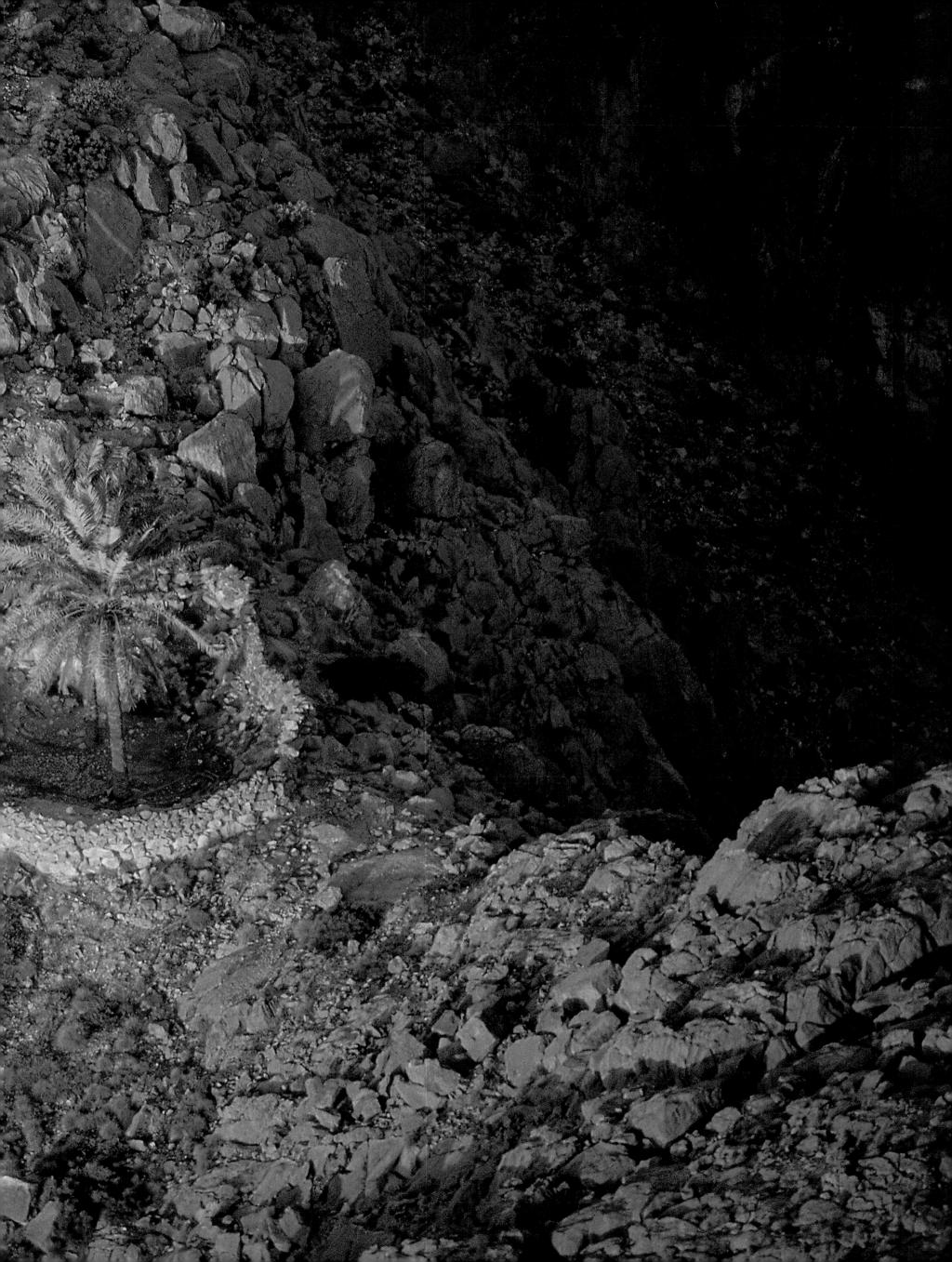

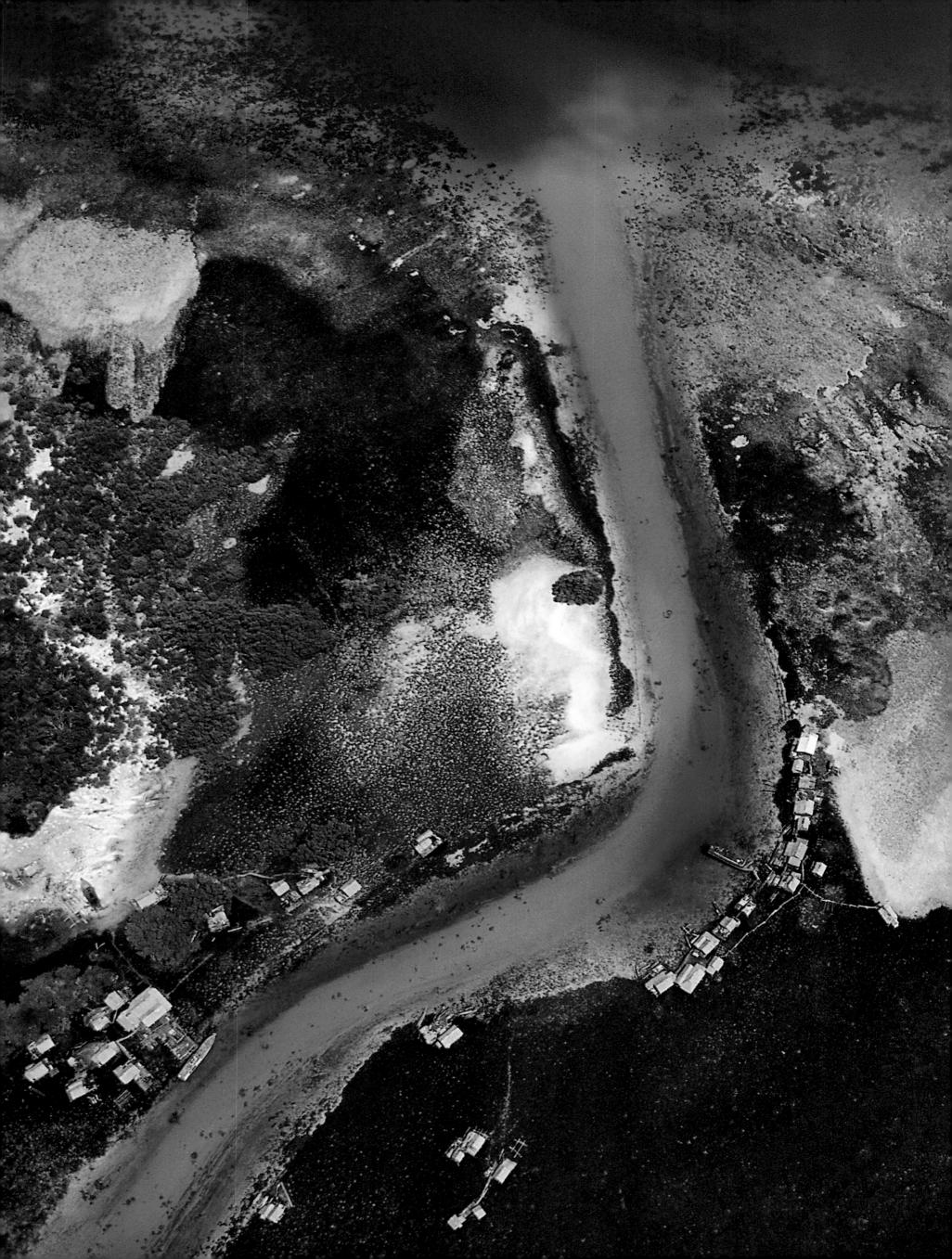

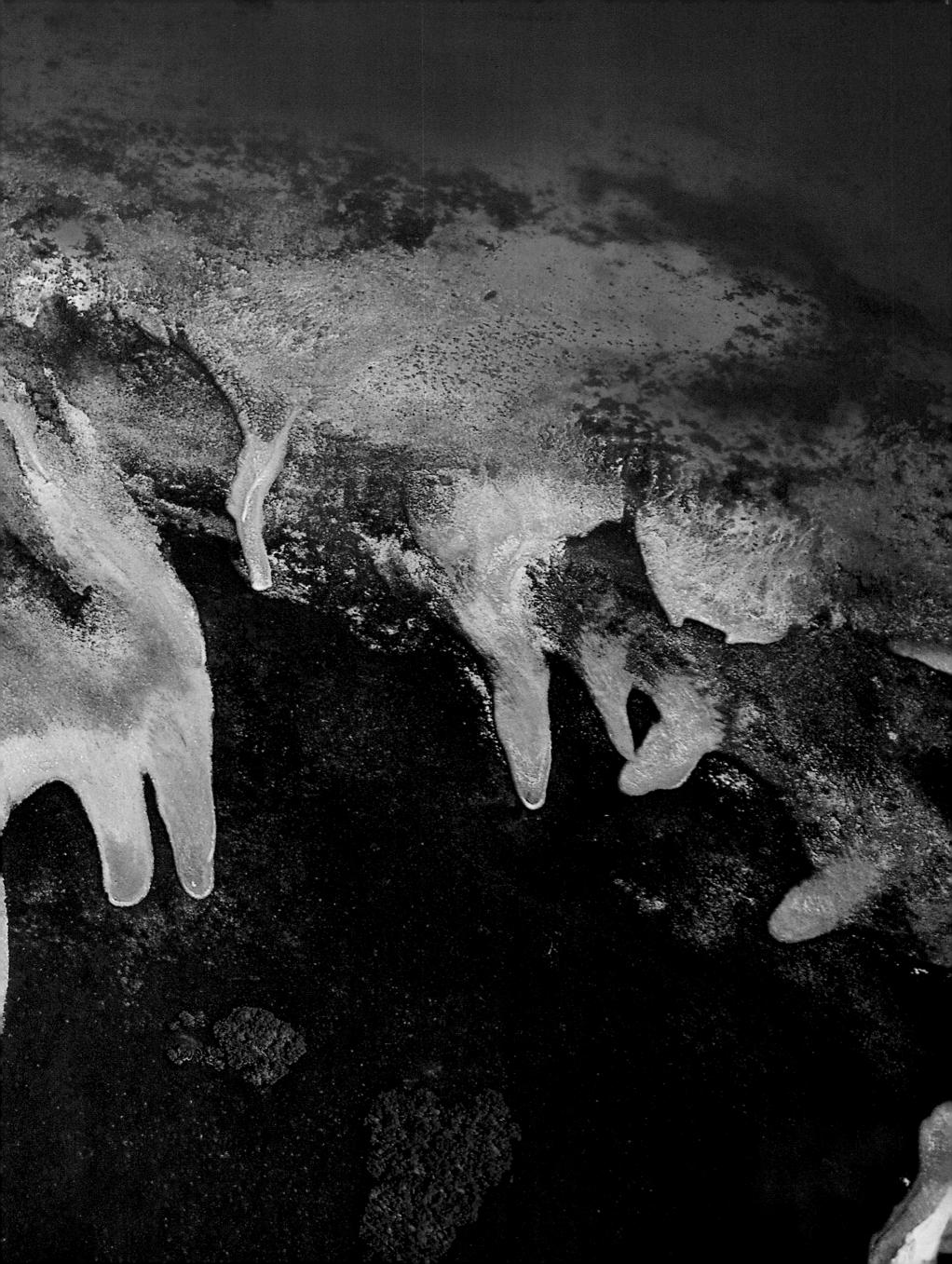

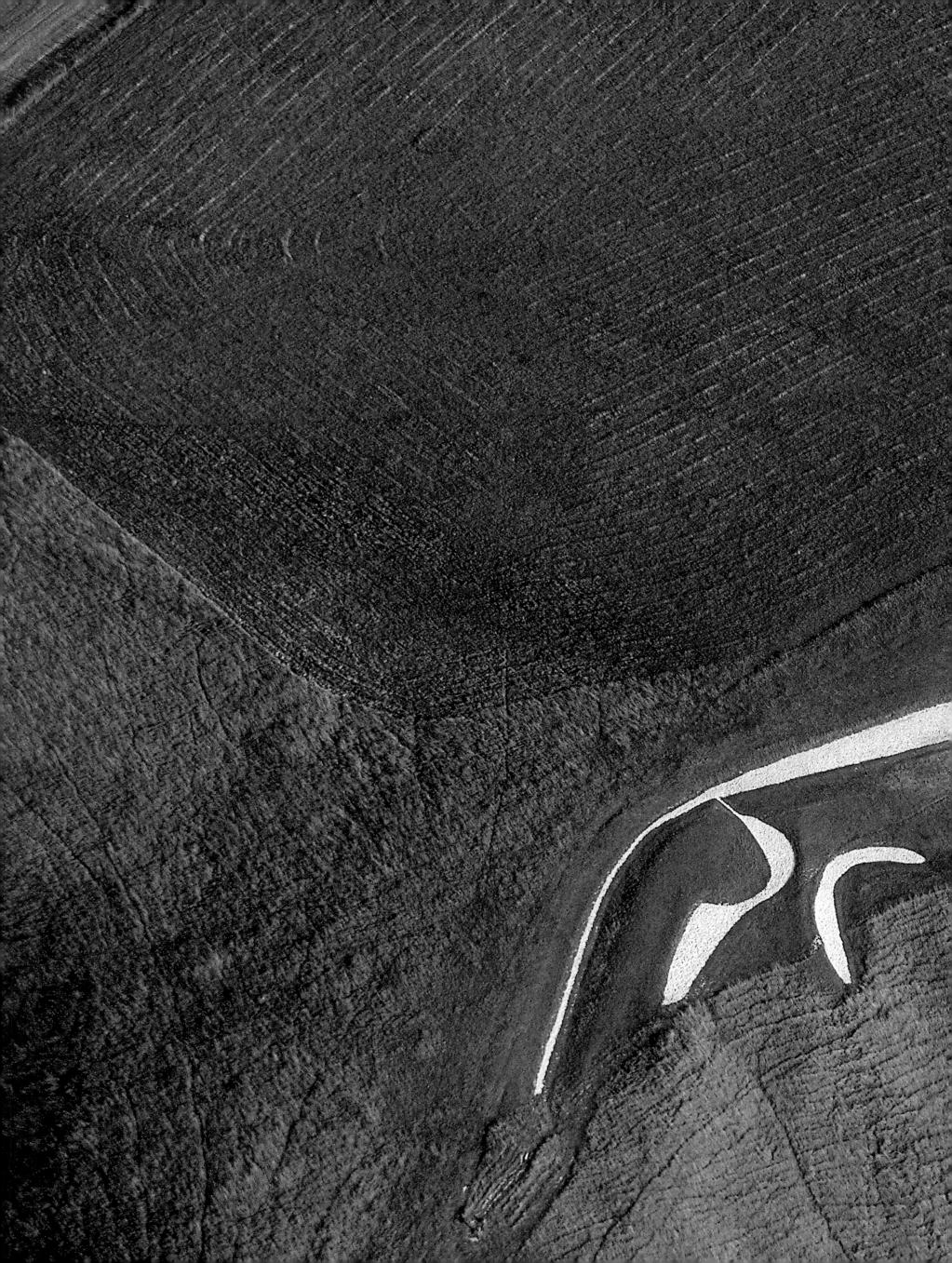

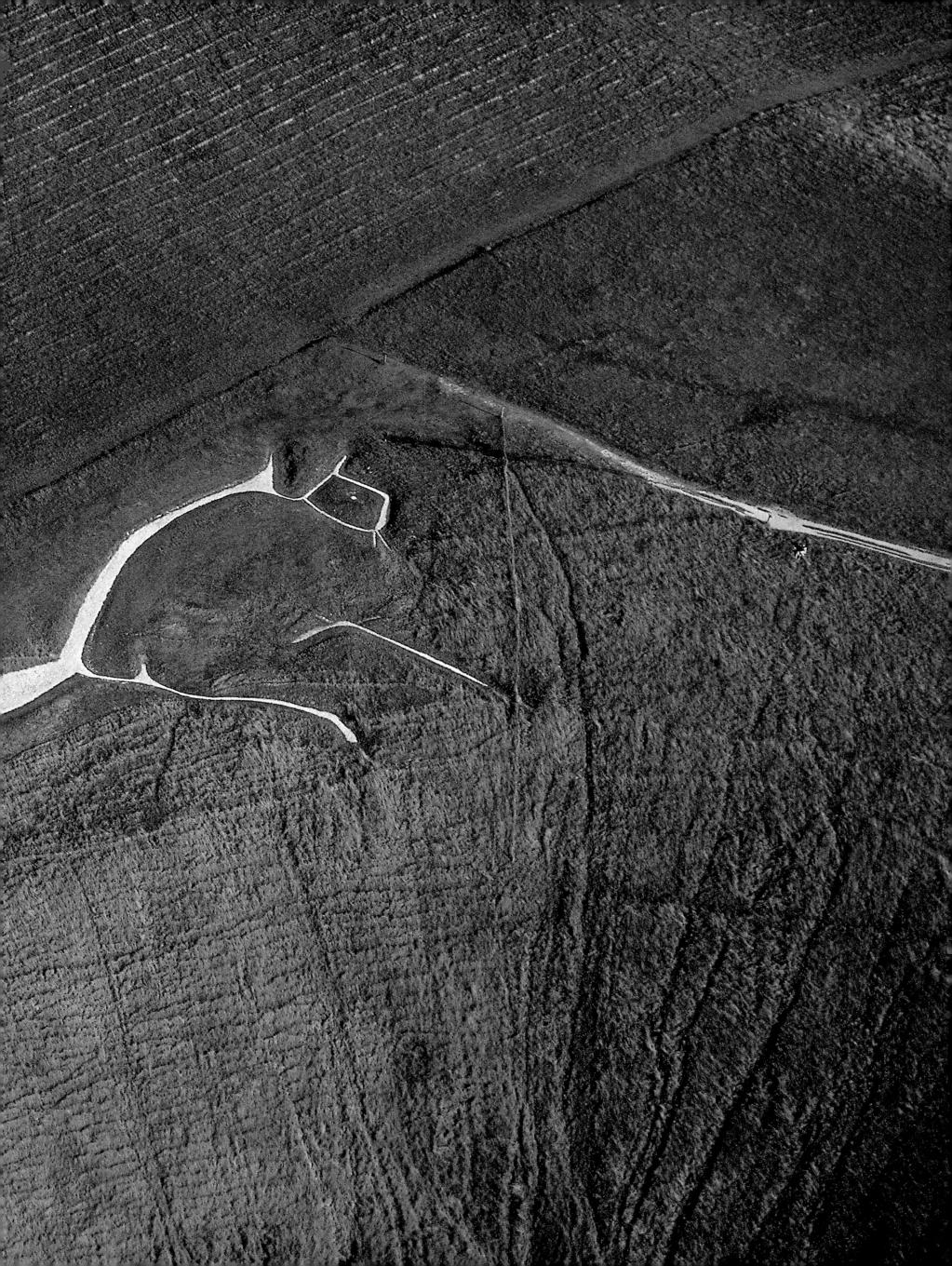

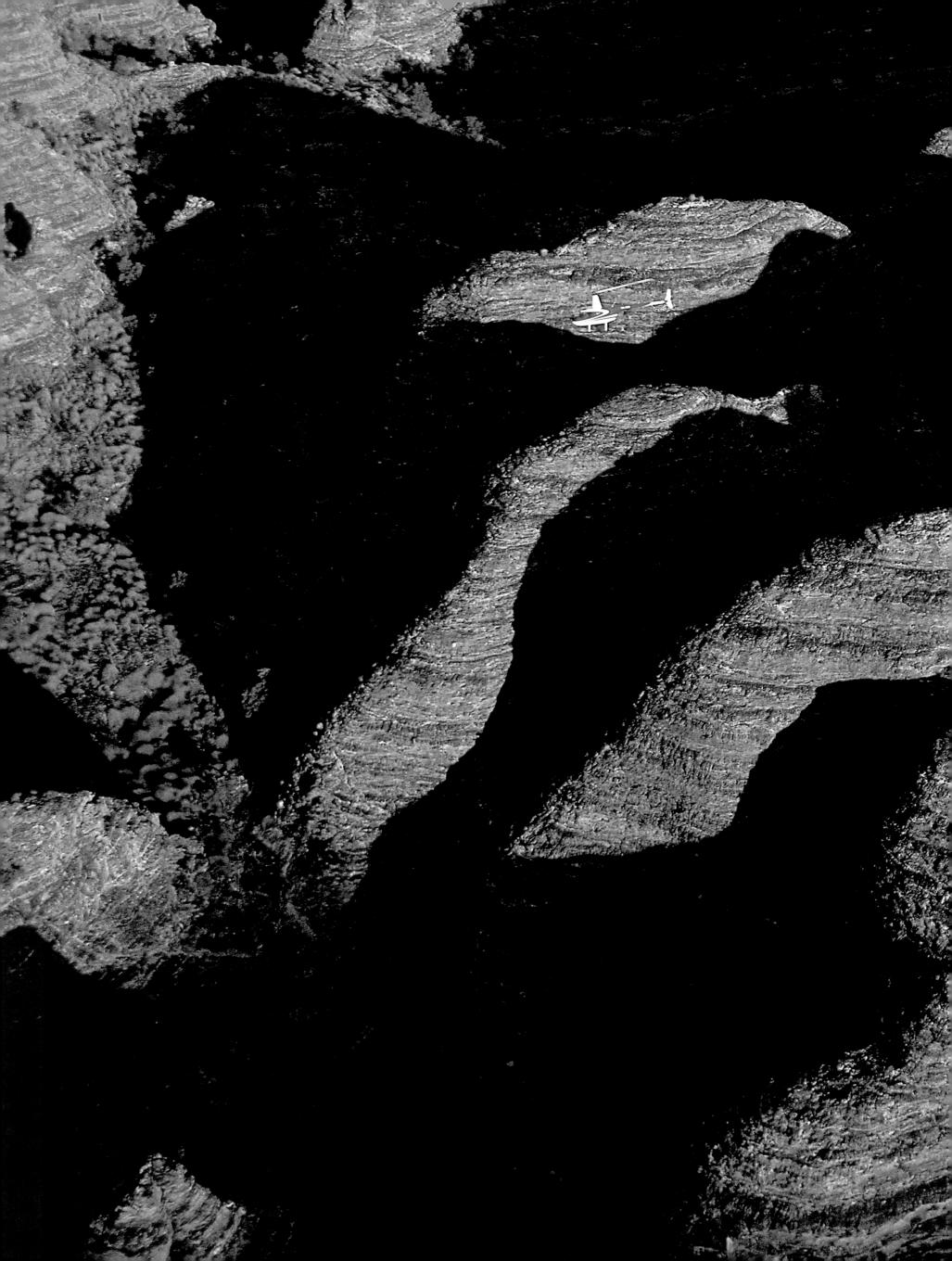

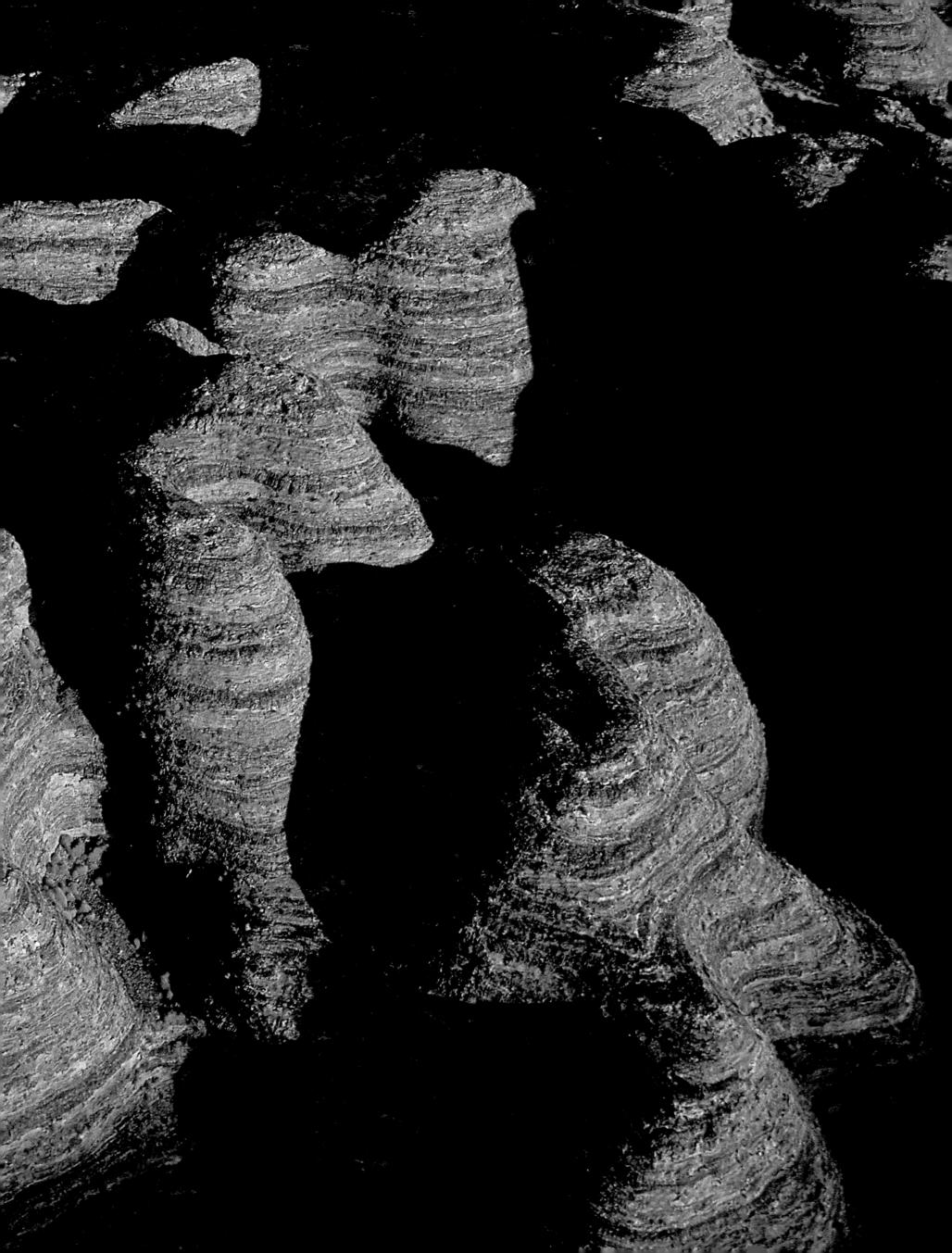

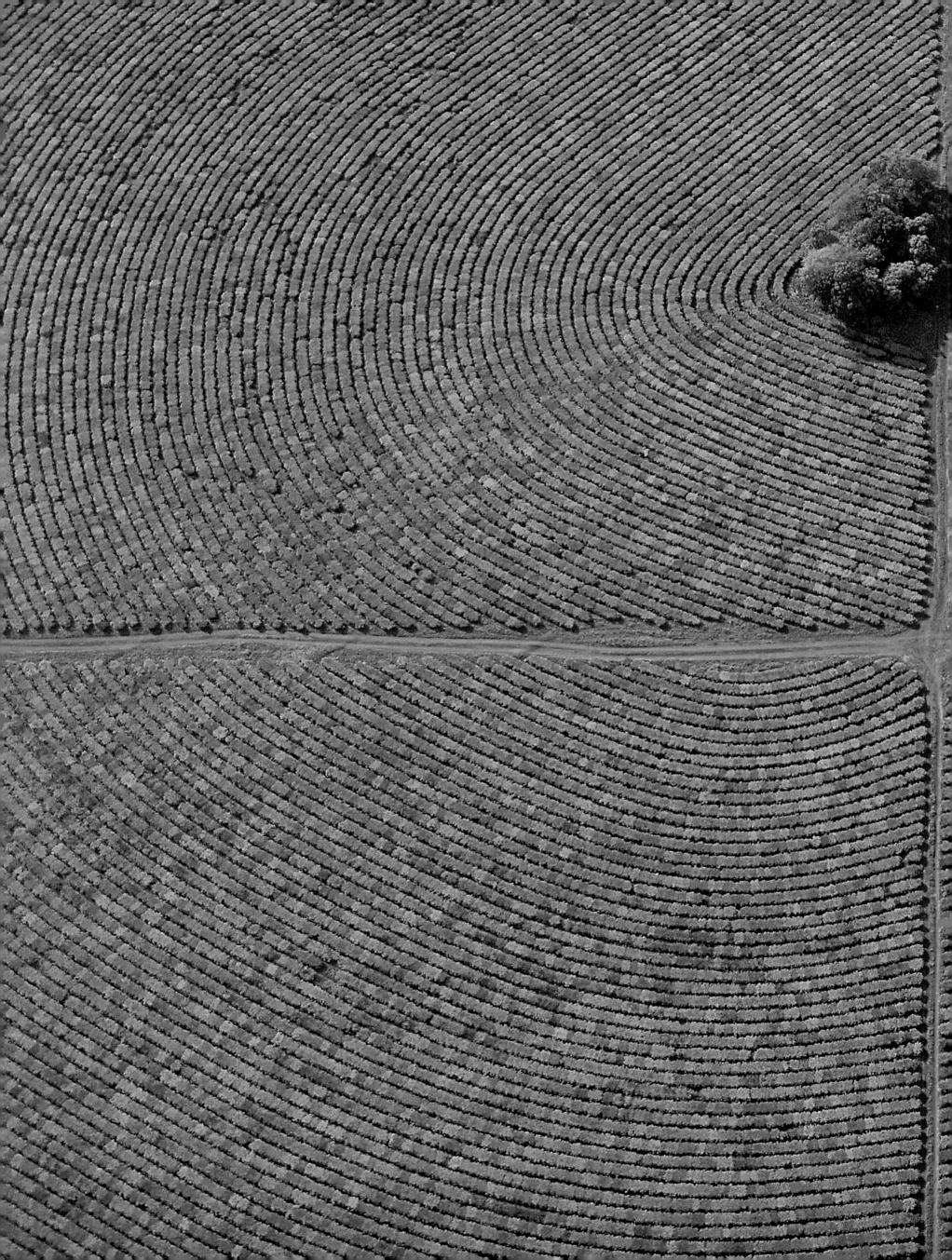

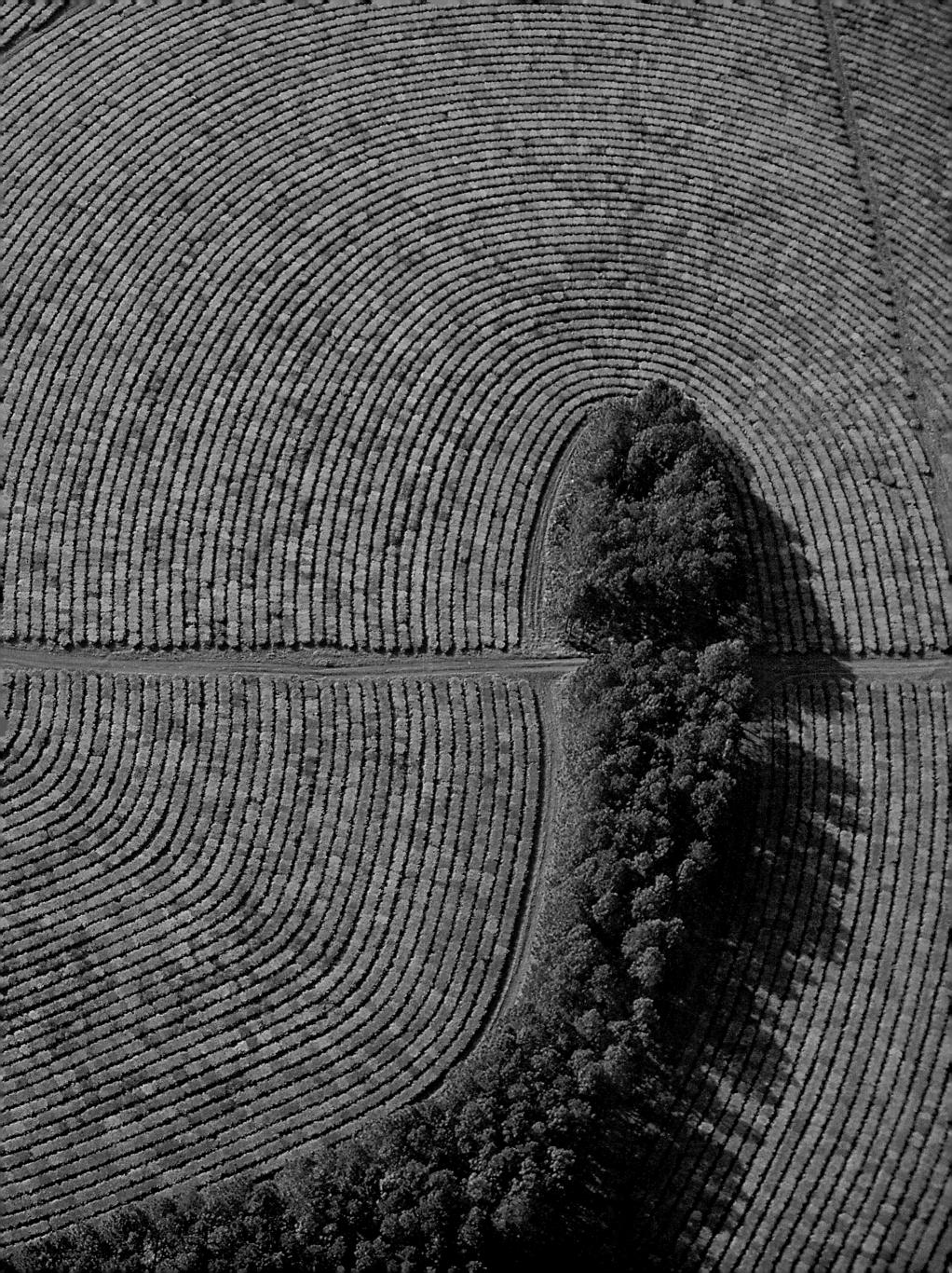

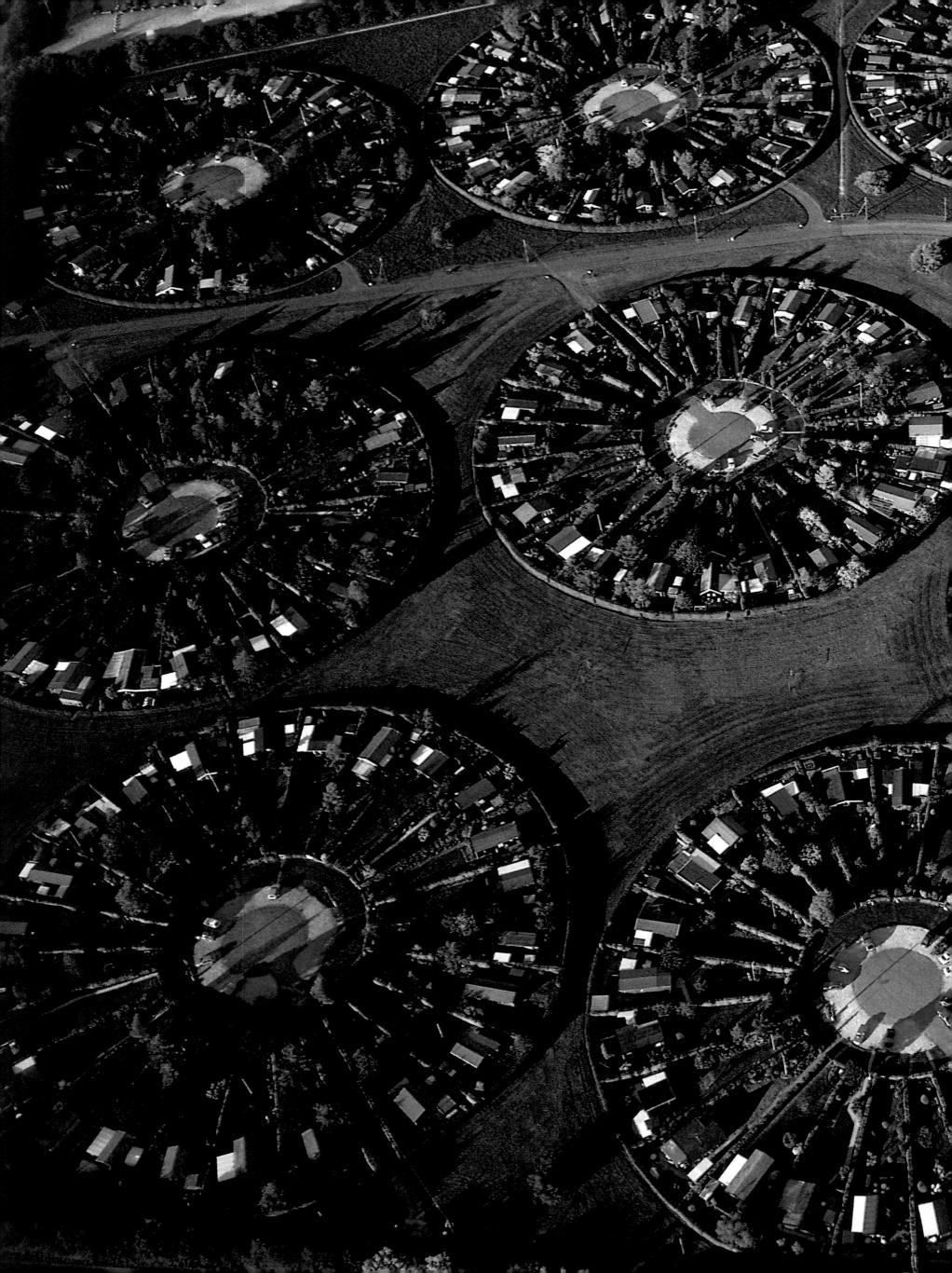

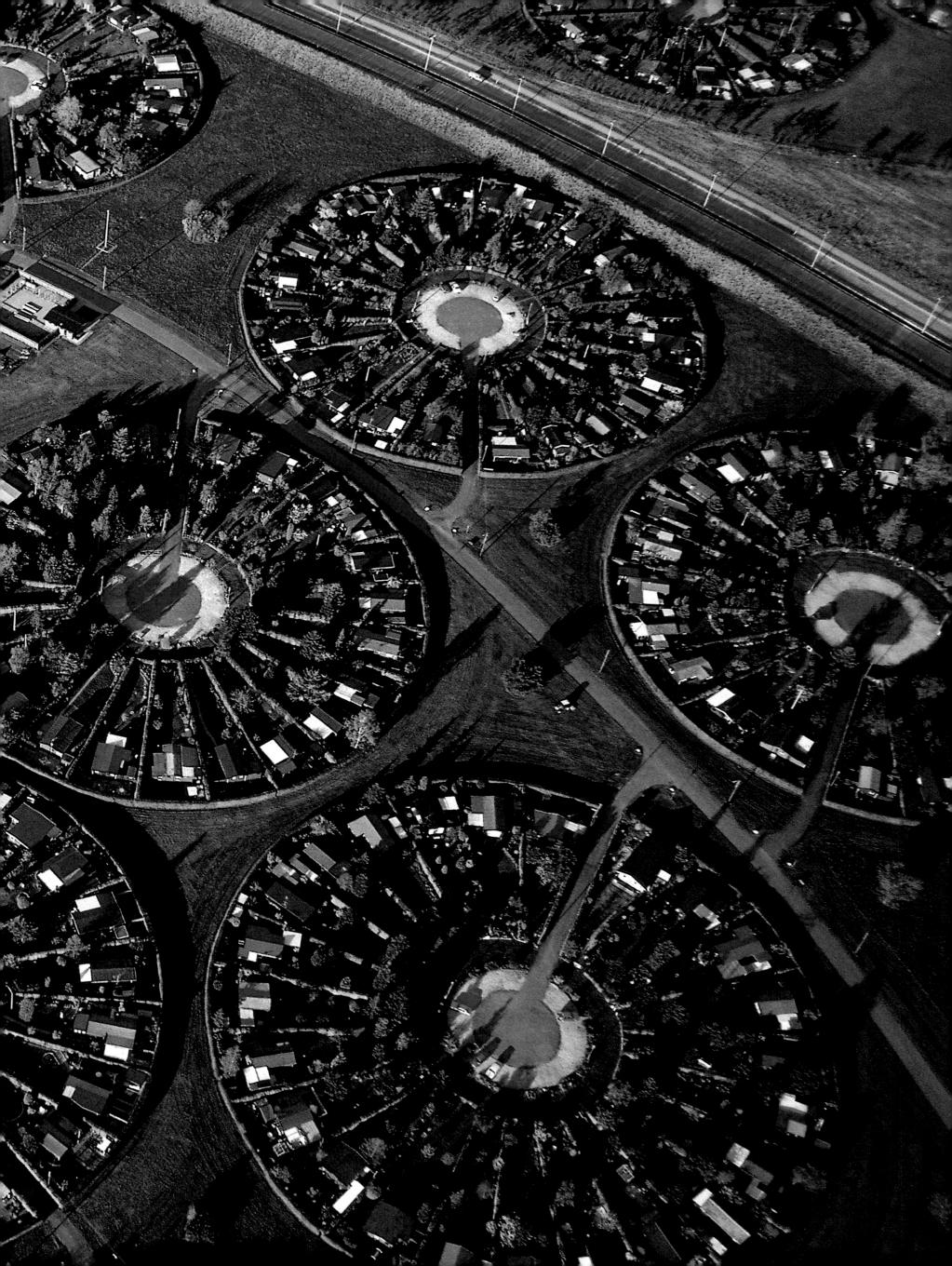

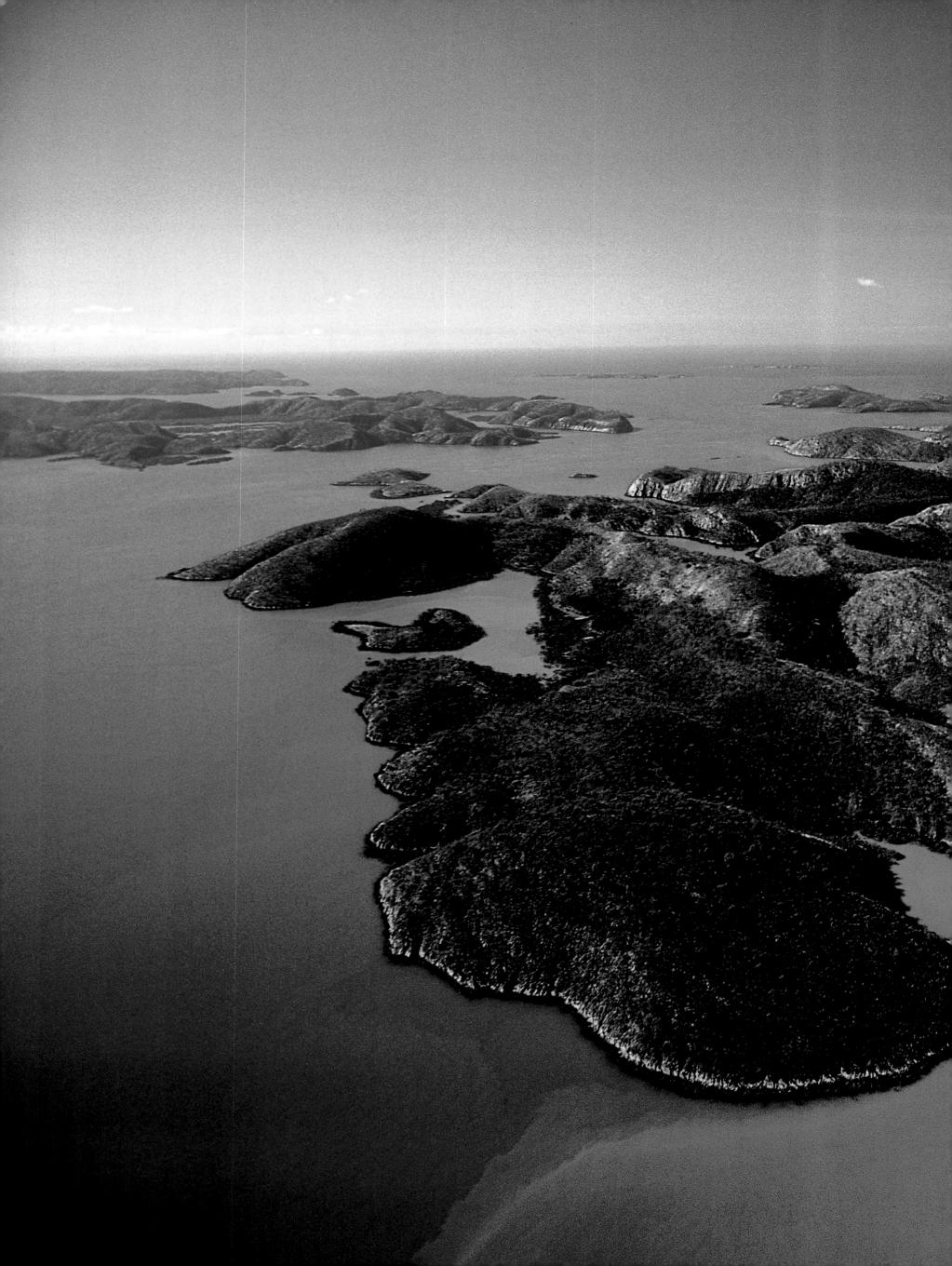

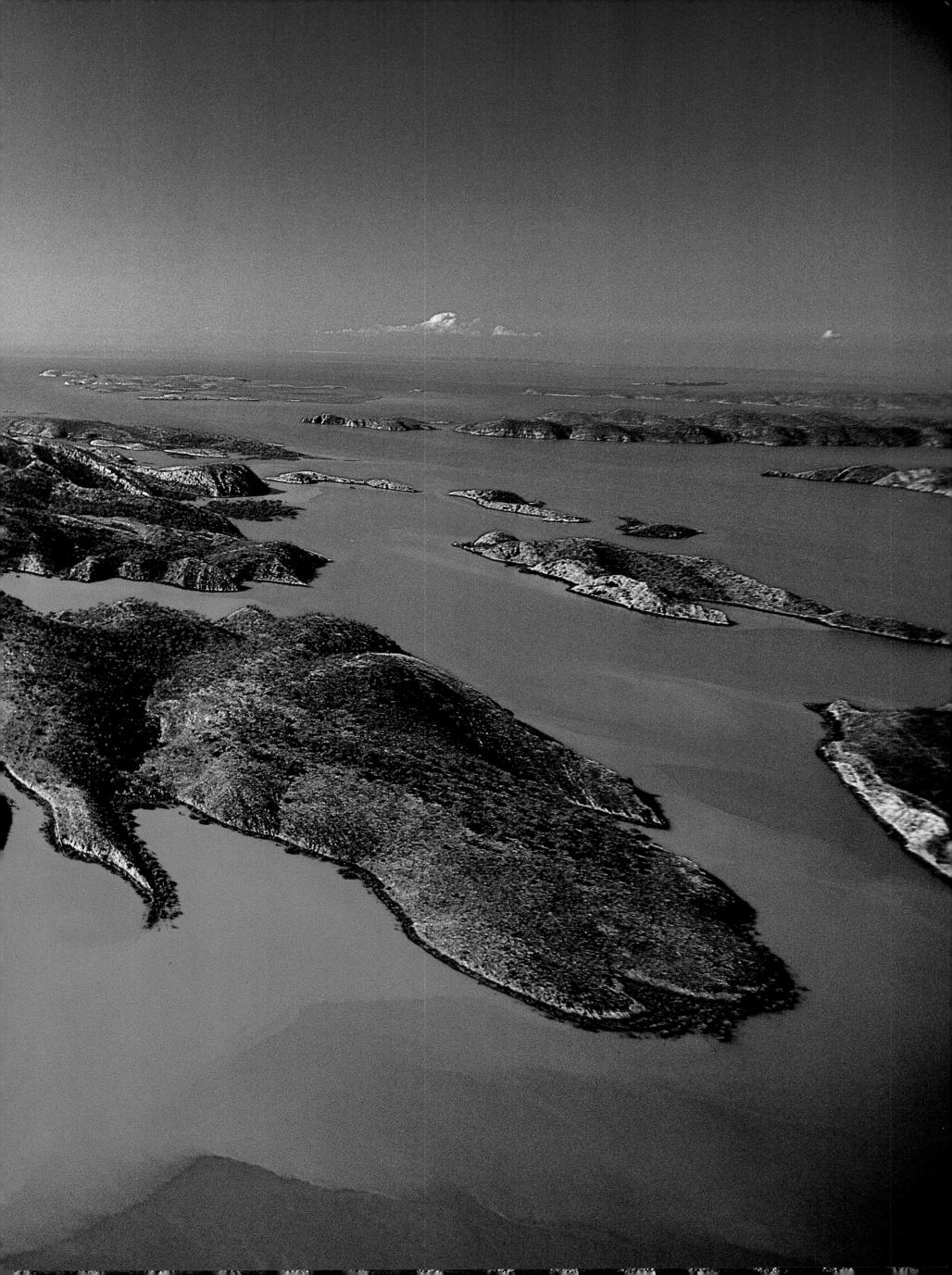

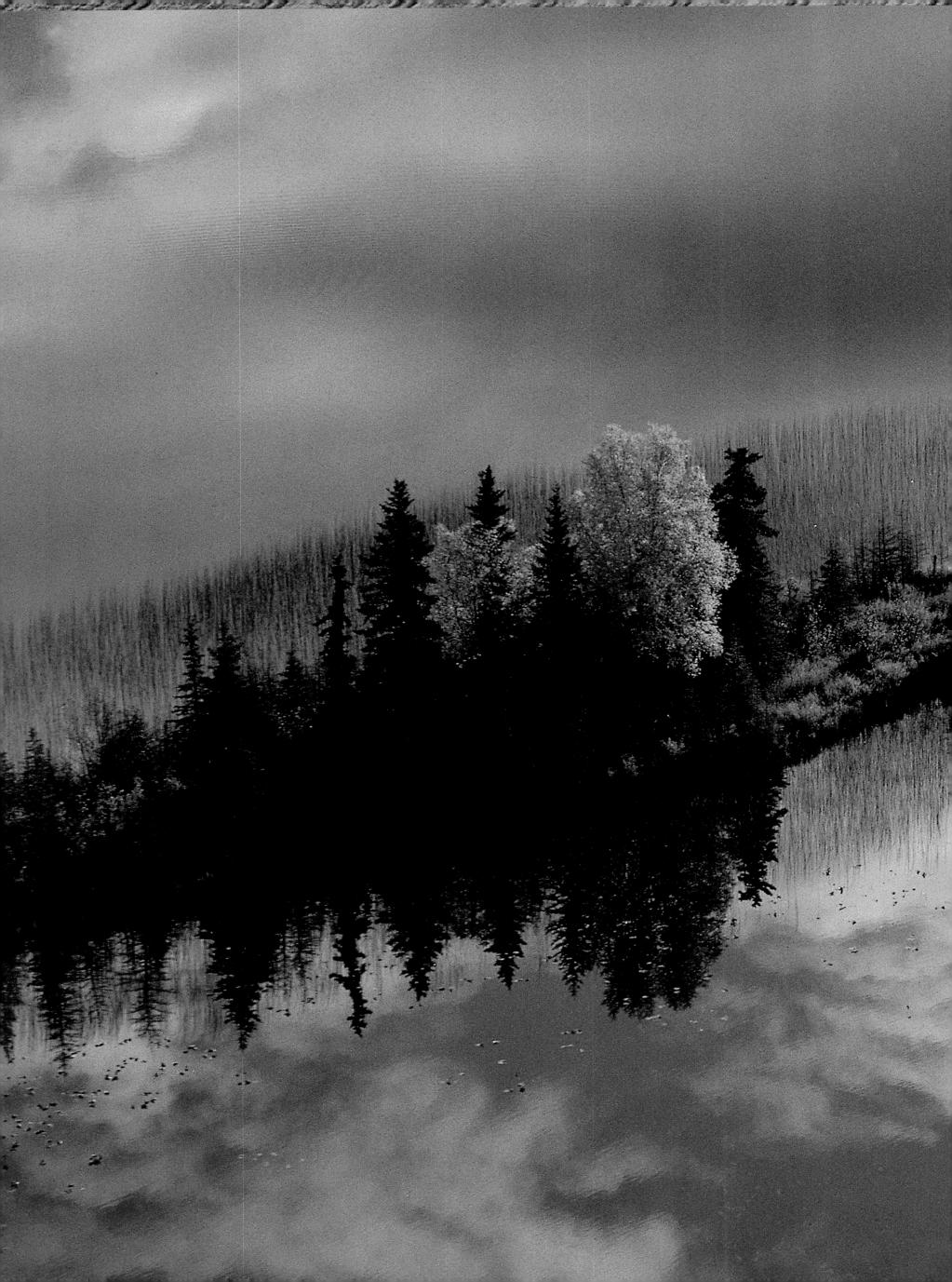

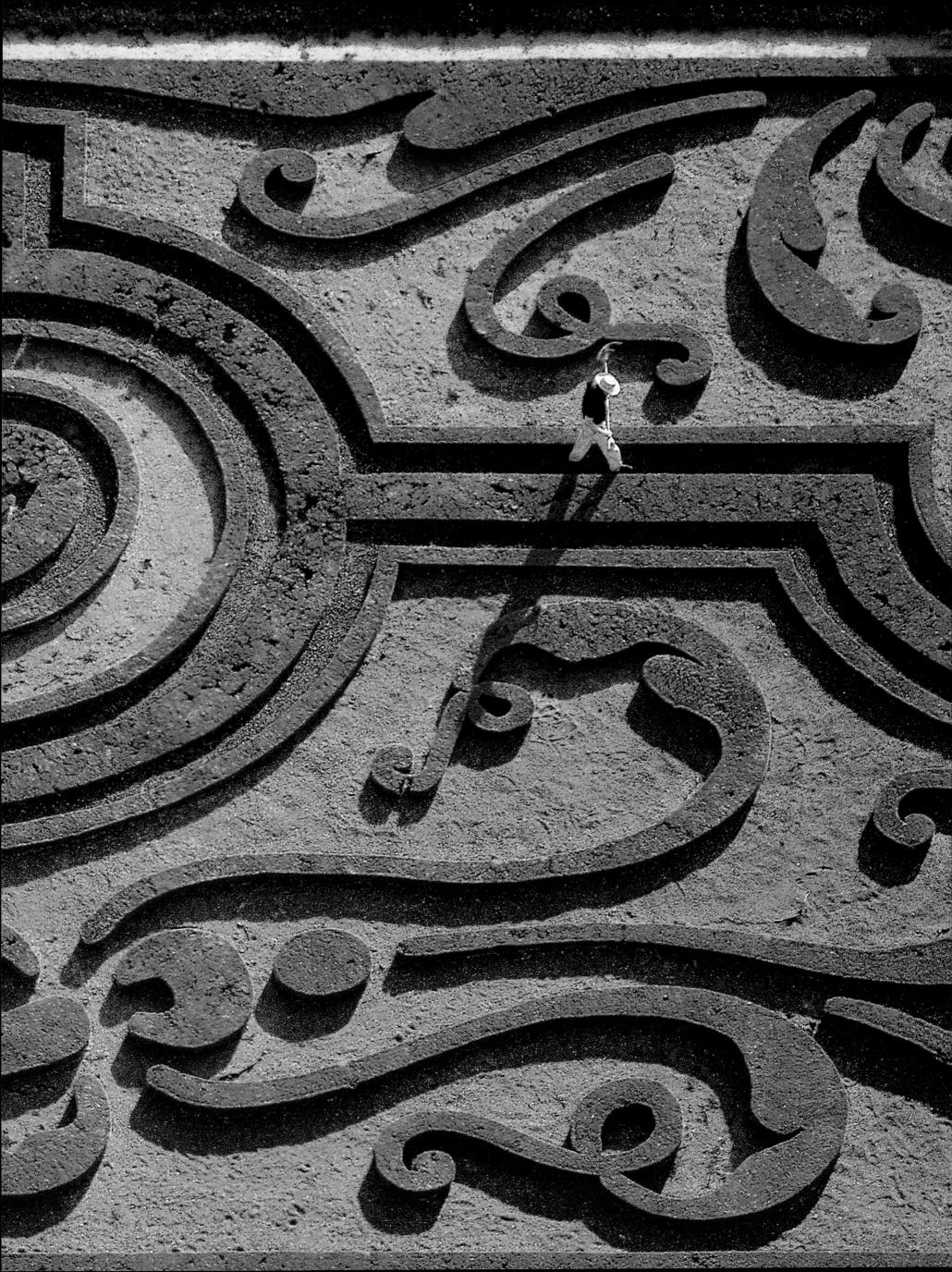

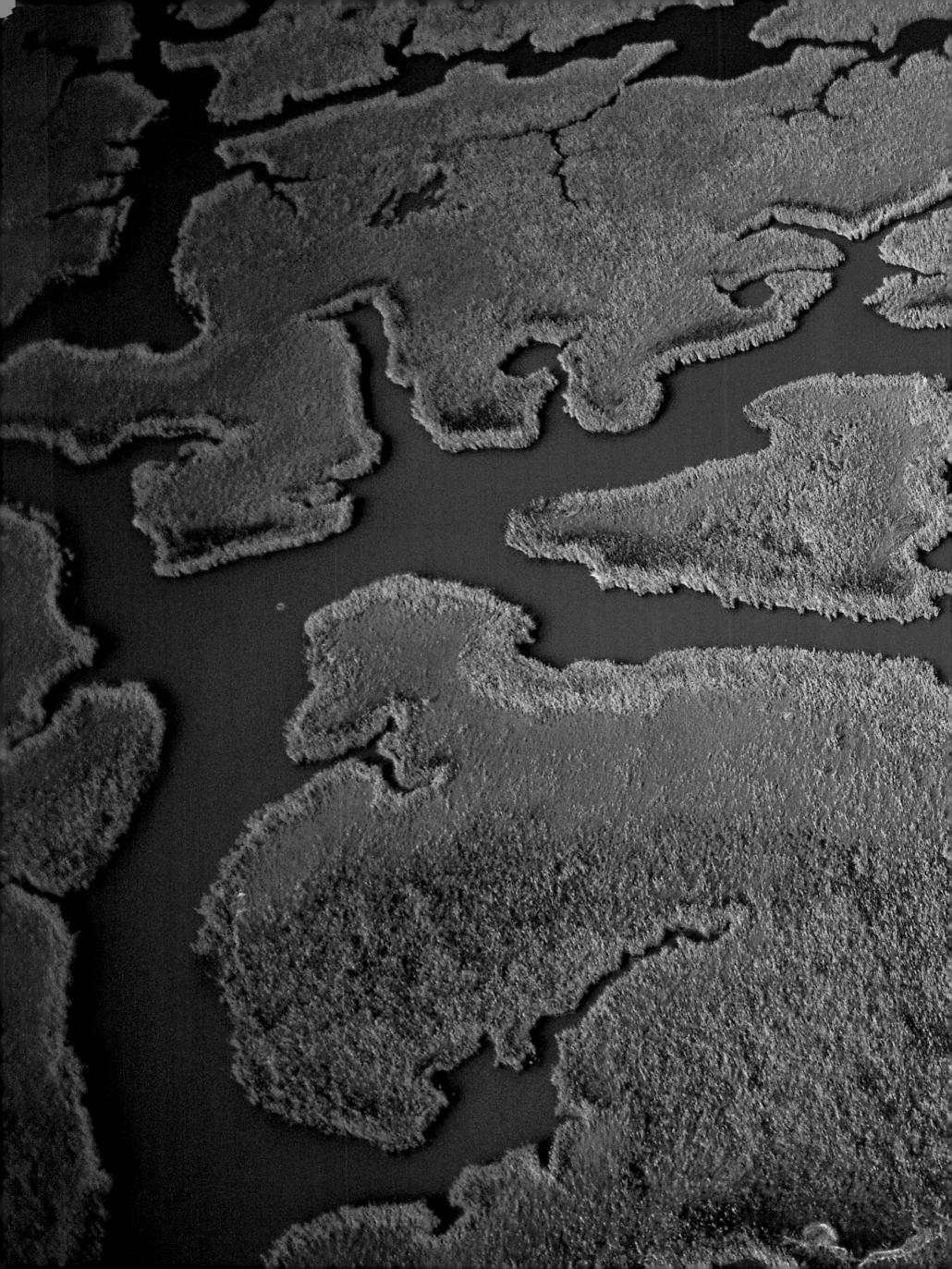

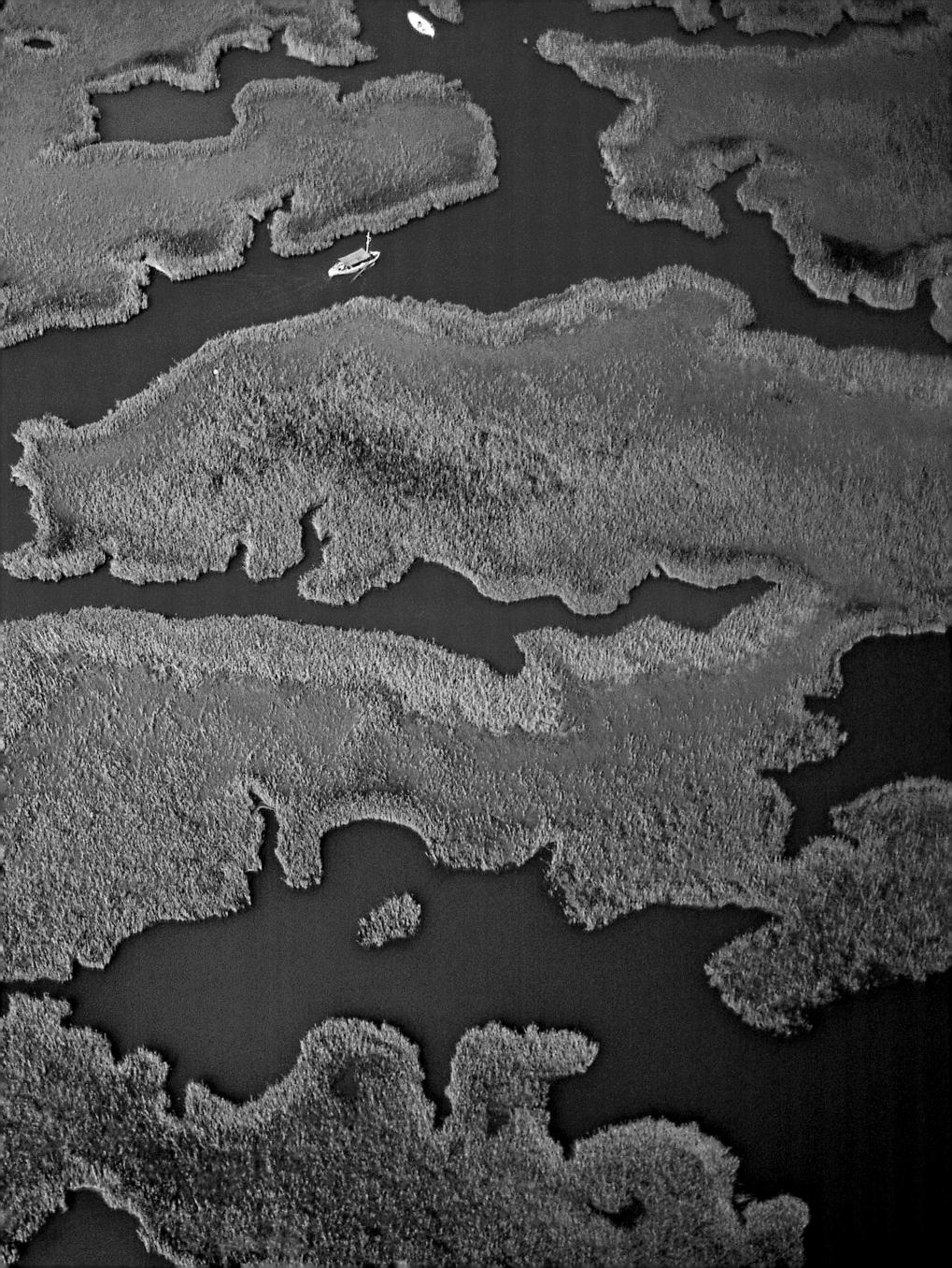

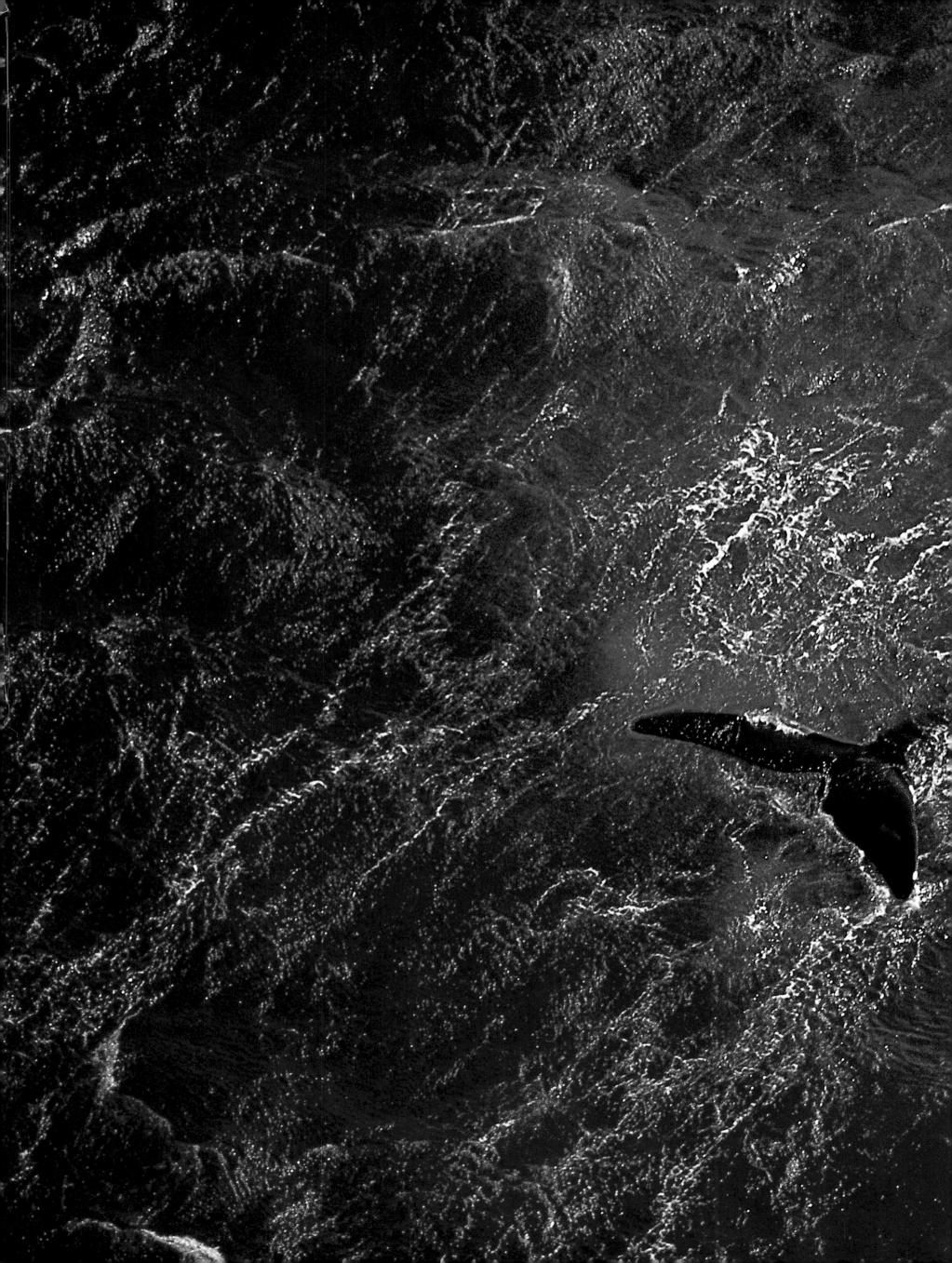

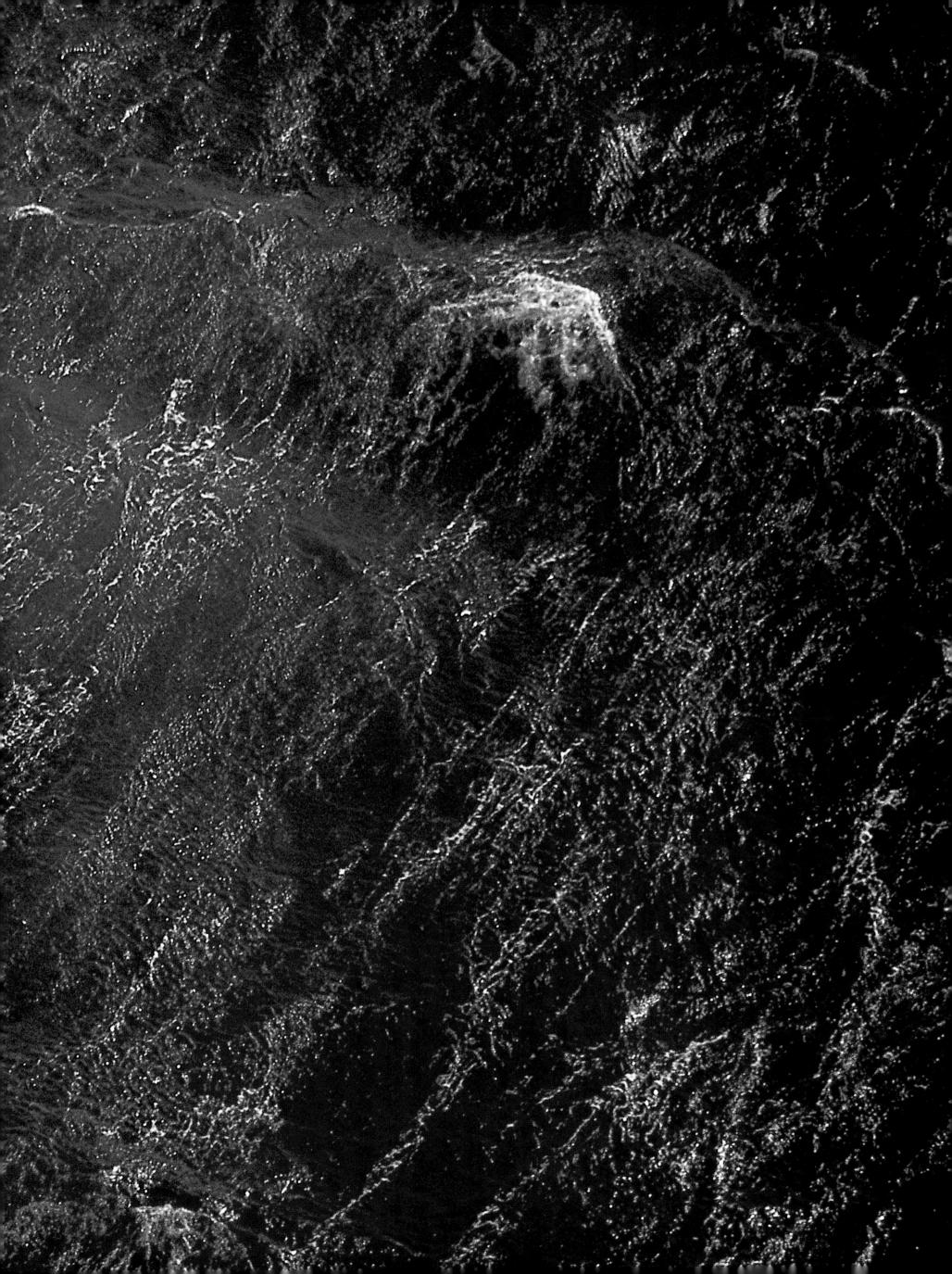

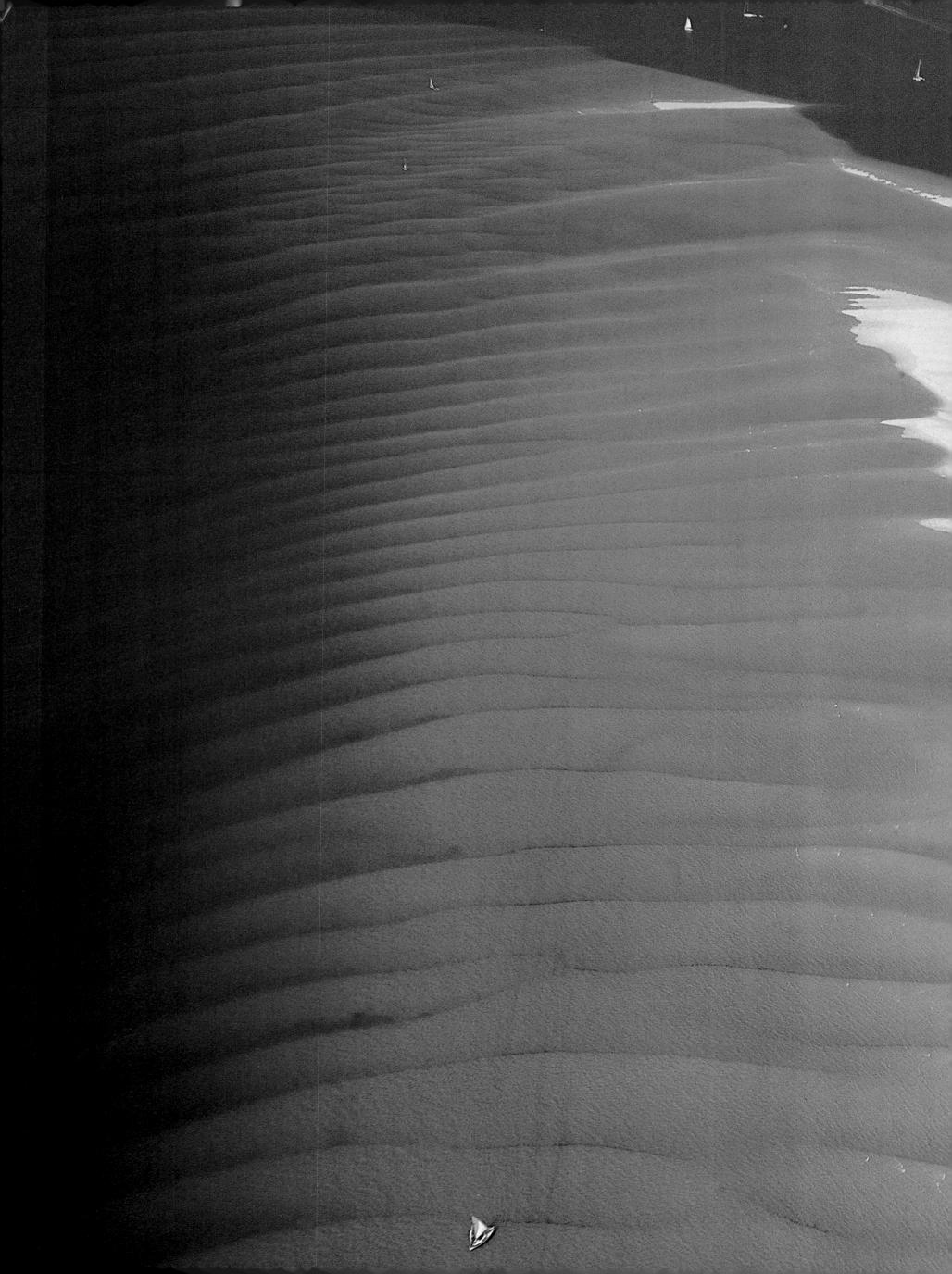

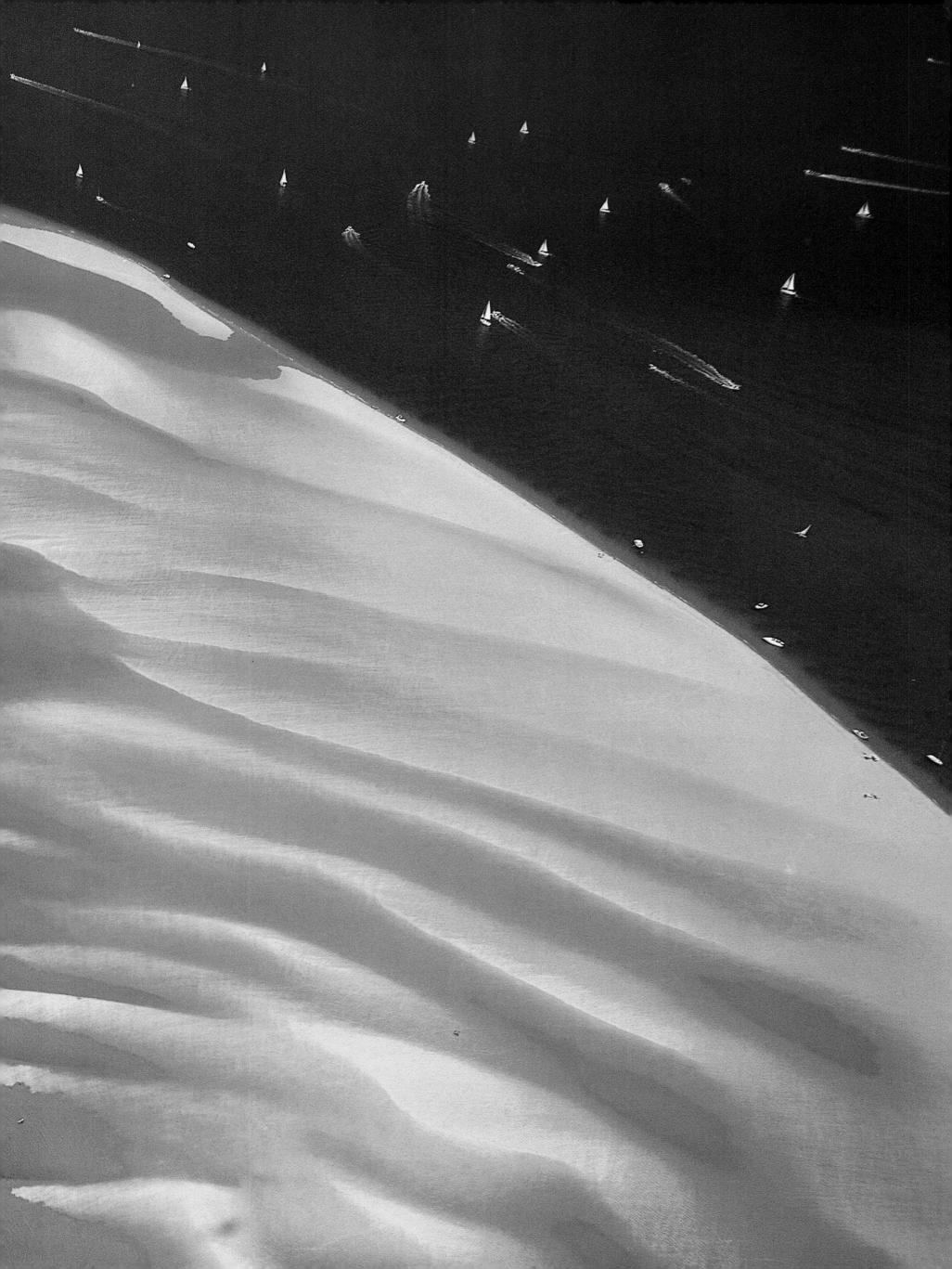

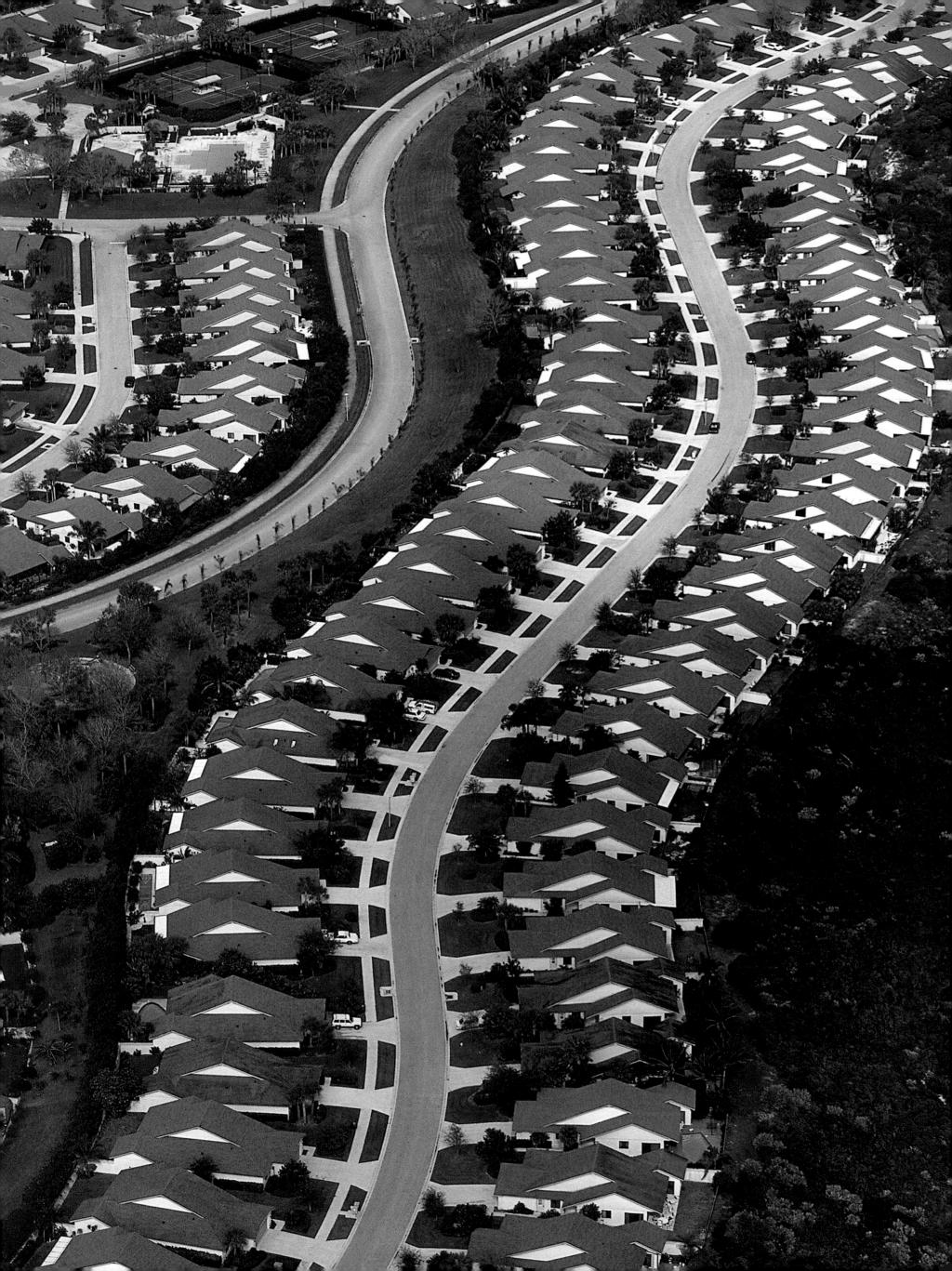

SPECTACLES AND LANDSCAPES

In the course of time, "human landscapes" have been constructed by societies. They represent the work of successive generations, completely different from "natural spectacles"—arrangements of natural objects such as rock, sea, sun, river, and beach. These are spectacles only for human beings, who view them and give them meaning; they are constructions of the human spirit. Human landscapes, on the

other hand, are the product of the transformation of nature by the human species; they contain a portion of nature and a portion of "culture," or civilization. Created as much by the social organism itself as by its technologies and tools, these landscapes deserve to be called "landscapes of custom." They are linked to the way of life of a society, to the populations of its different segments (hamlet, village, burg, city, port) as well as to its relations with neighboring societies.

p. 168 PAVILIONS NEAR MIAMI, Florida, United States

Famous for its beach tourism, Art Deco hotels, and luxury residences of movie stars, the city of Miami also contains residential suburbs with sober but comfortable pavilions. Built on former swampland that was dried up in the early twentieth century, these mushroom cities meet the demand of a population that keeps growing. Miami is located Dade County, a center of economic development, a place of refuge for exiles, and a favorite retreat for retirees. It has become the most densely populated region in Florida, claiming more than 2 million inhabitants. Florida was still largely wild at the beginning of the twentieth century but today, with a population of 14 million, it is the fourth-largest state in population. Its population has doubled in the past twenty years ago, and 85 percent live in urban areas.

THE NATURAL LANDSCAPE AND THE IMAGINATION

Dictionaries remind us that the word *landscape* is no more than a few centuries old in the world's various languages, except in China, where evidence reports the use of a specific word starting in the fifth century A.D. The first paintings of landscapes were dedicated to rustic sites, and the

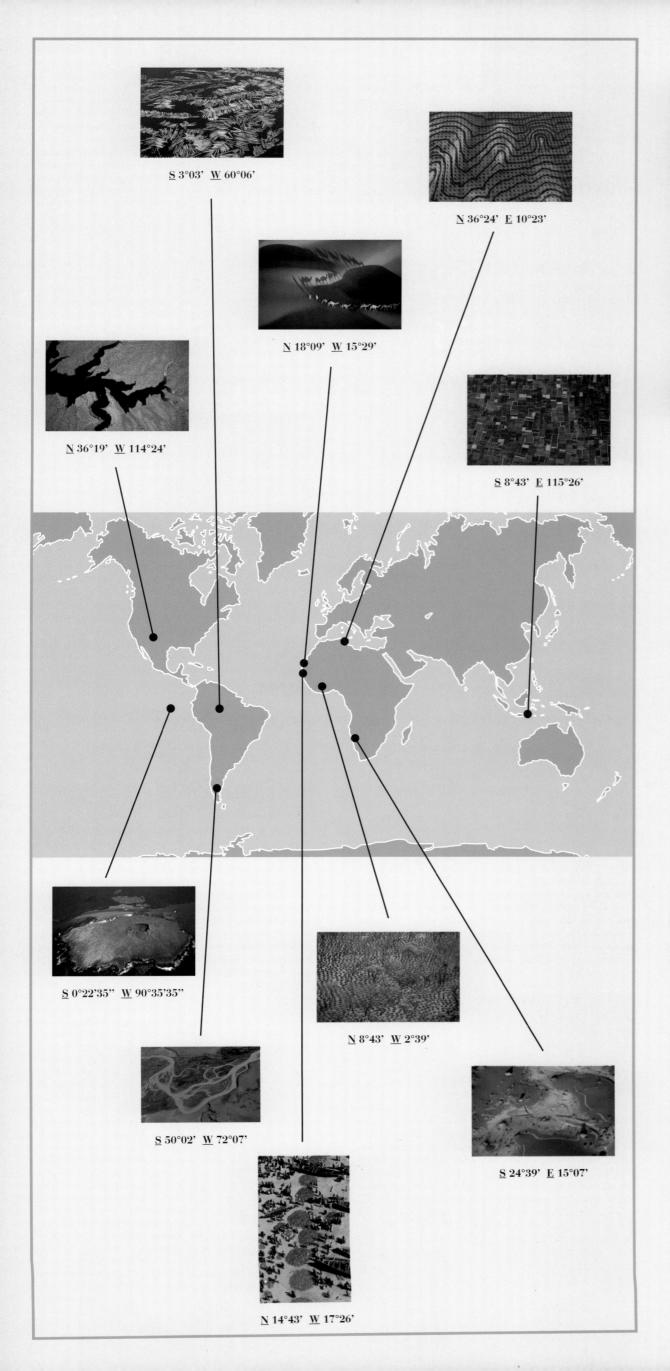

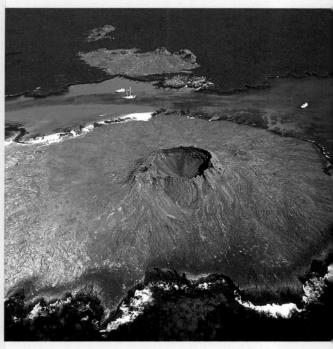

of gods reveals the powerlessness that the confronted by nature. They were overthey expressed this by imbuing nature I force. The response of the inhabitants ural landscapes stems from a quite difter now powerful, but we experience a refaced by a "simpler" world, a world armony with nature. We take comfort in at at one time we feared it. We may sense of nature when we see a waterfall, but moment in our life's experience.

re is a dreamlike magnification of everyon our earth preceding mass production. the nineteenth century was Neoclassical ng columns and spires, harking back to d. The design aesthetic of the industrial revolution was Art Nouveau, in which n als and glass were shaped into organic materials reconstructing the world they

This makes it easier to understand to quest conducted by those of our content ously seek out landscapes far removed place of residence, hoping to find purity and gentleness, silence and tenderness. To ily accessible proximity of a nature that industries, automobiles, and electric lichighly desirable by the very people who ity and the internal combustion enginerounded by industry.

Even measures taken to ensure the preservation of the "authentic" natural environment can end up by having a subversive effect. For instance, the creation of protected zones (such as natural parks and reserves) can signify tacit permission in other spaces to continue environmental exploitation. If the forest is safeguarded in one place, then it can be chopped down in another location. The separation—even opposition—between the human world and the natural world continues to grow, despite our increasing recognition of their interconnection. Untamed nature is thus tamed in these small, contained pockets; it is nature "quarantined," transformed into stage sets for humanity. In the modern world, authenticity is no longer possible.

Pierre Gentelle

p. 177 FISH MARKET NEAR DAKAR,

Senegal

The 435 miles (700 km) of the Senegalese coast benefit from a seasonal alternation between cool currents rich in minerals coming from the Canary Islands and warm equatorial currents. This makes the shoreline favorable to the development of rich and varied marine fauna. Fish resources are intensely exploited in this area, producing 360,000 tons annually. Eighty percent of the fishing is carried out from pirogues, dugout canoes of baobab or kapok trees, using lines or nets. The fish, Senegal's chief economic resource, mainly goes to the local market; tuna, sardines, and cod are sold right off the beach at the landing points of the pirogues. In Senegal, as in most developing countries, fish provides 40 percent of the protein consumed by the population.

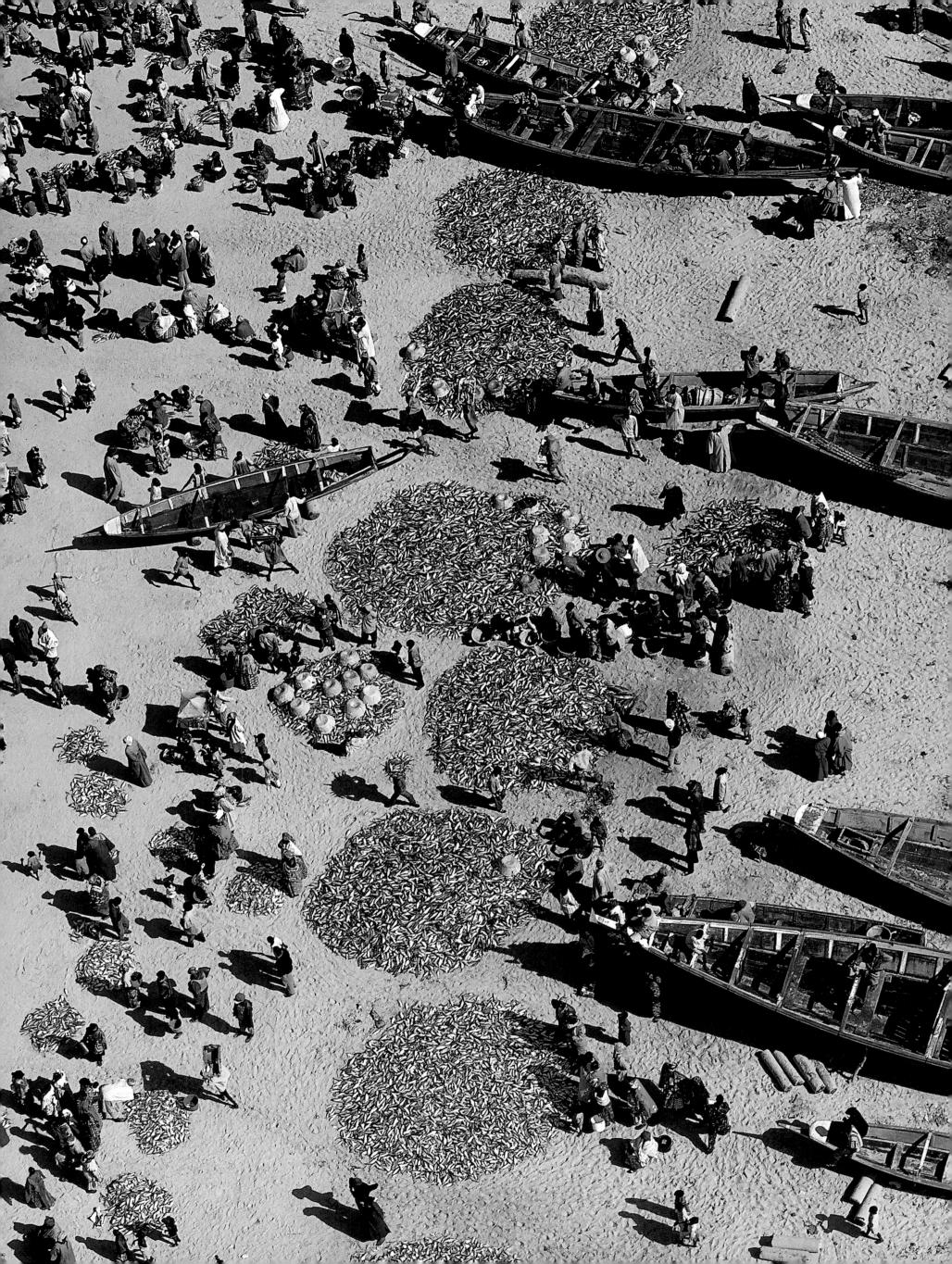

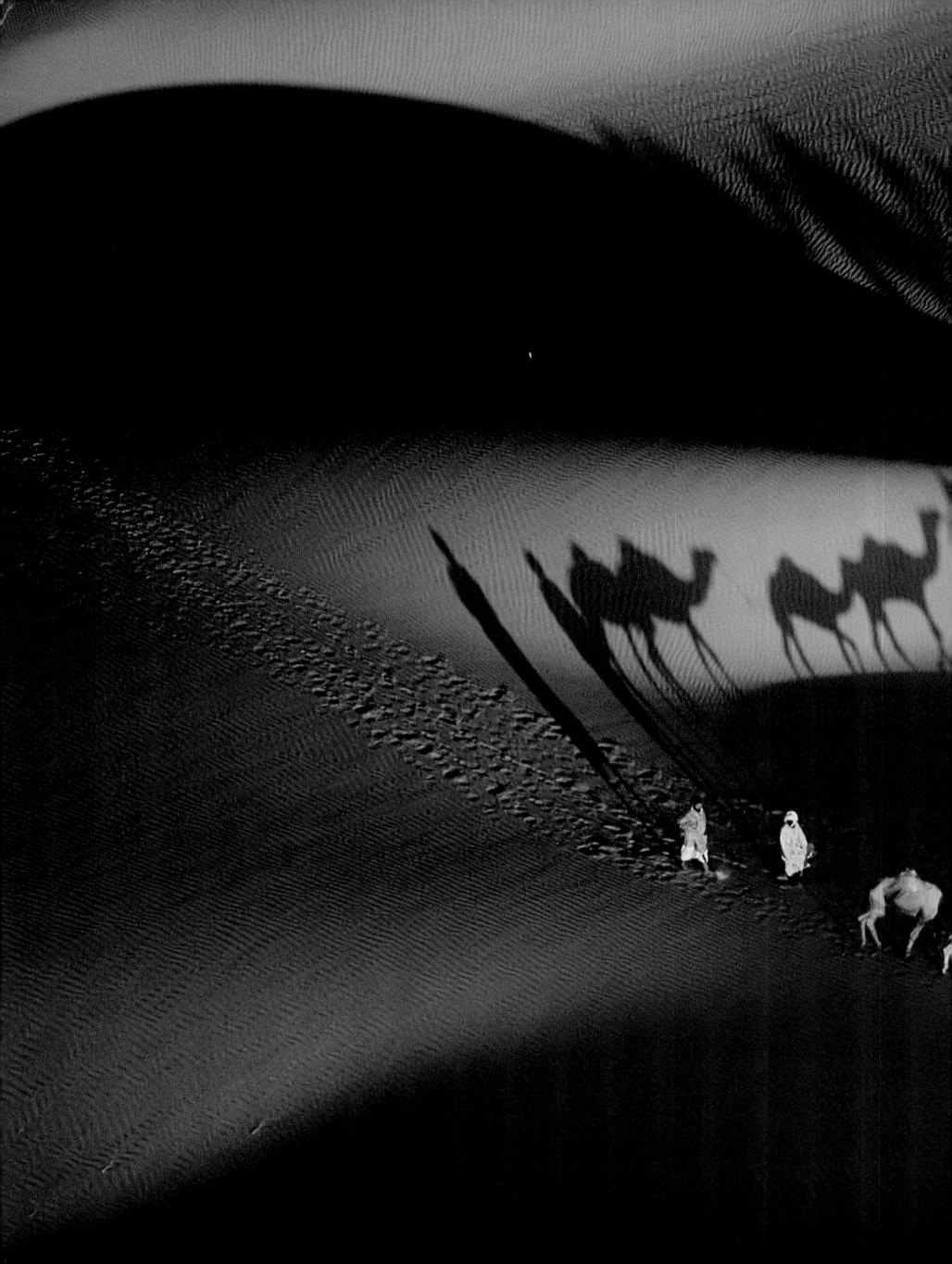

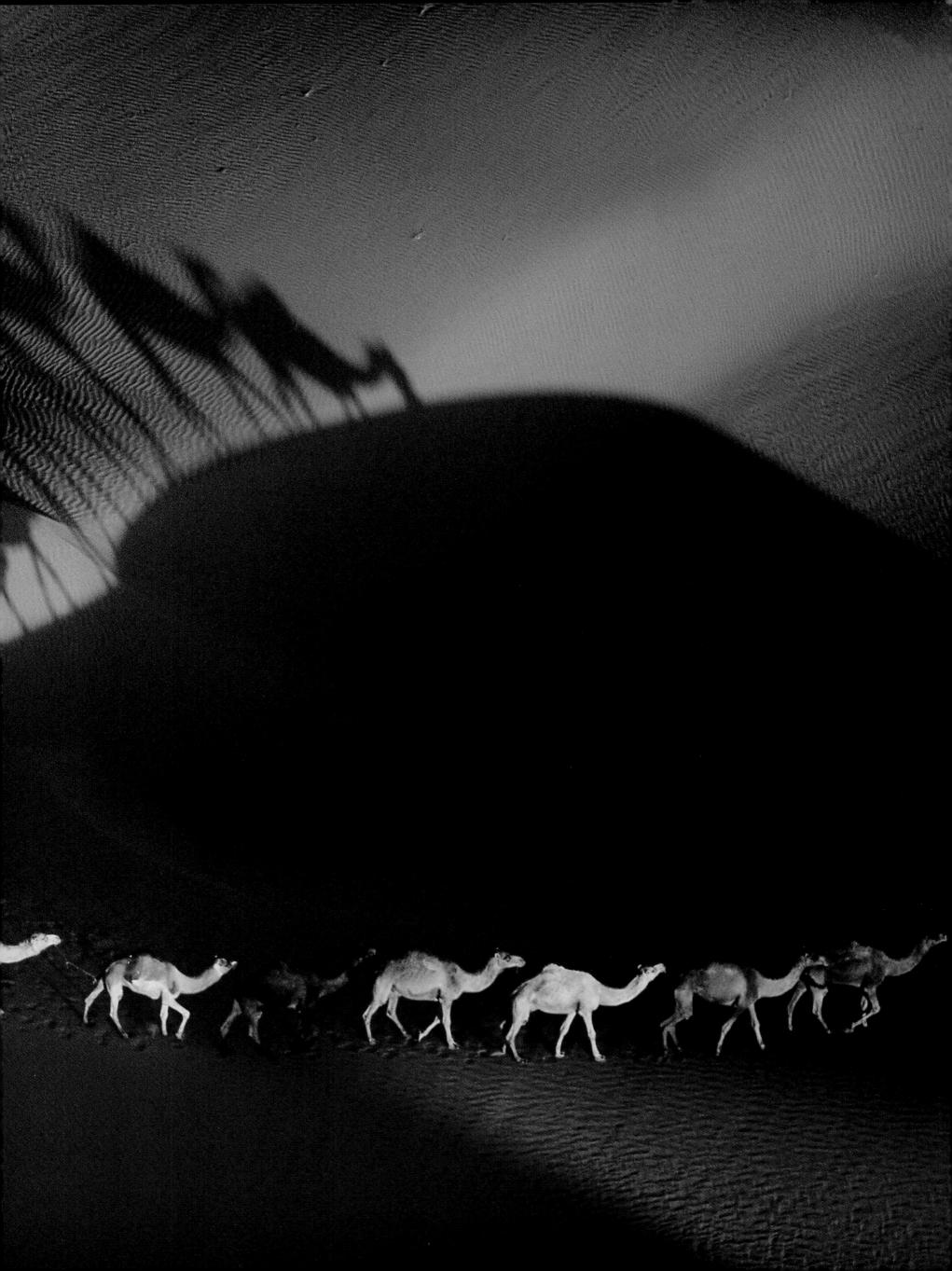

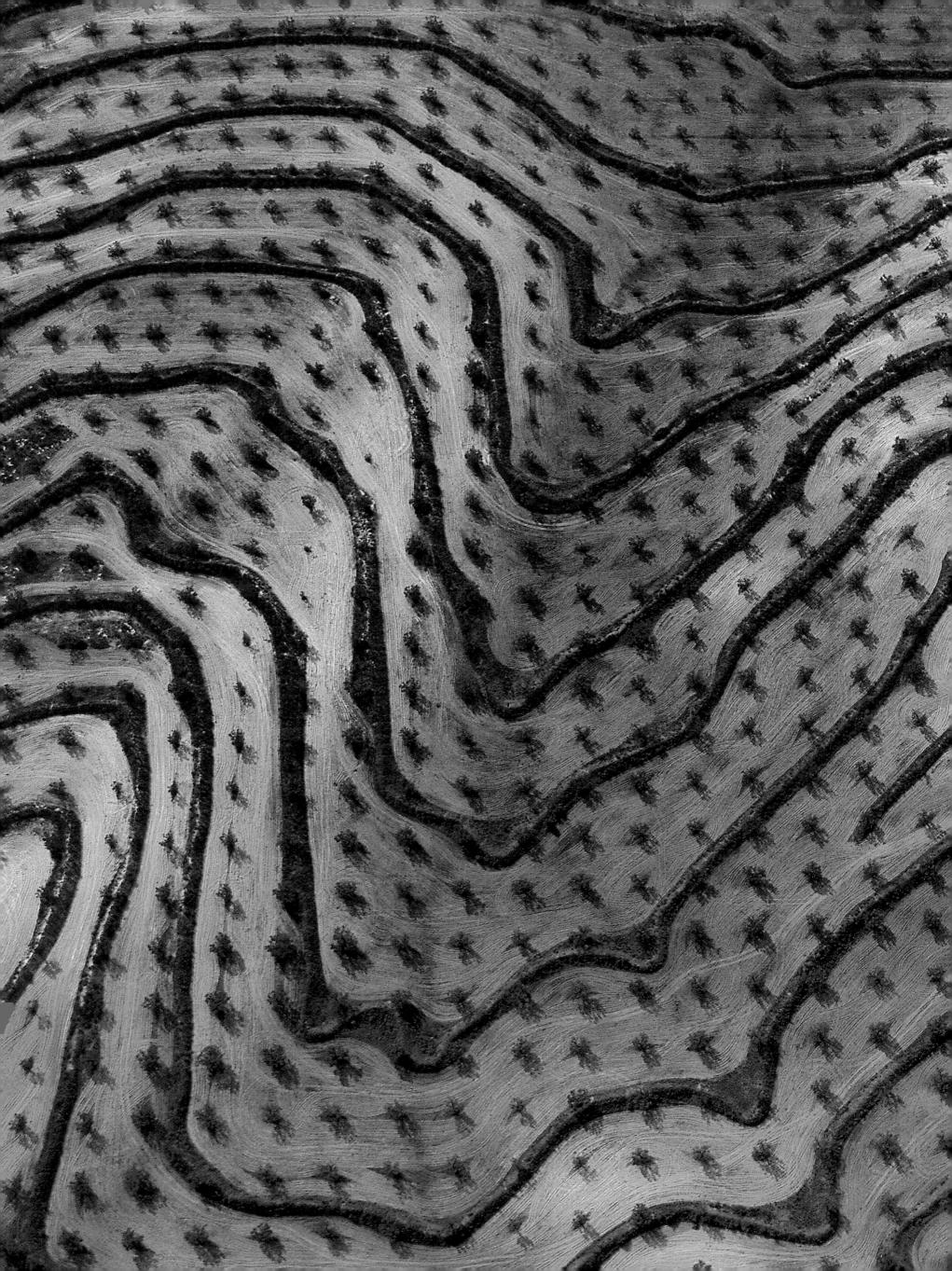

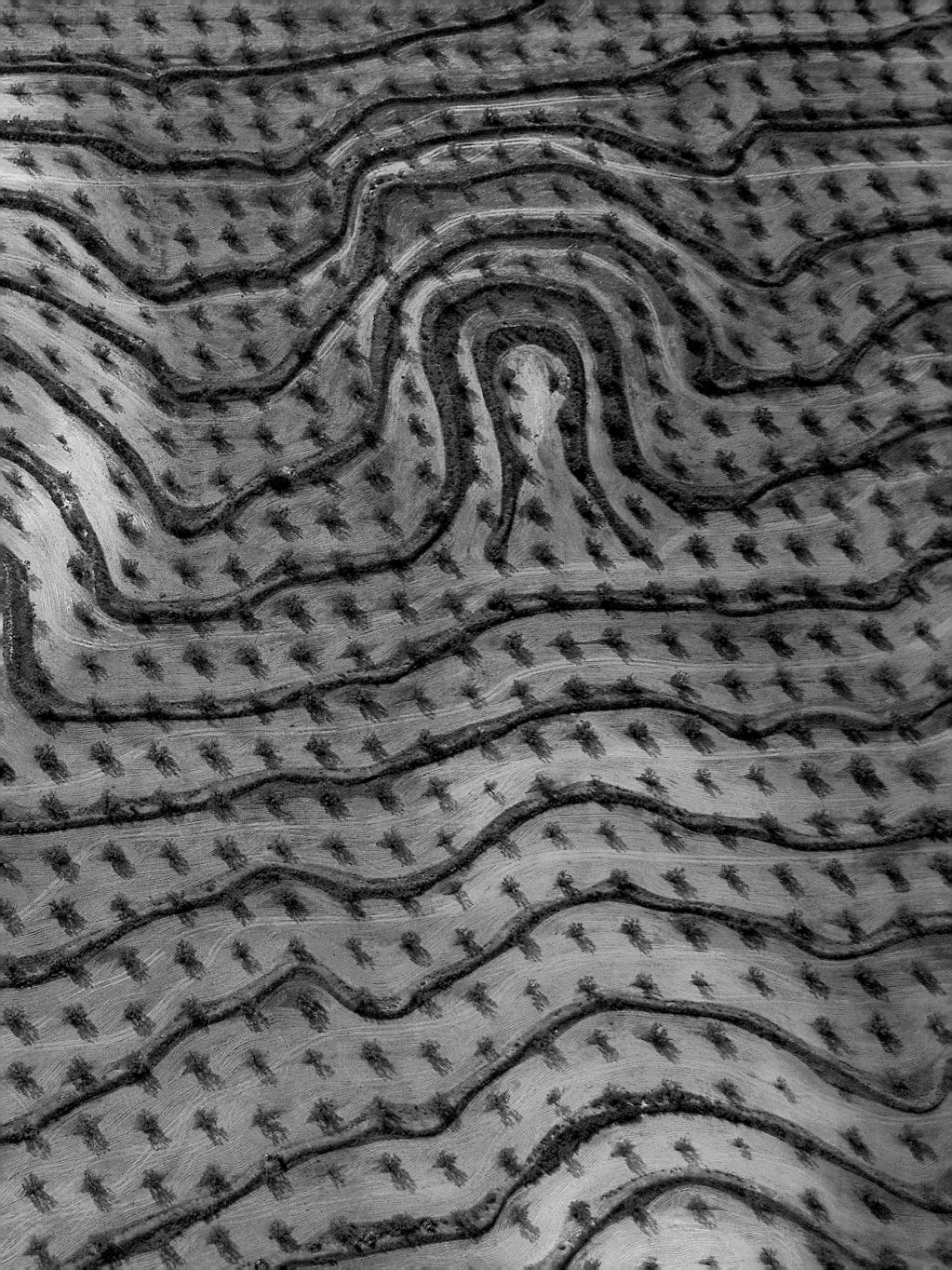

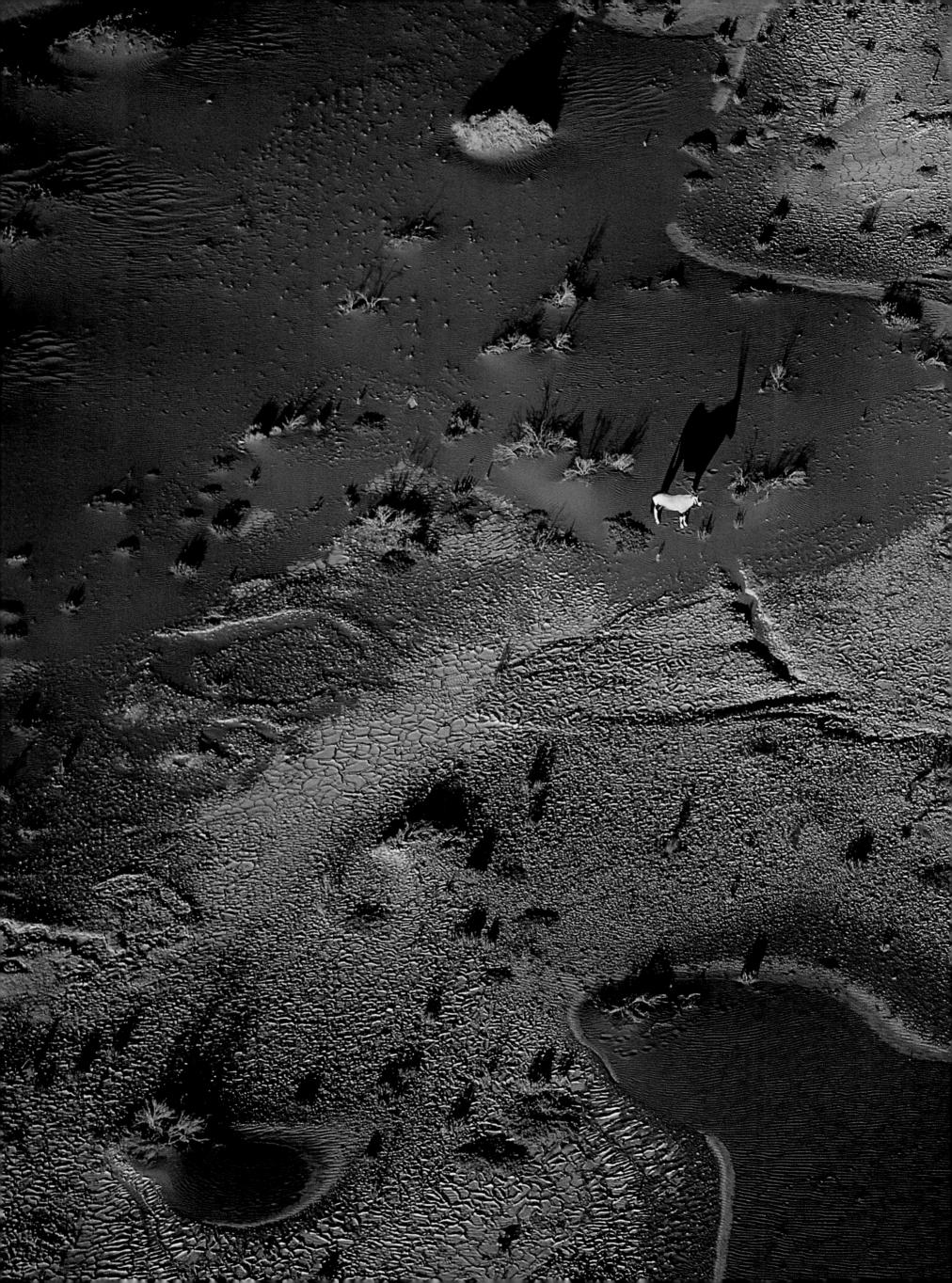

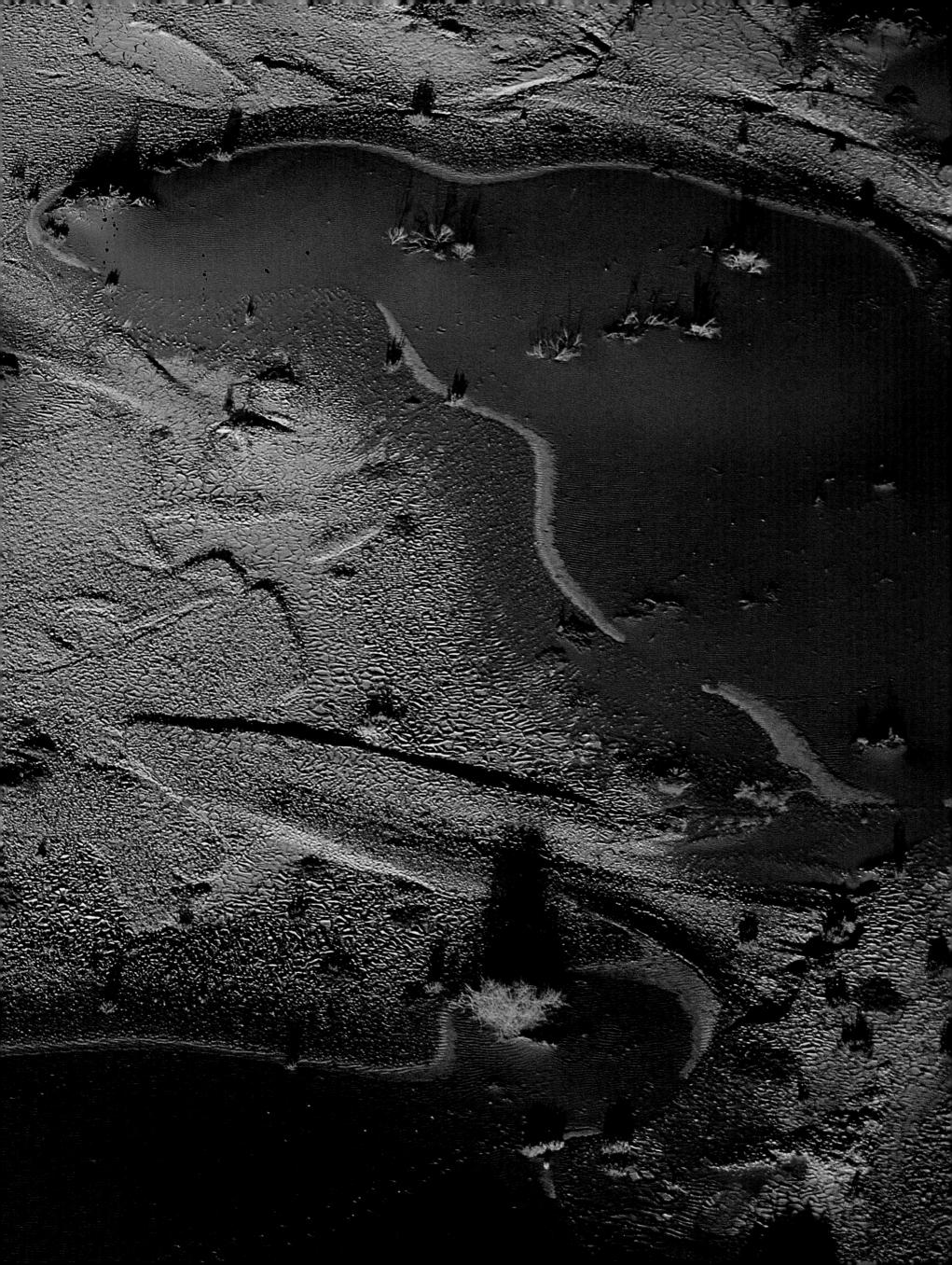

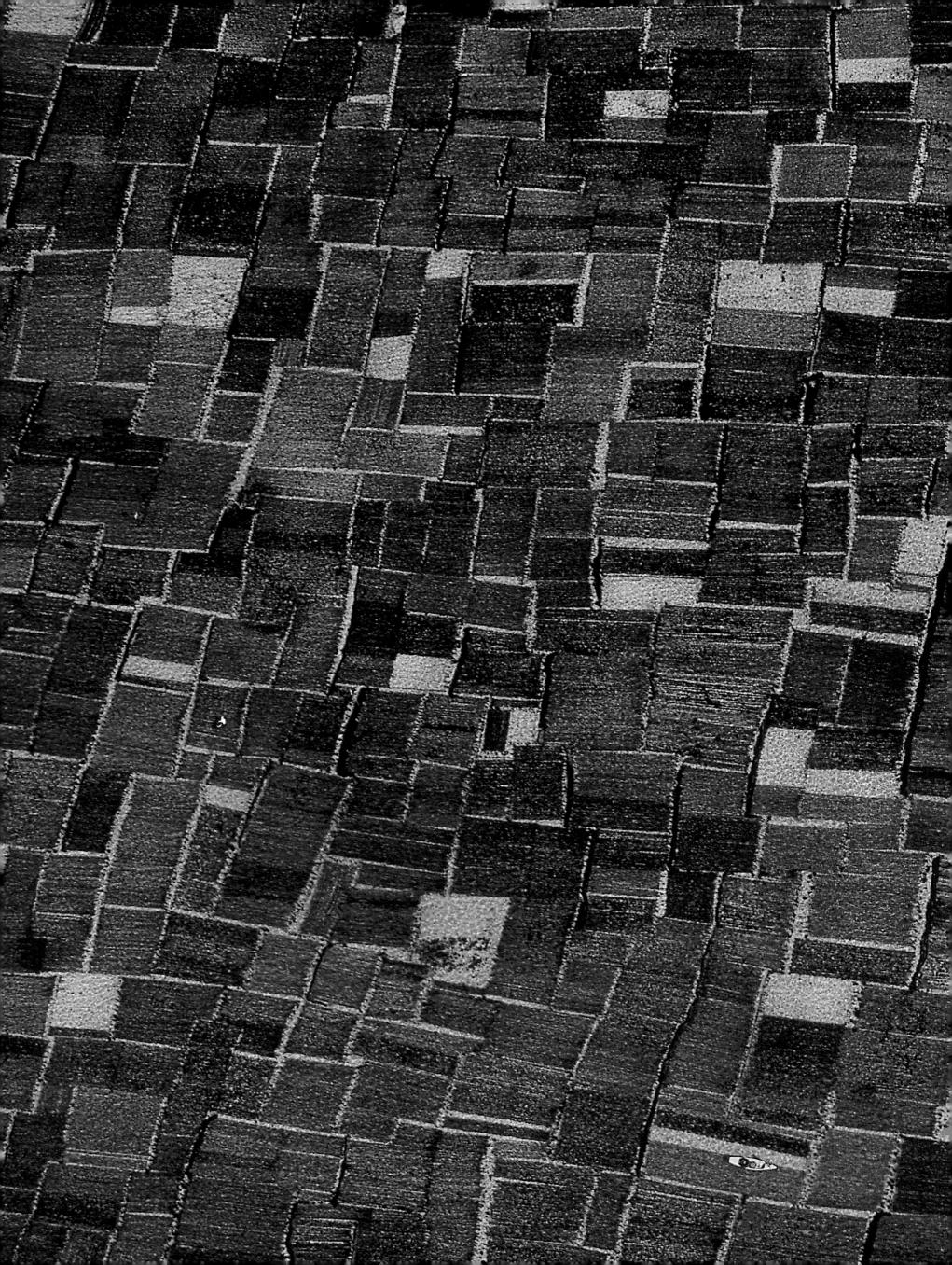

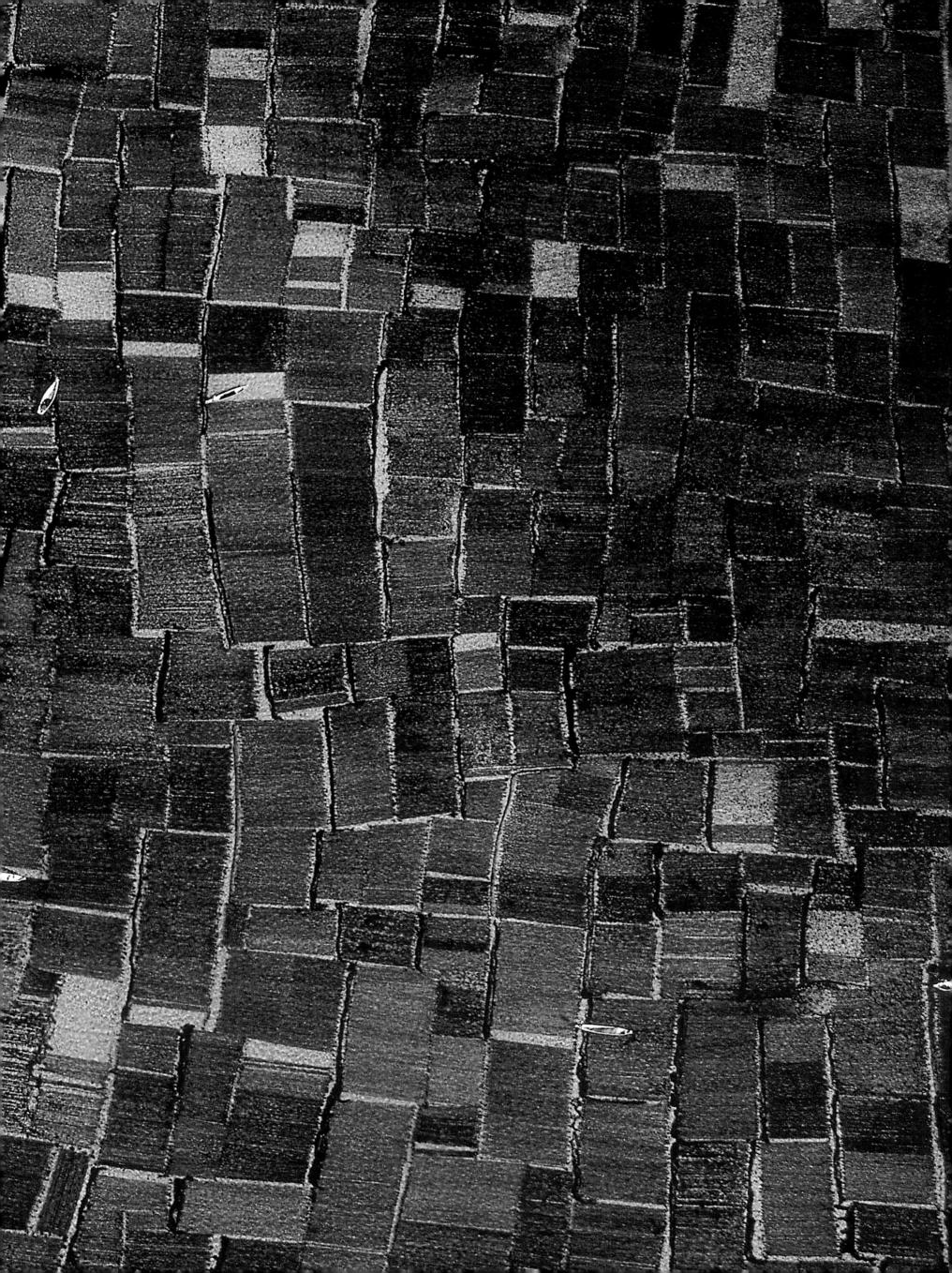

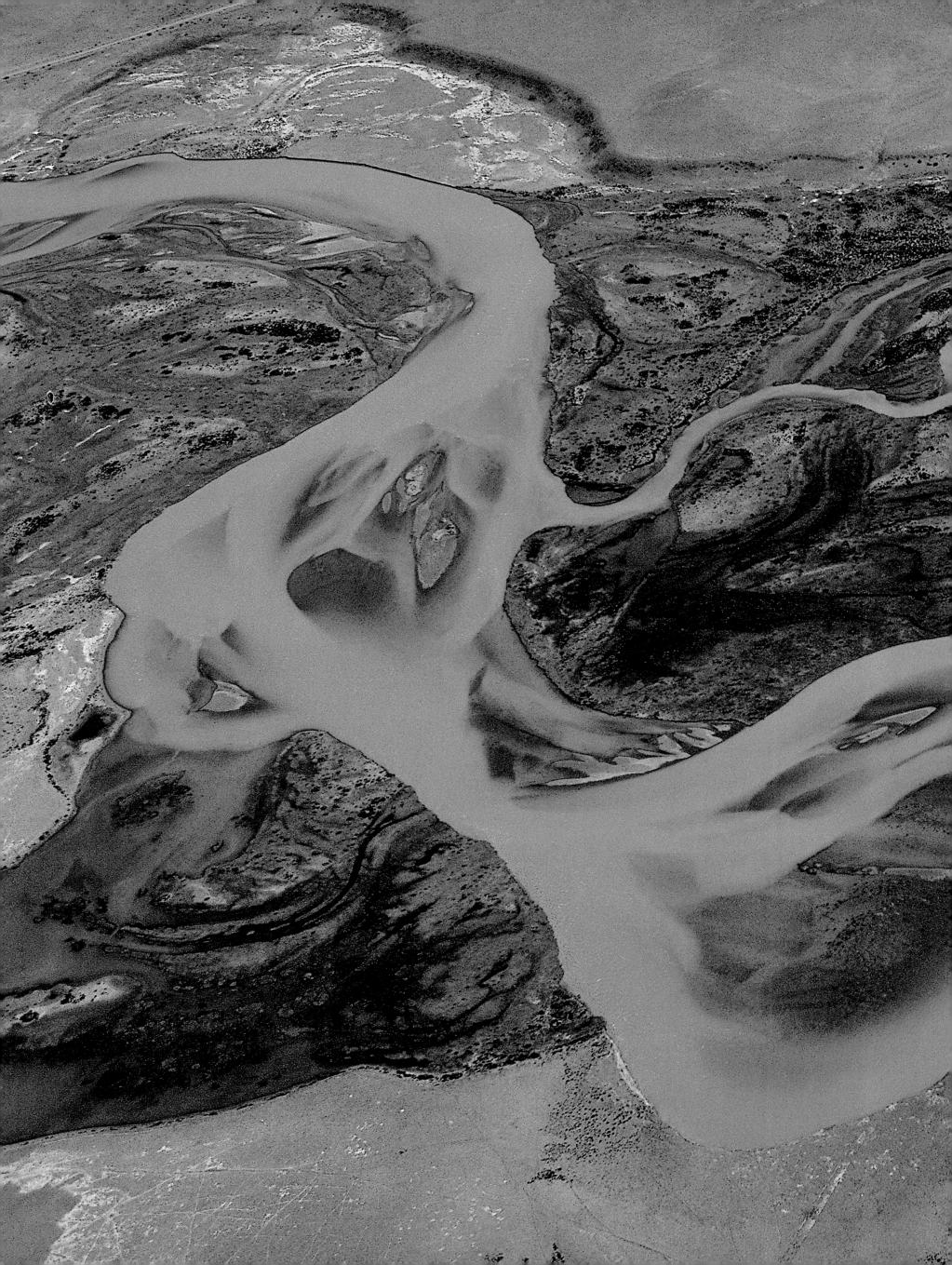

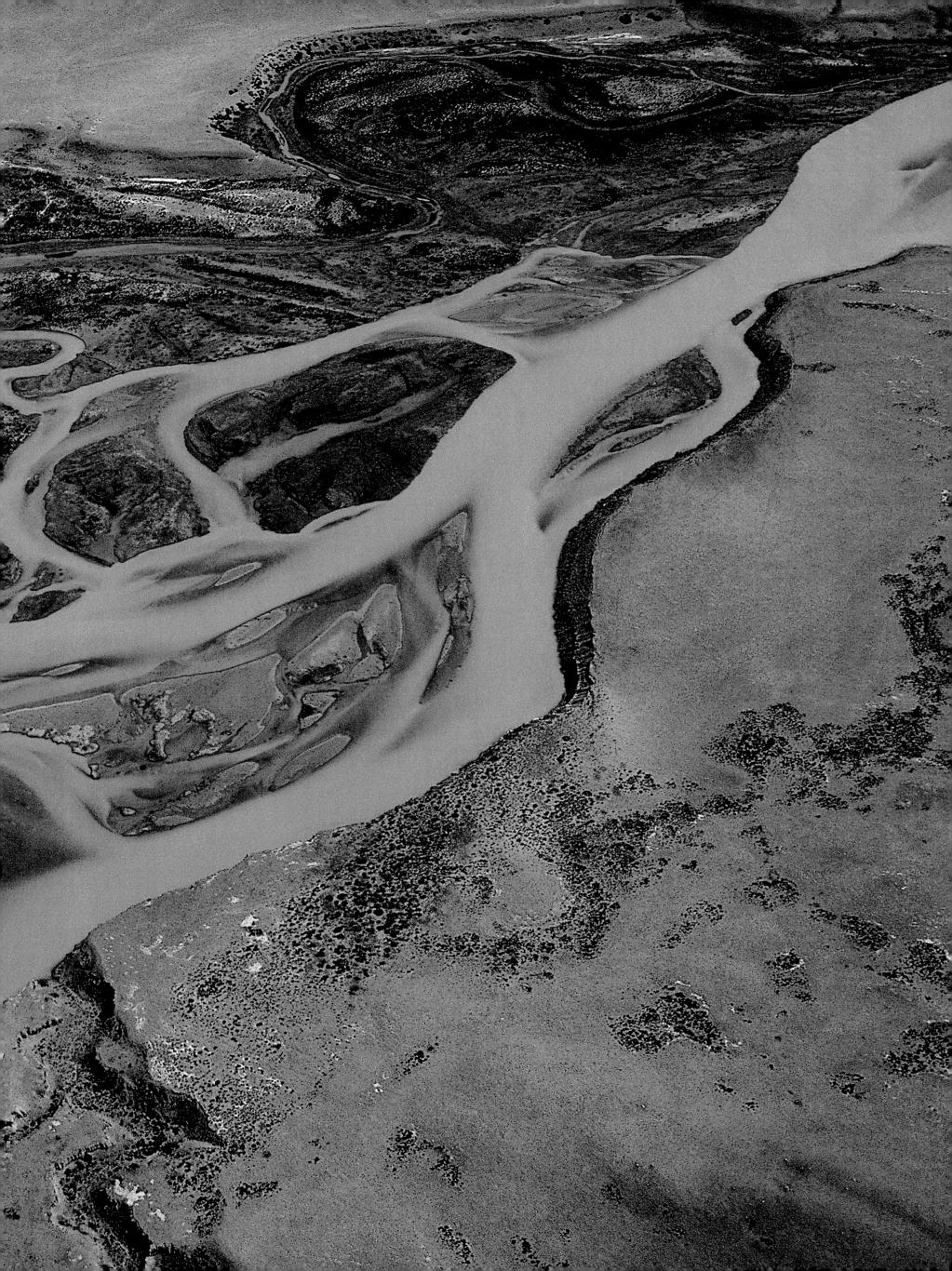

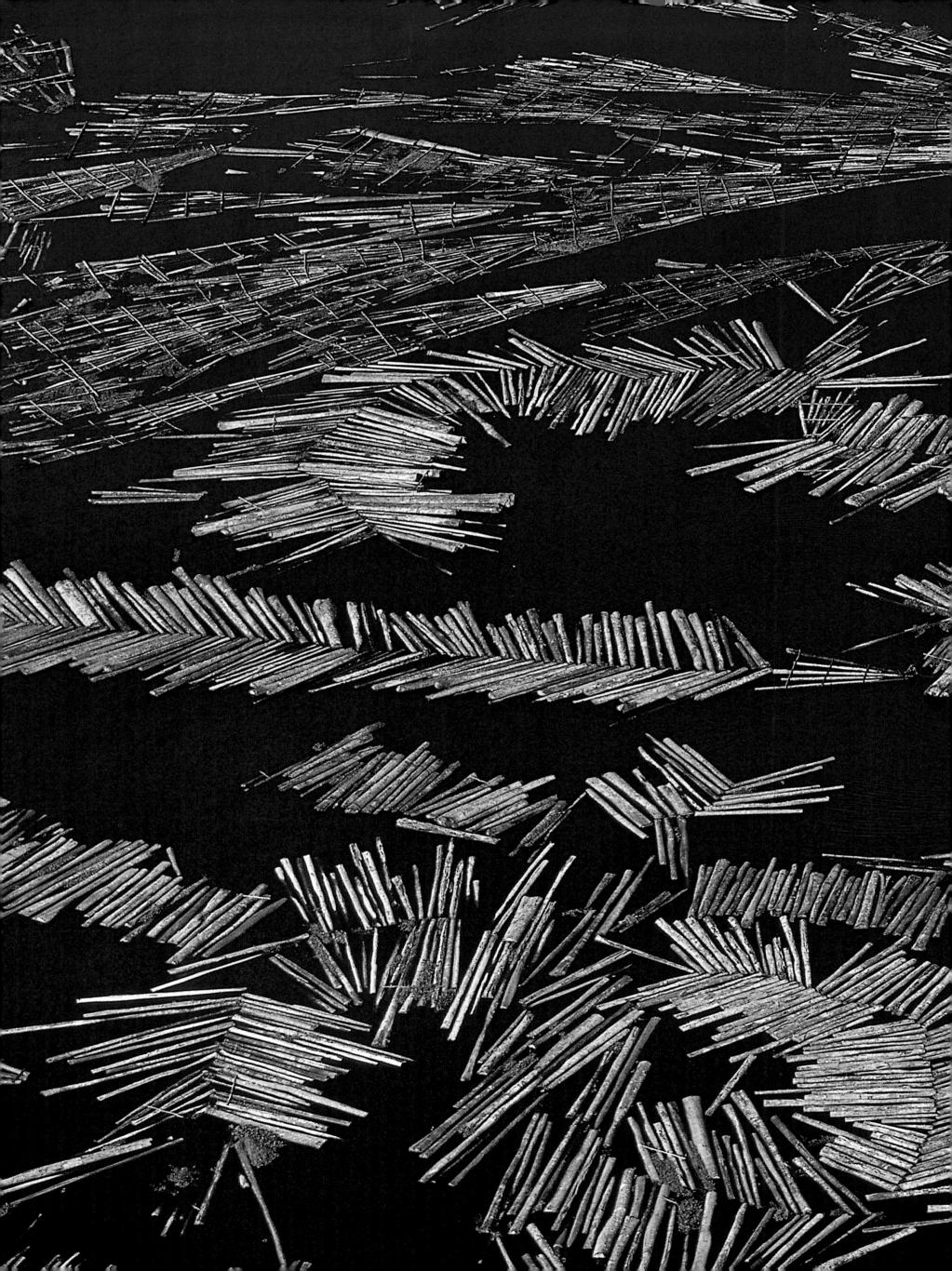

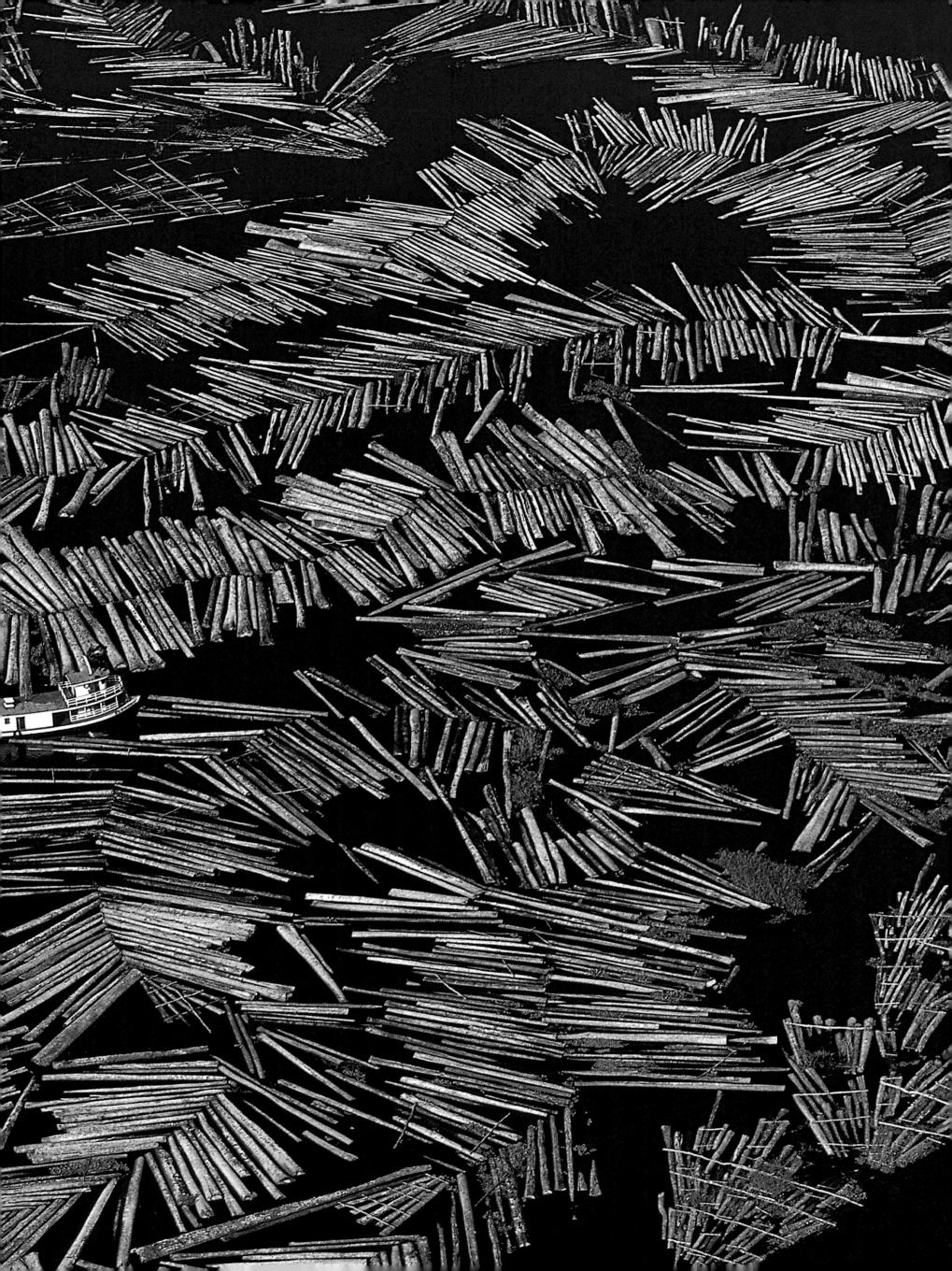

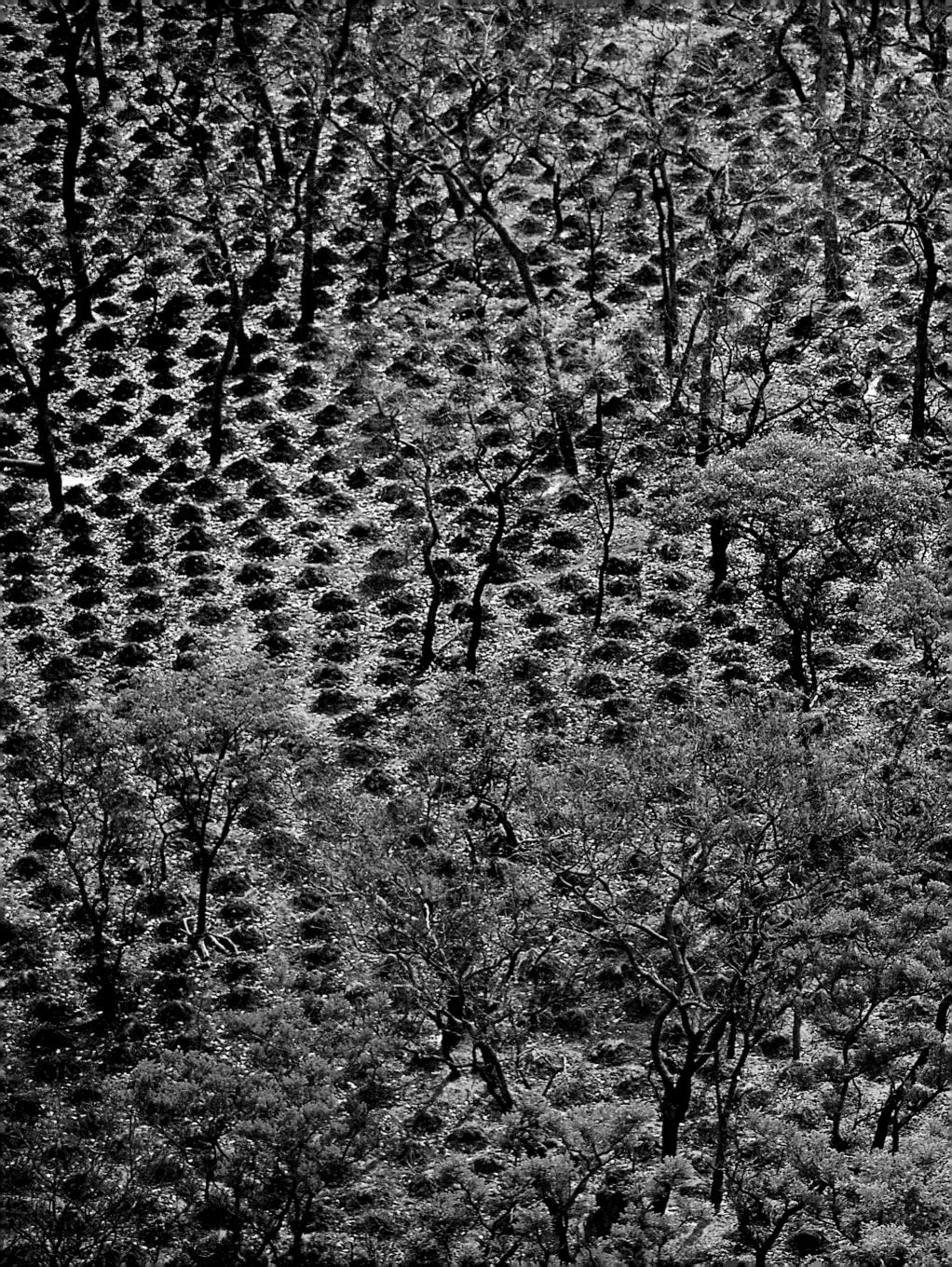

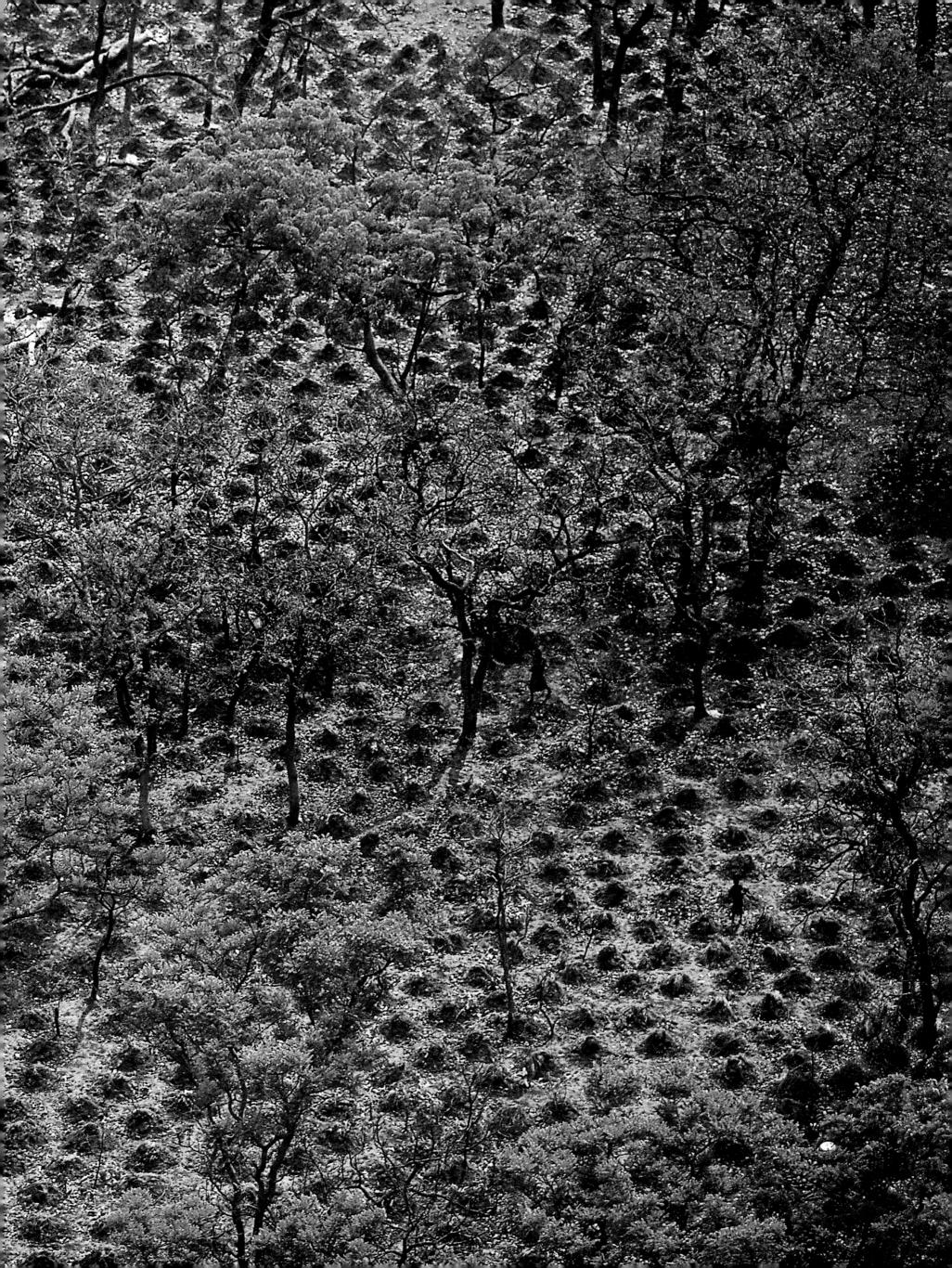

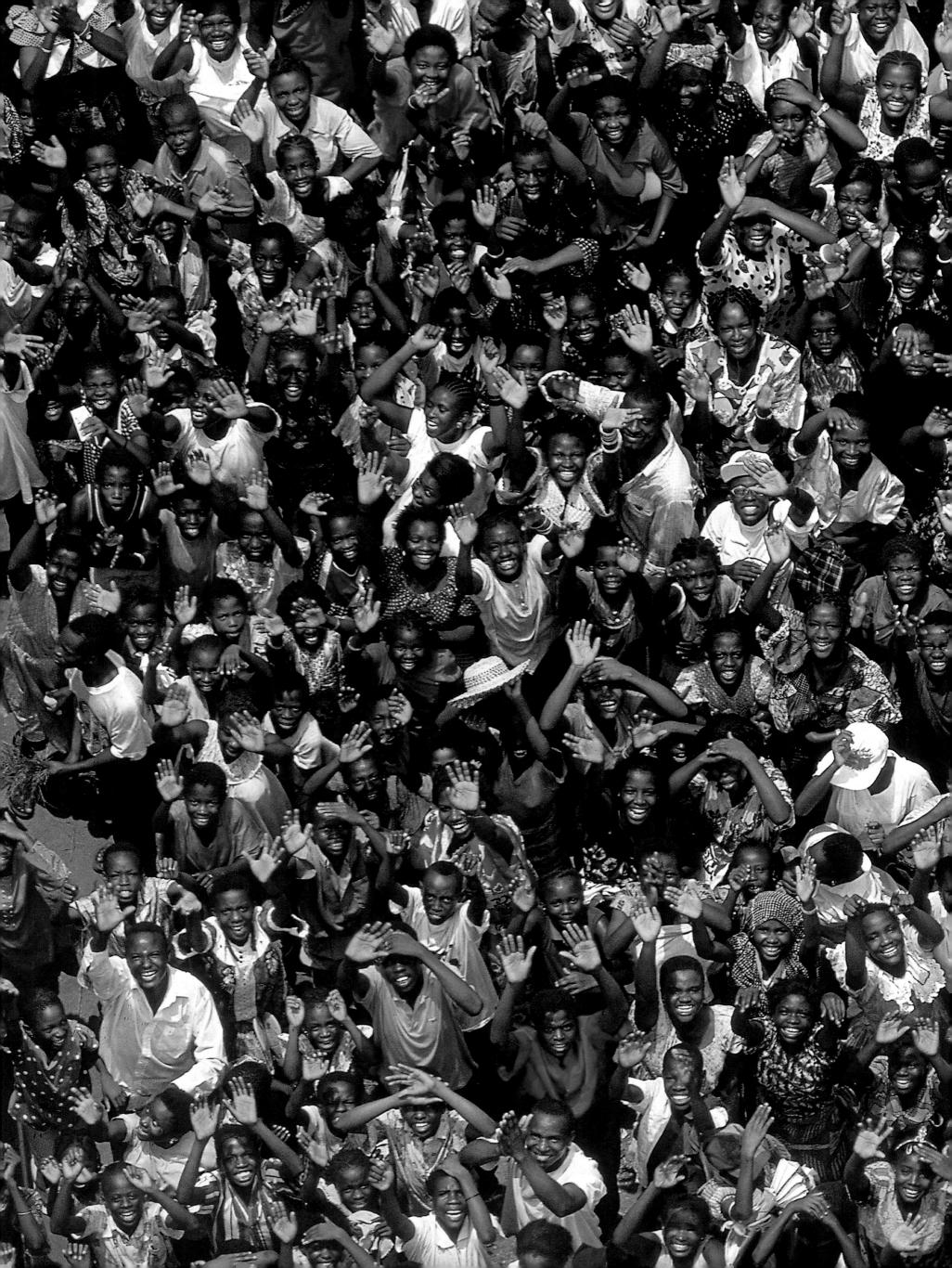

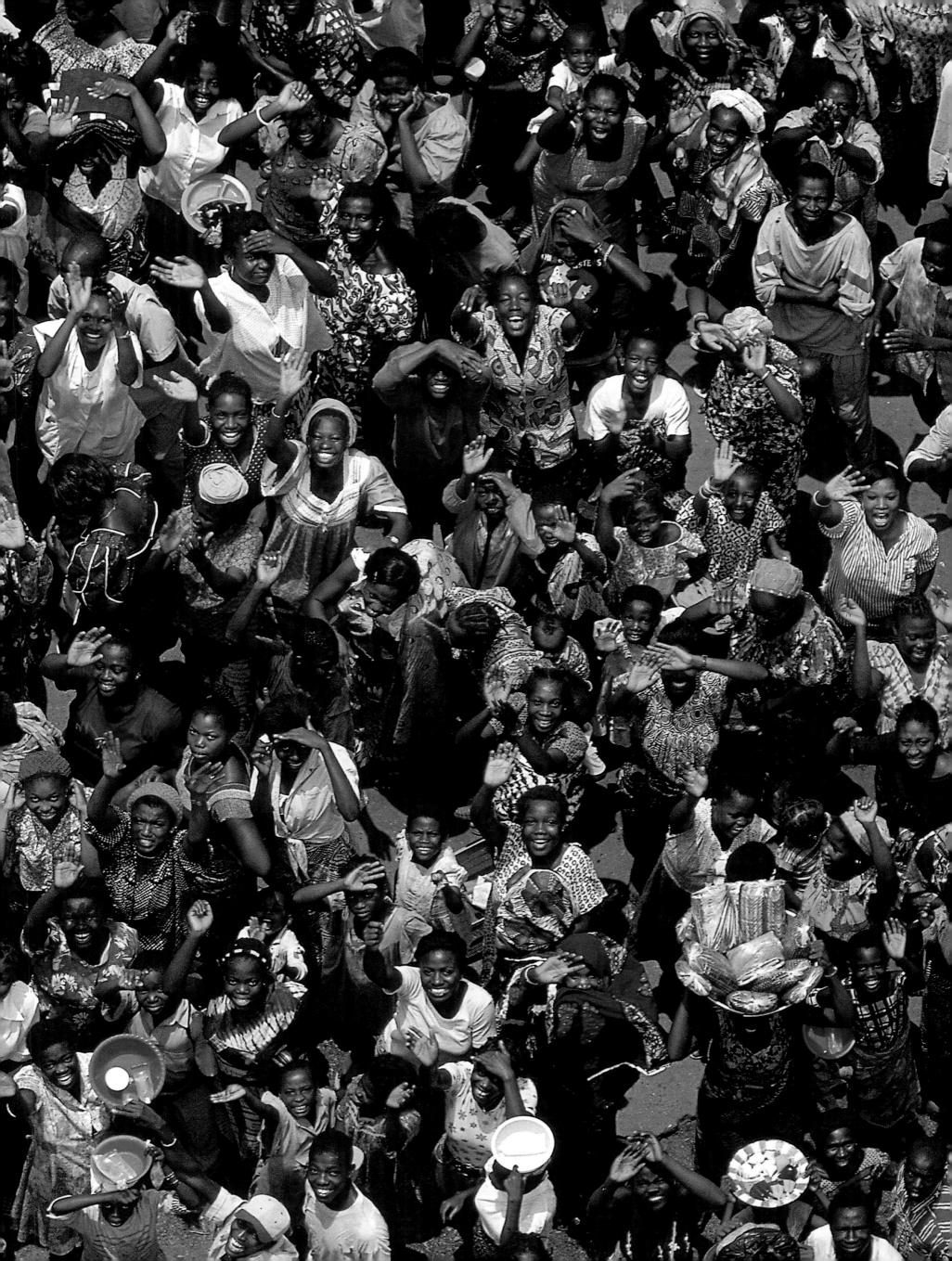

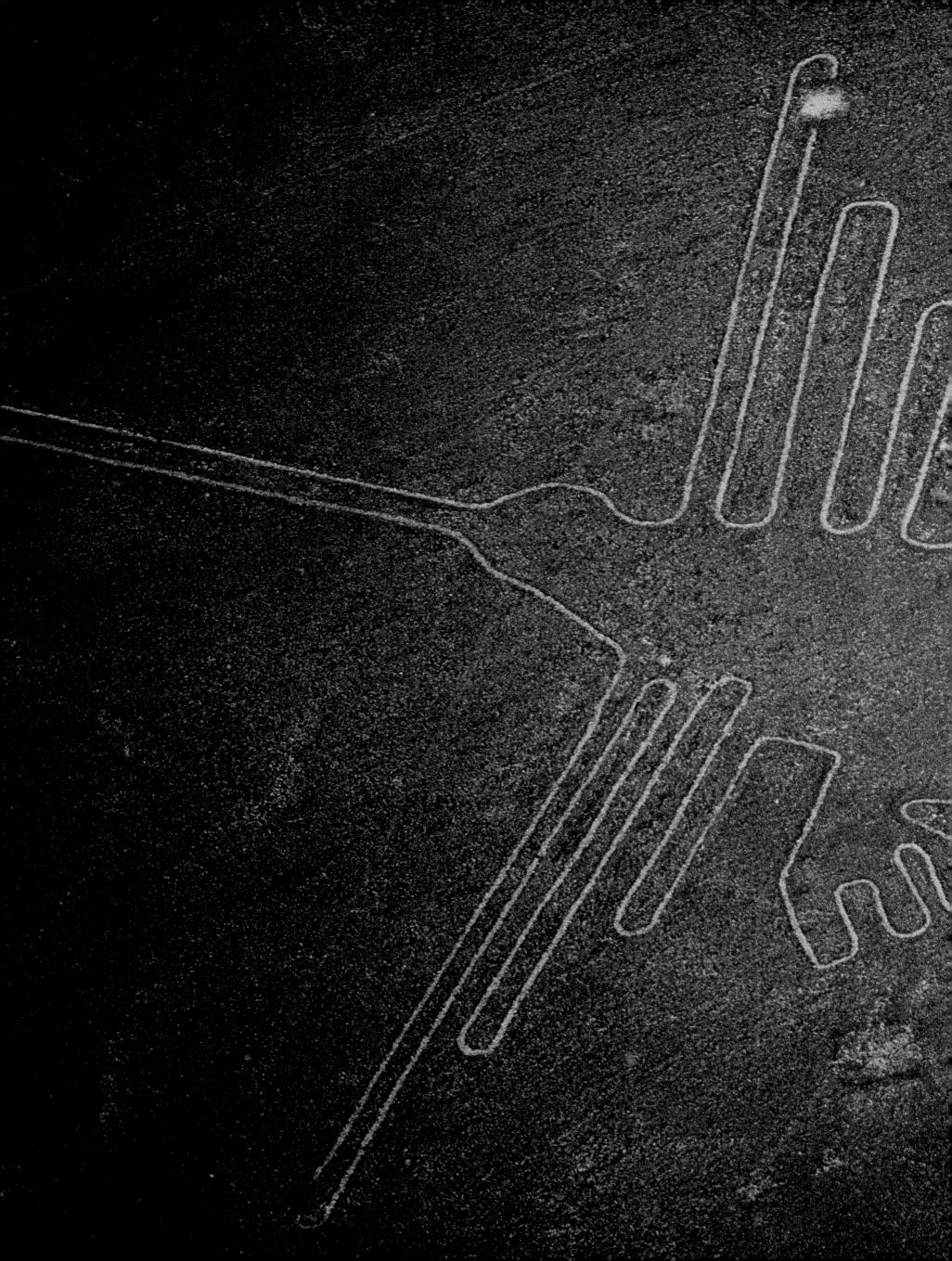

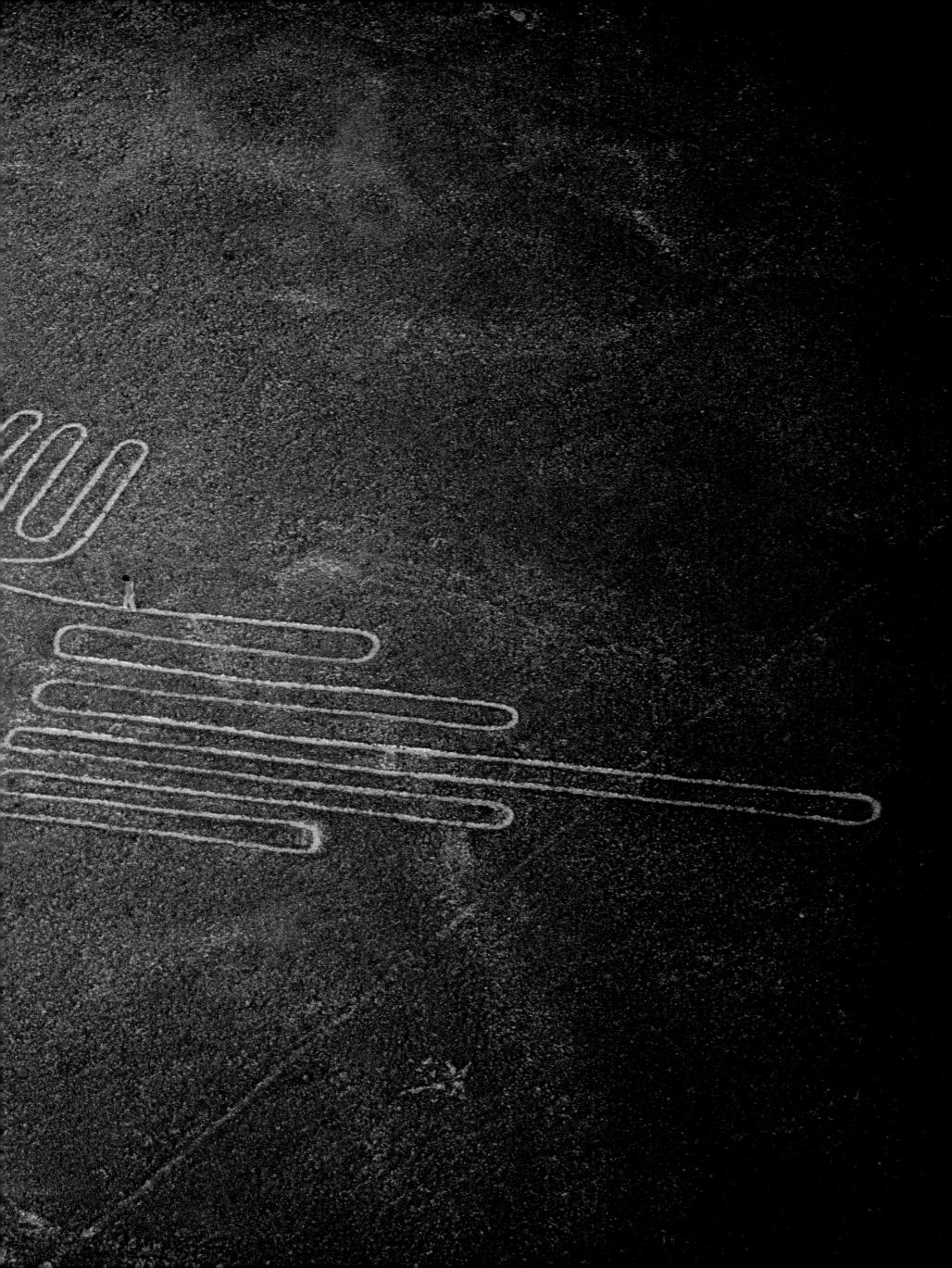

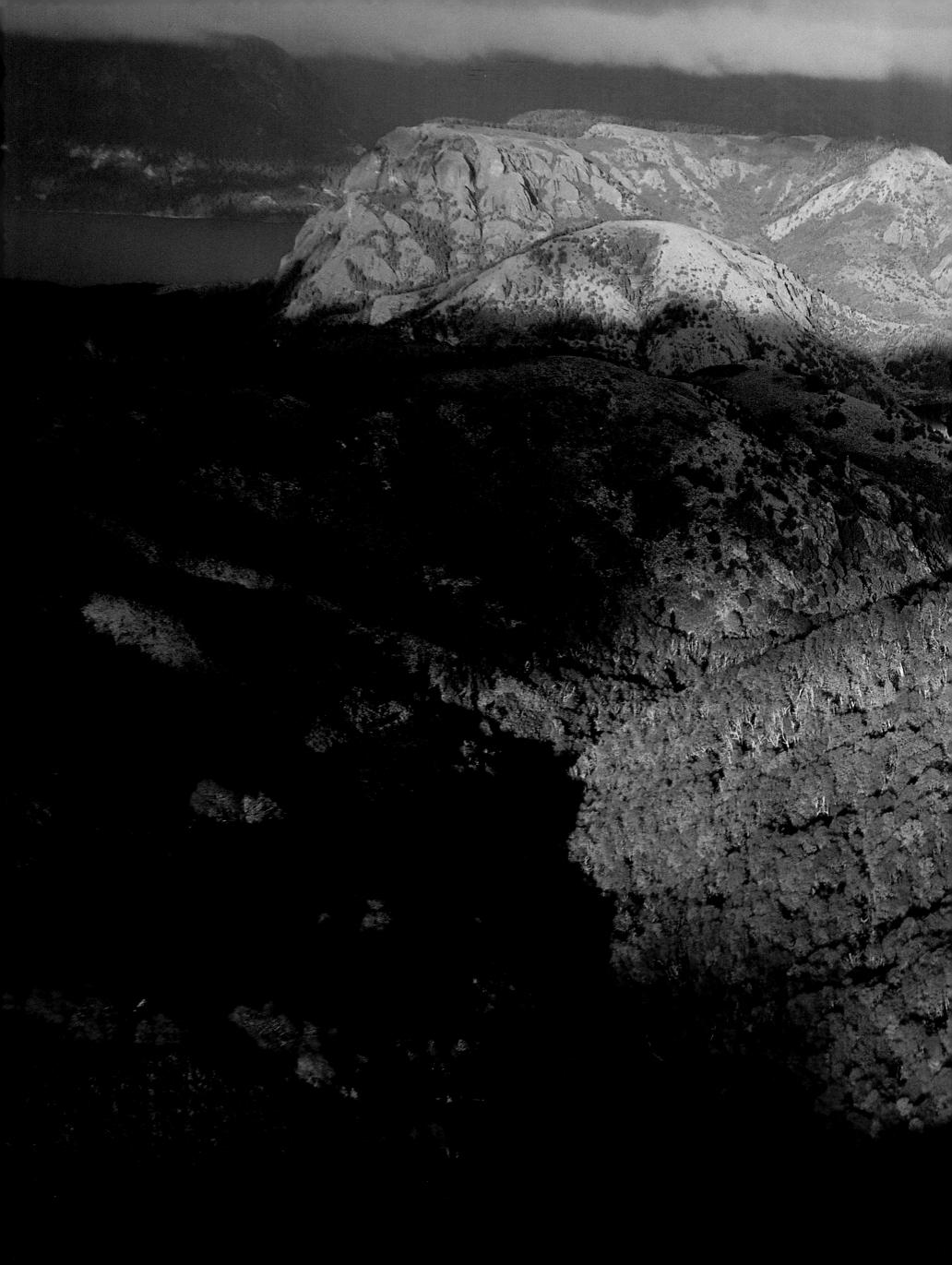

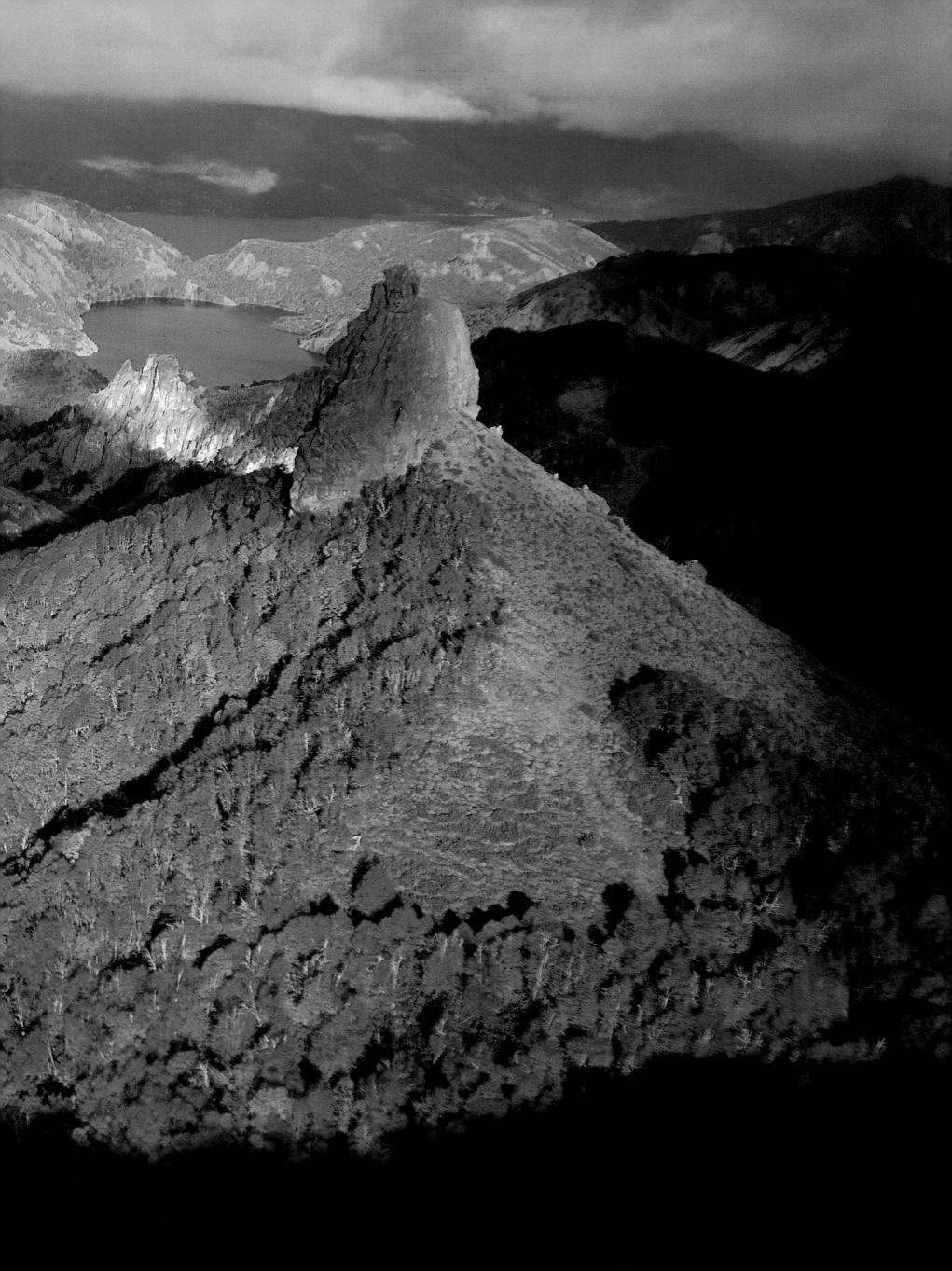

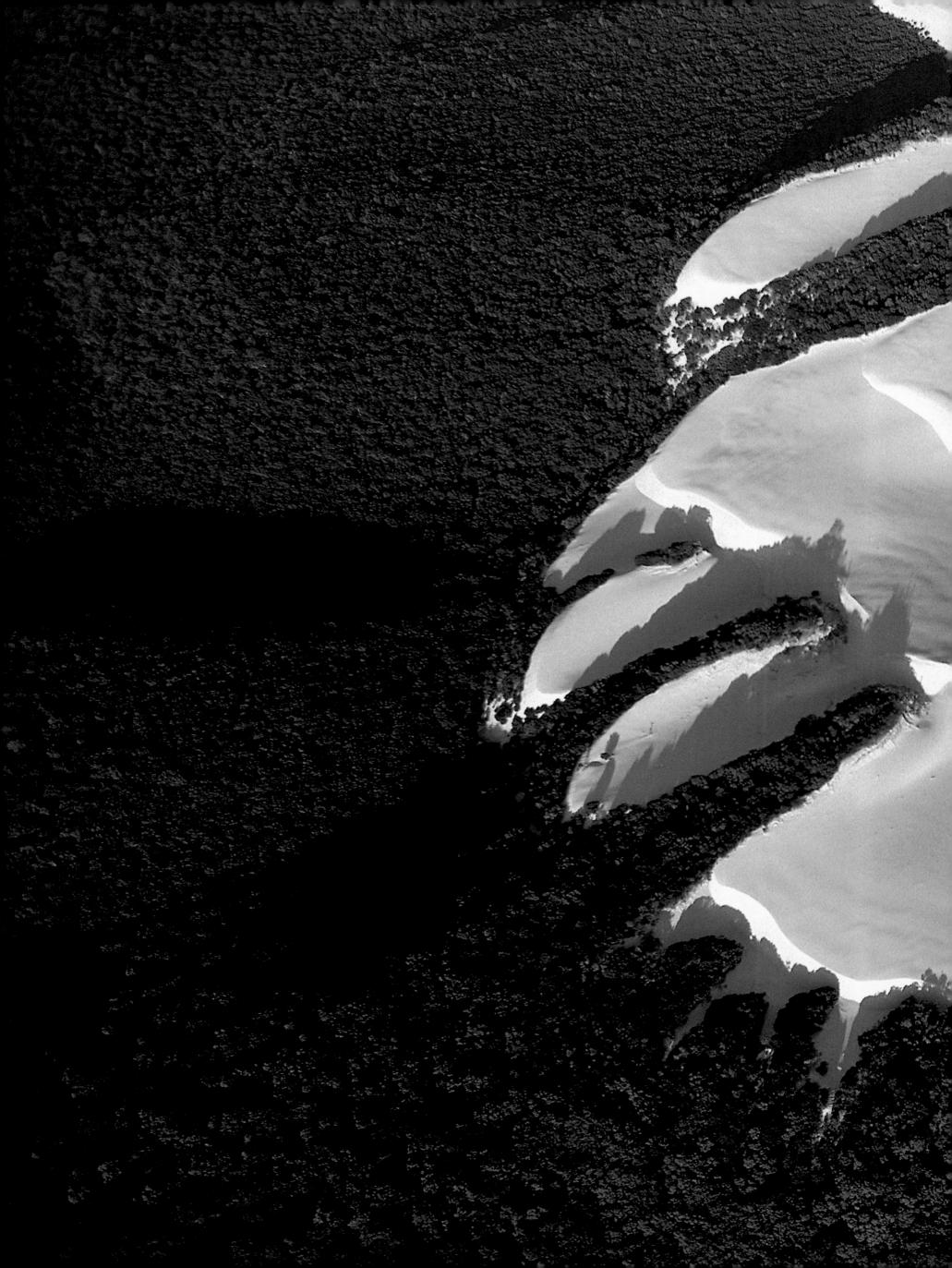

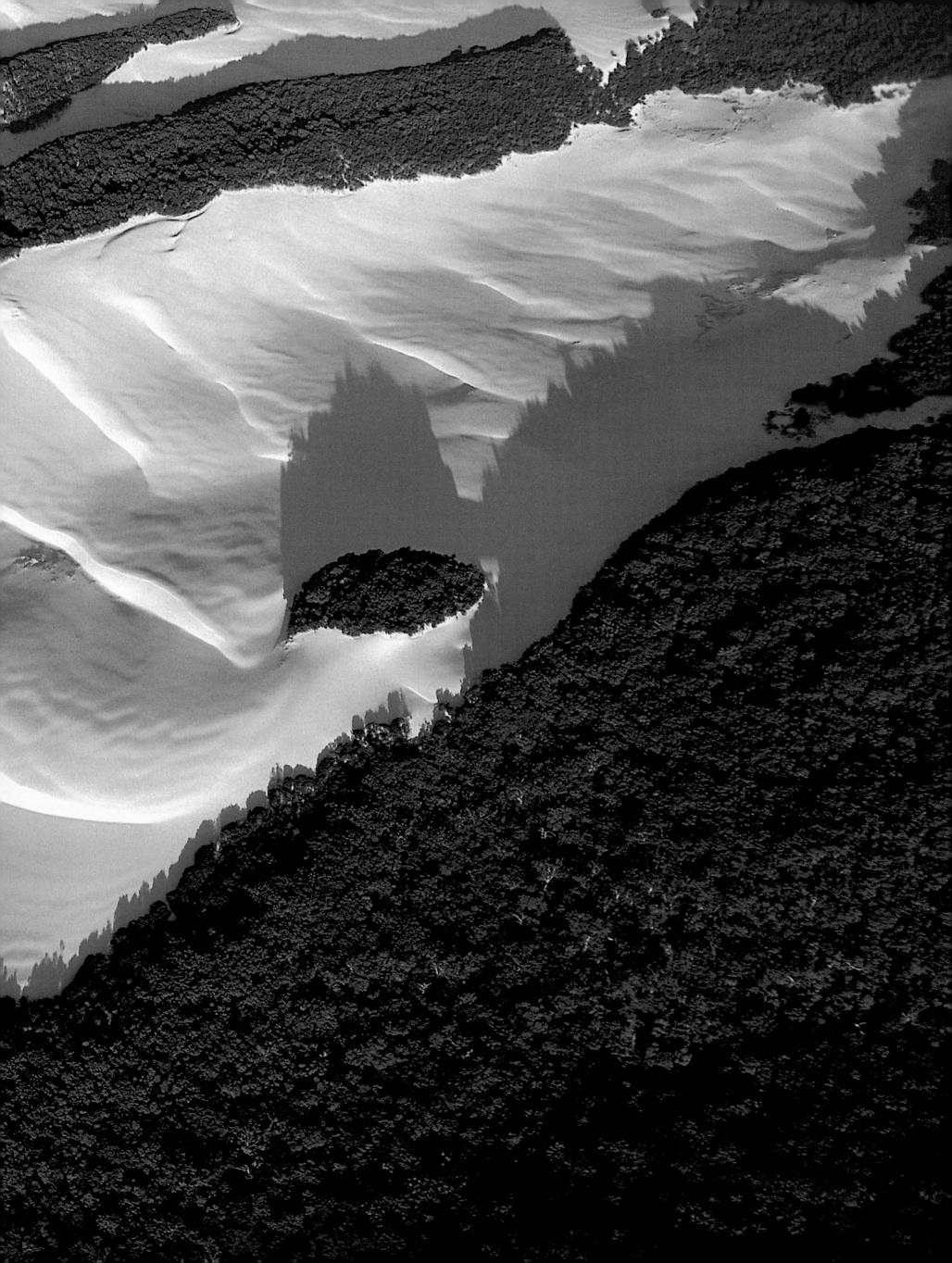

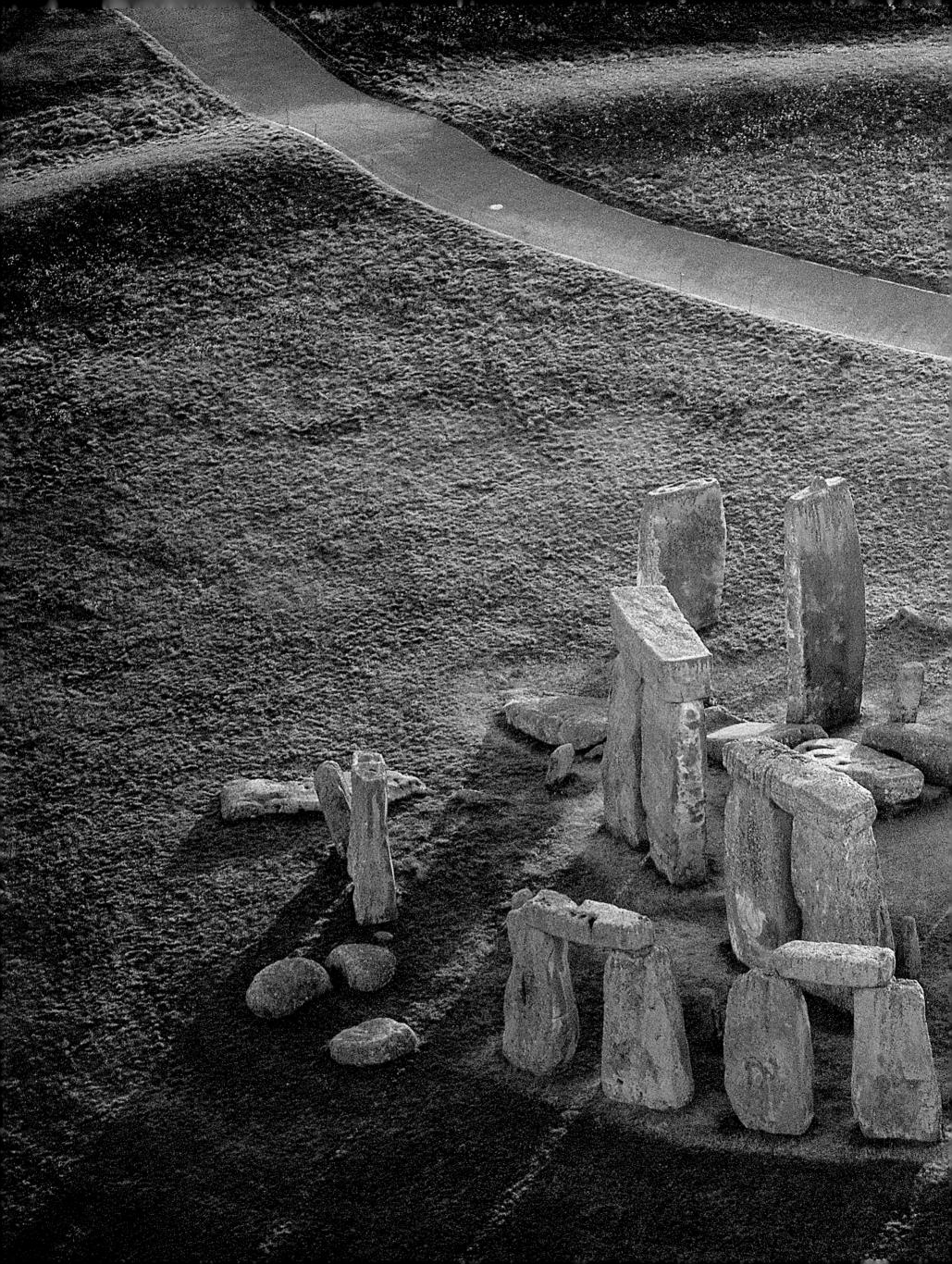

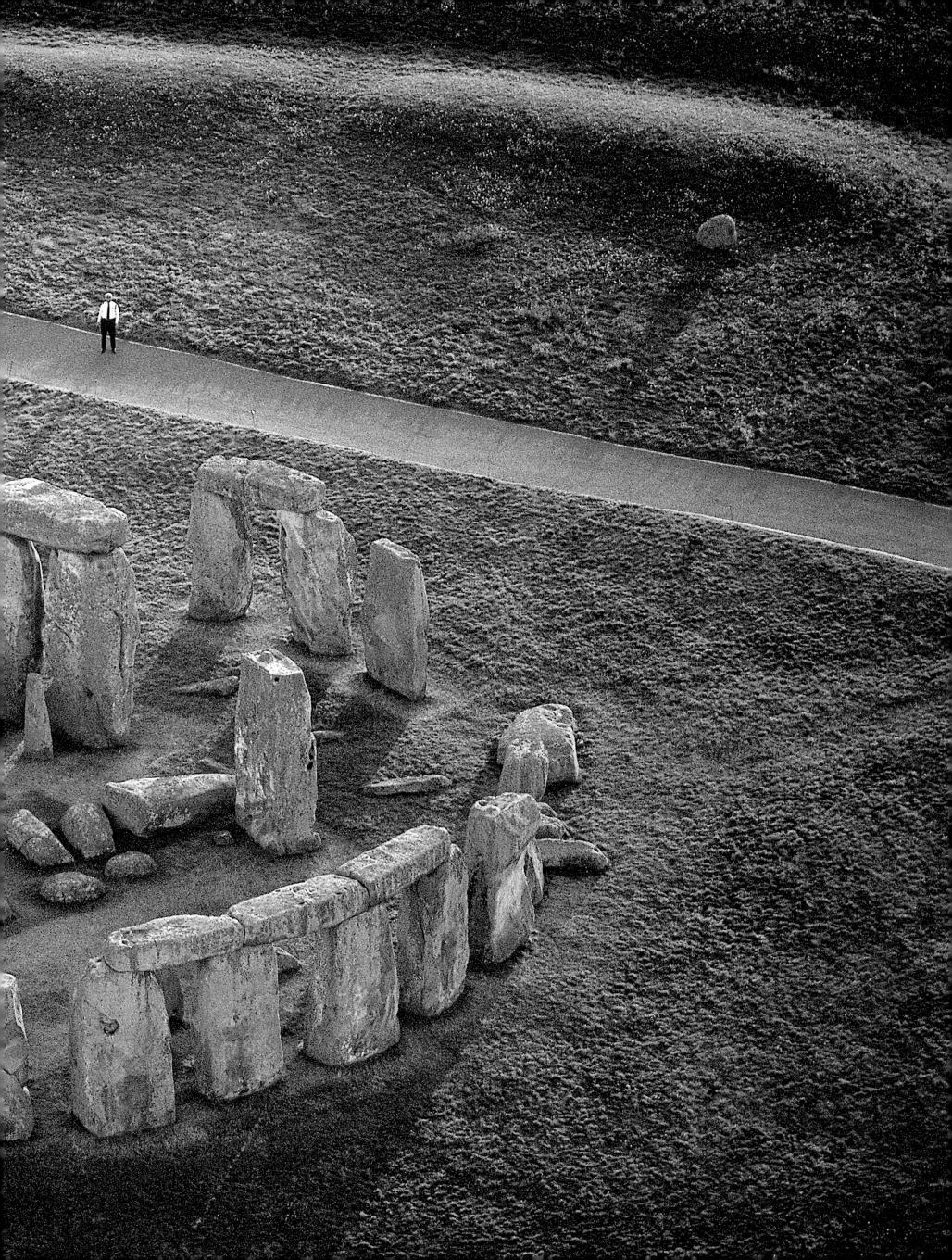

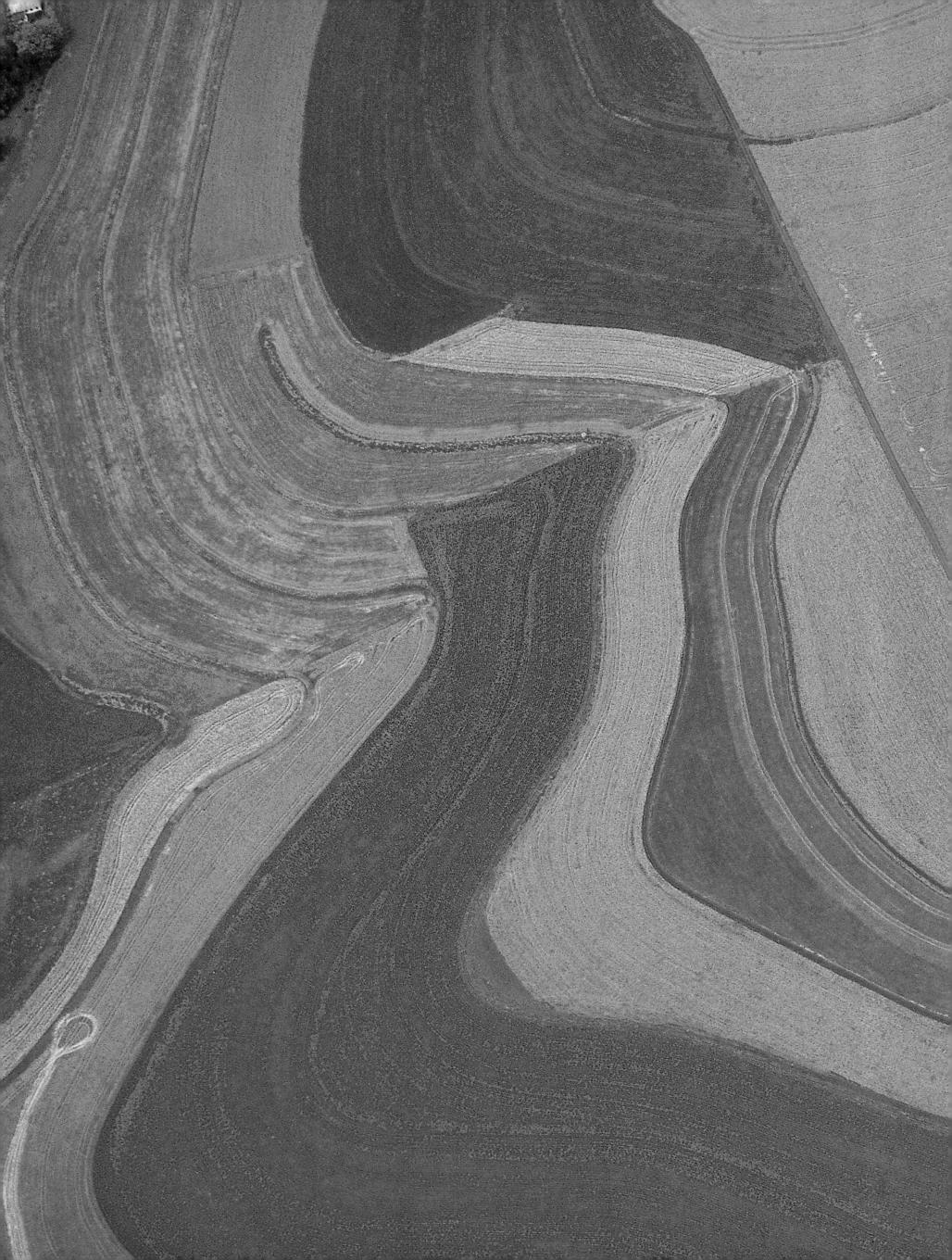

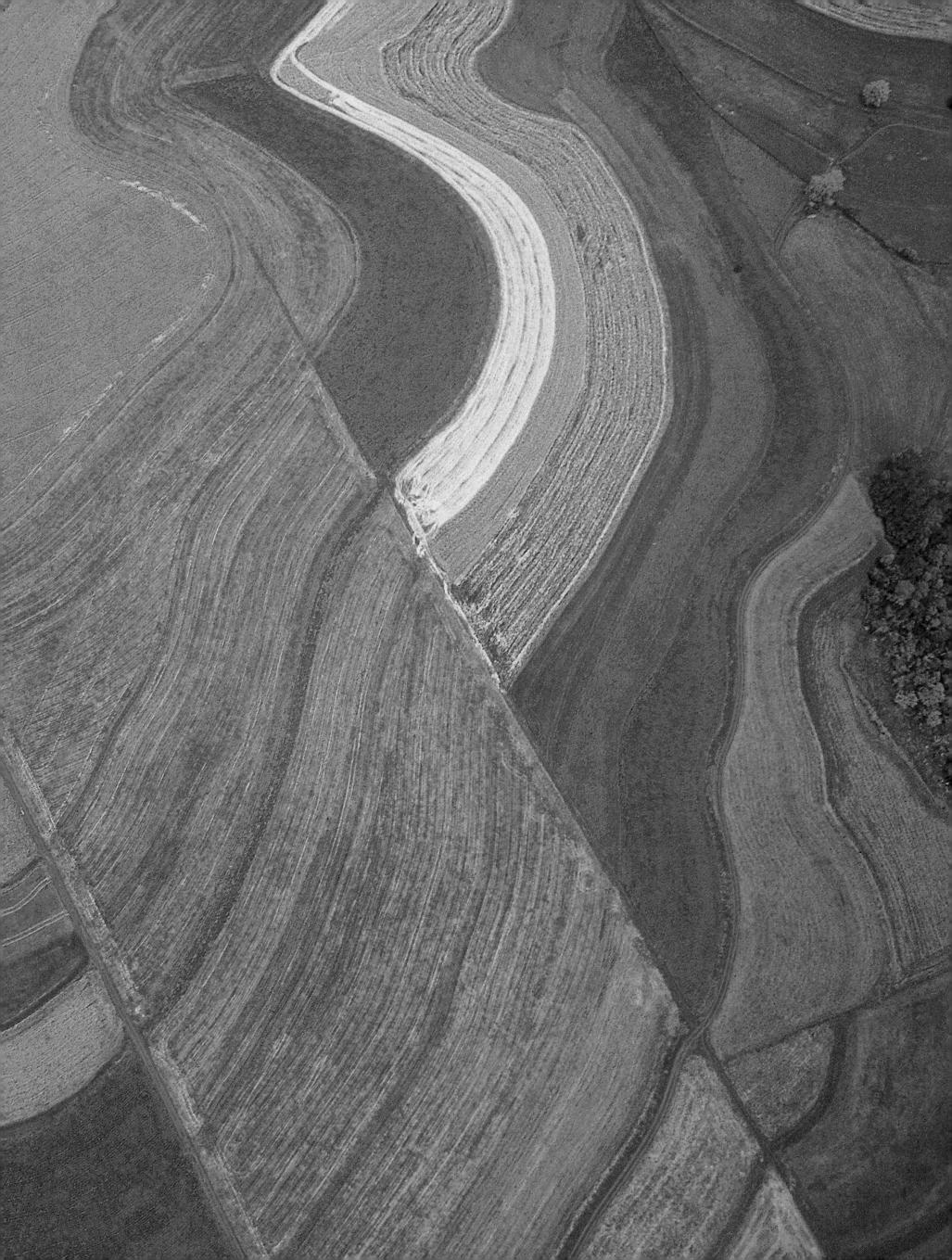

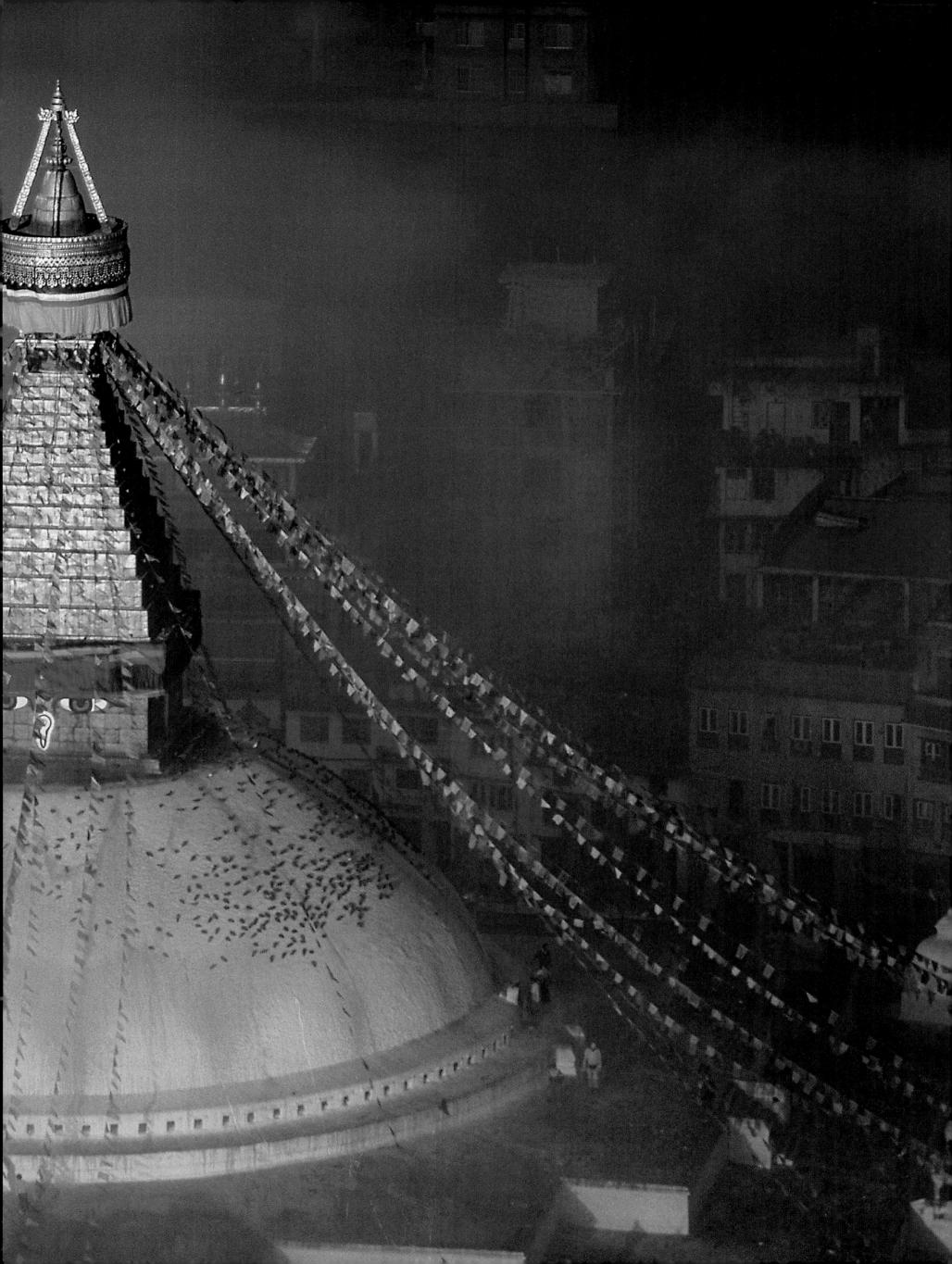

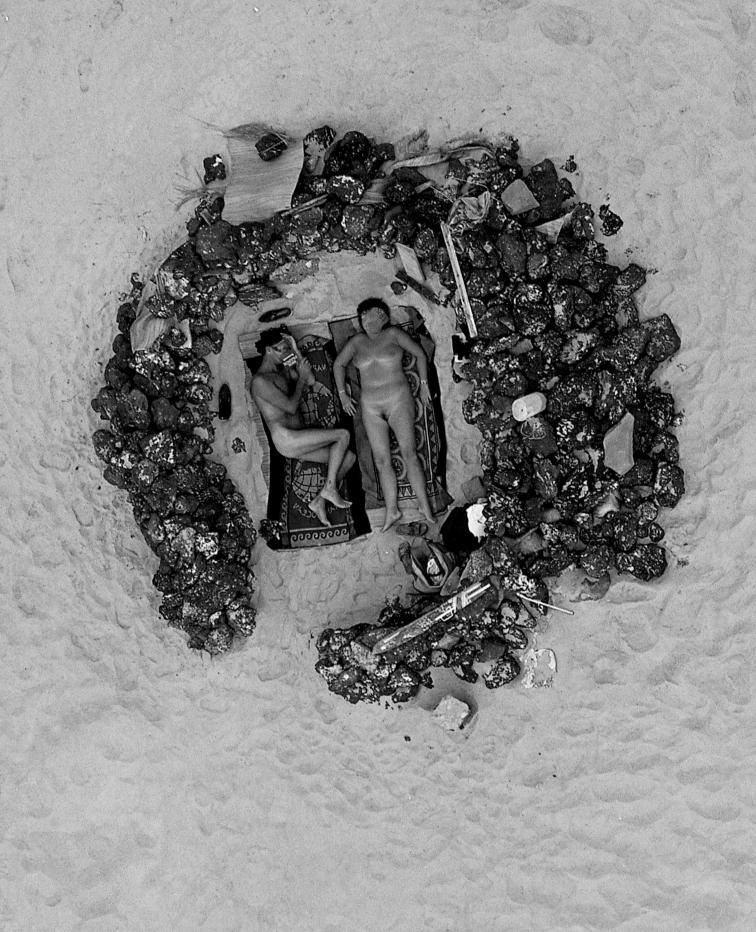

The same

FUTURE OF THE CITY, FUTURE OF LIFE

hat is a city? It is, spatially, the unity of a multiplicity. It shares this quality, in social or mental terms, with a society or an idea. Thus, through its urban, political, and intellectual constructs, humanity adapts the complexities of the universe to its own needs. At the dawn of the twenty-first century, however, the city is experiencing a crisis. We see the city fragment even as it proliferates; society is torn apart, while the population grows as never before. Is the city evolving or devolving?

p. 208

TOURISTS ON A BEACH AT FUERTEVENTURA, near Corralejo, Canary Islands, Spain

Fuerteventura, the second largest of the Canary Islands, has the most expansive beaches of the entire archipelago. Taking advantage of one of many isolated inlets, these tourists are enjoying the pleasures of nudity and full-body tanning. No doubt inspired by the practice of local farmers, they have built a low wall of volcanic stone as protection from the winds from the Sahara that continually sweep the coast, to the great joy of wind surfers. Fuerteventura was selected as the site for the largest hotel complex in the world, but the island's shortage of freshwater, a problem for nearly 20 percent of the population of the archipelago, quickly caused the ambitious project to be dropped. Tourism nevertheless remains the chief industry of the Canaries, which receive 4 million visitors each year, 97 percent of whom come from Germany.

UNITY AND MULTIPLICITY

The question is crucial: how shall we model the city and an increasingly urban society? To seek an answer, let us review the film of the city's history. Perhaps we will then be in a better position to detect, in the current upheaval, what is a danger for the future and what is an opportunity to be grasped.

Approximately one hundred thousand years ago our ancestors began to colonize the planet in groups of twenty or thirty, moving about while hunting and gathering. Then, about ten thousand years ago, some of them settled in one place, inventing agriculture and the village. All of these communities, and all of the individuals who constituted them (aside, of course, from certain distinctions based on gender and age), carried out the same activities.

Diversification was created by the city, through the division of labor. A new form of social organization, reciprocal yet hierarchical, was born: at the bottom the producers, above them the warriors, and at the top the sovereign, a power

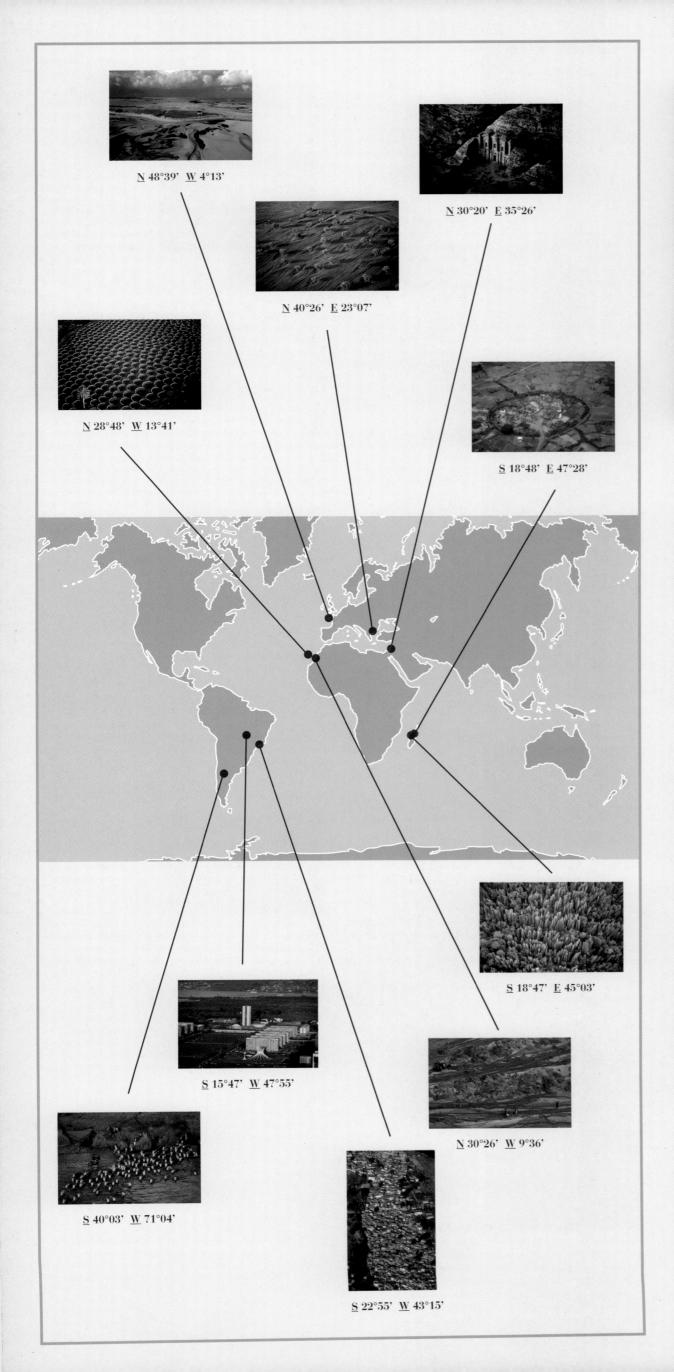

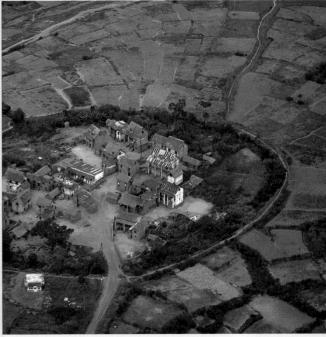

oirth to the modern city. It was released res by classical Greece and especially leolithic village by the medieval city of

Paris of the kings of France, emblemlisassociates itself from the religious, and with its powerful dynamism that trans-

e like to say, are marked by the spirit of sophy separates the infinite extension of aking subject. The former became homole, and the subject made itself the mastree, and the subject made itself the mastree, by try. The king was the master of his realm, on to flatten and square off his territory, "French garden." Recall the Paris of the atteenth centuries, its Place Royale, which les Vosges: identical buildings arranged closing in its center the equestrian statue war leader. The manifestation of power precision symbolized militarization, epit-

omized by the similar layout of the Invalcomplex in Paris, with Napoleon's tomb the sides of the quadrilateral, all of soci its king; and, from his central position, t society in his haughty gaze.

Thus, the city made society a great lated by techno-engineers (such as the N the military engineer whose tactics and in sible Louis XIV's wars, and Jean-Baptist ister of finance who oversaw the acader the arts). Normalization and academicist with social controls. This model, which which social controls. This model, which which social controls as St. Petersburg, posited a unnal, creative diversity. Here was an inert lascientific administration engendered s

and circulation, the industrial city made its distinctions completely visible and kept its denizens enslaved to this machine that heats, smokes, and floods the market with its products. Everything, including sexual energy, was co-opted, disciplined for work, manipulated for consumption. Life was reduced to one dimension, entirely instrumentalized. This means of unifying differences, far from complicating the human being, reduced it to material production alone.

And yet today there is a certain nostalgia for these figures of the past. This is because urban life is exploding before our eyes: forty-five percent of the population of the planet now lives in cities, some of which are becoming gigantic. In the developing nations of Latin America, Africa, South and Southeast Asia, over thirty cities have more than 5 million inhabitants. As the global marketplace unifies world trade, it anarchizes the cities. In the developing world, conglomerates are overtaking traditional agriculture, and the rural population is swarming to the cities. While the periphery spreads at a galloping rate, the former city disintegrates in its very center: city centers are lost in the city sprawl, and the historical city dissolves into a new form.

Everywhere the old areolar, concentric structure is giving way to a networked fabric, as seen in cities such as Los Angeles and Mexico City. In the historical city, the State and the productive machine regulated the functioning of a precise territory. But today, due to the fluidity of capital and intelligence, these pillars of power and effectiveness have been undermined, leading to a proliferation of edge cities, which, unregulated, can degenerate into violence. Global-

ization might have been expected to lead to homogenization and standardization. In fact, it has given rise to societal dislocation.

A NEW DYNAMIC

It would be taking a pessimistic and conservative stance, however, to view today's cities as on the verge of complete collapse. What we see today as chaos is a new stage in urban development, a new dynamic. The absence of a firm city center does not have to spell the breakdown of authority and regulation. The network of the city is a reflection of democratic society, a combination of individualization and socialization, independence and community. The history of the city is important to keep in mind, but it should not blind us to the innovation and opportunities of the present.

Paul Blanquart

p. 217

FAVELAS IN RIO DE JANEIRO, Brazil

Nearly one-fourth of the 10 million cariocas—the residents of Rio de Janeiro—live in the city's 500 shantytowns, known as *favelas*, which have grown rapidly since the turn of the twentieth century and are wracked by crime. Primarily perched on hillsides, these poor, underequipped neighborhoods regularly experience fatal landslides during the heavy rain season. Meanwhile, downhill from the *favelas*, the comfortable middle classes of the city (18 percent of cariocas) occupy the residential districts along the oceanfront. This social contrast marks all of Brazil, where 10 percent of the population controls the majority of the wealth while nearly half of the country lives below the poverty level. Approximately 25 million Brazilians live in shantytowns in the nation's large metropolitan areas.

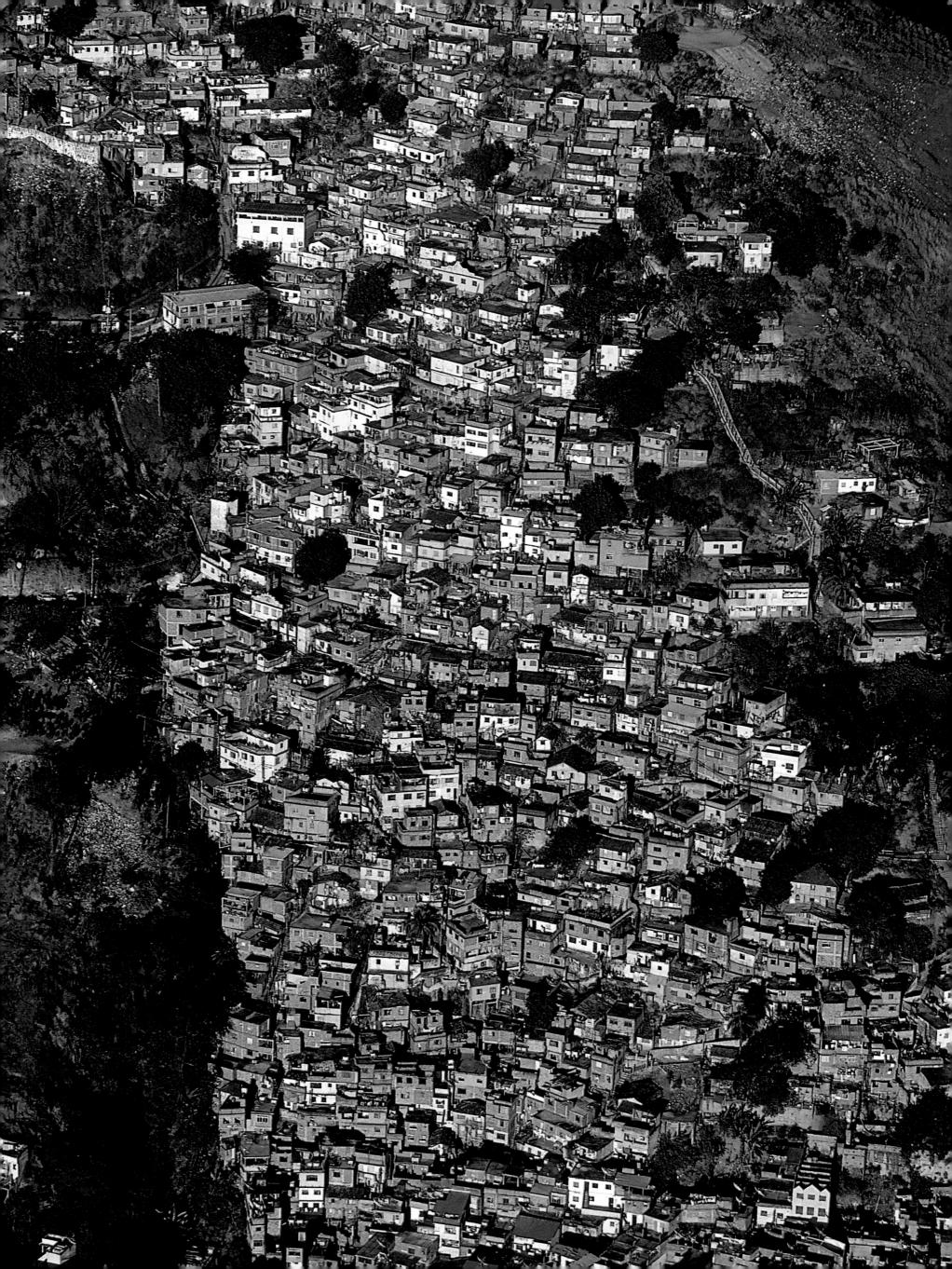

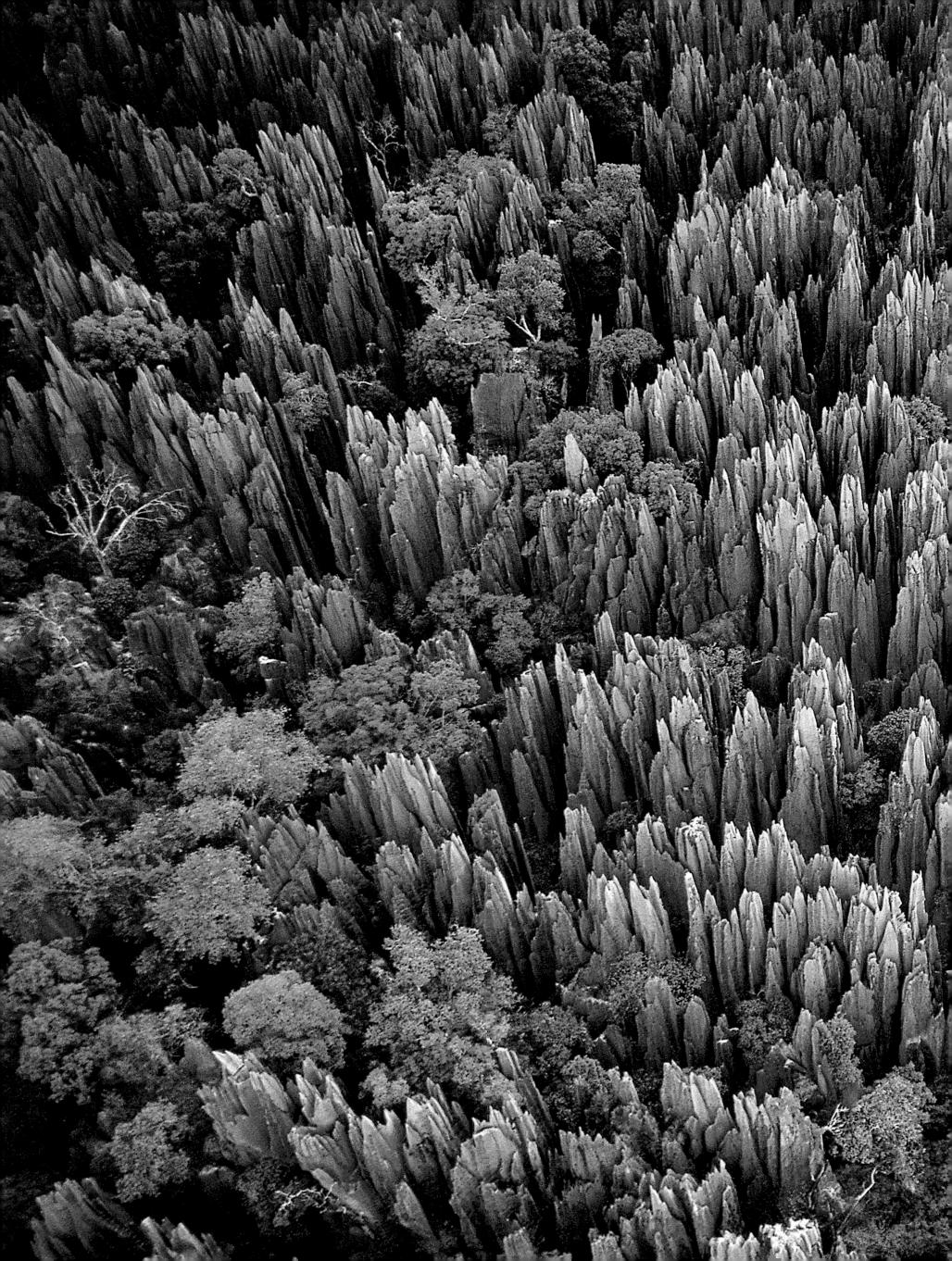

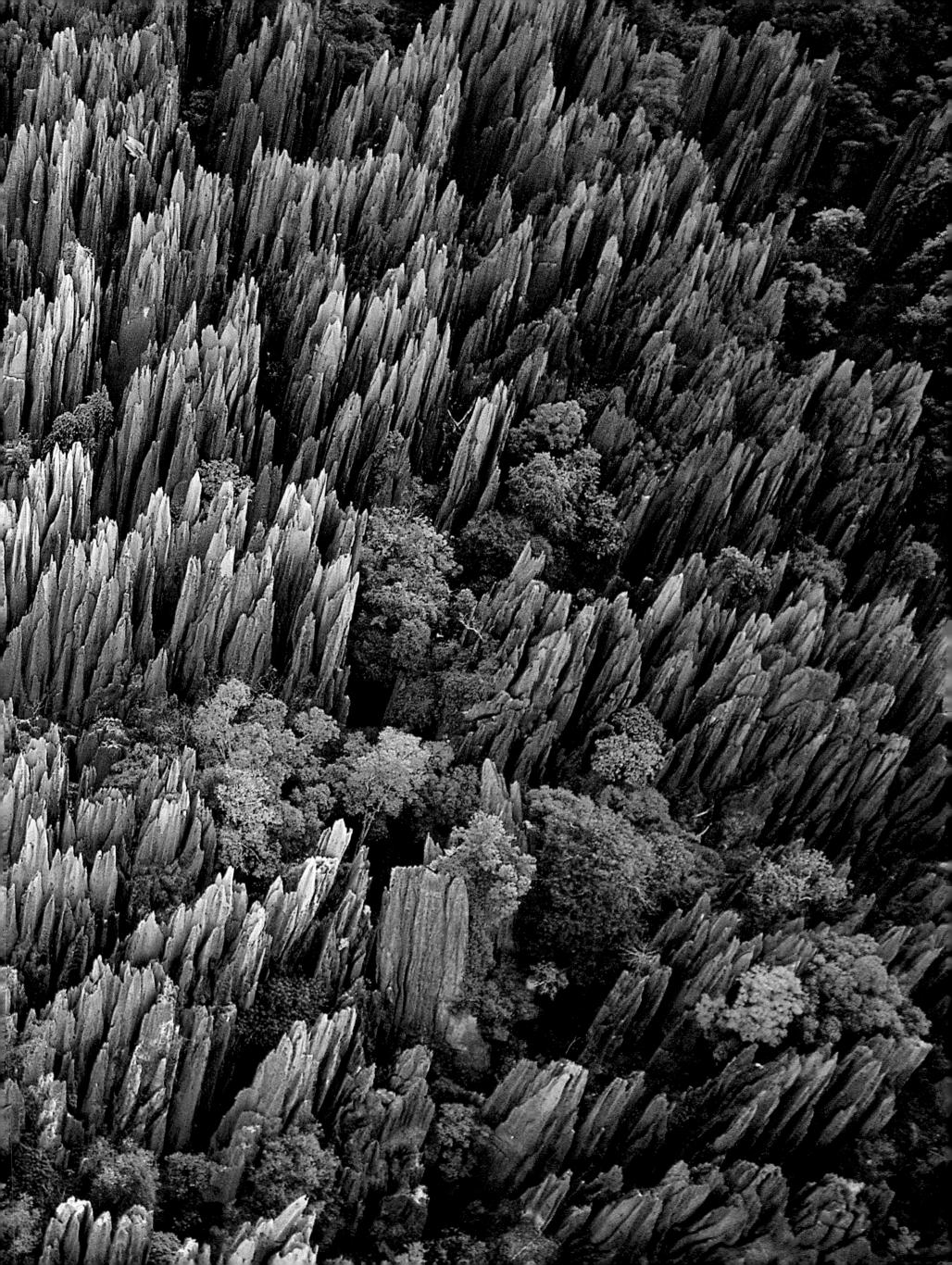

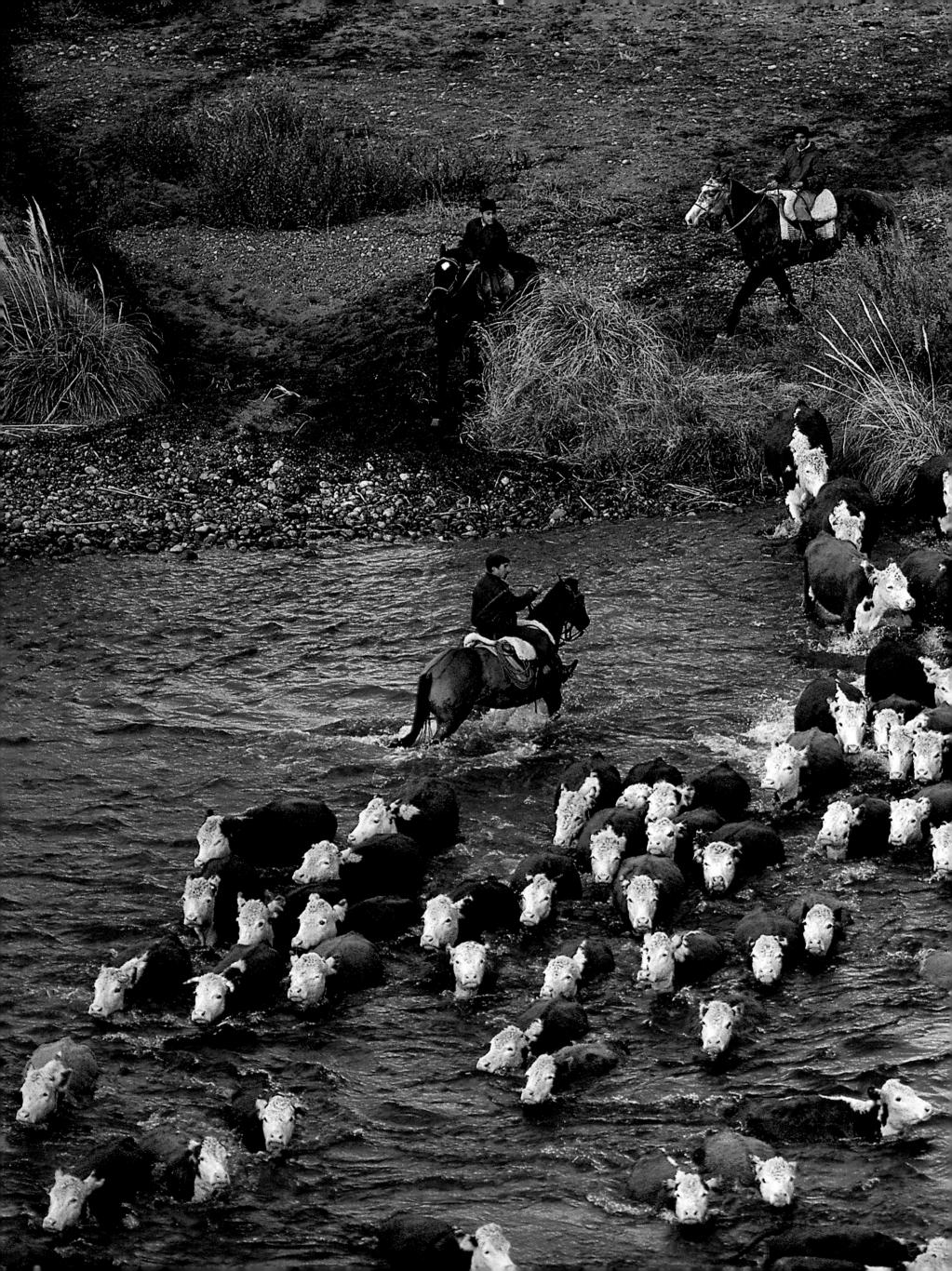

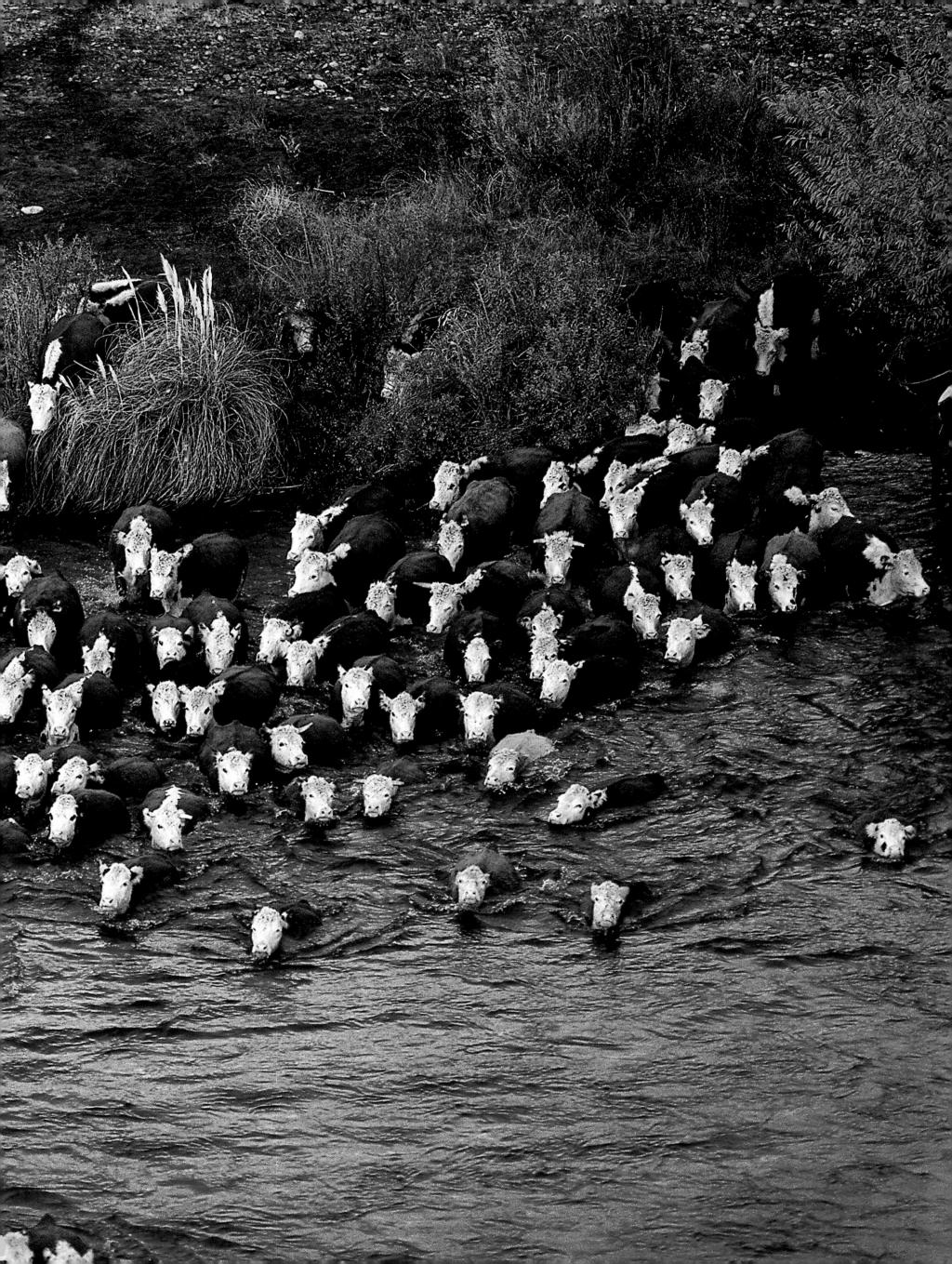

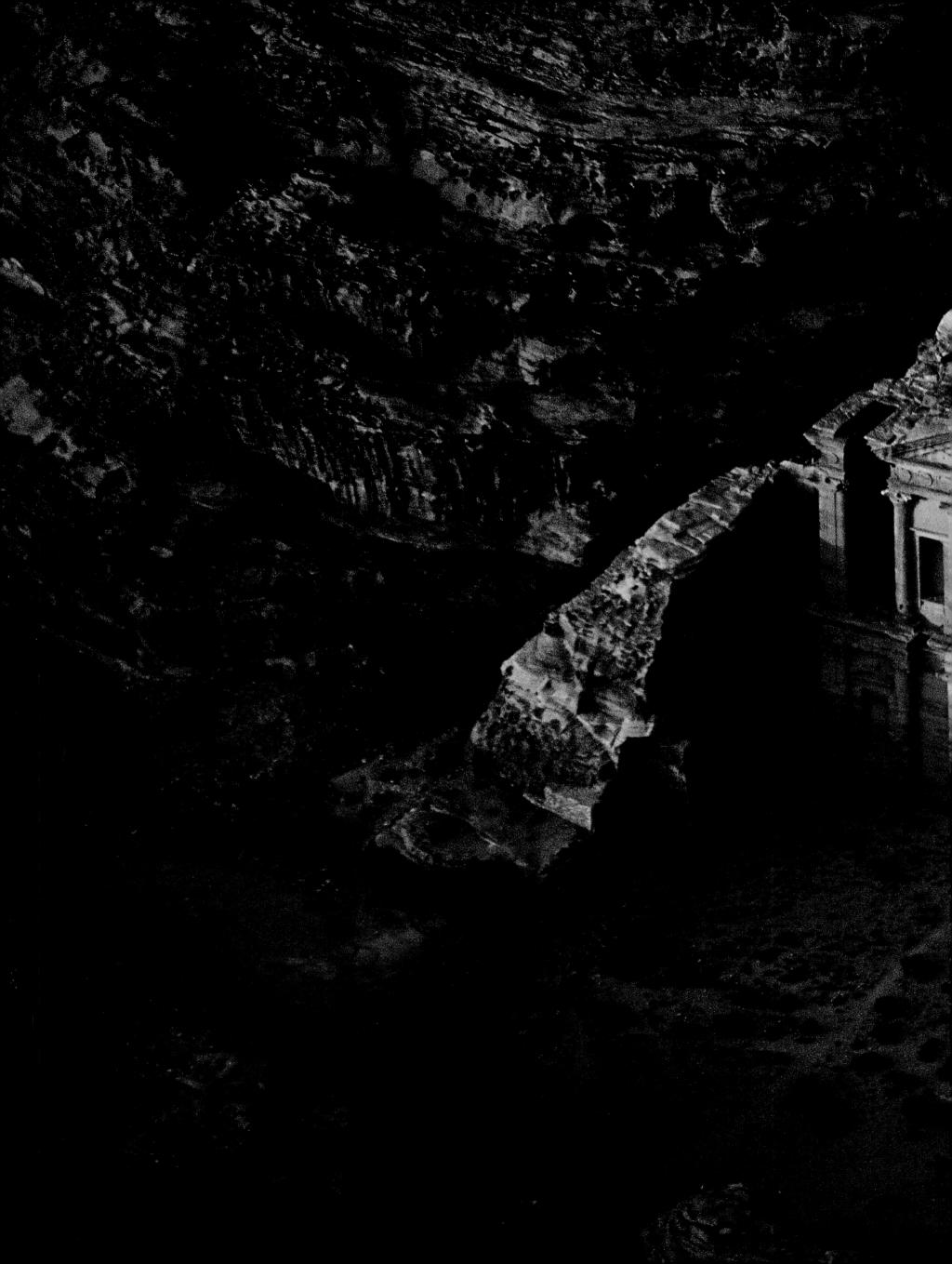

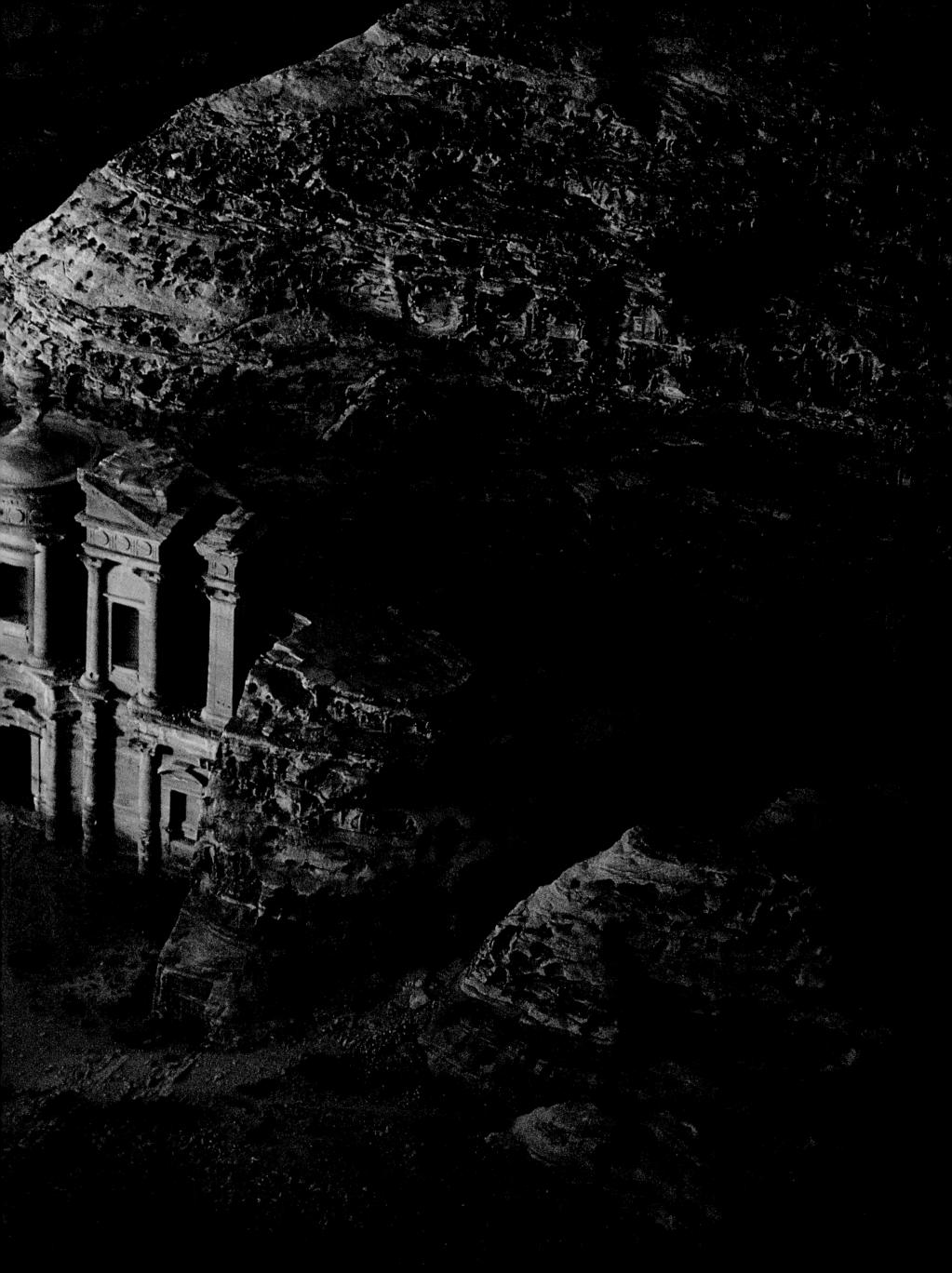

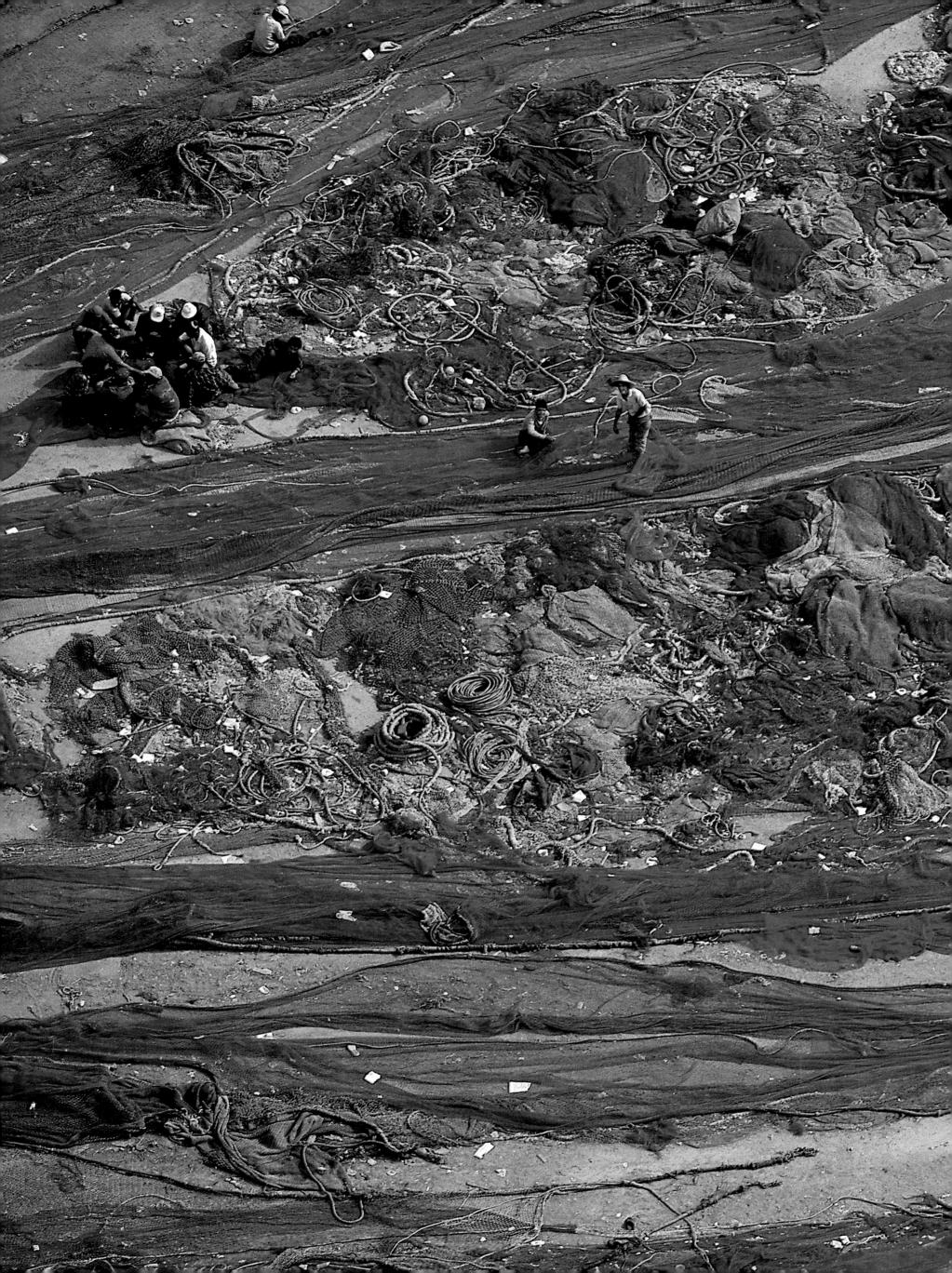

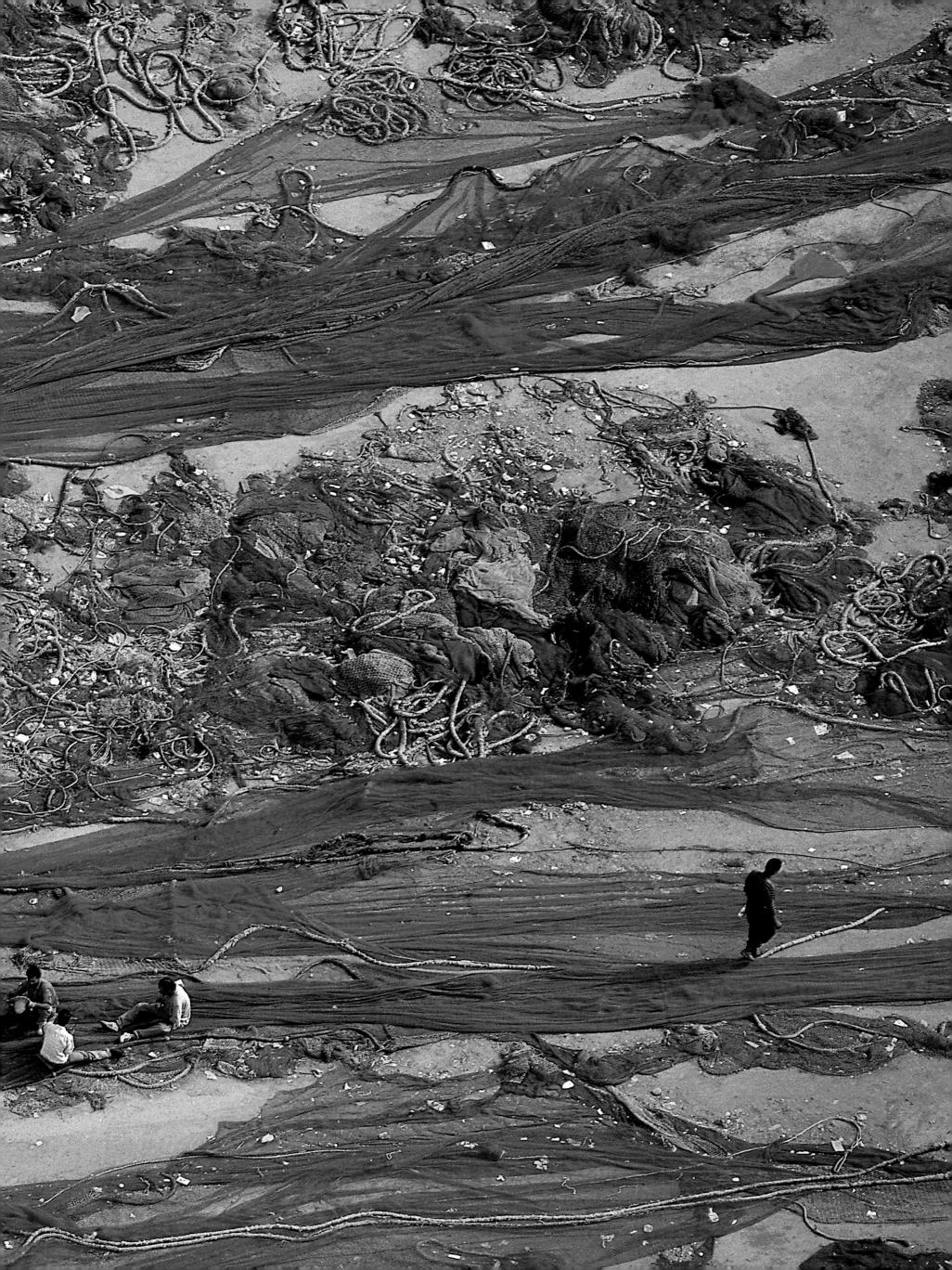

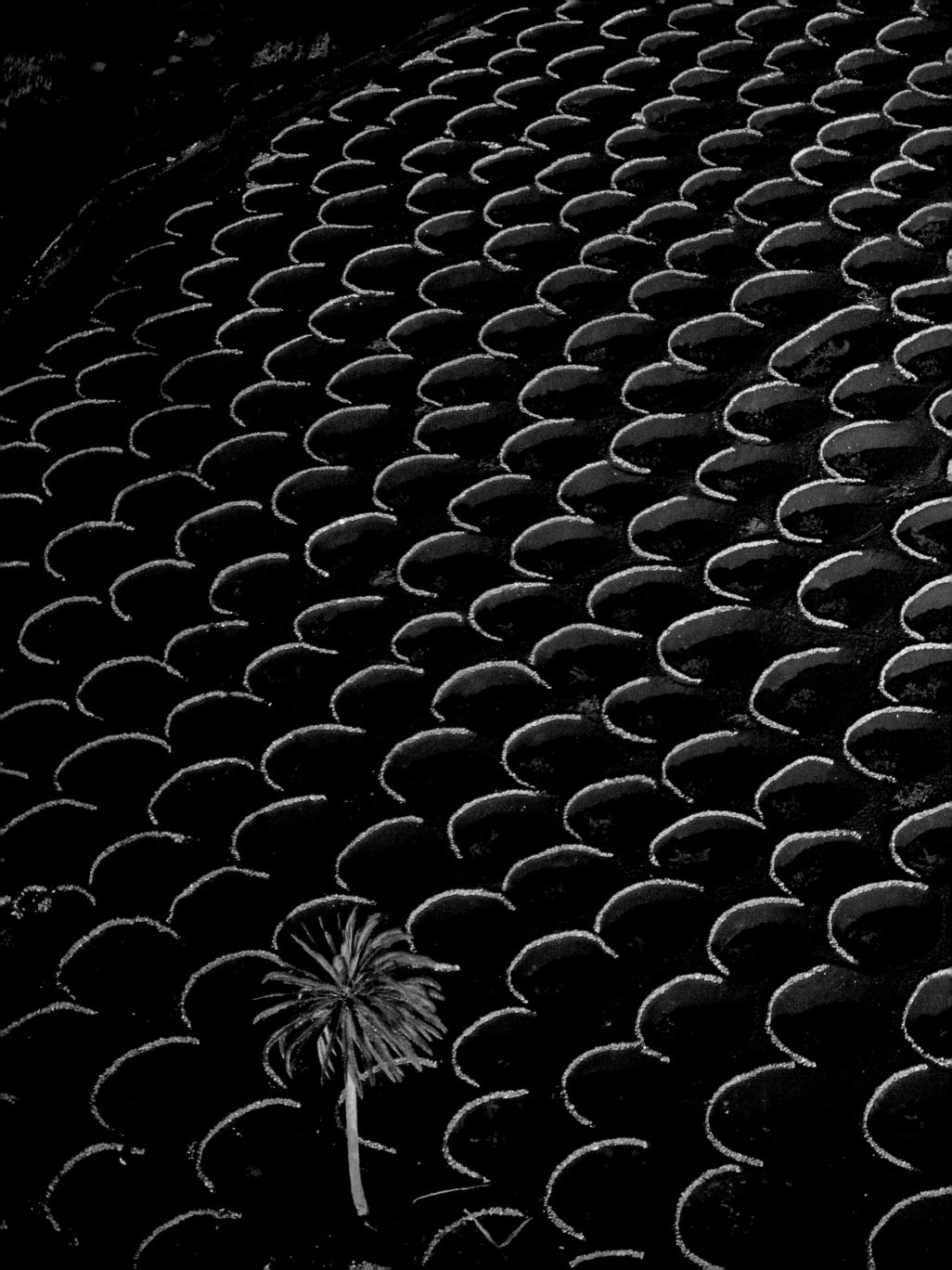

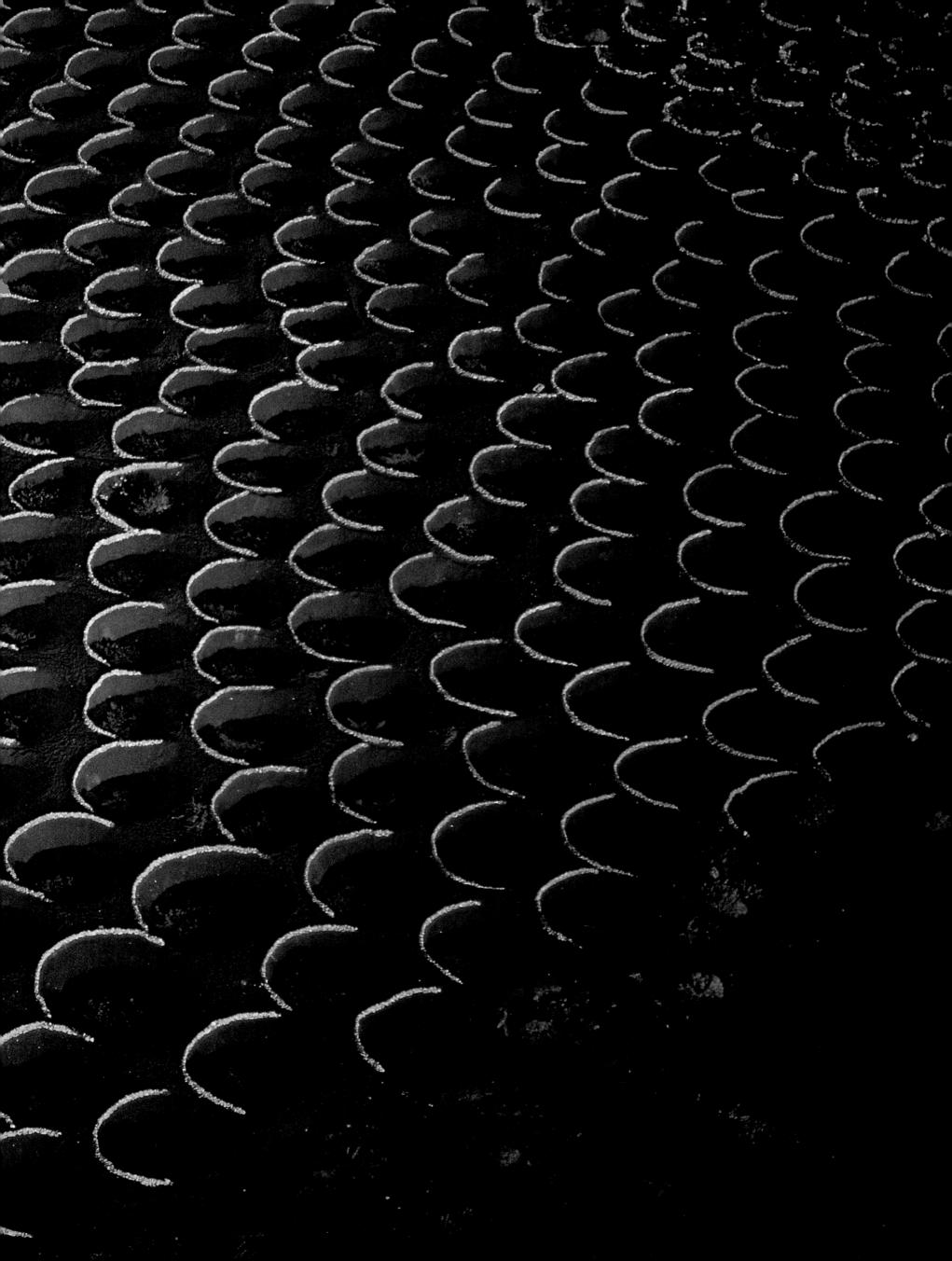

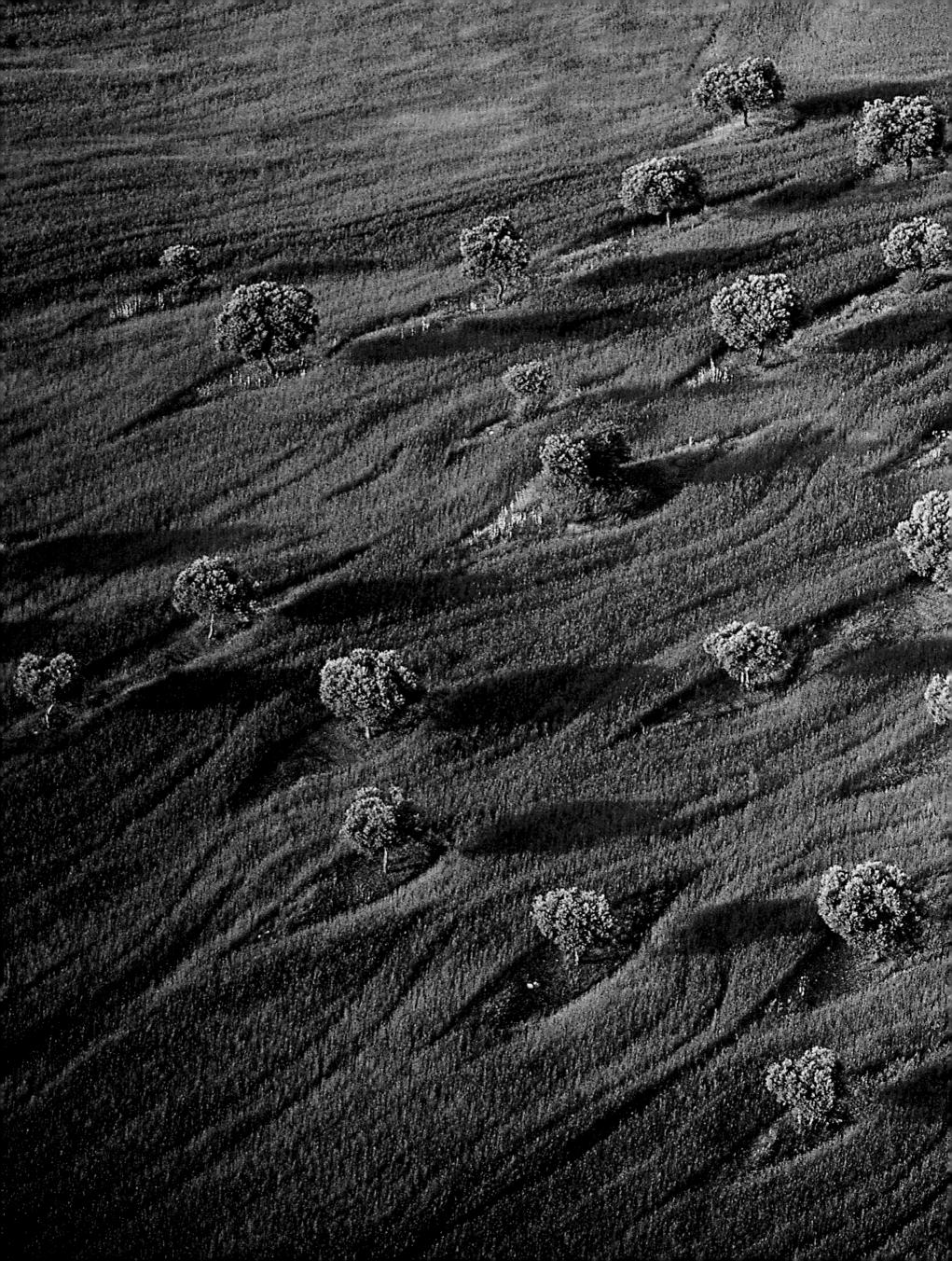

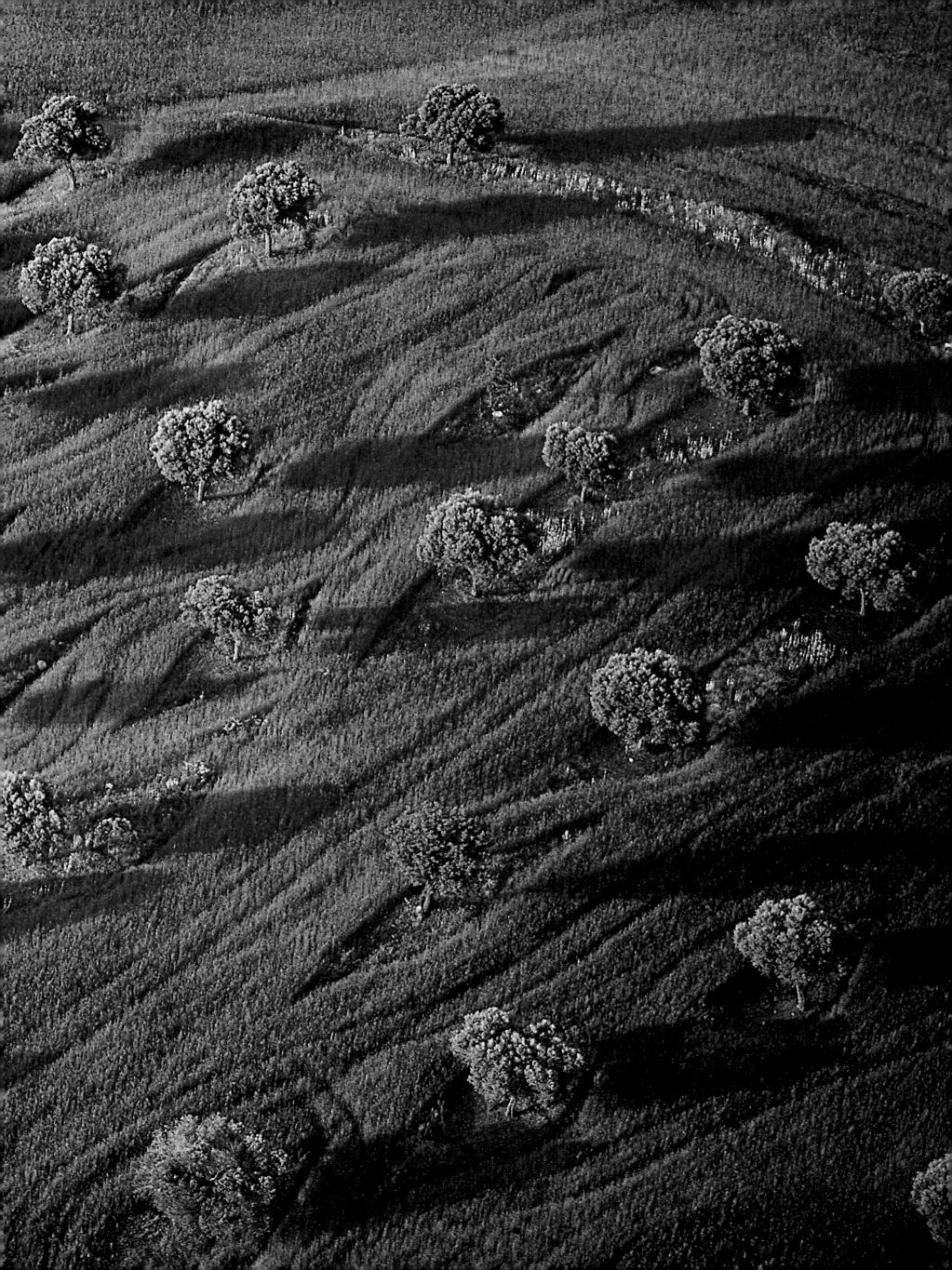

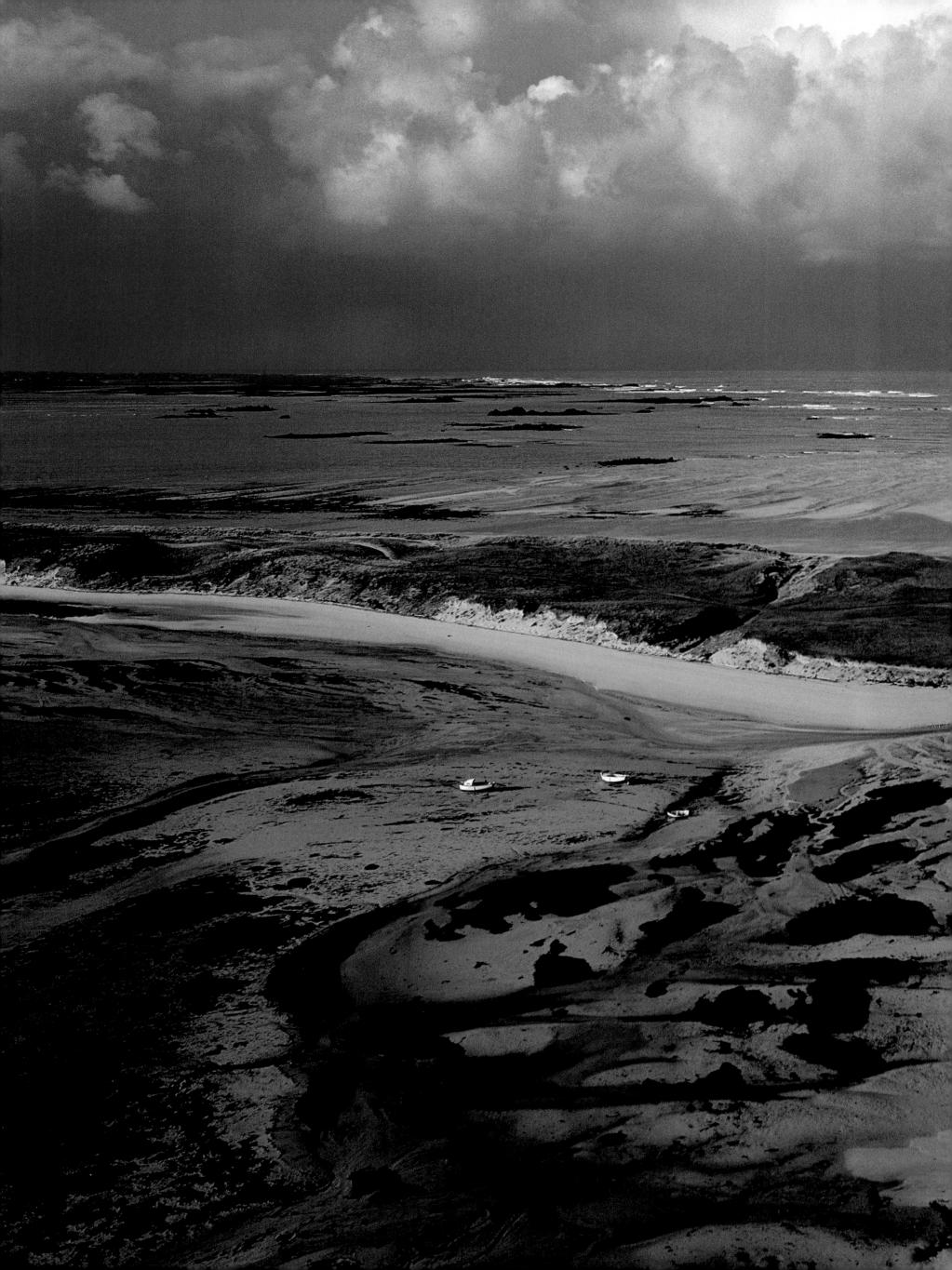

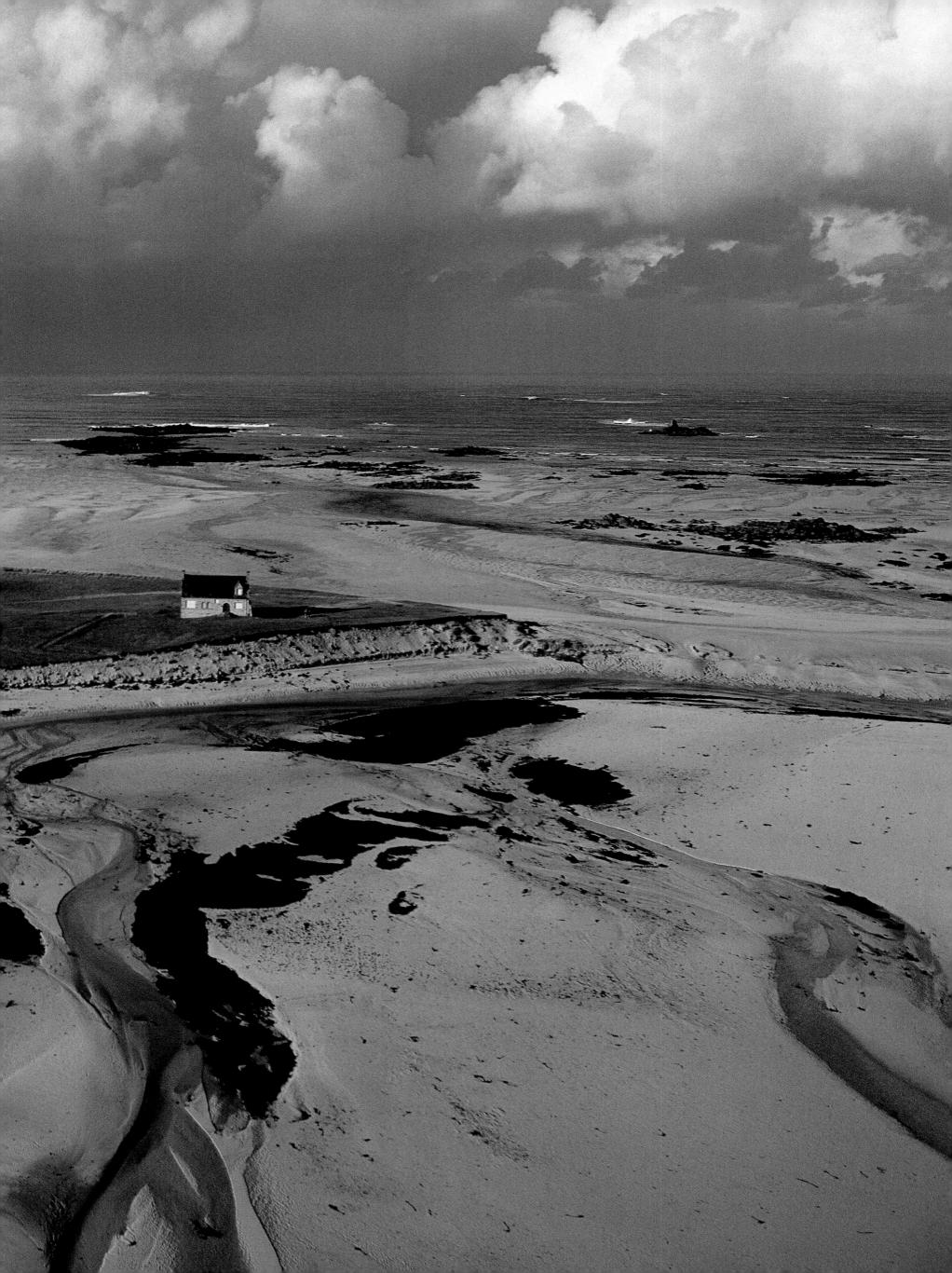

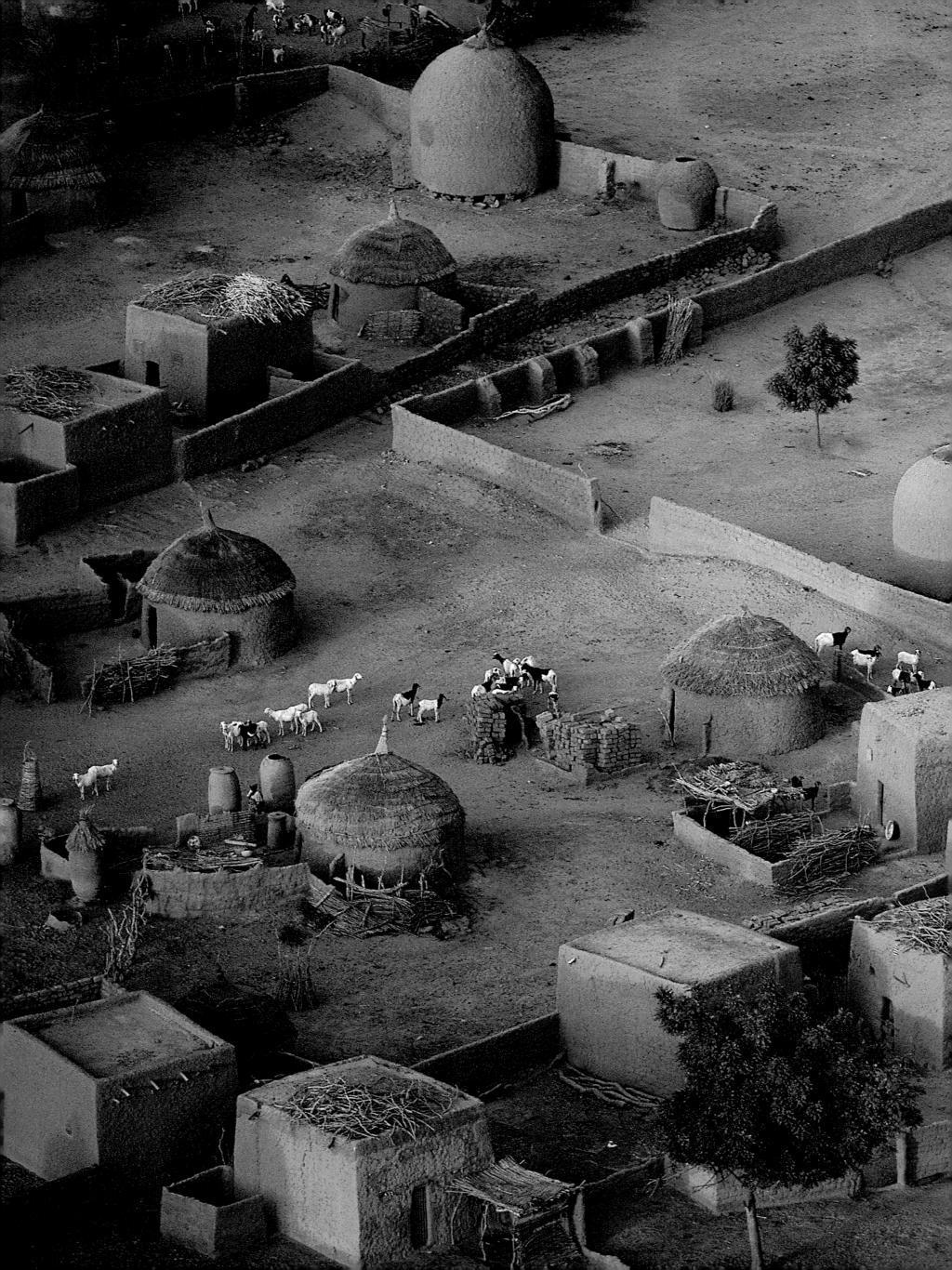

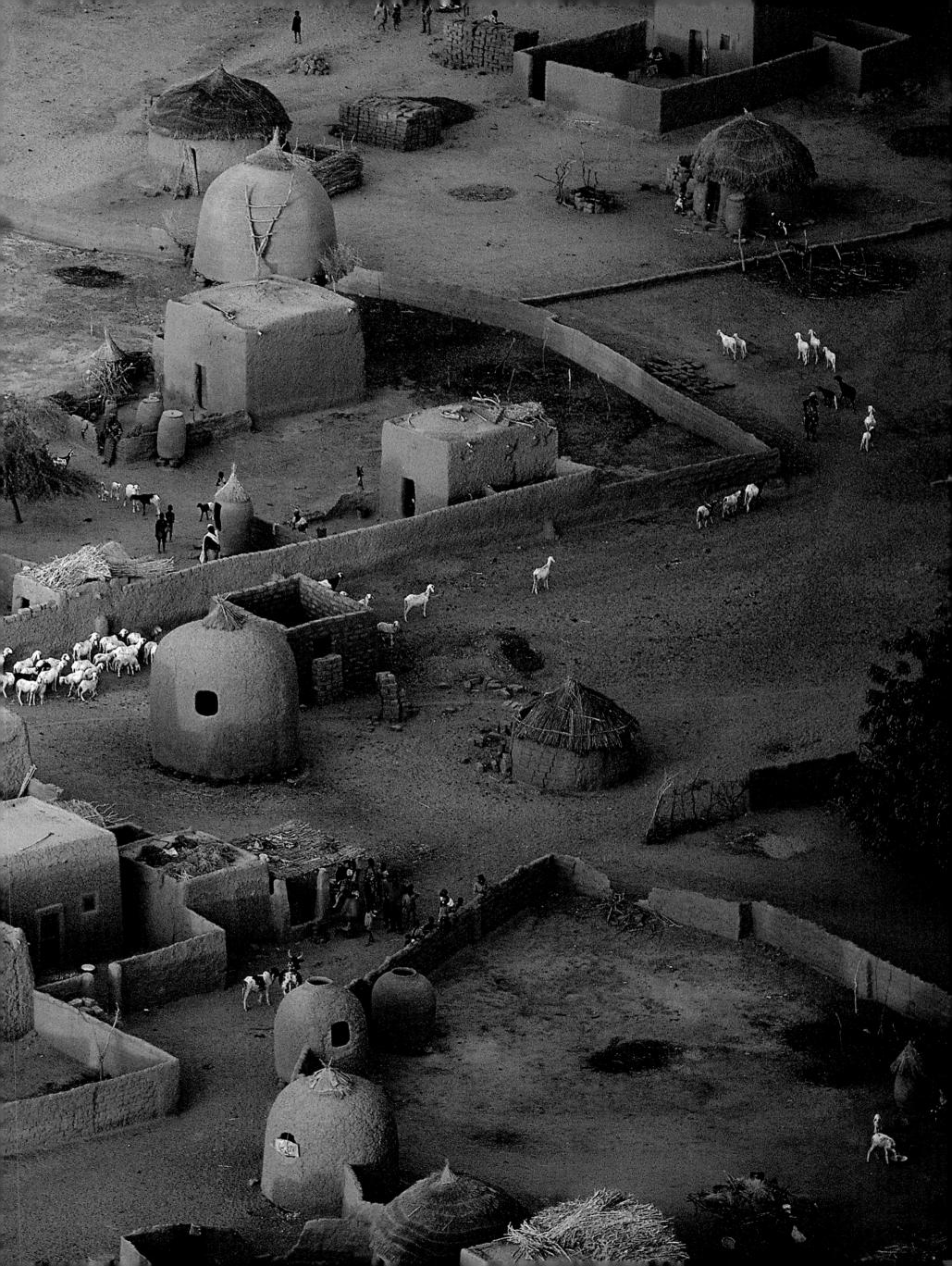

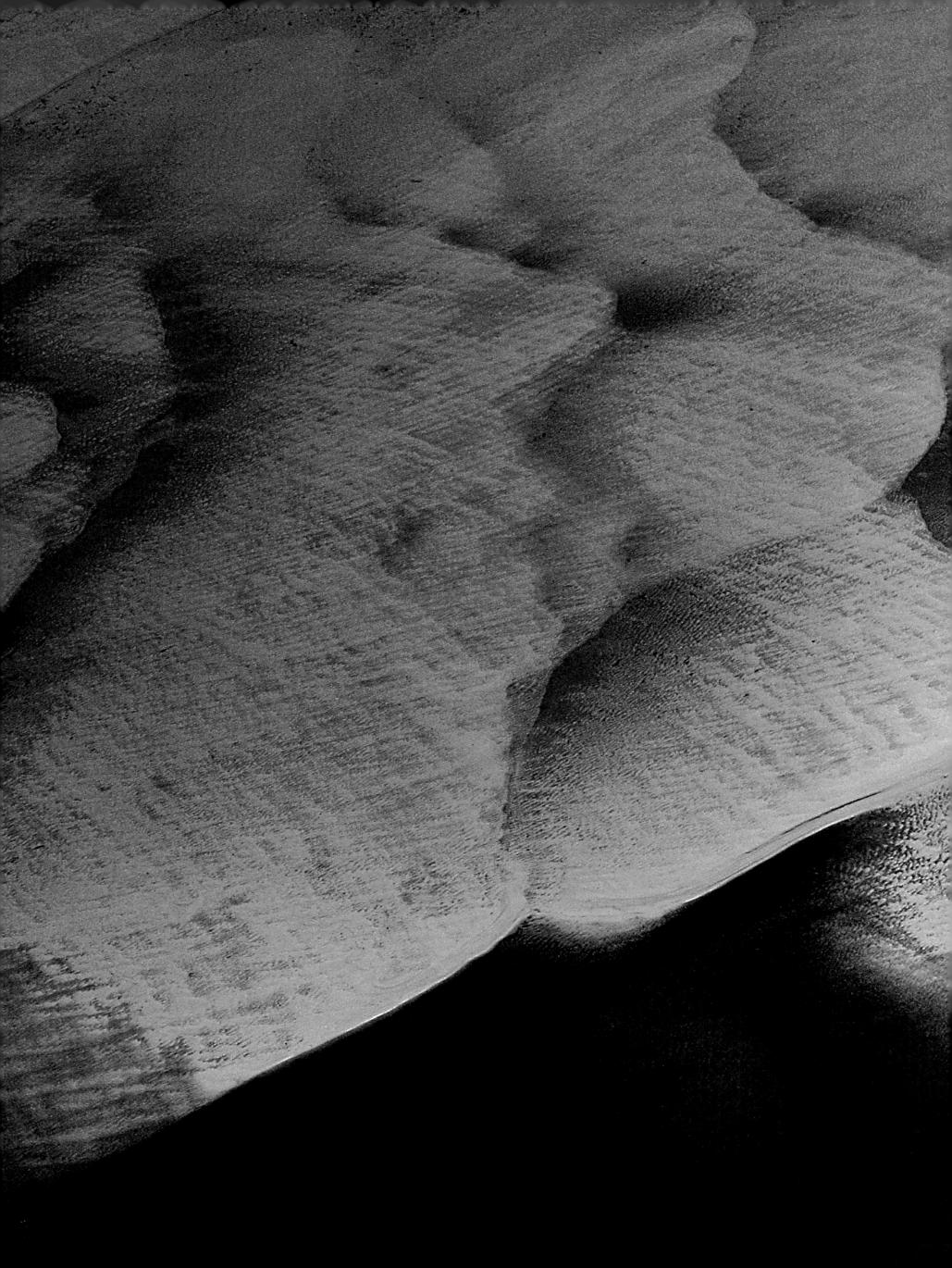

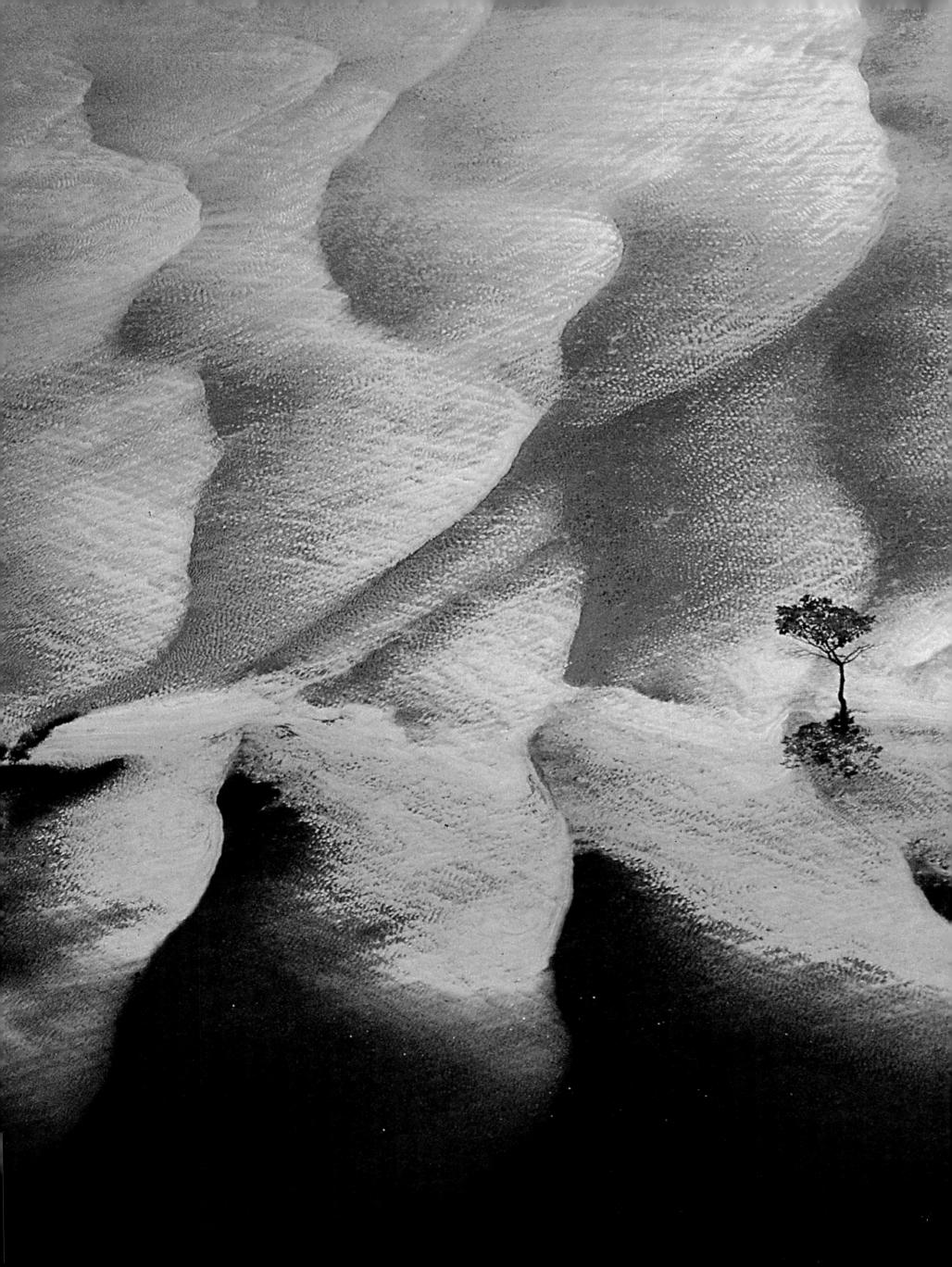

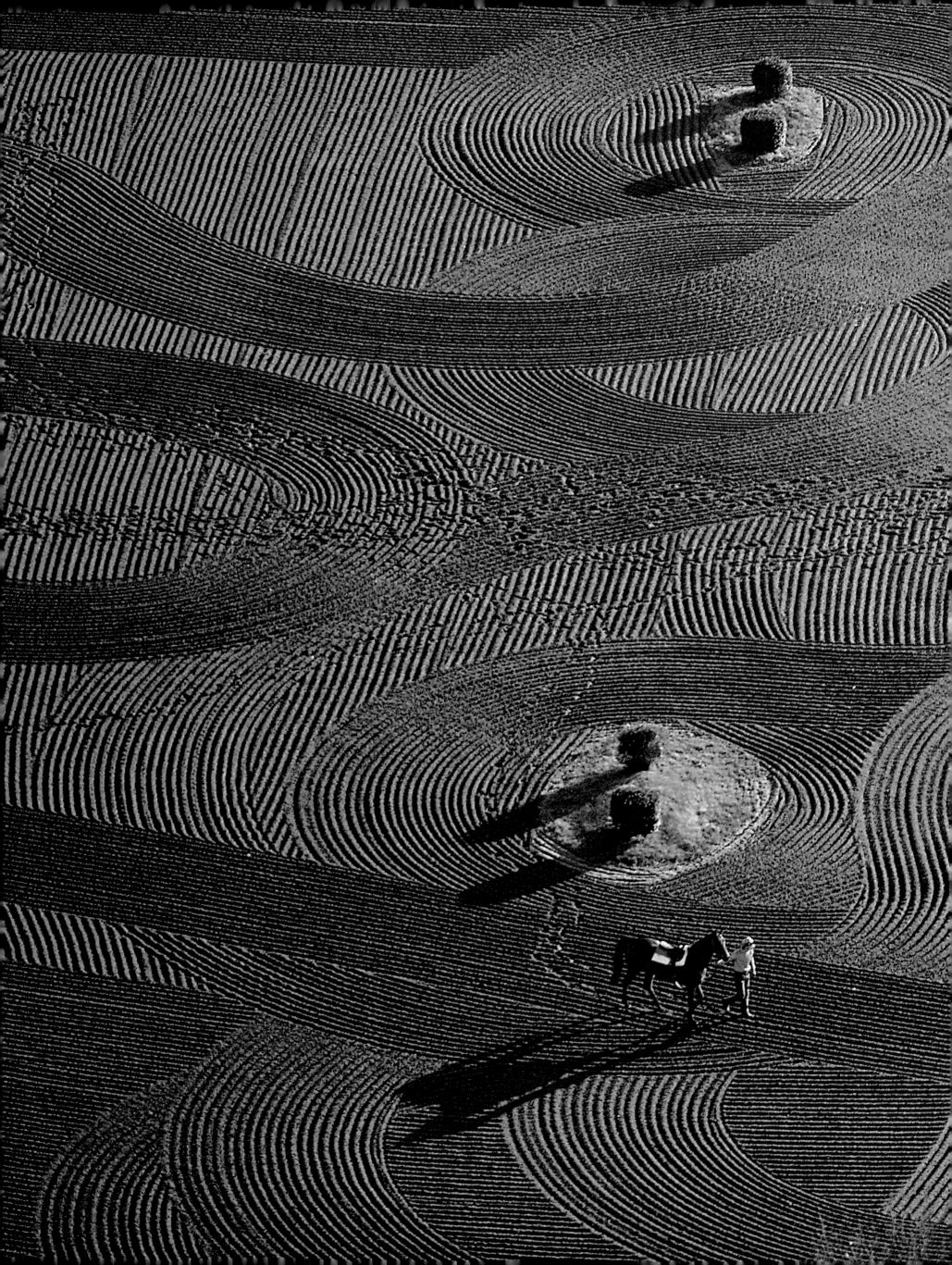

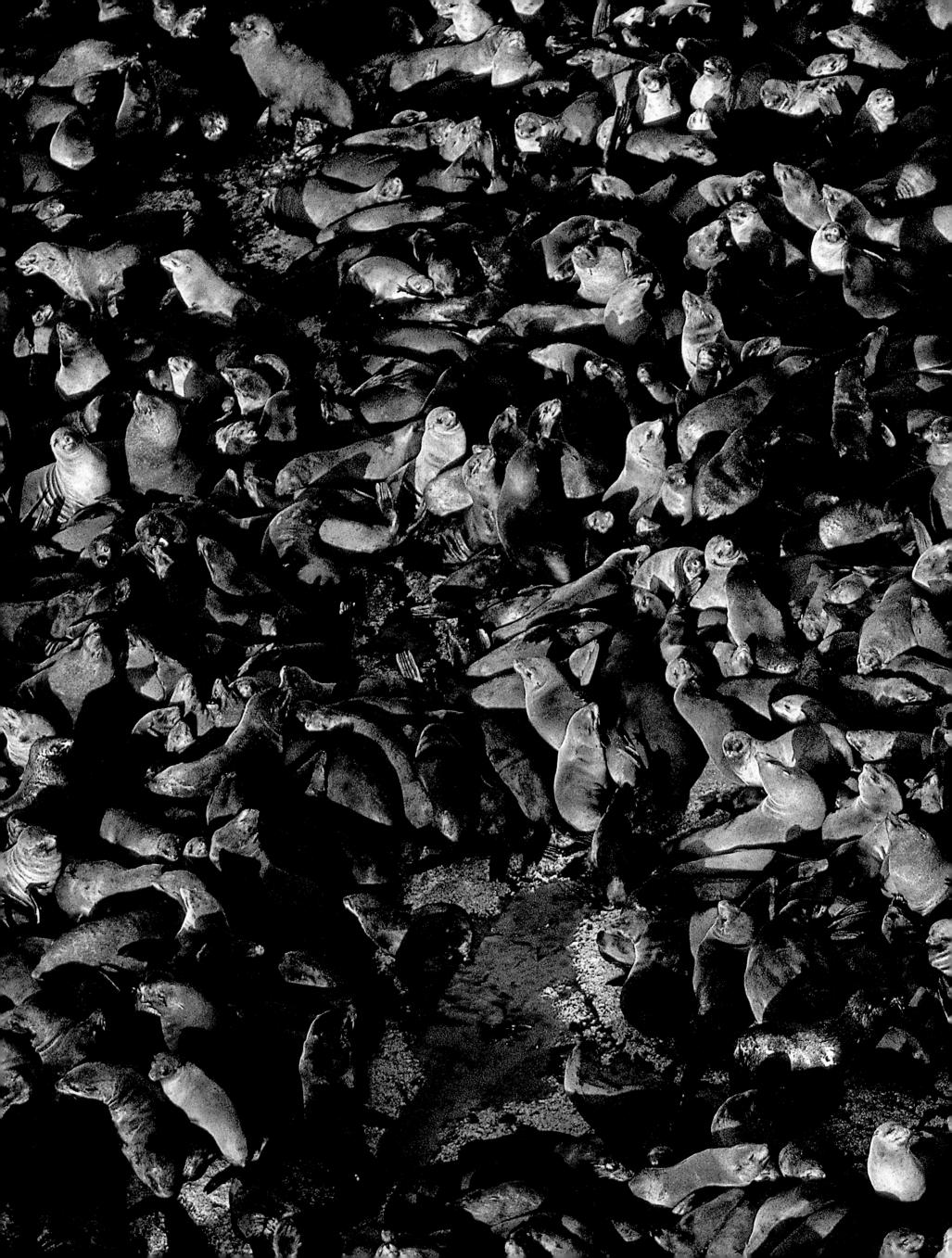

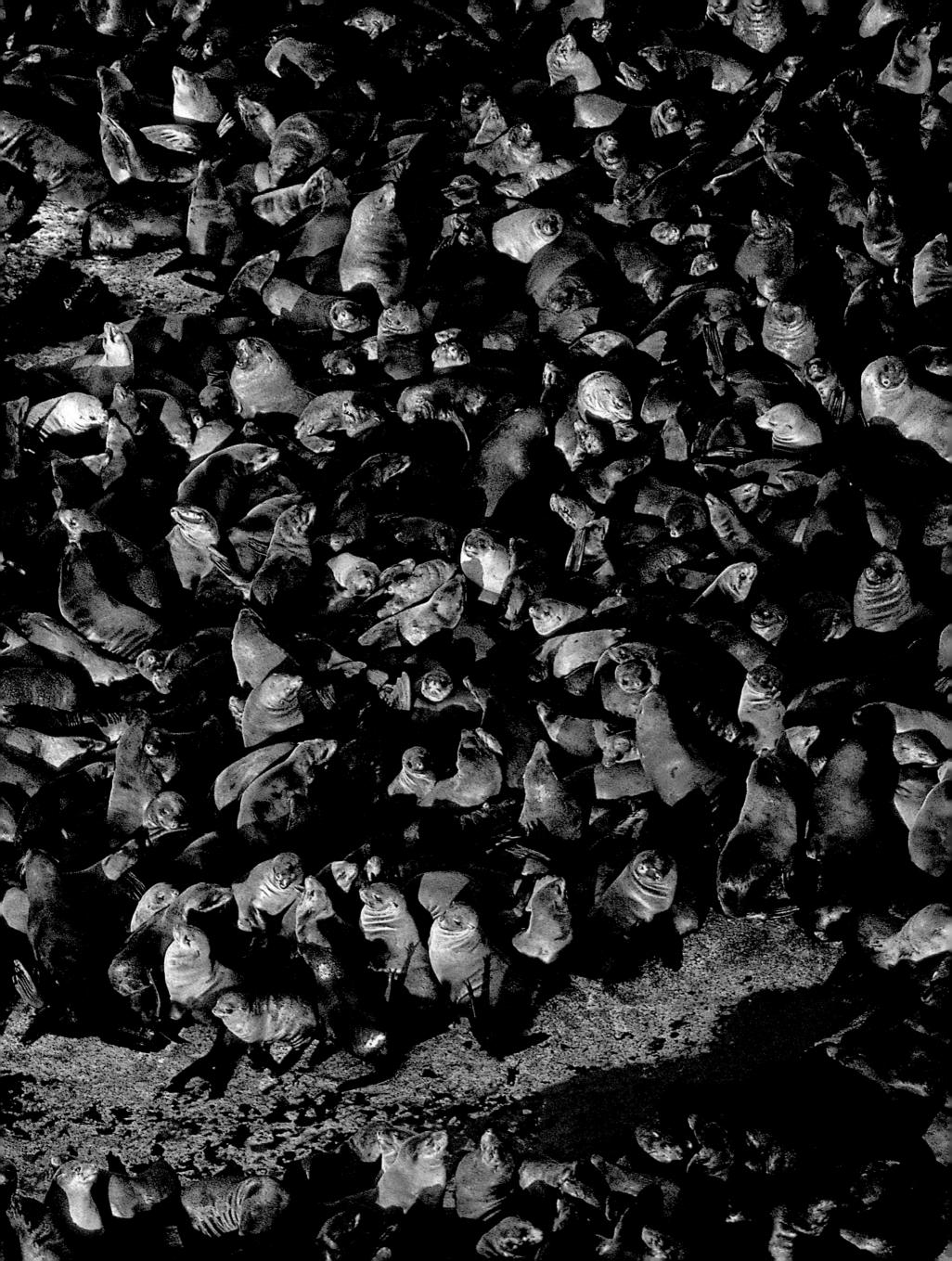

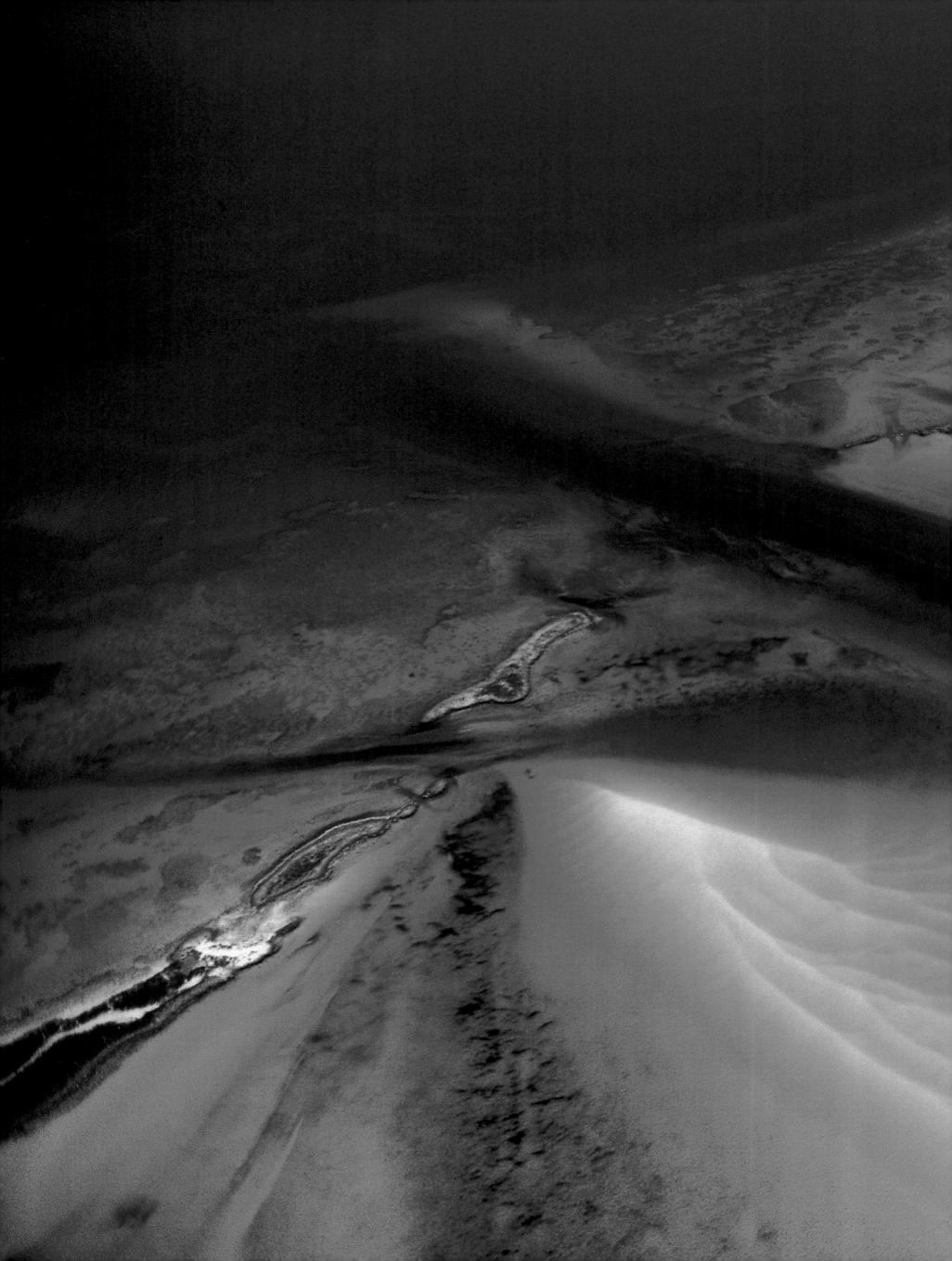

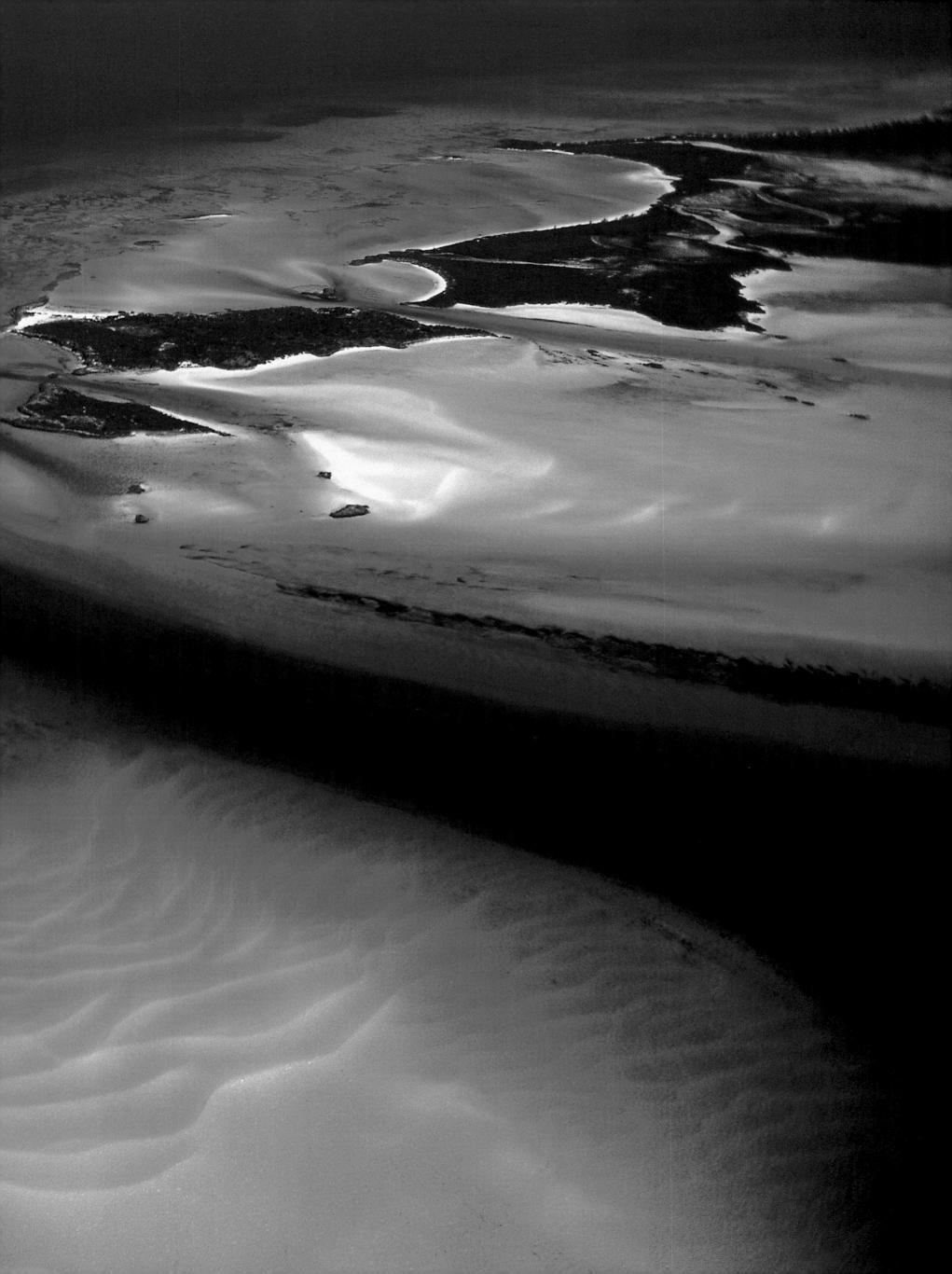

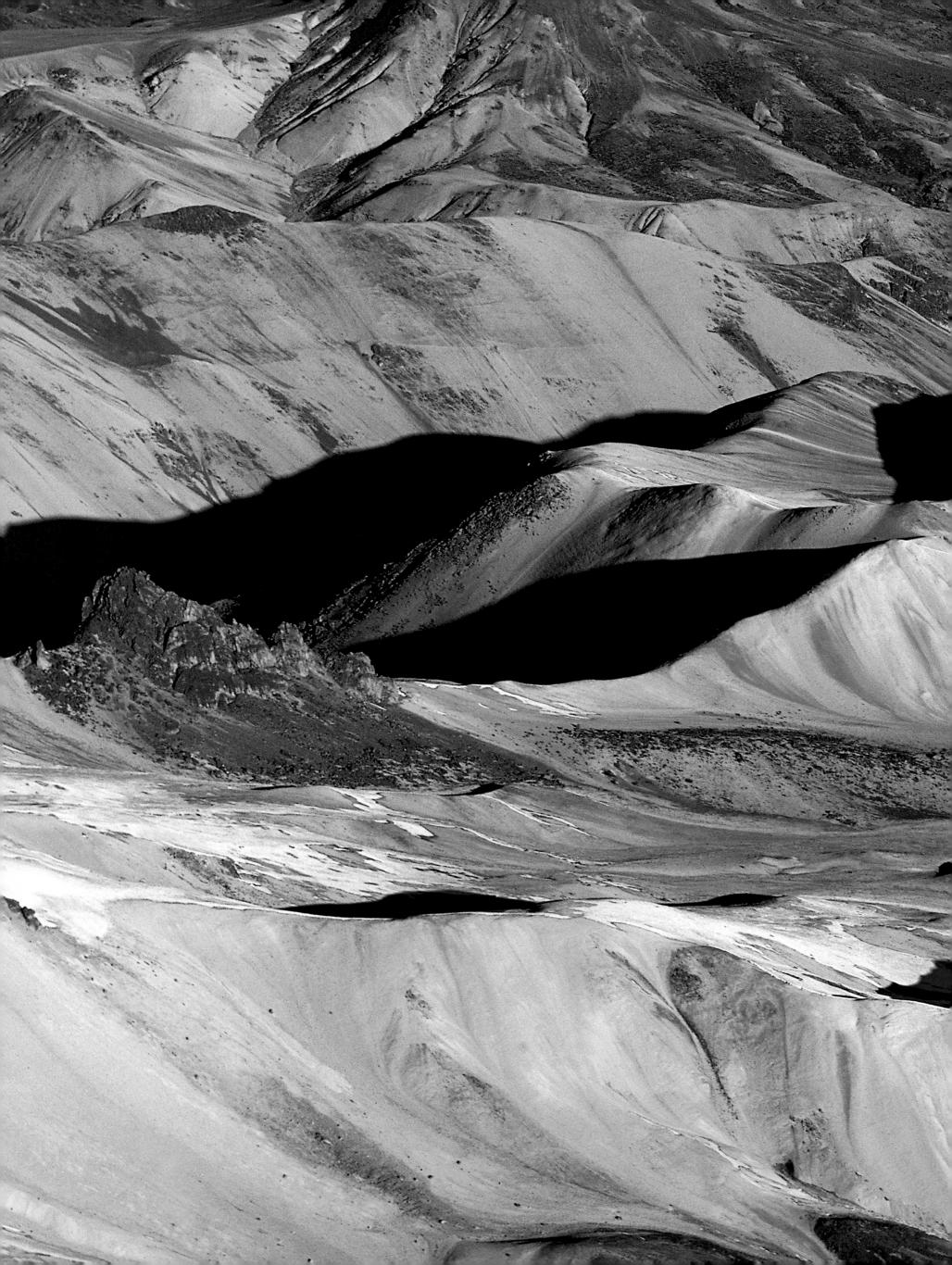

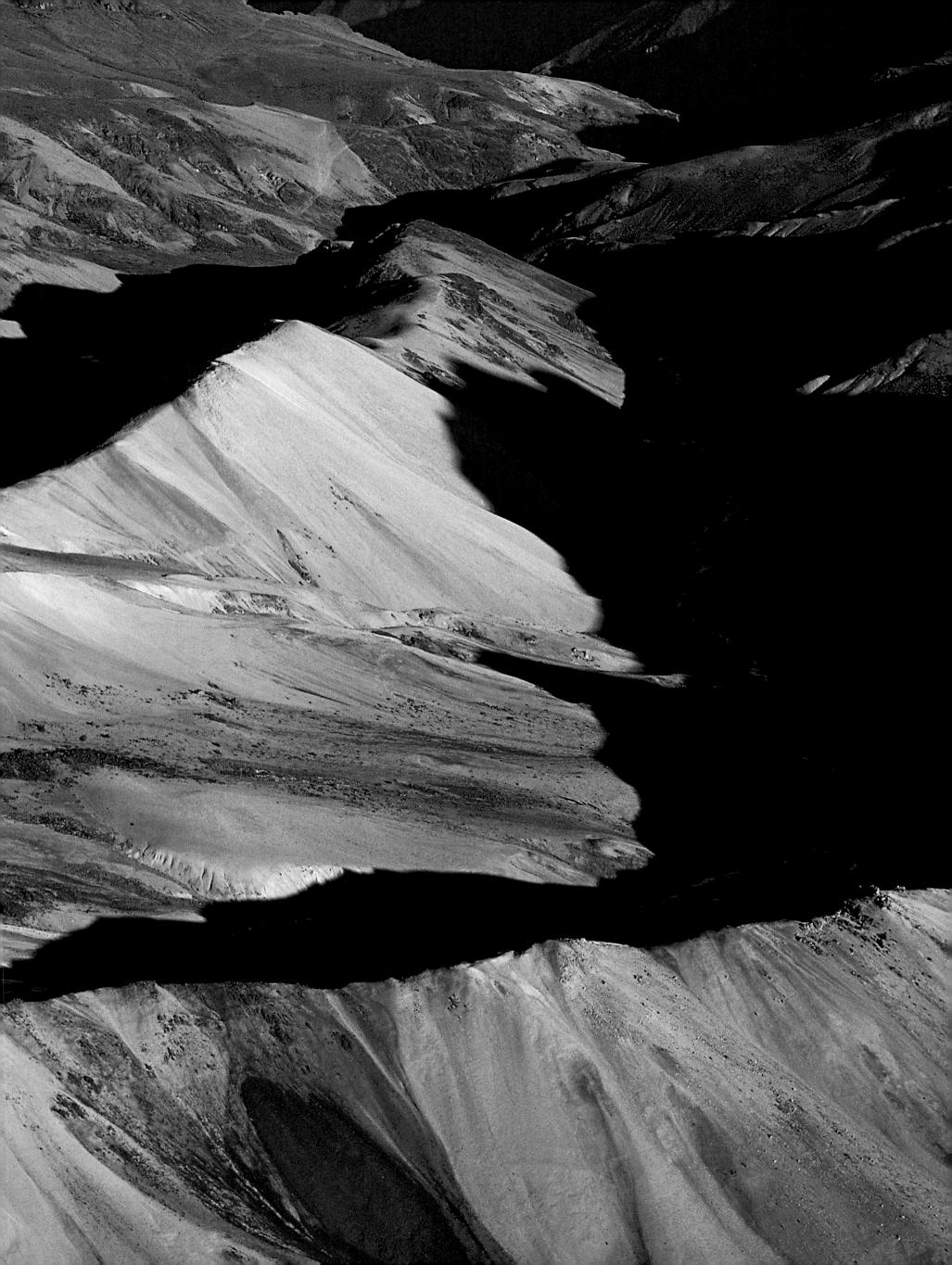

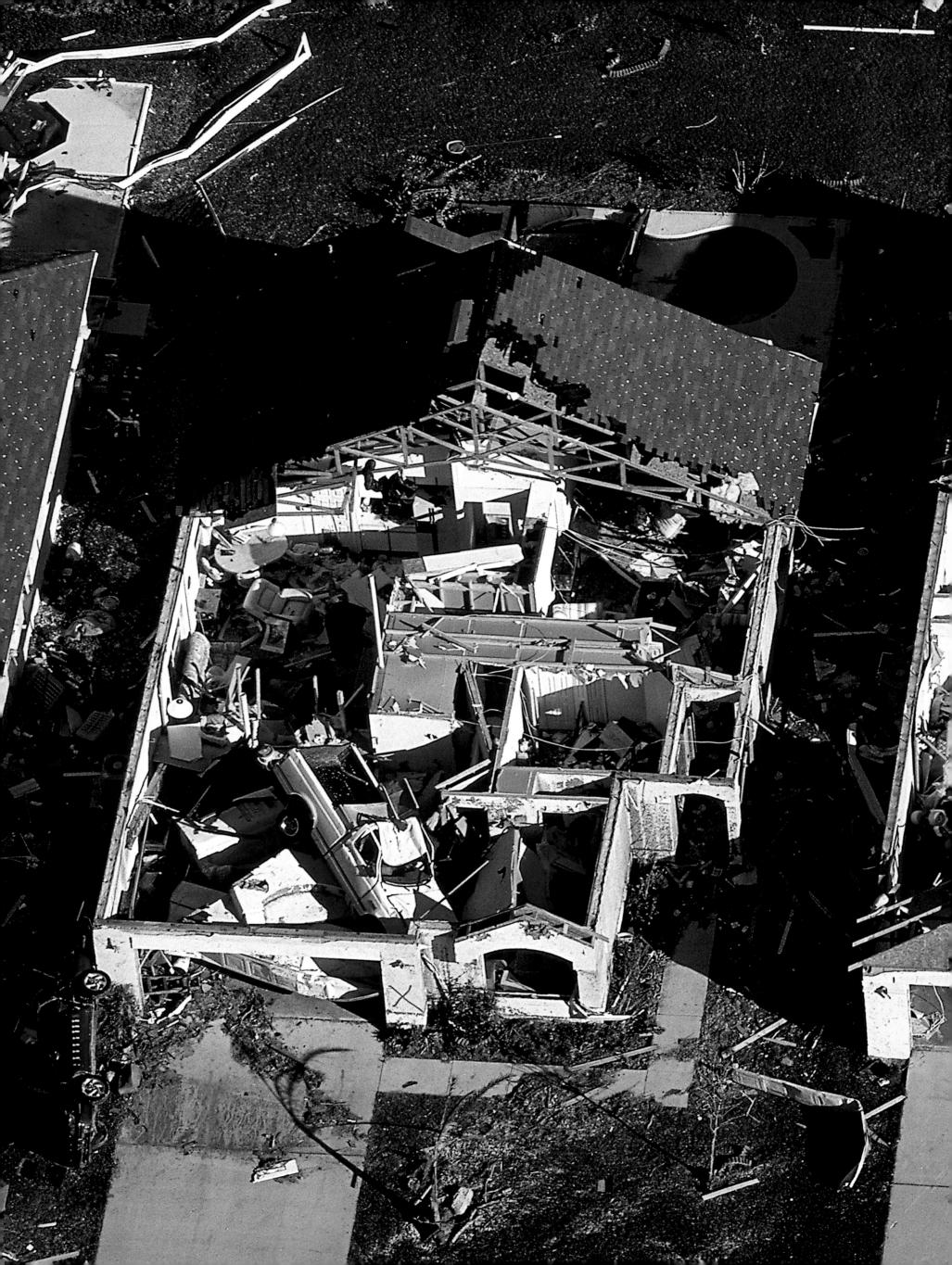

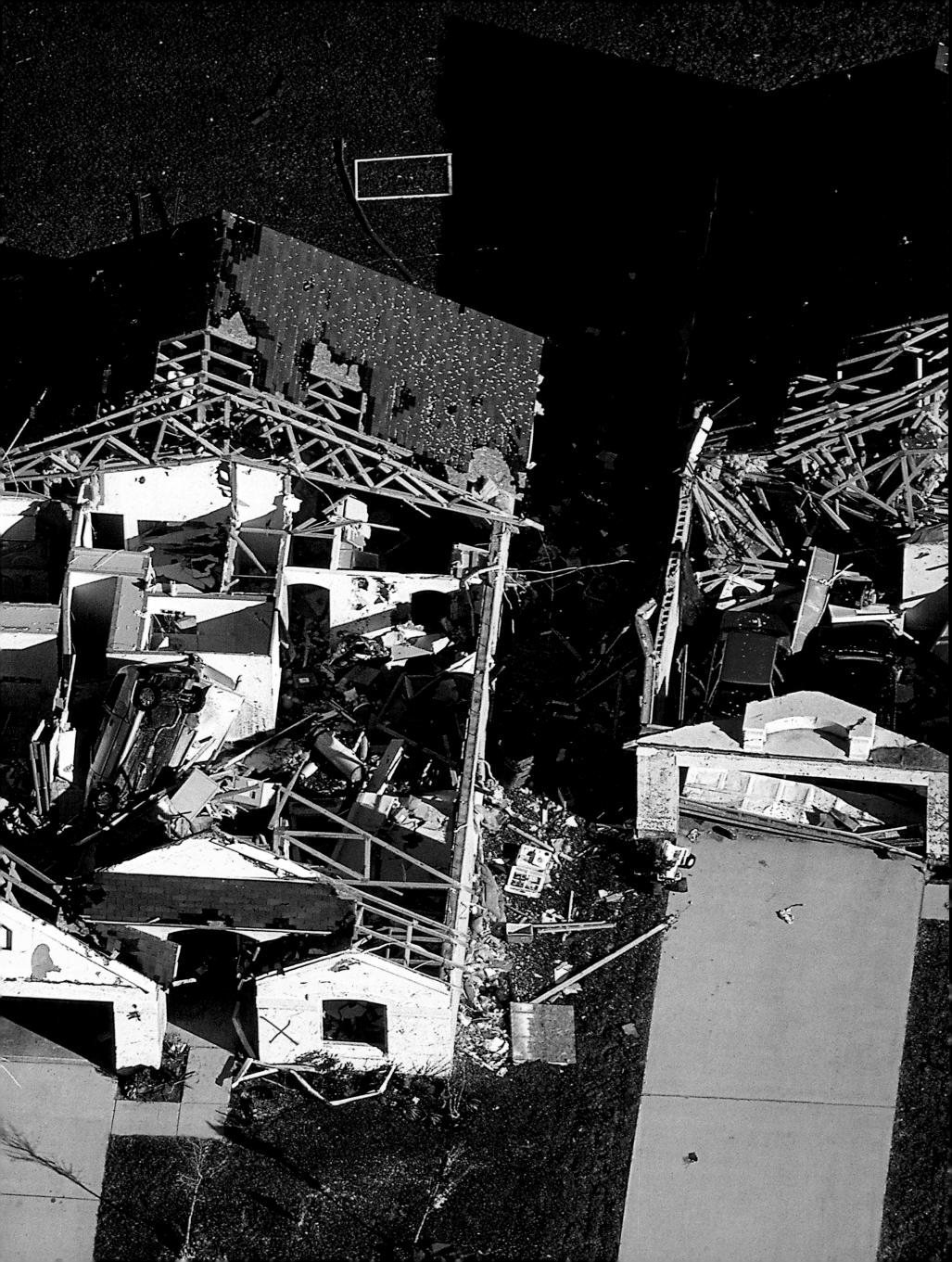

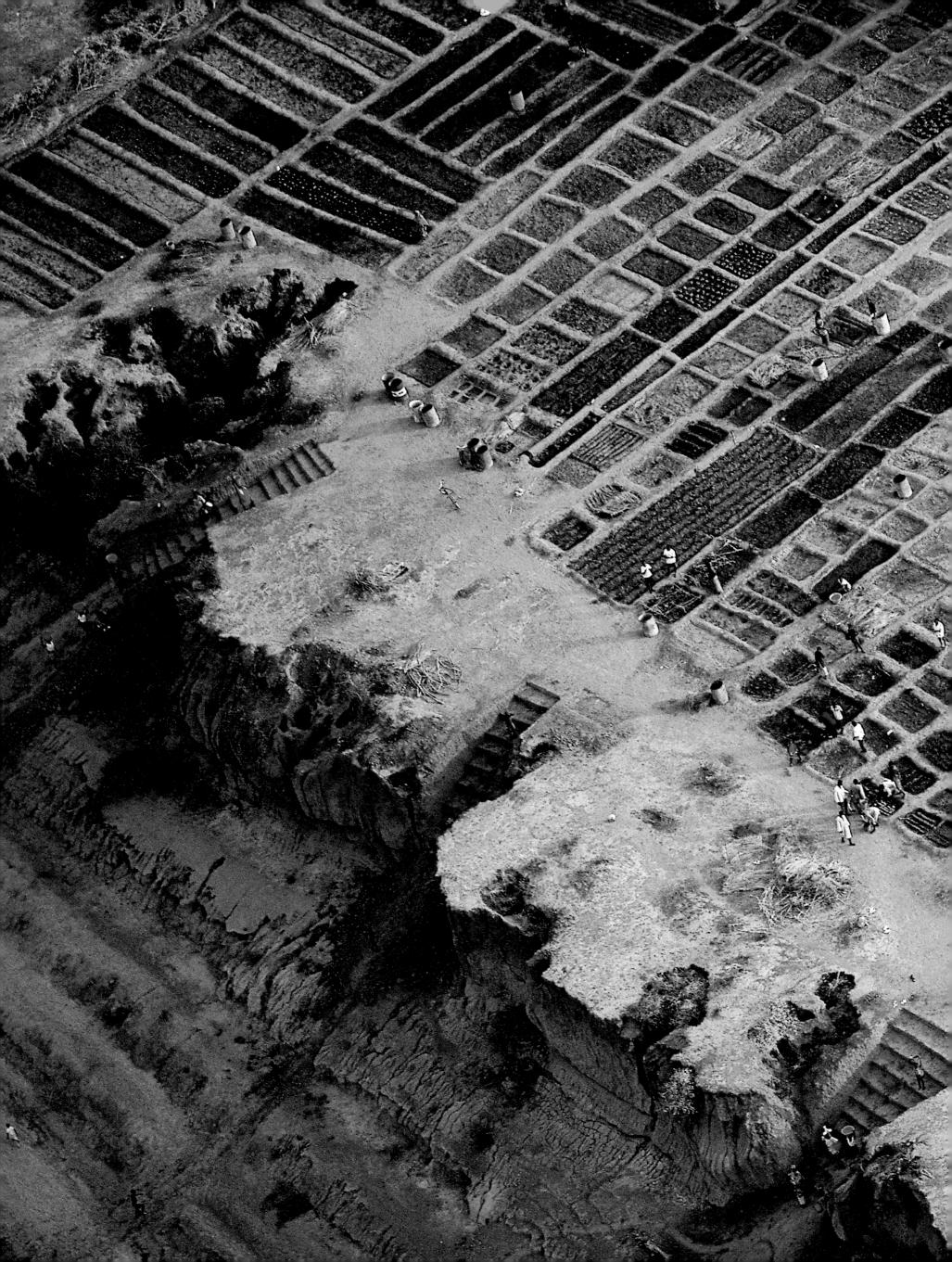

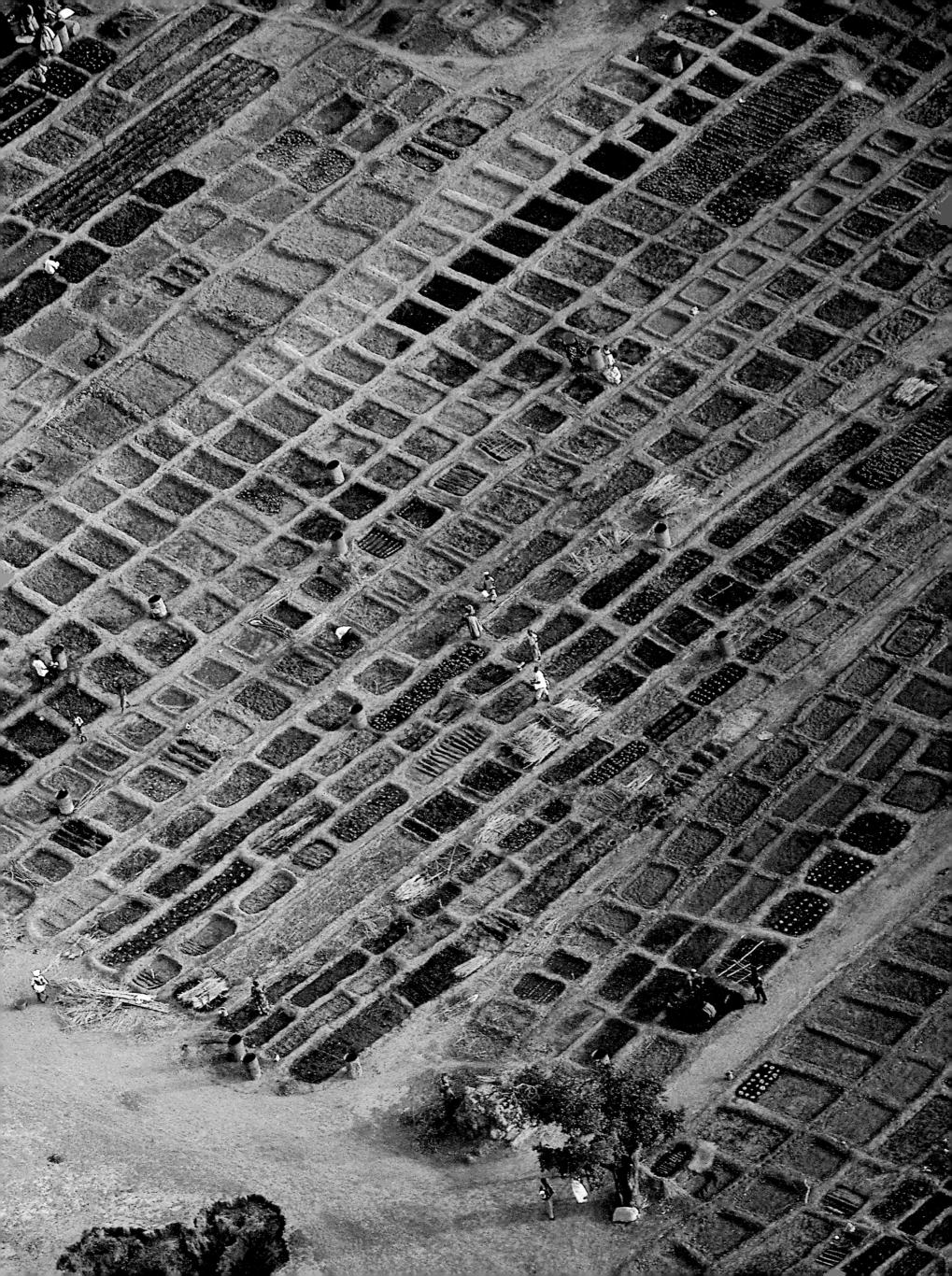

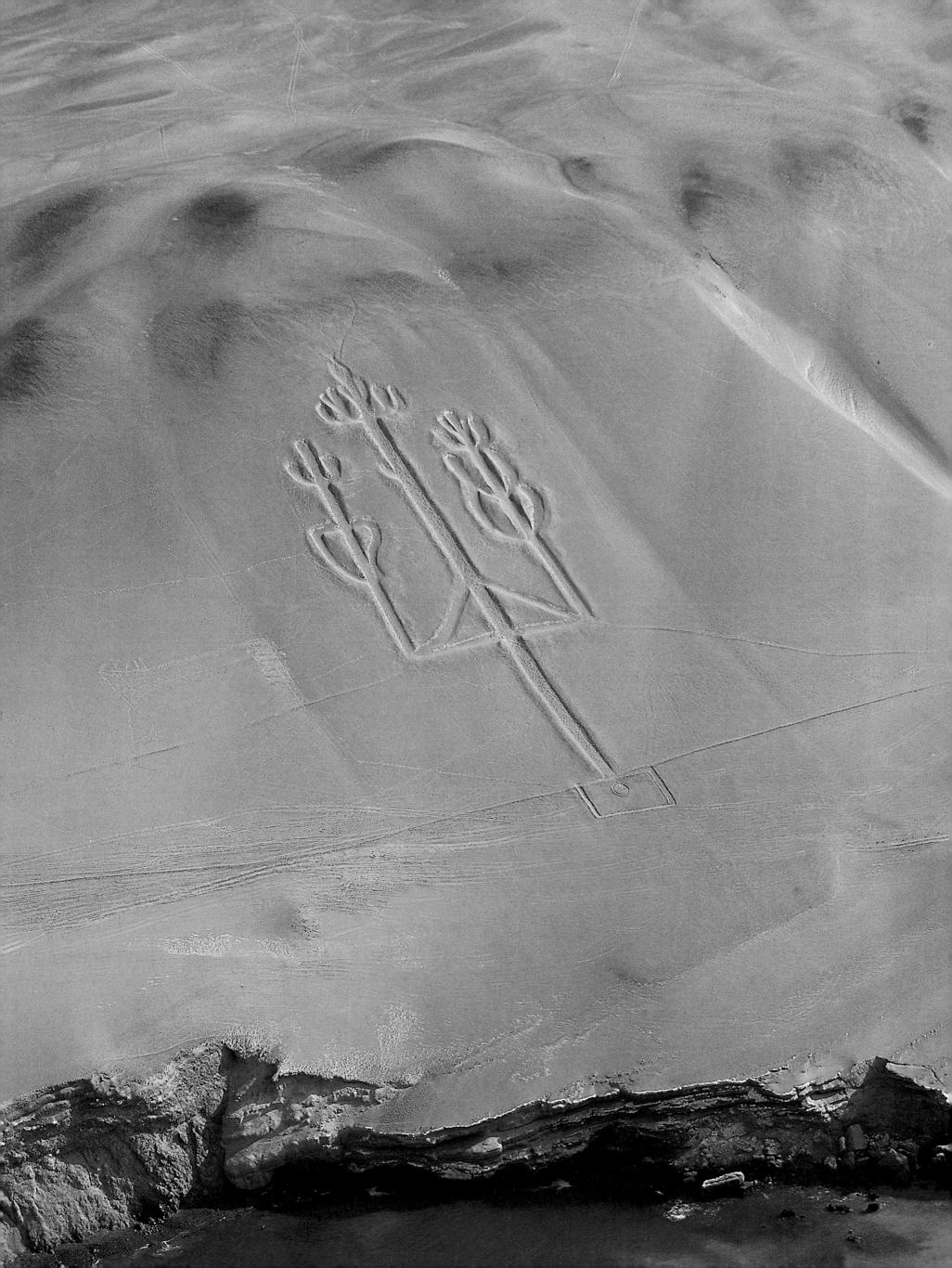

A WOUNDED ENVIRONMENT

between human activities and the biosphere, the living terrestrial world as a whole, is both global and irreversible. It affects immense populations: 4 million people were exposed to the nuclear catastrophe of Chernobyl in 1986; 20 million experience the smog of Mexico City; 60 million, in India and Bengal, are at risk from floods, a threat aggravated every year by the deforestation of the Himalayan slopes; more than 200 million could have their lives shattered by the rise in the ocean level by the end of the twenty-first century; and the depletion of the ozone layer, which protects life from excessive ultraviolet rays, concerns every one of us.

p. 248 CANDELABRA OF PARACAS PENINSULA, Peru

Commonly referred to as the "Candelabra," this design some 650 feet (200 m) high by 200 feet (60 m) wide is carved in the cliff of Paracas Peninsula on the Peruvian coast. Specialists believe that it depicts a cactus or the Southern Cross constellation. Although it shows some similarities with the famous designs at Nazca about 125 miles (200 km) southeast of here, it is the product of an earlier civilization, that of the Paracas. A Paraca necropolis was discovered in the region, with 429 mummified corpses, or funeral *fardos*. The Paracas, known for their textiles, embroidery, and pottery, were primarily a fishing people. Their civilization faded out about 650 B.C. The Candelabra, visible from far out at sea, was a navigational landmark, as it still is today for boats cruising off the peninsula.

FROM AGRICULTURE TO MONOCULTURE: THE END OF NATURE?

After ten millennia of development, agriculture has, in the past half-century, become a virtual mining activity. Since the end of World War II, an immense agricultural effort has quadrupled the production of grain in the world, but this success has its flip side. During the same period, the quantity of pesticides has multiplied by a factor of twenty-five, and the amount of synthetic fertilizers has grown from 14 million to more than 160 million tons. The ecological effect is severe: untimely clearings, destruction of soils, and water pollution.

We see everywhere the triumph of synthesized ecosystems, the functional units of the living world such as a forest, a lake, or a prairie. The "cultivated" forest and the "agrosystems" (cultivated ecosystems) are replacing nature. More and more high-risk monocultures exist. In all of Southeast Asia, the IR-36 variety of rice occupies two-thirds of the rice paddies. Today, twenty-nine species of plant provide more than 95 percent of human consumption all over the world, as opposed to a hundred species at the beginning of the century.

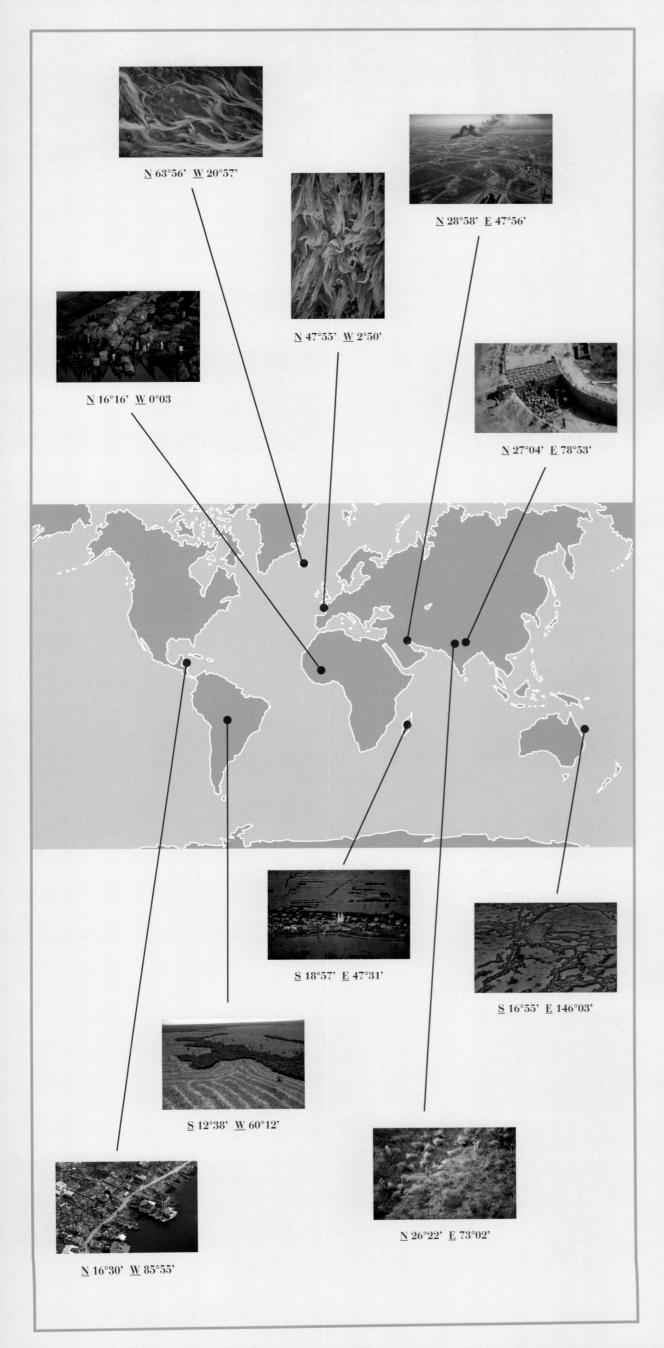

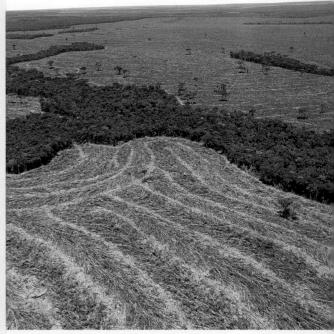

is a determining factor in the erosion of uction of many living species. This is one cular proofs of the planetary ecological vas one of the major issues in the famous ld in Rio de Janeiro, Brazil, in 1992. The rsity originates in intensive agricultural ally in the disappearance of tropical rain ts shelter more than 50 percent of the species of the globe. One reason among it the intertropical zones have been less latitudes to the great climatic shifts that h geological period.

he result of more than 3.6 billion years sters the future evolutions of life, but it is I toward extinction. The earth has already eriods of ecological upheaval that set off tinction. Today we are in the sixth great Evidence suggests that the dual effect of e industrialization of agriculture plays a mean that humanity alone is responsible.

VD SOILS IN DANGER

n essential resource for agriculture. Agrifor three-fourths of its consumption globveloping countries, for nearly all of it (92) percent in China, 90 percent in India a tion is already encountering serious s regions of the world: northeastern Africa sula; northern China; the plains of the In Great Plains in the United States, where gation now depends on the water of the Irrigation systems often suffer from lack of our regions are affected by the salination percent of irrigated lands), Pakistan (America (40 percent), and North America (40 percent), and North America (40 percent).

The ecological costs of agriculture a the size of interferences in the biogeoch cially those of nitrogen and phosphorus by runoff waters or drained toward groun sible for massive pollution in all regions to intensive systems of agriculture and I

Long considered as a receptacle for nite dilutive capacities and as an inexhaus resources, the world's oceans are also so Coastal zones such as estuaries and con among the ecologically richest and most the outlets of polluted rivers, these zone degraded. The accelerated extinction of o

THE NEW VOLCANISM AND URBAN INDUSTRY

The most spectacular changes, however, have been caused by the growth of heavy industries (chemistry, metallurgy, and energy, for example). Poorly controlled technological innovation or criminal negligence accompanies the quest for profit "at any price." This can lead to tragic consequences: in the 1950s in Minamata, Japan, mercury used by the paper industry killed several hundred people; dioxin pollution caused tremendous harm in Italy in 1976; the wreckage of the *Amoco Cadiz* in France in 1978 and the sinking of the *Exxon Valdez* off the coast of Alaska in 1989 created enormous oil spills and immense ecological damage. The dissemination of products such as DDT and other pesticides, explosive agents, asbestos, and radioactive elements are also causing the deterioration of the environment.

Pollution of the atmosphere has reached disastrous proportions. After World War II the industrial system created an artificial volcanism. Atmospheric pollution in the last twenty years of the twentieth century has become an enormous problem in emerging industrial nations such as China, where heavy industry relies primarily on coal. Several kinds of pollutants are having a growing effect on the biosphere, including the colossal quantities of air emissions from the combustion of various forms of fossil fuel: carbonic gas, which is not a direct health threat but causes global warming; carbon monoxide; unburned hydrocarbons; nitrous oxides; sulfur dioxide and trioxide, the source of acid rains that affect many forests, especially in Europe and North America. The effect of atmospheric micropollutants and diverse particles in the form of

aerosols is no less harmful. And the radioactive fallout of nuclear accidents has particularly dramatic consequences. With the Chernobyl catastrophe of April 26, 1986, human history entered a new phase.

The growth of automobile traffic is a factor in specifically urban forms of air pollution. Despite the continuous improvement in engines, the growing number of cars in circulation and the increase in highways are making "automobile civilization" more and more dangerous to human health. If all of humanity attained the level of automobile use that exists in the United States, the total number of automobiles in the world would rise from 500 million to 3 billion. This is an intolerable scenario, considering its environmental effects. The start of the twenty-first century could mark the ephemeral apogee of an automobile civilization soon asphyxiated by its own success.

The question is now raised: after hundreds of thousands of years of evolution, are our societies now endangering the very conditions for life on earth?

Jean-Paul Deléage

p. 257

ALGAE IN THE GULF OF MORBIHAN, France

An epidemic in the 1920s decimated *Crassostrea angulata*, the most widely exploited oyster species in France. A Japanese species, *Crassostrea gigas*, was introduced and, involuntarily along with it, some thirty species of animals and algae that live today in the waters of the English Channel and the Atlantic Ocean. One example is the Sargasso (*Sargassum miticum*), which replaced local species here in the Gulf of Morbihan. It was feared that there might be a galloping proliferation, but this species, while becoming abundant, seems to have found its place in the ecosystem. The algae is nevertheless being carefully watched. Brittany has a sea coast of 1,700 miles (2,730 km), 70 percent of which is undergoing urbanization. It is the site of the Coastal Conservatory, which covers approximately 10,000 acres (4,000 hectares), more than half of which contains sites with an area of more than 250 acres (100 hectares).

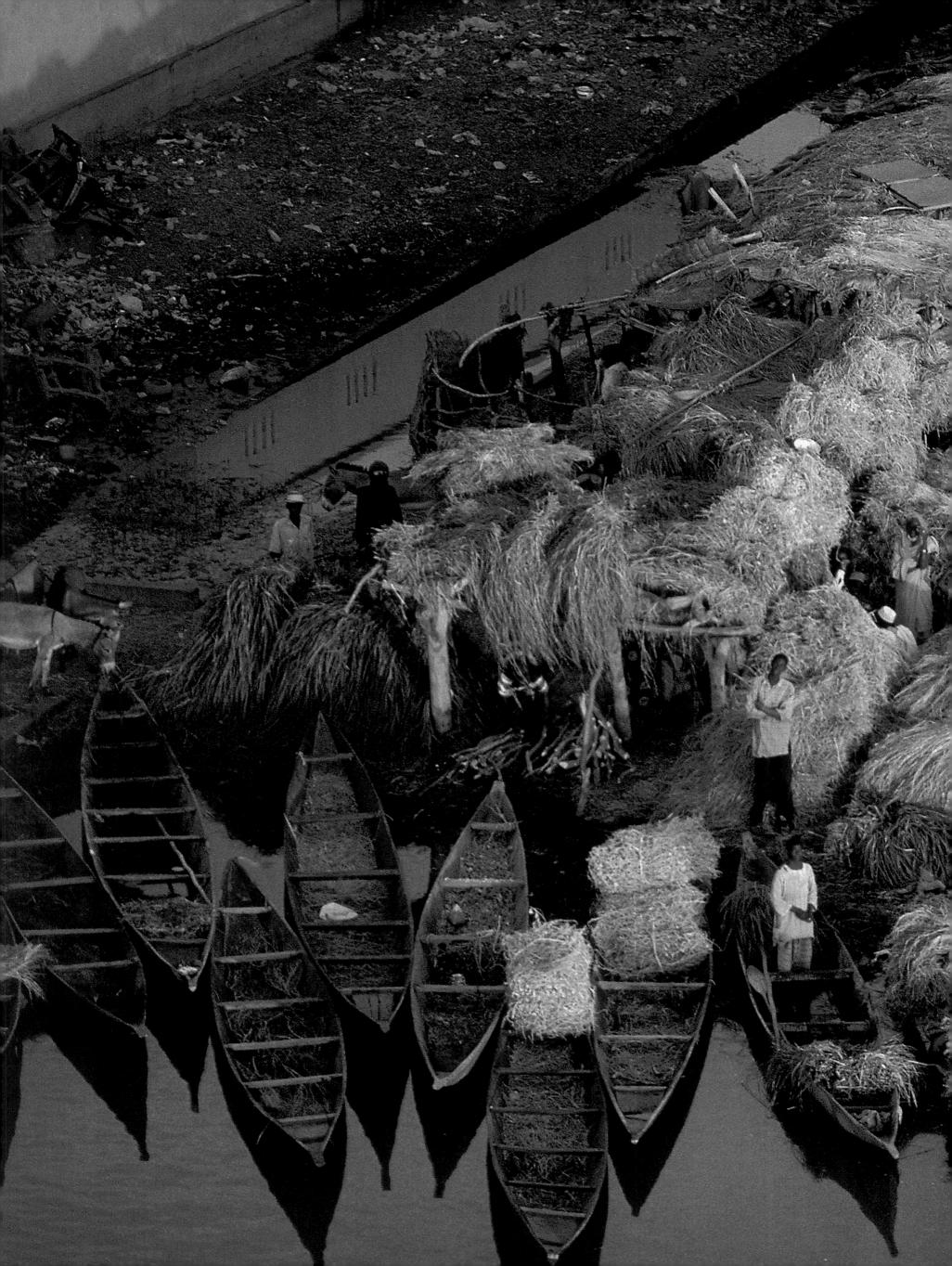

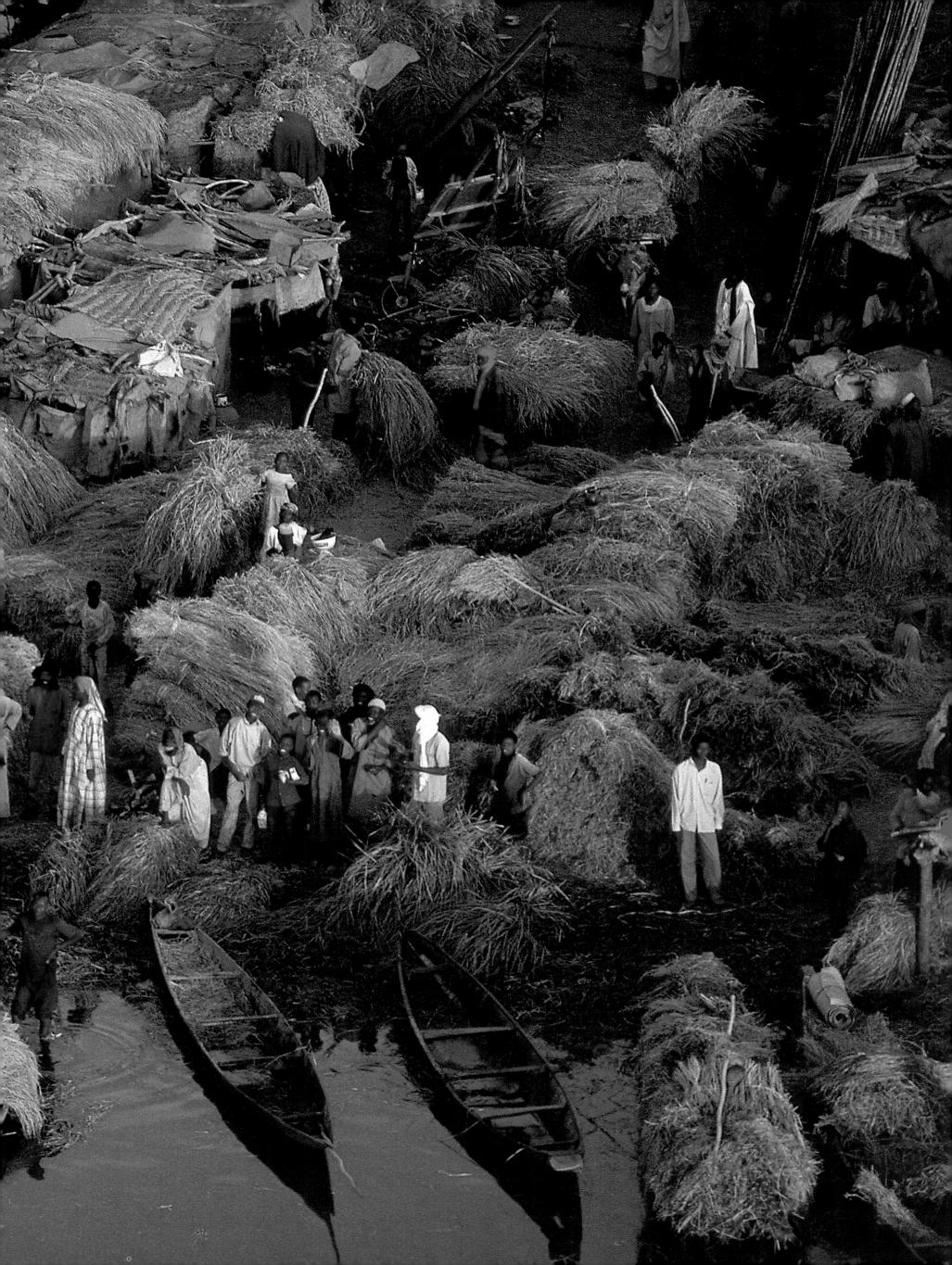

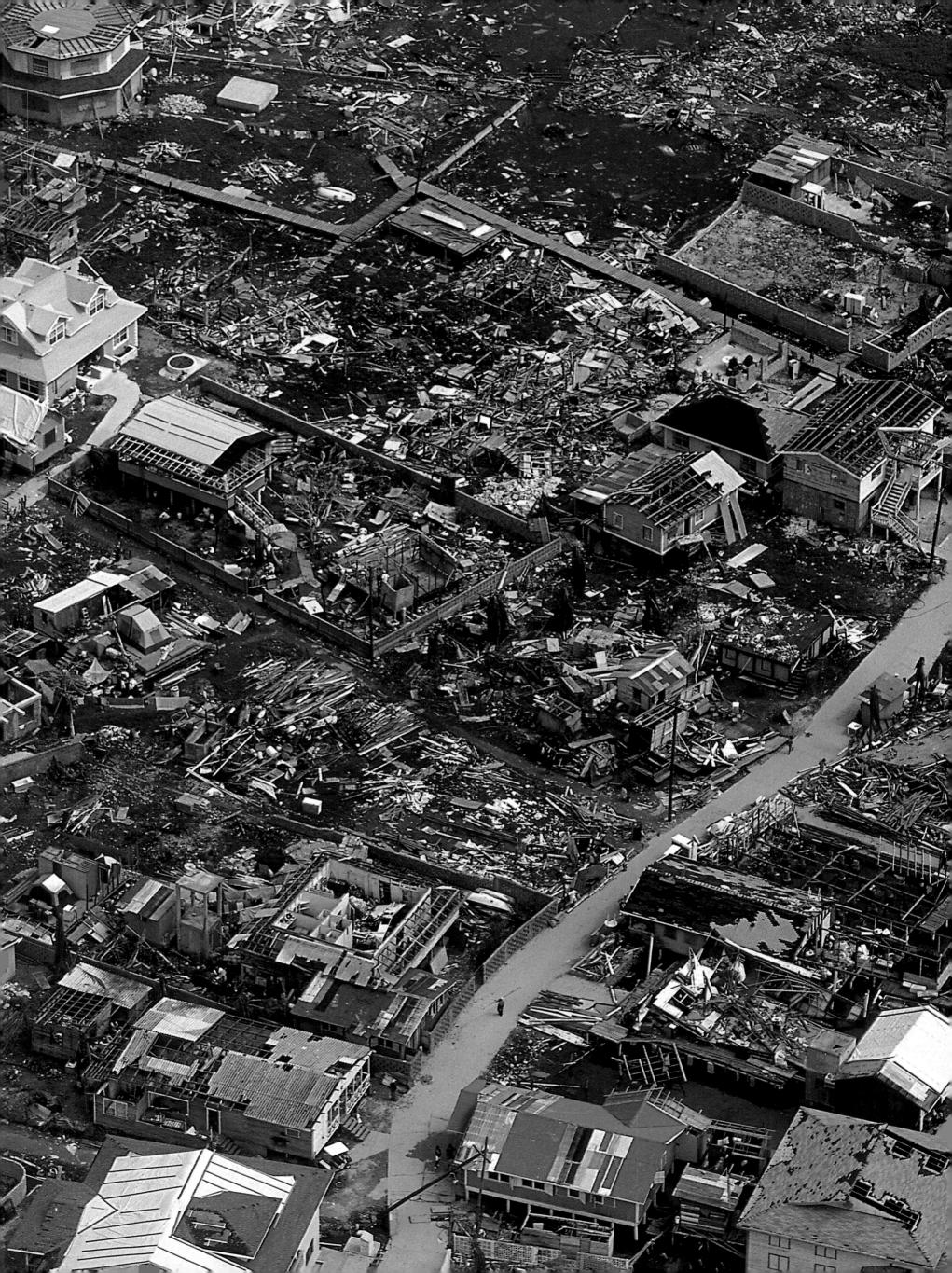

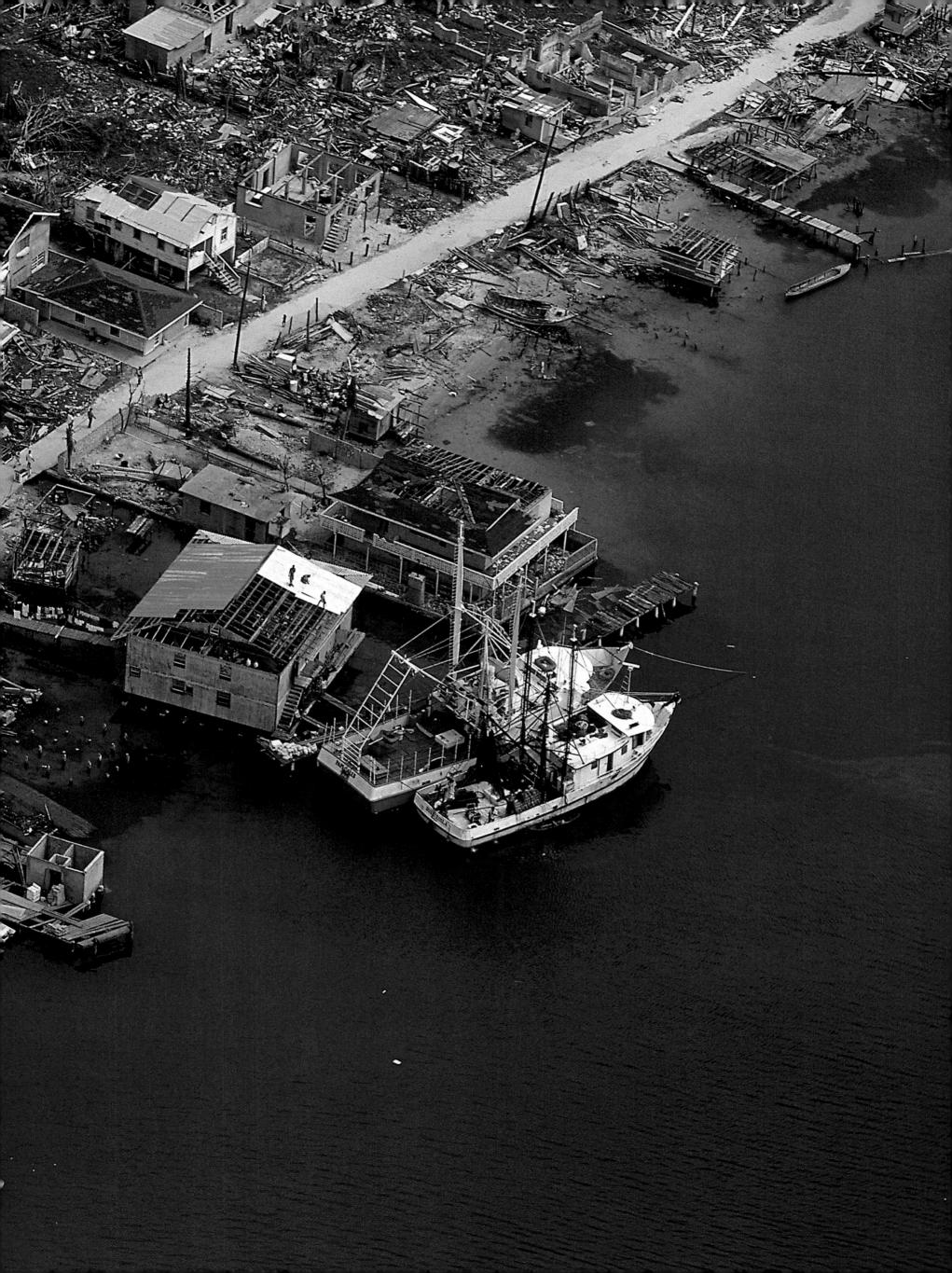

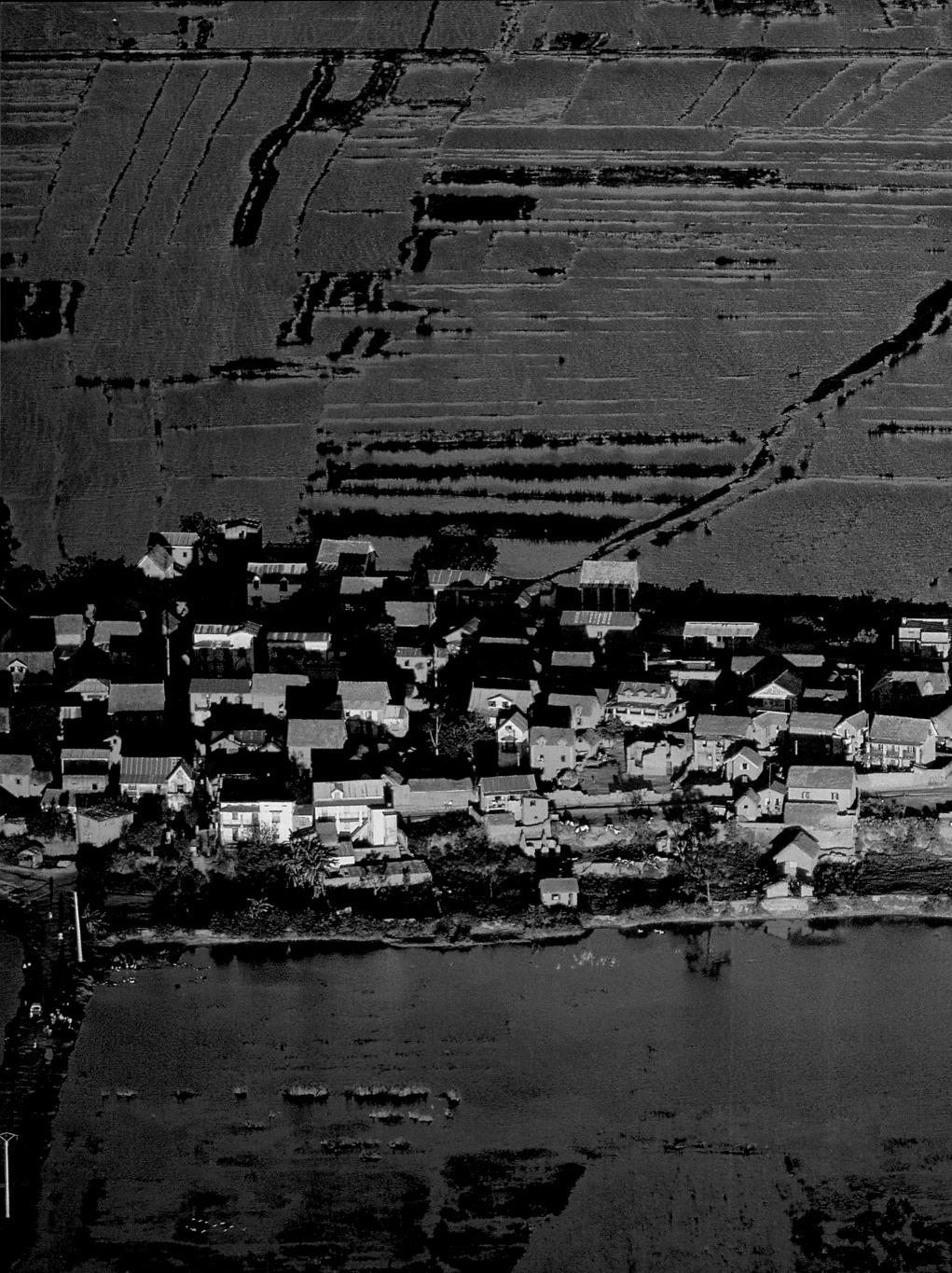

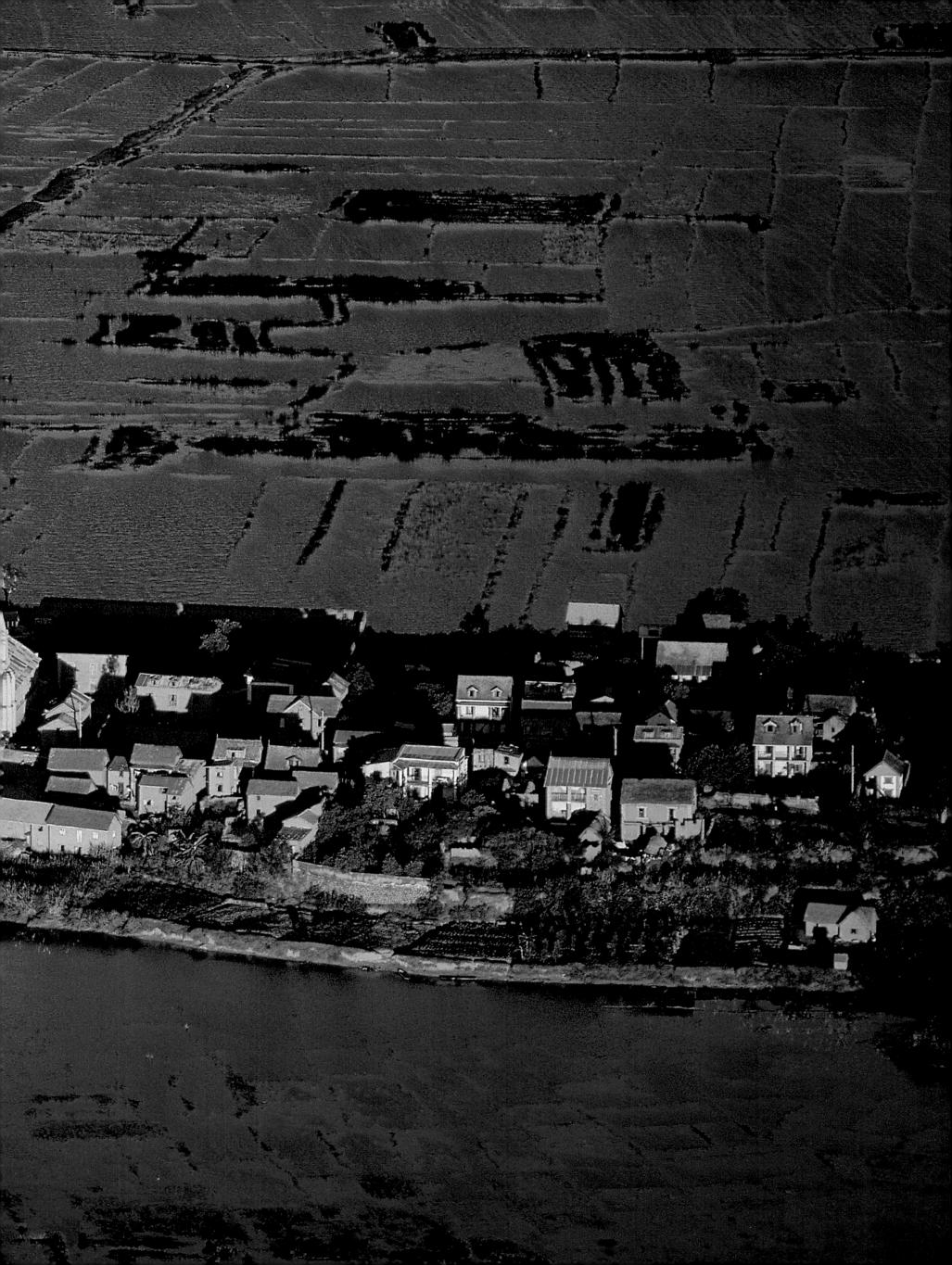

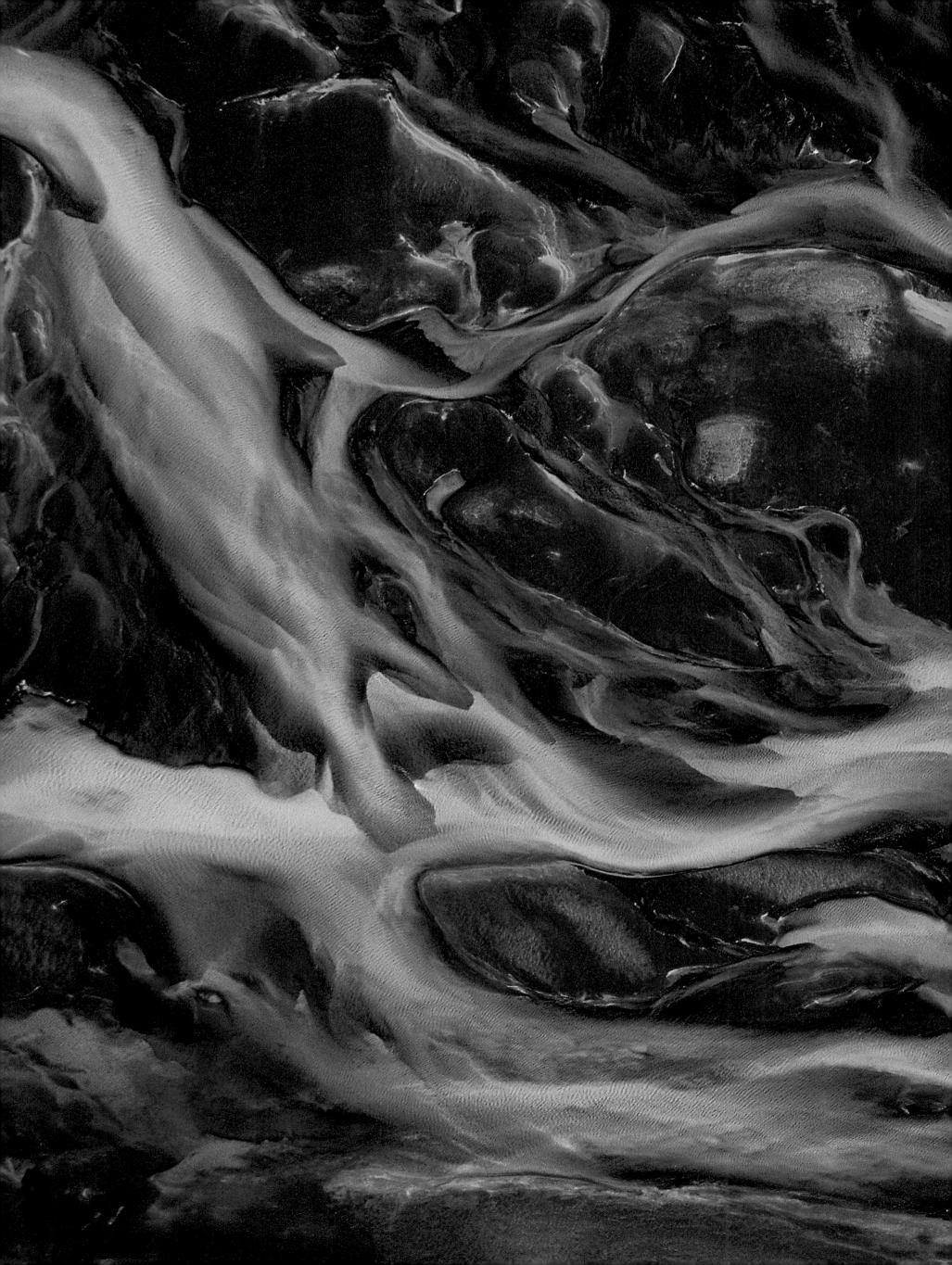

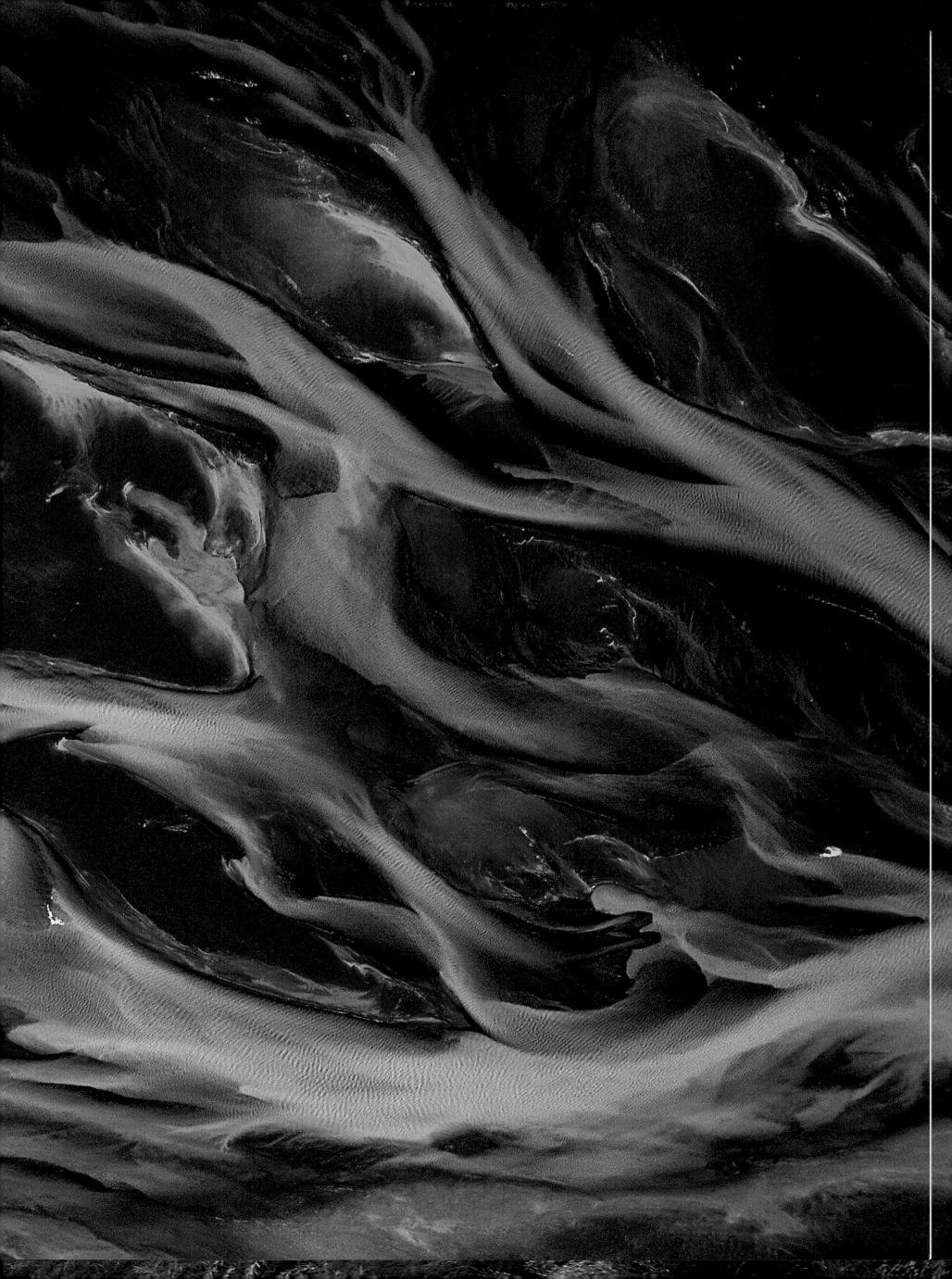

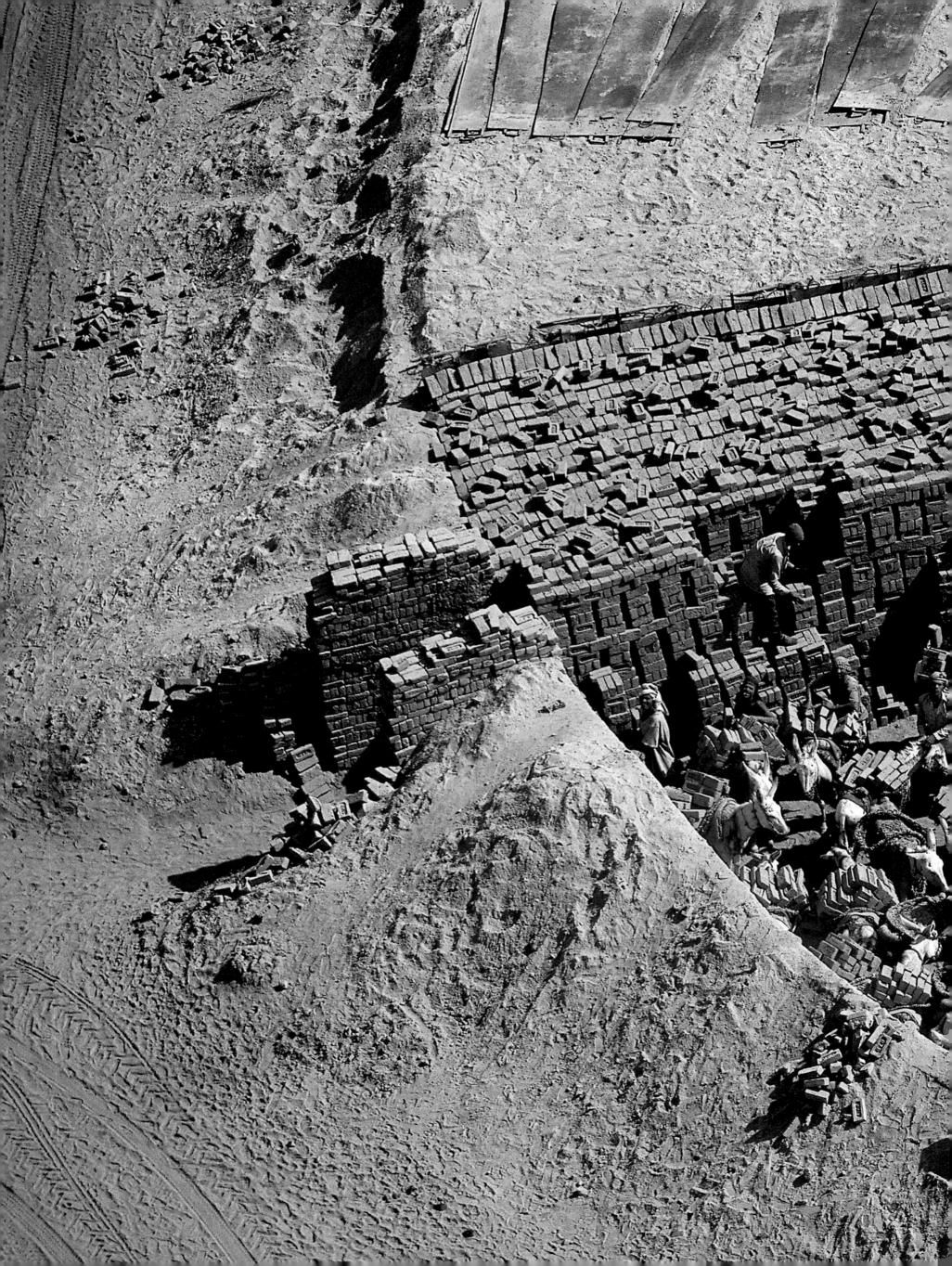

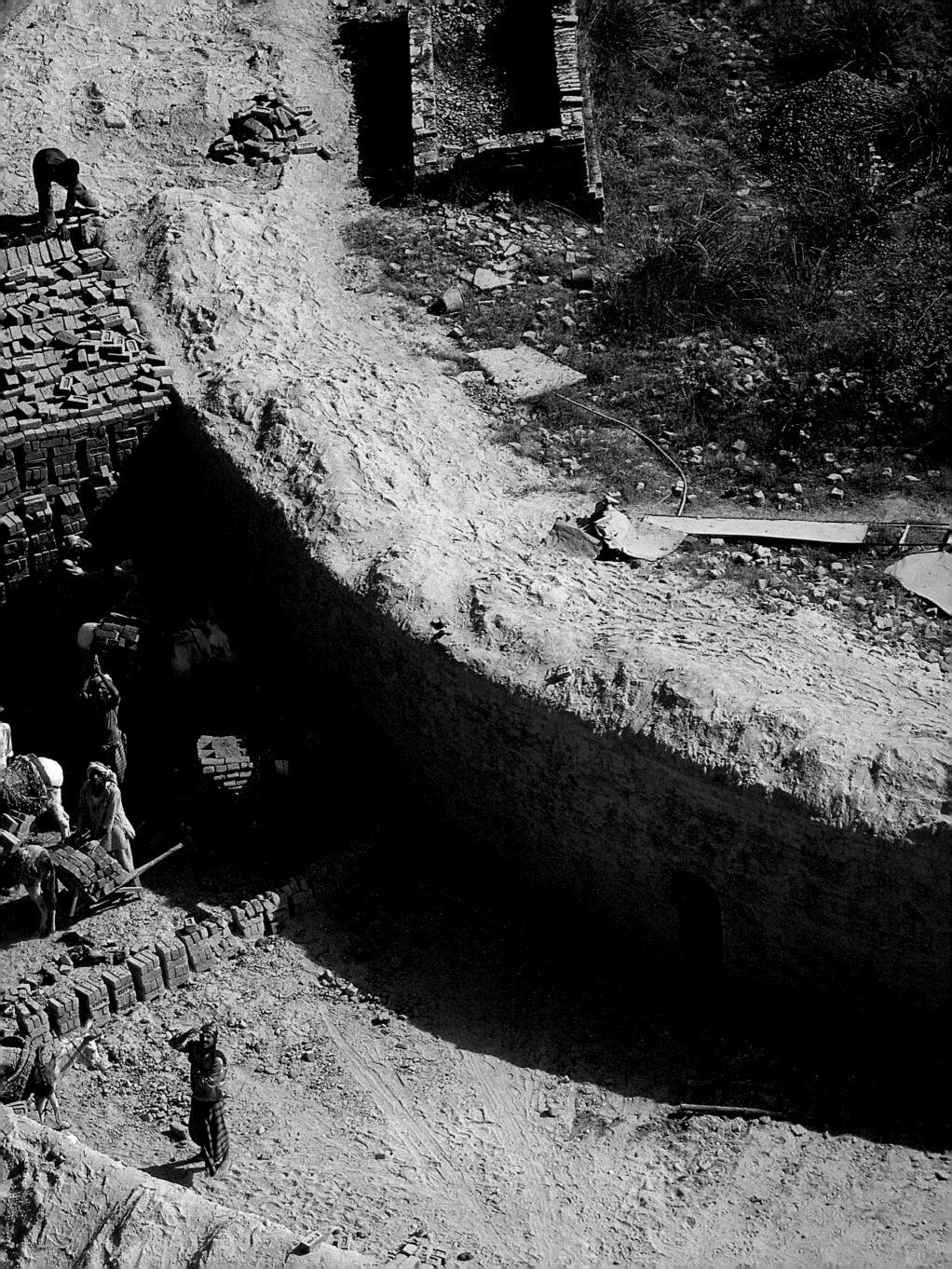

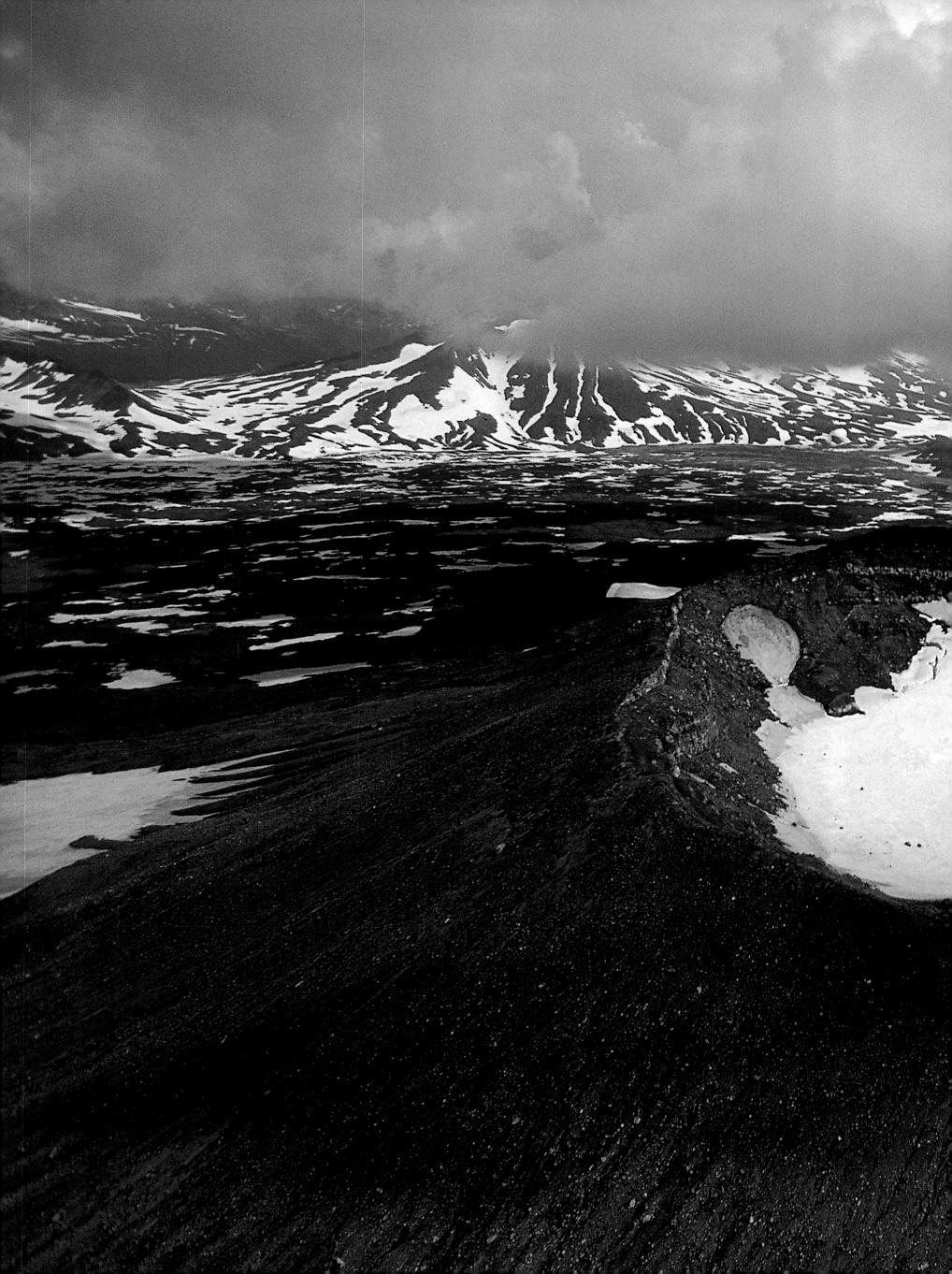

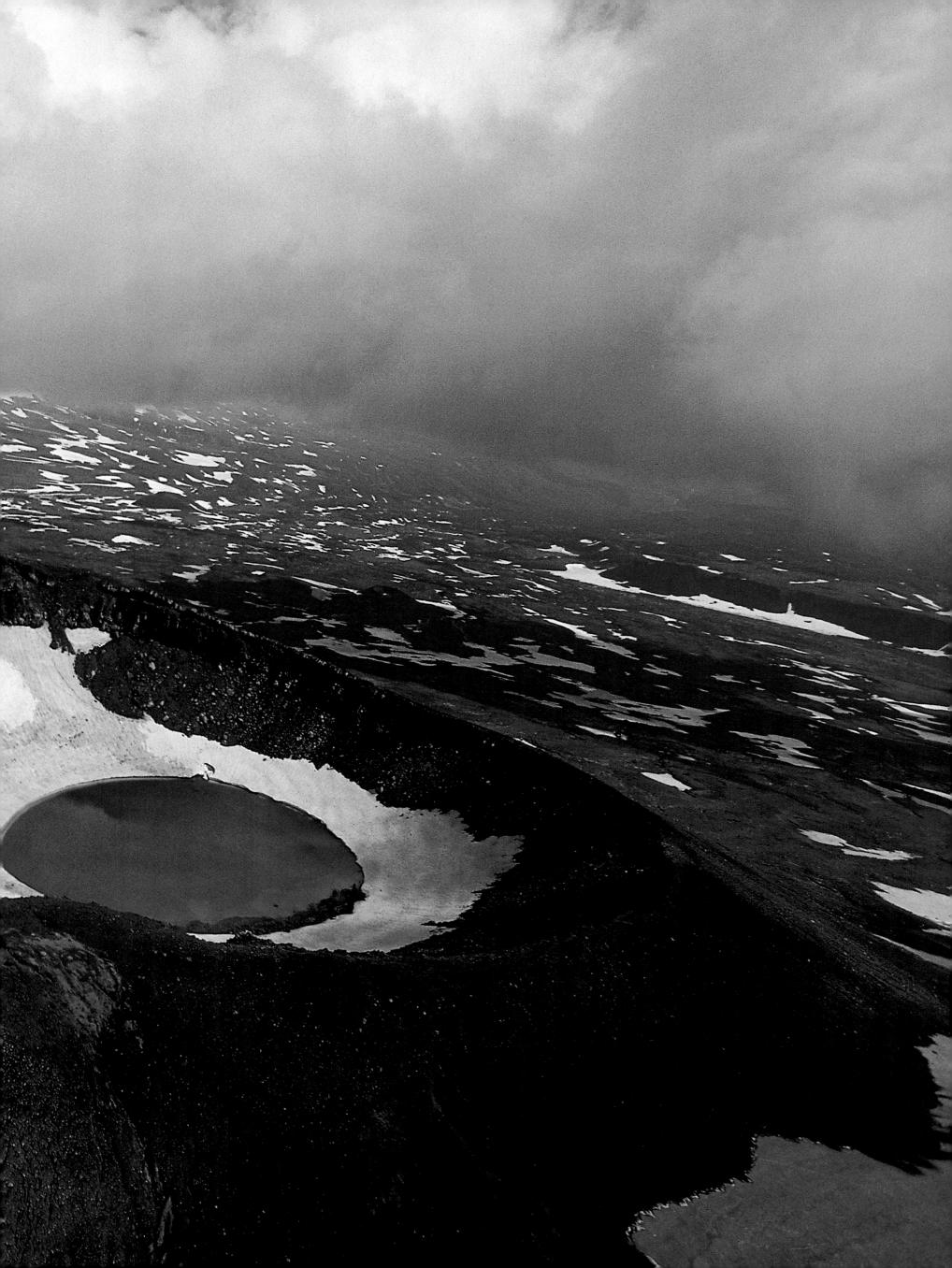

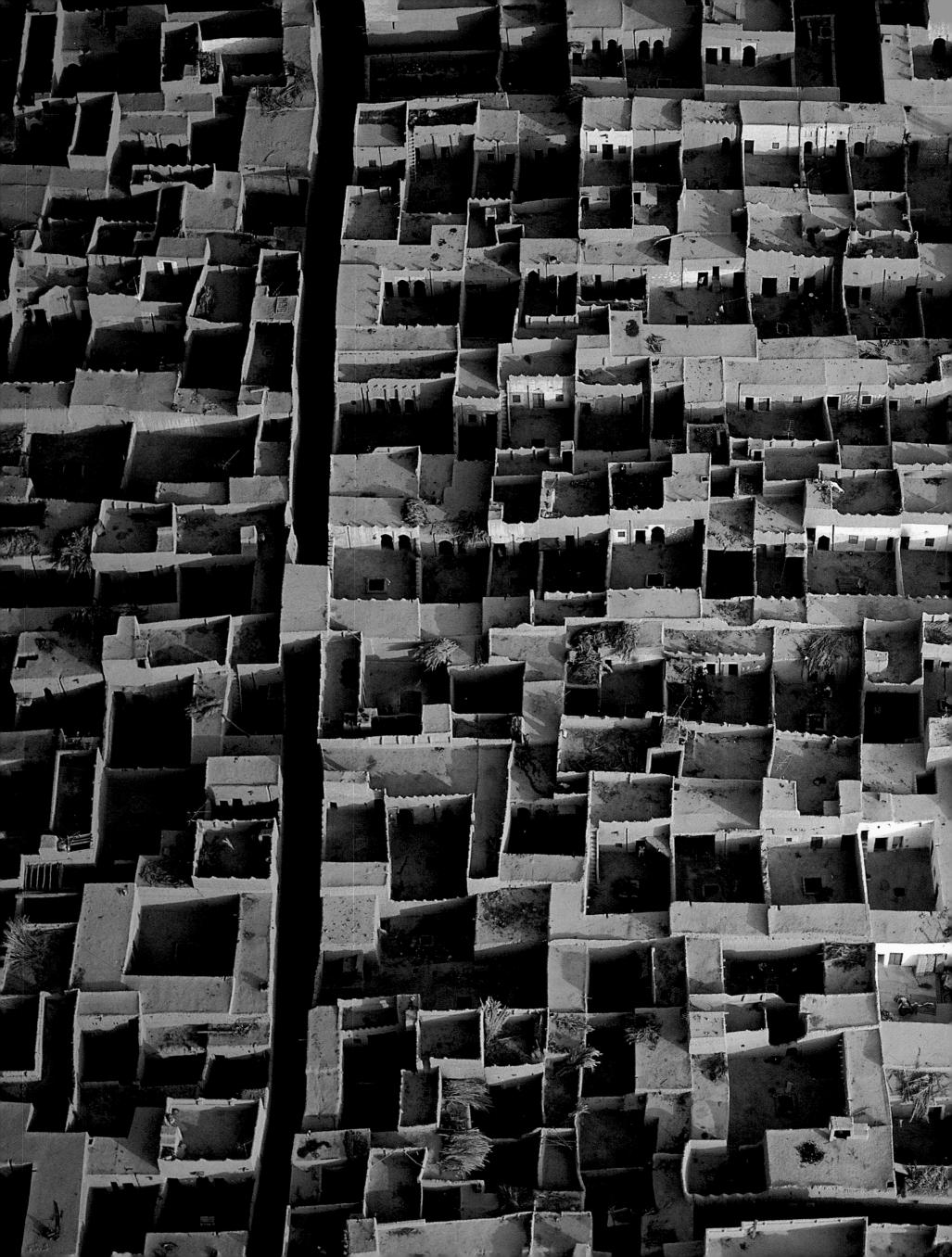

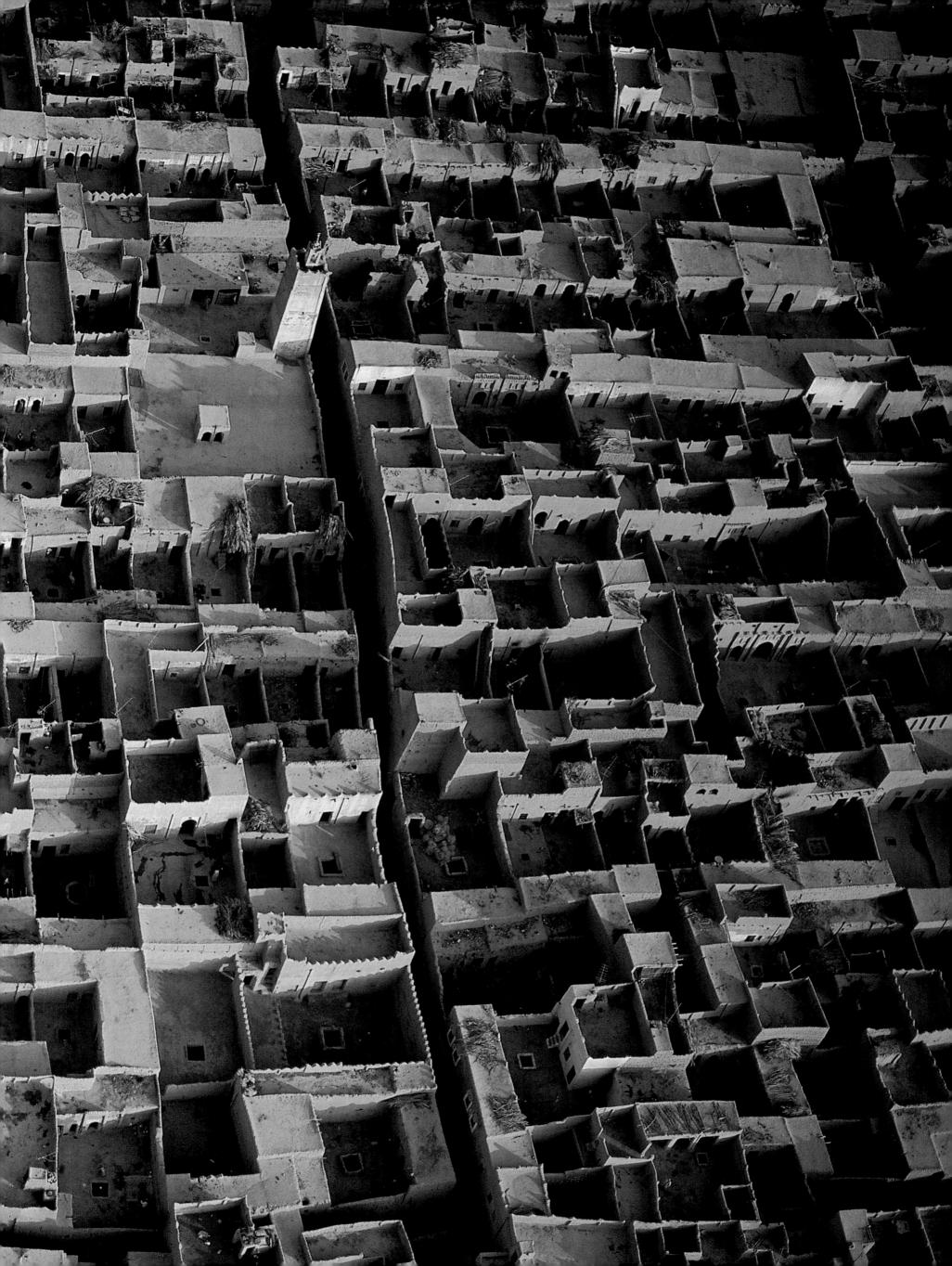

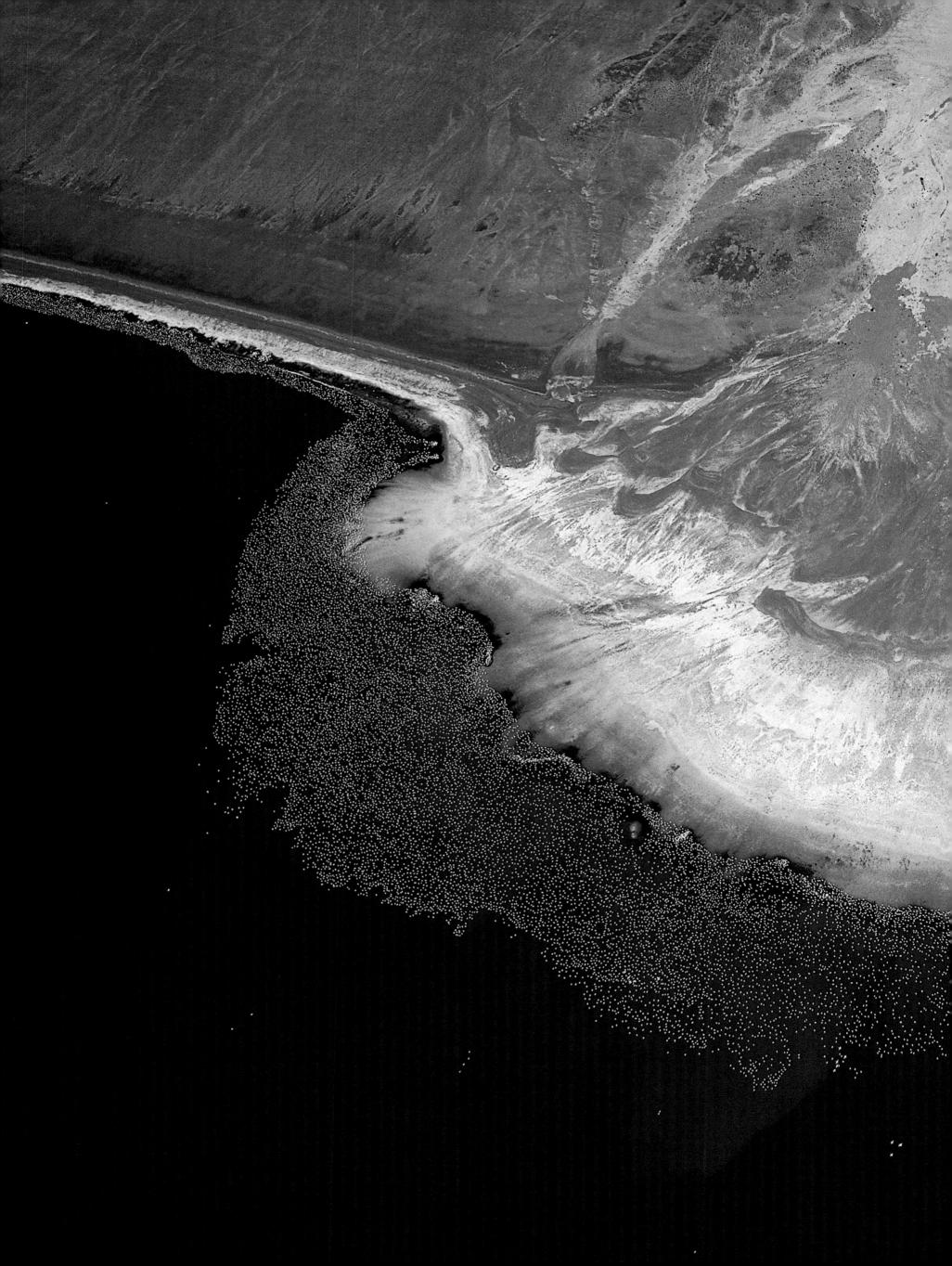

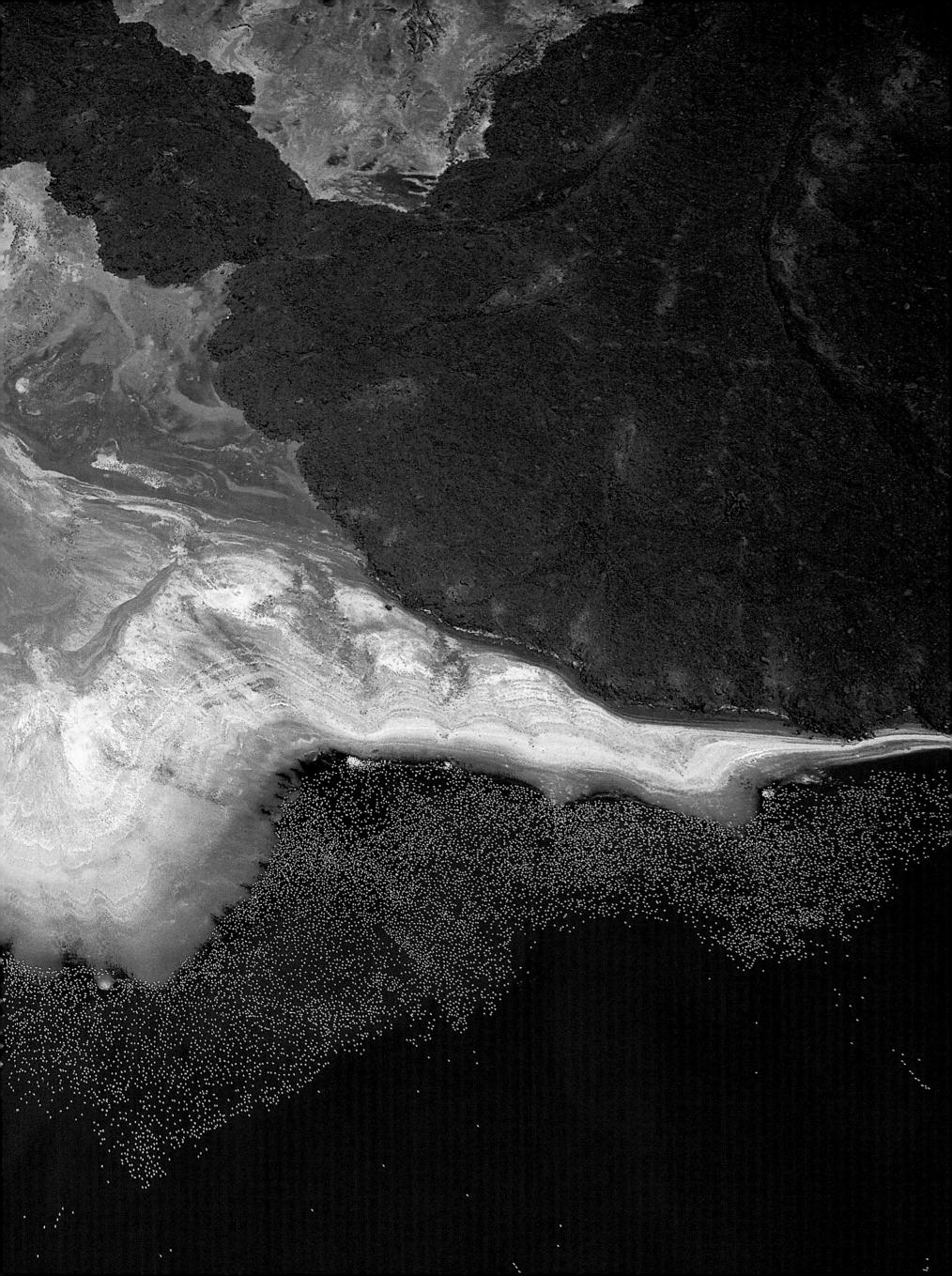

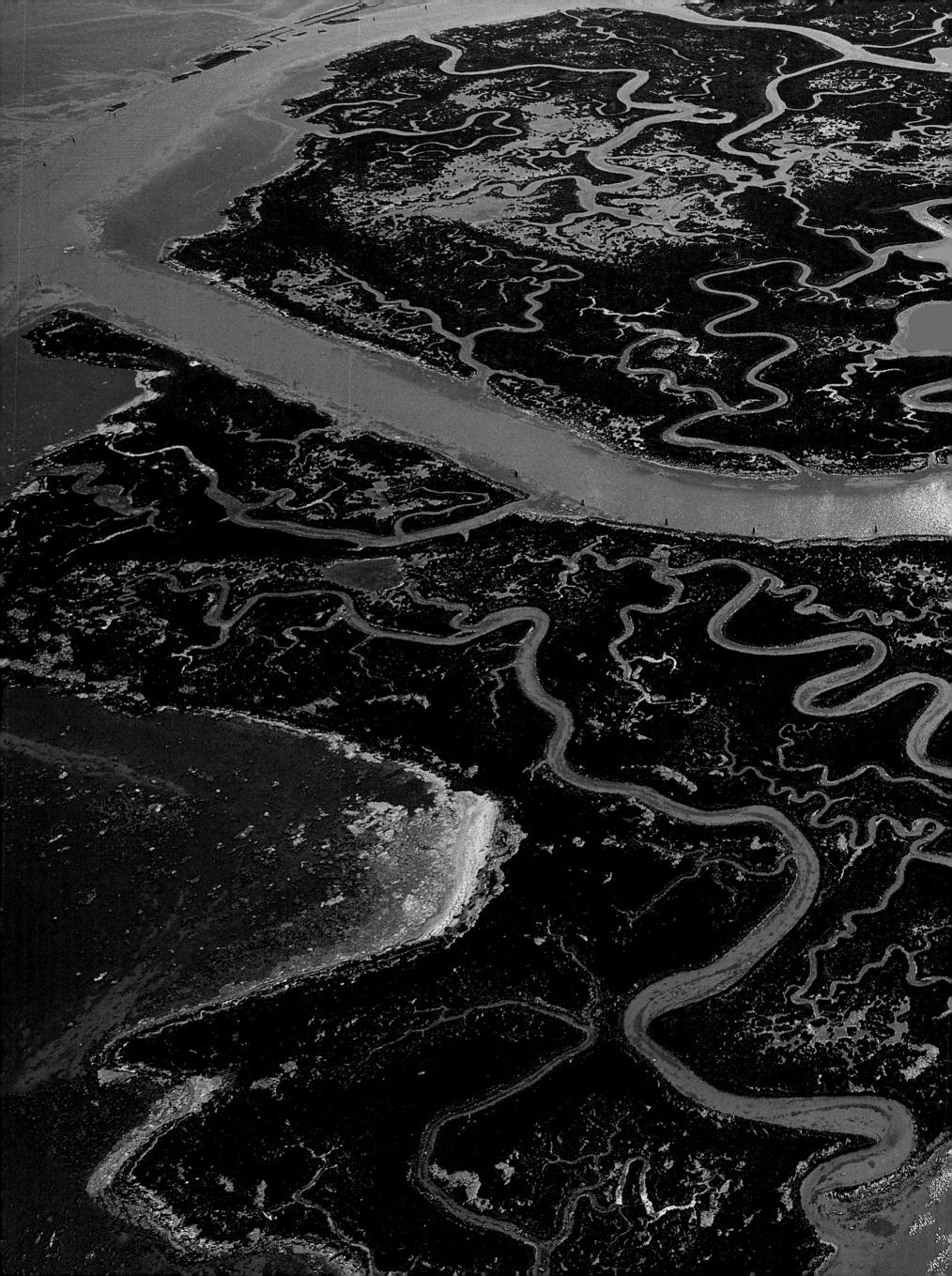

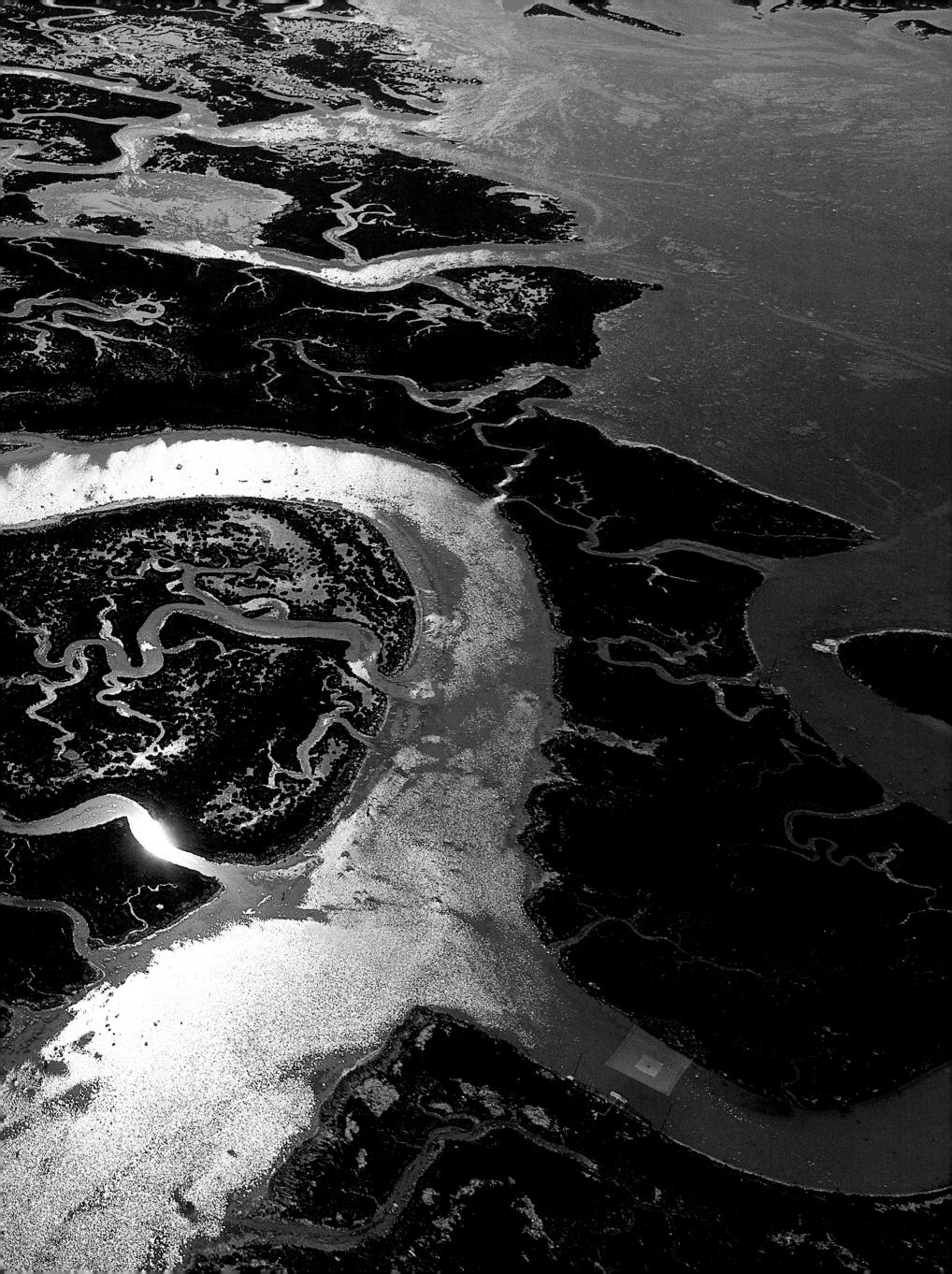

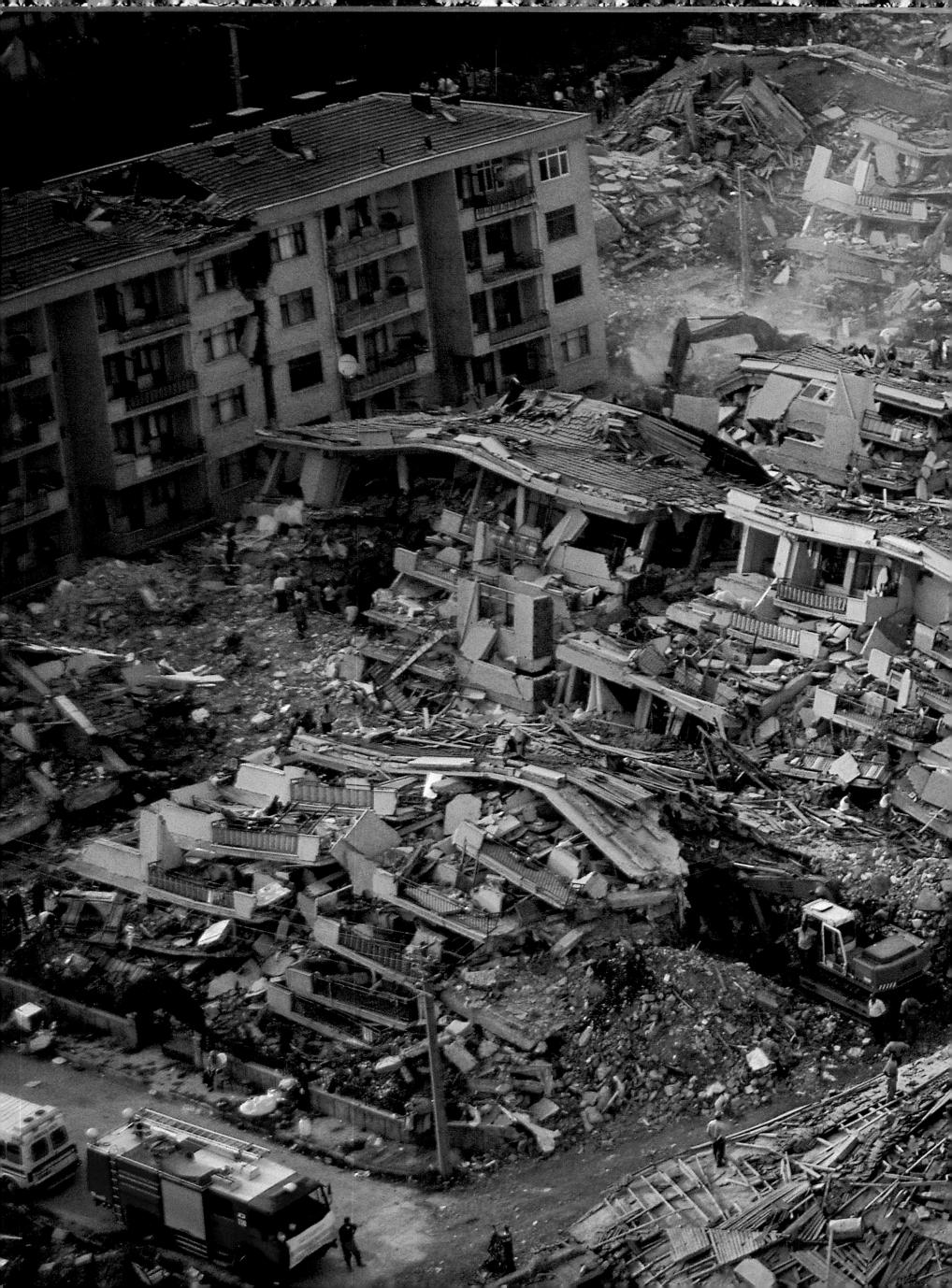

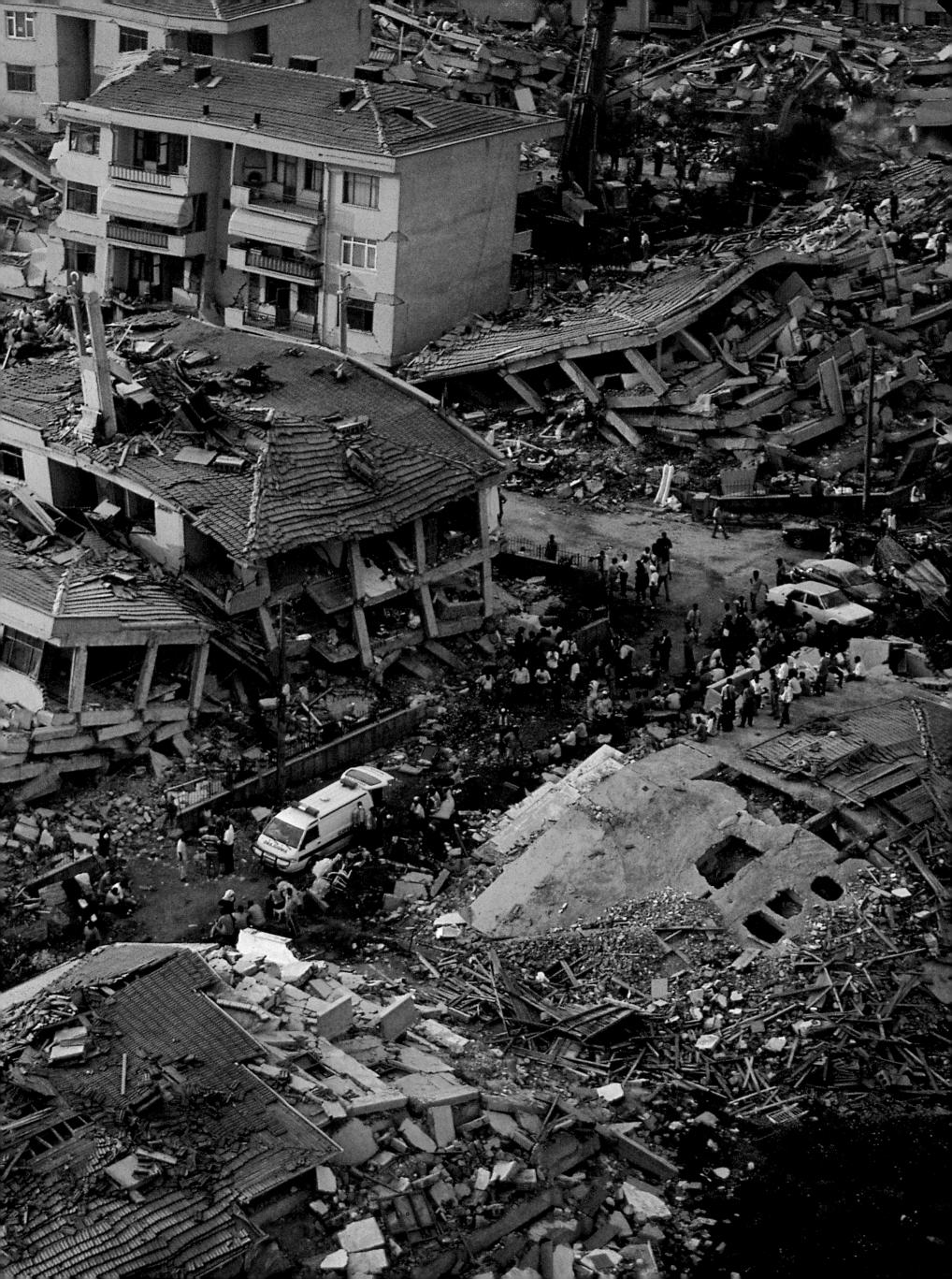

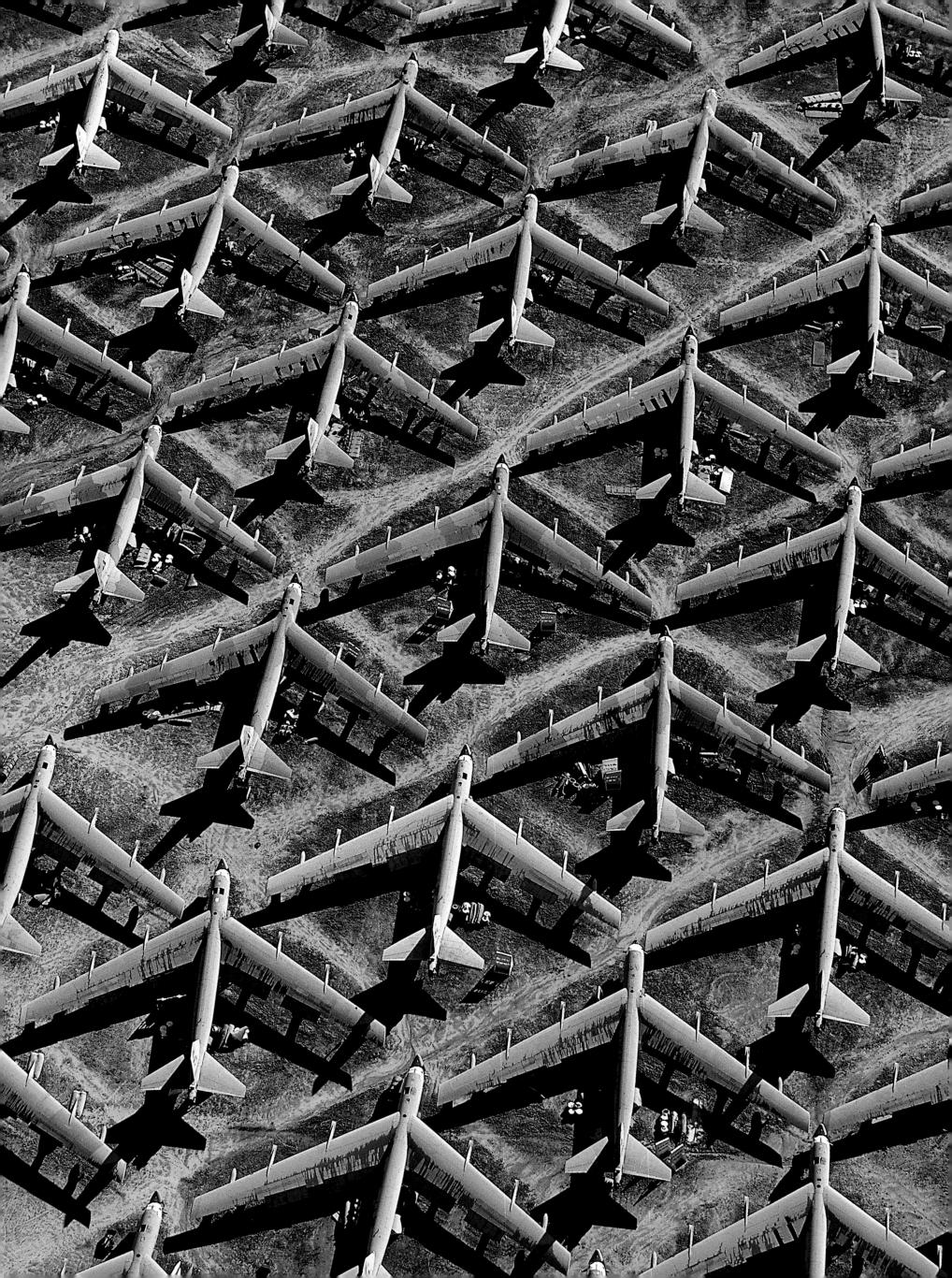

POPULATION AND THE FUTURE OF HUMANITY

ix billion people inhabit the earth today. Yesterday, in the year 1800, there were only 1 billion of us, and tomorrow, in about fifty years, there could be 9 billion. Is this more than the planet can hold?

At the beginning of the common era the earth's population was approximately 250 million, roughly the same as that of the United States today. The growth in population was at first slow, but in the modern era it suddenly sped up. Tens of thousands of years had passed before the population reached the level of 1 billion, but it took only 123 years to reach a second billion and twelve years to rise from 5 billion to 6 billion. The world, which had seemed stable and balanced, appeared to be toppling. The "population explosion" became common parlance, and population alone was held responsible for poverty and environmental threats.

But this is too cursory a glance at the history of humanity and the world's population. What we consider to have been an era of almost stagnant population was, in fact, a series of growth spurts and shrinking phases of the population. These shifts were induced by natural catastrophes, famines, or plagues such as the Black Death of the fourteenth century, which decimated the population of Europe.

p. 288

B-52 AT DAVIS MONTHAN AIR BASE NEAR TUCSON, Arizona, United States

Hundreds of American Stratofortress B-52 bombers are stored at Davis Monthan air base in the Arizona desert. These planes, whose flying days are probably over, are nevertheless preserved for spare parts. The B-52, a strategic bomber designed by the Boeing company in 1946, made its first test flight in Seattle, Washington, in 1952. It was heavily used during the Vietnam war (1964–73) and a modernized version was flown in the Gulf War (1991). The last models, which the United States planned to retire from service before the end of the twentieth century and replace with B-1 and B-2 bombers, saw action during the 1999 military operations in the Balkans, "Determined Force" and "Allied Force."

IS THE WORLD TOO "HUMAN"?

The nineteenth and twentieth centuries have witnessed a rupture in the progression of world population, which increased sixfold in less than two centuries. China now has more inhabitants than the whole world contained in 1804; China and India combined exceed the population of the entire world in 1927. In the 1970s we were told that the "exponential curse" was going to be our downfall and that to avoid doomsday we had to take emergency intervention. Two major threats to the human race existed: the nuclear bomb and the population explosion.

In order to claim that the population is too high, however, we must be able to define or calculate an actual limit. Many specialists, in speaking of the earth's sustainable capacity, have given a figure for the maximum population. The present level has been widely proposed as the ceiling, whereas other researchers have argued that 3 billion was already the saturation point. Another argument states that our concerns are unnecessary because advances in technology will provide the resources needed for an increasing population.

However, the pace of growth that we saw at the end of the 1960s is cause to wonder just when humans might reach the point of "covering the face of the earth." This, then, is the fundamental issue—we must not confuse population itself with the rate of growth of population. The hardships that many regions, such as Africa, might face in the future issue less from the current level of population than from the accelerating rate of growth: Africa is not overpopulated, but the population is growing too quickly. In some countries the pop-

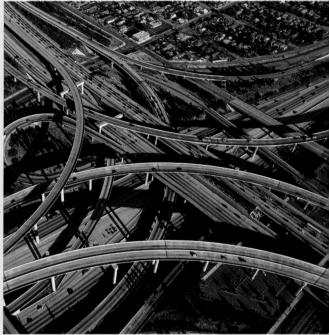

deny that the challenges faced by the d in the future are in part due to popuhould we hold that increase solely responnt development of the poorest nations y of environmental damage. Population al factors in a complex equation; conof technology are two others. For examt enough potable drinking water, we can opulation as a source of the problem: as bitants increases, so does the consumpdustrial and agricultural waste and polrivers are equally important issues. ist not be an obstacle to raising the stancularly among the poorest. The future of ends largely on our capacity to reconcile and healthy, lasting development.

LIZATION SCENARIO

regularly undertakes the delicate task of I population long term. Stabilization is a scenario. Some years ago it was thought pulation would stabilize at 12 billion in population would have to double one last

time to attain a steady state in which the harder tries would guarantee renewal of generation estimations put that stabilization figure at ference is explained by an unexpectedly birthrate, particularly in China. If this scential stabilization is realized, two major transforms a very significant aging of the population was matically shift in the distribution of the earth

At present almost a third of the v younger than fifteen years old. With a p tion under conditions we can reasonably e population in 150 years' time would be ov As the French demographer Alfred Sauvy of "grow or grow old." It is difficult to

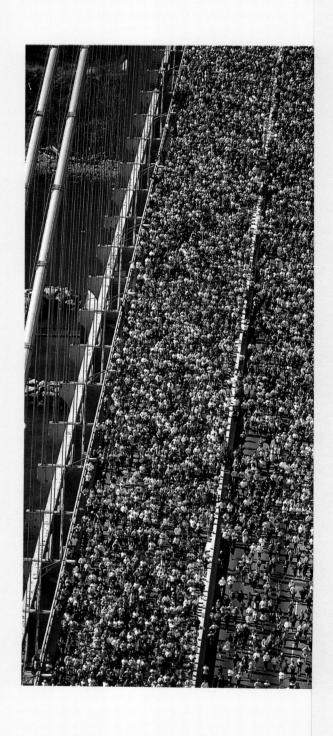

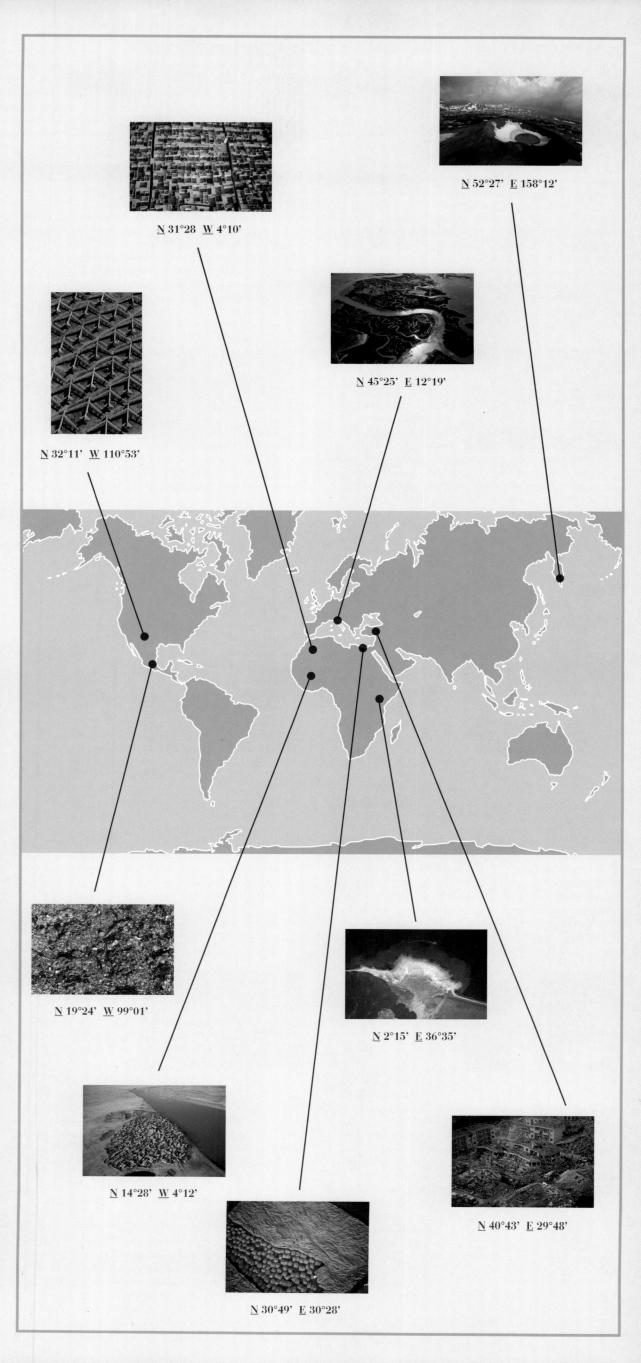

past, but one of the most progressive advances in human history has been the successful combat against early mortality—at the price of a population spurt. One assumption is that the widespread use of contraceptives will ensure a population balance, but this is not an entirely accepted prediction.

However, it is missing the point to make population stabilization a precondition for economic development. In order to achieve global population stability, minimal development is needed to persuade countries in the Southern Hemisphere to adopt new patterns of behavior or pursue social changes. Feeding the hungry, unemployment, and public health are among the issues that we must deal with now. The 6 billion people who are alive today and the 8 or 9 billion of tomorrow must be able to feed themselves but also to live without overburdening the environment and without doing it irreparable harm. One of the great challenges facing the human race is to redress the inequalities between the Northern and Southern Hemispheres while making sure that newly developing countries do not make the same environmental mistakes as today's richest nations.

Striking inequality is not only found between hemispheres, however; extreme poverty can exist alongside extreme wealth even within the same country. For example, the inequalities between men and women are pronounced in many areas. Women are sometimes at a disadvantage because they live in a poor region or one that is in crisis, such as the Sahel or Haiti. But other causes are culturally ingrained: the great inequality in education between men and women, as in southern Asia; the strong preference for male offspring, as

in China; the practice of genital mutilation of female children, as in West and East Africa and the Middle East; the very early age for marriage, as in sub-Saharan Africa; and spousal violence in areas throughout the world.

At the world conferences held at the initiative of the United Nations during the 1990s and the 1995 conference in Beijing, delegates stated the necessity of improving the status of women. This is a matter of vital importance for development and a necessary condition for the stabilization of the world population. For the birthrate to continue to decline, the status of women must rise.

Population stabilization is not the solution to the problems we face today. It is necessary, but it is an impossible first step. Developing nations must create environmentally sound models of economic development and address the immediate issues of inequality and poverty.

Jacques Véron

p. 297

RIVER ON THE AUYAN TEPUÍ, Gran Sabana region, Venezuela

The Gran Sabana region in southeastern Venezuela is a wide plain covered with savannas and dense forest, interrupted by imposing mesas of sandy rock, known as *tepuis*. The mesa of Auyan Tepui, or "devil's mountain," covers 275 square miles (700 km²) and rises to 8,500 feet (2,580 m). The Rio Carrao zigzags across Auyan Tepui and, at its edge, plunges in a steep waterfall. The Salto del Angel waterfall is the world's highest free-falling waterway; at a height of 3,210 feet (979 m), it is fifteen times higher than Niagara Falls. Rich in gold and diamond ore, the Gran Sabana region and its many waterways have attracted prospectors since 1930. They have been especially drawn to towns like Icabaru, which was made famous by the discovery of a diamond of more than 150 carats, called El Dorado, a name that conjures up the days of the conquistadors.

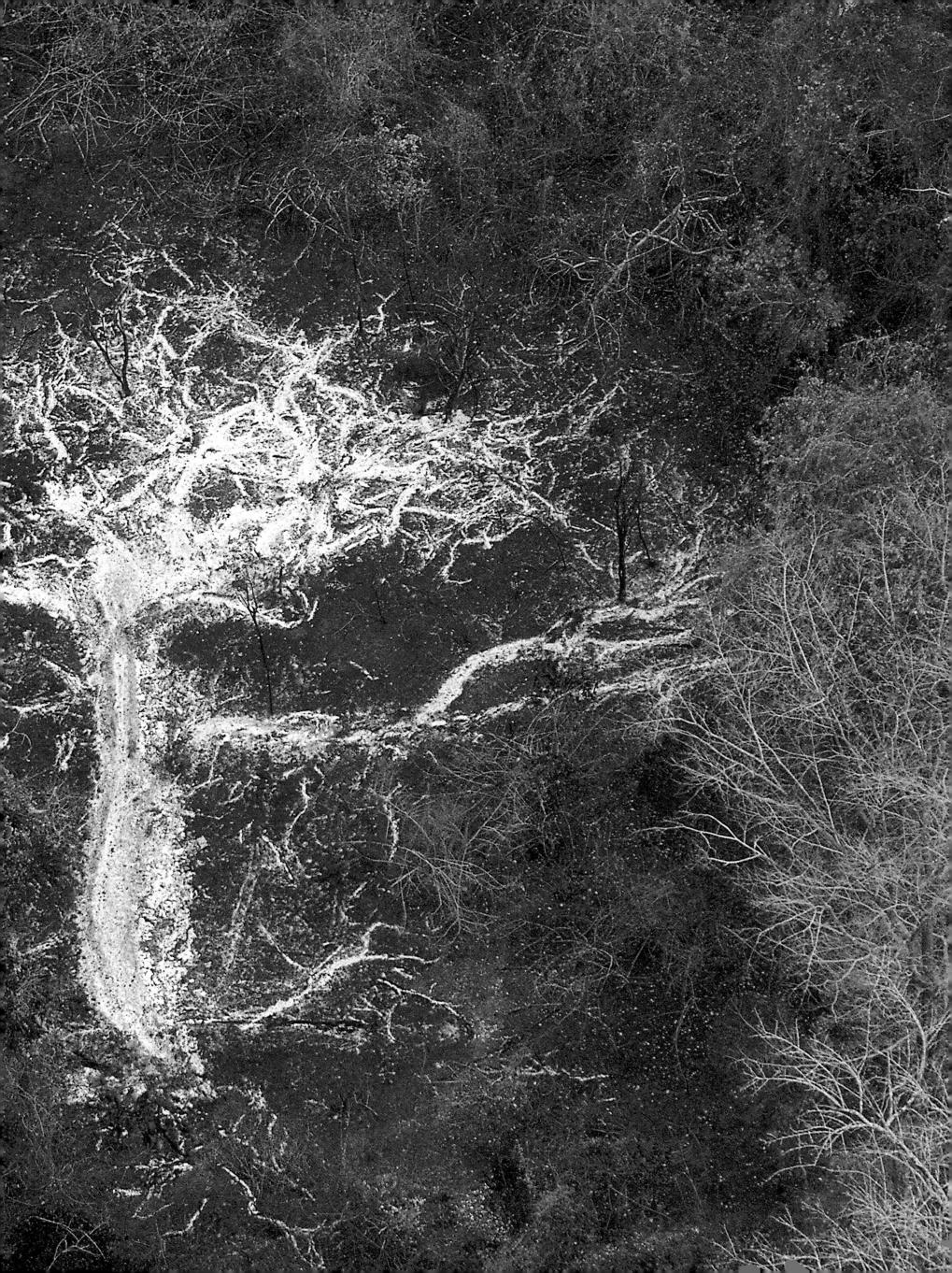

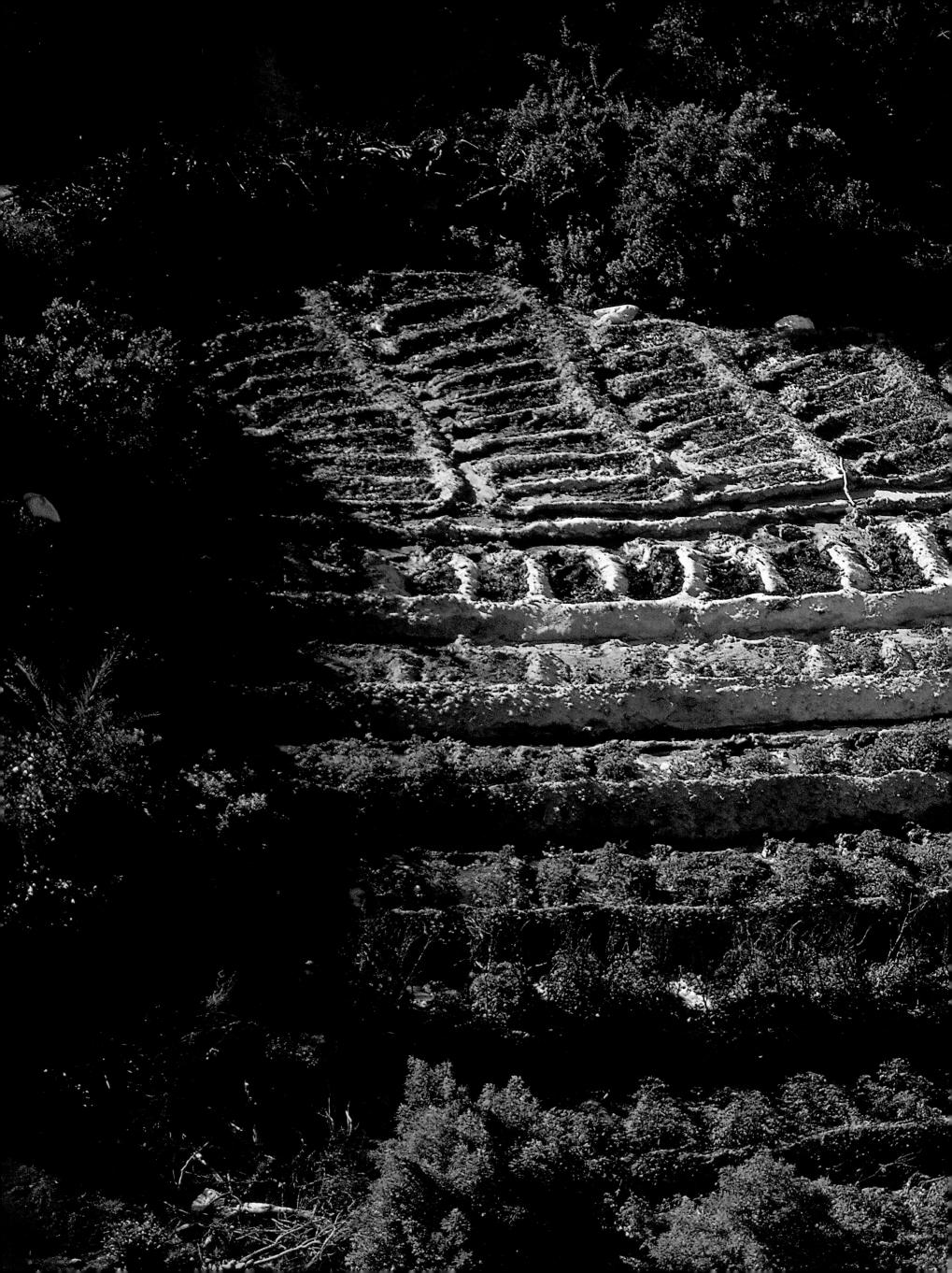

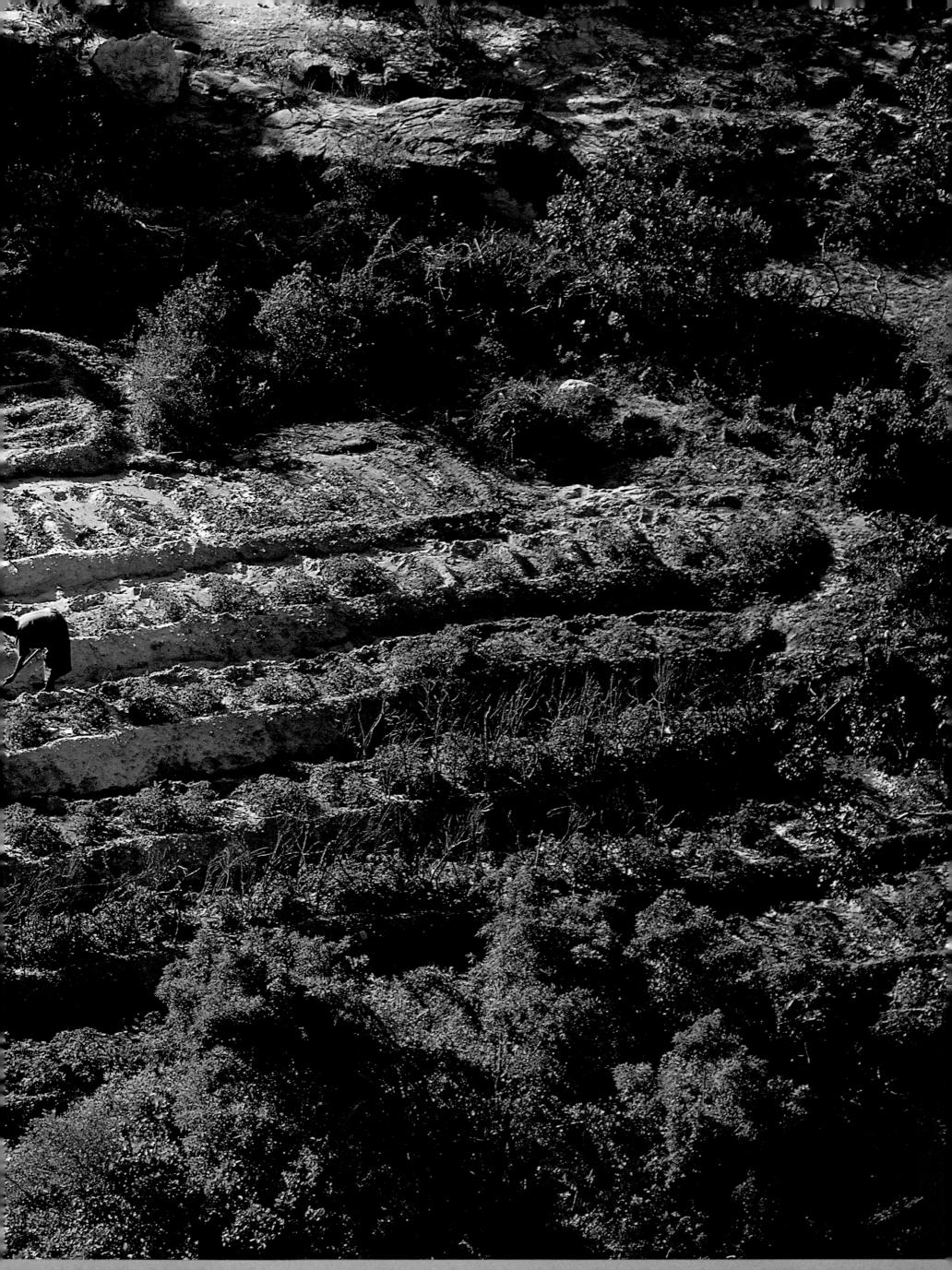

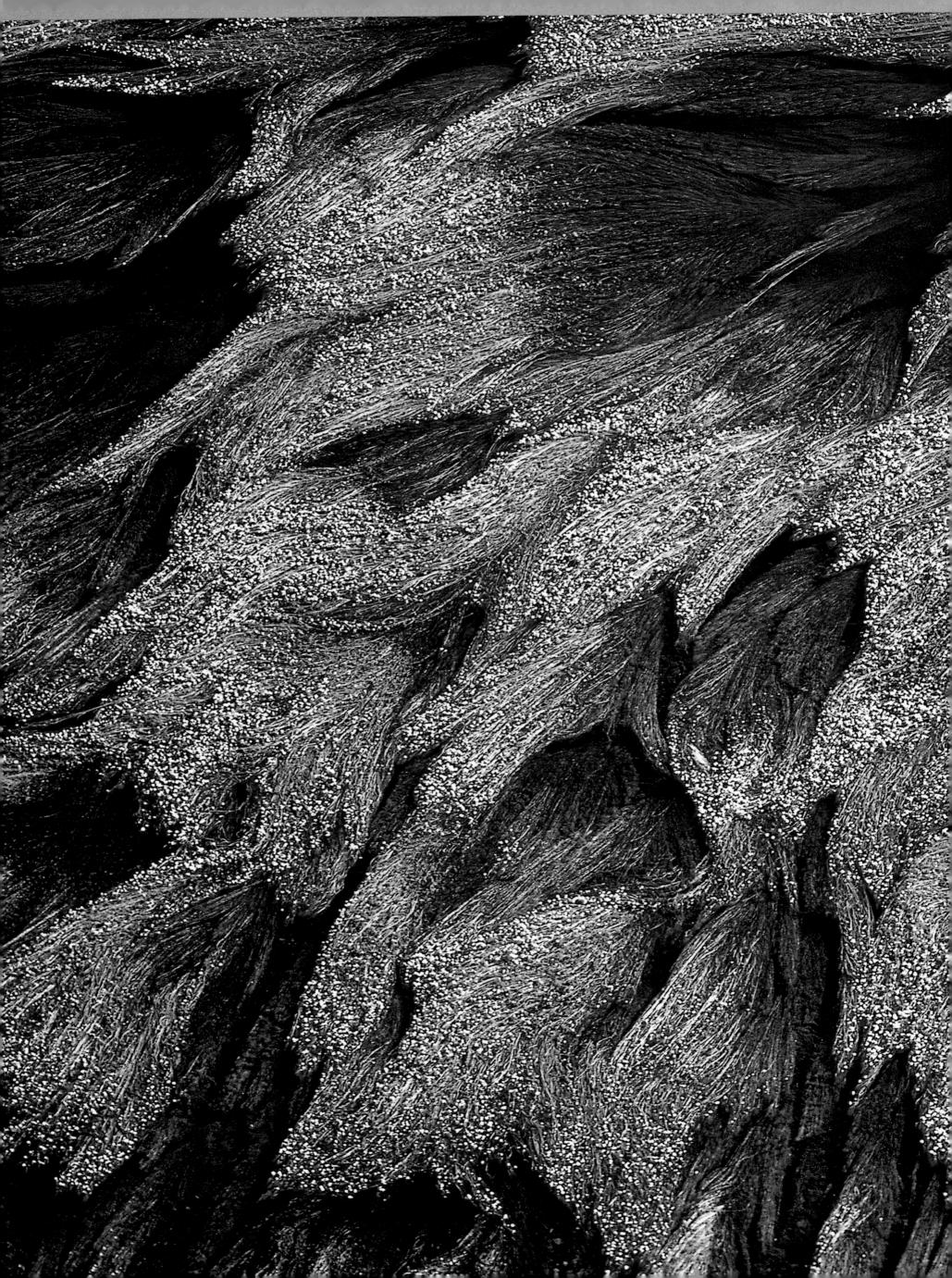

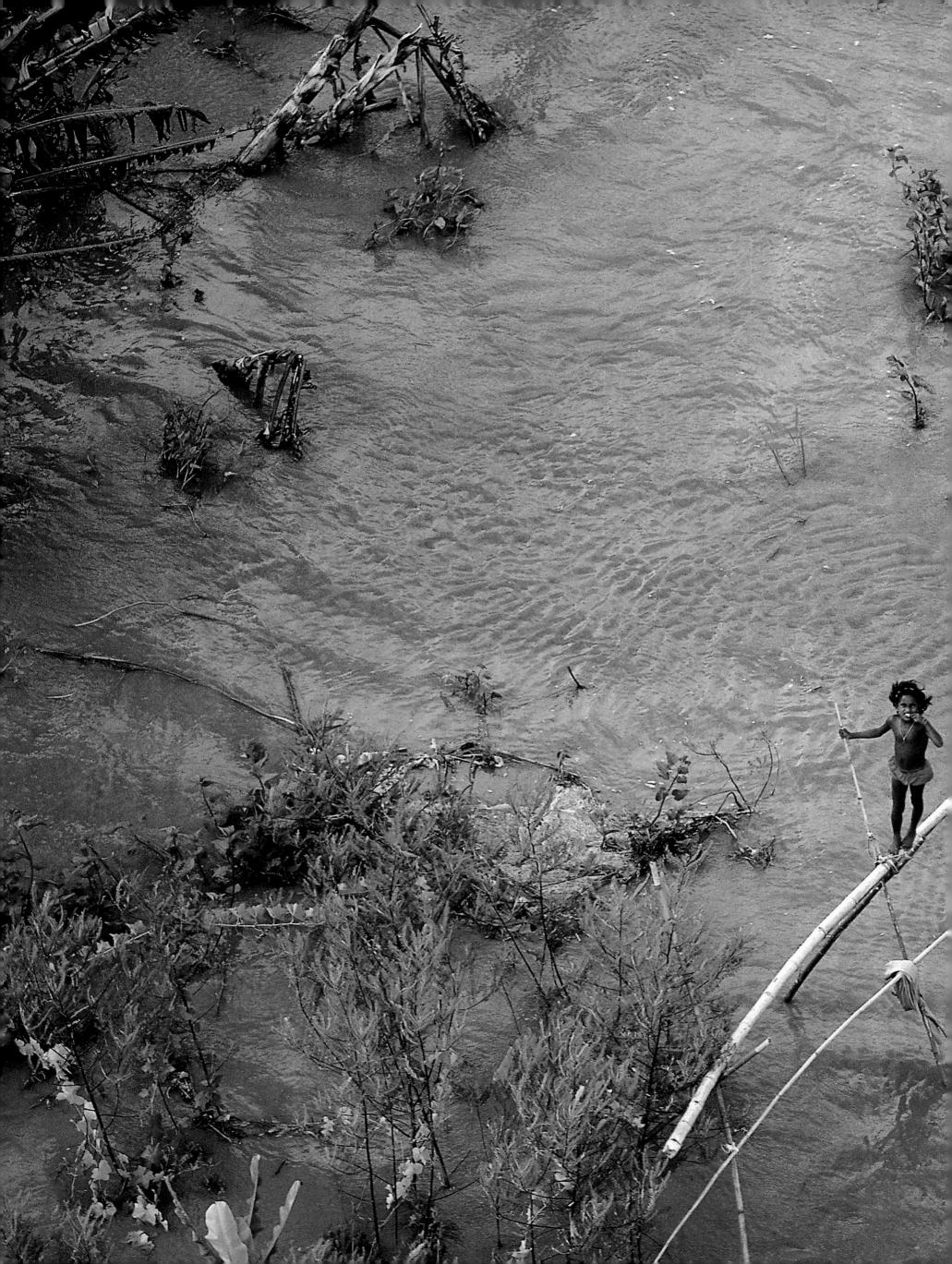

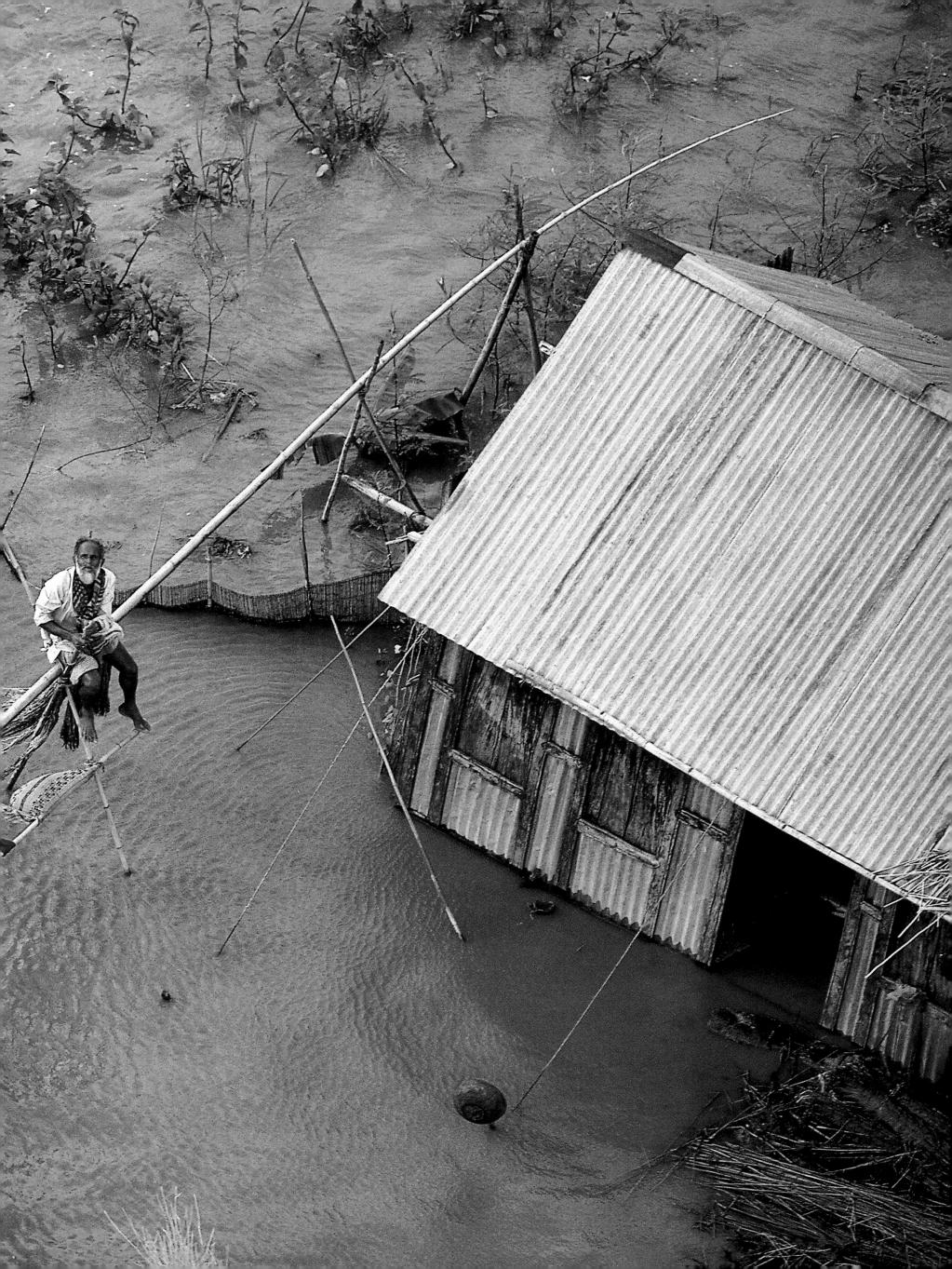

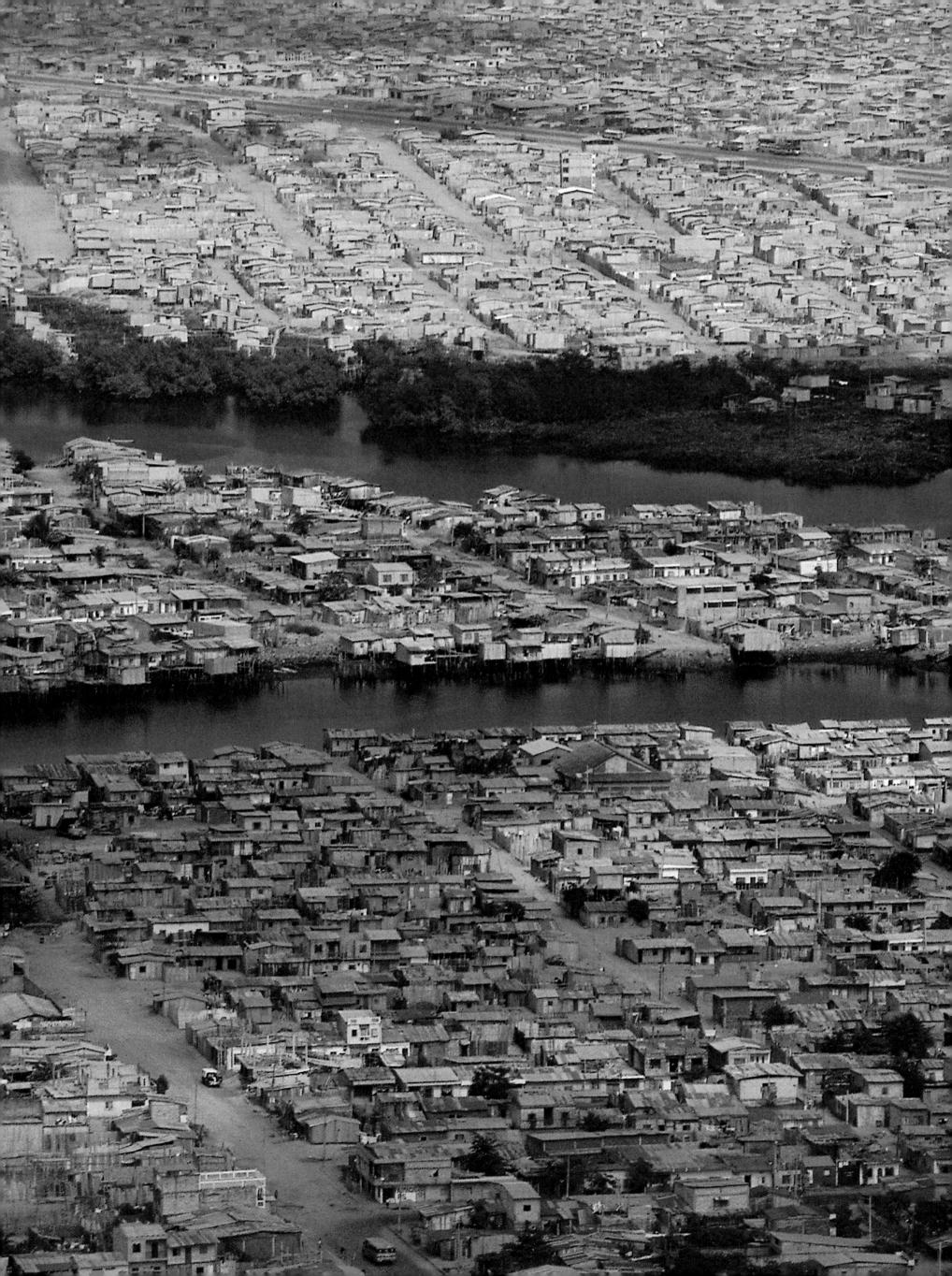

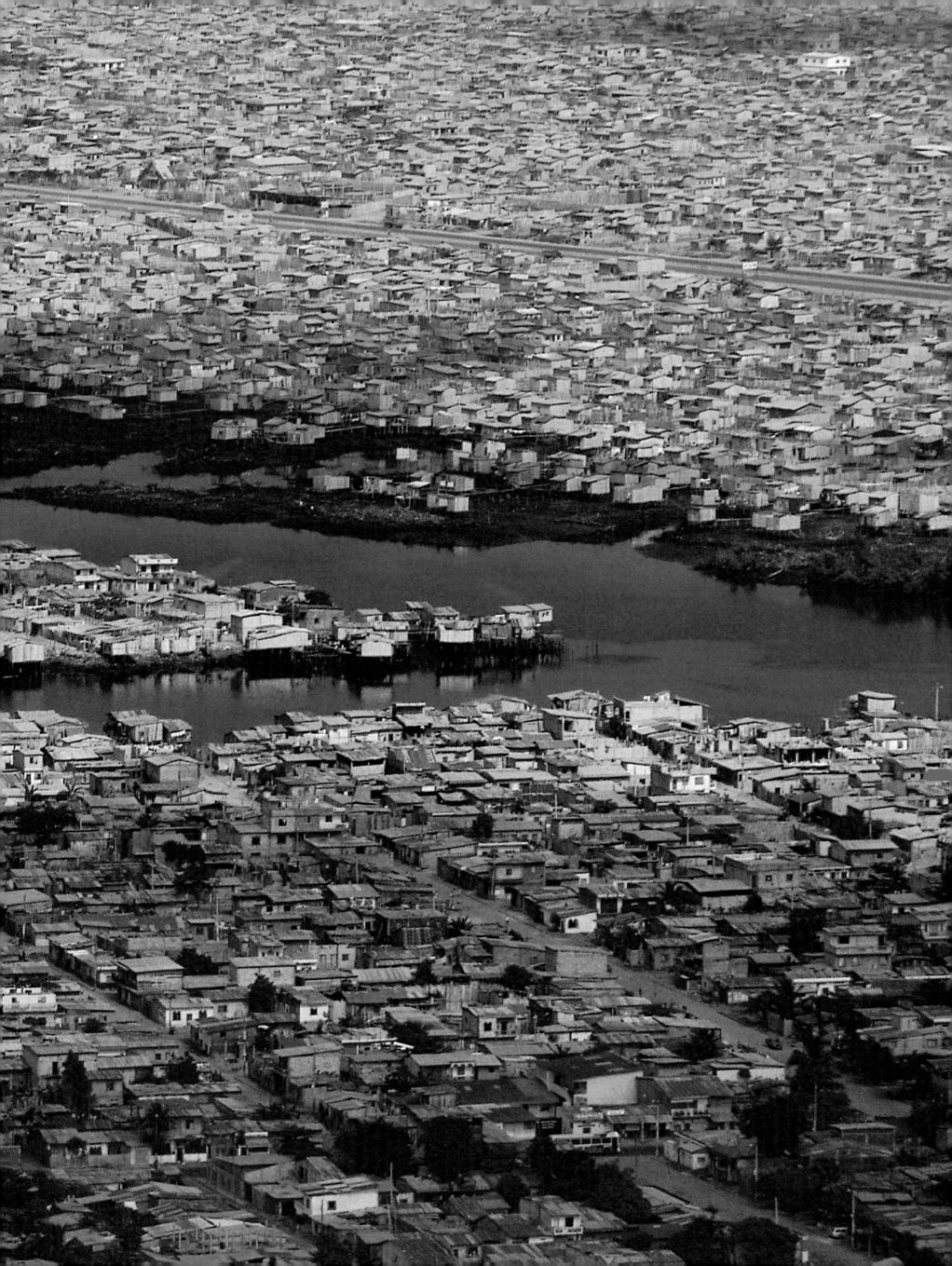

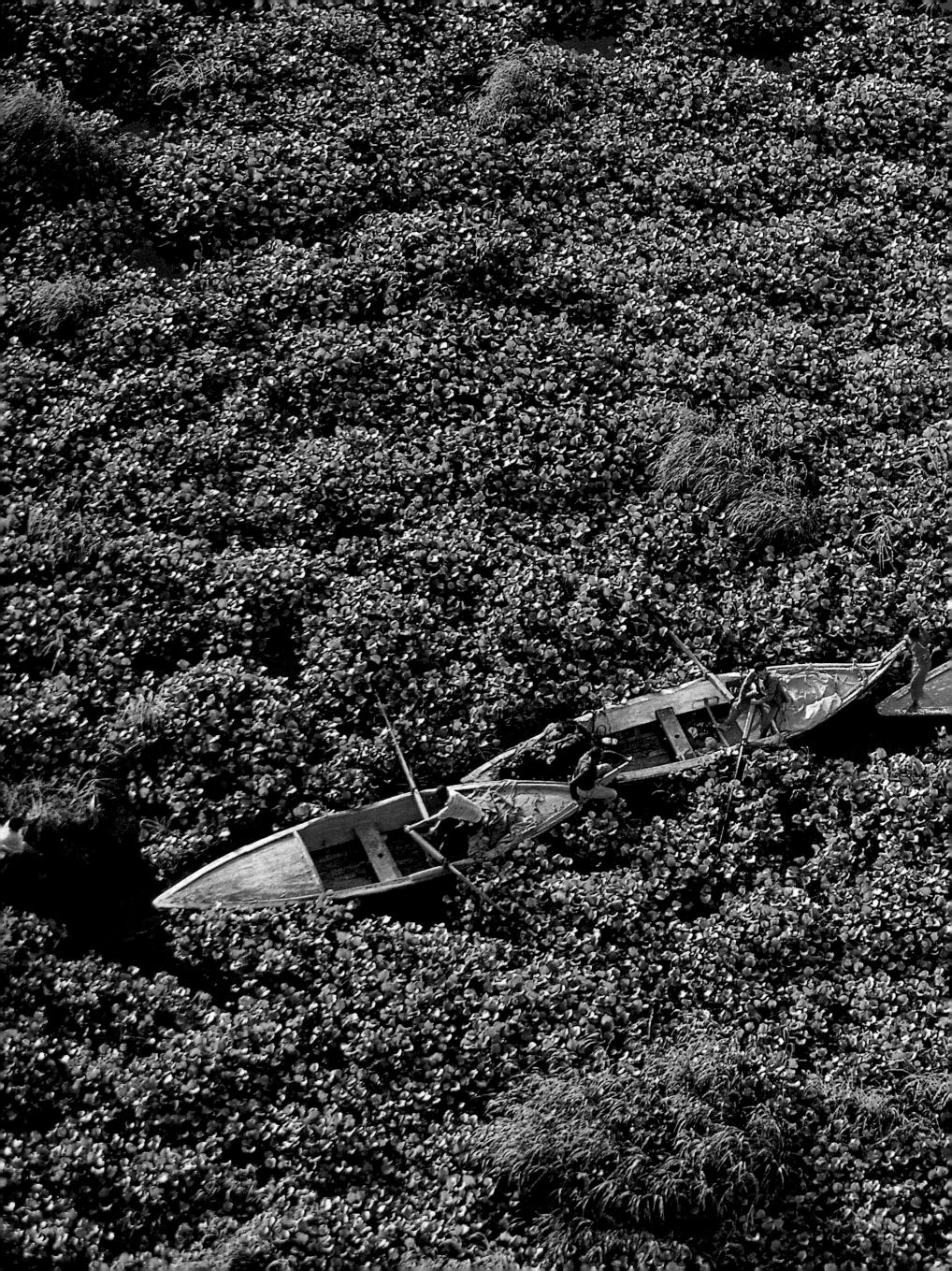

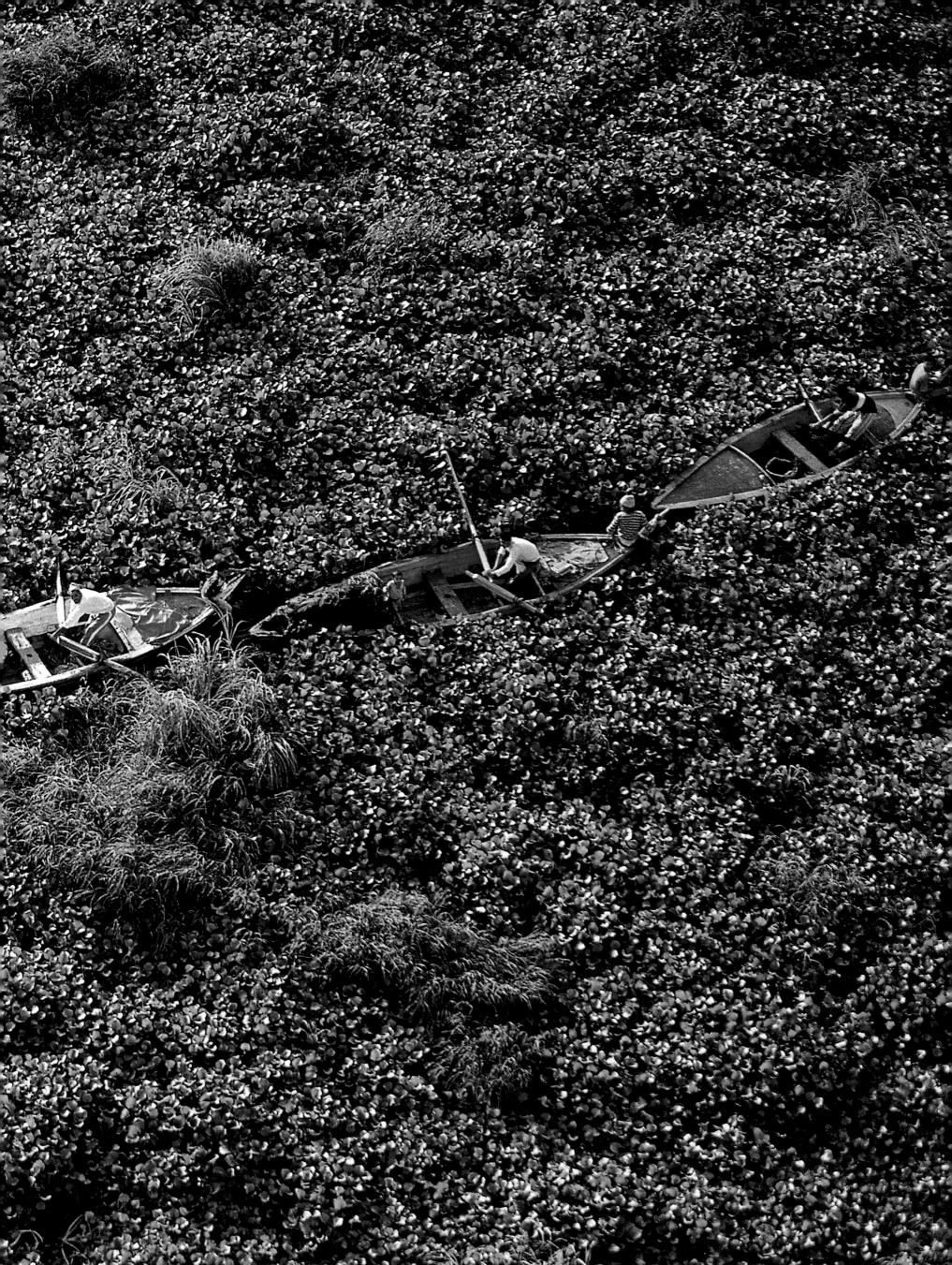

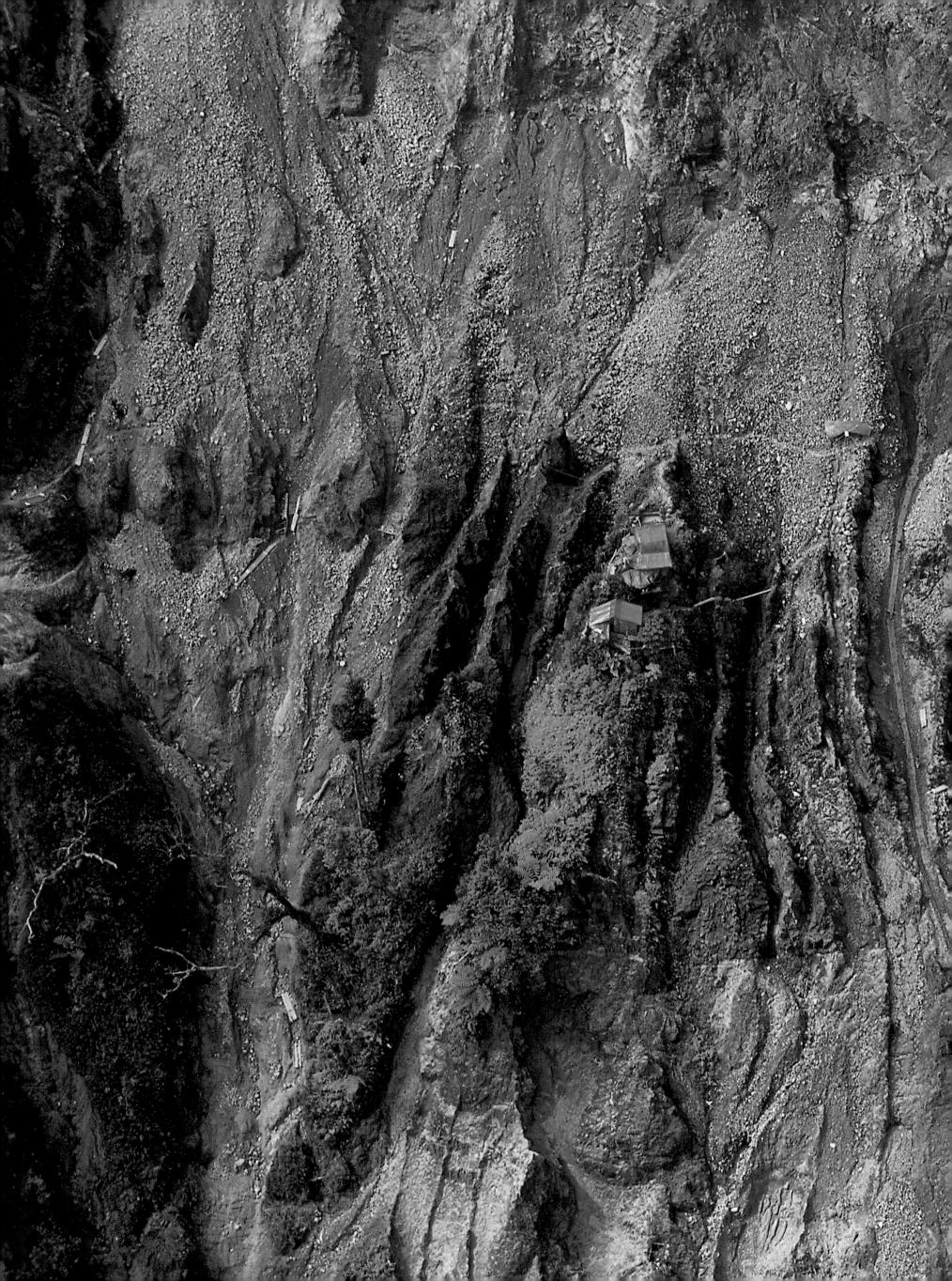

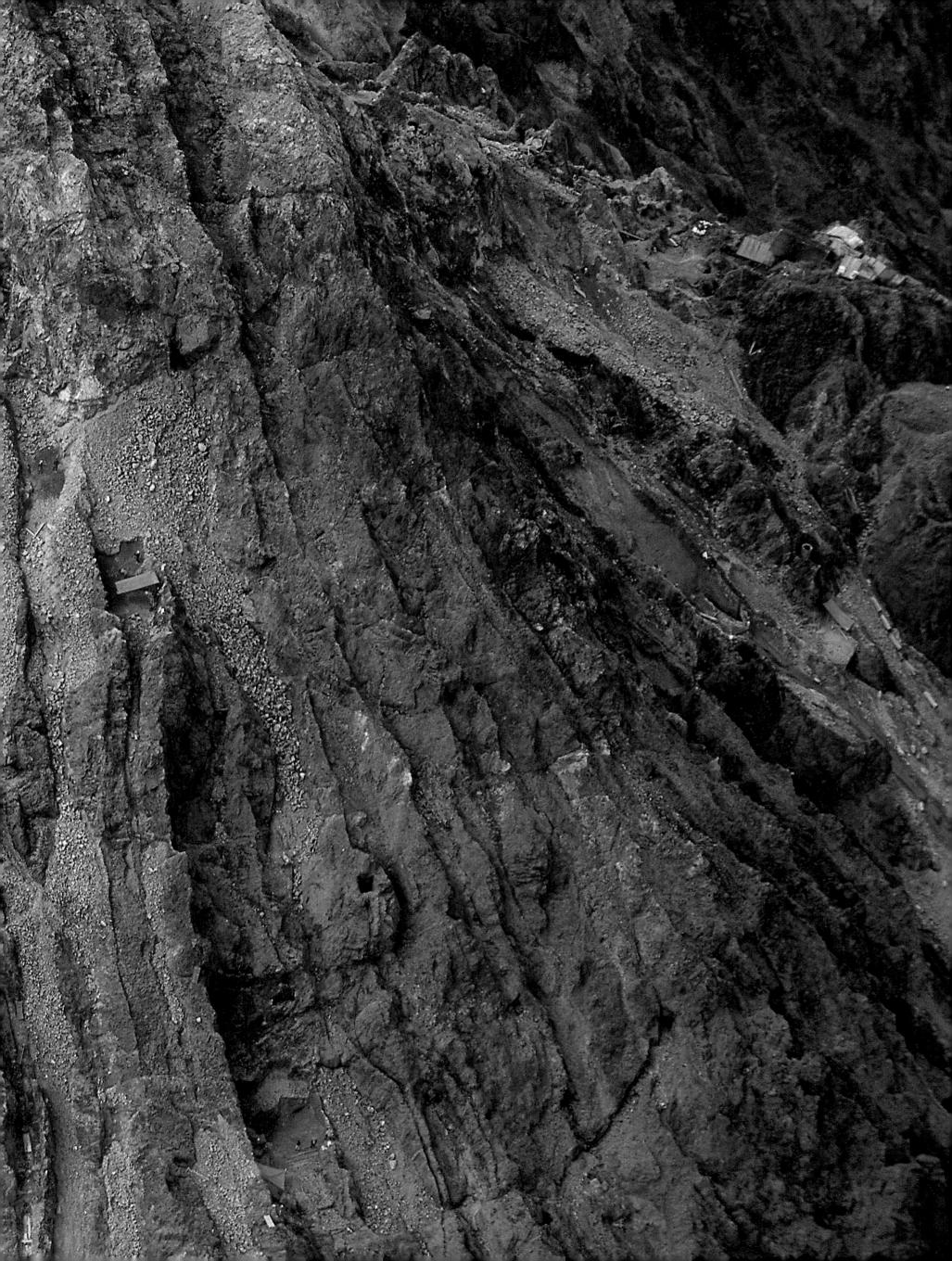

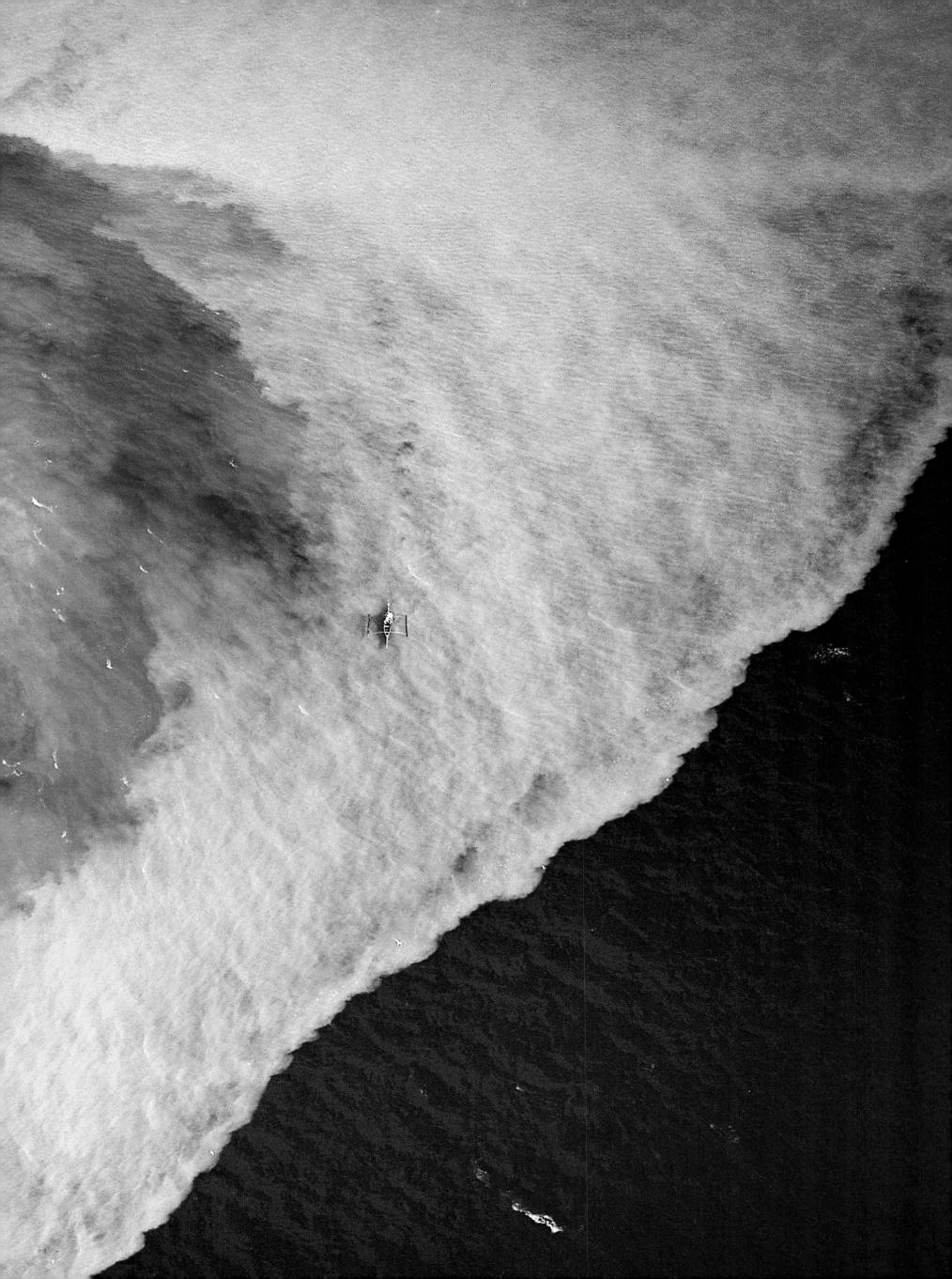

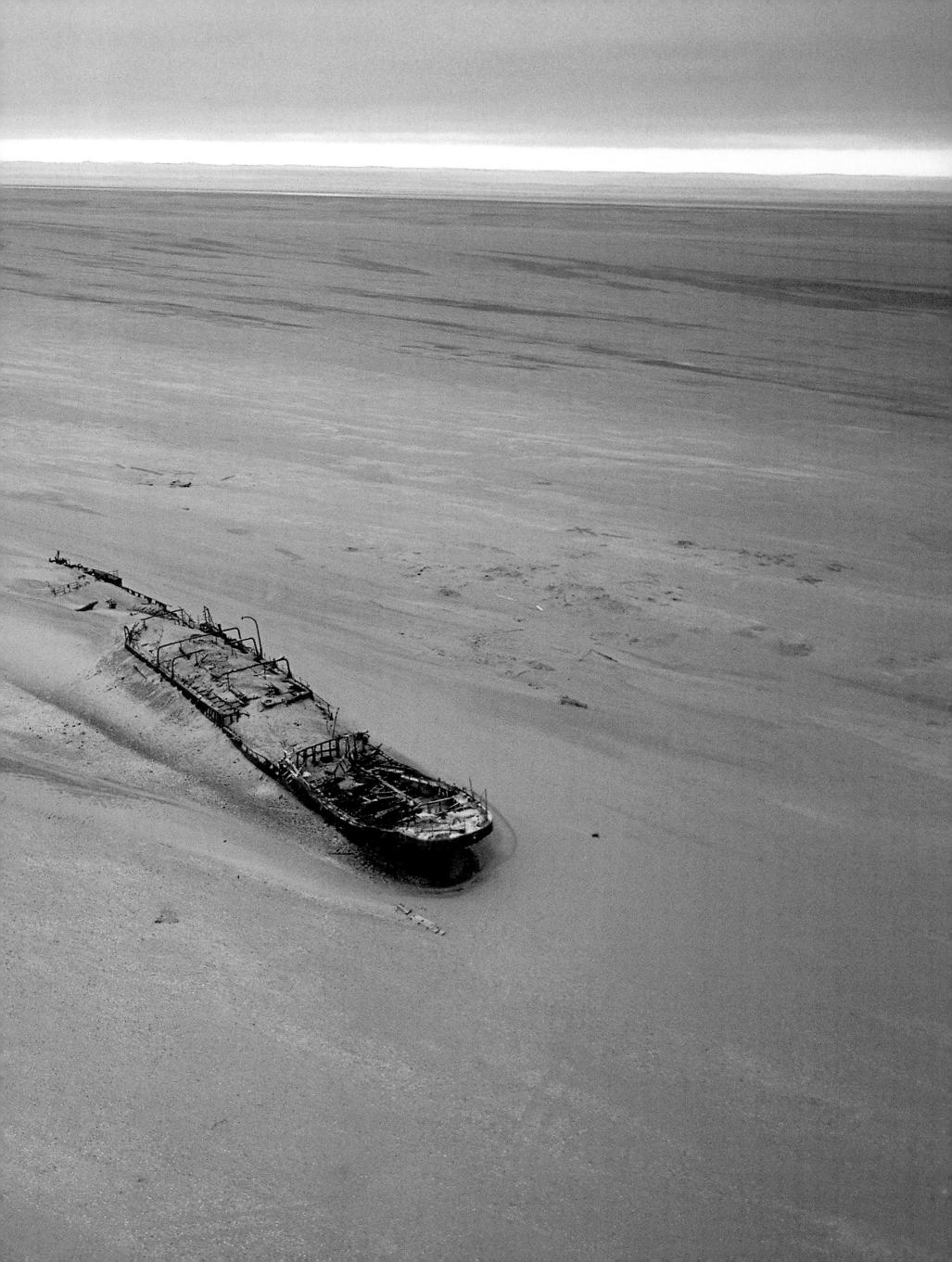

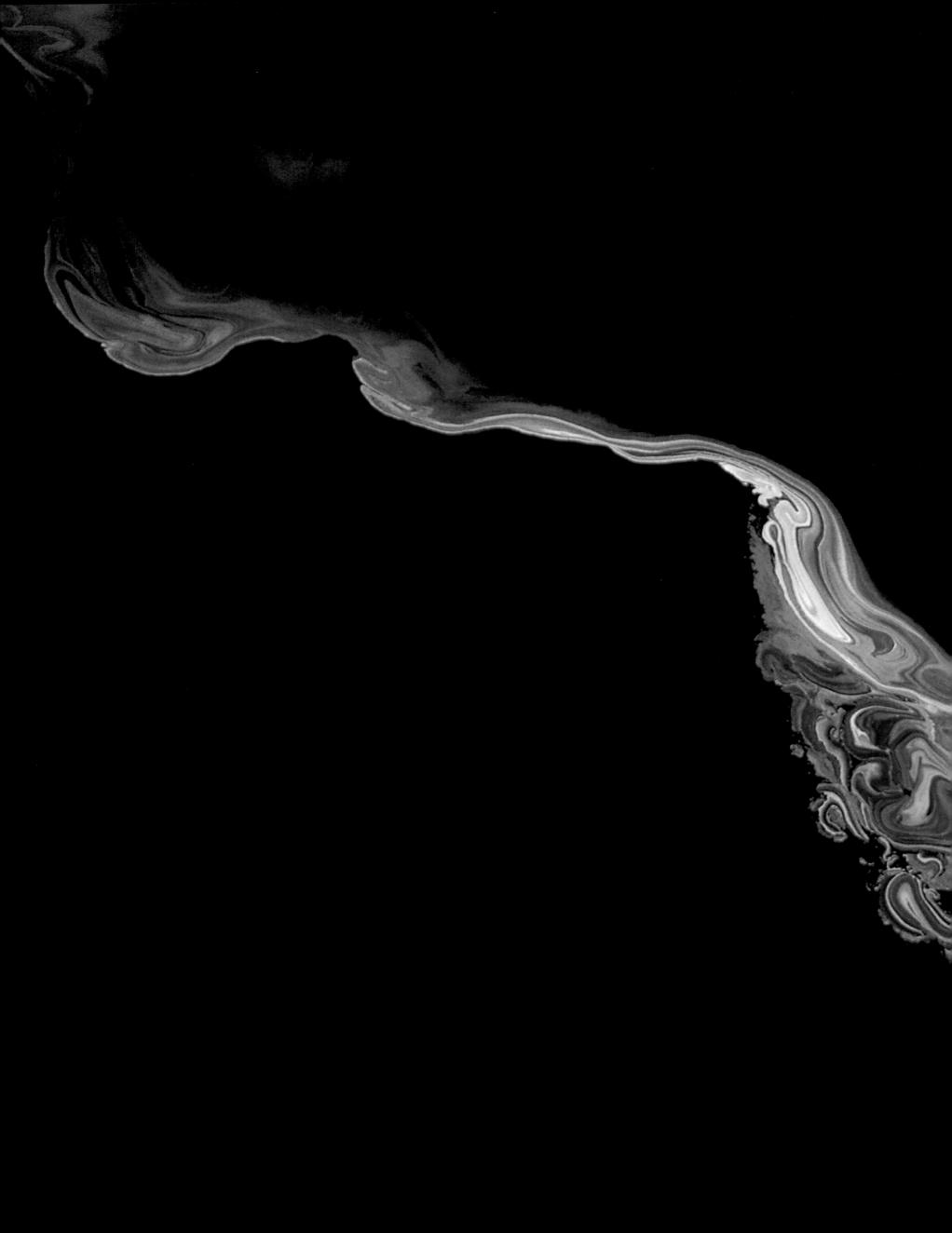

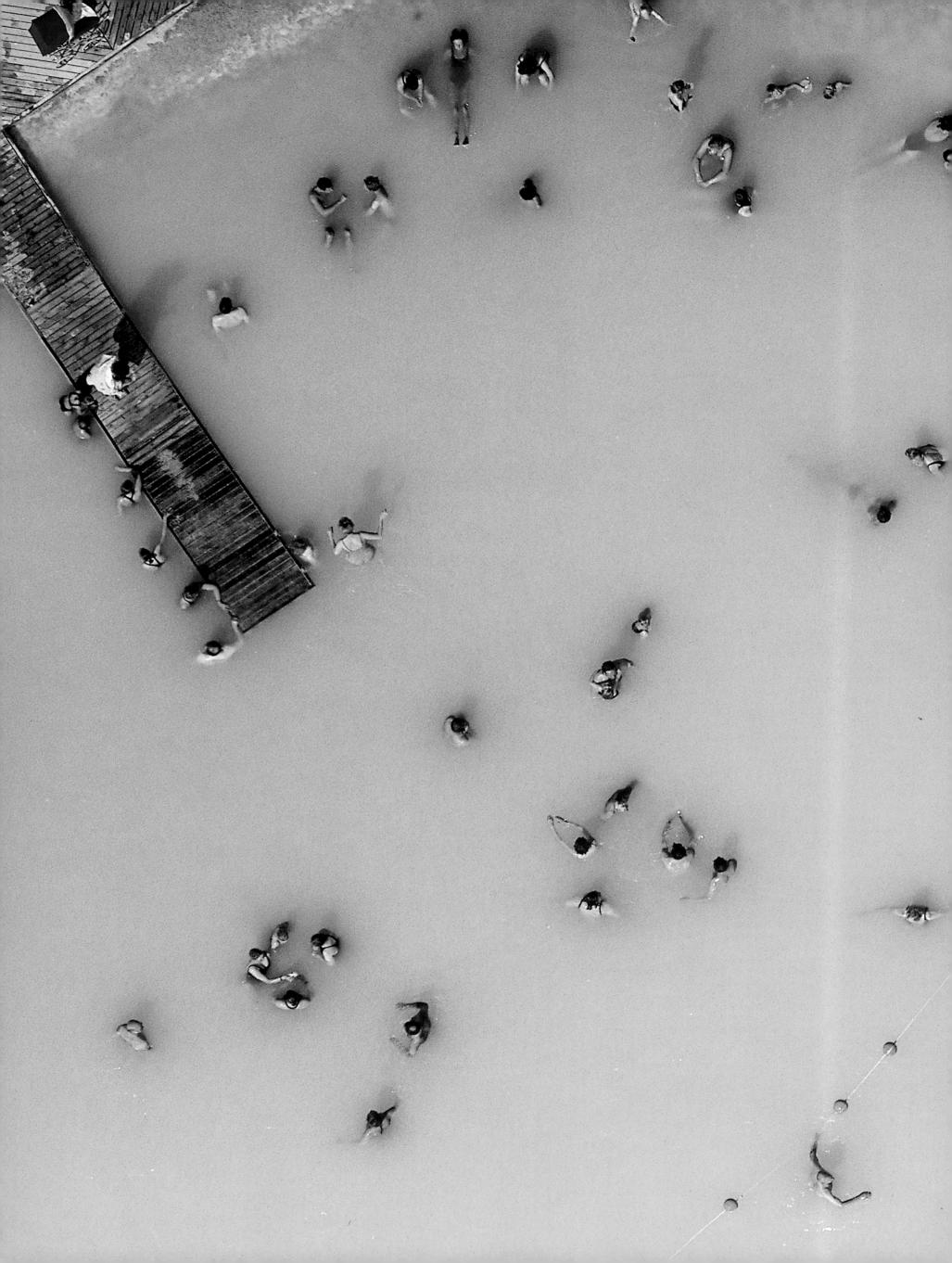

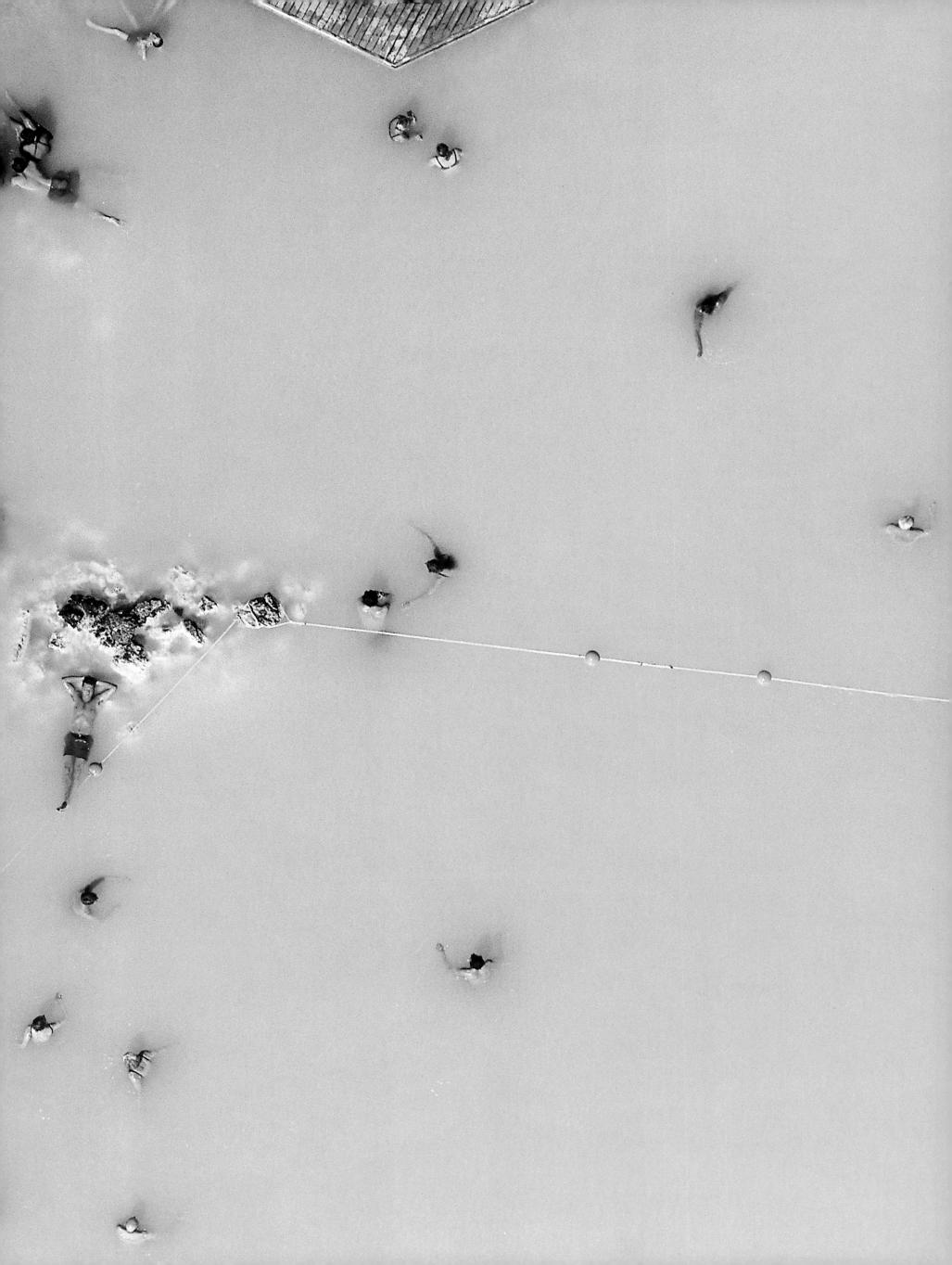

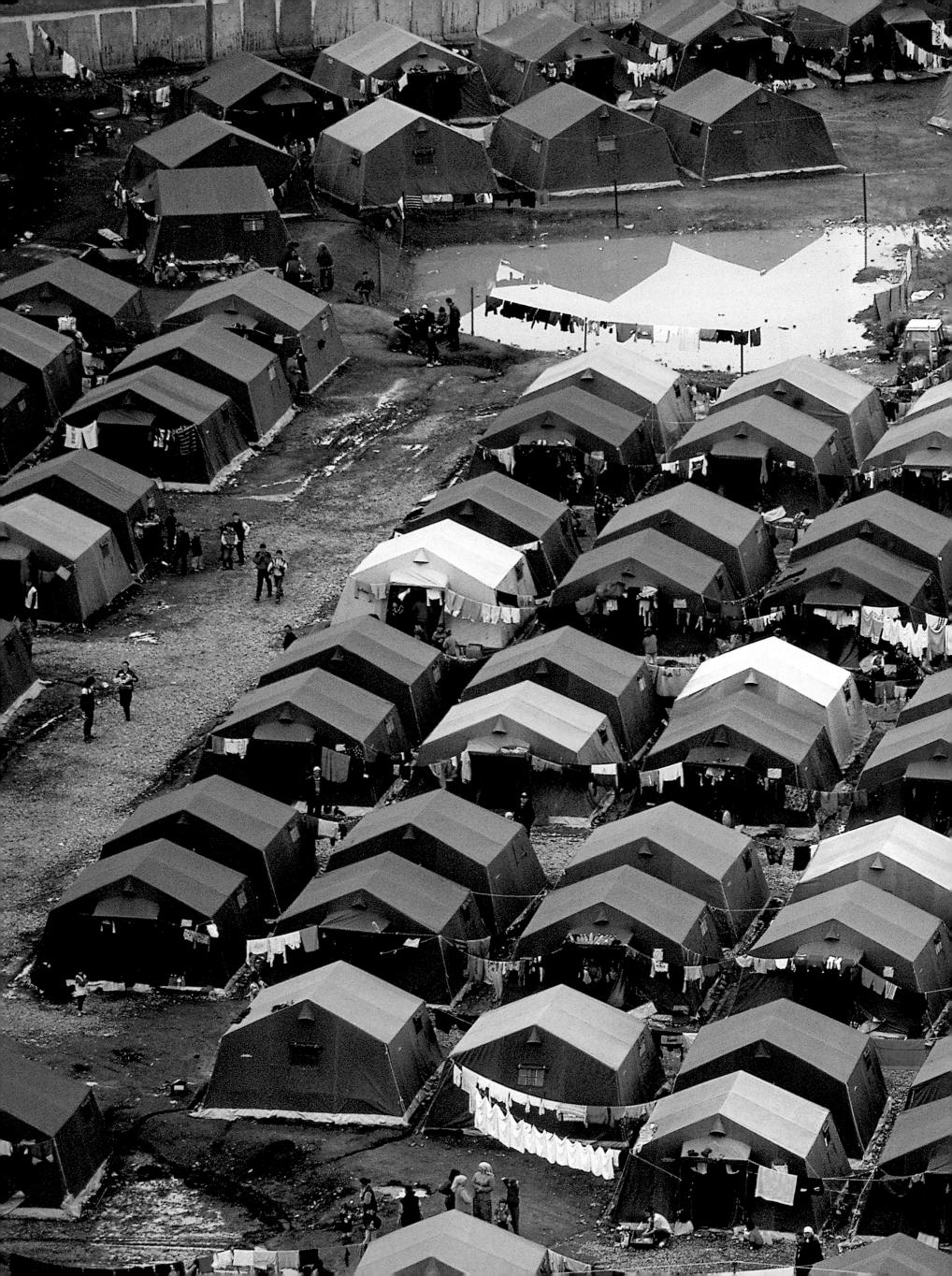

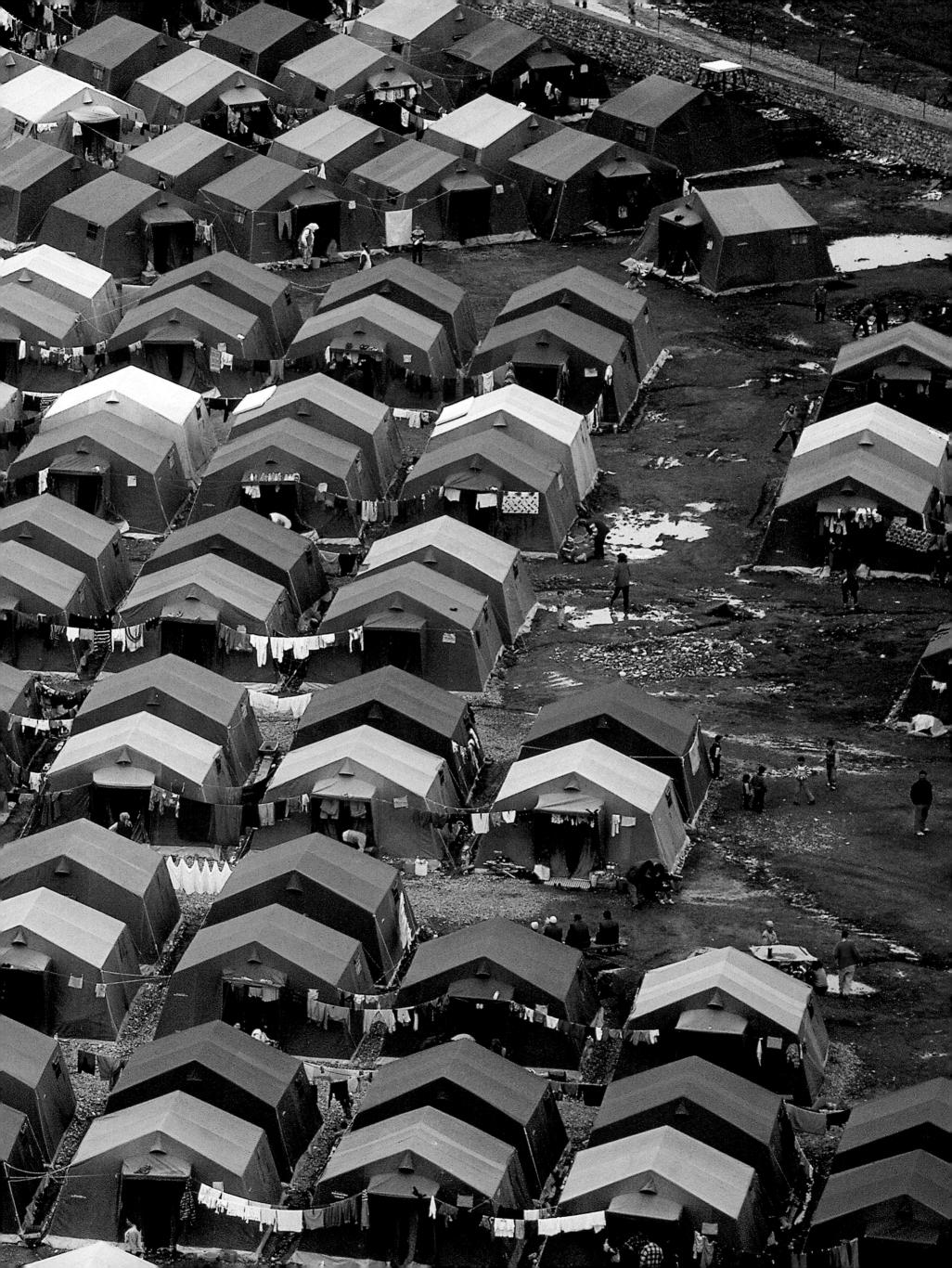

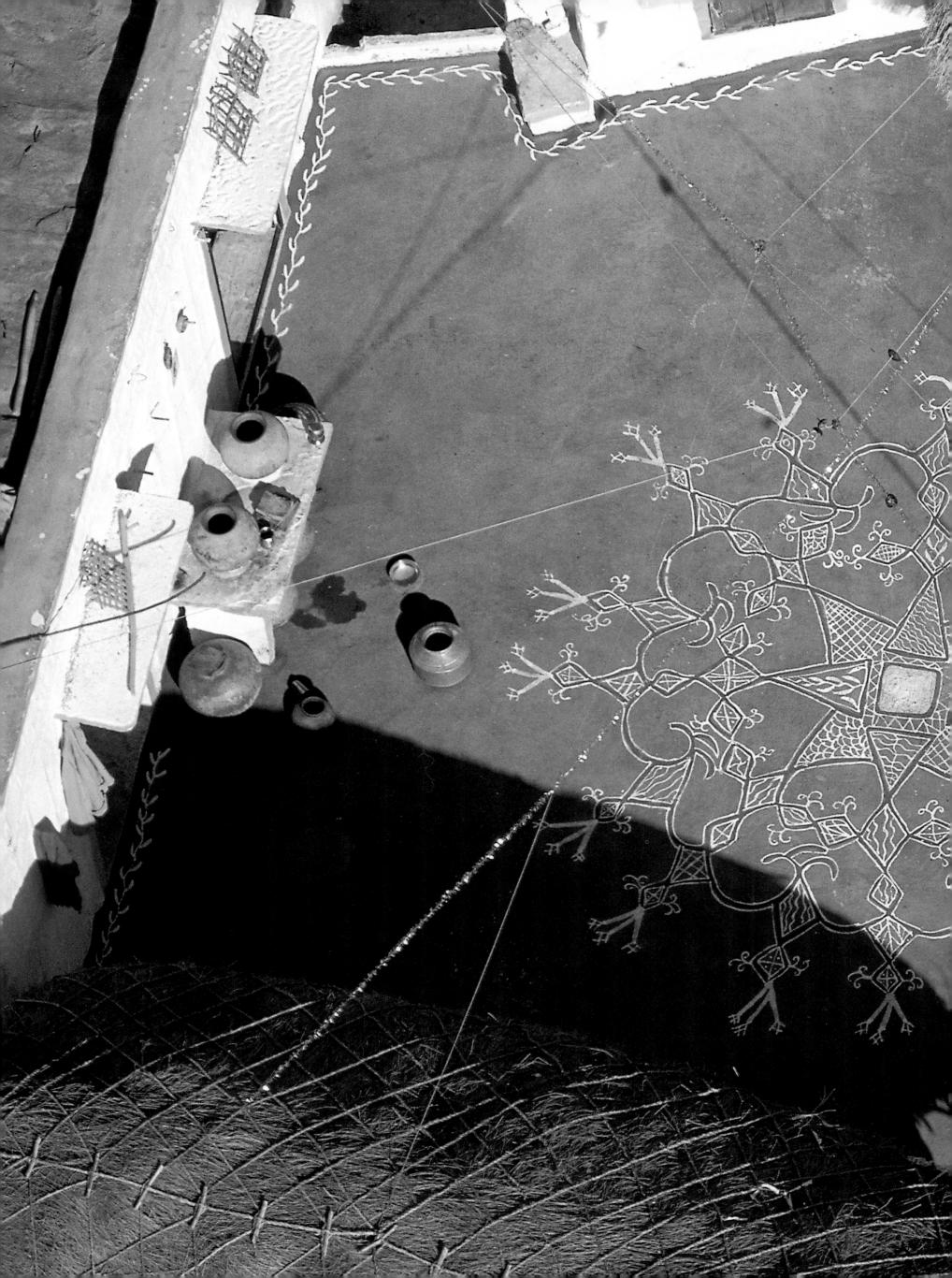

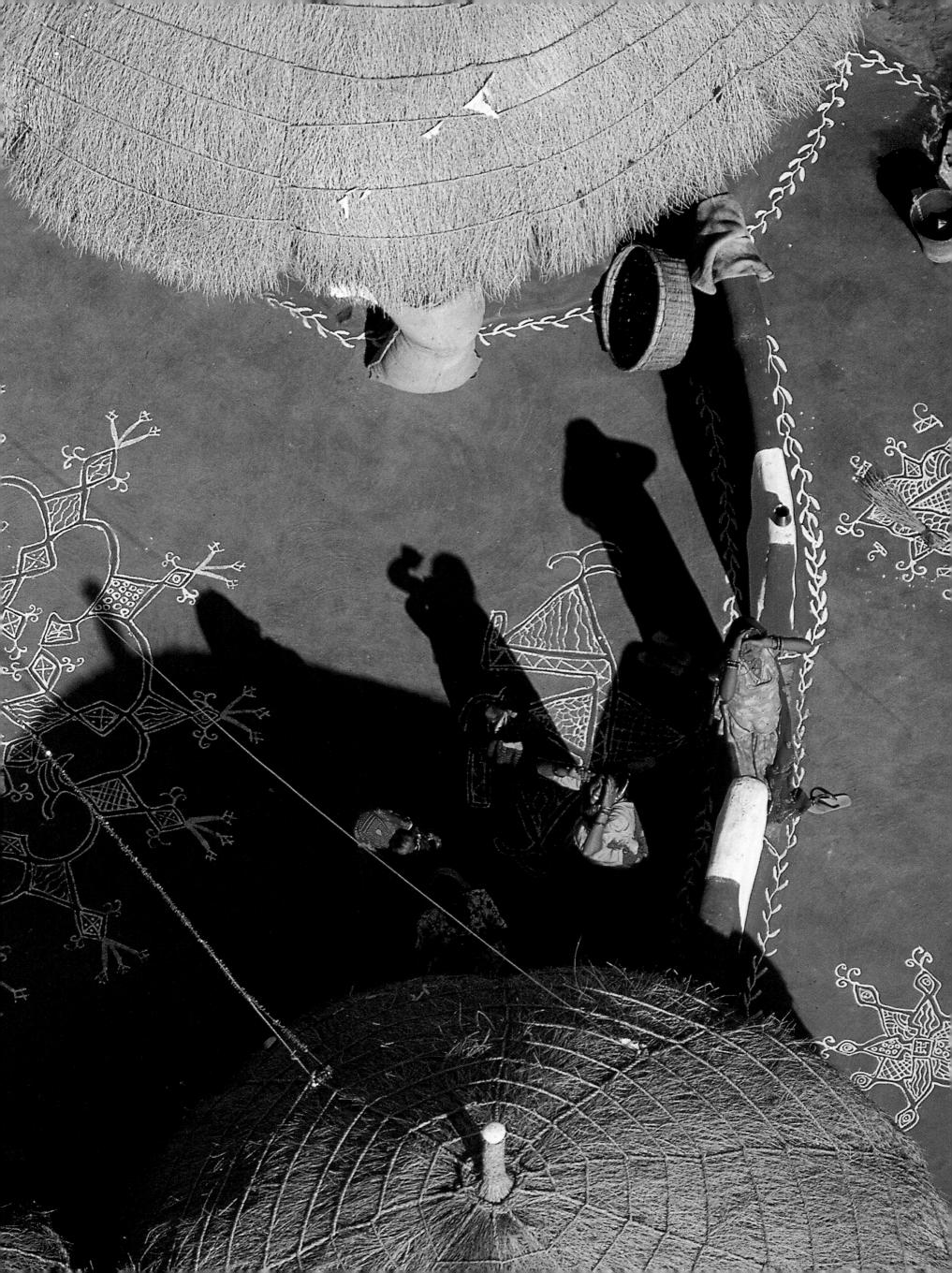

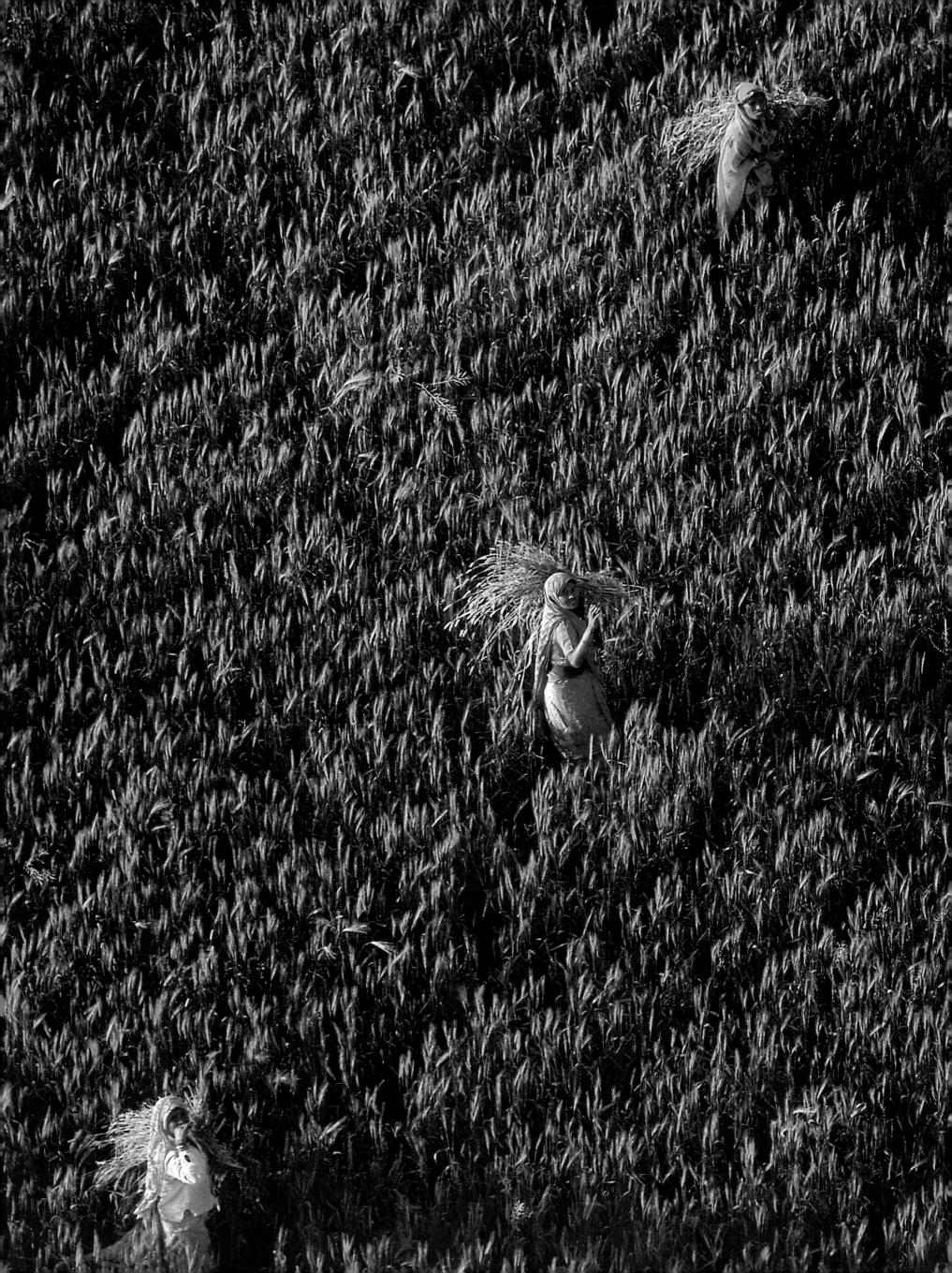

GROWING ENOUGH TO FEED THE WORLD

s our planet unable to meet increasing demands caused by the mathematical progression of the world's population? Do we run the risk of entering a new era of global famine? In the 1960s and 1970s we were able to avert such a danger by making innovative technology available to countries with severe malnutrition. Now known as the "green revolution," the plan was meant to satisfy these countries' expanding needs and allow them to reach self-sufficiency. The results were not long in coming. Since the 1960s the growth of agricultural production worldwide has regularly outpaced the growth of population, even in the most heavily populated countries of the Southern Hemisphere. Large countries formerly plagued by recurrent famine experienced a boom: in a span of twenty years, grain production in India more than tripled and in China increased by more than 50 percent, while pork production in both countries quadrupled. Progress was so striking that today we should, in theory, be able to feed the entire population of the globe. Famines have disappeared, except in countries at war or where leaders use food as a political weapon.

According to some predictions, however, famine could return in the coming century. A new era of food insecurity could result from a war unleashed by an overflowing population in a world with limited riches. Overexploitation of nonrenewable natural resources, the predatory nature of modern agriculture, and accelerating urbanization that each year appropriates millions of acres of arable land have all contributed to slowing down the growth of food production at the very moment that the earth is experiencing an unprecedented population explosion.

A CATASTROPHIC PROJECTION

The increase in the starvation rate has not matched the population increase, but for some 800 million people in the southern hemisphere—almost 200 million in Africa and more than 500 million in Asia—starvation continues. Available statistics confirm the worst fears: according to the United Nations Food and Agriculture Organization (FAO), the population of non-freshwater fish has had a zero increase between 1990 and 1996, grain production worldwide has only increased by 0.5 percent per year since the beginning of the 1990s, and per capita grain supply declined by 1.1 percent.

Several researchers have nonetheless strongly challenged this gloomy picture. If it is true that between 1950 and 1980 the population has grown at an alarming rate, in the past ten years the *rate* of growth has dramatically slowed down. In addition, food production worldwide has up to now largely met the challenge of demographic growth, and the theoretical per capita grain supply has risen in the past fifty years. The FAO, which now posits 1,900 calories a day as the min-

p. 328

WHEAT HARVEST IN THE REGION OF MATHURA, Uttar Pradesh, India

The state of Uttar Pradesh is located in the country's most fertile region, blessed with alluvial terrain that is permanently irrigated by the waters of the Ganges and its many tributaries fed by the Himalayan snows. The climate of this state, which is marked by mild winters and hot, humid summers, also contributes to making it one of the greatest agricultural regions of the country. Wheat, a major local crop, as shown here near Mathura, is harvested manually by women at the end of the dry season; it is raised mostly for local consumption and for the national market. With an annual harvest of 69 million tons, India is among the world's leading wheat producers, ranked just behind China and equal to the United States.

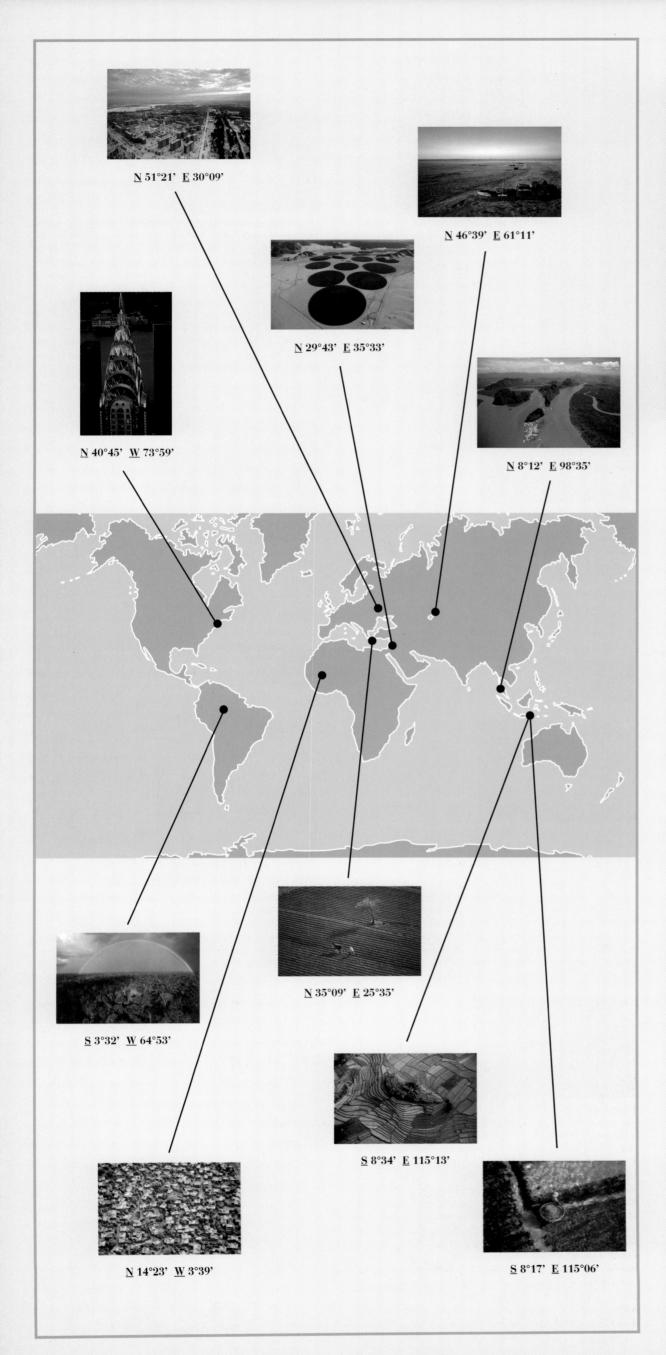

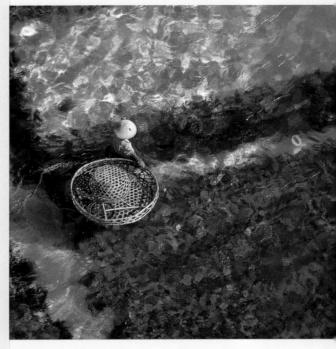

brecasts conceal important regional disabelt Asia, which has a predominantly buntries such as Bangladesh are facing ems. The situation of sub-Saharan Africa, percent of the population is still largely disturbing; this region may replace Asia highest rate of malnutrition. The FAO the number of Africans suffering from a by 70 percent in fifteen years, rising 1990 to 296 million by 2010, when the Asia will be at 200 million.

IES AND ION MODELS

owever, is not the only factor to be conbreveal that the number of undernourscline over the next fifteen years—regardproduction increases—unless specific are enacted. It is scandalous that hunger planet that produces everything in abuncause of the uneven distribution of this obe.

ronic hunger remains restricted to the d to those with an extremely unequal diss, it has been easy to cite insufficient production or climatic disturbances as the s nutrition. Today, however, food shortage af tion of the population of the world's leading ducing countries. Brazil offers almost a world's third-largest agricultural exporte age to feed its 160 million inhabitants adarchaic agrarian structures inherited from the great landholders retain disproportion. These factors help explain why 8 million workers without land are prevented from alongside large landed estates that have g guarded by private armies. More paradorampant in the heart of the world's riches in the United States and Western Europe

The appearance in rich countries believed to have been eradicated will for sider the matter in political terms rathetechnical thinking that has prevailed for today prevents Europeans or North Amethemselves adequately, this does not meatof the Northern Hemisphere have globally of food consumption. These countries, we 21 percent of the earth's population, ab

cient enclaves of the Southern Hemisphere are causing irreversible harm to the environment. The planners of the agrarian and nutrition policies of the large producing countries show no concern about sterility of overirrigated lands in Asian regions long since devoted to the green revolution. Nor have they worried about pollution and exhaustion of the groundwater in areas where the use of chemical fertilizers has reached record heights, or about the infertility of overused soils in Europe and North America, among other alarms. At the same time, the regions left out of the technological revolution have seen their productive potential exhausted for other reasons: under pressure of exploding demand, much of sub-Saharan Africa has abandoned the practice of crop rotation that allowed soil fertility to be restored in the absence of fertilizer. Elsewhere, overgrazing is causing serious damage to the vegetal cover. Finally, demographic growth, poverty, and the absence of substitute energy policies are increasing the demand for fuel woods, leading to a sometimes irreversible degradation of the forest cover. Such practices speed up the process of aridification under way throughout the Sahel region.

Two schools of thought are at odds today in the field of agriculture. Partisans of a "green super-revolution" see the pursuit of technological progress and genetic engineering as the only possible response to the rise in demand and pay little attention to the dangers of exhausting the world's productive potential: the new genetically modified food plants represent the panacea of the twenty-first century. But before they can prove their usefulness, these plants run the risk of further degrading the biodiversity already at risk, without reducing the nutrition shortages of the farm populations of the Southern Hemisphere—for those farmers the plants will remain financially out of reach.

Other researchers urge the implementation of a

"double-green revolution." This new agricultural revolution will supposedly meet the dual challenge of being more productive and still "greener" than the first one. It will indeed have to meet a considerable growth in demand, but it also faces the new task of natural resource conservation and pollution limits. In addition, contrary to the revolution of the 1960s that largely ignored needs of rural populations, this second revolution will aim to ensure food security for everyone.

Agricultural policies that deal with both the increasing immediate needs and the preservation of natural resources to meet needs in the long term are not at all utopian. But in the countries of the Northern Hemisphere as well as the Southern, these policies will require a radical change in current thinking. Thanks to the slowing of demographic growth and to reasonable expectations (although not assurances) of progress from agronomical research, the world is not in danger of starvation—on two conditions: a rapid reduction in the inequalities that are the main cause of hunger today; and a refusal to yield to the folly of short-term profitability, which could compromise the ability to feed the 8 billion to 10 billion of us who will live on the earth tomorrow.

Sophie Bessis

p. 337 SPIRE OF THE CHRYSLER BUILDING, New York, United States

In the heart of the borough of Manhattan, in New York City, rises the Chrysler Building. The spire, made up of a series of superimposed steel arches, reflects the rays of the sun by day and is illuminated at night. Architect William Van Alen designed this Art Deco building on the orders of automobile magnate Walter P. Chrysler. At 77 stories and 1,050 feet (319 m) high, it was the tallest building in New York when it opened in 1930; but it was dethroned by the Empire State Building, which rises 1,250 feet (381 m), in 1931. The Chrysler still counts among the city's forty tallest skyscrapers, all of which are above 655 feet (200 m) in height. The demographic and economic growth of the world's megalopolises inspires buildings of ever-growing height. The record in the year 2000 is held by the Nina Tower in Hong Kong, which is 1,705 feet (520 m) tall.

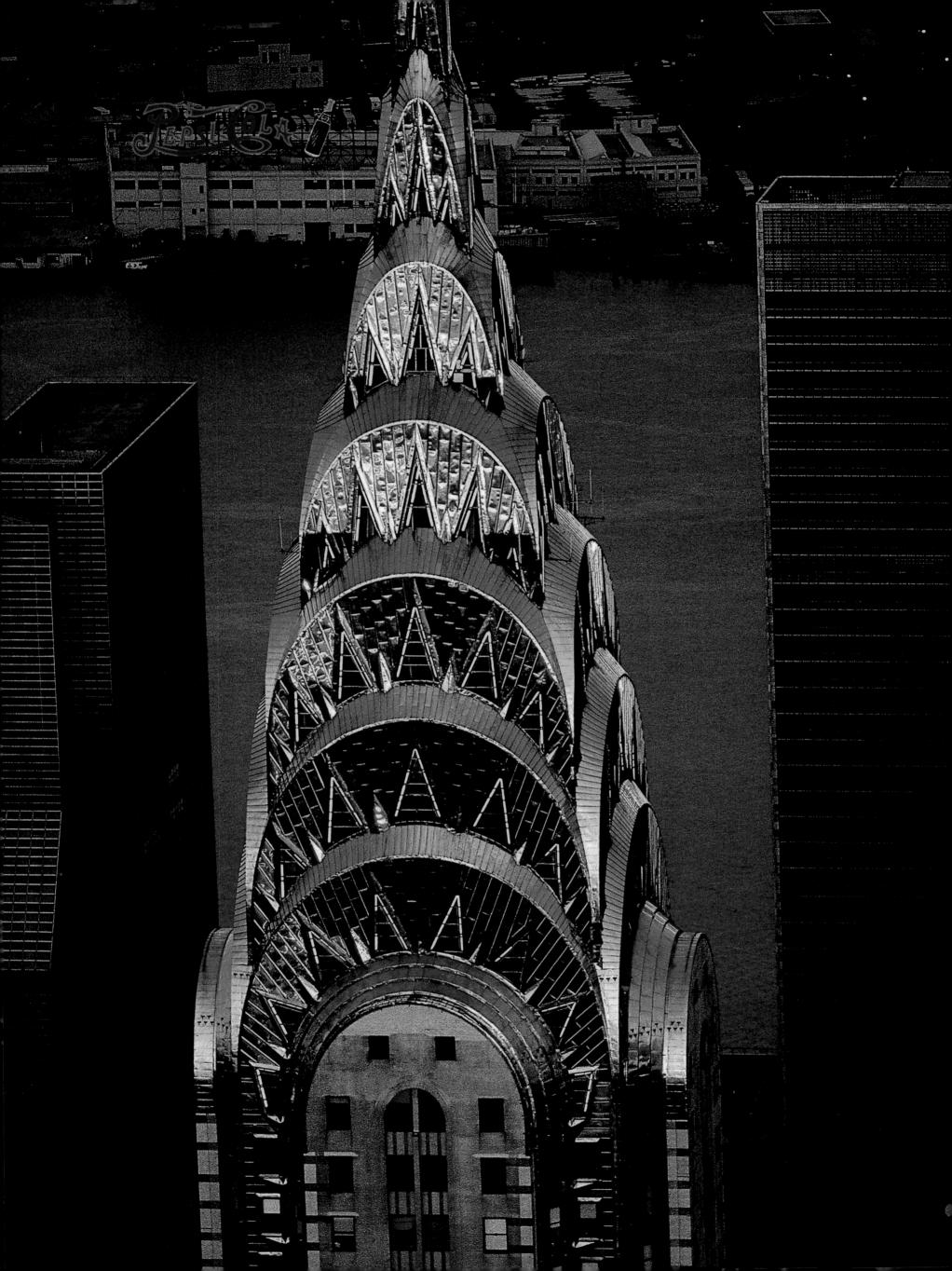

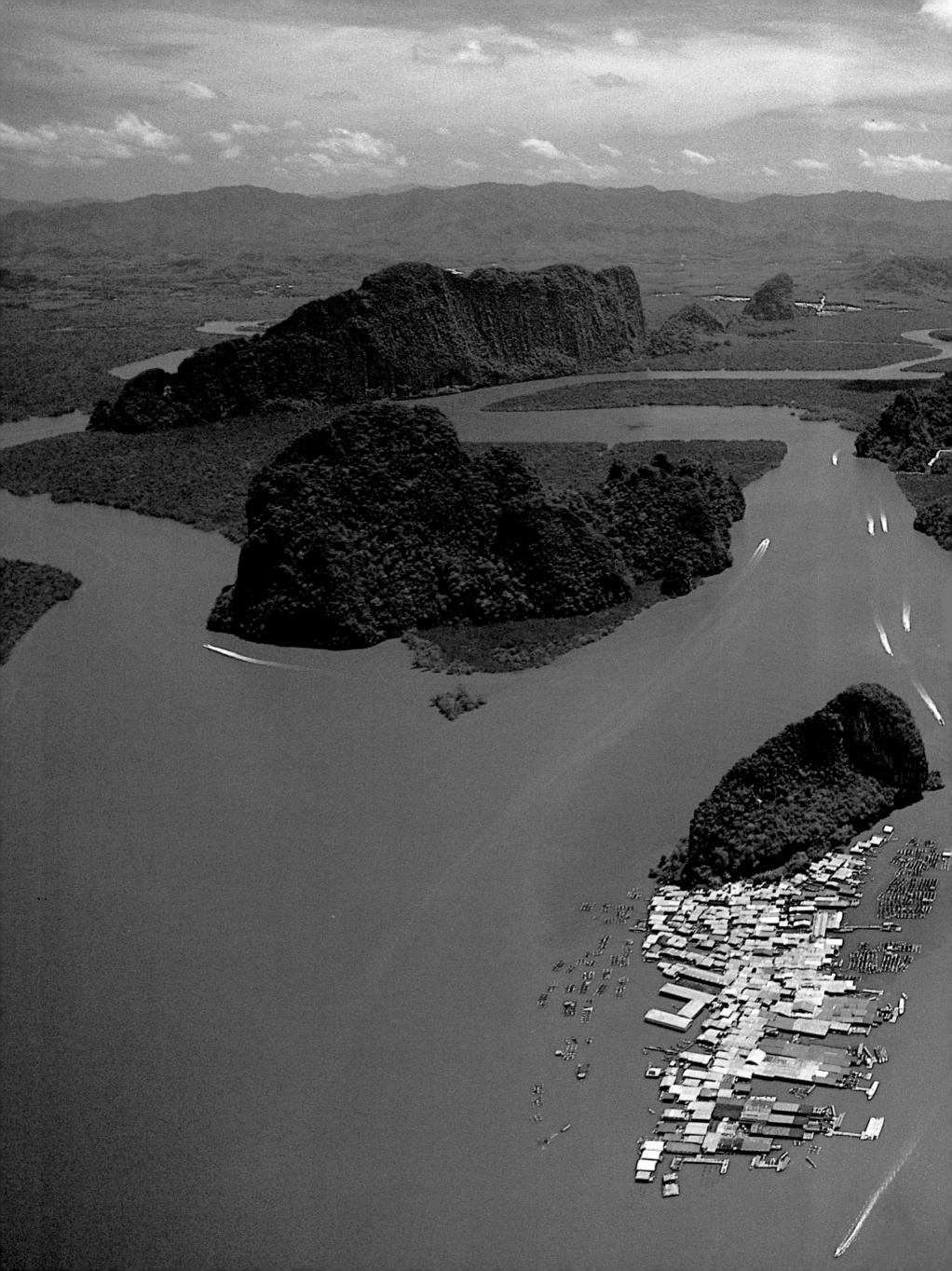

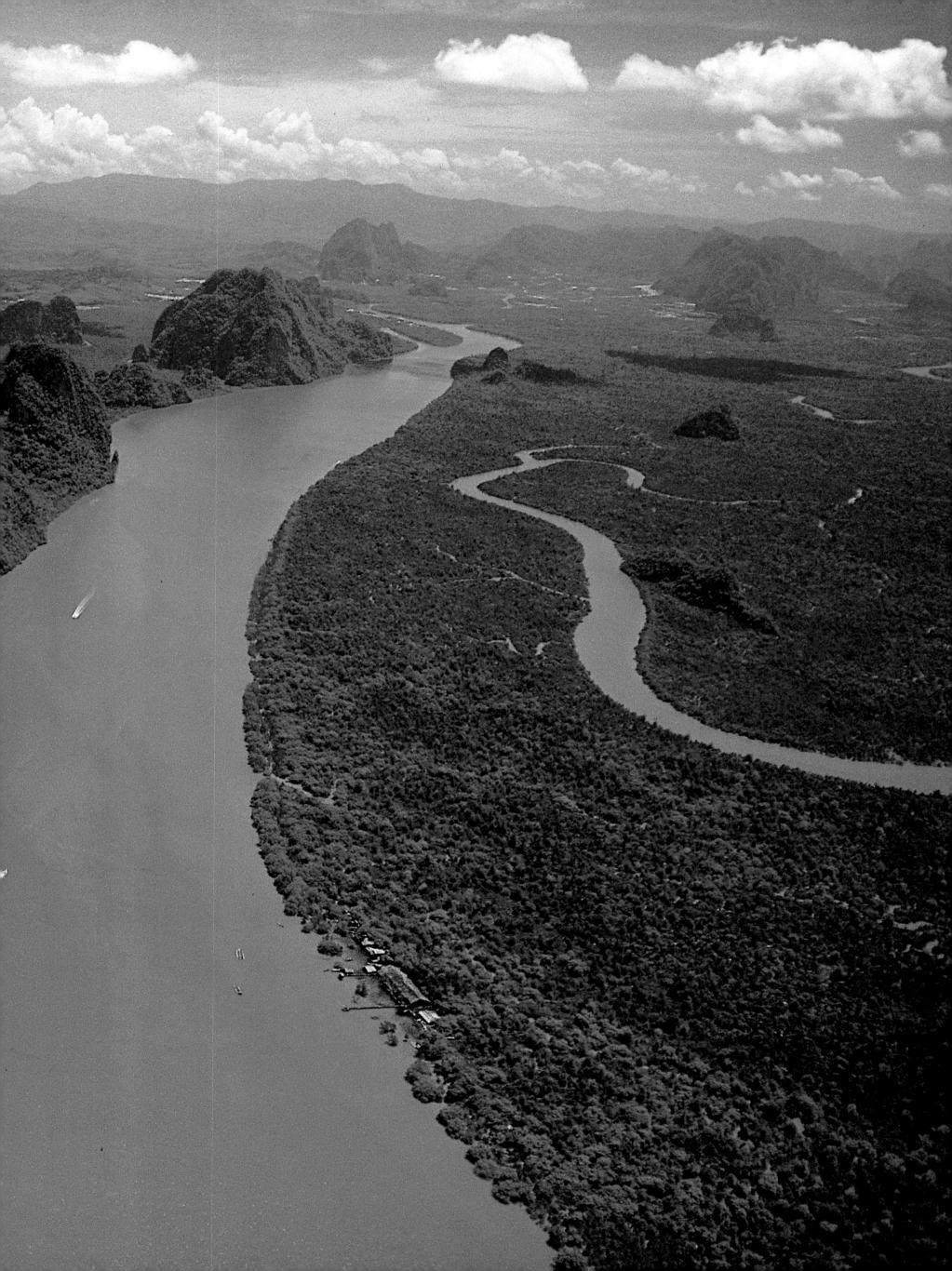

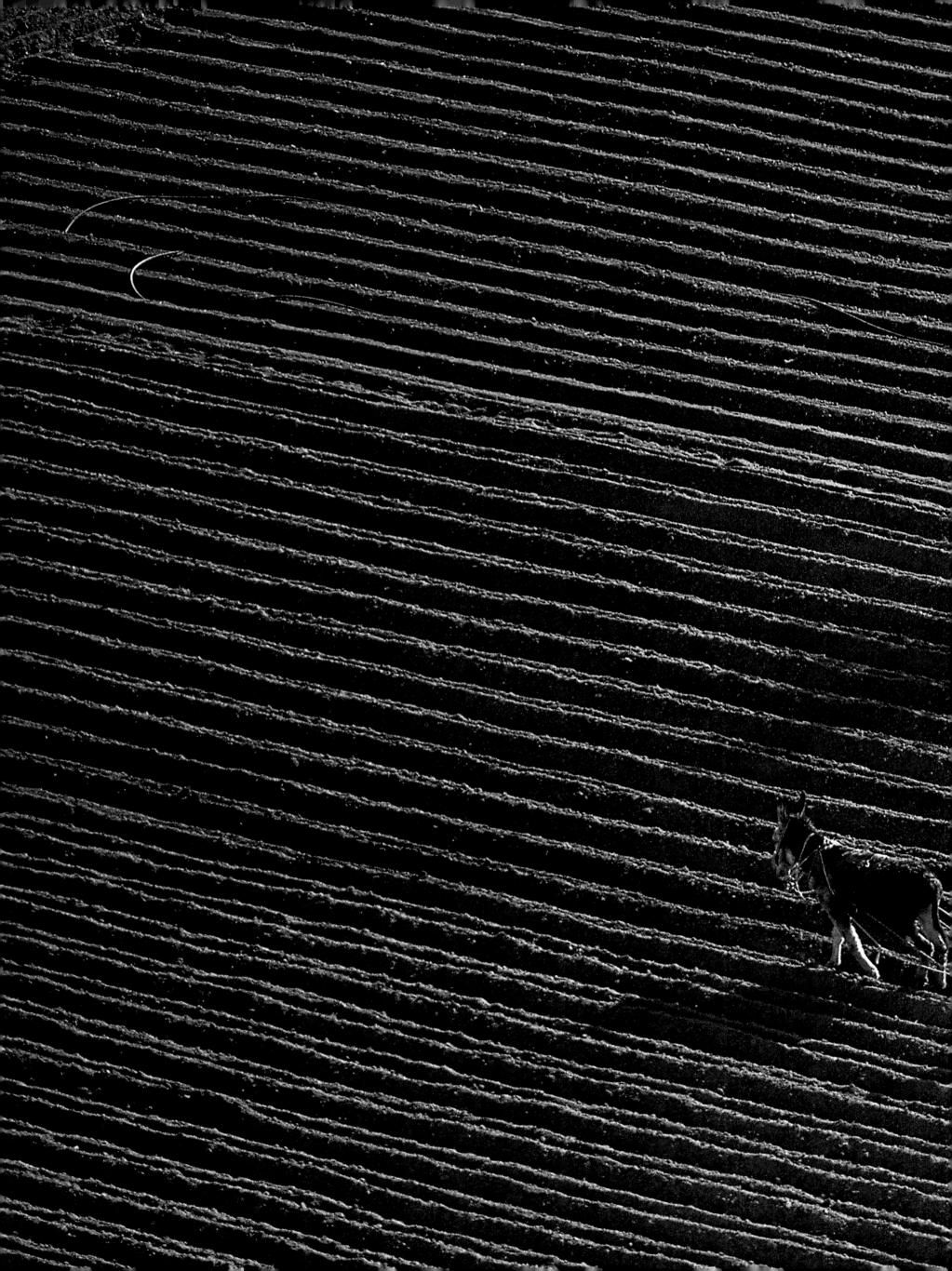

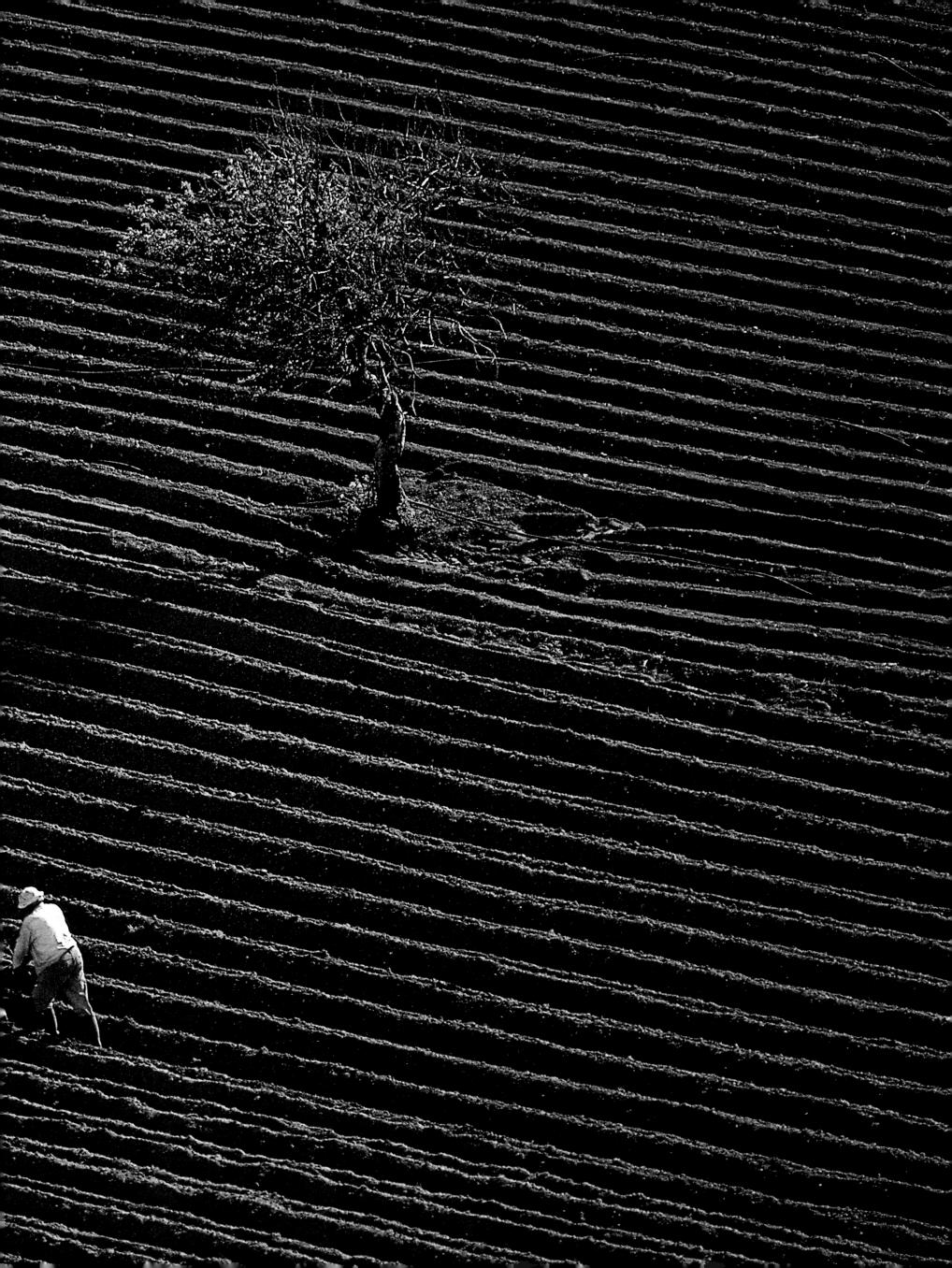

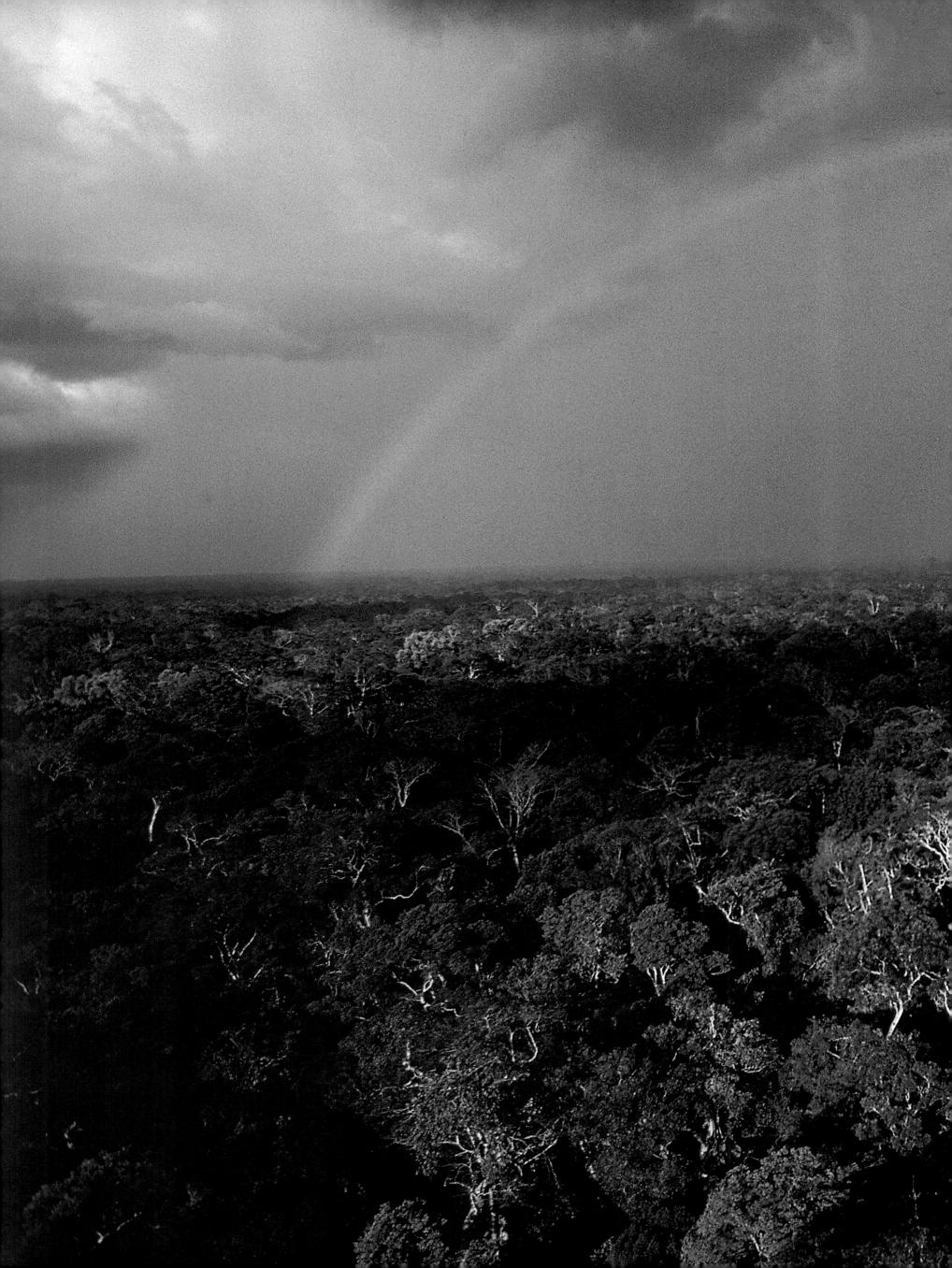

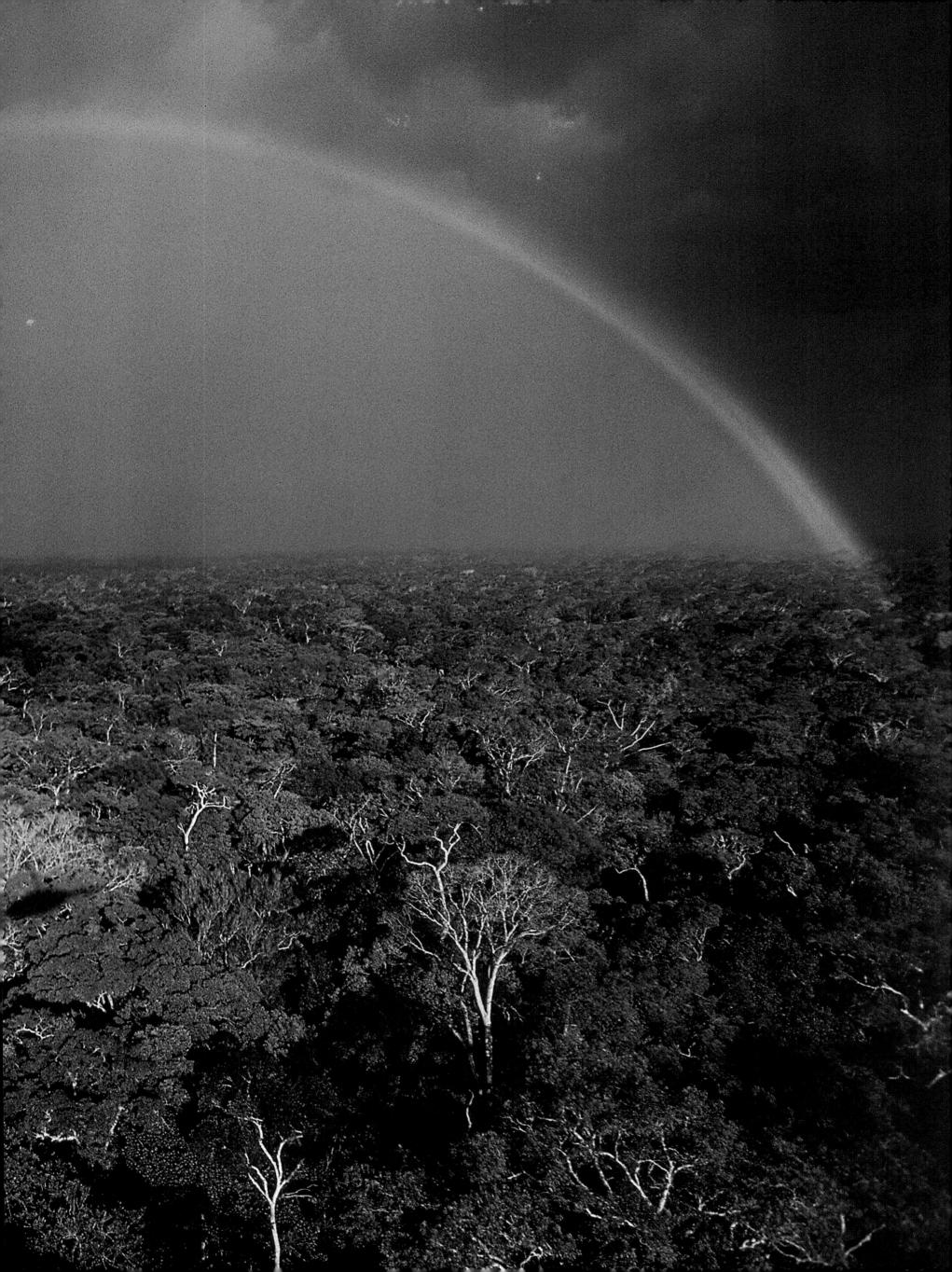

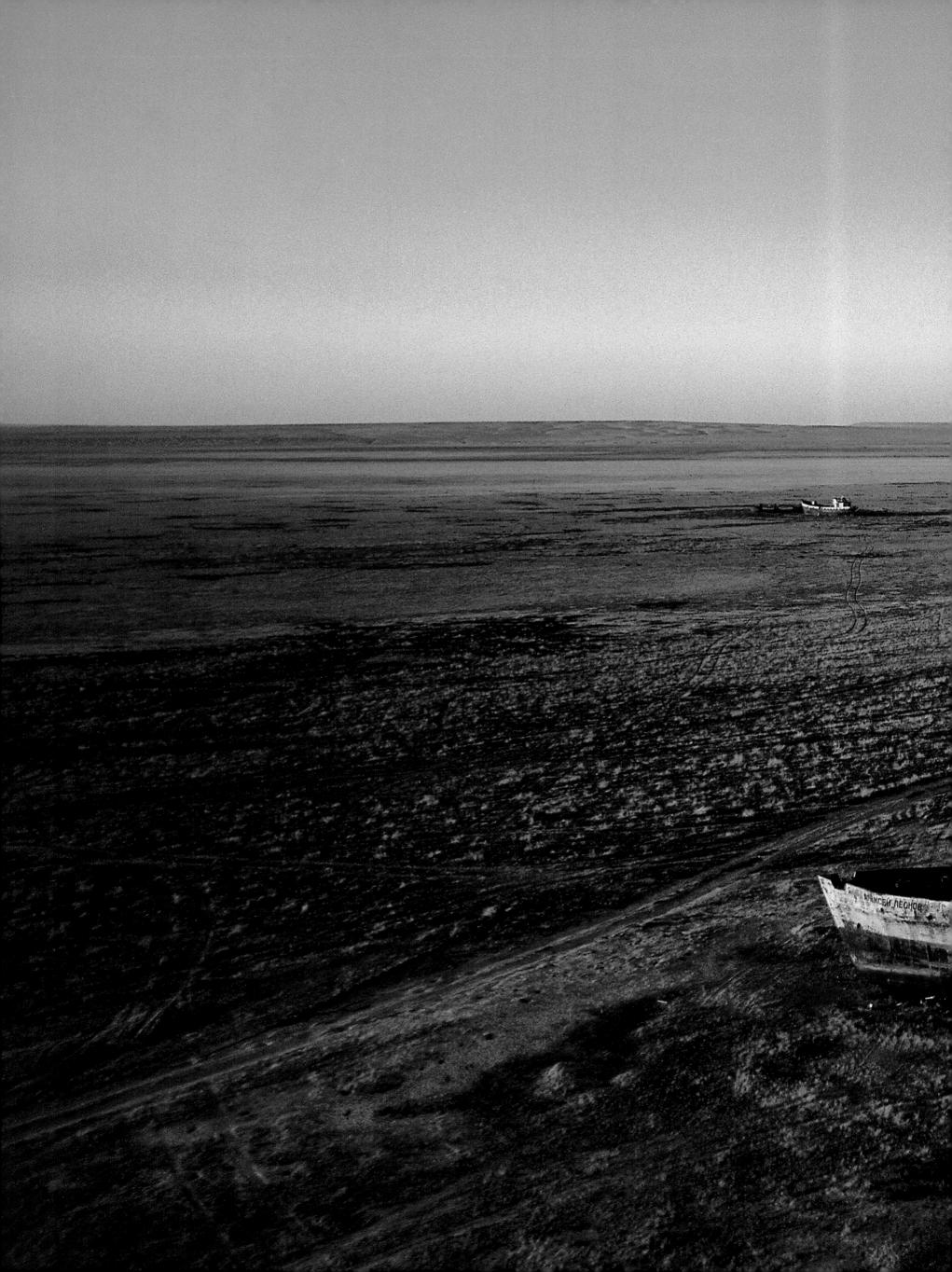

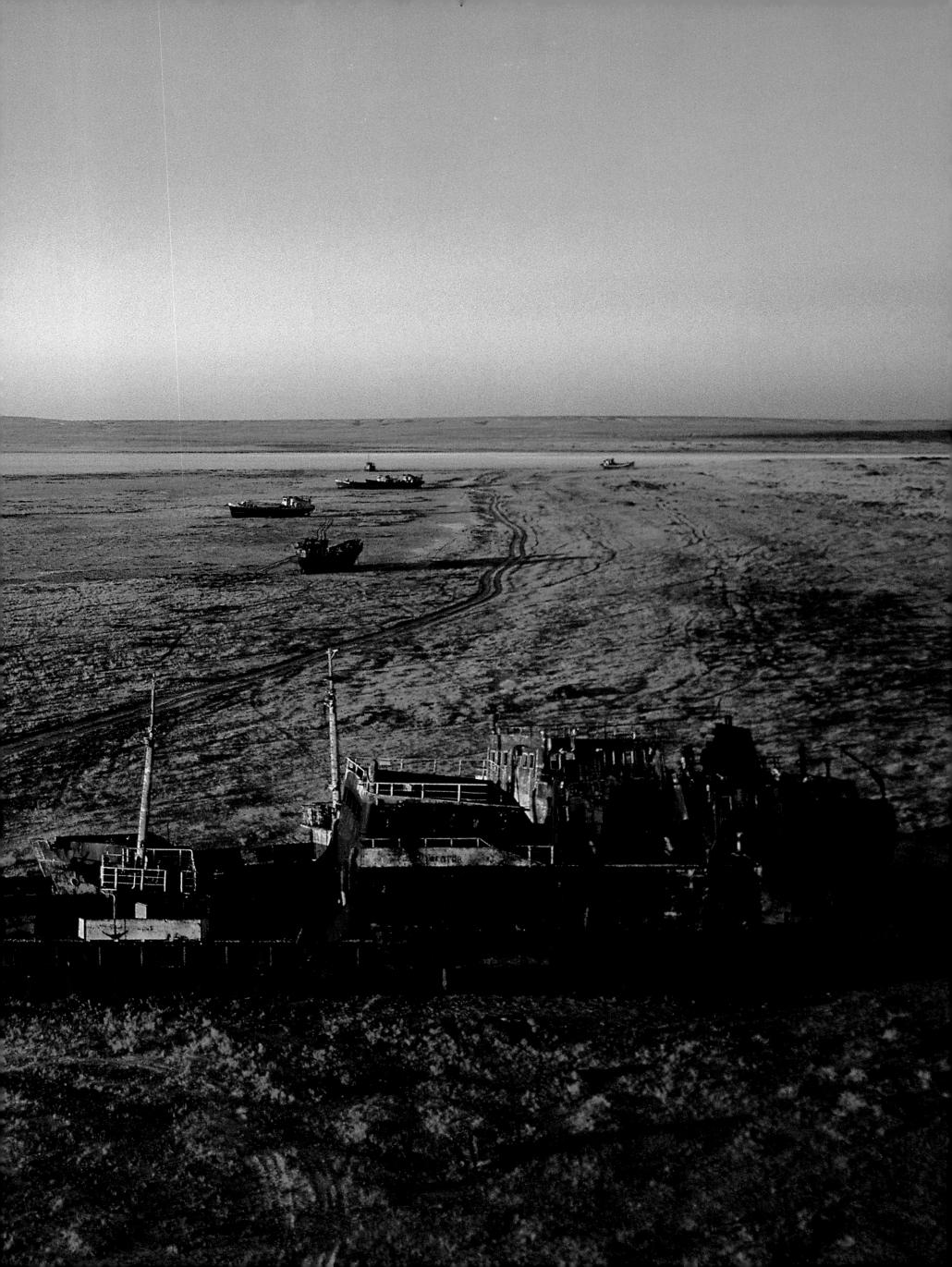

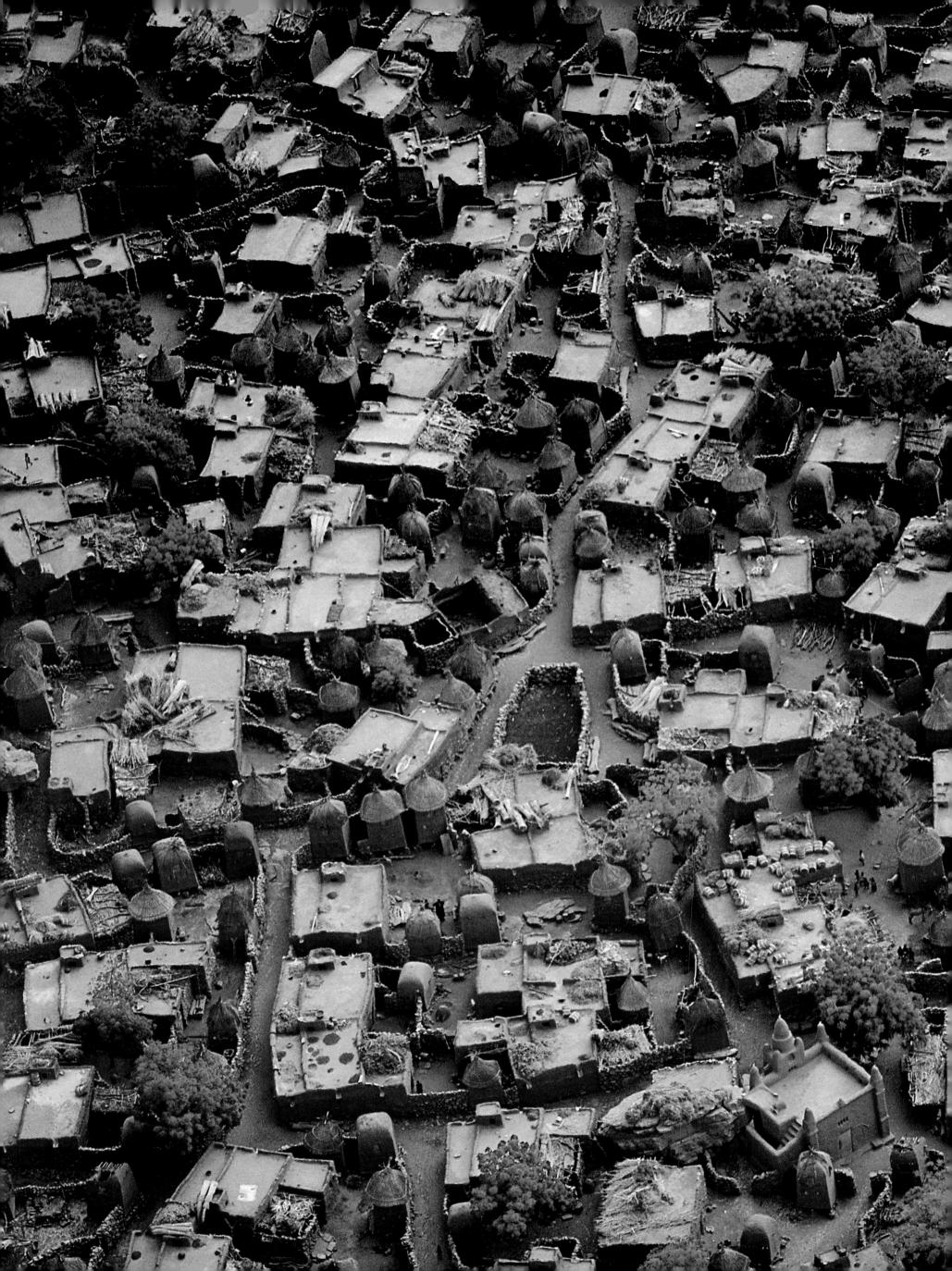

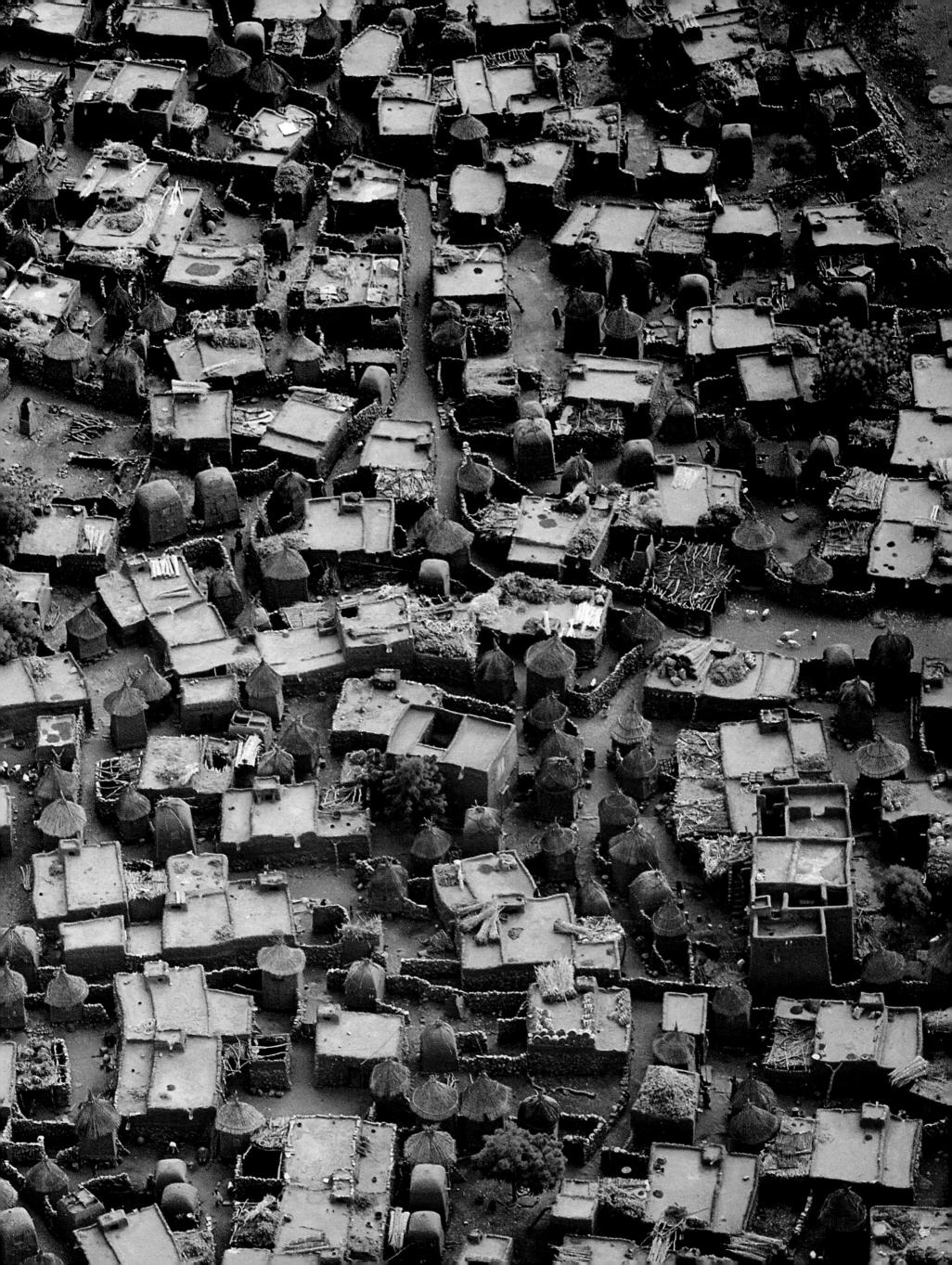

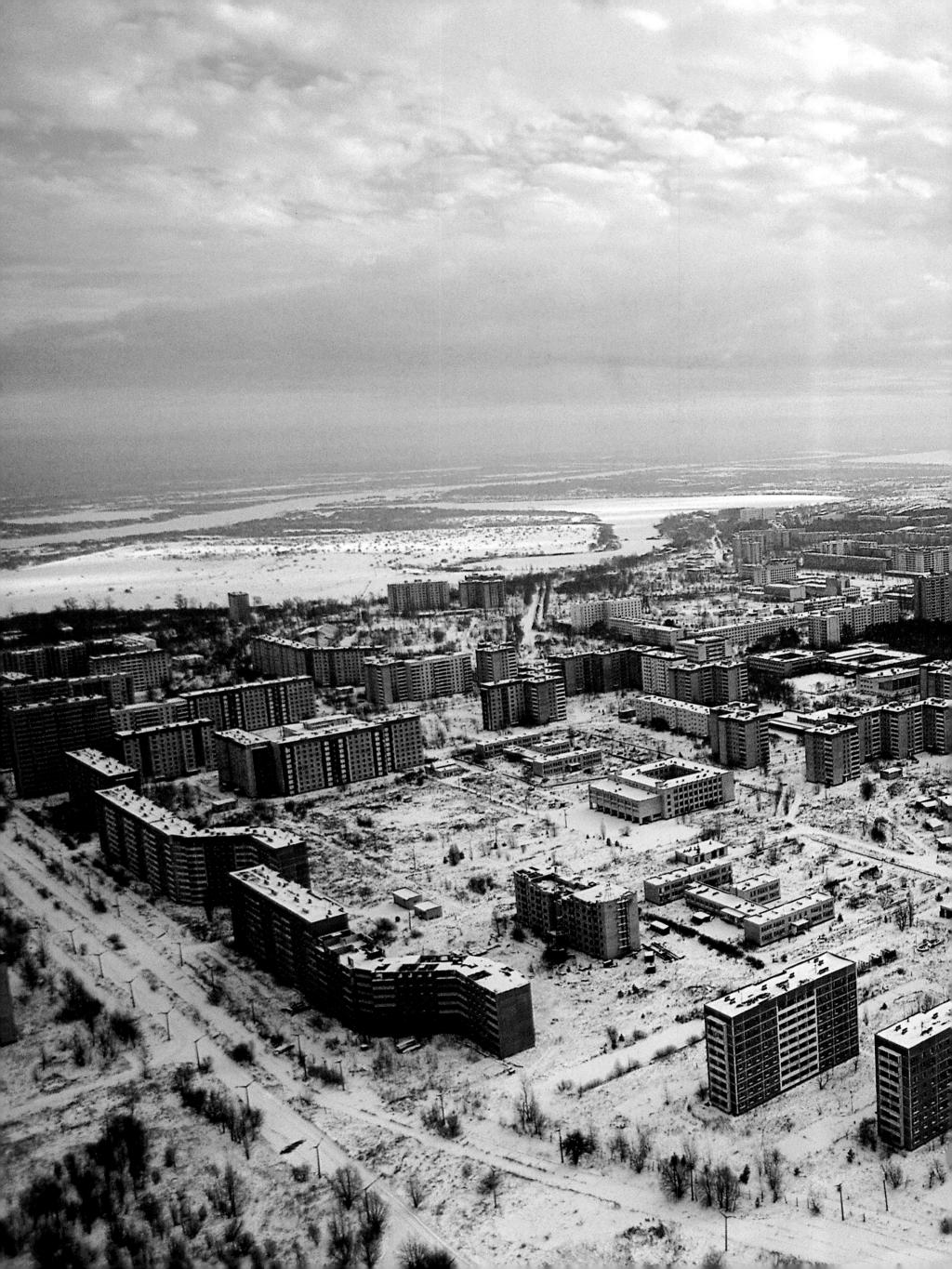

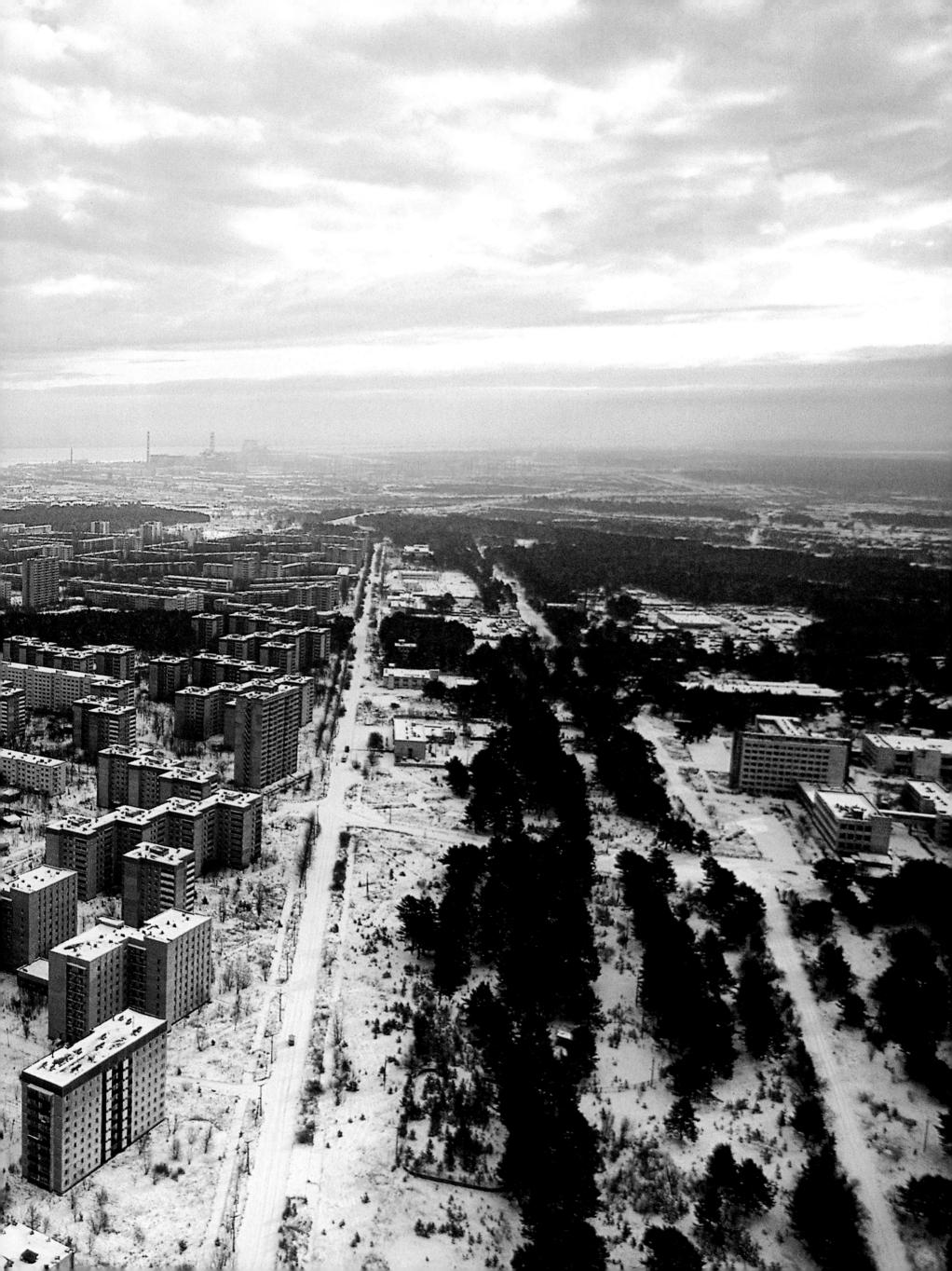

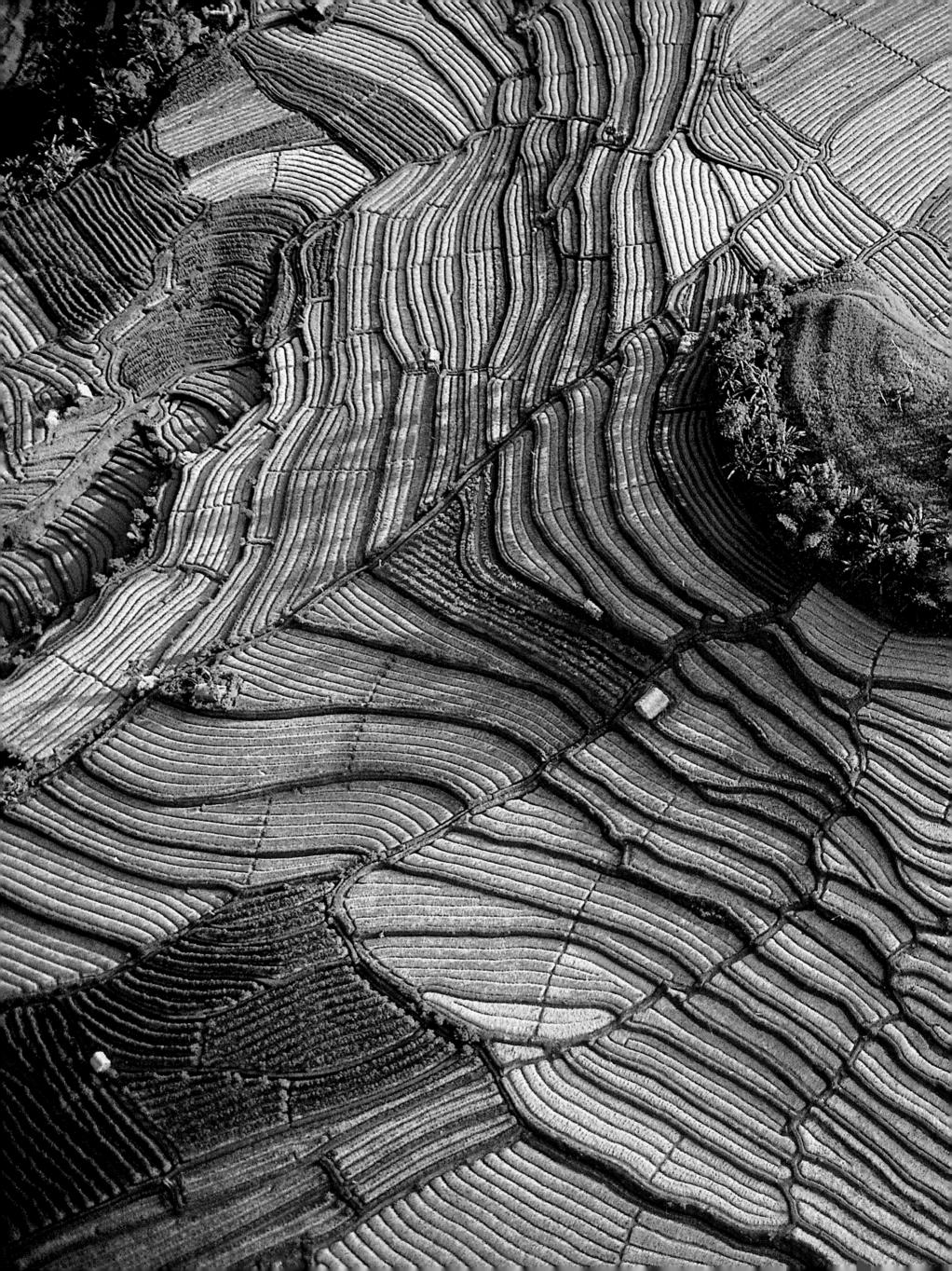

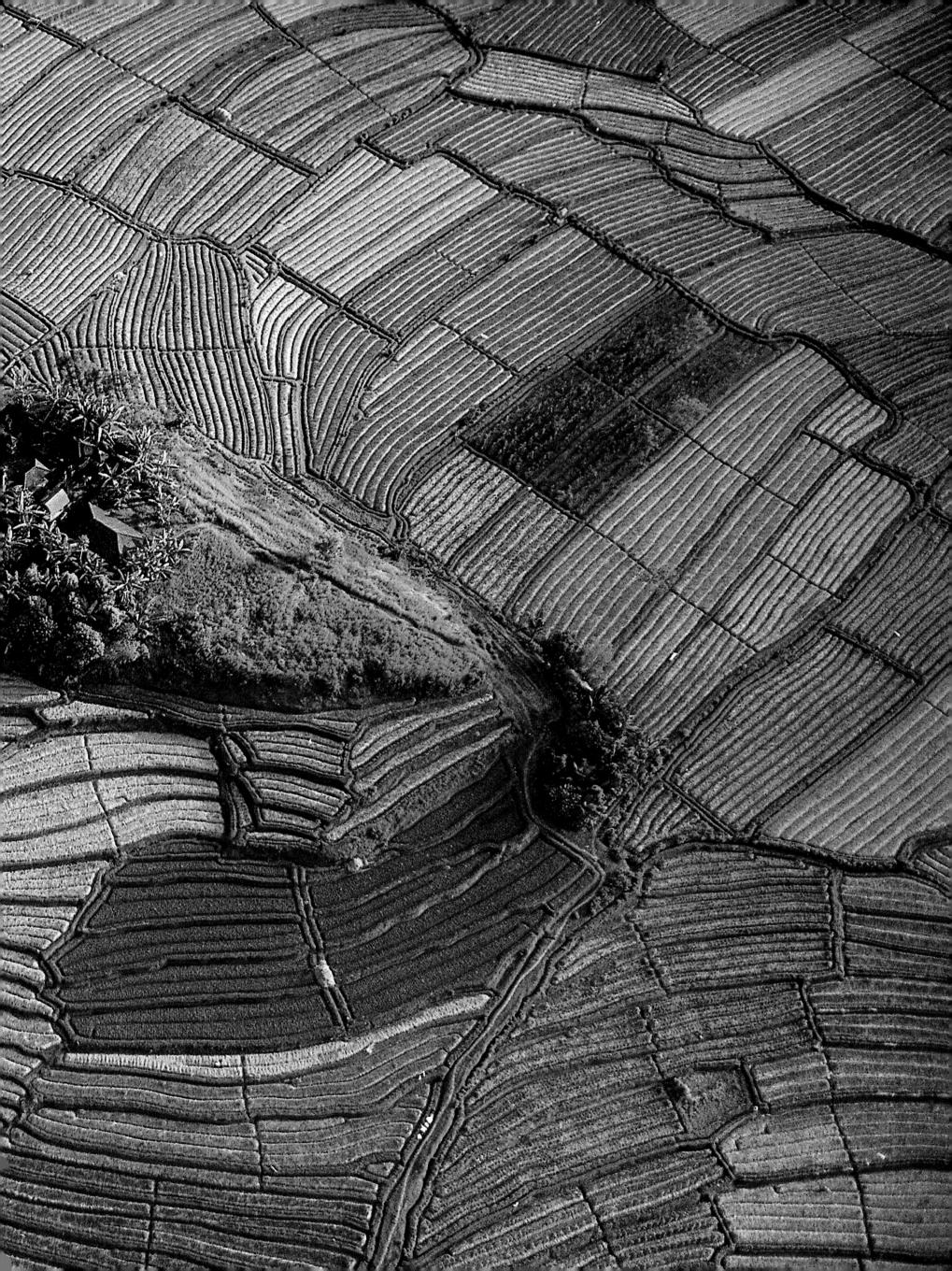

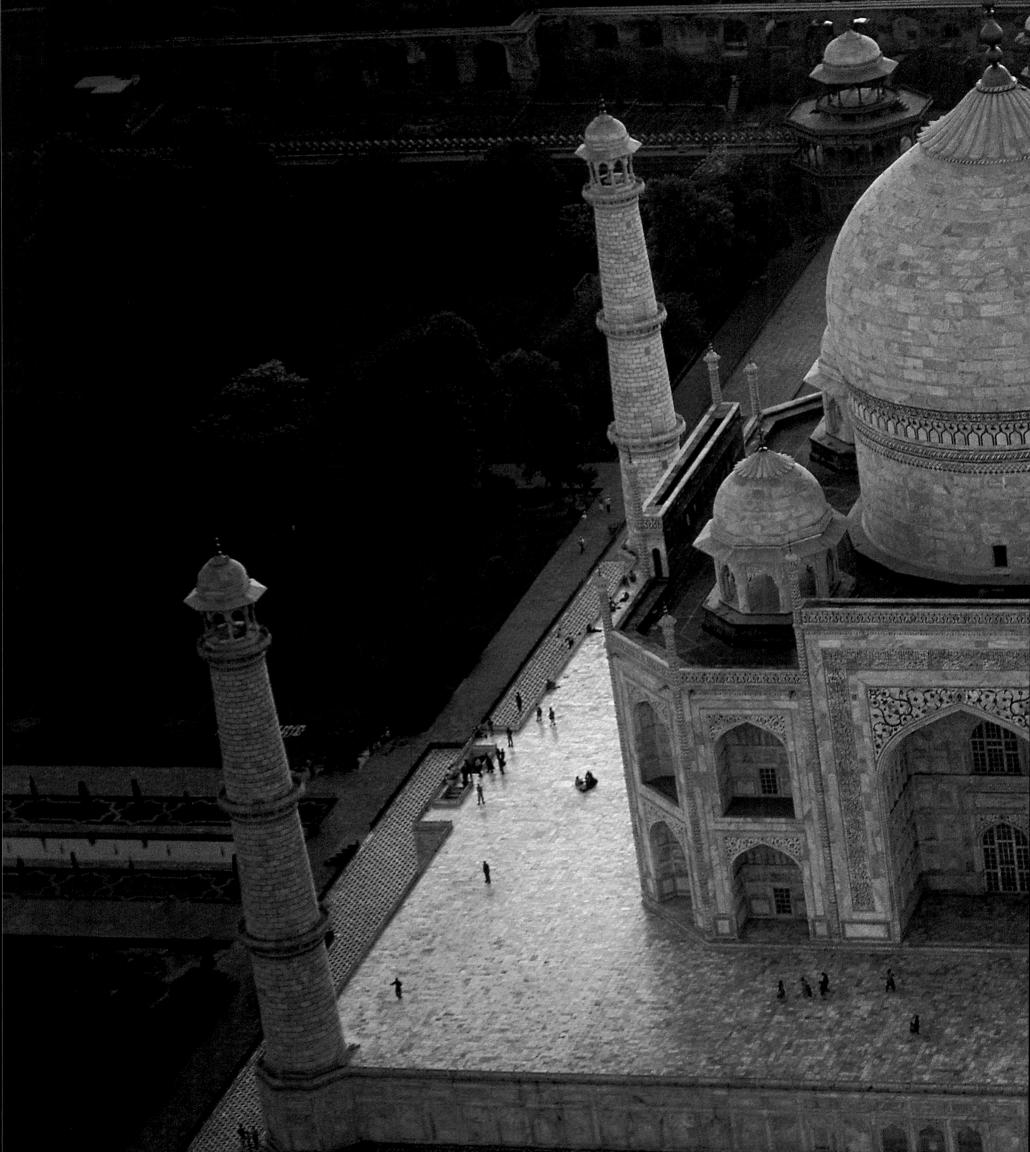

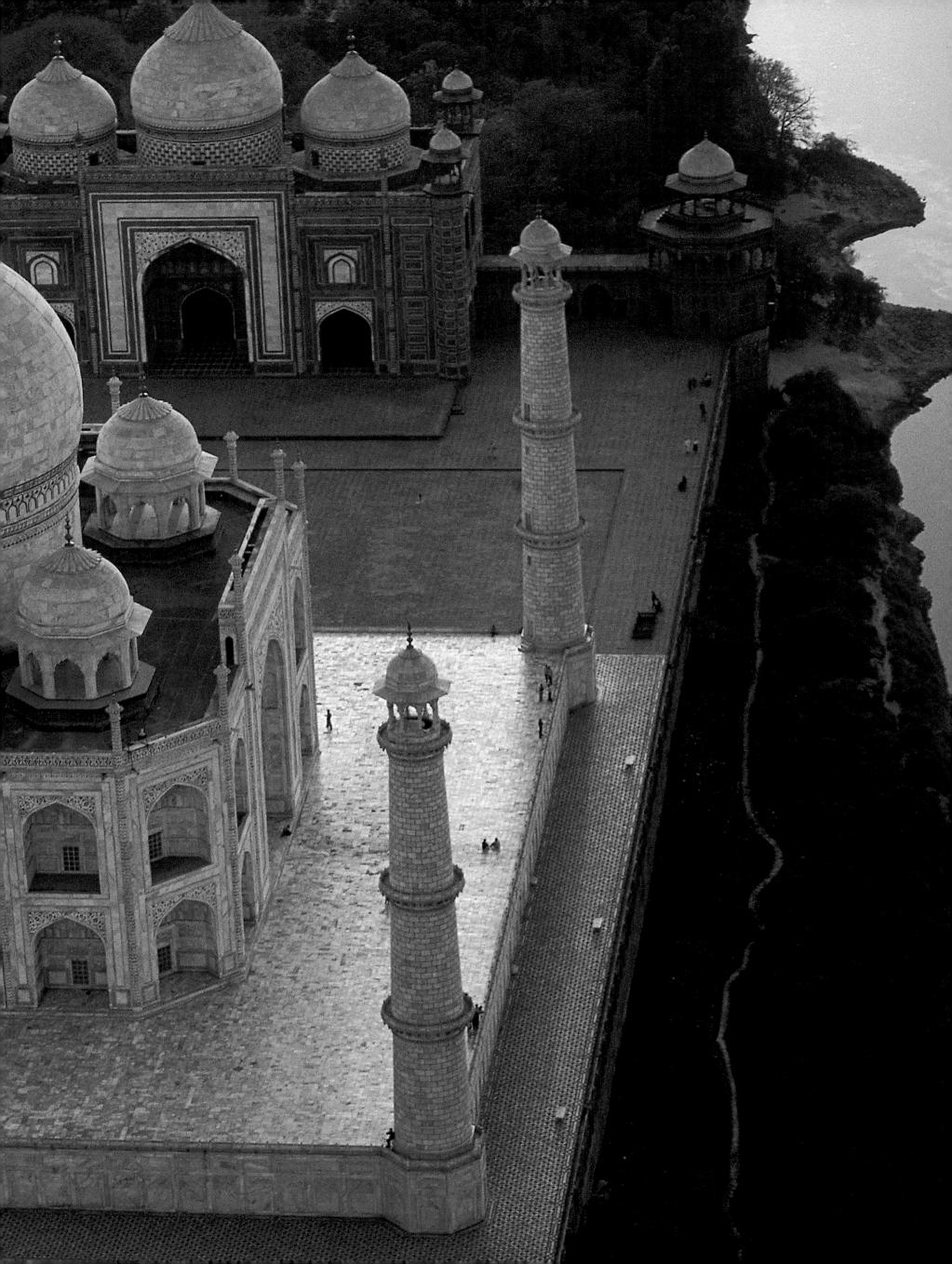

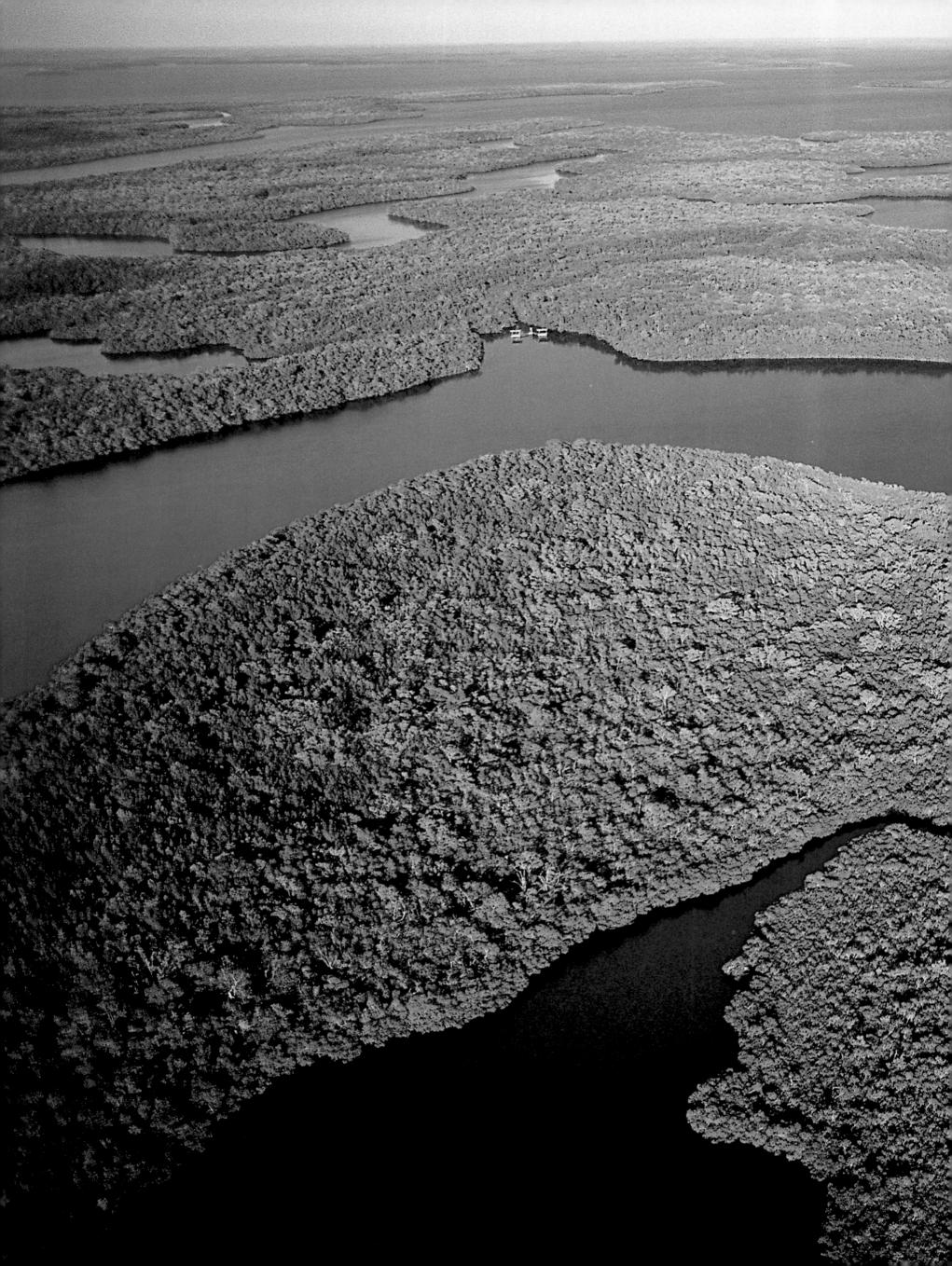

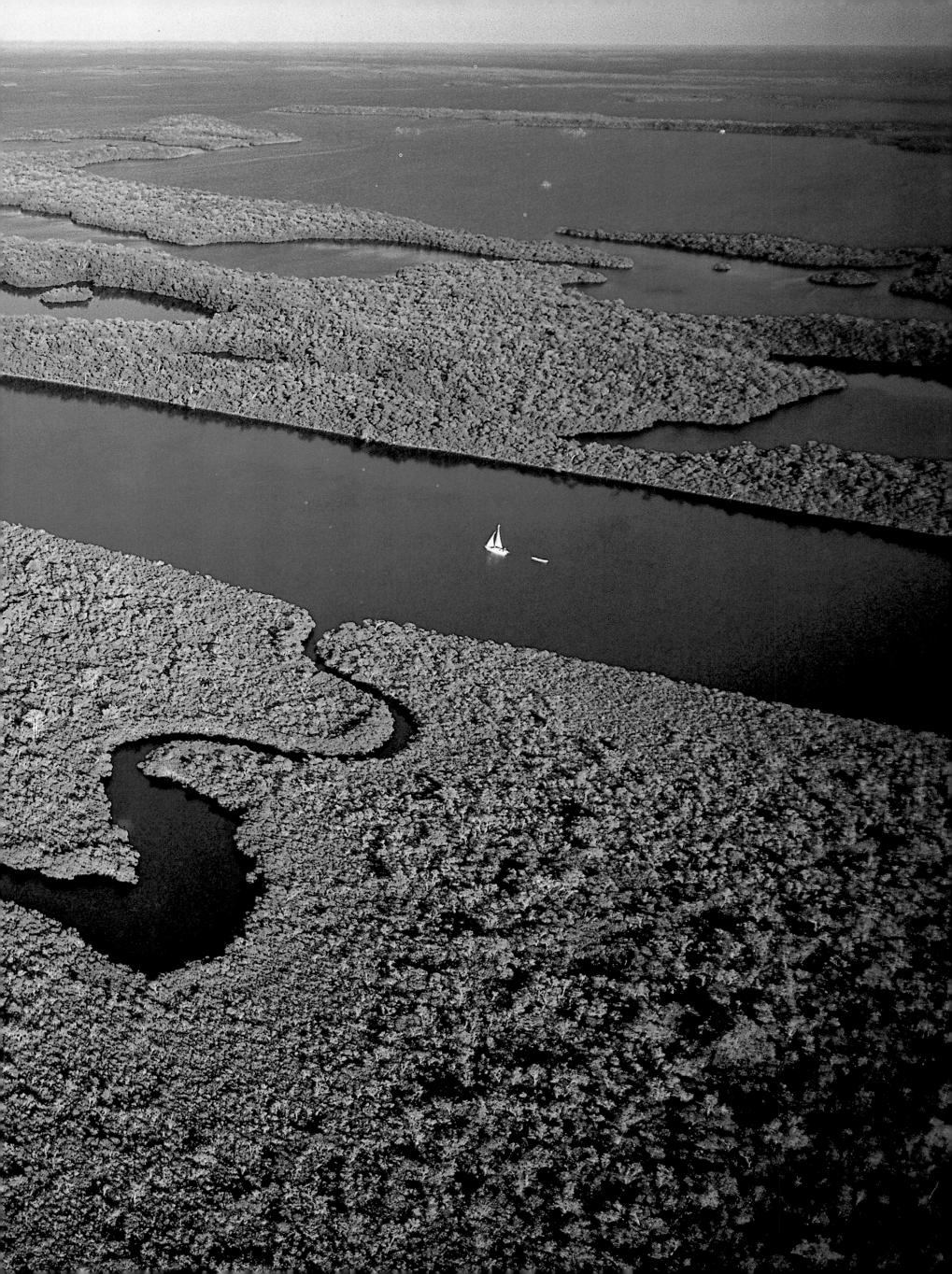

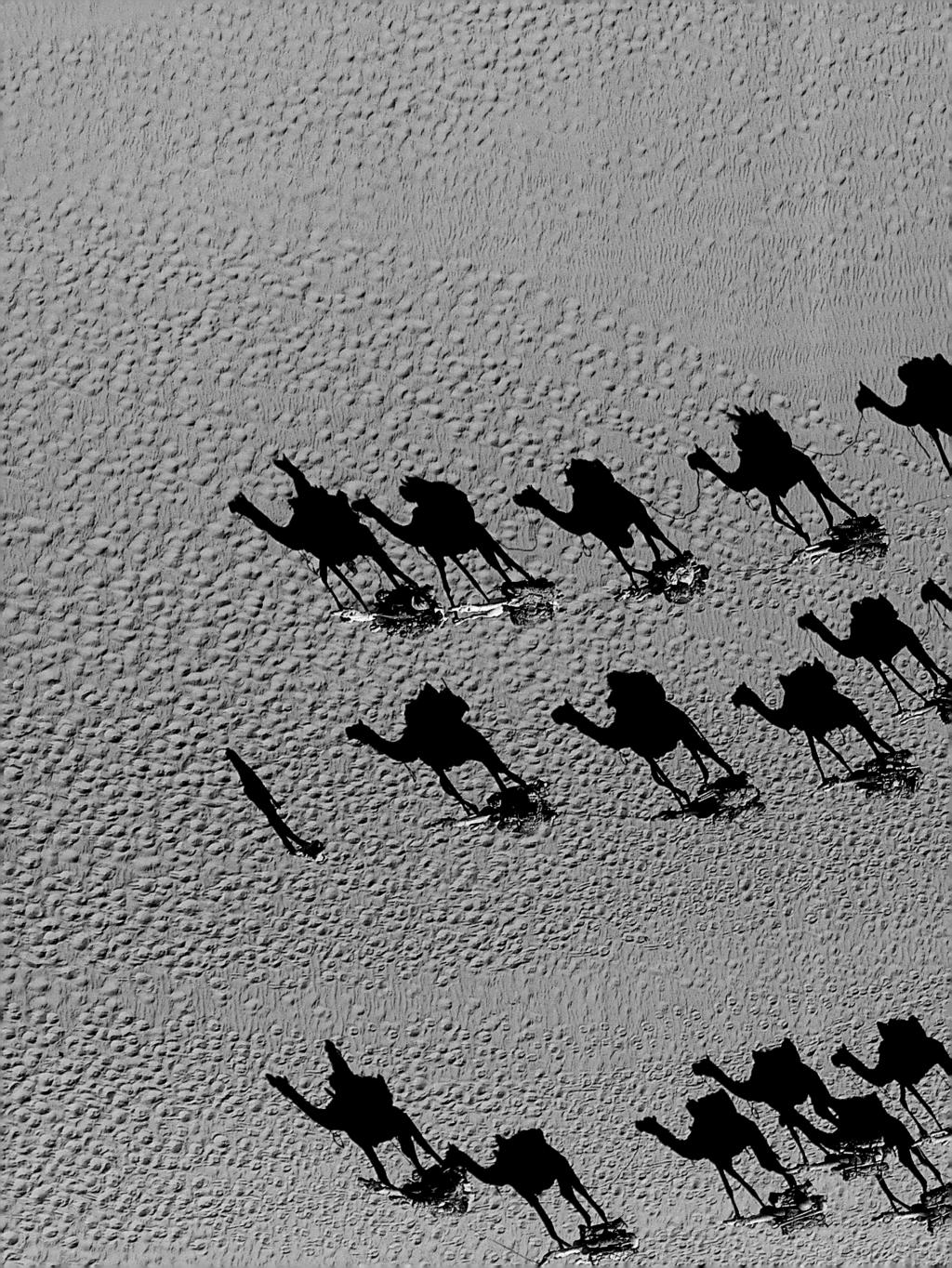

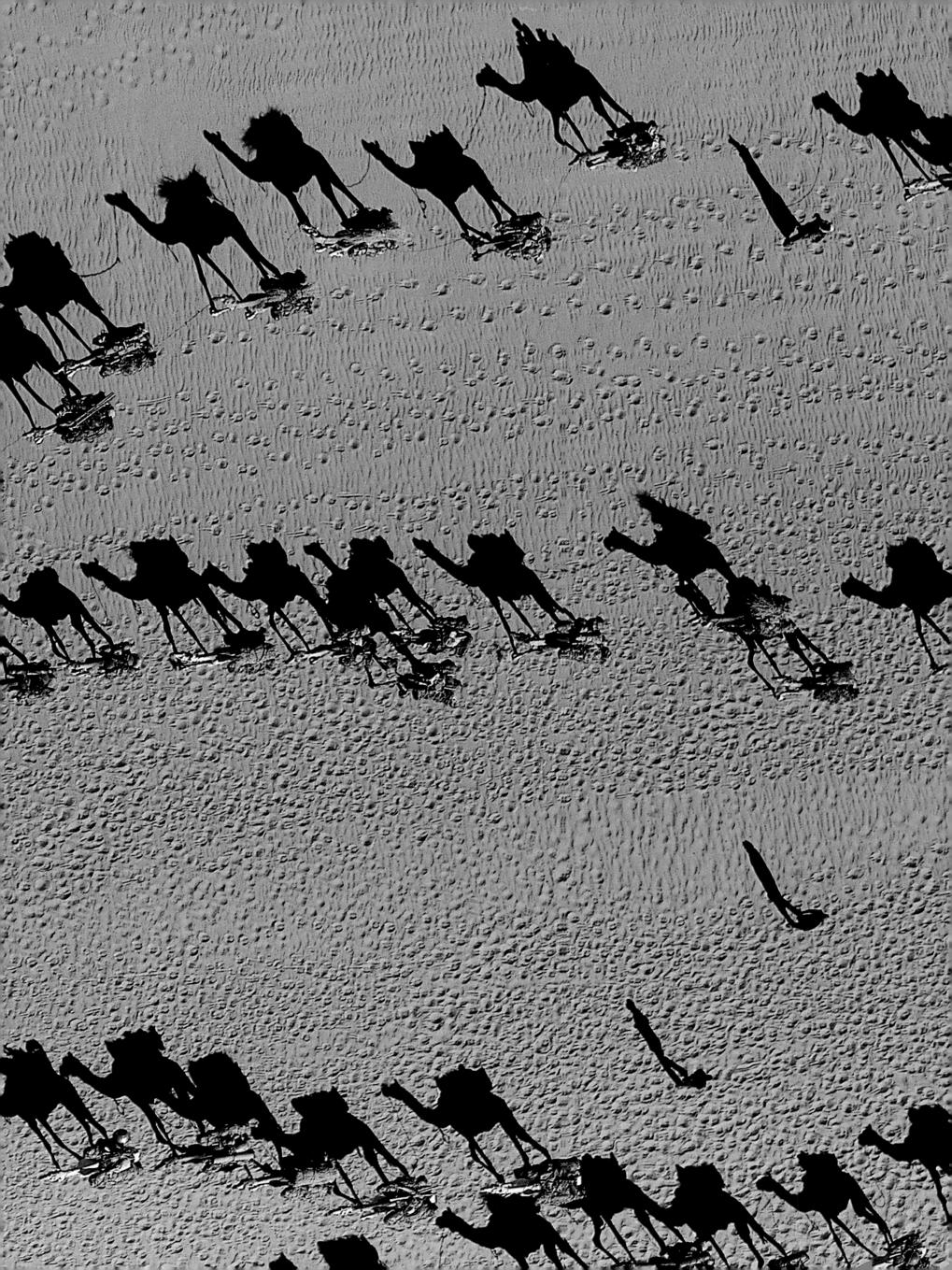

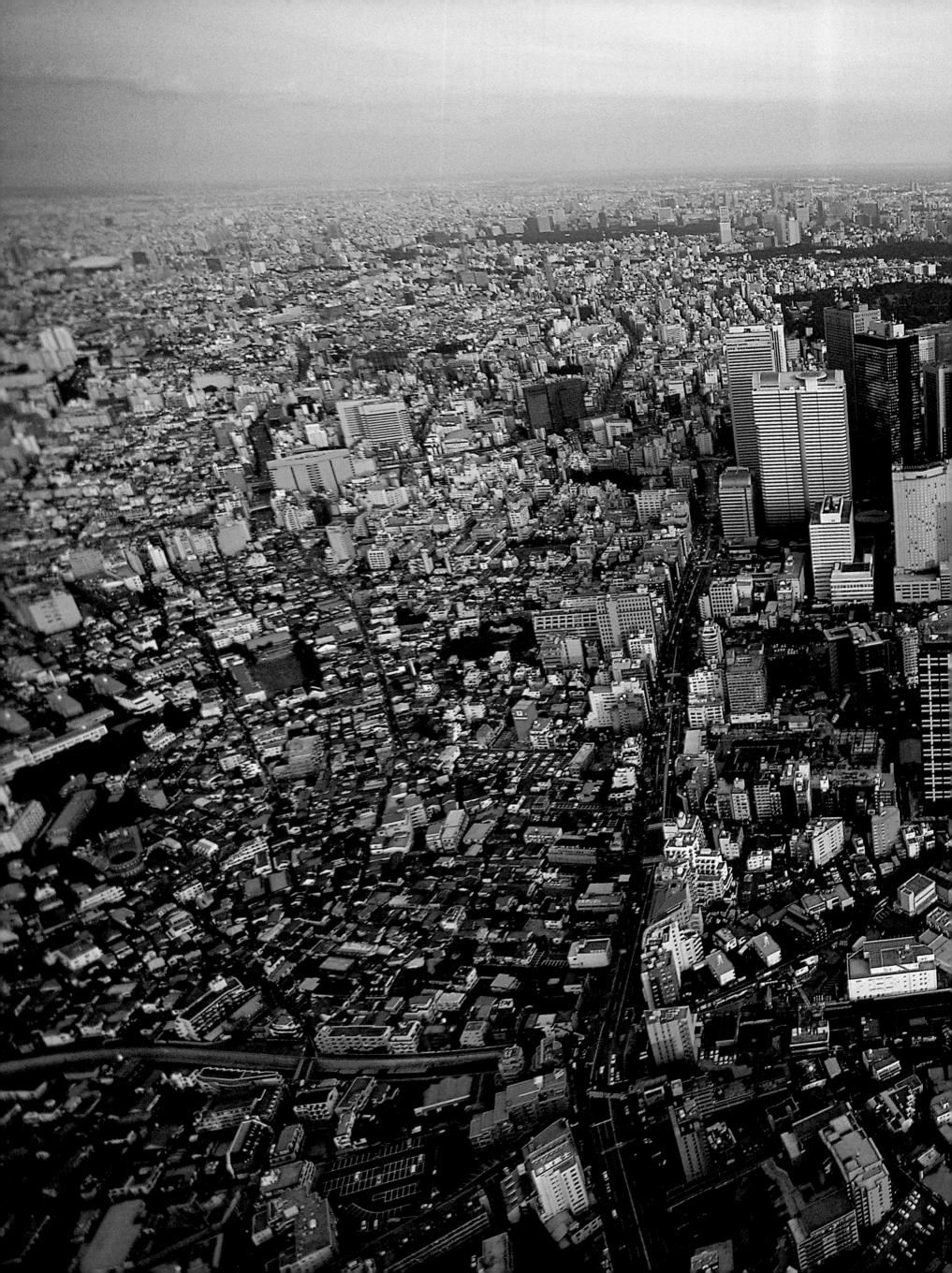

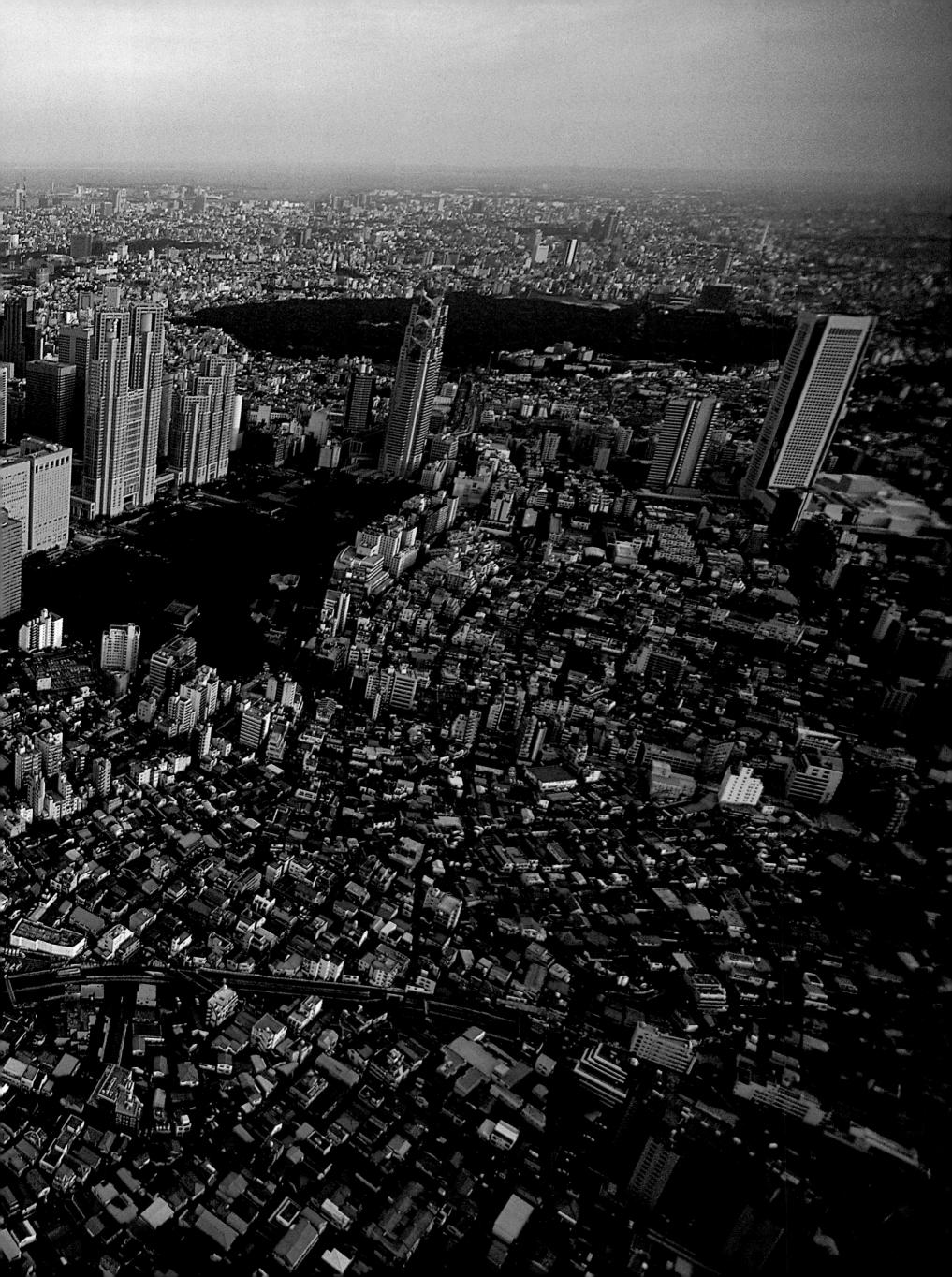

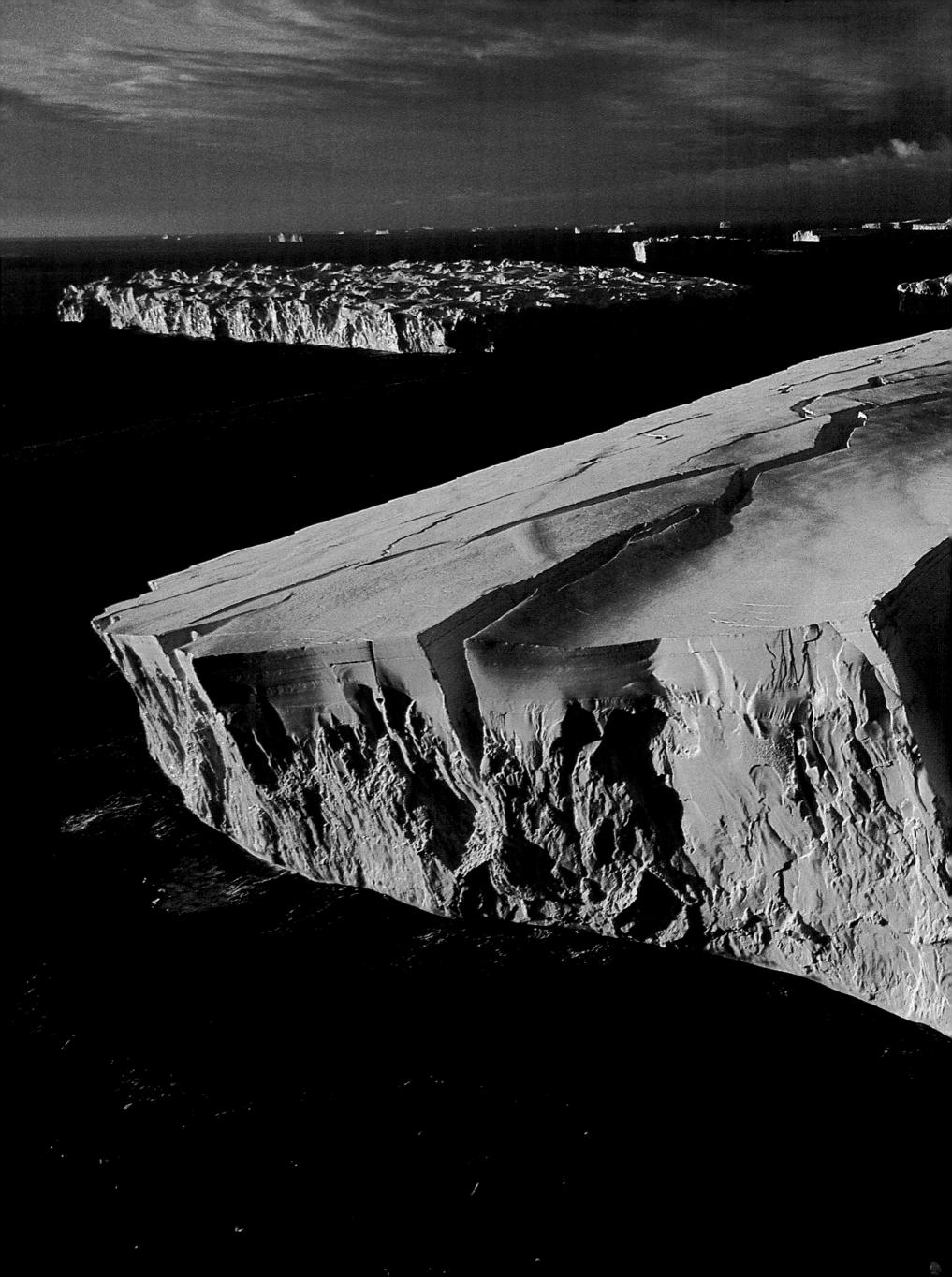

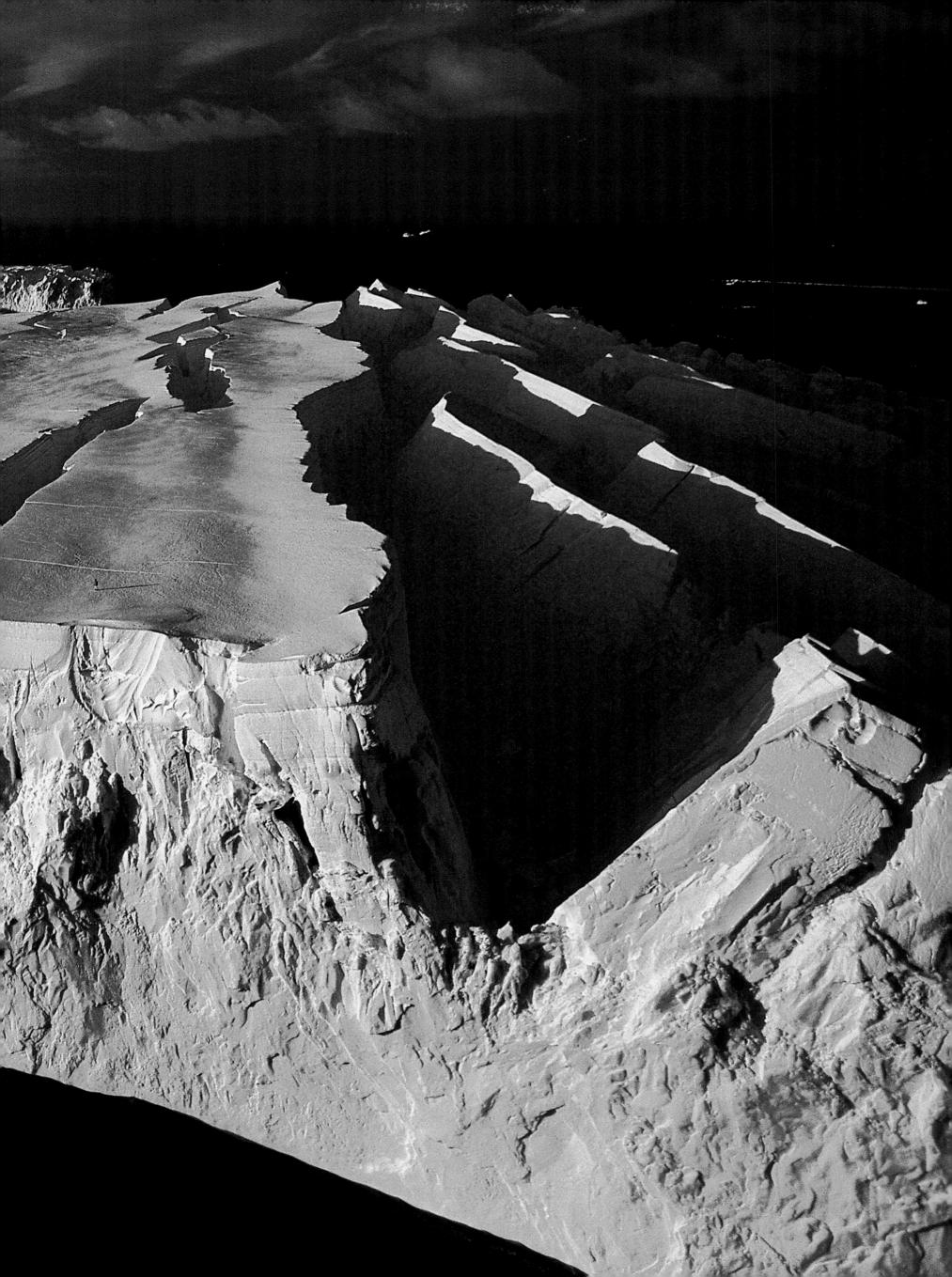

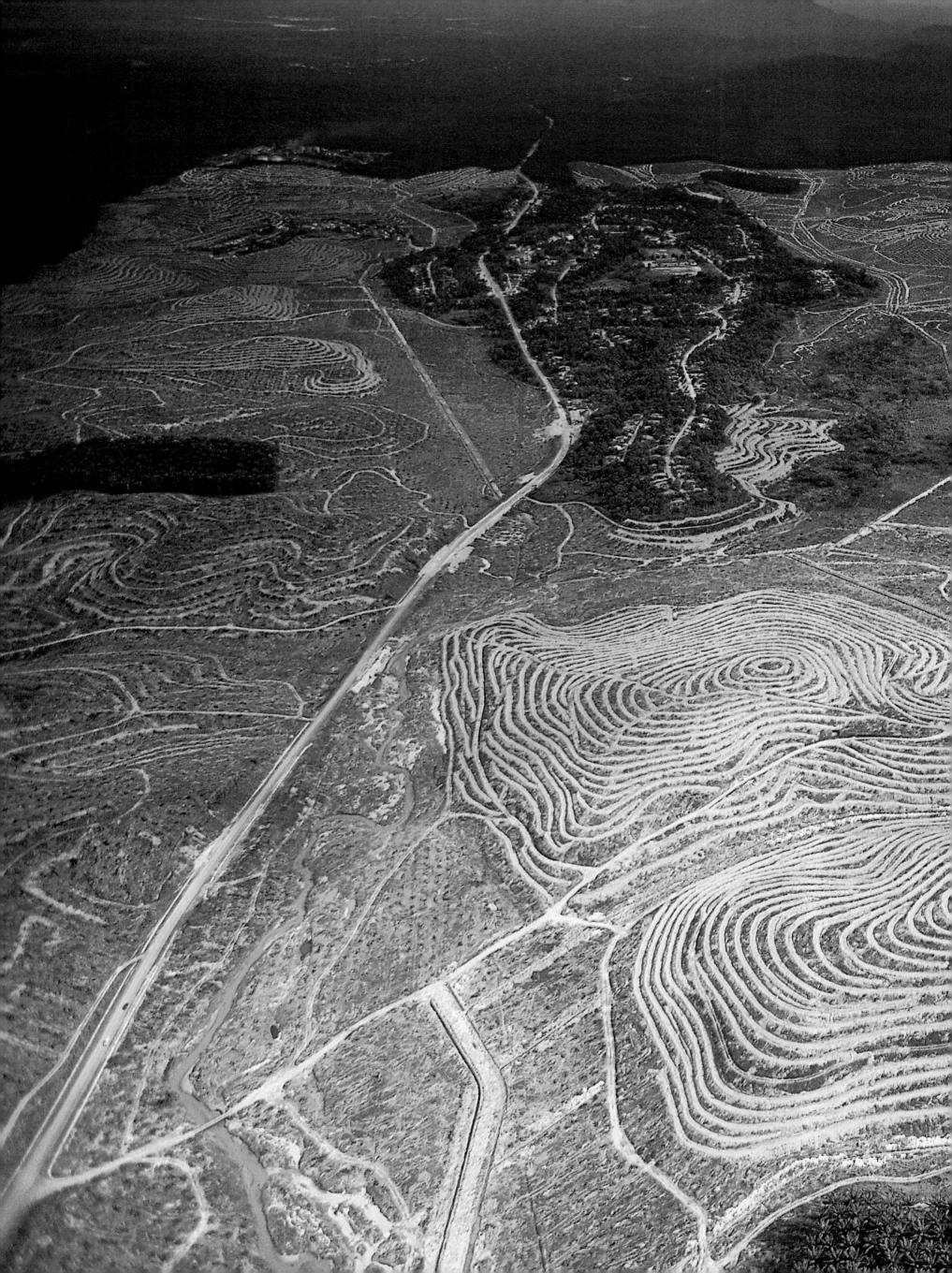

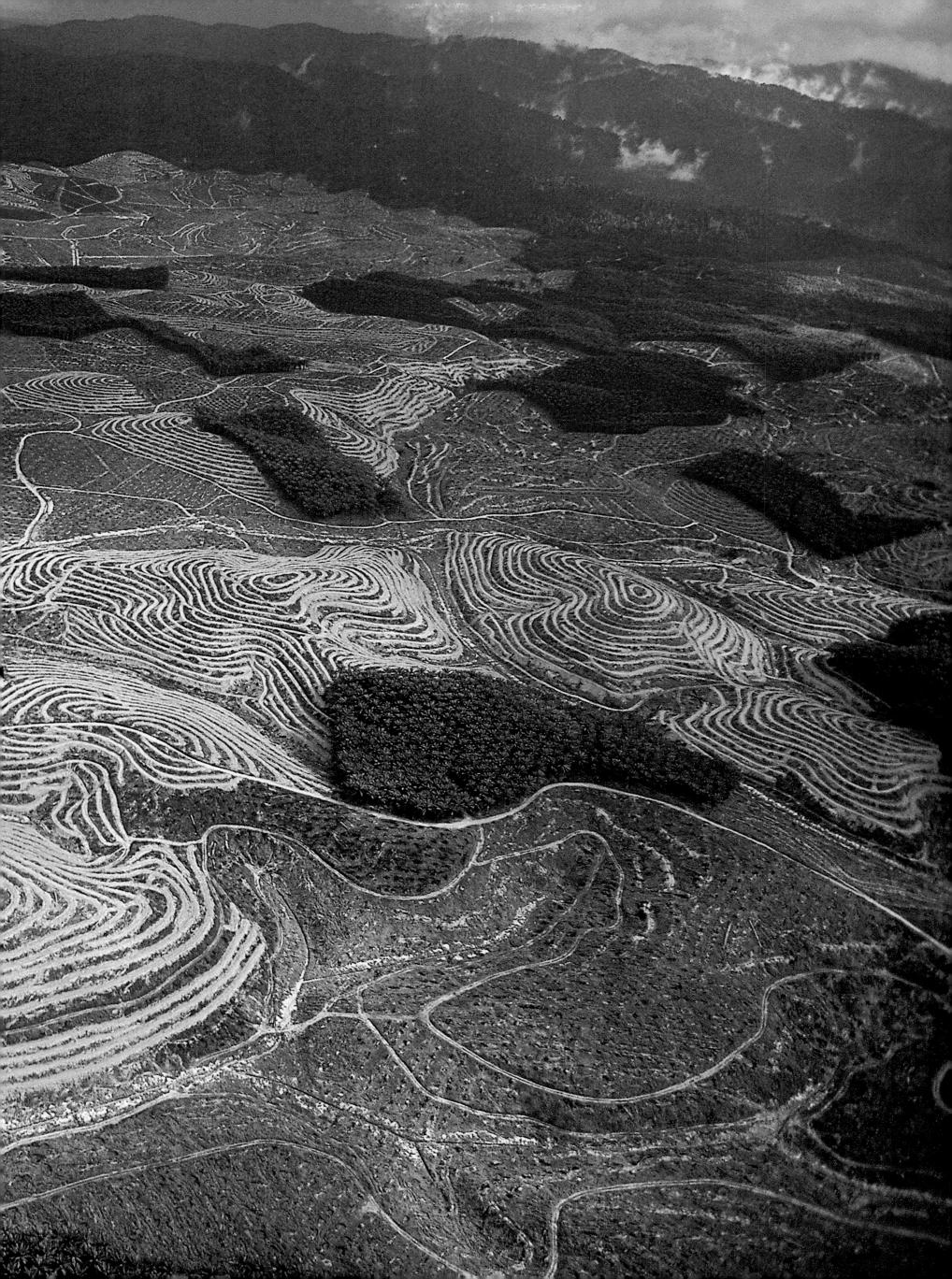

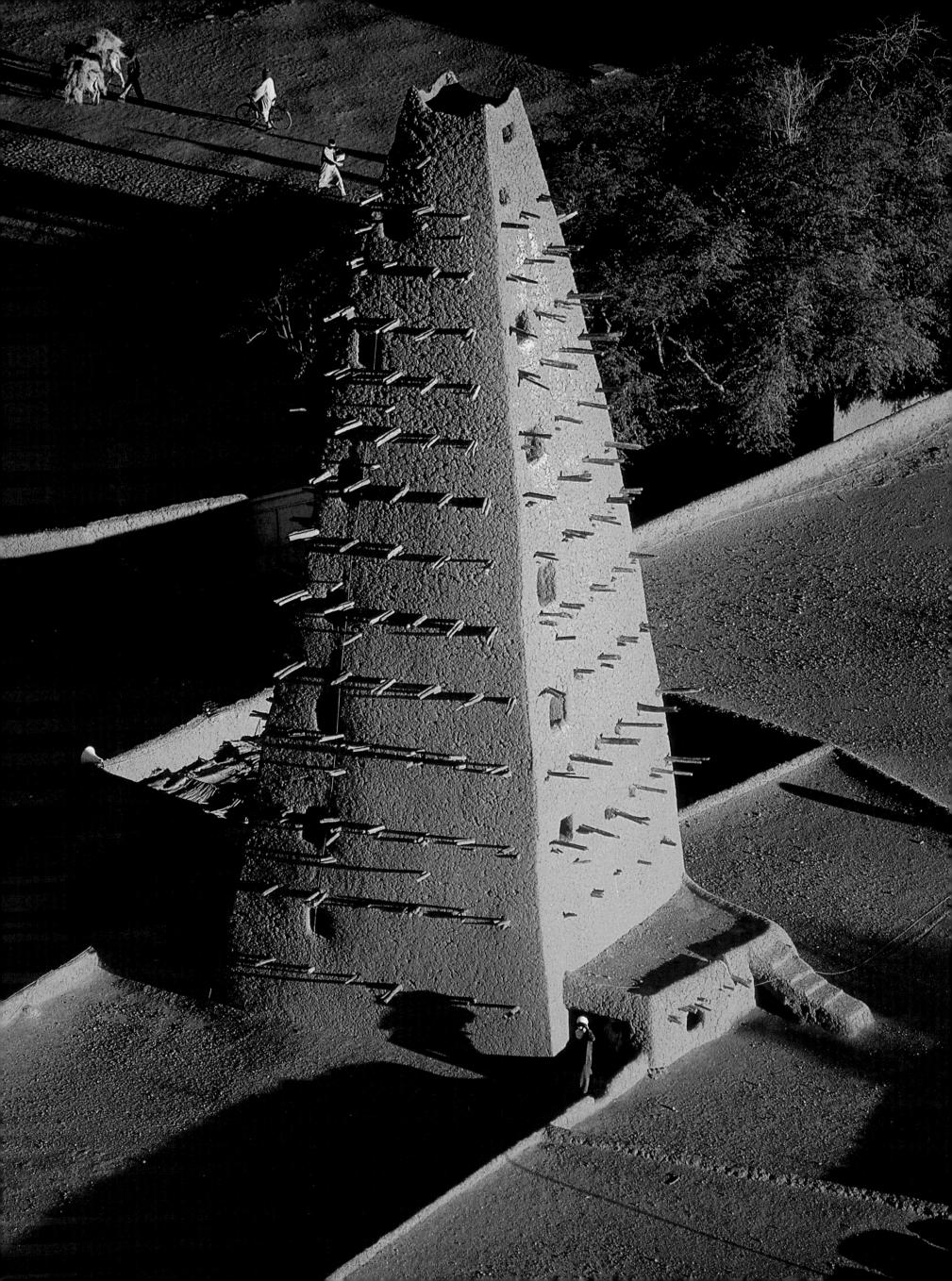

ENDANGERED CLIMATES

gest that climate can vary significantly over the long term, even if we know that the Sahara once knew a relatively humid climate and that Scandinavia at one time lay buried under two to three kilometers of ice. The variation in past climates is explained basically by astronomical causes. But now a new actor has appeared on the scene of climatic change: humanity itself.

Our daily perception concerns temperature, rain, or wind in the course of days or seasons. These short-term fluctuations are matters of meteorology. Contrary to the variable nature of daily weather, the Sahara, Amazon, and the Siberian taiga are natural regions associated with a certain image of stability and regularity in meteorological conditions and the very notion of climate. Climatology concerns itself with evolutions in the "average" meteorological conditions over long periods (multiple decades, centuries). Thus, the word climate evokes a set of natural conditions over the course of centuries, leaving a sustained impression on populations in a particular region of the world.

n 368

MINARET OF THE GREAT MOSQUE OF AGADEZ, Air Mountains, Niger

The Great Mosque of Agadez was built in the sixteenth century, at a time when the city was at the height of its power. This dried-earth building in the Sudanese style is crowned with a pyramid-shaped minaret that is 90 feet (27 m) high, bristling with thirteen rows of stakes that reinforce the fragile structure and serve as scaffolding for the periodic restoration of its surface. Agadez, known as the "gate to the desert," is the last major settlement before the Sahara and an important commerical center. It stands at the intersection of important trans-Saharan carayan routes. It is one of the holy cities of Islam, and its population is predominantly Muslim, as is 99 percent of Niger. Islam has more than 1.1 billion followers worldwide, the second-largest religion following in the world.

THE ATMOSPHERE AND THE GREENHOUSE EFFECT

The sun is the source of energy for the climatic engine. Energy received by the earth is sent toward space, but only after it has undergone numerous transformations, the global balance of which is known as the toll of radiation. The atmosphere redistributes heat surpluses from the tropical regions toward the higher latitudes. The oceans, which cover 71 percent of the earth's surface, also take part in this redistribution, by means of two essential mechanisms: the marine currents (such as the Gulf Stream) and evaporation, which initiates the water cycle.

About 30 percent of solar energy reaching the borders of the atmosphere is directly reflected into space by clouds and dust. An additional 23 percent of this solar energy is absorbed by the atmosphere, and 47 percent reaches the earth's surface. The atmosphere can be permeated by radiation received from the visible light of the sun. In contrast, the radiation reemitted by the earth is conveyed essentially in infrared form. The earth's atmosphere strongly reabsorbs this radiation by way of water vapor and carbon dioxide, as well as through other gases that it contains in very small quantities. These molecules play a role comparable to that of a glass greenhouse by allowing the sunlight to pass through while retaining the reemitted infrared rays of the earth. This is the "greenhouse effect." Without this effect, the earth would probably be uninhabitable, because its average temperature would be approximately -4° F (-20° C) rather than 49° F (15° C). The increase in this greenhouse effect because of human action is at the center of current debates on future climatic changes.

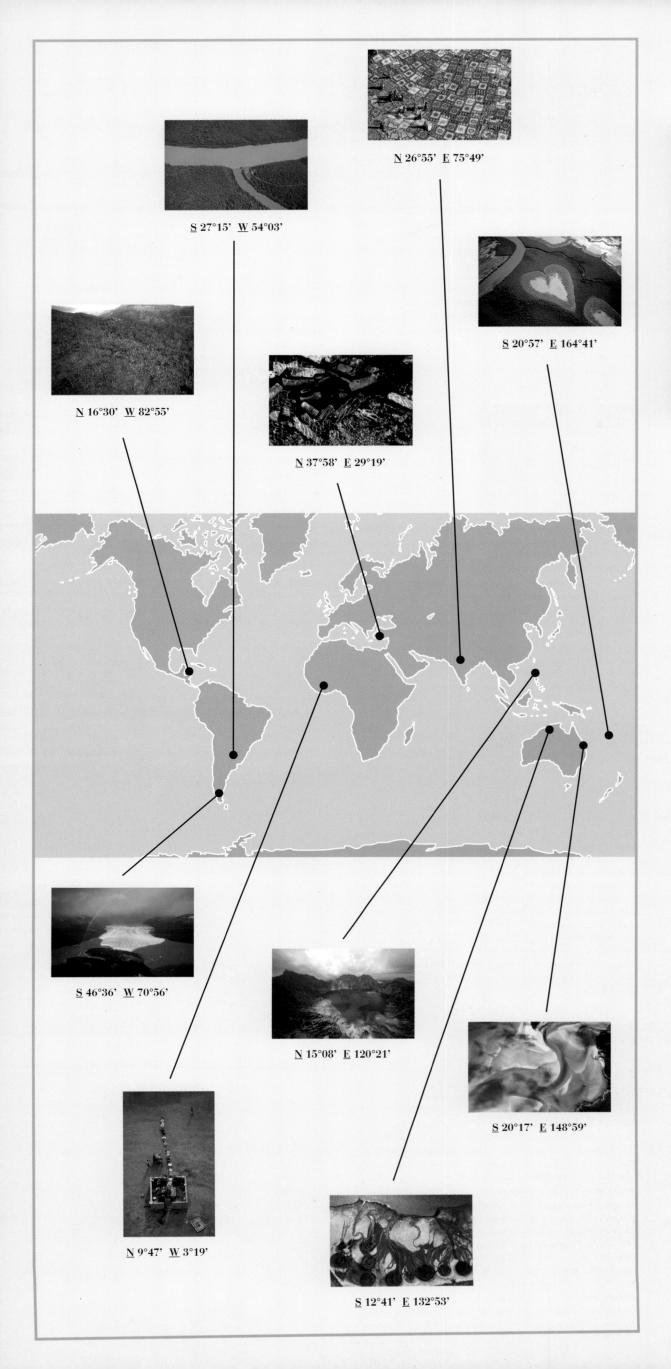

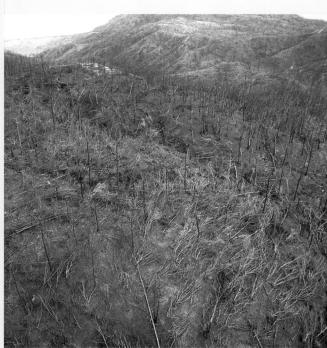

mperatures and in their inertia. In addinate of the atmosphere shows that the ally heated from below. In fact, it draws ergy from direct rays of the sun, 22 perty reemitted by the continents, and the at from the energy from the oceans, prier evaporation.

e main source of energy for the atmoid energy vector, the well for carbon dioxmaster of climatic change on every scale

e, atmospheric and oceanic circulations ry different scales. They range from disd disappearing within a few days to seaveather for the atmosphere, from equaits that change with the rhythm of the ow circulation of deep waters, whose typthousand years.

overlook the more local variations linked particular the consequences of changes n which the vapor present in the air is nponents of the greenhouse effect. The ed by human societies has tripled in the trimarily on account of increased irrigarepresents 10 percent of the drainage

waters, which are almost directly evapor gation is employed mainly in the warm re where the air is far from the threshold of This vapor, drawn toward higher latitudes cover. The water cycle has also been affect tion of forests, whose role as humidity re ing along with the process of tropical def

These issues prompt scientific ques tions of climate in the twenty-first centu are leading to various important climatic lems cannot be reduced to the emission of global warming, which are practically raised and discussed in major internation

CLIMATIC CHANGE AND HUMAN RESPONSIBILITY

There is no doubt that a climatic of geopolitical consequence is under way responsibility is heavily involved, through

Although many uncertainties still persist, the effects of these changes on a planet that is already badly off could clearly assume catastrophic dimensions, with a multiplication of these extreme climatic conditions. On the eve of the twenty-first century, nineteen countries—particularly in the Middle East and the Maghreb—already suffer from drought, and their number will probably double by the year 2025. In Africa aridity will especially affect the fringes of the Sahel, as well as the west and south of the continent. Southern Europe will also undergo a reduction in rain, from 20 percent (in winter) to 30 percent (in summer), while the northwest of the continent could see rains and the risk of floods increase, similar to those that ravaged the plains alongside the Oder and Neisse Rivers of Eastern Europe in July 1997. A comparable scenario could occur in Australia, where the immense central desert might become increasingly arid, while the coastal regions that today receive the most precipitation could experience diluvial rains.

Thus, the extremes of today's earth are becoming intensified: the drop in temperature of the polar night above the Arctic Ocean; the increasing violence of El Niño and La Niña above the South Pacific and of tropical hurricanes.

THE RESTRICTION AND PREVENTION OF MAJOR RISKS

The scientific debates continue as to the precise amplitude of the climatic changes, but their global impact is without doubt. On average, the climatic shifts toward the poles and mountain peaks are 95 miles (150 km) toward the north

and 500 feet (150 m) toward the summit, respectively, per degree of temperature increase. Some vegetable species cannot survive the speed of this change and will disappear.

Global warming can also directly affect human health. According to a report of the World Health Organization (WHO) published in 1996, a rise in the average earth temperature of 9° F (5° C) could allow malaria to spread an additional 7 million square miles (17 million km²)—about twice the area of Europe—endangering 60 percent of the world population, as opposed to 45 percent today. Mediterranean Europe and the southwestern states of the United States are already regions of concern. The WHO also foresees the spread of other tropical illnesses, such as yellow fever and sleeping sickness.

The importance of climatic risks justifies intensified scientific research as well as serious dissemination of information among citizens—and it also demands action.

Jean-Paul Deléage

p. 377 HYDRAULIC DRILLING STATION IN A VILLAGE NEAR DOROPO, Bouna region, Côte d'Ivoire

All over Africa, the task of collecting water is assigned to women, as seen here in northern Côte d'Ivoire. Hydraulic drilling stations, equipped with pumps that are usually manual, are gradually replacing the traditional village wells, and containers of plastic, enameled metal, or aluminum are supplanting canaris (large terracotta jugs) and gourds for transporting the the precious resource. The water of these pits is more sanitary that that of traditional wells, 70 percent of which is unfit for drinking. At the dawn of the year 2000, three-quarters of the earth's inhabitants lack running water. Approximately 1.6 billion people have no drinkable water, and illnesses from unhealthy water are the major cause of infant mortality in developing nations.

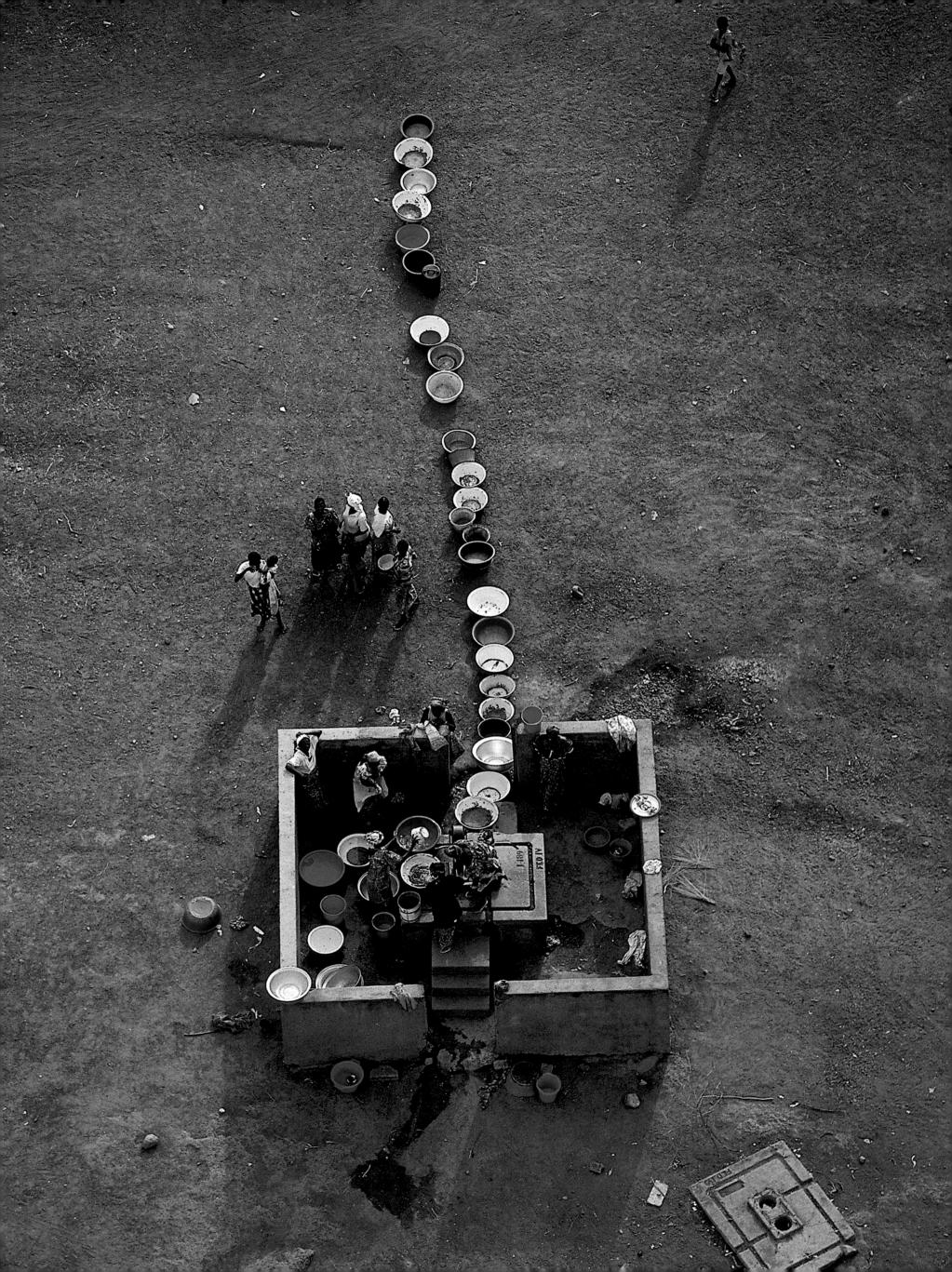

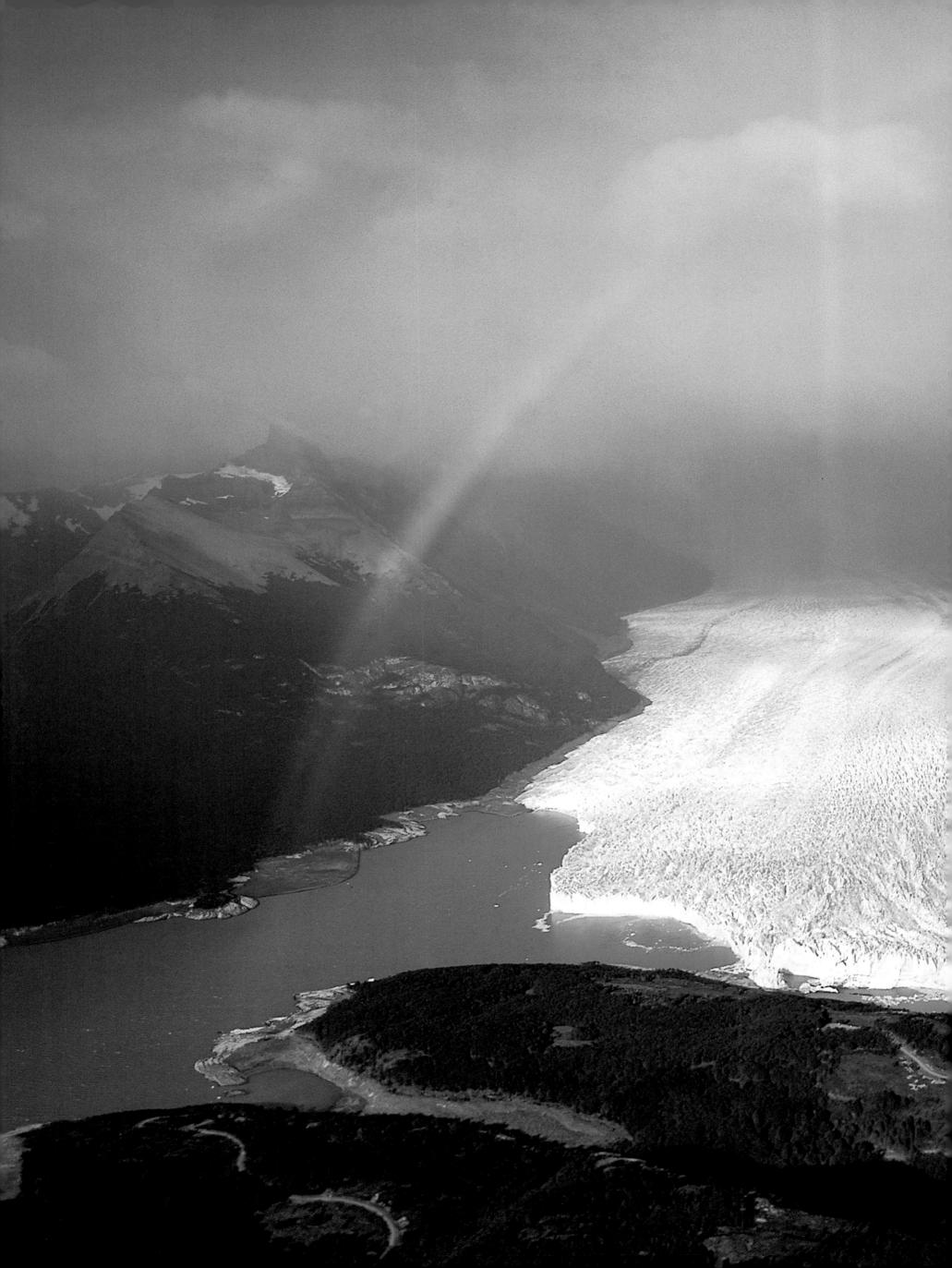

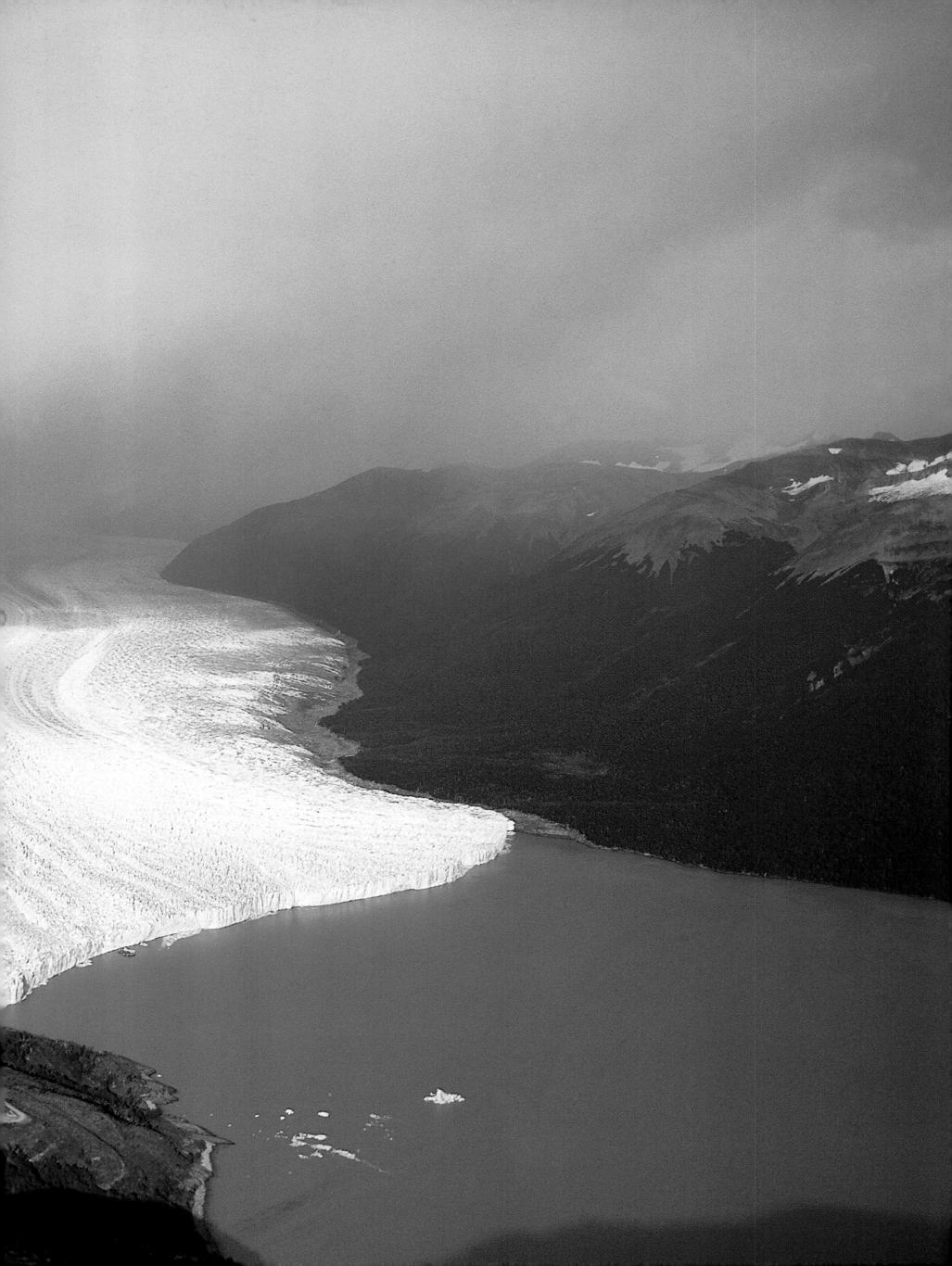

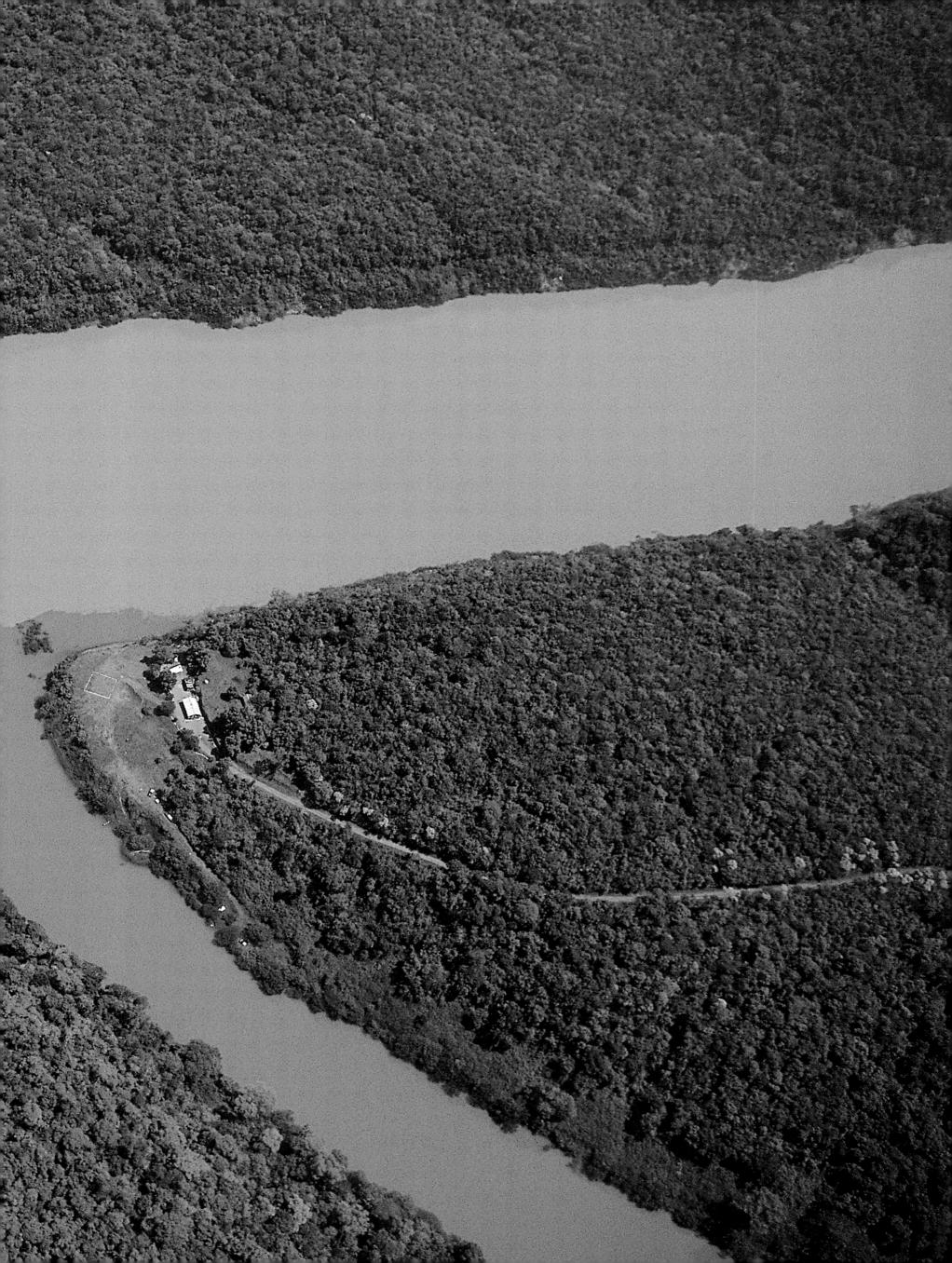

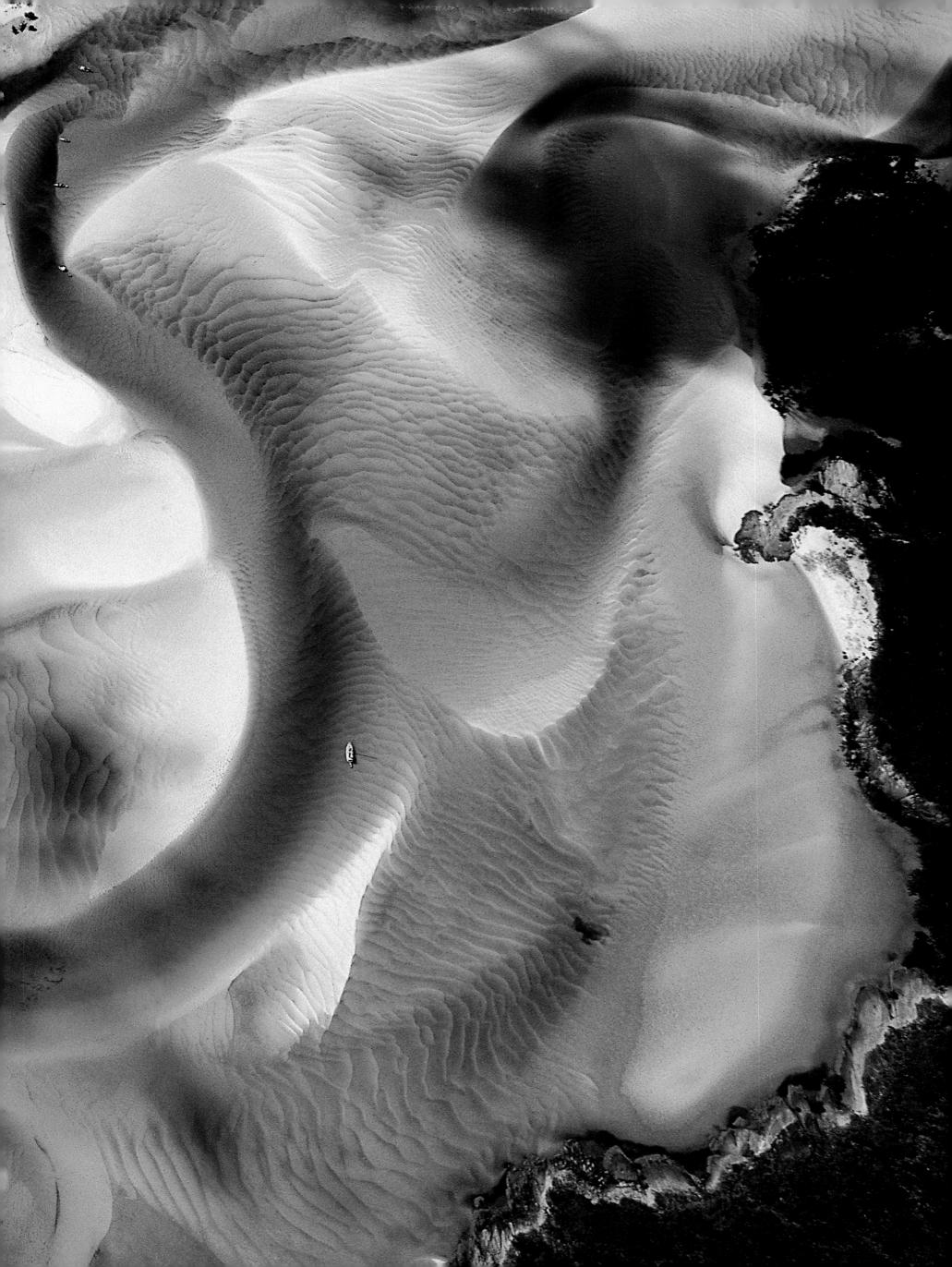

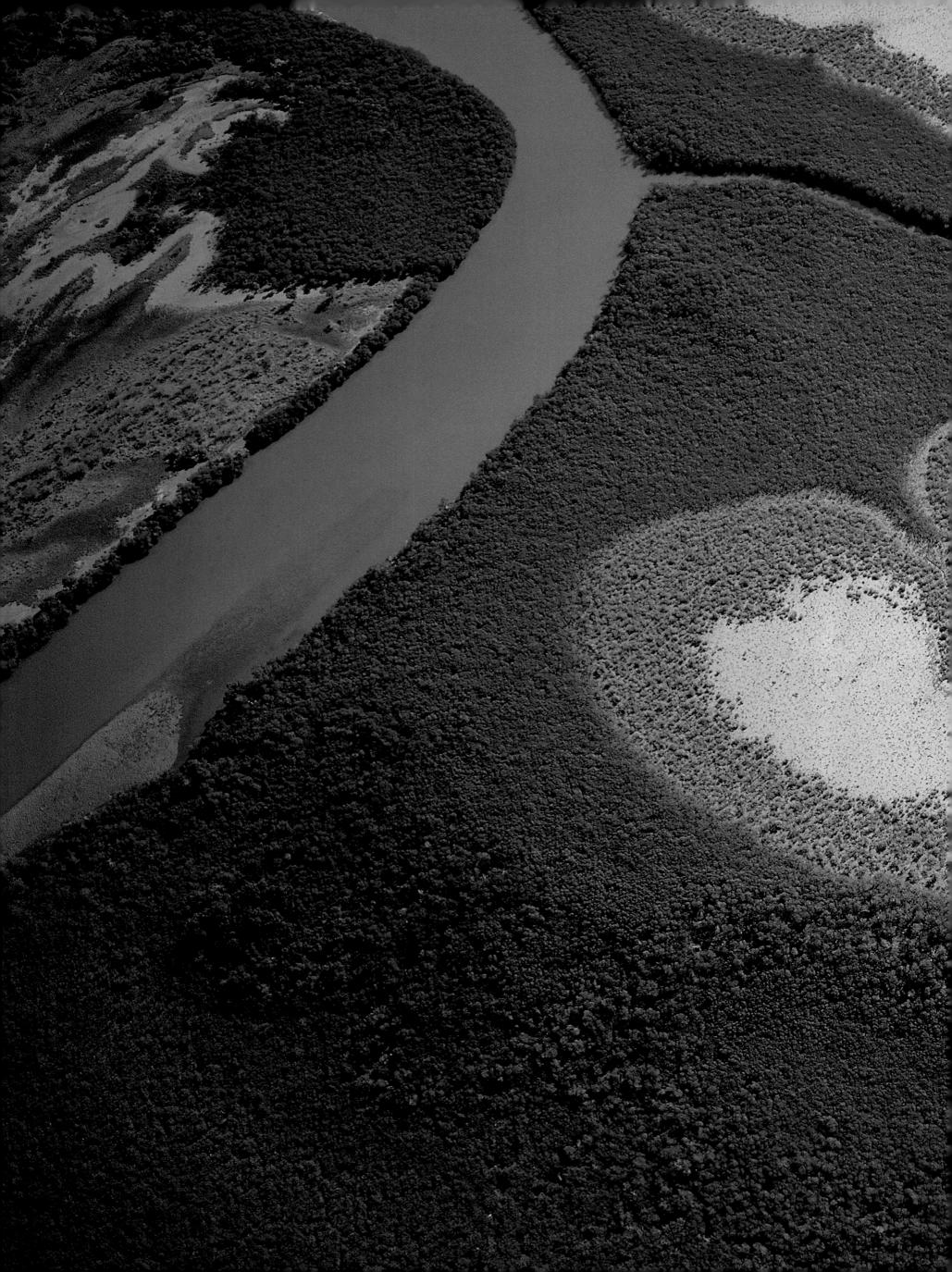

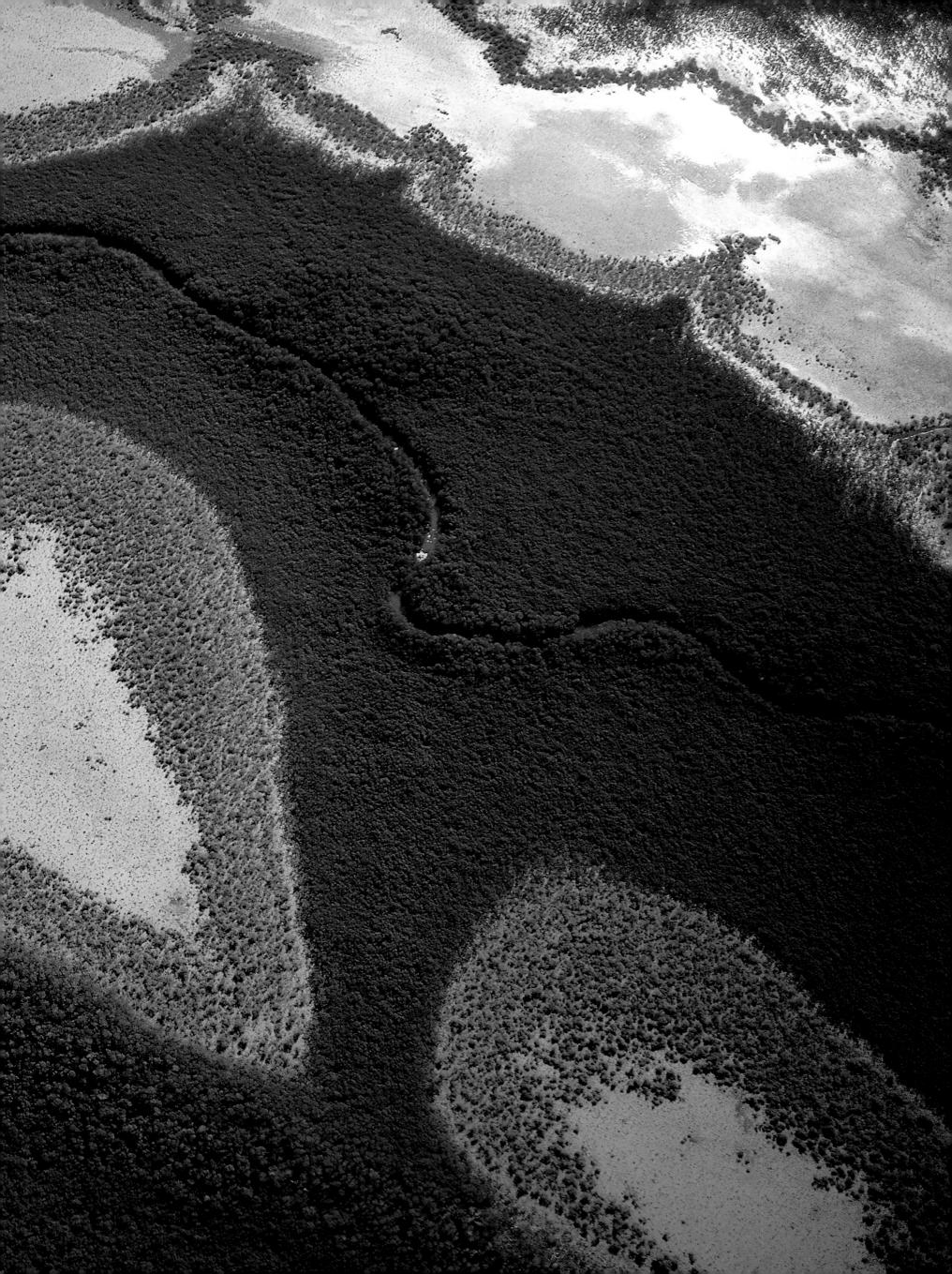

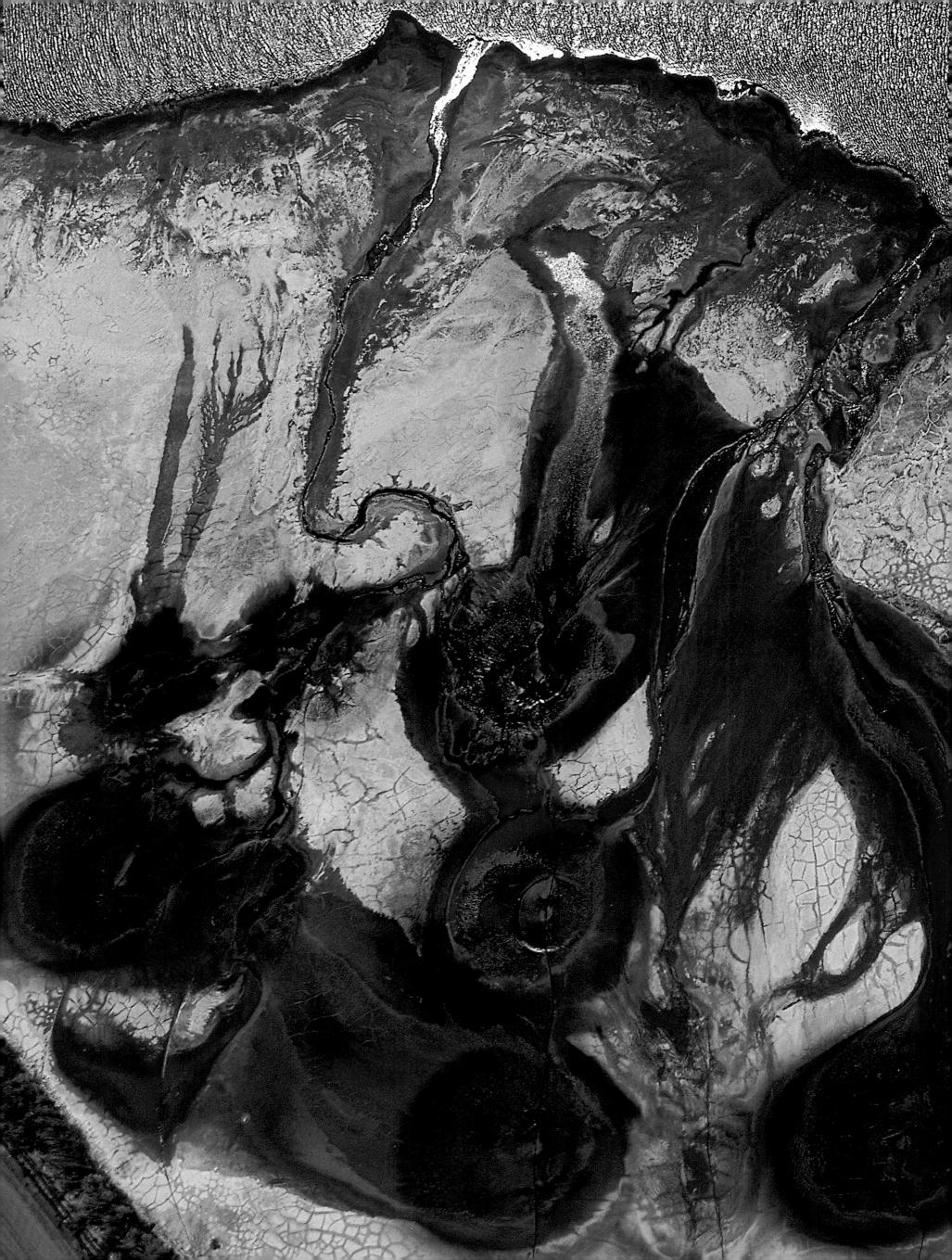

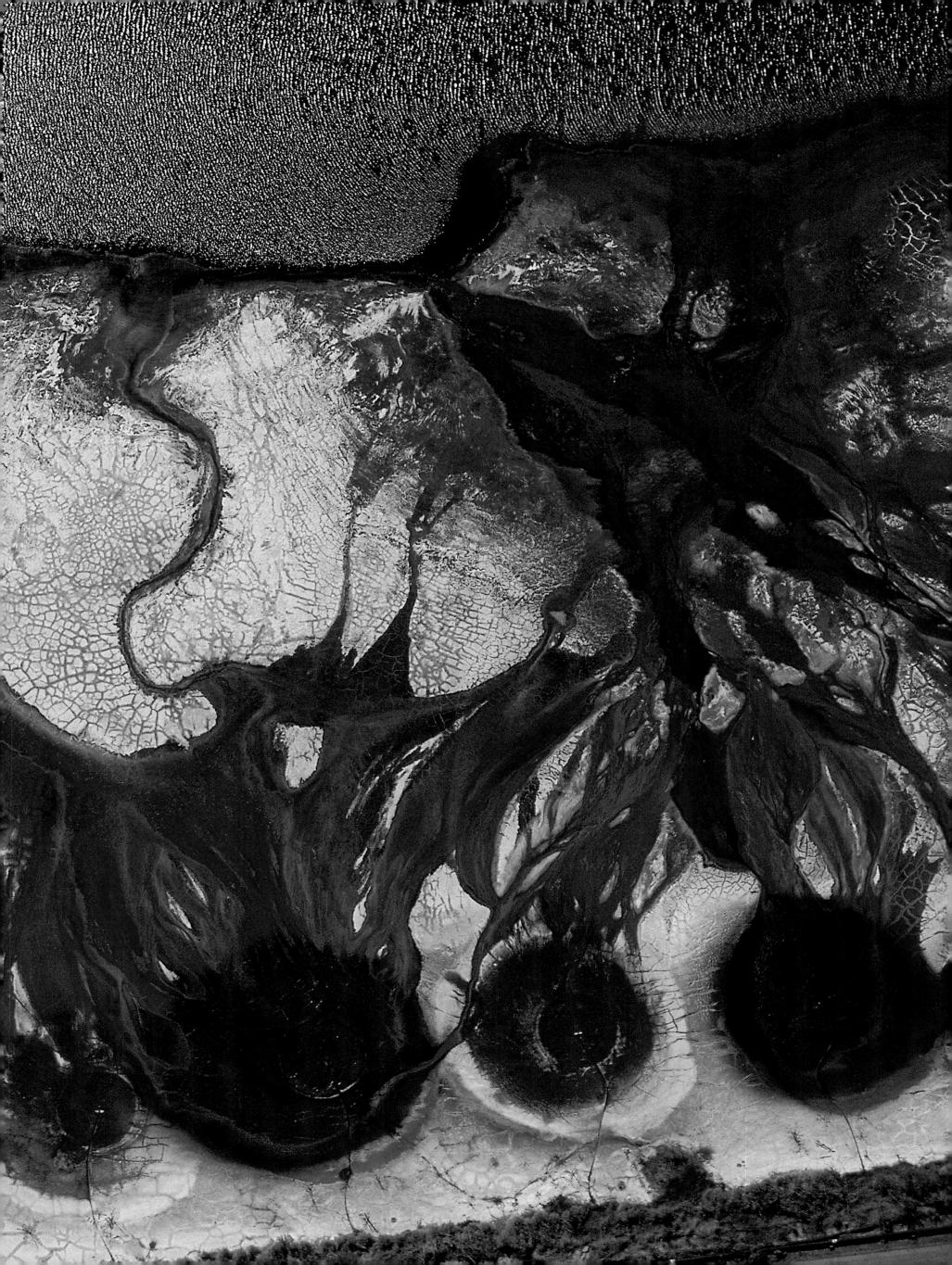

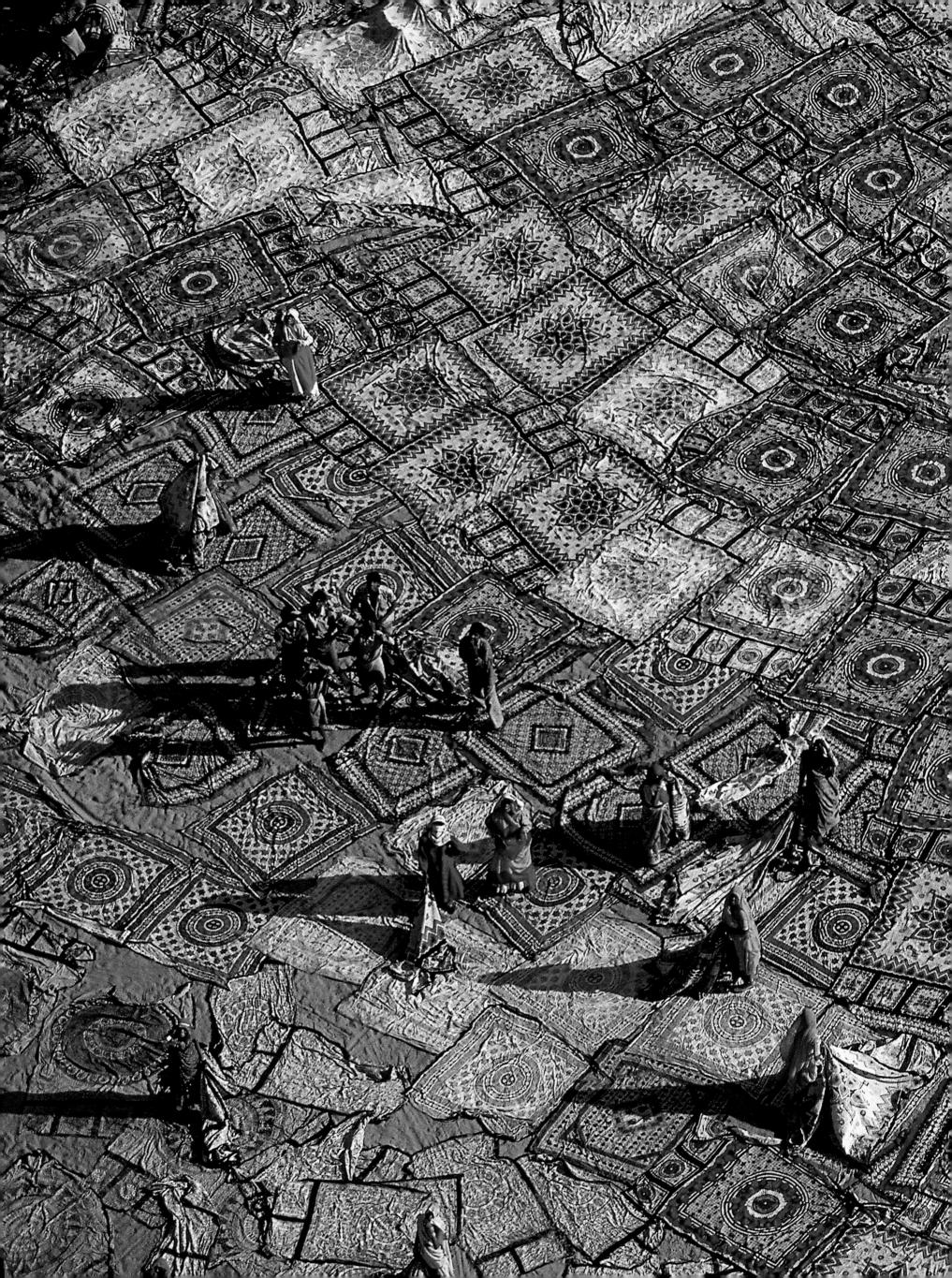

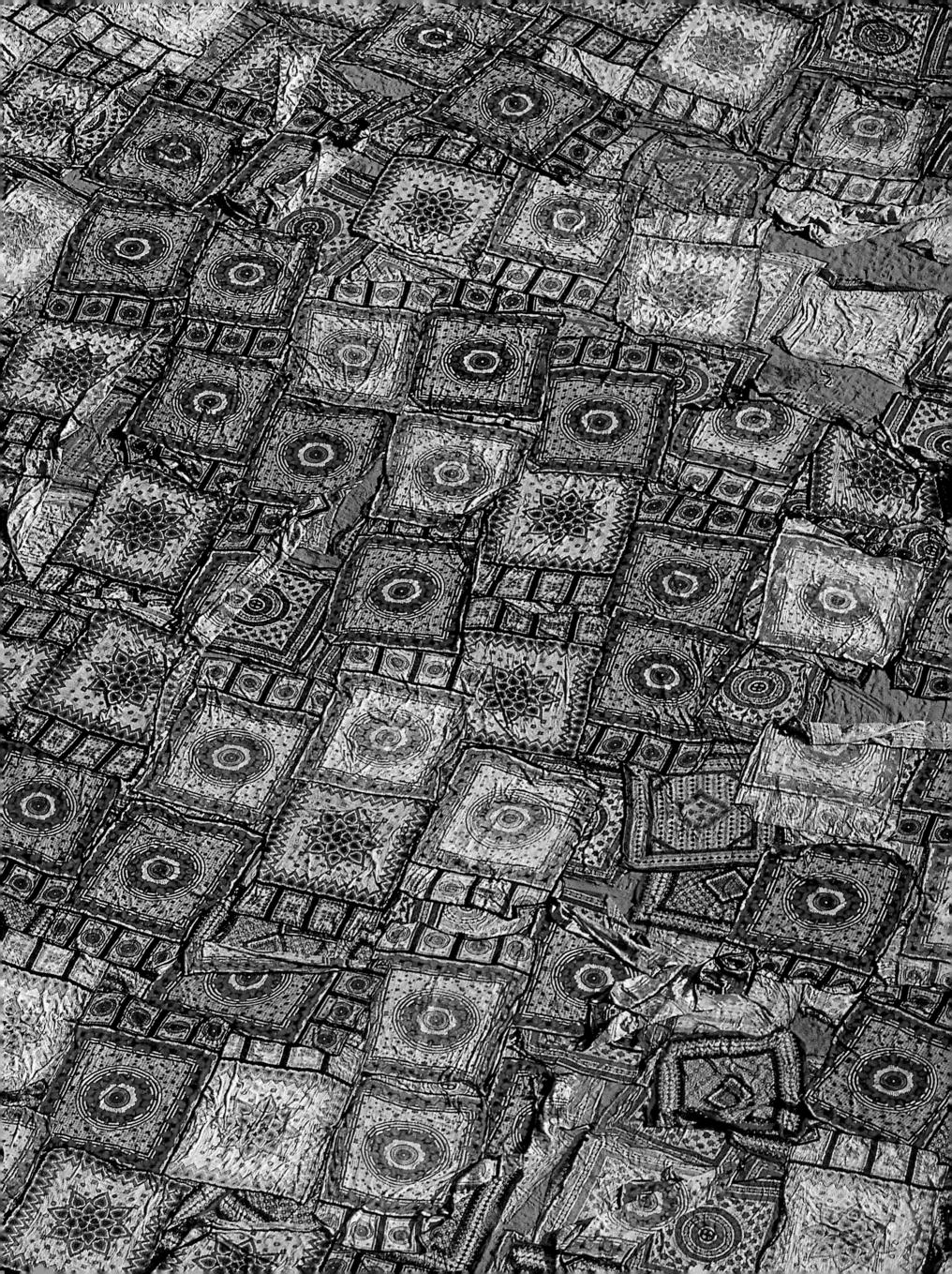

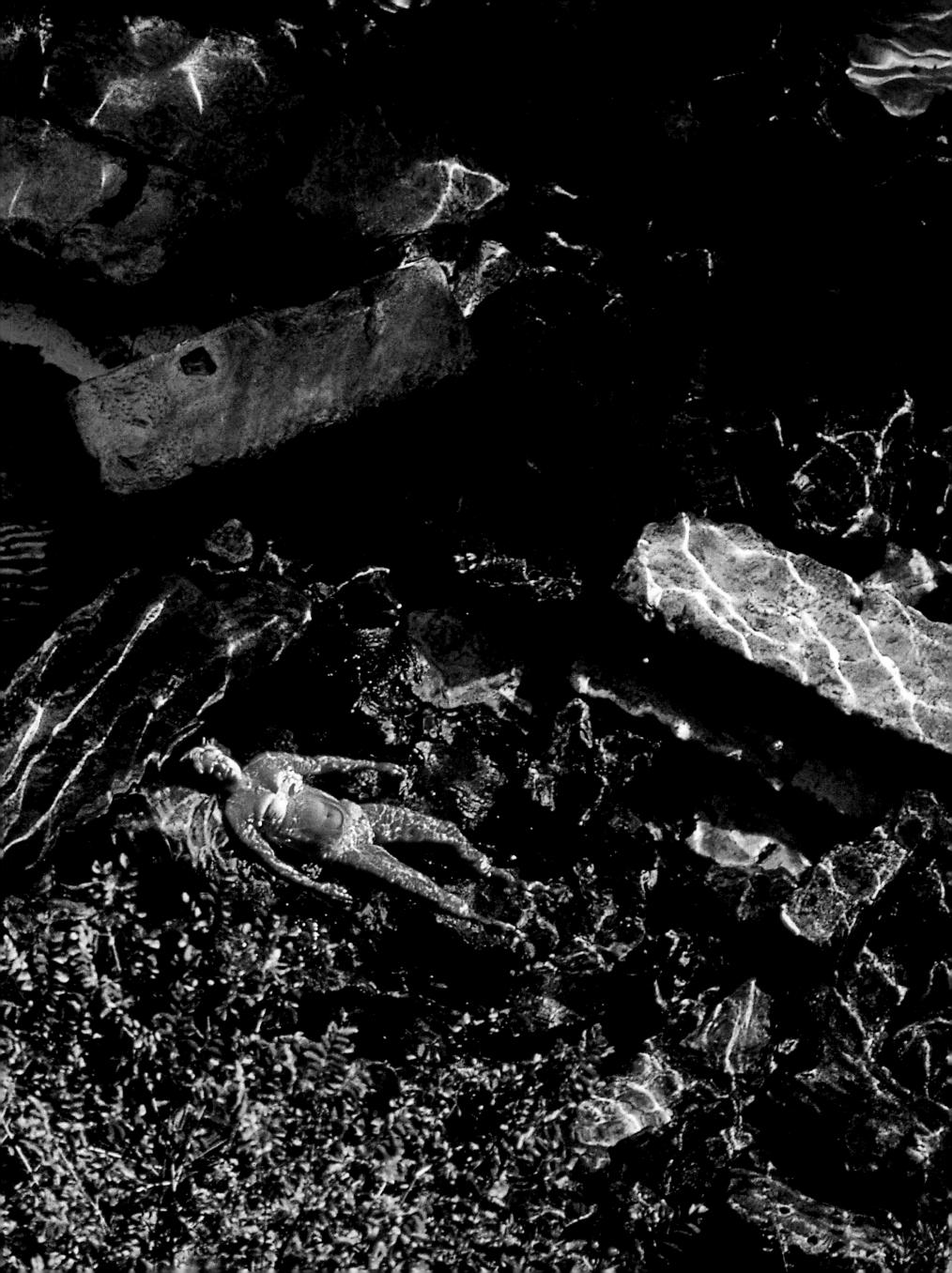

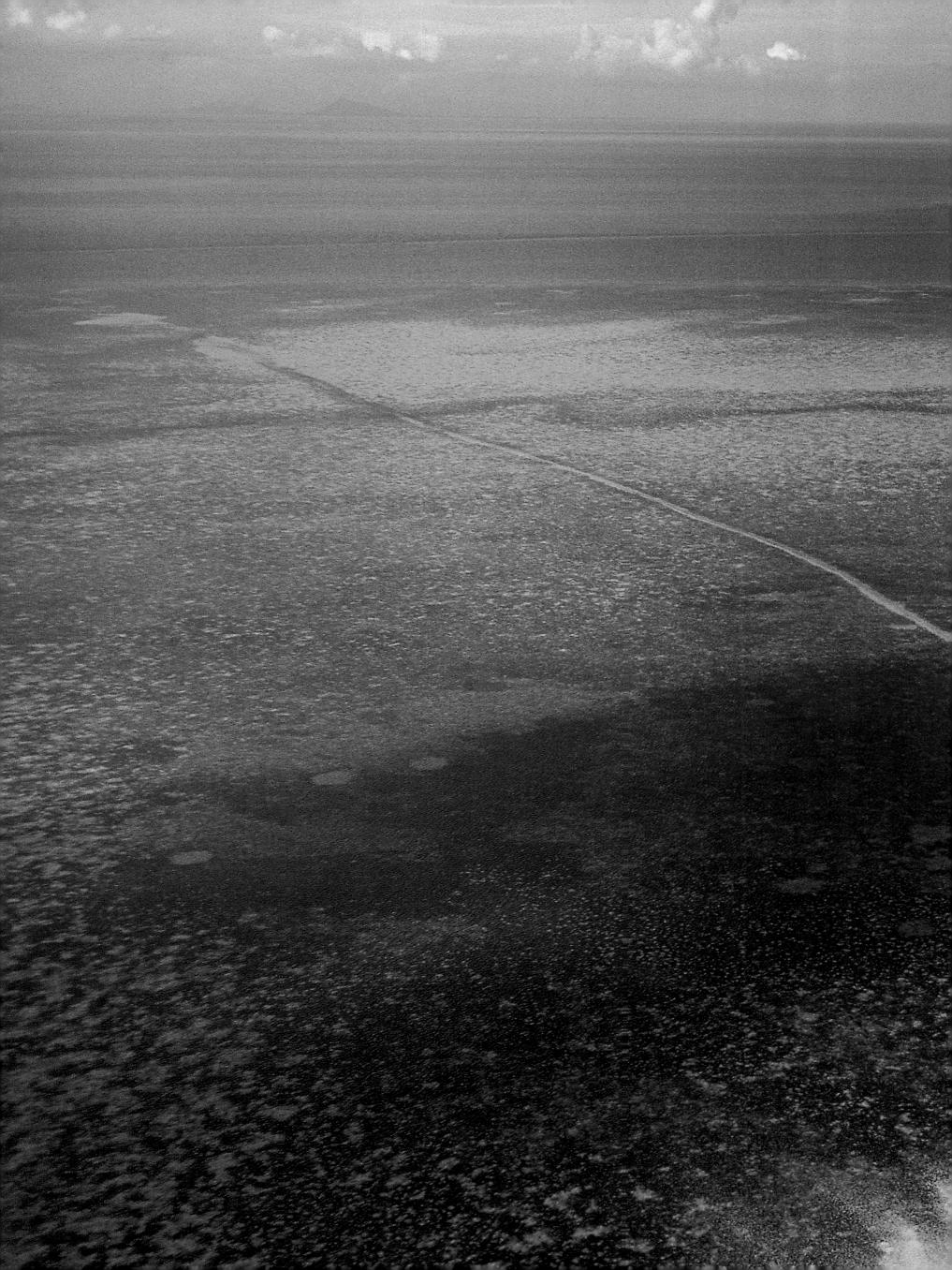

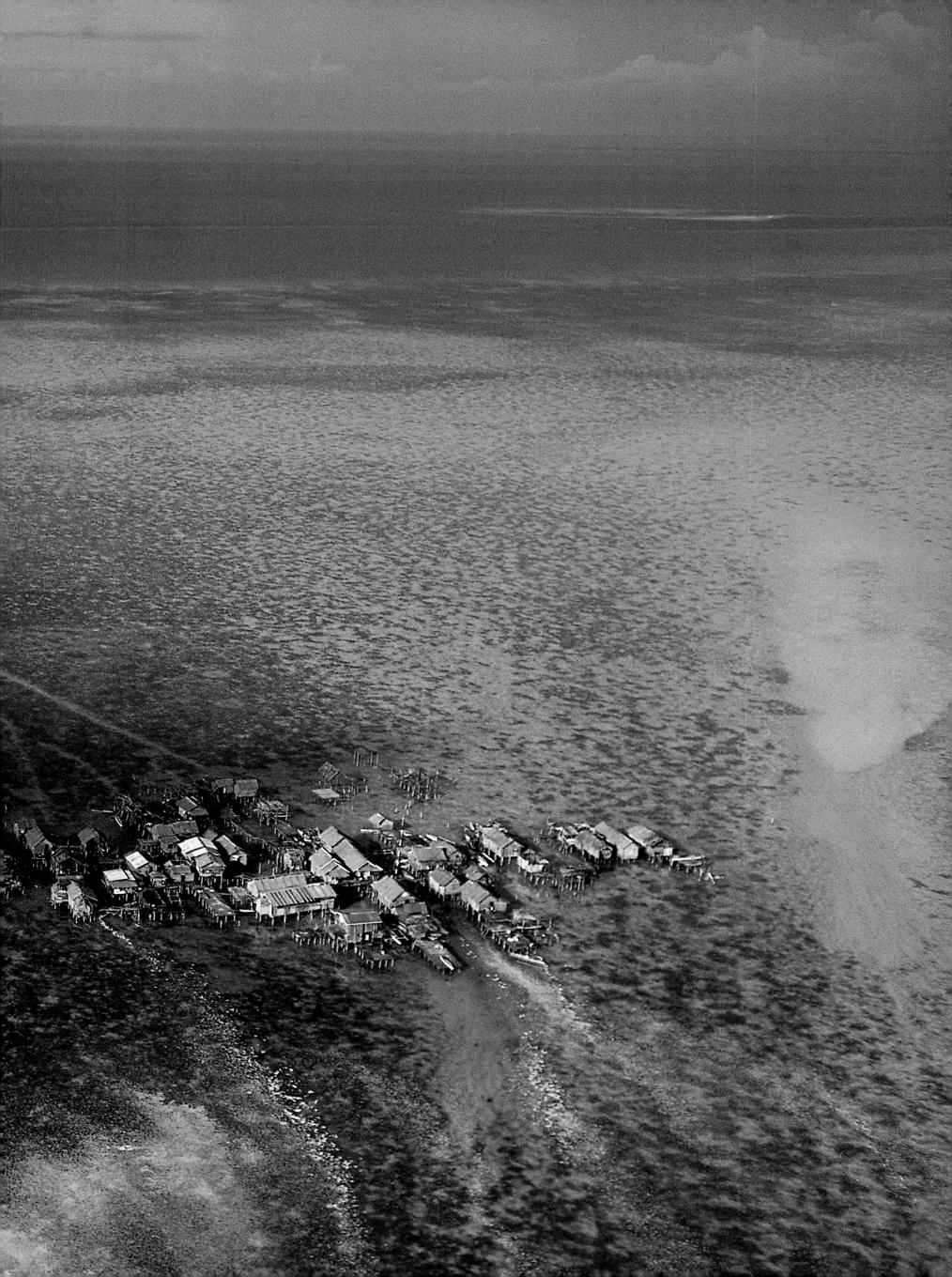

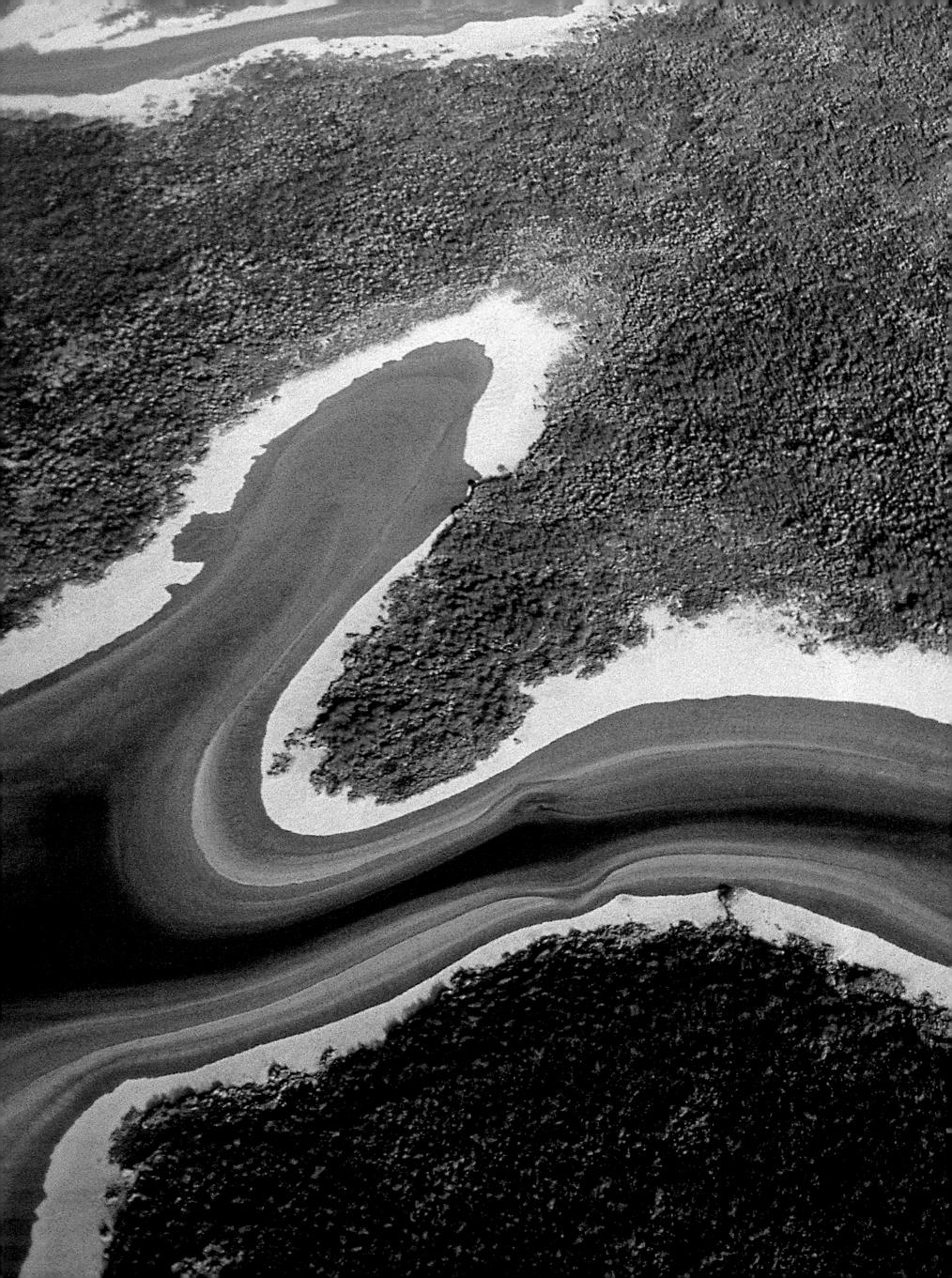

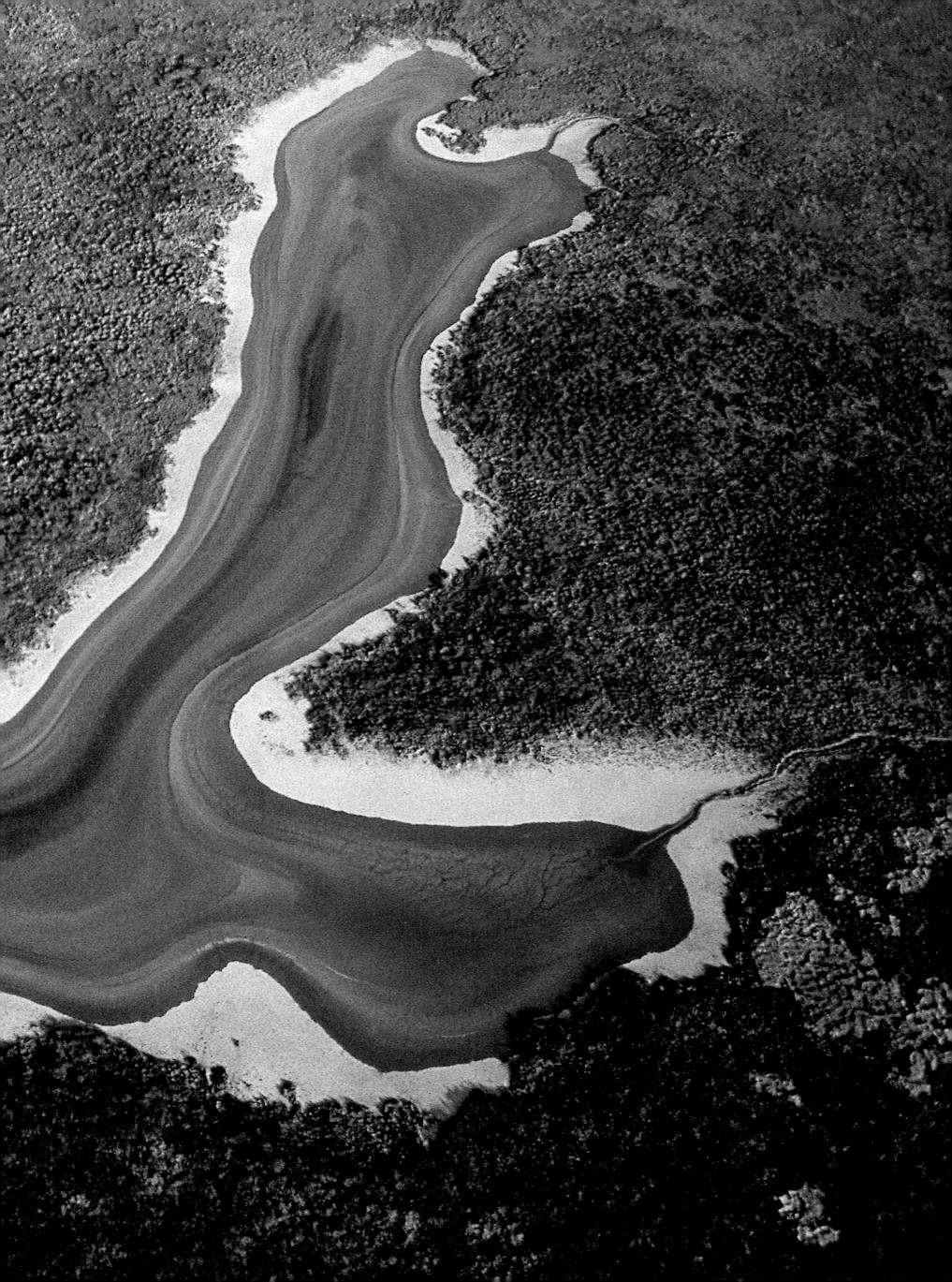

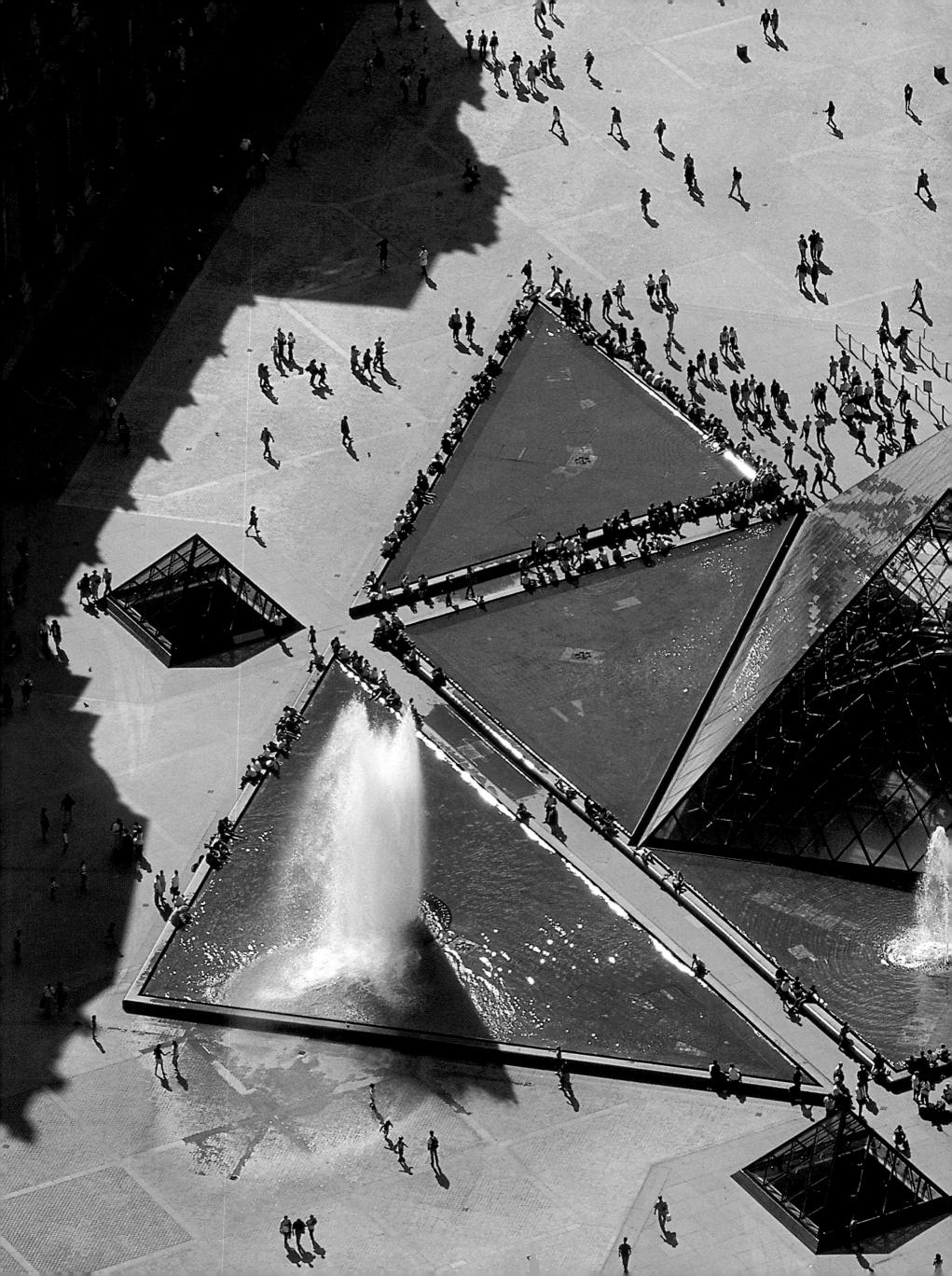

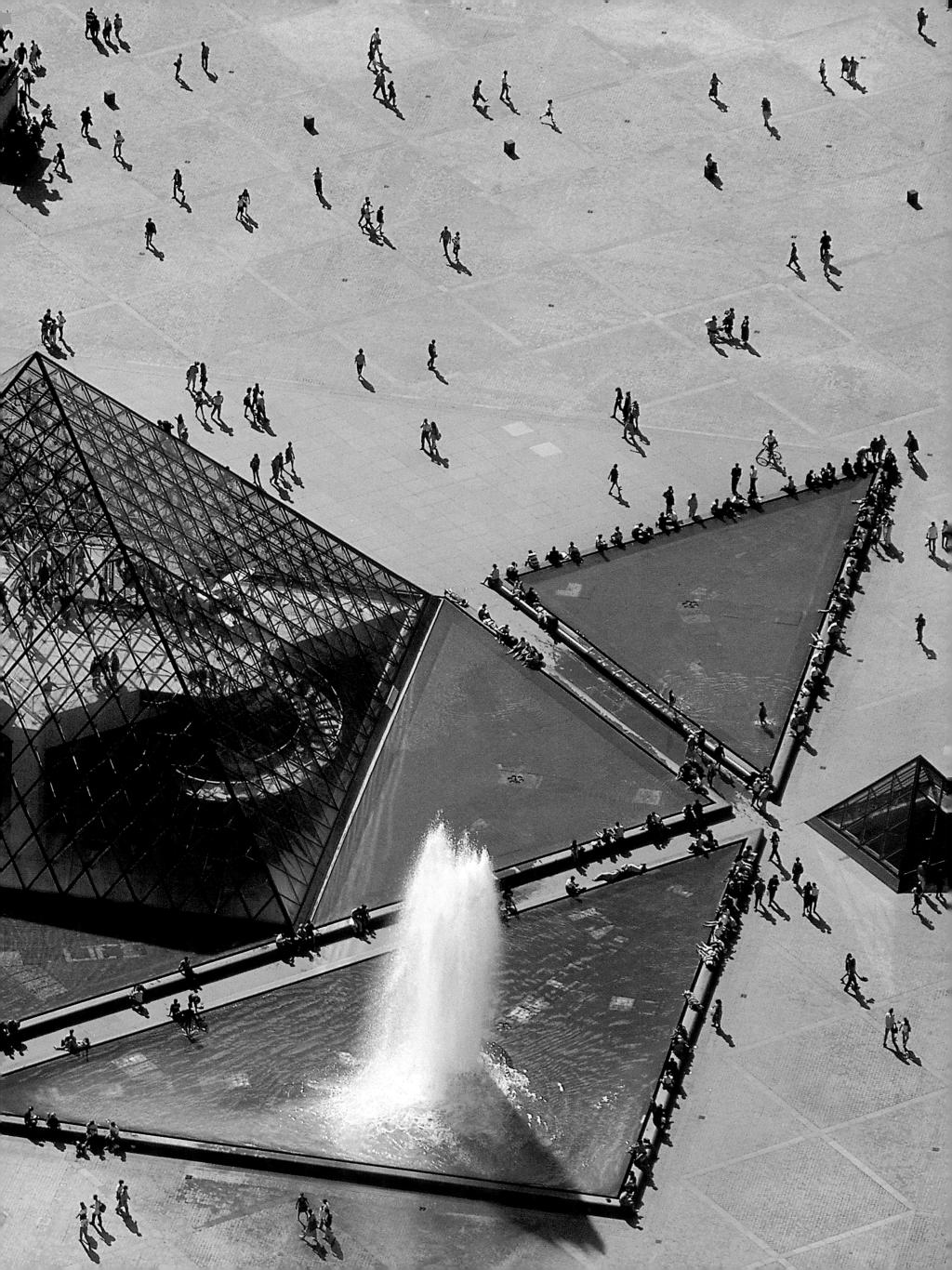

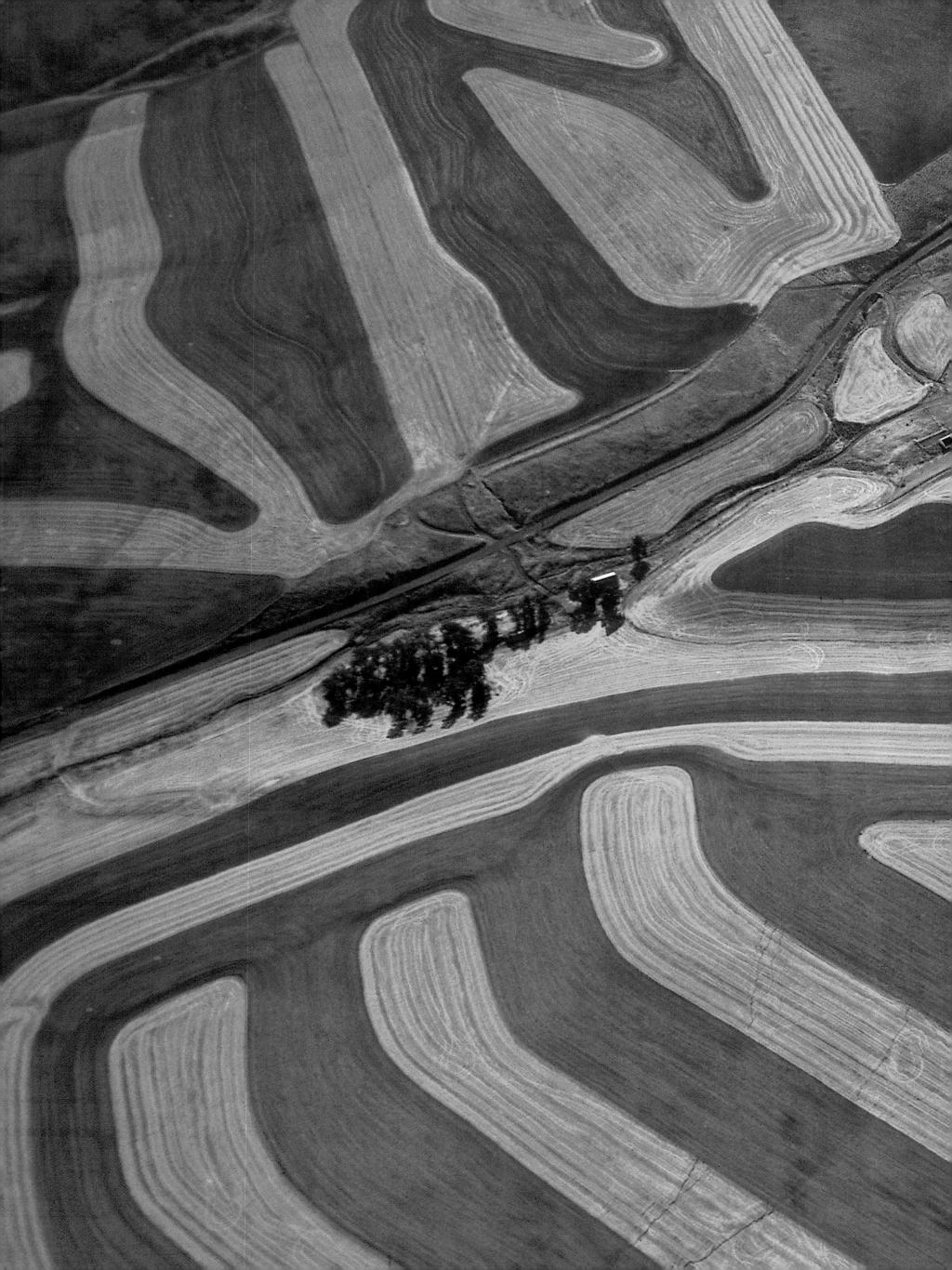

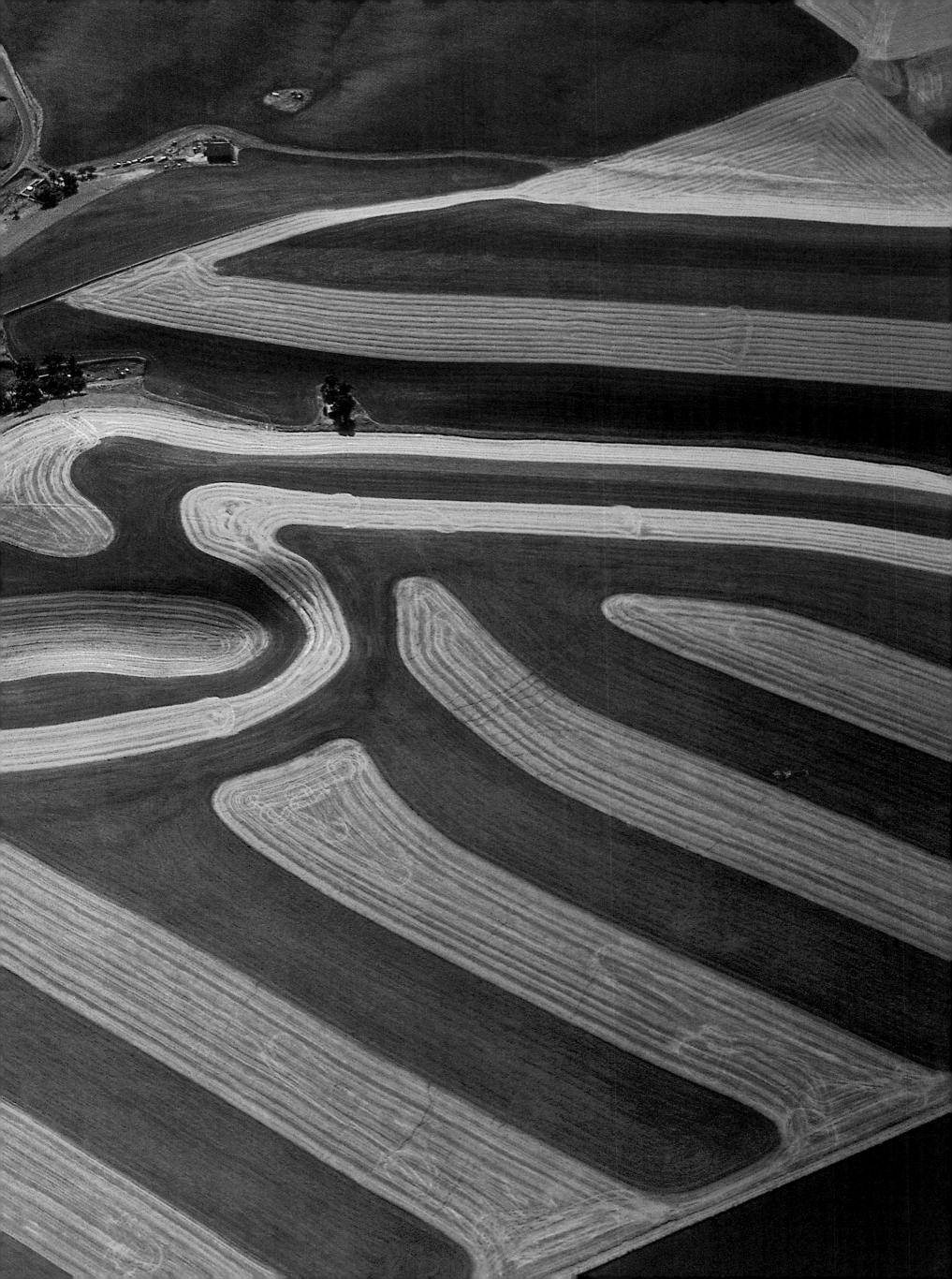

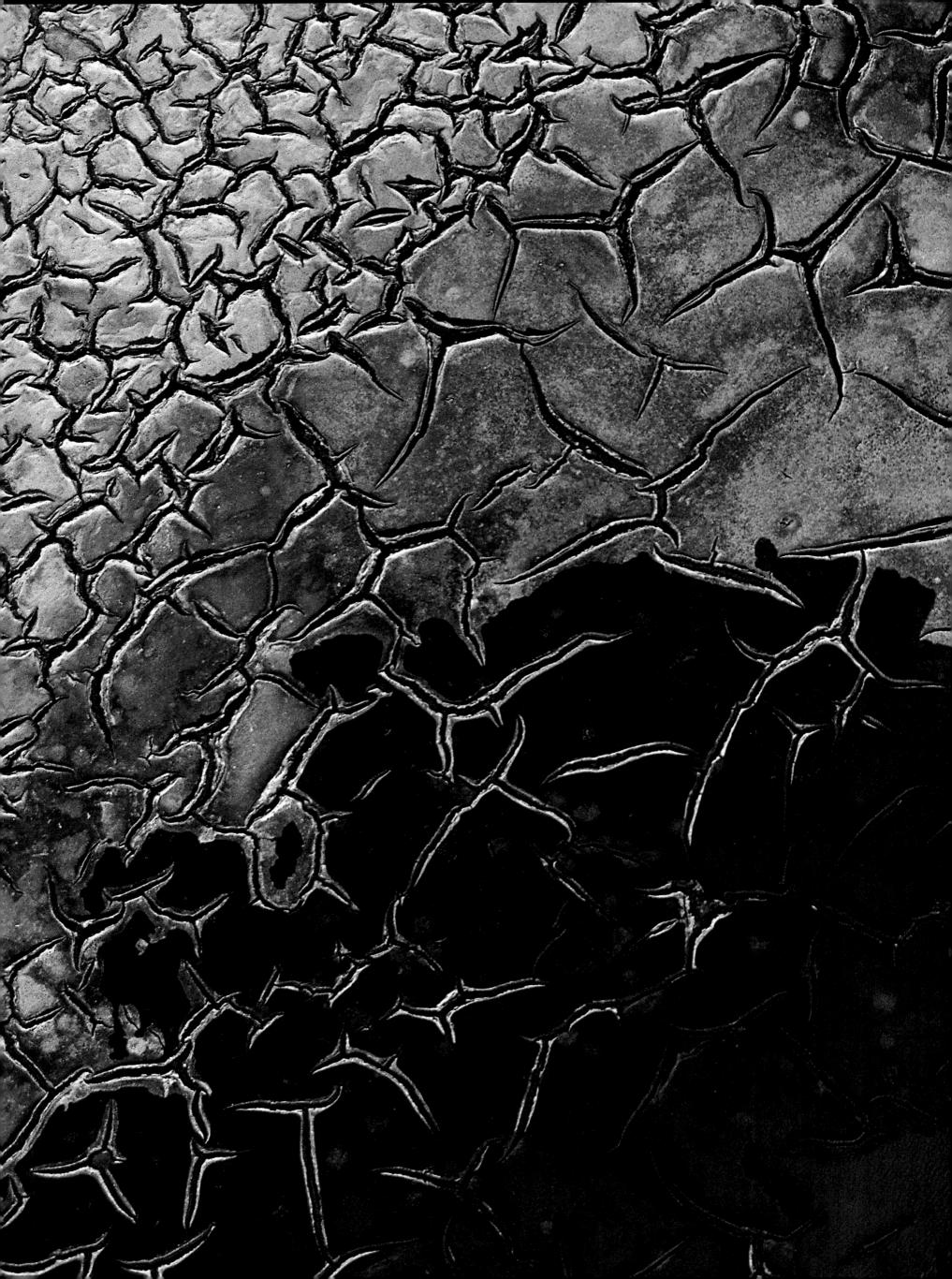

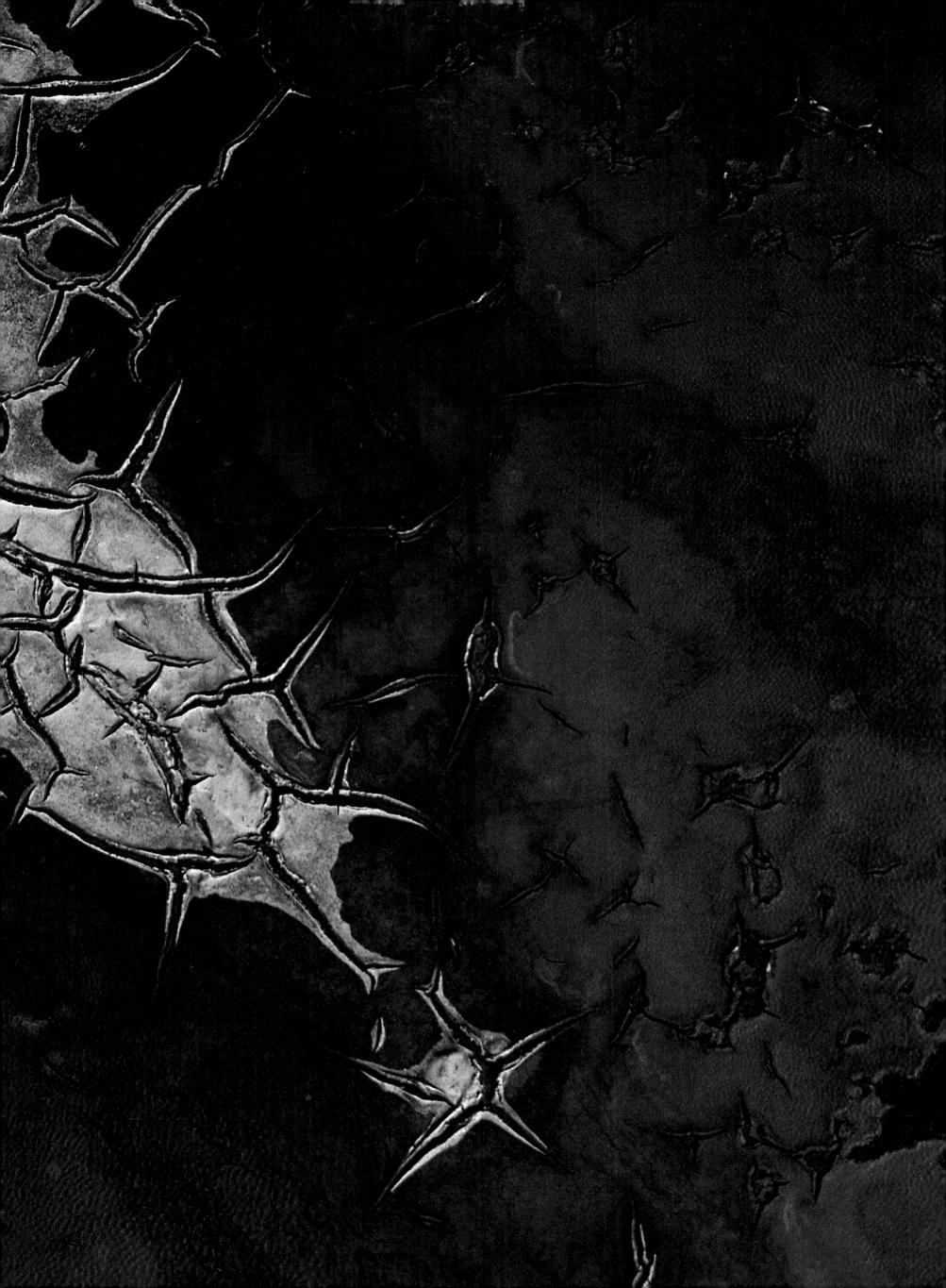

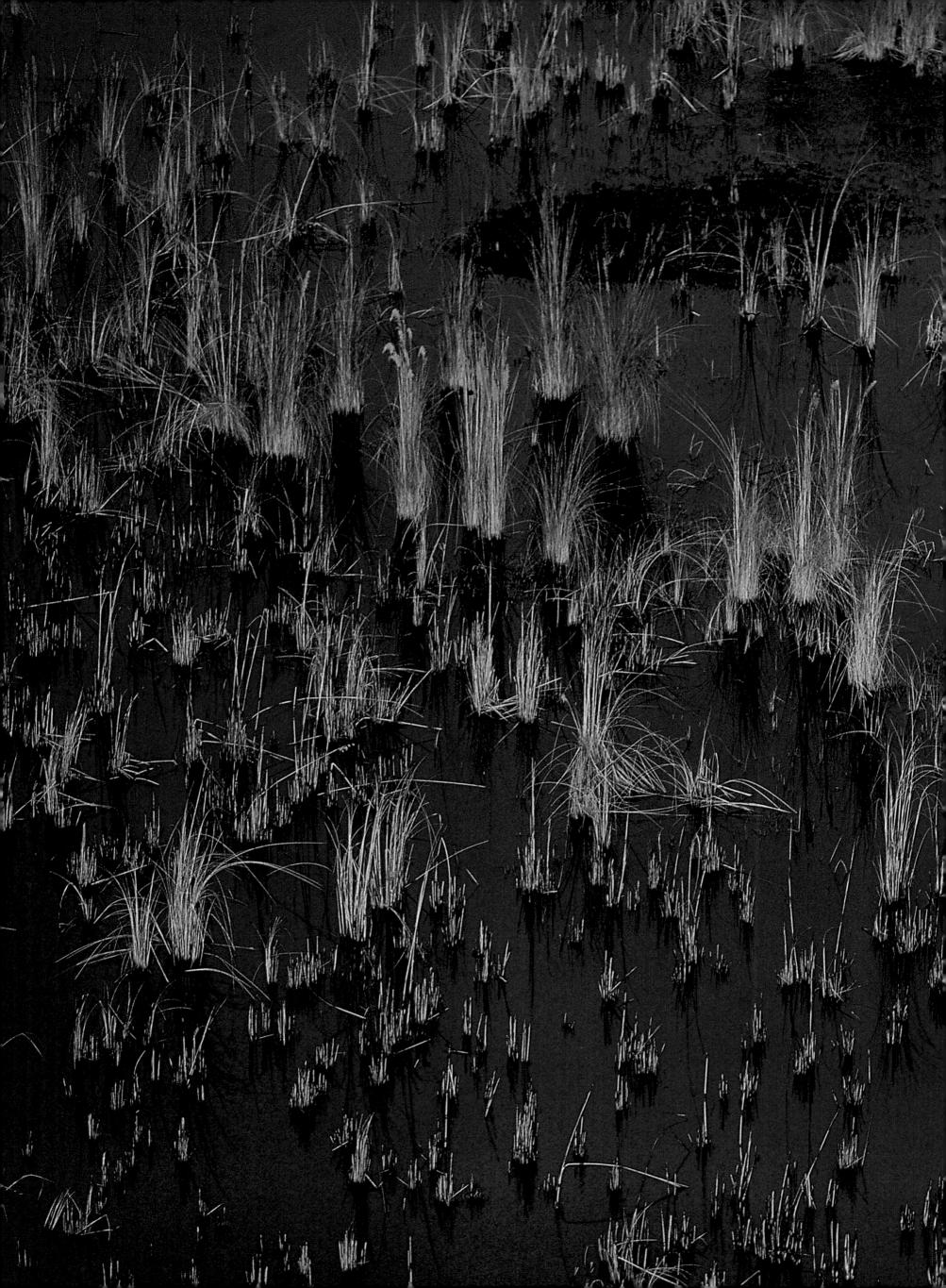

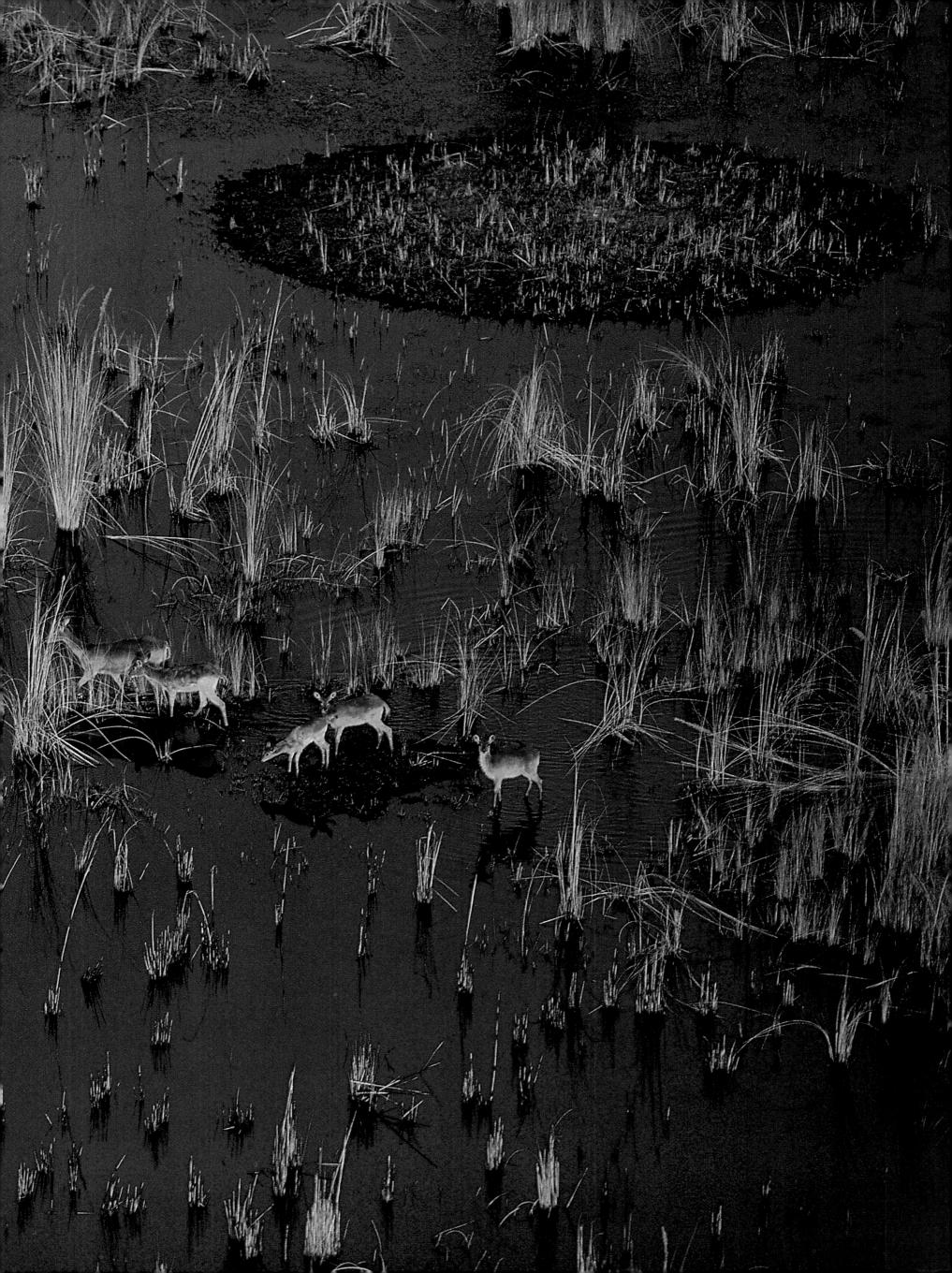

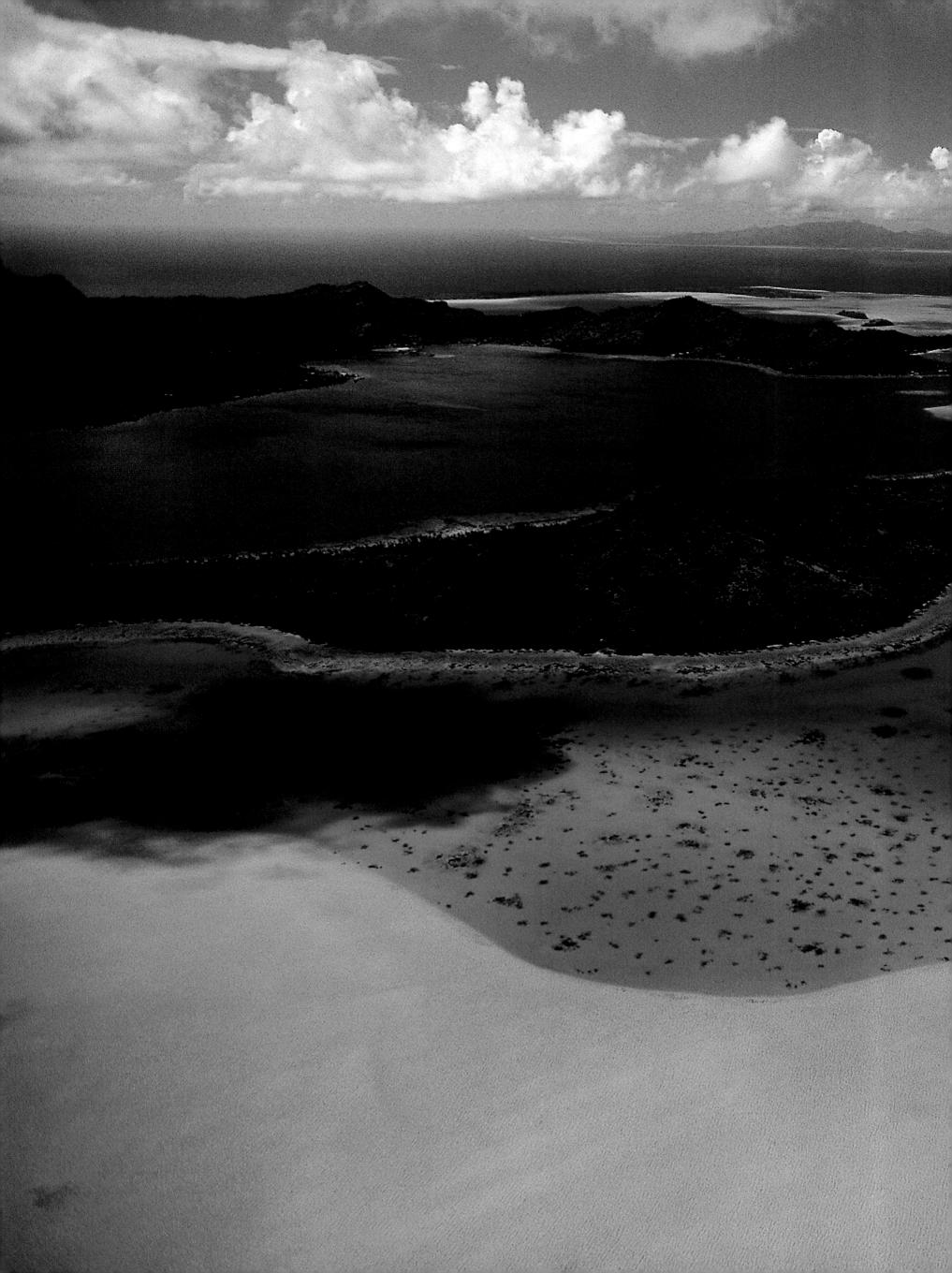

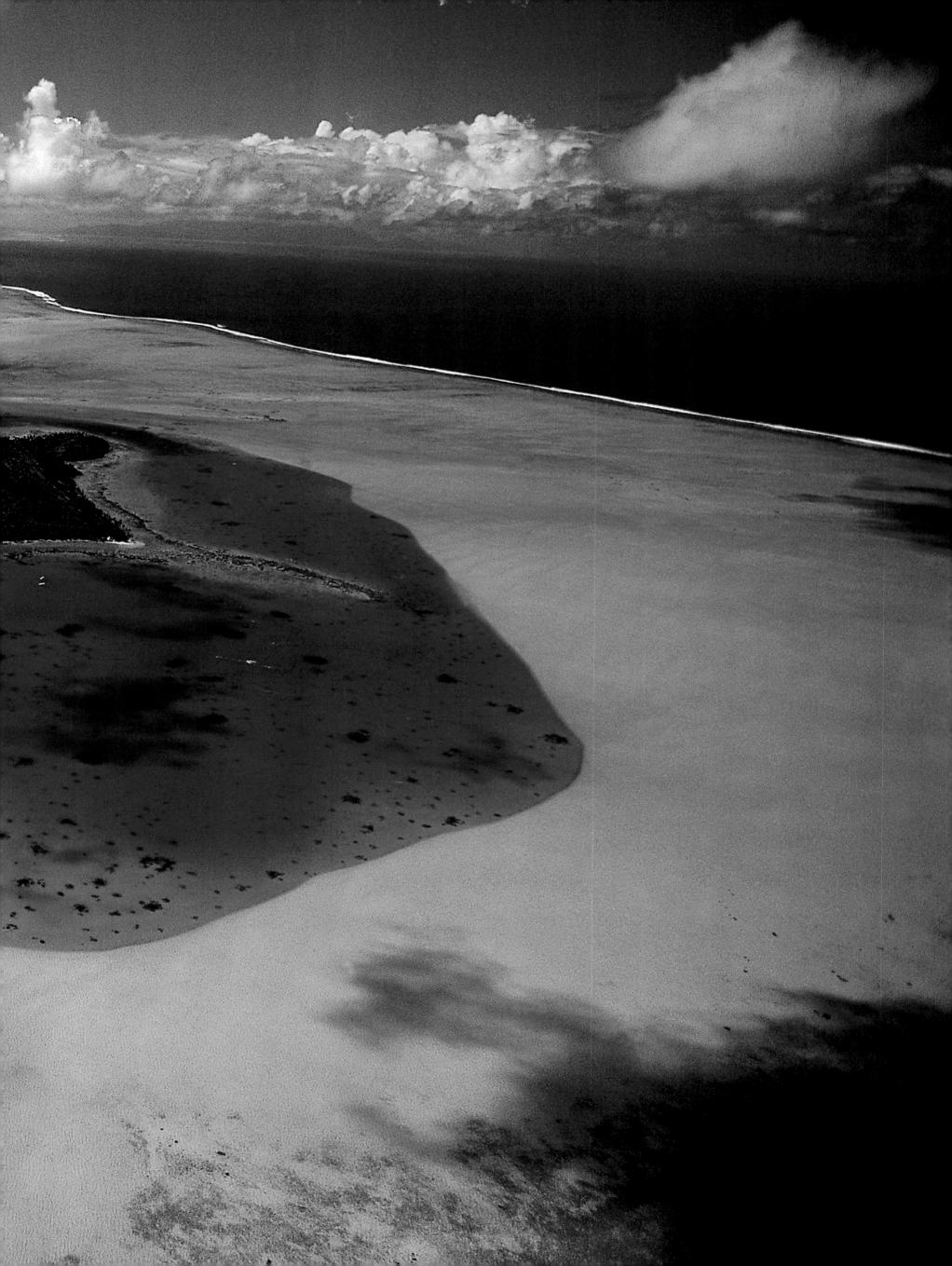

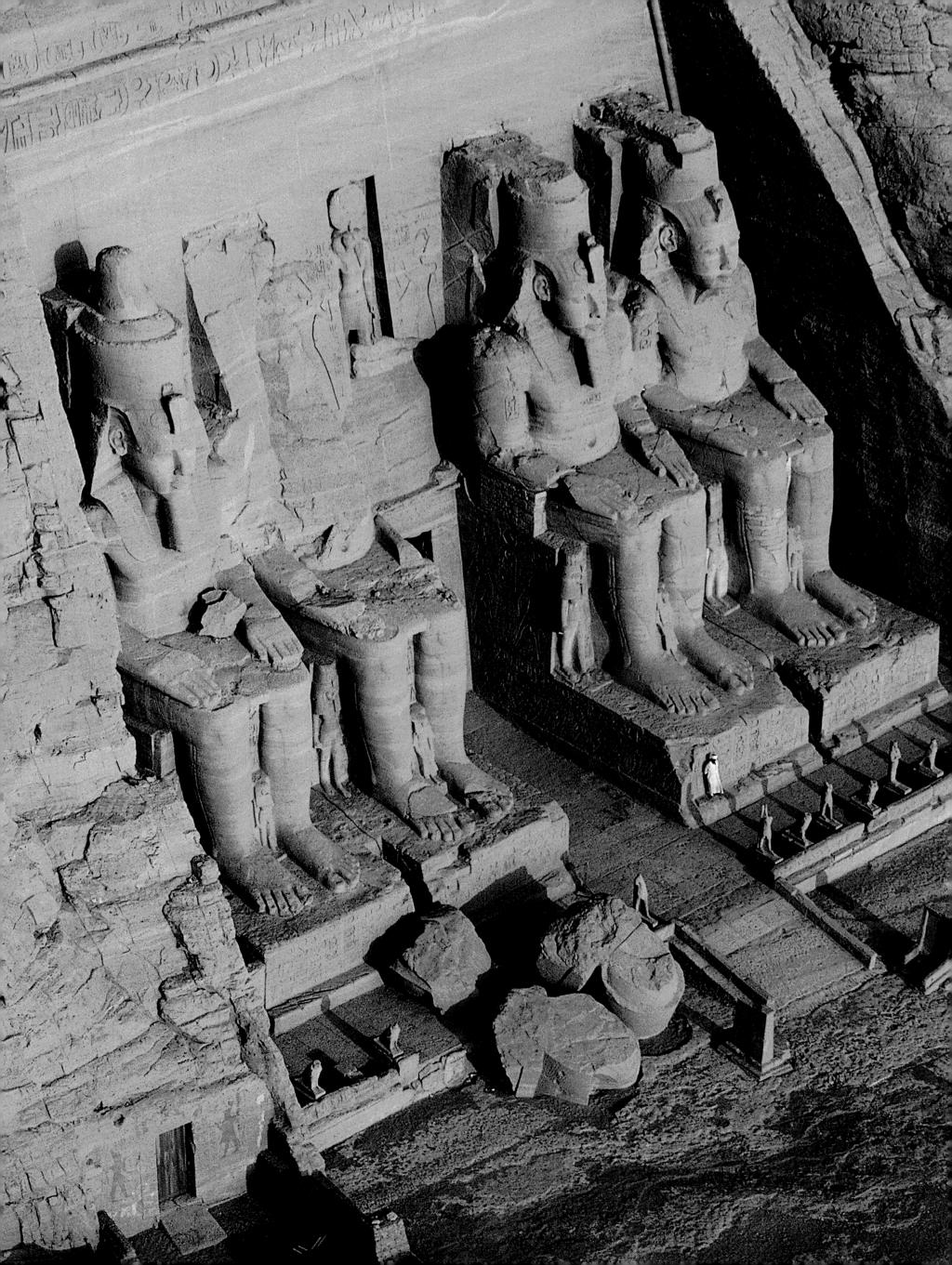

TOWARD A SUSTAINABLE DEVELOPMENT

he "Earth Summit" at Rio in 1992 focused its concerns on the conditions required for a "sustainable development" by making a close association between the environment and development. According to the report *Our Common Future*, published in 1987 in preparation for the Rio meeting, the aim was "to make development sustainable—to ensure that it meets the needs of the present without compromising the ability of future generations to meet their own needs."

These conditions presuppose several actions. The first is to prioritize the urgency of environmental risks; the second is to define concrete commitments needed in order to avoid the worst disasters; the third is to identify the resources that wealthy nations in particular ought to devote to the realization of these commitments; the fourth and final initiative is to evaluate the changes called for in this new form of development.

p. 408

ABU-SIMBEL TEMPLE, Nile Valley, Egypt

The archaeological site of Abu-Simbel consists of two monumental temples of pink sandstone, built under the reign of Ramses II to mark the southern boundary of the Egyptian empire. The facade of the larger one, facing toward the rising sun, holds four statues of the pharaoh that are 65 feet (20 m) tall. After Egypt announced the construction of the Aswan Dam on the Nile, a group of more than 20 nations under the direction of UNESCO allocated both financial and material resources so that this legacy would not be swallowed up by the newly created waters. For more than a decade starting in 1963, an army of 900 workers, overseen by experts from 24 countries, broke these temples down into 11,305 blocks each weighing dozens of tons, which were then reassembled identically at a site 200 feet (60 m) higher on an artificial cliff supported by a concrete vault. Along with 582 other monuments around the world, Abu-Simbel is a UNESCO world heritage site.

These proposals are based on one implicit assumption: the *un*sustainability of the present type and speed of growth. The earth's resources are not inexhaustible; the biosphere constitutes a finite world, and the human species has already dealt it irreparable blows. Can economic development occur without endangering our natural heritage? How can this need be met while still providing for the vital needs of all people?

THE MIRAGE OF CATCH-UP THEORY

We must first understand the dynamics of demographic growth in order to master its consequences better. The world population is growing by approximately 80 million people each year, and 80 percent of that growth occurs in developing nations. Data from the United Nations Food and Agricultural Organization (FAO) indicate that 800 million people around the world suffer from malnutrition, and 13 million children under five years of age die each year from the direct results of malnutrition or from illnesses linked to it; the World Health Organization (WHO) reports that 1.8 billion people lack healthy drinking water.

It is also crucial to modify the current trends of economic development and the distribution of wealth between the Northern and Southern Hemispheres, as well as within each hemisphere. This will oblige us to give up a popular tenet that

MEXICO CITY, Mexico

Exceeding 17 million residents at the end of the twentieth century, or 20 million including its suburbs, Mexico City is the fourth largest of the world's megacities and symbolizes the new gigantism that marks many cities in developing countries. The problems these cities face are on a scale comparable to their enormity: housing, access to water, transport, waste treatment, and pollution. The insufficiency of mass transport and the growing use of the automobile are sources of considerable air pollution and serious health problems. Subject to almost permanent smog, Mexico City is one of the world's most polluted cities, along with Changqing in China, Bangkok in Thailand, Santiago in Chile, and a few others.

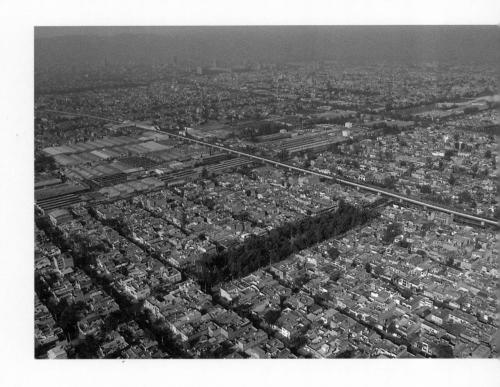

continues to inspire many visions of the future: the catch-up theory, which states that the benefits of uninterrupted economic growth cannot fail to reach all of humanity by trickling down from the top of societies. If we wanted to guarantee the 6 billion inhabitants of the earth in the year 2000 the income of the American middle class, the flow of resources consumed by the world economic engine would have to be multiplied by a factor of about five. It would have to be still higher if we wanted to ensure this catch-up effect for the 9 billion to 11 billion who will occupy the planet by the midtwenty-first century.

The catch-up theory is even more untenable if we consider the new ecological constraints. If countries can only catch up with the wealthiest by imitating their development model, this attempt will run into insurmountable difficulties long before attaining success. This applies above all to the degradation of natural resources.

Extraordinary economic growth is enjoyed today by just over one-third of humanity, and it remains a hope for the other two-thirds. Near the end of the eighteenth century, the gap in the standard of living between Europeans and the rest of the world did not exceed the level of 2 to 1; by the

beginning of the twentieth century, this ratio was nearly 10 to 1. According to a computation by the United Nations Development Program (UNDP), the richest 20 percent of the world population in 1960 had an income 30 times higher than that of the poorest 20 percent. By the mid-1980s, the same source placed this ratio at 60 to 1.

THE NORTH-SOUTH GAP

We cannot plan a sustainable growth that would not be equitable. The call for a sustainable development thus means not only the preservation of resources and a livable environment for our children and grandchildren; it also signifies the correction of this historic tendency to widen inequalities. We must work for a development that is humane and equal.

Attempts have been made to estimate, in concrete financial terms, the implementation of such a form of development. At the Copenhagen Summit of 1995 devoted to social development, the UNDP estimated this cost at an annual total of at least \$40 billion, covering four priorities: education, population, health, and access to drinking water. According to the recommendations of Agenda 21 (thus named because of the twenty-one main recommendations made by the Rio

Conference in 1992), a total of \$120 bill be devoted each year to a humane develops environmental demands. But these figure unless they are seen in the wider context of the Northern and Southern Hemispheres.

In the Northern Hemisphere the envir massive pollution effects are directly trace sive gains in the production of consumsince the end of World War II. In contrast Hemisphere the destruction of the environ price exacted by misery and poverty. Thestries, following the lead of the industrializ utilize their labor force while overexploresources: mines, forests, soils, coastlines. The enormous national debts, and an essent exports must go to paying off these debts

The environmental crisis presents it cal terms. Undoubtedly, the ailments unled by an economic system that seeks product any price are universal in nature. But in the sphere the dominant problem is a crisis of the Southern Hemisphere, as well as increasely hundreds of millions of people are unable

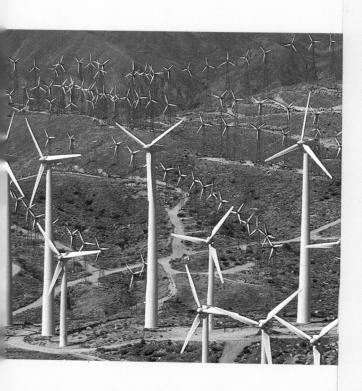

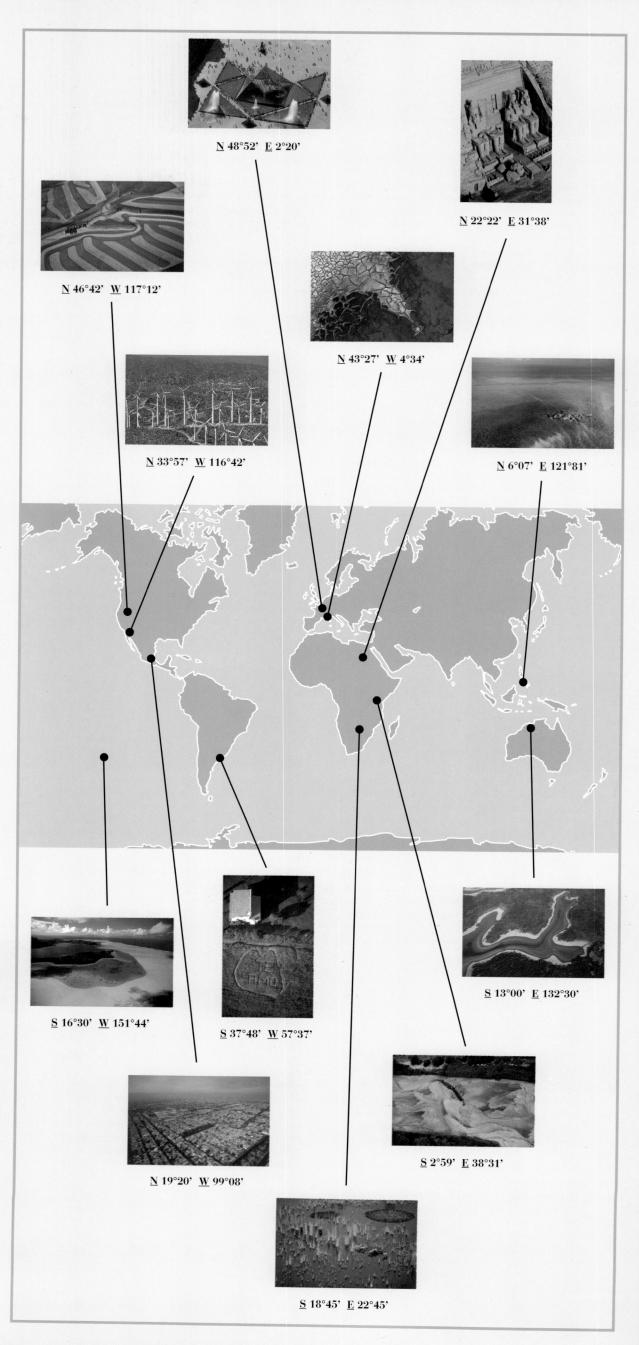

exerted on the biosphere. Numerous courses of action have been proposed with a view to making a simultaneous attack on the problems of poverty and the environment: increased efforts in the recycling of materials and reduced energy consumption; support for small-scale peasant farming; development of social services and education; and public works to improve national infrastructures.

We already know the potential sources of financing for these projects. An eco-tax of one dollar per barrel of petroleum would correspond to \$60 billion per year. The proposal by Nobel Prize laureate James Tobin to levy a 0.05 percent tax on speculative profits on currency transactions in cash could bring in \$150 billion per year. And setting aside 0.7 percent of the gross national product of industrialized nations to aid the development of southern countries would amount to approximately \$140 billion per year.

The question, then, is whether the industrial world has the political will for this implementation. The wealthiest societies are reticent when faced with the financial contributions demanded of them, whereas the poorest nations have difficulty accepting restrictions imposed on them when they remain excluded from the amenities of mass consumption. The objective of a sustainable development will have to be pursued on the transnational level. The Gordian knot of the environmental question can be solved only by a true reversal of our historical relationship to the environment. A new system of governability for our planet must emerge from a new ethic of planetary solidarity and responsibility toward future generations. Today the crisis of the environment and development puts the future of humanity at risk. At this time, we must renew the inspirational hope of the UN Charter, which opens with this great formulation: "We the peoples of the United Nations."

Jean-Paul Deléage

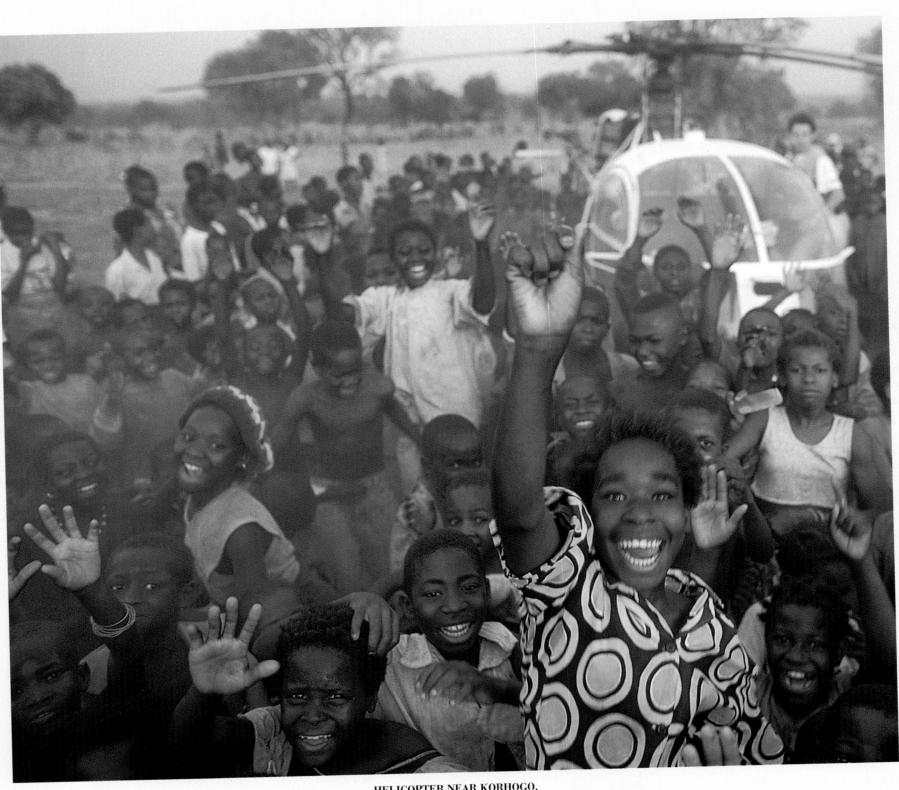

HELICOPTER NEAR KORHOGO, Côte d'Ivoire

ACKNOWLEDGMENTS

UNESCO: Federico Mayor, Director General; Pierre Lasserre, Director of the Divison of Ecological Sciences; Mireille Jardin, Jane Robertson, Josette Cainche and Malcolm Hadley, Hélène Gosselin, Carlos Marques, Mr. Oudatchine of the Office of Public Information; Francesco di Castri and Jeanne Barbière, of the Environmental Coordination division

FUJIFILM: Masayuki Muneyuki, President, Toshiyuki "Todd" Hirai, and Minoru "Mick" Uranaka of Fujifilm in Tokyo; Peter Samwell of Fujifilm Europe; Doris Goertz, Ms. Develey, Marc Héraud, Jean-Pierre Colly, François Rychelewski, Bruno Baudry, Hervé Chanaud, Franck Portelance, Piotr Fedorowicz, Françoise Moumaneix, and Anissa **Auger of Fujifilm France**

CORBIS: Stephen B. Davis, Peter Howe, Graham Cross, Charles Mauzy, Vanessa Kramer, Tana Wollen, and Vicky Whiley

AIR FRANCE: François Brousse and Christine Micouleau, Mireille Queillé and Bodo Ravoninjatovo

As we complete this final page, mindful of so many good memories from evey corner of the planet, our only fear is that we may have forgotten one of the many people who have helped us to realize this project. We sincerely apologize for any such oversight, and we assure you of our heartfelt gratitude.

ALBANIA

ECPA, Lieutenant Colonel Aussavy DICOD, Colonel Baptiste, Captain Maranzana, and Captain Saint-Léger SIRPA, Charles-Philippe d'Orléans DETALAT, Captain Ludovic Janot Staffs of the French air force, Etienne Hoff, Cyril Vasquèz, Olivier Ouakel, José Trouille, Frédéric Le Mouillour, François Dughin, Christian Abgral, Patric Comerier, Guillaume Maury, Franck Novak, pilots

ANTARCTICA

Institut Français pour la Recherche et la Technologie Polaires, Gérard Jugie L'Astrolabe, Captain Gérard R. Daudon, Sd Capitaine Alain Gaston Heli Union France, Bruno Fiorese, pilot Augusto Leri and Mario Zucchelli Projetto Antartida, Italy Terra Nova

ARGENTINA Jean-Louis Larivière, Ediciones

Larivière

Mémé and Marina Larivière, Felipe C. Larivière of Fernández Beschtedt Sergio Copertari, pilot; Emilio Yañez and Pedro Diamante, co-pilots; Eduardo Benítez, mechanic Squadron of Federal Air Police, ommissioner Norberto Edgardo

Captain Roberto A. Ulloa, former governor of the province of Salta Orán precinct house, Salta province, Commander Daniel D. Pérez Military Geograpical Institute Commissioner Rodolfo E. Pantanali **Aerolineas Argentinas**

AUSTRALIA

Helen Hiscocks Australian Tourism Commission, Kate Kenward, Paul Gauger, and Cemma Tisdell **Jairow Helicopters** Heliwork, Simon Eders Thai Airways, Pascale Baret Club Meds of Lindeman Island and **Byron Bay Beach**

BAHAMAS

Club Meds of Eleuthera, Paradise Island, and Columbus Isle

BANGLADESH Hossain Kommol and Salahuddin-Akbar, External Publicity Wing of the Ministry of Foreign Affairs, Dacca

His Excellency Tufail K. Haider, ambassador of Bangladesh in Paris, and Chowdhury Ikthiar, first secretary

Her Excellency Renée Veyret, ambassador of France in Da Mohamed Ali and Amjad Hussain of Biman Bangladesh Airlines, Vishawjeet

Mr. Nakada, Fujifilm in Singapore Mr. Ezaher of the Fujifilm laboratory,

Dacca Mizanur Rahman, director, Rune Karlsson, pilot, and Eldon, mechanic, MAF Air Support Muhiuddin Rashida, Sheraton Hotel,

Dacca Mr. Minto

BOTSWANA Maas Müller, Chobe Helicopter

BRAZIL

Governor of Mato Grosso do Norte e

Fundação Pantanal, Erasmo Machado Filho, and the Regional Natural Parks of France, Emmanuel Thévenin and Jean-Luc Sadorge

Fernando Lemos His Excellency Mr. Pedreira, Brazilian ambassador to UNESCO

Dr. Iracema Alencar de Queiros, Instituto de Proteção Ambiental do Amazonas, and his son Alexandro

Brasília Tourism Office Luis Carlos Burti, Editions Burti Carlos Marquès, OPI Division, UNESCO **Ethel Leon, Anthea Communication**

José Augusto Wanderley and Juliana Marquès of Golden Cross Hotel Tropical, Manaus VARIG

CANADA

Anne Zobenbuhler, Canadian Embassy in Paris and Tourism Office Barbara di Stefano and Laurent Beunier, Destination Québec Cherry Kemp Kinnear, Nunavut **Tourism Office Huguette Parent and Chrystiane** Galland, Air Canada First Air

Vacances Air Transat André Buteau, pilot, Essor Helicopters Louis Drapeau, Canadian Helicopters Canadian Airlines

Tourism Office, Hong Kong, Mr. Iskaros Chinese Embassy in Paris, His Excellency Mr. Caifangbo, Li Beifen French Embassy in Beijing, His Excellency Pierre Morel Shi Guangeng Serge Nègre Yan Layma

COTE D'IVOIRE

Vitrail & Architecture, Pierre Fakhoury Hugues Moreau and pilots Jean-Pierre Artifoni and Philippe Nallet, Ivoire Hélicoptères Patricia Kriton and Mr. Kesada, Air

DENMARK

Afrique

Weldon Owen Publishing, the entire production team of "Over Europe"

ECUADOR

Loup Langton and Pablo Corral Vega, ndo Ecuador Descubriendo Ecuador Claude Lara, minister of foreign affai

in Ecuador Mr. Galarza, Ecuadorian co

France Eliecer Cruz, Diego Bouilla, Robert

Bensted-Smith, Galapagos National Park Patrizia Schrank, Jennifer Stone, European Friends of Galapagos"

Danilo Matamoros, Jaime and Cesar, Taxi Aero Inter Islas M.T.B. Etienne Moine, Latitude O° Abdon Guerrero, San Cristobal airport

Rallye des Pharaons, "Fenouil," organizer, Bernard Seguy, Michel Beaujard, and Christian Thévenet, pilots

FRANCE

Dominique Voynet, minister of land use and the environment Defense Ministry/SIRPA Préfecture de Police, Paris Montblanc Hélicoptères, Franck Arrestier and Alexandre Antunes,

Corsica Tourism Office, Xavier Olivieri Departmental Tourism Committee of Auvergne, Cécile da Costa Conseil Général of the Côtes d'Armor,

Charles Josselin and Gilles Pellan Conseil Général of Savoie, Jean-Marc Eysserick

Conseil Général of Haute-Savoie, **Georges Pacquetet and Laurent** Guette

Conseil Général of the Alpes-Maritimes, Sylvie Grosgojeat and Cécile Alziary Conseil Général of Yvelines, Franck

Borotra, president, Christine Boutin, Pascal Angenault, and Odile Roussillon

CDT of the Départements de la Loire Rémy Martin, Dominique Hériard-Dubreuil Nicole Bru

artistic director

Hachette, Jean Arcache Moët et Chandon/Rallye GTO, Jean Berchon and Philippe des Roys du

Printemps de Cahors, Marie-Thérèse Perrin

Philippe Van Montagu and Willy Gouere, pilot

SAF hélicoptères, Christophe Rosset, Hélifrance, Héli-Union, Europe Hélicoptère Bretagne, Héli Bretagne, Héli-Océan, Héli Rhône-Alpes,

Hélicos Légers Services, Figari Aviation, Aéro service, Héli air Monaco, Héli Perpignan, Ponair, Héli-inter, Héli Est

Réunion: Tourism Office of Réunion Jean-Marie Lavèvre, pilot, Hélicoptères Helilagon René Barrieu and Michèle Bernard

French West Indies: Club Med des Boucaniers and Club Med de la Caravelle

GREECE

Culture Ministry, Athens Eleni Methodiou, Greek delegation to

Hellenic Tourism Office

Club Meds of Corfu Ipsos, Gregolimano, Helios Corfu, Kos, and Olympia Olympic Airways

INTERJET, Dimitrios Prokopis and Konstantinos Tsigkas, pilots, and Kimon Daniilidis Meteo Center, Athens

rera, director, and Carlos rena, pilot, Aerofoto, Guatemala

Rafael Sagastume, STP villas, **Guatemala City**

ICELAND

Bergur Gislasson and Gisli Guestsso Icephoto Thyrluthjonustan Helicopters

Peter Samwell National Tourism Office, Paris

Indian embassy in Paris, His Excellency Kanwal Sibal, ambassador, Rahul Chhabra, first secretary, S. K. Sofat, general of aerial brigade, Mr. Lala, Mr. Kadyan, and Vivianne Tourtet

Ministry of foreign affairs, Teki E. Prasad and Manjish Gover N. K. Singh, office of the Prime Minister

Mr. Chidambaram, member of Air Headquarters, S. I. Kumaran, Pande

Mandoza Air Charters, Atul Jaidka Indian International Airways, Captain Sangha Pritvipalh French embassy in New Delhi, His Excellency Claude Blanchemaison,

ambassador, François Xavier Reymond, first secretary

INDONESIA

TOTAL Balikpapan, Ananda Idris and Ilha Sutrisno Mr. and Mrs. Didier Millet

IRELAND

Aer Lingus Irish National Tourism Office Captain David Courtney, Irish Rescue Helicopters David Hayes, Westair Aviation Ltd.

ITALY

French embassy in Rome, Michel Benard, press service Heli Frioula, Gianfranco Greco, Stefano Fanzin, and Pierino Godicio

JAPAN

Eu Japan Festival, Shuji Kogi and Robert Delpire Masako Sakata, IPJ NHK TV **Japan Broadcasting Corporation**

Ms. Sharaf, Anis Mouasher, Khaled Irani, and Khaldoun Kiwan, Royal Society for Conservation of Nature **Royal Airforces** Riad Sawalha, Royal Jordanian Regency Palace Hotel

KAZAKHSTAN

His Excellency Nourlan Danenov, ambassador of Kazakhstan in Paris His Excellency Alain Richard, French ambassador in Alma-Ata, and Josette

Professor René Letolle Heli Asia Air and its pilot, Mr. Anouar

Safari Tours, Nairobi, Patrix Transsafari, Irvin Rozental

KUWAIT
Kuwait Center for Research and
Studies, Prince Abdullah Al
Ghunaim, Dr. Youssef
Kuwait National Commission for
UNESCO, Sulaiman Al Onaizi
Kuwaiti delegation to UNESCO, His
Excellency Dr. Al Salem, and Mr. Al
Baghly
Kuwait Airforces, Squadron 32, Major
Hussein Al-Mane, Captain Emad AlMomen
Kuwait Airways, Mr. Al Nafisy

Kuwait Airways, Mr. Al Nafisy

MADAGASCAR

Riaz Barday and Mr. Norman, pilot,

Sonja and Thierry Ranarivelo, Yersin Racearlyn, pilot, Madagascar Hélicoptère Jeff Guidez and Lisbeth

MALAYSIA Club Med of Cherating

MALDIVES Club Med of Faru

MALI

TSO, Rallye Dakar, Hubert Auriol Daniel Legrand, Arpèges Conseil Daniel Bouet, pilot of Cessna

MAURITANIA TSO, Rallye Paris-Dakar, Hubert Auriol Daniel Legrand, Arpèges Conseil Daniel Bouet, pilot Sidi Ould Kleib

Club Meds of Cancun, Sonora Bay, Huatulco, and Ixtapa

OROCCO Royal Moroccan Gendarmerie General El Kadiri and Colonel Hamid Laanigri François de Grossouvre

NAMIBIA **Ministry of Fisheries** French Cooperation Mission, Jean-Pierre Lahaye, Nicole Weill, Laurent Billet, and Jean Paul Namibian Tourist Friend, Almut Steinmester

NEPAL Nepalese embassy in Paris Terres d'Aventure, Patrick Oudin Great Himalayan Adventures, Ashok Basnyet Royal Nepal Airways, J. B. Rana Mandala Trekking, Jérôme Edou Bhuda Air Maison de la Chine, Patricia Tartour-Jonathan, director, Colette Vaquier and Fabienne Leriche Marina Tymen and Miranda Ford, Cathay Pacific

NETHERLANDS Paris Match Franck Arrestier, pilot

NEW CALEDONIA Charles de Montesquieu

NICER

TSO, Rallye Paris-Dakar, Hubert Auriol Daniel Legrand, Arpèges Conseil Daniel Bouet, pilot of Cessna

Airlift A.S., Ted Juliussen, pilot, Henry Hogi, Arvid Auganaes, and Nils Myklebust

His Majesty the Sultan Quabous ben Saïd al-Saïd Defense Ministry, John Miller Villa d'Alésia, William Perkins and Isabelle de Larrocha

Dr. Maria Reiche and Ana Maria Cogorno-Reiche Ministry of foreign relations, Juan Manuel Tirado National Police of Peru Faucett Airline, Cecilia Raffo and Alfredo Barnechea

PHILIPPINES Filipino Airforces Seven Days in the Philippines, by Editions Millet, Jill Laidlaw

Eduardo Corrales, Aero Condor

PORTUGAL Club Med of Da Balaia

POLYNESIA Club Med of Moorea

RUSSIA

Yuri Vorobiov, vice-minister, and Mr. Brachnikov, Emerkom Nidolai Alexiy Timochenko, Emerkom in Kamchatka Valery Blatov, Russian delegation to UNESCO

ST. VINCENT AND THE GRENADINES Paul Gravel, SVG Air Jeanette Cadet, The Mustique Company David Linley Ali Medjahed, baker Alain Fanchette

SENEGAL TSO, Rallye Paris-Dakar, Hubert Auriol Daniel Legrand, Arpèges Conseil Daniel Bouet, pilot Club Meds of Almadies and Cap Skirring

SOMALIA

His Royal Highness Sheikh Saud Al-Thani of Qatar Majdi Bustami, E. A. Paulson and Osama, bureau of His Royal Highness Sheikh Saud Al-Thani d Viljoen, pilot ein. UNESCO-Peer Hargeysa, Somalia Nureldin Satti, UNESCO-Peer, Nairobi,

Kenya Shadia Clot, correspondent of the Sheikh in France Waheed, Al Sadd travel agency, Qatar Cécile and Karl, Emirates Airlines, Paris

SOUTH AFRICA SATOUR, Ms. Salomone South African Airways, Jean-Philippe de Ravel Victoria Junction, Victoria Junction Hotel

His Excellency Jesus Ezquerra, Spanish ambassador to UNESCO

Club Meds of Don Miguel, Cadaquès, Porto Petro, and Ibiza

Canaries: Tomás Azcárate y Bang, Viceconsejería de Medio Ambiente Fernando Clavijo, Protección Civil de las Islas Canarias

Jean-Pierre Sauvage and Gérard de Bercegol, IBERIA

Elena Valdés and Marie Mar, Spanish **Tourism Office**

Basque Country: President's Office of the **Basque Government**

Zuperia Bingen, director, Concha Dorronsoro and Nerea Antia, Press and Communication department of the President's Office, Basque Government

Juan Carlos Aguirre Bilbao, chief of the helicopter unit of Basque police force (Ertzaintza)

THAILAND

Royal Forest Department, Viroj Pimanrojnagool, Pramote Kasempsap, Tawee Nootong, Amon Achapet NTC Intergroup Ltd., Ruhn Phiama Pascale Baret, Thai Airways Thai National Tourism Office, Juthaporn Rerngronasa, Ms. Watcharee, Lucien Blacher, Satit Nilwong, and Busatit Palacheewa Fujifilm Bangkok, Mr. Supoj Club Med of Phuket

TUNISIA

President Zinet Abdine Ben Ali Office of the President of the Republic, Abdelwahad Abdallah and Haj Ali Air Force, Laouina base, Colonel Mustafa Hermi

Tunisian embassy in Paris, His Excellency Mr. Bousnina, ambassador, and Mohamed Fendri

Tunisian National Tourism Office, Raouf Jomni and Mamoud Khaznadar

Editions Cérès, Mohamed and Karim Ben Smail

The Residence Hotel, Jean-Pierre Auriol Basma-Hotel Club Paladien, Laurent Chauvin

Meteorological Center, Tunis, Mohammed Allouche

TURKEY

Turkish Airlines, Bulent Demirçi, former director, and Nasan Erol,

Mach'Air Helicopters, Ali Izmet Oztürk, Seçal Sahin, Karatas Gulsah General Aviation, Vedat Seyhan and Mr. Faruk, pilot

Club Meds of Bodrum, Kusadasi, Palmiye, Kemer, Foça

UKRAINE

Alexandre Demianyuk, UNESCO secretary general
A. V. Grebenyuk, administrative
director of the Chernobyl exclusion

Rima Kiselitza, attaché at Chornobylinterinform

UNITED KINGDOM

England: Aeromega and Mike Burns, pilot David Linley Philippe Achache **Environment Agency, Bob Davidson and David Palmer** Press Office of Buckingham Palace Scotland: Paula O'Farrel and Doug
Allsop of Total Oil Marine, Aberdeen Iain Grindlay and Rode de Lothian Helicopters Ltd., Edinburgh

UNITED STATES

Alaska: Philippe Bourseiller; Yves Carmagnole, pilot

Wyoming: Yellowstone National Park, Marsha Karle and Stacey Churchwell *Utah:* Classic Helicopters *Montana:* Carisch Helicopters, Mike

Carisch California: Robin Petgrave of Bravo

Helicopters, Los Angeles, and pilots Akiko K. Jones and Dennis Smith; Fred London, Torrance Cornerstone Elementary School Nevada: John Sullivan and pilots Aaron

Wainman and Matt Evans, Sundance Helicopters, Las Vegas Louisiana: Suwest Helicopters and Steve

Eckhardt Arizona: Southwest Helicopters and Jim

McPhail New York: Liberty Helicopters and

Daniel Veranazza; Mike Renz, Analar Helicopters; John Tauranac Florida: Rick Cook, Everglades National

Park; Rick and Todd, Bulldog Helicopters in Orlando; Chuck and Diana, Biscayne Helicopters, Miami; Club Med in Sand Piper

UZBEKISTAN

Uzbekistan Embassy in Paris, His Excellency Mr. Mamagonov, ambassador, and Djoura Dekhanov, first secretary

His Excellency Jean Claude Richard, French ambassador in Uzbekistan, and Jean Pierre Messiant, first secretary

René Cagnat and Natacha Vincent Fourniau and Bruno Chauvel, Institut Français d'Etudes sur l'Asie Centrale (IFEAC)

VENEZUELA

Centro de Estudios y Desarrollo, Nelson Prato Barbosa Intercontinental Hotels **Ultramar Express** Lagoven Imparques ICARO, Luis Gonzales

We would also like to thank the companies that allowed us to fly on the basis of orders or exchanges:

AEROSPATIALE, Patrice Kreis, Roger Benuigui, and Cotinaud

AOM, Françoise Dubois-Siegmund, Felicia Boisne-Noc, Christophe Cachera CANON, Service Pro

CANON, Service Fro CLUB MED, Philippe Bourguignon, Henri de Bodinat, Sylvie Bourgeois, Preben Vestdam, Christian Thévenet DIA SERVICES, Bernard Crepin FONDATION TOTAL, Yves le Goff and

his assistant, Nathalie Guillerme JANJAC, Jacques and Olivier Bigot, Jean-François Bardy, and Michel

KONICA, Dominique Brugière METEO FRANCE, Mr. Foidart, Marie-Claire Rullière, Alain Mazoyer, and

all of the suppliers RUSH LABO, Denis Cuisy, Philippe Ioli, Christian Barreteau, and all of our friends in the lab

WORLD ECONOMIC FORUM of Davos, Dr. Klaus Schwab, Maryse Zwick

"Earth from Above" team, Altitude agency:

Photo assistants:

Franck Charel and Françoise Jacquot, who followed the entire project, and all those who took part, Tristan Carné, Christophe Daguet, Stefan Christiansen, Pierre Cornevin, Olivier Jardon, Olivier Looren, Marc Lavaud, Franck Lechenet, Antonio López Palazuelo, Stéphane Rabaud, Jean-Paul Thomas

Coordination office:

Production coordination: Hélène de Bonis
Editorial coordination: Françoise Le Roch'Briquet
Exhibition coordination: Catherine Arthus-Bertrand
Production team: Antoine Verdet, Catherine Quilichini, Gloria-Céleste Raad for Russia,
Zhu Xiao Lin for China

Editing: Judith Klein, Hugues Demeude and PRODIG, geographic laboratory, Marie-Françoise Courel, Lydie Goeldner, Frédéric Bertrand Illustration documentation: Isabelle Lechenet, Florence Frutoso, Claire Portaluppi

Yann Arthus-Bertrand also wishes to thank his friend Hervé de La Martinière and the entire team who worked on the book, particularly Benoit Nacci, artistic director, for his graceful support, Carole Daprey, Marianne Lassandro, Christel Durantin, Amaëlle Génot, Marie-Hélène Lafin, Jeanne Castoriano. And thank you to Quadrilaser, Kapp-Lahure-Jombar, and SIRC for the printing and binding.

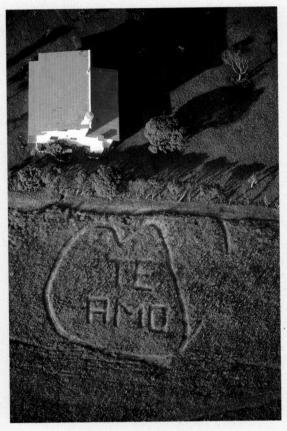

NEAR MAR DEL PLATA, Buenos Aires, Argentina

Previous spread: CRYSTALLINE FORMATION ON LAKE MAGADI, Kenya

All of the photographs were taken with Fuji VELVIA film (50 ASA). Yann Arthus-Bertrand worked primarily with CANON EOS 1N cameras and lenses. Photographs were also taken with PENTAX 640.

The aerial photographs of Yann Arthus-Bertrand are distributed by the Altitude agency in Paris: 30, rue des Favorites, 75015 Paris, France; e-mail: altitude@club-internet.fr www.yannarthusbertrand.com